ART IN THREE DIMENSIONS

Art in Three Dimensions

NOËL CARROLL

OXFORD
UNIVERSITY PRESS

OXFORD
UNIVERSITY PRESS

Great Clarendon Street, Oxford OX2 6DP

Oxford University Press is a department of the University of Oxford.
It furthers the University's objective of excellence in research, scholarship,
and education by publishing worldwide in

Oxford New York

Auckland Cape Town Dar es Salaam Hong Kong Karachi
Kuala Lumpur Madrid Melbourne Mexico City Nairobi
New Delhi Shanghai Taipei Toronto

With offices in

Argentina Austria Brazil Chile Czech Republic France Greece
Guatemala Hungary Italy Japan Poland Portugal Singapore
South Korea Switzerland Thailand Turkey Ukraine Vietnam

Oxford is a registered trade mark of Oxford University Press
in the UK and in certain other countries

Published in the United States
by Oxford University Press Inc., New York

British Library Cataloguing in Publication Data

Data available

Library of Congress Cataloging in Publication Data
Library of Congress Control Number 2009944007

Typeset by Laserwords Private Limited, Chennai, India
Printed in Great Britain
on acid-free paper by
MPG Books Group, Bodmin and King's Lynn

ISBN 978–0–19–955931–2

1 3 5 7 9 10 8 6 4 2

To my mother,
Evelyn Carroll,
who taught me to love learning.

Contents

PART V. NARRATIVE AND HUMOR

PART VI. THE ARTS

Art in Three Dimensions: An Introduction

1. OVERVIEW

Art in Three Dimensions is a collection of my essays in the philosophy of art, written during the last decade of the 1990s and the first decade of the twenty-first century. The animating idea behind this collection is that philosophers of art should eschew the sort of aestheticism that often implicitly—but sometimes explicitly, as in the case of aesthetic theories of art and of their commitments to the notion of the autonomy of art—governs their methodology. Instead, I argue that philosophers of art need to refocus their attention on the ways in which art enters the life of culture and the lives of individual audience members. The reference to "three dimensions" in my title refers to my view that philosophers of art should look at art from multiple angles and treat it as a substantial participant not only in society, but also as a significant influence upon the moral and emotional experiences of audiences.

In this regard the book takes as its foil aesthetic theories of art, of which formalism is perhaps the best known, as well as the ideas of art for art's sake and artistic autonomy—artworld positions that are often translated into philosophical methodology under the rubric of a concern with art *qua* art. Let us call this "art in one dimension." In contrast, the view advanced and defended throughout *Art in Three Dimensions* is avowedly pluralistic.

The first section of the book—"Art"—not only criticizes formalism and other attempts to define *art*, but also attempts to develop an approach to identifying art that is based on exploiting the resources of the tradition of art and which supports the kind of pluralistic enterprise pursued throughout the rest of the book, especially in Parts III, IV, V, and VI. Part II is devoted to the notion of aesthetic experience since that notion, as it is presently deployed, is crucial to the kind of aestheticism and suppositions of artistic autonomy to which I am opposed. In its stead, I develop a deflationary conception of aesthetic experience that is compatible with the project of interrogating art in three dimensions.

One tenet of formalism and even of weaker versions of the aesthetic theory of art is the denial of the relevance of the relation of art to society, ethics, and politics. Part III attacks not only the arguments that encourage the studious neglect of these relations but attempts to initiate alternative philosophical approaches to them.

When considering the relation of art to the emotions, formalists, such as Clive Bell, only countenanced the pertinence of what he called the aesthetic emotion—an experience of elation divorced from the flow of life. In Part IV, "Art and Affect," I attempt to demonstrate how much more diverse art is in engaging the feelings of its audiences. Part V, "Narrative and Humor," continues the theme of art's affective address by looking at the cases of the affect of comic amusement and the feeling of narrative closure, while also rounding off our earlier preoccupations with the relation of art and morality by means of an examination of the contribution of narrative to the ethical life.

An underlying presupposition of aesthetic theories of art is that the philosophy of art should develop a theory or a definition of what we might call Art with a capital "A." Indeed, the aesthetic theory of art is precisely such a theory and, I will argue, many of the methodological exclusions it advocates, whether conscious or unconscious, are a consequence of the philosophical commitment to the ambition of essentially defining art *qua* art. However, in the absence of such a definition, it may make more sense to focus upon the various artforms and their effects as well as the special problems that they raise. This is the project that Peter Kivy has called "The Philosophies of the Arts."[1] In this spirit, the last section of the book looks closely at certain individual artforms—notably theater, literature, dance, and music—for the purpose of broadening the scope of the philosophy of art in the direction of the philosophies of the arts.

2. BACKSTORY: FROM THE MODERN SYSTEM OF THE ARTS TO THE AESTHETIC THEORY OF ART

Notions of the autonomy of the art, of which the aesthetic theory of art is one of the most precise articulations, began to take hold in the eighteenth century as a result of the established crystallization and subsequent vicissitudes of what has been called "The Modern System of the Arts." Thus, in order to understand the way in which the philosophy of art has arrived at its current impasse, it is instructive to review how the aesthetic theory of art emerged from the presumption of a *system* of art, while questioning, along the way, the continued viability of that assumption.

2.1. The Modern System of the Arts

As is widely known, Paul Oscar Kristeller has argued that it is only in the eighteenth century that "Art" with a capital "A" decisively enlisted its core

[1] Peter Kivy, *Philosophies of the Arts: An Essay in Differences* (Cambridge: Cambridge University Press, 1997).

membership.[2] That is, "Art" with a capital "A" is a modern idea. In premodern times, the arts were any practice whose exercise required skill, based upon training, rather than solely upon some innate capacity.[3] So, carpentry was an art as was medicine, rhetoric, statesmanship, archery, and navigation. This conception of art was descended from the Latin notion of *ars* which itself was descended from the Greek idea of *techne*. Often when these arts (with a small "*a*," in the Latin sense) were sorted into different categories, the categorizations would be made on the basis of social status.

For example, the liberal arts, such as rhetoric and grammar (and by extension poetry), were those associated with free men, while the contrasting practical or mechanical arts, such as armature, building, and agriculture, were associated with slaves or laborers. That is, the liberal arts were liberated—the arts to be cultivated by those who did not have to work by the sweat of their brow as opposed to menial workers.

Many of the arts that we presently think of as card-carrying members of the Modern System of the Arts were previously classified as useful, or mechanical, or practical arts; painting, for example, was sometimes grouped with saddle-making, since saddles were painted. Even Vasari refers to painters as artificers rather than as artists.[4] If the liberal arts were cerebral and/or theoretical, the mechanical arts, including painting, sculpture, and architecture, were manual and held in diminished esteem for that reason.[5]

However, in the eighteenth century a consolidated way of grouping some of the arts (with a small "*a*") took root. In 1747, Abbé Charles Batteux wrote a treatise entitled *Les Beaux Arts réduits à un même principe* (*The Fine Arts Reduced to a Single Principle*). Batteux wrote: "We will define painting, sculpture, and dance as the imitation of beautiful nature conveyed through colors, through relief, and through attitudes. And music and poetry are the imitation of beautiful

[2] Paul Oskar Kristeller, *Renaissance Thought and the Arts* (Princeton, NJ: Princeton University Press, 1980). See also: W. Tatarkiewicz, "Classification of the Arts in Antiquity," *Journal of the History of Ideas*, 24/2 (April–June, 1963): 231–40; and Larry Shiner, *The Invention of Art: A Cultural History* (Chicago, IL: University of Chicago Press, 2001).

[3] Following Raymond Geuss, I define a skill as "an ability to act in a flexible way that is responsive to features of a given environment with the result that action or interaction is enhanced or facilitated, or the environment is transformed in ways that are positively valued." Moreover, that ability is learned and rests upon the body of practice, know-how, and norms associated with the art and acquired by training. See: Raymond Geuss, *Philosophy and Real Politics* (Princeton, NJ: Princeton University Press, 2008), pp. 15–16.

[4] See G. Vasari, *Lives of the Painters, Sculptors, and Architects*, 2 vols (London: Everyman's Library, 1996). This observation is corroborated by Catherine King, "Making Histories, Publishing Theories," in Kim Woods, ed., *Making Renaissance Art* (New Haven, CT: Yale University Press, 2007), p. 255.

[5] Indeed, artists of the Renaissance who we count as Artists with a capital "A" were often also engaged in pursuits that we would not readily count as Fine Arts such as military engineering, casting armor, and designing sugar sculptures. That is, painters and sculptors of the period did not regard those activities as utterly distinct from what—by the lights of the Modern System of the Arts—we might consider their more mundane labors.

nature conveyed through sounds, or through measured discourse."[6] Here, of course, the principle that unifies these practices under the same umbrella concept is the imitation of beautiful nature or the imitation of the beautiful in nature.

The idea of the imitation of nature, on this view, derives from the Platonic-Aristotelian identification of poetry and painting as essentially arts of imitation or *mimesis*. But the beautiful in nature that the arts are intended to portray also would appear to suggest a Platonic residue or, at least, a Neoplatonic one.

The beauty in question is most likely to be understood as the perfection, or completion, or idealization of nature. It is that which, Plotinus maintains, is accordant with the Ideal-Form which when stamped upon common shapes "gathers into unity what still remains fragmentary, catches it up and carries it within, no longer a thing of parts, and presents it to the Ideal-Principle as something concordant and congenial . . ."[7] The pertinent arts, on Plotinus's view, do not simply "imitate the visible world, but refer back to the emanation (*logoi*) from which nature derives."[8] The beautiful in nature is, so to speak, a construct. As Alberti suggests, "excellent parts should be selected from the most beautiful bodies and every effort should be made to perceive, understand, and express beauty."[9]

The tree in my garden, in other words, will never exemplify the Idea of tree-ness inasmuch as it will suffer the wavering material vicissitudes of wind, weather, and water. But the artist can offer us a more perfect approximation of the ideal. And that is what is involved in the imitation of the beautiful in nature—it provides us with a glimpse of reality, with an intimation of the Ideal, understood as that which really exists. Goethe says, for example: "The highest demand made on artists is this: that he be true to nature, that he study her, imitate her and produce something that resembles her phenomena," where he goes on to indicate that the resemblance pertains to the deep character of the phenomena, not its surface appearance.[10]

The Fine Arts or the Beaux Arts—poetry (presumably including theater), music, painting, sculpture, and dance—belong together conceptually on this account, since they, by their different means, share this common function. Moreover, insofar as this view assigns the relevant arts a cerebral or theoretical mission—the disclosure of the true nature of reality—this approach hives those arts off from the merely mechanical ones.

According to commentators like Kristeller, this way of organizing the arts was not stable before Batteux.[11] Comparisons between the arts under discussion were

[6] Abbé Charles Batteux, *Les Beaux-Arts réduits àun meme principe,* ed. Jean-Rémy Mantion (Paris: Aux Amateurs de Livres, 1989), p. 101.

[7] Plotinus, *Enneads* I.6.3. [8] Ibid., 5.8.1.

[9] Leon Battista Alberti, *On Painting,* Book III (London: Penguin, 1991), p. 90.

[10] Johann Wolfgang von Goethe, "Introduction to the *Propyläen* (1798)," in *Goethe on Art,* selected, edited, and translated by John Gage (Berkeley, CA: University of California Press, 1980), pp. 6–7.

[11] It is true that in the beginning of his *Poetics,* Aristotle lists the arts that Batteux lists under the rubric of mimesis and differentiates them. And there is no doubt that Batteux was influenced

often only pairwise—as in the cases of Plato, and Horace. In the Renaissance, comparisons between painting and poetry occurred, but often in the context of attempting to bolster the social status of painters and painting.

Artist-writers like Alberti and da Vinci desperately wanted to garner respect for their profession. To this end, they employed a number of strategies. They showed, for instance, that the painter possesses the kinds of knowledge, like knowledge of geometry, which was associated with the liberal arts, and, therefore, presumably the painter should be counted among the gentle folk. Moreover, artist-writers of the period produced theoretical treatises, another mark of the liberal arts. And, of greatest significance for my purposes, painting was frequently compared to poetry.

In his 1390 treatise *Il libro del arte*, the Florentine painter Cennino Cennini argues that painting is only second to poetry among the arts because both painters and poets have the power to reconstruct reality.[12] Da Vinci went further and drew the comparison to the benefit of painting, rating painting higher than poetry.[13] In the pursuit of status, sculpture then followed the lead of painting. In his 1504 treatise *De Sculptura*, Pomponio Gaurico links sculpture and poetry by arguing "writers work in words and sculptors work with things: the former narrate while the latter portray and exhibit."[14]

Of course, underlying these comparisons is the idea that if poetry has an elevated cultural status as a liberal art, then so should the arts that are either abundantly like it or that outdo it on its own terms. Comparison between painting and poetry and between sculpture and poetry were ways of socially enfranchising these visual arts as something more than mechanical or manual arts and of raising the symbolic capital of the artists who practiced them. Likewise when da Vinci semi-systematically compares painting not only to poetry, but to music and to sculpture—finding painting superior to music in virtue of being more permanent and superior to sculpture in terms of its ability to represent more aspects of things—he is not attempting to work out a principle that unifies these various endeavors; rather he is clamoring for social recognition.

by Aristotle. But I think Kristeller's point is not that the list was unprecedented but that it doesn't become canonical until the Enlightenment. In earlier days, as we've seen, various of the arts could easily find themselves grouped differently—music with mathematics, for example—whereas in the modern period this was less likely because the so-called Modern System had *become stabilized*, so to speak. Similarly, Tatarkiewicz, in his "Classification of the Arts in Antiquity," *Journal of the History of Ideas*, 24/2 (1963): 231–40, emphasizes the fluidity of the alternative groupings of the various arts in the ancient world. What happens in the eighteenth century is that the Arts with a Capital "A" are finally gathered into a fixed category such that it comes to strike us in the West as counterintuitive that these might be grouped in some other way. I think that this aspect of Kristeller's argument was neglected in the recent attack on Kristeller by James Porter in "Is Art Modern? Kristeller's 'Modern System of the Arts' Reconsidered," *British Journal of Aesthetics*, 49/1 (January, 2009): 1–24.

[12] King (2007), p. 256 (see n.4).

[13] Leonardo da Vinci, *The Notebooks of Leonardo Da Vinci* (Oxford: Oxford University Press, 1990), p. 201.

[14] King (2007), p. 274 (see n.4).

But the creation of the Modern System of the Arts appears to be about something more than achieving status (although, as my discussion of dance will indicate, it was about that too). The Modern System was, in addition, presented as a theoretical discovery. Poetry, painting, sculpture, music, and dance, it was hypothesized, formed a kind unto themselves. Undoubtedly, previous ventures in comparing the arts, especially in terms of poetry, paved the way for this conjecture. I say this because poetry, as theorized by Aristotle and Plato in terms of imitation, appears to have set the framework for yoking these particular arts in a single category. Nevertheless, it took a philosophical leap to go from those comparisons to the generalization that founded and stabilized the Modern System of the Arts.

Furthermore, the generalization—that this group of arts specialized in imitation—seemed approximately accurate, at least for a short time. That is, much of the most prominent art around the time that the Modern System of the Arts was erected fit the mimetic patent. For instance, most painting, sculpture, and poetry were imitative, as were the dominant musical forms with words, such as opera and song. Yet I only say "approximately accurate" here, because the very notion that a condition for membership in the church of modern muses was imitation also inspired some artists to reform and thereby transform their practices in that direction in order to be taken seriously. Choreography is an excellent example of this.

For Adam Smith, dance was merely "a certain measured step . . . which keeps time with, and, as it were, beats the measure of Music which accompanies and directs it . . ."[15] That is, for a philosopher like Smith, a country air or a social reel counts as dance, although it imitates nothing. Professional choreographers like Jean-Georges Noverre, however, realized that this conception of dance, given the cultural context, lessened its stature. And, as a result, Noverre attempted to annex the Aristotelian conception of poetry as a theory of dance. This highly revisionist maneuver not only involves excluding much social dancing from the order of ballet, but also cashiers from its ranks much of the non-imitative jumping and scampering that audiences of Noverre's own day would have considered the epitome of theatrical dancing.

Nevertheless, in spite of popular opinion, Noverre wrote, in 1760, in his *Lettres sur la Danse et les Ballets* that "I am of the opinion, then, that the name of ballet has been wrongly applied to such sumptuous entertainments, such splendid festivals which combine magnificent scenery, wonderful machinery, rich and pompous costumes, charming poetry, music and declamation, seductive voices, brilliant artificial illumination, pleasing dances and *divertissements*, thrilling and perilous jumps, and feats of strength."[16] Instead, Noverre argued that "A well-composed ballet is a living picture of the passions, manners, ceremonies, and customs of all nations of the globe . . .; like the art of painting, it exacts a perfection the

[15] Adam Smith, *Essays on Philosophical Subjects* (Oxford: Oxford University Press, 1980), p. 207.
[16] Jean-Georges Noverre, *Letters on Dancing and Ballets* (New York: Dance Horizons, 1975), p. 52.

more difficult to acquire in that it is dependent on the faithful imitation of nature."[17]

In his *Letters*, Noverre explicitly acknowledges his debt to Aristotle and the reigning concept of imitation. At the same time, Noverre realizes that not everything that might be called dance by his contemporaries fell into what might be called the Art of dance with a capital "A", that is, the dancing that belongs in the Modern System. In large part, that kind of dance remained to be created in the very image of the Modern System of the Arts and, of course, Noverre, himself, was a major agent in that project, inventing as he did the so-called *ballet d'action* that served as the staple of the emerging Romantic Ballet which would come to reign over the early nineteenth century. Noverre, in effect, broadcast a self-fulfilling prophecy, using the defining feature of the Modern System of the Arts as his touchstone, and thereby enfranchising theatrical dance as an Art with a capital "A."

Peter Kivy has suggested that a similar story might be told about the evolution of program music. Program music became increasingly important in the eighteenth century, beginning with Johan Kuhnau's publication of his six Bible sonatas in 1700. Later examples include Vivaldi's *Four Seasons* and Couperin's *Apothéoses*. The development of program music was connected to the production of music for the ballet. But by the mid-eighteenth century, program music was being produced independently of the dance as in the case of Ignazio Raimondi's *Les aventures of Télémaque dans l'isle de Calypso*, which was based on an epic poem by Fénélon. By taking on the function of narrative, Kivy speculates, composers, heretofore held in lowly esteem, were attempting to elevate themselves to the status of poets, a hypothesis perhaps partly confirmed by Liszt who in coining the phrase program music spoke in terms of the articulation of a "poetic idea."[18]

With other of the relevant artforms, regimentation was perhaps less immediately urgent than with dance and program music. Poetry, whether narrative, dramatic, or lyrical, was generally representational, as, of course, was music with words, including songs, hymns, and opera; likewise the most prominent painting and sculpture was imitative. Thus, the notion that what unified these practices was the imitation of the beautiful in nature seemed persuasive, by and large,

[17] Ibid., p. 16.

[18] The material on program music comes from Roger Scruton's "Programme Music: 1. The Form and its Meaning; and 2. History of the Concept," in *Grove Music* online, available at: <http://www.grovemusic.com>. Peter Kivy's remarks were made at the Aesthetics Conference in Honor of Gary Iseminger at Carlton College on October 20, 2007. Concerning the low repute with which composers and instrumentalists were regarded, consider this quotation from Boethius's *Consolations of Philosophy*: he depreciates instrumentalists as "servants who do not make any use of reason and are altogether lacking in thought" and composers as tune makers whose activity originates "not so much by speculation and reason as by a certain natural instinct." Boethius only has fine words for music when it is connected to theory, as when philosophers contemplate the music of the spheres. See: Oliver Strunk, ed., *Source Readings in Music History*, rev. edn by Leo Treitler (New York: W.W. Norton, 1998), p. 142, and Tim Blanning, *The Triumph of Music: The Rise of Composers, Musicians, and Their Art*, (Cambridge, MA: Harvard University Press, 2009), p. 11.

while, at the same time, it also accorded these practices a certain dignity. For, insofar as they were in the business of disclosing nature shorn of the cluttering details of contingency, these practices could lay claim to subserving the quest for knowledge in a way parallel to the sciences.

On the founding conception of the Modern System, the relevant practices were committed to revealing reality, as were the sciences. There can be no doubt, I think, that representation was the most important entry ticket into the Modern System. For, even when theorists like Lessing and Dubos attend to what differentiates the arts in the Modern System, what they focus upon is what the different arts *represent* best. Moreover, the emphasis on representation fit well empirically with the art that surrounded audiences in the eighteenth century, while also, undoubtedly with the approval of da Vinci, placing these practices alongside of the sciences in the knowledge game.

However, no sooner is the Modern System of the Arts gotten up and running, then both of these advantages began to unravel. Internal to the System, the growing popularization of absolute music, as explicitly distinguished from program music, threatened the unity of the System, since most absolute music imitates nothing. That is why it is called *absolute music*. Nor is this a minor anomaly, like non-imitative folk dancing, since pure orchestral, non-programmatic music quickly became a leading artform, one to whose condition other artistic practices in the System were at least alleged to aspire. Thus, the System appeared imperiled from the inside virtually upon its arrival on the scene.

But things were not working out in favor of the System externally either. For, by tying the reputation of the Modern System of the Arts to its capacity to deliver knowledge through representation, the arts were pitted in a losing competition with the natural sciences whose breakthroughs from the seventeenth century onwards, especially with reference to nature, manifestly dwarfed the contributions of the arts. Thus, the Modern System of the Arts started teetering, almost as quickly as it was erected.

On my view, much of the subsequent development of the philosophy of art has most often involved the attempt to find a replacement for the notion of the imitation of nature or of representation that first rationalized the Modern System of the Arts. Most notably, there have been two recurring strategies for repairing the unity of the Modern System. The first has involved versions of the expression theory of art, including Hegel's expression-of-history-theory-of-art, but, more often than not, perhaps under the influence of Romanticism, these theories have been about the expression of the various mental states of individual artists. The second strategy is what I previously called the aesthetic theories of art.

It is my contention that both these approaches have failed to find some principle of unity for the Modern System of the Arts. The reason is that the Modern System of the Arts is no longer a system. Indeed, in my estimation, it was a barely a system in the first instance, since it ignored various claimants for theoretical attention, such as non-imitative dance, but, even in this unstable state, it only lasted very briefly. And since that time, the prospects for repairing

the incongruities amongst the practices thought to be within the ambit of Art with a capital "A" have dwindled exponentially.

Rather, the so-called system is by now at best a collection of disparate practices whose actual unity is historical. What we now recognize as members of the Modern Collection of *a*rts are practices that are genealogically related to those practices which once at least fleetingly appeared to have a generally shared function in the eighteenth century. Since that time, no other singular, shared function of comparable persuasiveness has been identified. And that is a fact that the philosophy of art needs to negotiate, in part, by re-tooling itself in terms of the philosophies of the arts (where being one of the relevant arts is to be determined by means of historical narration).

Yet before I say anything further about this, I need to indicate why I think that neither expression theories nor aesthetic theories can make sense of what we still call, if only honorifically, the Modern System of the Arts, which, to speak frankly, might be better labeled "Our Inherited Collection of the *a*rts."

2.2. The Autonomy of Art and Aesthetic Theories

According to Kafka's parable of "The Leopards in the Temple," "Leopards break into the temple and drink to the dregs what is in the sacrificial pitchers; this is repeated over and over again; finally it can be calculated in advance, and it becomes part of the ceremony." Likewise, since the eighteenth century philosophers of art have been indulging in an obsessive return to the origin of the Modern System which has become a ceremony, namely, the recurring search for some principle to relieve the obsolescence of the representational theory of art that founded the system and, thereby, to return order to the Modern System. As Deleuze and Guattari might put it, our inherited collection of arts has shot off rhizomatically in so many different directions—ones often chosen in explicit defiance of the theories of art that would pretend to organize them—that our almost compulsive reversion to the search for these theories has become effectively ritualistic. The invention of new artforms, like the cinema, video art, conceptual art, and so forth, and over a century of avant-garde attempts to outrage not only the bourgeoisie, but the philosophers of art, have made a shambles of the Modern System.[19] We are living in its ruins.

Of course, as noted previously, developments within the inaugural artforms had already challenged the Modern System, almost upon arrival. For it was difficult to incorporate a great deal of the pure orchestral music by means of the

[19] For example, many of the novel artforms that have arrived on the scene—such as cinema, photography, and video—appear only to lay claim to art status, as in our earlier example of dance, by aping artforms already in the System. Cinema at first apes theater; photography, painting; and video, cinema. But, after this first stage of imitating pre-existing artforms, the new entries declare their independence from the artforms they initially copied and they emphasize their differences from their forebears, often by exploiting what are allegedly unique features of the relevant media. This then leads to further refinements, revolutions, and counter-revolutions, branching off rhizomatically into many different programs such that the artforms in question can only be related genealogically.

concept of imitation. Thus, if the Modern System was to be sustained, it would have to be founded upon some other principle.

The notion of expression was one option, one encouraged by Romanticism, and, indeed, it is probably still the most popular opinion regarding the nature of art among the lay audience. And it has also influenced many philosophers for at least half a century. It even served, more so than any other theory, as the philosophy of art that enfranchised film as an artform on all fours with the original members of the Modern System.[20]

However, much of the ambitious art of the twentieth century was created in ways that aspired to defeat expression theories of art. Conceptual artworks, found objects, and aleatoric art challenged the expression theory of art by devising strategies predicated upon severing the connection between the relevant mental states of the artist and his artworks. The Dadaist, Tristan Tzara, made poems by cutting words out of newspaper articles, tossing them into a hat, and drawing them out randomly. The resulting concatenation could scarcely count as an authentic expression of his emotions, if, indeed, he was feeling any.

Nor could it help the expression theorist to protest that anything produced by a human being cannot avoid being an expression of the feelings of its maker, because (1) this is patently false and (2), if it were true, that would entail the existence of far too many artworks.

I will not dwell on the shortcomings of the expression theory of art, since it does not appear to be a pressing theoretical option at present.[21] However, there are a growing number of philosophers who still have faith that some form of the aesthetic theory of art can put the Modern System back together again.

The aesthetic theory of art—and the corresponding idea of artistic auton-omy—begins to take shape in the eighteenth century around the same time that the Modern System of the Arts is being cobbled together, although the theory does not emerge fully formed until the nineteenth century. The notion of disinterestedness, introduced by Shaftesbury, is an initially important ingredient. For Francis Hutcheson uses the idea of disinterested pleasure as the cornerstone of what we might call, albeit with some strain, a proto-aesthetic theory of art, although what it is, more precisely, is an aesthetic theory of beauty.

On Hutcheson's account, beauty is a sensation and the experience of beauty in response to an artwork is a feeling of disinterested pleasure triggered by a certain proportion of uniformity amidst variety in the stimulating object. Kant agrees with Hutcheson that, with respect to judgments of free beauty, these judgments rest upon a subjective experience of disinterested pleasure which arises from the free play of the imagination and the understanding while attending to forms of finality. From here it is but a short step—taken by popularizers, perhaps beginning with Benjamin Constant, who understood Kant's *Critique*

[20] See, for example, Rudolf Arnheim, *Film as Art* (Berkeley, CA: University of California Press, 1956).

[21] For criticism of expression theories of art, see Noël Carroll, *The Philosophy of Art: A Contemporary Introduction* (London: Routledge, 1999).

of Judgment insufficiently—to an aesthetic theory of art, i.e., to the contention that an artwork is such that it is intended to afford experiences of disinterested pleasure.[22]

This viewpoint is captured initially by the phrase *l'art pour l'art* which first appears in an entry in Constant's *Journal intime.* Constant uses the slogan to summarize what he's just been told about Kant's aesthetics by Henry Crabbe Robinson, a student of Schelling's; apparently Robinson or Constant used the expression *l'art pour l'art* as a synonym for Kant's notion of disinterestedness.[23] For Constant, this appears to signify that art is not useful and that it has no purpose other than to be beautiful. Art is, so to speak, for its own sake and not for the sake of something else, like moral education or edification.

The view of "Art-for-Art's Sake," sometimes stated as *l'art pur,* initially broadcast by Constant and Madame de Staël was disseminated in Paris where it influenced people like the popular philosophy professor Victor Cousin, and the writer Theophile Gautier, who spread the doctrine even more widely.[24] The term was also used by the critic Saint Beuve to describe contemporary artistic tendencies.[25] Throughout the nineteenth century, as witnessed by Tolstoy's vituperations against it, the idea of *l'art pour l'art* flourished, blossoming into the aestheticism of Walter Pater, James McNeill Whistler, and Oscar Wilde.

This form of aestheticism corresponded neatly with changes in the patterns of consuming art that occurred as the bourgeoisie became an important part of the clientele for art. In premodern times, the primary consumers of art had been imposing social players: the monarchy, the aristocracy, the Church, the guilds, the municipalities, and so forth. These patrons commissioned artworks to serve important social purposes: to honor the king, to instill loyalty or obedience, to preach the commandments, to commemorate historical achievements and sacrifices, etc.[26]

In contrast, the rising bourgeois classes, with increasing amounts of leisure at their disposal, frequently looked to the arts as a delightful way of passing time. Although people continued to use the arts for ends other than amusement, the association, that was evolving in theory, of the arts with beauty, of beauty with pleasure, and of the arts as a source of that pleasure, also fitted the new patterns of consumption nicely.

Of course, as a matter of definition, the connection between art and pleasure was obviously inadequate.[27] Pleasure is not a necessary condition for art. Think of all those altarpieces of the crucified Christ. They were not meant to instill

[22] John Wilcox, "The Beginnings of *l'art pour l'art*," *The Journal of Aesthetics and Art Criticism,* 11 (1953): 363. See also: Irving Singer, "Aesthetics of Art for Art's Sake," *The Journal of Aesthetics and Art Criticism,* 12 (March 1954): 343–59.

[23] Wilcox, "The Beginnings of *l'art pour l'art.*" [24] Ibid. [25] Ibid.

[26] As also noted by Terry Eagleton in his *The Meaning of Life: A Very Short Introduction* (Oxford: Oxford University Press, 2007), p. 21.

[27] Also, it should be noted that there is an obvious problem with the *disinterestedness* component of the notion of disinterested pleasure with respect to artworks, since many artworks mandate emotional responses and most emotions are underwritten by interests.

pleasure in the hearts of the faithful, nor did they. Likewise, innumerable visions of hell, though undeniably art, were clearly not intended to provoke gladness, but horror. Nor was pleasure, even disinterested pleasure, sufficient for art status, since so many other things, such as mathematics could be said to impart it.

Because disinterested pleasure was too narrow to cover the field, it was replaced by a more elastic concept, namely that of aesthetic experience, understood as experiences valued for their own sake. Moreover, crucially, where Hutcheson and Kant had proposed disinterestedness as a condition for making judgments of taste, subsequent theorists made having disinterested experiences—experiences valued for their own sake—the very point of engaging with things like artworks. Arthur Schopenhauer is a decisive moment in this transition, since for him aesthetic experiences liberate one from the mundane world of suffering and are occasioned by a feeling of release. This notion of aesthetic experience then is given a less Wagnerian inflection by Clive Bell who domesticates it somewhat in his book *Art*.

In Bell, someone unquestionably familiar with the aestheticism of Pater, Whistler, and Wilde, one finds a distillation of the kind of thinking that we saw emerging from the eighteenth century and its redeployment in an aesthetic theory of art. For Bell, art is defined in terms of significant form (an echo of Kant's forms of finality), which is what gives rise to aesthetic emotion (aka aesthetic experience), itself said to be a release from ordinary, garden-variety emotions and the concerns and interests they serve. It remains for subsequent philosophers like Monroe Beardsley to attempt to weave the basic eighteenth-century elements of Bell's theory into an effective aesthetic definition of art.

Although I am anything but a friend to this sort of theory, I do concede that it is undeniably alluring. Its keystone is the concept of aesthetic experience, experience valued for itself and not for any end that it might serve. By making this the essence of art, the aesthetic theorist, in the same breath, separates art from every other end (moral, cognitive, political, religious, etc.), since the aim of art is an experience disconnected from everything else. Thus, the aesthetic theorist appears to realize the goal of a successful analysis almost automatically by the choice of his central, defining concept.

Moreover, the aesthetic theory of art offers an appealing, systematic set of answers to some of the most nagging questions in the philosophy of art. For example: what determines the degree of goodness of a work of art? The amount of aesthetic experience it affords. And: what counts as a reason for commending a work of art? Any feature of the work that contributes to its capacity to deliver aesthetic experiences. And so on.

In fact, I would contend that, due to the undeniable attractions of the aesthetic theory, it has come to function as something like the super-ego of the analytic philosophy of art. For many of the unexplored, under-examined, or forbidden aspects of art under the analytic dispensation—such as authorial intention, art history, emotional arousal, morality, politics, etc.—have been exiled exactly because they are irrelevant from the perspective of the aesthetic theory of art. Even many philosophers who do not endorse the aesthetic theory of art explicitly,

nevertheless seem persuaded by arguments subtly based upon it—arguments with names like the intentional, genetic, and affective fallacies. Indeed, it is my contention that it is the influence of the aesthetic theory of art that is responsible for the kinds of exclusions—with regard to moral and cognitive value, for example—that this book is partly devoted to recuperating.

Stated in one of its best-known formulations, the aesthetic theory of art maintains that something is a work of art if and only if it is created with the *primary* intention to afford aesthetic experiences. This theory combines the eighteenth-century desire for a principle that defines art with a capital "A" by means of a concept, here that of aesthetic experience, which concept, in turn, also owes its provenance to the eighteenth century. Admittedly, this theory is very elegant. But it doesn't take much effort to show that this version of it is misguided.

Much of what we call art was not created with the primary intention to afford aesthetic experience. Many objects that we regard as art objects were originally intended to be ritual objects, like the masks of the Dan tribe of Liberia; they were not intended to be contemplated but to be utilized and were discarded after they were used to wipe the blood off sacrificial blades after circumcisions.[28] Some of what we recognize as art—like the images on tribal shields and war-paint on the faces of warriors—are not meant to be delectated by invaders, but to scare them away. The Maori invented a dance called the *haka* which involves stamping feet, beating the chest, bulging one's eyes, sticking out one's tongue, and so forth for the purpose of sending intruders running off for their lives rather than in order to entrance them in experiences that they would value for their own sake. Indeed, had they entranced invaders, these dances would have been self-defeating. Nor do we have to go to remote, alien societies in order to find counterexamples to the claim that a necessary feature of art is that it be primarily intended to support aesthetic experiences. Innumerable religious paintings in our own culture were created to assist devotion and their creators would have found it sacrilegious for them to be treated otherwise.

In response, the aesthetic theorist might dilute the definition by dropping the qualification "primary." But then it may be hard to exclude very many contemporary, manufactured items from the order of art, since most of them are designed to afford, one way or another, some inkling of the sort of experience the aesthetic philosopher would accept as meeting his requirements. Even toilet plungers are designed nowadays. I have one that looks like an abstract sculpture. So, jettisoning "primary" from the formula would entail a grievous loss of definitional sufficiency. It would not only admit a flood of manufactured goods, but also mathematical theorems that are elegantly contrived intentionally.[29]

[28] Roy Harris, *The Necessity of Art Talk* (London: Continuum Books, 2003), p. 114.

[29] At this point, it might be argued that my victory here over aesthetic theories of art is too easy, since I have not tackled a very sophisticated version of the theory. A more sophisticated version, it might be maintained, would be able to stand its ground. To my mind, the most sophisticated version of an aesthetic theory is Gary Iseminger's *The Aesthetic Function of Art* (Ithaca, NY: Cornell

Furthermore, the concept of aesthetic experience that the aesthetic philosopher typically relies upon so heavily is also problematic. Clearly, it is not sufficient to pick out only art-relevant experiences, since, if one accepts the notion of intrinsically valued experiences, there are many sources for them besides artworks, including ones involving controlled substances and sex.

Nor is it evident that aesthetic experiences must necessarily be experiences valued for their own sake. The classic case here is the student who attends to a work of art *qua* the kind of work it is, noticing all of its pertinent artistic features and understanding their relationships perfectly, but who does so solely in order to pass an examination. He values the experience, in other words, instrumentally rather than for its own sake. Yet it would appear arbitrary to say the student did not have an aesthetic experience of the work. If he is focused with understanding upon the relevant patterns in the music, if he is following the music as it unfolds, then what kind of experience could he be having, if not an aesthetic experience?

However, an even deeper worry about the version of aesthetic experience on the table is that it is so empty and impoverished. Imagine trying to tell someone how to go about having one. I can assist another person's understanding of a piece of dance by calling her attention to certain recurring patterns of figures and movements. I can show what there is to look for and, thereby, how to absorb herself in the choreography. But telling her to try to value the experience for its own sake is about as unhelpful a piece of advice as I can imagine.

Although putatively pertaining to an appropriate mode of attention to art-works, the ruling notion of aesthetic experience supplies no substantive guidance regarding how one might do it. It is even less helpful than Bell's notion that such experiences are grounded in attention to significant form. In short, from the perspective of explaining how to appreciate art, the concept of aesthetic experience is nearly vacuous. Nor would it be of any service in attempt-ing to design experiments regarding our responses to artworks, since it is so elusive.

Thus, given the liabilities of the notion of aesthetic experience that gen-erally fuel aesthetic theories of art and corresponding affirmations of artistic autonomy, it should be no surprise that the time has come for a reinvention of the philosophy of art. The natives are restless. Instead of the autonomy of art, we need heteronomy; instead of a definition of art, like the aes-thetic definition, we need genealogies; instead of the philosophy of art with a "Capital A," more attention should be paid to the philosophies of the arts, their effects, and the special problems they raise; rather than search-ing for uniformity across all the arts, respect differences. In short, let us endorse not merely pluralism, but pluralisms. Let a wealth of research programs bloom.

University Press, 2004). For my objections to this view, see my review of Iseminger's book, in *The Philosophical Quarterly*, 58/233 (October 2008): 732–40.

3. MY AGENDA

The eighteenth century evolved and refined the concept of aesthetic experience, which subsequently suggested to many philosophers a key for solving the problem of defining art, namely: art is something that is produced with the intention to promote or afford aesthetic experience. This view whose prototype perhaps makes a fledgling appearance in Hutcheson's theory of relative beauty has been distilled and defended in the contemporary philosophy of art from the nineteenth century into the present.

However, throughout this book, I argue that even the most sophisticated versions of the aesthetic theory of art have failed. Moreover, it is not even clear that the question such theories appear to be designed to answer are still pressing. For even if there were a System of the Arts, rooted in a coherent principle, in the eighteenth century, that system has since broken down under the pressure of history. Among other things, its walls have been breached by readymades and found objects. At this juncture, it makes more sense to recalibrate our inquiries in terms of the various arts (with a small *a*) which command our attention, asking about their functions and purposes, their means of discharging them, and the special problems these practices raise. In other words, as Peter Kivy has urged, let us transform the philosophy of art into the philosophies of the arts. We have no reason to worry that we will be mistaken for philosophers of law, if we give up the title of philosopher of art and call ourselves philosophers of music or of literature. All we will be forswearing is the responsibility we never mastered anyway, the definition of art with a capital "A."[30]

Along with the idea of art with a capital "A," aesthetic experience, conceived of as an experience valued for its own sake, is also a dead end. Appearances notwithstanding, I do not think that it helps us construct a serviceable definition of art. Even less does this concept enhance our understanding of the nature of our engagements with works of art.

For it is too thin a conception to do so. It has virtually no substance. It is too elusive to operationalize. I can tell you how to look at an impressionist painting in a way that will enable you to experience it appropriately. I can design experiments to ascertain which structures in musical works correlate with certain feelings rather than others. But I cannot tell you how to go about having an

[30] Another advantage in speaking of the philosophies of arts, rather than of Art, is that it will dissolve the perplexing question of the identification of so-called first-art that bedevils the family-resemblance approach, as well as other approaches, to the question of sorting the Art from the Non-art. For, even if there is a problem in principle with naming the first work of Art with a capital "A" on some theories, the problem is not so daunting when it comes to identifying the earliest sculptures or proto-sculptures. Needless to say, I am not claiming that this can be accomplished empirically; I am only suggesting that it is not a theoretical impossibility as it might appear to be on certain proposals regarding the application on the concept of art with a capital "A" to the relevant objects and performances.

aesthetic experience of any unspecified kind of work of art whatsoever, nor can I test for variations in aesthetic experience when it is defined so abstractly, or, less charitably, amorphously. Just as it may be more instructive to speak of categories of artworks rather than Art with a capital "A," I suspect that we will learn a great deal more by focusing upon our responses to specific kinds of artworks rather than artworks bereft of functional and structural differentiation—that is to say, in terms of aesthetic experience, as that notion has come down to us from the eighteenth century.

Of course, we need not focus exclusively upon the nature, effects, or responses that pertain to all and only singular artforms. Some problems (like the paradox of fiction) and some of our responses to artworks (such as comic amusement) may cross artforms and be comparatively studied with profit. Likewise some artistic practices (such as narrative) may occur in several artforms, and it will be useful to compare and contrast the way that they function in different contexts. Moreover, clearly some artistic functions (such as moral acculturation) span many artforms, and the ways in which those artforms perform such functions deserve to be theorized, not only in isolation but in tandem.

My point is not that we should never compare the arts or that we should never philosophize across them. Rather, my point is that we should not proceed under the assumption that the pertinent philosophical problems and practices will apply to *all* the arts that concern us; nor should we presuppose that there is some single affective state, or experience, that every artform is designed to deliver. That is, if we endeavor to make statements across a range of artistic practices and responses they engender, we should proceed from the bottom up rather than from the top down.

Furthermore, by severing the notion of aesthetic experience, as experience valued for its own sake, from the concept of art, the possibility opens up of re-appropriating as topics for the philosophy of art all of those purposeful relations that the aesthetic theory of art bracketed in principle—including the relation of art to morality, politics, religion, sociality, the garden-variety emotions, and so forth. If Clive Bell, that arch-aesthetic theorist, advocated art as a means to escape the stream of life, it is the ambition of this book to plunge it once again back into the flow of our vital personal and cultural concerns.

PART I

ART

1

The Descent of Art

In this chapter, I will introduce what is called analytic philosophy in the Anglo-American tradition; I will discuss the relevance of analytic philosophy to certain questions about art, especially how one identifies something as a work of art; I will rehearse several ways in which analytic philosophers have attempted to answer this question; finally, I will suggest that such questions, like questions of species membership in biology,[1] might be best thought of in terms of descent.

1. INTRODUCING ANALYTIC PHILOSOPHY

Theoretical positions or schools of thought like analytic philosophy are difficult to summarize because there is intense controversy—often among their own practitioners—over what their central tenets really are. Often people supposed to be card-carrying members of the tradition challenge what are thought to be its fundamental presuppositions or regard them as false. In this respect, a tradition such as analytic philosophy is more like an ongoing conversation—often in the sense of a spirited debate—than it is like a list of essential doctrines or unrevisable theses.

To offer a simplified description of analytic philosophy, one may begin by saying what many—but not all—once took it to be. A natural first question about analytic philosophy is: "what exactly does this form of philosophy *analyze*?" We might say it analyzes concepts. That is why it is also sometimes called conceptual analysis. Many would argue that this is not all that analytic philosophy does, but, for the purposes of this chapter, I think it fair to say that this is what many analytic philosophers have attempted to do in the past and what many, at least part of the time, continue to do today. They analyze concepts.

Concepts, of course, are fundamental to human life. Concepts organize our practices. The concept of a person, for example, is central to myriad practices, including those of politics, morality, the law, etc. The concept of a number is fundamental to mathematics, while the concept of knowledge is indispensable throughout the widest gamut of human activities. A rough and ready way to characterize analytic philosophy is to say that it is concerned with the analysis of

[1] For an introduction to the issue of biological speciation, see Sober (1993).

concepts that are key to human practices and activities, including not only those of inquiry, like science, but, as well, of pragmatic endeavors, such as governance. Analytic philosophers in this regard may trace their heritage back to Socrates who walked the streets of Athens asking "what is knowledge?" and "what is justice?" in ways that undermined commonplace and often complacent answers to these questions, thus paving the way, the analytic philosopher might say (in a self-congratulatory tone of voice), for more rigorous analyses.

Much Anglo-American philosophy takes the form of "the philosophy of —" where the blank is usually filled in by a name, such as biology, or history, or law, or art. The name that fills in the blank is the name of some practice of inquiry or practical affairs, and what the philosophy of the practice in question investigates are the concepts that are central to or fundamental to the arenas under discussion—the concepts that organize the practice in question and that make activities within the practice possible (or, to say it another way, the concepts that constitute the practice).

The philosophy of law, for example, examines the central concepts of jurisprudence. Of course, one of the central concepts of this area is indeed the very notion of a law. So a major question of the philosophy of law is "What is a law?" That is, under what conditions do we classify an injunction as a law? Is a law whatever a duly constituted assembly endorses as a law in accordance with established procedures? Or does a law, properly so called, have to follow from or at least be consistent with deeper principles—maybe deep constitutional principles or even the claims of human rights? Analytic philosophers also attempt to identify the criteria we use to categorize things one way rather than another. Sometimes this is dismissed as merely playing with words. However, when one considers how much can ride on questions of categorization, it seems that analytic philosophers are generally less naive than those who disparage them as "mere logic choppers."

Much Anglo-American philosophy has thus increasingly become a "second order" form of inquiry. It is the philosophy of this or that—of physics, or of economics, or of art. That is, analytic philosophy has taken significant forms of human practice as its domain, not in terms of discovering within them recurring patterns of social behavior, as a social scientist might, but in terms of clarifying the concepts that make activities within the relevant domains of practice possible.

Of course, art is a significant form of human practice, one that deploys a wide range of concepts that make the activities of artmaking, art appreciation, art history, and art criticism possible. Some of these concepts include representation, expression, aesthetic experience, authorial intention, fiction, interpretation, aesthetic quality, style, and the like. An analytic philosopher of art analyzes concepts such as these.

Wollheim, for example, has advanced a very important account of the concept of representation, notably of pictorial representation, in terms of what he has called "seeing-in" (1987: Ch. 2). He has also offered a penetrating analysis of perceptual meaning (1998). In both cases, he is involved in the prototypical activity of analytic philosophers, namely the analysis of concepts. Periodicals such as *The Journal of Aesthetics and Art Criticism* and the *British Journal of*

Aesthetics—which are the leading venues for the analytic philosophy of art in the English-speaking world—specialize in articles that analyze not only the aforesaid concepts but many others, including dance, metaphor, ugliness, musical meaning, beauty, aesthetic properties, and so on.

Of course, one of the concepts fundamental to the practice of art is the very notion of "art" itself. This gives rise to the question "What is art?" However, this question can be taken in at least two ways. It can be a question about the practice of art as a whole in contradistinction to other practices like sports. What is the difference between the artworld and the sportsworld? Or it can be a question about individual works of art—what makes this item, a painting by Georgia O'Keeffe, an artwork, in contradistinction to my kitchen sink, which cannot be subsumed under the concept of an artwork? Or what leads us to classify certain things rather than others as artworks?

I will now be concerned with what analytic philosophy has to contribute to answering this variation on the question "What is art?"—i.e., to the issue of articulating the conditions under which something counts as an artwork. Though the question may seem academic, a little reflection should reveal that it is absolutely foundational to our participation in the practice of art. For instance, for those of us who make up the audience, how we respond to an object—interpretively, appreciatively, emotively, and evaluatively—hinges crucially upon whether or not we categorize it as an artwork. If a scattering of debris on the floor is categorized as an artwork—an installation, for example, by Robert Morris—then an interpretation of the meaning of the work will be appropriate, including, perhaps, recondite allusions to art history; but if it is an ordinary mess, a cleaning up is probably what's called for. Whereas cleaning up a Robert Morris installation might be tantamount to vandalism, not cleaning up my garage is merely shiftlessness. In short, classifying something as an artwork makes possible or is essential to many of the other artworld activities that preoccupy us.

Perhaps in days gone by the question of how we go about classifying objects and performances as artworks was not so pressing. For centuries, it seemed that many people could do this with a high degree of accuracy and consensus, almost intuitively, even across cultures. That is not to say that people understood the art of other cultures intuitively, but only that cross-cultural recognition of the artifacts different cultures regard as falling into the category Westerners call "art" obtained at rates that were anything but random.

Nevertheless, the emergence of avant-garde art in the West, at least, problematized whatever easy, general convergence in identifying art might have existed hithertofore. Readymades, such as Marcel Duchamp's notorious *Fountain*, thwarted ordinary expectations about what counted as art rather than non-art in such a way that, if *Fountain* were to count as art, the concept of art that enfranchised it would have to be made explicit and defended. The days of intuitive consensus, if they ever truly existed, were over and the practices of the avant-garde artworld made the clarification of the concept of art an almost existential question.

It is no accident that the analytic philosophy of art has expanded most dramatically during what we might call the age of the avant-garde, since developments in avant-garde art, like hard cases in the law, have grievously taxed us to become aware of what is and is not presupposed by our concept of art. The evolution of the avant-garde has forced us to regard certain familiar features of artworks—like beauty and verisimilitude—as contingent, and to refine ever more expressly the conditions in accordance with which we classify something as art. One way to understand the analytic philosophy of art is as an attempt to come to terms with avant-garde art—specifically, to explain how the initially strange mutations of the avant-garde fit within the concepts that regulate already existing artistic practices.

2. THE ANALYTIC PHILOSOPHY OF ART

One might say there have been three major movements in the analytic philosophy of art. I will call them: unselfconscious essentialism, the neo-Wittgensteinian interlude, and self-conscious essentialism.

Unselfconscious essentialism, as represented by Clive Bell in the early years of the twentieth century, attempted to explicate the concept of art by means of what we might call the classical theory of concepts. On this view, concepts could be explicated by sets of necessary conditions that were jointly sufficient.

A necessary condition for x, is a feature that x must possess in order to count as an x. For example, maleness is a necessary condition for bachelorhood, femaleness is a necessary condition for being a princess. X is a princess, only if x is female; if x is a male and x is unmarried, then that is sufficient for x being a bachelor; so being male and being unmarried are each necessary conditions for being a bachelor and together they are jointly sufficient—x is a bachelor if and only if x is male and x is unmarried. For the classical theory of concepts, to analyze or to explicate a concept is to advance the necessary and sufficient conditions for its application.

Clive Bell offers such an analysis or essential definition of art: x is an artwork if and only if x possesses significant form. Significant form, then, was the essential feature of art, that which distinguished art from everything else. I call Bell's position "unselfconscious essentialism," for he thought that this approach to the analysis of concepts was unproblematic.

Bell's theory was open to many criticisms—not the least of which was that the notion of significant form was woefully unspecified. Bell offered little indication of what constituted significant form and, with no idea of that, there was no way of using it as a sign of art status. However, by mid-century, another type of criticism was directed not at the content of theories like Bell's, but at their underlying presupposition that art was the type of concept that could be analyzed in terms of essential definitions—that is, in terms of sets of necessary conditions that were jointly sufficient.

Since this sort of criticism claimed to be influenced by the later writings of Wittgenstein, it is often referred to as neo-Wittgensteinian.[2] Neo-Wittgensteinian aesthetics contained at least two components: first, a critical component that argued that all previous attempts at art philosophy, which all allegedly relied on the application of the classical theory of concepts, were mistaken; and, second, a constructive component which proposed an alternative means—referred to as the method of family resemblances—for identifying candidate works as artworks.

On the negative side, the neo-Wittgensteinians argued either that no concepts were analyzable by means of the classical theory of concepts, or, at least, that very few were. We are able to identify the instances of many concepts (such as chairs) for which we lack essential definitions in terms of necessary conditions that are jointly sufficient. Why suppose that art is not like this?

It was also argued that art was not the sort of concept that could be analyzed in this way because art was an open concept, a label denominating a field of activity where originality and invention were, so to say, permanent possibilities. But if art could be defined by sets of necessary conditions that were jointly sufficient, then allegedly that implied that there were limits to what could be art—limits beyond which creativity could not extend—and this was held to be strictly incompatible with the notion that art was an open concept. The presupposition that the concept of art could be explicated in virtue of sets of necessary conditions that were jointly sufficient, according to the neo-Wittgensteinians, contradicted central features of the concept of art. Therefore, unselfconscious essentialists like Bell were methodologically wrong in the way they attempted to sort artworks from non-artworks.

But if one does not distinguish artworks from non-artworks on the basis of a formula or definition, how is this to be done? Neo-Wittgensteinians, often citing Wittgenstein's analysis of games in his *Philosophical Investigations*, suggested the idea of family resemblances. Basically, the approach worked like this. There are many different kinds of games. Some involve equipment, some don't; some involve competition, some don't; some involve boards, some don't, etc. For any perceptible feature of some games that you can mention, there will be other games that lack them. There are no perceptible features of games that represent necessary conditions that all games must possess; nor is there some set of such conditions that pick out all and only games.

How, then, do we determine whether some yet unencountered activity is a game? By taking note of whether or not it resembles in significant respects some things that we already regard as paradigmatic games. When certain computer activities arrived on the scene, we counted them as games because of their many similarities to things that we already took to be paradigmatic cases of games: they involved competition, scoring, turn-taking, counters, leisure time, etc. There was no fixed number of similarities required. Rather, when the similarities mounted, the weight of reflection upon the correspondences gradually led us to decide in

[2] Perhaps the best-known statement of this position can be found in Weitz (1956).

favor of the game status of the computer arrays. Moreover, when confronting a skeptic about the status of a recent candidate for gamehood, we would point to resemblances between our game paradigms and new arrivals as the appropriate way of arguing on behalf of something like *Donkey Kong*.

According to the neo-Wittgensteinian, we do not classify objects and performances as artworks by means of an essential definition, for this is putatively incompatible with the open concept of art. We identify artworks in terms of their resemblance to paradigmatic artworks. We start with some things that everyone agrees are artworks—e.g., *King Lear, The School of Athens, Citizen Kane, Water Music, Ulysses*, etc. Then when inspecting a new candidate for art status or when arguing on its behalf, we note similarities between it and various features of our paradigms. The new work is not an exact replica of any of our pre-existing paradigms. It shares some similarities with some of our paradigms in some respects and other similarities with other paradigms in other respects. Just as a family member may recall his mother's coloring and his grandfather's nose, so a candidate artwork may correlate with some of the expressive potentials of *King Lear* and the architectonic unity of *The School of Athens*. No correspondences are necessary or sufficient, yet the accumulation of family resemblances between a candidate and the standing family of art supply the grounds for calling a new work, including an avant-garde work, an artwork.

The neo-Wittgensteinian approach held sway for almost two decades. A moratorium on definitions of art was virtually in effect throughout the fifties and the sixties. But eventually both the positive and the negative dimensions of the neo-Wittgensteinian program became objects of criticism.

Negatively, the neo-Wittgensteinians argued that art could not be defined essentially in terms of necessary conditions that were conjointly sufficient because this closed the open concept of art, thus presumably precluding artistic experimentation.

This worry was questionable in at least two ways. First, definitions of art—such as George Dickie's Institutional Theory of Art—were proposed that involved the invocation of necessary conditions that were conjointly sufficient, but which did not in principle foreclose on any sort of conceivable artistic experimentation. Dickie's theory functioned as a counterexample to the neo-Wittgensteinian assertion that an essential definition of art would perforce obstruct, if only theoretically, artistic innovation. Second, given clearcut counterexamples to the assertion, commentators began to wonder why the neo-Wittgensteinians ever thought that necessary and sufficient conditions were inconsistent with artistic experimentation. How, indeed, does the possibility of innovation figure in what neo-Wittgensteinians call the concept of art in such a way that the concept of art is incompatible with the very idea of an essential definition of art? Apart from some vague notions of openness and closure, the argument has never been made out rigorously and clearly.

If the negative claims of neo-Wittgensteinianism have been treated roughly, the positive program is in even further retreat. Supposedly, the family resemblance method supplies the means for sorting the art from the non-art. But the method is

hardly reliable, since, if used as recommended, the approach will count everything as art. The problem here is with the logic of resemblance. It is a law of logic that everything resembles everything else in some respect. Artists and asteroids resemble each other, if only with respect to being physical objects. Thus, if we start, as the neo-Wittgensteinian advises, with a package of paradigmatic artworks with an indeterminately large number of features, then with any candidate object, we should be able to find some ways in which it resembles some of either the paradigms or, at least, some other objects (descendants of the paradigms) that resemble the paradigms in some respects.

On its own, similarity, unqualified, is just too broad a relationship to employ to pick out artworks. One might try to argue that the similarities between candidates and our paradigms are of a certain required sort, but, if we speak of required sorts of similarities, then it sounds as though we are speaking about necessary conditions for art status, something that most neo-Wittgensteinians eschew. Nor is it open to neo-Wittgensteinians to talk about what might be called disjunctive sets of relevant artistic similarities because that reintroduces the notion of sufficient conditions, another commitment that most neo-Wittgensteinians suspect in the way that Methodists distrust gin.

Thus, neo-Wittgensteinianism is caught in a dilemma: on the one hand, given the logic of resemblance, the family resemblance method cannot discriminate artworks from anything else, unless, on the other hand, the method is supplemented with the kinds of qualifying conditions that, as a matter of principle, the neo-Wittgensteinian believes is incompatible with the concept of art. Paradoxically, the neo-Wittgensteinian might have to become non-Wittgensteinian in order to make the family resemblance method serviceable.

Because of these problems and others, the last two and a half decades have witnessed a return to essentialist definitions of art. Dickie and Danto are two of the best-known representatives of this return to the essentialist project, but there are numerous other workers in these fields, including, among them, Eaton, Levinson, and Stecker (see References and Further Reading). I call this self-conscious essentialism, since these authors are well aware of the neo-Wittgensteinian position and come prepared with arguments designed to refute it. It is impossible to summarize all of the different maneuvers and subtleties that the self-conscious essentialists have introduced into the discussion. However, it is feasible to note some of the nagging problems that still plague essentialist attempts to articulate the conditions in accordance with which we classify artworks.

Two well-known theories of art in the self-conscious essentialist mode are those of Dickie and Danto. The early versions of Dickie's Institutional Theory of Art argued that x is an artwork if and only if (1) x is an artifact (2) upon which some person or persons, acting in behalf of a certain institution (the artworld), confers the status of candidate for appreciation (1974). This definition of art is quite complex, however simple it may appear on first reading. Nevertheless, for all its complexity, as a definition, it contains a very evident flaw, namely it is circular, inasmuch as it uses the notion of an artworld to define art. But then

how will one characterize an artworld, without referring to art in a viciously circular way?

Dickie, himself, has not tried to rid his theory of circularity in subsequent versions, but instead has attempted to convince readers that it is not viciously circular. Moreover, one version of Danto's characterization of art is also beset by circularity, since Danto has, until very recently, regarded enfranchisement by an art theory to be a necessary condition for art status. But how, one wants to know, can one define art in terms of art theories without already presupposing a notion of art sufficient to tell art theories from other sorts of theories?

Circularity, then, is one problem that continues to dog essentialist definitions of art. Other problems include the fact that most candidates for necessary conditions of art are heavily contested, while no sets of putative necessary conditions advanced so far have been jointly sufficient. A brief review of Danto's theory of art (1997) may illustrate both these points (see Carroll, 1997).

In *After the End of Art*, Danto says that in order to be a work of art, x must (1) be about something and (2) must embody its meaning, where "to embody a meaning" amounts to discovering "a mode of presentation that is intended to be appropriate to its meaning"—i.e., is intended to be appropriate to whatever subject it is about. As Danto knows, these two putatively necessary conditions are not conjointly sufficient. Danto himself draws a distinction between ordinary Brillo Boxes—what he thinks of as mere real things—and Andy Warhol's. Warhol's are supposedly art, whereas ordinary Brillo Boxes are not. However, Danto's theory of art will not draw this distinction, for ordinary Brillo Boxes are about something, namely, Brillo—about which their colorful iconography has a lot to say by means of appropriate expressive devices. The wave on the box suggests a rush of cleanliness, just the sort of thoughts Proctor and Gamble, the manufacturers of Brillo, wish to instill in the minds of prospective customers. Nor is this a problem merely with Brillo Boxes. Danto's theory of art will have systematic problems differentiating artworks proper from all sorts of expressive cultural artifacts ranging from chewing-gum wrappers to bell-bottom trousers.

However, Danto's conditions do not just fail to be jointly sufficient. It is not clear that they each constitute necessary conditions for art status. The notion of embodiment is at best obscure. At least in one sense, disjunction between the mode of presentation of a work and its subject seem possible in art, unless these terms are so interconnected that they always correspond by definition. But if that is how matters stand, then it is hard to see how any distinction is being drawn, since anything that presents its subject will embody it. On the other hand, it does seem doubtful that every work of art is about something, even under a very generous construal of about-ness. Surely, there is art that is purely decorative and not about anything, and art designed solely to stimulate delight without, in any sense, being about that delight. Thus, Danto's most straightforward candidate as a necessary condition for art status appears to fall far short of doing the job.

Essentialist definitions of art continue to be propounded by analytic philosophers. At the same time, these accounts continue to fall afoul of certain problems. As we saw from our brief look at some of the views of Dickie and Danto, existing

essentialist accounts of art court circularity, or they fail to identify successfully necessary conditions for art, let alone ones that are jointly sufficient. Of course, the repeated failure of theories like these does not show that no one will ever be able to solve these problems. However, rather than ending this chapter by taking note of the continued frustration of analytic philosophers of art of an essentialist bent, I would like to suggest another alternative for explicating the way in which we apply the concept of art in order to categorize new works, especially new works of the often intentionally bewildering and enigmatic variety that hail from the avant-garde.

3. ART AND NARRATIVE

The neo-Wittgensteinians mistakenly thought they had an argument showing that a definition of art in terms of necessary and sufficient conditions was impossible in principle. Although repeated failure does not show the impossibility of the project, it may suggest the advisability of rethinking the way to solve it.

Essentialists like Dickie and Danto remain committed to what I referred to as the classical theory of concepts. However, this approach has been challenged by competing views, including prototype theory in psychology and the causal theory of reference in the analysis of natural kinds (see Griffiths, 1997: Ch. 7). Thus, there is no reason to believe that all concepts behave in the way presumed by the classical theory. Perhaps we apply the concept of art to objects in virtue of factors other than necessary and sufficient conditions.

But if we do not sort artworks from other things by means of essential definitions, how do we do it? My suggestion is that we do so by means of narratives (see Carroll, 1986, 1993, 1994). Consider how we assuage the disbelief of spectators who are convinced that the latest avant-garde offering is not art. Such accusations have echoed throughout the twentieth century, leveled at different times at Duchamp's readymades, Pollock's drip paintings, Merce Cunningham's choreography, and the works of Damien Hirst and Matthew Barney. How are such challenges met?

Generally, the proponent of the work in question responds by telling a story that links the contested work to preceding art, and artmaking practices and contexts, in such a way that the work under fire can be seen to be the intelligible outcome of recognizable modes of thinking and making already of a sort commonly adjudged to be artistic. This mode of proceeding, of course, presupposes that we already know that some objects are art, that we understand what is important about these objects, and that there is agreement about this. Then we attempt to show how new work evolves from works already acknowledged to be artistic activities guided by concerns regarded as central to the practice. Thus, the figural distortion of German expressionist painters is not dismissed as an inept attempt at verisimilitude and, therefore, as defective or pseudo art, but as an intelligible and well-precedented artistic response—a revolt—against realism

for the sake of securing a widely and antecedently acknowledged artistic value, namely expressivity.

It is an expectation of artists that they be concerned to make original contributions to the tradition within which they work. These contributions can range along the creative scale from slight variations in established genres to wholesale revolutions. In certain respects, art history is analogous to a conversation in which each artist-discussant makes, or at least is expected to make, a contribution. However, as in a conversation, the contribution must also have some relevance to what has gone before—otherwise, there simply is no conversation. In relation to their predecessors, artists must be posing or answering some question, amplifying what someone else has proposed or disagreeing with or even repudiating it, or demonstrating that some neglected option is possible and the like. In such ways as this, the artist's contribution should be relevant to the already existing practice of art—to its abiding concerns and interests.

Of course, the problem frequently presented by avant-garde art is that some of the artist's interlocutors—aka the general public—often fail to catch onto the relevance of the artist's "remark" to the ongoing conversation in its artistic context. The audience may discern the "originality" of the work, but not its relevance. There is, in a manner of speaking, a gap or a glitch in the conversation.

But if this is the problem, there is an evident way to repair it: reconstruct the conversation in such a way that the relevance of the artist's contribution is perspicuous—bring perhaps unremarked or unnoticed presuppositions into the open, point to overlooked features of the context, make the intentions the artist means to convey explicit, show that the said intentions are intelligible in terms of the conversation and context, and so on. Reconstructing the conversation in this way amounts to a historical narrative. Where something is missing from the conversation—some connection—it is supplied by a retelling of the conversation that historically reconstructs it. I claim that, with suitable qualifications, where we can produce a genuine historical narrative of this sort, we have sufficient grounds for categorizing a candidate work as an artwork.

This narrative approach to classifying artworks establishes the art status of a candidate by connecting the work in question to previously acknowledged artworks and practices. In this regard, it may appear to recall the family resemblance approach. However, the narrative approach is not merely an affair of similarities between past and present art. The pertinent correspondences must be shown to be part of a narrative development—to track processes of cause and effect, decision and action, and lines of influence. Unlike the neo-Wittgensteinian method for identifying artworks, the narrative approach links present art to past art not in terms of some unspecified notion of similarity, but in terms of descent. Contemporary avant-garde works are classified as artworks in virtue of their ancestry, where that ancestry is explained by means of a narrative or genealogy.

Undoubtedly, the suggestion that we sort objects into a kind by means of a historical narrative will strike some as bizarre. Often we derive our models of kindhood from physics and chemistry where an element is grouped in virtue of some intrinsic, micro-physical property that explains its other projectible

properties. But not all kinds, even in the sciences, are like this. For example, species are historical entities—they are groups of organisms that are sorted together by virtue of their common history rather than by virtue of intrinsic resemblances that they bear to each other (see Sober, 1993: Ch. 6).

The reason for this is that species, by their nature, evolve, typically showing variations not merely in some of their peripheral characteristics, but, in principle, in all of their features. No particular feature, no matter how central to our stereotype of the species, to its genotype or its morphology, is essential for an individual organism to be a member of the species in question. What is crucial, as Darwin already indicated, is descent.

Indeed, within the branch of biology called systematics, one important debate was between pheneticists, who proposed to sort species in terms of putatively essential similarities between organisms, versus cladists, who argued that taxa are unified historically by the mechanism of common descent. In certain respects, this debate in biology repeats themes rehearsed in the analytic philosophy of art, including not only the problem of fixing the essential properties of a kind that is essentially evolving, but also the problem of the slackness of similarity as an organizing principle. Of course, there are also important differences between questions of art classification and speciation. I am only drawing attention to selected, suggested analogies. However, the fact that cladism is regarded as a respectable solution to the problem of speciation at least indicates history can supply the grounds for membership in a kind in certain cases. And if descent is a viable condition for classifying an organism as a member of a biological species, there need be no problem, at least in principle, with supposing that candidates are also classified under the concept of art in virtue of descent as explicated by the appropriate types of historical narratives.

Since I am arguing that we identify artworks by means of narratives rather than of definitions, the problems of circularity that confront essentialists such as Dickie are not a problem for narrativist solutions to the problem of identifying artworks. For circularity is a problem for definitions, but not for narratives.

Similarly, the narrativist may remain neutral with respect to the question of whether art possesses any necessary conditions, since narratives of the evolution of art can be told without presupposing that there is any one feature or combination of features that all artworks must have. It is enough to recognize that there are prevailing goals, interests, and preoccupations of art in a given context, or even that they endure over long periods of time, and that new work can be shown to evolve from them by way of intelligible processes of making and thinking already regarded as artistic.

4. CONCLUSION

I began by claiming that analytic philosophy specializes in the examination of concepts and that the analytic philosophy of art has been greatly exercised by

the project of articulating the conditions in accordance with which we classify candidates under the concept of art—a project made urgent by the existence of the historical avant-garde. The solution to that problem is that historical narration provides a major conceptual instrument for sorting artworks from non-artworks, especially in the context of the cascading productions of the avant-garde.

Some might argue that, by opting for a narrative or genealogical solution, I have abandoned the project of analytic philosophy. But I wonder whether this sort of worry doesn't belie a nettlesome presupposition, namely, that analytic philosophy is essentially defined by a positive commitment to the classical theory of concepts. Thus, if one does not analyze concepts in terms of necessary conditions that are jointly sufficient, one is simply not doing analytic philosophy.

But traditions, including analytic philosophy, are difficult to summarize simply because many of their deep presuppositions are contested even by their practitioners. This seems to me to be the case with respect to the issue of whether a commitment to the classical theory of concepts determines whether or not one is an analytic philosopher, since many distinguished analytic philosophers have challenged aspects of the classical theory. They are still invested in the analysis of concepts, though not necessarily by the lights of the classical theory. I regard my proposals about art status in this way.

But if membership in an intellectual tradition like analytic philosophy is not essentially defined in terms of commitments to a certain theory of concepts, what determines it? Perhaps predictably, let me suggest that it is a matter of participation in a continuous conversation—a conversation where not all the discussants agree, but where their positions are relevant responses to the positions articulated by other acknowledged participants in the conversation. If this is correct, then membership in an intellectual tradition is established by means of a narrative that reconstructs the pertinent dialogical maneuvers in the ongoing conversation. Moreover, if narration is a major means for determining membership in a tradition—as I have at least attempted to illustrate—then, once again, we see that, as with the case of cladism in biology, history, in principle, is a perfectly serviceable grounds for categorization.[3]

REFERENCES AND FURTHER READING

Bell, Clive. 1958. *Art*. New York: Capricorn.
Carroll, Noël. 1986. "Art, Practice and Narrative." *The Monist*, 71: 57–68.
——1993. "Historical Narratives and the Philosophy of Art." *Journal of Aesthetics and Art Criticism*, 51: 313–26.
——1994. "Identifying Art," in R. Yanal, ed., *Institutions of Art*. University Park, PA: Penn State University Press, pp. 3–38.
——1997. "Danto's New Definition of Art and the Problem of Art Theories." *British Journal of Aesthetics*, 37 (October): 386–92.

[3] Hull argues that intellectual traditions are identified historically (1988: Ch. 7).

Danto, Arthur. 1981. *The Transfiguration of the Commonplace.* Cambridge, MA: Harvard University Press.

—— 1997. *After the End of Art: Contemporary Art and the Pale of History.* Princeton, NJ: Princeton University Press.

Dickie, George. 1974. *Art and the Aesthetic.* Ithaca, NY: Cornell University Press.

—— 1984. *The Art Circle.* New York: Haven.

Eaton, Marcia. 1983. *Art and Non-Art: Reflections on an Orange Crate and a Moose Call.* Washington, DC: Associated University Presses.

Griffiths, Paul E. 1997. *What Emotions Really Are: The Problem of Psychological Categories.* Chicago, IL: University of Chicago Press.

Hull, David. 1988. *Science as a Process: An Evolutionary Account of the Social and Conceptual Development of Science.* Chicago, IL: University of Chicago Press.

Levinson, Jerrold. 1979. "Defining Art Historically." *British Journal of Aesthetics* 19: 232–50.

Sober, Elliott. 1993. "Systematics." *Philosophy of Biology.* Boulder, CO: Westview, pp. 145–83.

Stecker, Robert. 1997. *Artworks: Definition, Meaning, Value.* University Park, PA: Penn State University Press.

Weitz, Morris. 1956. "The Role of Theory in Aesthetics." *The Journal of Aesthetics and Art Criticism* 15: 27–35.

Wollheim, Richard. 1987. *Painting as an Art.* Princeton, NJ: Princeton University Press.

—— 1998. "On Pictorial Organization." A lecture for the conference "Frameworks for Art: Theory and Practice" at the Mobile Parikh Centre for the Visual Arts, Bombay, January.

2

Formalism

The term "formalism" can refer to many different things. In art criticism, it has been used to refer to the important writings of Clement Greenberg; in literary history, it has been associated with the influential school of Russian Formalism; and in art history it has been used to refer to the writings of Alois Riegl and Heinrich Wölfflin. For the purposes of this chapter, however, attention will be paid to its usage in philosophical aesthetics, where "formalism" denotes a position on the nature of art which has important implications for the limits of artistic appreciation.

Historically, the formalist position finds two of its strongest early polemical statements in Eduard Hanslick's *On the Musically Beautiful* (Hanslick, 1986), first published in 1854, and in Clive Bell's *Art* (1914). In both cases, it is possible to see formalism as a historically situated response to significant artworld developments: to the triumph of absolute or pure orchestral music, on the one hand, and to the emergence of modern painting, on the other hand. Both books signaled a revolution in taste with regard to their respective artforms. Hanslick questioned whether all music trafficked in the arousal of garden-variety or everyday emotions (such as fear, anger, and joy), and argued instead that the proper object of musical attention should be musical structure. Bell denied that painting was an affair of representation and of the emotions associated with the representation of events, places, and people, and in contrast maintained that the real subject of painting was what he called significant form: the play of striking arrangements of lines, colors, shapes, volumes, vectors, and space (two-dimensional space, three-dimensional space, and the interaction thereof).

Bell's statement of the formalist position has been particularly important for the development of philosophical aesthetics in the twentieth century. Perhaps the leading reason for Bell's influence has been the fact that he connected his version of formalism with the project of advancing an explicit definition of art. For this reason, Bell can be considered one of the major forerunners of the twentieth-century's philosophical obsession with discovering an essential definition of art.

According to Bell, we "gibber" if we do not base our theories and prognostications about art and its relevant forms of appreciation in an explicit definition of art. Unless we establish what art is, what we say about the value and importance of art, and what we think we should attend to in artworks, will be wildly off the

mark. We will, from his point of view, go on blathering about the drama and anecdote of something like Poussin's *Achilles among the Daughters of Lycomedes*, rather than attending to its pictorial structures.

As a result, Bell is eminently straightforward about what, in essence, he takes painting-as-an-artwork to be. Essentially, it is significant form. That is, where a painting is a genuine artwork, it addresses the imagination like the figures of Gestalt psychology, prompting the viewer to apprehend it as an organized configuration of lines, colors, shapes, spaces, vectors, and the like.

Bell's conception of painting is a rival to other general theories of art. Bell rejects the traditional view that the art of painting is essentially an imitation of nature, a practice defined by a commitment to verisimilitude: to the production of recognizable depictions of persons, places, actions, and events. Bell, of course, does not deny that many paintings are representations, but he argues that where paintings qualify as art that is due to their possession of something other than their representational content. It is due to their possession of significant form. Indeed, according to Bell, whether or not an artwork possesses representational content is always *strictly* irrelevant to its status as an artwork. That is, a painting's being a painting of a horse counts not at all towards its classification as a work of art; only its possession of significant form, if it has any, does.

Similarly, though less explicitly, Bell's theory contrasts with expression theories of art, which maintain that what makes something art is its expression of the emotions of its creator. For Bell believes that a painting, such as a neo-impressionist still life by Cézanne, can be remarkable for its invention of an arresting formal design, while expressing no detectable garden-variety emotions.

With Bell, formalism found its natural home in the realm of painting. Nevertheless, it is easy to extend his view to the other arts. Obviously, most orchestral music is not representational. This was always a vexation for philosophers in the lineage of Plato and Aristotle, who supposed that all art is essentially representational. But it scarcely seems controversial to describe music, especially after the popularization of pure orchestral music, in terms of the temporal play of aural form. In dance in the twentieth century, due to the influential writings of critics like André Levinson, a kind of formalism not unlike Bell's came to be a leading position with regard to ballet, while in modern architecture the idea of form became a shibboleth.

Literature might appear to be a more intractable artform to explicate exclusively in terms of form. However, formalists can point to the centrality of features in poetry like meter, rhyme, and generic structures (such as the sonnet form); while stories also possess formal features, such as narrative structures and alternating points of view, which theorists can claim lie at the heart of the literary experience. Such formalists, of course, cannot deny that most literature possesses representational content. Instead, formalists, notably the Russian Formalists, argue that such content only serves to motivate literary devices, and add that ultimately it is the play of literary devices that accounts for the artistic status of poems, novels, dramas, and the like: at least in the cases where the works in question are artworks.

Thus, the kind of formalism that Bell introduces with reference to fine art (notably painting and sculpture) can be (and has been) turned into a comprehensive theory of art, a competitor to other major philosophies of art, such as the representational theory of art and the expression theory of art. Where those philosophies maintain respectively that art is essentially representation or that it is by its very nature expressive, the formalist says that art is form. Or, to state the matter more precisely, anything x is an artwork if and only if x possesses significant form. The possession of significant form is a necessary condition for status as an artwork: that is, something is an artwork *only if* it possesses significant form. And significant form is a sufficient condition for status as an artwork: *if* something possesses significant form, then it is an artwork.

To take something of a departure from Bell, it is possible to reconstruct a series of initially compelling arguments in support of formalism. The formalist alleges that a candidate is an artwork only if it possesses significant form; this is a necessary condition. But why suppose that this is so? Here the formalist mobilizes what can be called the *common denominator* argument.

The common denominator argument begins with the unobjectionable pre-supposition that if anything is to count as a necessary condition for art status, then it must be a property possessed by every artwork. This is just what it means to be a necessary condition. Next the formalist invites us to consider some of the leading competing proposals for the role of necessary criteria for art status. The two that are most relevant for the formalist debate are that something is art only if it is representational, and that something is art only if it is expressive.

However, not all artworks are representational. The bejeweled patterns on Islamic funeral monuments, Bach's fugues, and Ellsworth Kelly's wall sculptures are all pertinent examples here. They are not representational but they are undeniably art. Thus it cannot be the case that representation is a necessary condition for status as an artwork.

Similarly, not all art is expressive of the emotions of its creator. Some artists, like John Cage, have adopted aleatoric methods of composition in order to remove any trace of authorial expression from their work. Many of George Balanchine's abstract ballets also attempt to erase expressive qualities for the sake of exploring pure formal qualities. Thus, expression is not a necessary condition for status as an artwork.

That leaves us with form as the most viable candidate. Moreover, though we have reached this conclusion indirectly by negating the most prominent competing alternatives, the result, it might be said, rings true directly, since all artworks do seem at the very least to possess form. It appears obvious that form is the common denominator among all artworks and the property that they all share whether their medium is painting, sculpture, drama, photography, film, music, dance, literature, architecture, or whatever. In searching for a necessary condition for art status, we are looking for a property possessed by every artwork. Formalism seems to make the most promising proposal, especially in contrast to rival theories like representationalism and expressionism.

The common denominator argument suggests that form is the most plausible contender we can find for a necessary condition of art status. But this argument does not provide us with a sufficient condition for art status, since many things other than art also possess form. Indeed, some might argue that in some sense everything possesses form. That, of course, is why the formalist speaks of *significant* form. But, even with this ostensible refinement, it is still not the case that the formula "x is art only if it possesses significant form" will differentiate art from many other things. An effective political speech and a theorem in symbolic logic may possess significant form, but they are not art. In order to block such counterexamples, and to establish the sufficiency of the theory, the formalist needs to add something to his or her view. Here the formalist may advert to a hypothesis about the *function* of artworks.

Political speeches and theorems in logic may possess significant form, but it is not their primary purpose to display their form. The primary function of a political speech is to convince an audience. The primary function of a logical theorem is to deduce a conclusion. Speechmaking and logic may result in activities noteworthy for their form, but exhibiting their form is not what they are primarily about. If they lacked significant form, they could still be extremely successful in acquitting their primary functions. Art is different from these and other activities insofar as it is, so the formalist hypothesizes, uniquely concerned with displaying significant form.

No other human activity, the formalist alleges, has the exhibition of form as its special or peculiar province of value. Its primary preoccupation with the exploration of form demarcates the realm of art from other human practices. Whereas representational content is not irrelevant to political speeches or logical deductions, representation is always, the formalist says, strictly irrelevant to artworks.

Likewise, though artworks may express the emotions, other things, such as battle cries, do so as well. However, artworks can be differentiated from battle cries if one supposes that the primary function of art is to exhibit significant form, since battle cries are not uttered in order to foreground their rhythmic structures.

Artworks may be concerned with religious or political themes, moral education, philosophical world-views, or martial emotions. But so are many other things. Indeed, many other things, including sermons, pamphlets, newspaper editorials, and philosophical treatises generally do a better job of conveying cognitive and moral information and emotional contagion than does art. What is special about art above all else, according to the formalist, is its concern with discovering formal structures that are designed to encourage our imaginative interplay with artworks.

The claim that the primary function of art is the exhibition of significant form can be worked into what we can call the *function* argument. This argument is designed to establish that the exhibition of significant form is a sufficient condition for status as an artwork. The argument presupposes that only if x is a primary function that is unique to art can it be a sufficient condition for status as

an artwork. As in the case of the common denominator argument, the formalist then goes on to canvas the relevant alternatives: representation, expression, and the exhibition of significant form. As we have already seen, neither representation nor expression is a unique function of artworks. Other activities also share these functions. But the exhibition of significant form is a primary function unique to art. Therefore, it is a sufficient criterion of art status.

Along with the function argument and the common denominator argument, formalism also gains credibility from its apparent capacity to explain certain of our intuitions about art. For example, we often criticize certain films for being too message-oriented, while commending other films for being good of their kind. Why is this? The formalist has a ready answer: a dumb, amoral film may be formally interesting—it may deploy its formal devices (editing, camera movement, color schemes, and so on)—in compelling ways. In many such films, the thematic content is negligible, or even silly, but its formal organization is riveting, whereas a film with a big idea, however important and earnestly expressed, may strike us as altogether, as they say, uncinematic. Formalism makes sense of comparative judgments like these.

Likewise, formalism explains why we regard much of the art of the past as worthwhile despite the fact that the sentiments it expresses and the ideas it represents are now known to be obsolete. This contrasts with physics, where discredited theories are long forgotten and rarely consulted. The formalist explains this phenomenon by reminding us that the primary function of physics is to give us knowledge about the universe. The information contained in many past artworks is believed to be wrong, but nevertheless we still read Lucretius's *On the Nature of Things*, the formalist hypothesizes, because of its evident formal virtues.

Because of its explanatory power, and because of arguments like the common denominator argument and the function argument, formalism is an appealing view. For those who expect an essential definition in response to the question "What is art?" it provides a tidy response: x is an artwork if and only if x is primarily designed in order to possess and to exhibit significant form. (Note: the inclusion of "designed" in this formula is intended to differentiate art from nature.) Additionally, formalism has important implications about art appreciation, properly so-called.

If the essential, artmaking characteristic of a work is its possession and exhibition of significant form, then the pertinent object of our attention to an artwork *qua* art is significant form. Artworks may contain other features, such as representation and garden-variety emotions, but these are incidental and strictly irrelevant to their status as artworks. Thus, when it comes to appreciating artworks, attention should be focused exclusively on their formal properties.

Formalism has been an influential doctrine. For decades, schoolchildren were taught not to let their attention wander away from the text: not to allow their concentration to become caught up in the story's relation to real life, rather than to savor its formal organization and features (for example, its unity, complexity, and intensity). But formalism does not simply advocate certain protocols for

aesthetic experience. It also attempts to ground those protocols in an ambitious philosophical theory.

According to formalism, the intended primary function of exhibiting significant form is a necessary condition for art status. But this cannot be right. Many of our greatest works of art were produced with patently different primary intentions, such as many military monuments whose primary function was to commemorate great victories. In response, the formalist may attempt to modify this condition, arguing that an artwork is something that has *among* its primary functions the exhibition of significant form. But this too seems unlikely.

Modern art is full of examples of what are called found objects, or readymade objects, such as Duchamp's *Why not Sneeze?* These ordinary objects are selected and put forward as artworks in order to provoke conceptual insights. Frequently, such objects are chosen expressly because of their palpable lack of what can be called significant form. Inasmuch as these found objects are art, it cannot be the case that the exhibition of significant form is a necessary condition for art status.

Moreover, counterexamples to the formalist thesis can also be located in traditional art. Many cultures produce statues of demon figures whose intended function is to frighten intruders who wander into forbidden precincts. Such figurines are art, coveted by museums and collectors alike. But it is unimaginable that their creators could have in any way intended them as vehicles for the exhibition of significant form. Such an intention would be at odds with their intention to scare off viewers. So, once again, we must conclude that the intended function of exhibiting significant form cannot be a necessary condition for art status.

Is it a sufficient condition, however? Here let us return to the case of the theorem from symbolic logic. Such theorems may possess significant form. The formalist, however, maintains that they are not artworks because the exhibition of significant form is not among their intended primary functions. However, consider the case of a theorem whose proof has already been established, but by means of a lengthy or cumbersome set of steps. Suppose some logician decides to find a more elegant way of solving the problem, and succeeds in doing so. "Elegance" is surely a formal property, and in this case the point of the exercise is that the theorem in question possess and exhibit formal beauty. The formalist would appear to be compelled to recognize this as an artwork, but this is a fallacious result. Thus, the intended function of exhibiting significant form is not a sufficient condition for art status.

Nor does our argument hinge on this one example. An athlete may have among his or her primary intentions the desire not only to win, but to do so with arresting visual style. And though a baseball catch can be a thing of nearly balletic beauty (and be intended as such), it is not a work of art. (If we refer to it in this way, as we often do, we are, of course, only speaking metaphorically.)

If the intended exhibition of significant form is neither a necessary nor a sufficient condition for art status, what are we to make of the common denominator argument and the function argument? These arguments can be

stated in ways that are logically valid, yet logically valid arguments can reach false conclusions when their premises are false. The problem with the common denominator argument and the function argument is that both contain false or misleading premises.

The common denominator argument presupposes that the possession of representational, expressive, or formal properties constitutes a necessary condition for art status. This presupposition can be criticized from two different directions. First, it can be pointed out that this array of alternatives does not spell out all of the relevant options, and that consequently the argument lacks proper logical closure. Unless we know that these are the only candidates available as necessary conditions for art status, we have no reason to accept formalism as the result of an argument by elimination like this one. Furthermore, we have every reason to believe that there are other candidates, such as certain historical properties (Danto, 1981) and/or institutional properties (Dickie, 1984). These possibilities, especially given the consensus, as already discussed, that "found objects" can qualify as works of art, may be even more comprehensive than the exhibition of formal properties. Thus, the common denominator argument is false because one of its central premises misleadingly insinuates that it has exhausted all the pertinent alternatives when it has not.

A second frequently mentioned, though very different, line of objection to the common denominator argument is that it presupposes that there must be a necessary feature shared by all artworks. Followers of Ludwig Wittgenstein, such as Morris Weitz (1956), have questioned this. Believing that all artworks necessarily possess a common feature seems to be more an article of faith than an established fact. What we call art seems so very diverse. There are so many different artforms and so much variety within artforms. Why suppose that they share a single common property or even a single set of common properties? Is it plausible to suppose that John Cage's *4′ 33″* has an essential property that corresponds to an essential feature of the Taj Mahal?

Bell said that we gibber if we cannot adduce a feature common to all artworks. But we apply many concepts, like the concept of game, in ordinary language without being able to name an essential property that every object that falls under the concept possesses. Many theories abound about how we are able to do this. Thus, we may not have to worry about gibbering if we deny that the concept of art is governed by necessary conditions. Moreover, if one agrees that one of the alternatives that should be added to the common denominator argument is the possibility that art has no necessary conditions, one may resist the conclusion that formalism is the obvious survivor of the sort of process of elimination that the common denominator argument invites.

Similar problems beset the function argument. It too ignores the possibility that there may be no primary function (or set of primary functions) *unique* to art, as well as the possibility that the functions of art may reside somewhere other than in representation, expression, or the exhibition of significant form. Thus, the function argument does not compel us to agree that the exhibition of significant form is a sufficient condition for art status.

Moreover, both the common denominator argument and the function argument, along with the general statement of the formalist definition of art, are plagued by a problem that we have so far left unremarked, namely, that the concept of significant form that is the central term of the formalist's arguments and definition is regrettably indeterminate. Without some idea of the nature of significant form or some criteria for recognizing it, we must worry (stealing a line from Bell) that when we employ it, we gibber.

What exactly is significant form? The formalist gives us no way to discriminate between significant form and insignificant form. Formalists may give us examples of each, but no principles. What makes one juxtaposition of shapes significant and another not? We have no way to decide. Nor can it be said, as some say of art, that reliable criteria for applying significant form inhere in ordinary language, since "significant form" is not a term of ordinary usage, but a piece of jargon. Thus, obscurity lies at the heart of formalism; the theory turns out to be useless, because its central term is undefined.

The formalist might say that a work has significant form if it is arresting. But that is not enough, since a work can be arresting for reasons other than formal ones or even in virtue of formal properties that are not significant in the formalist's sense: such as its unusual, all-over monotone color. How, without a characterization of significant form, will we know whether a work is arresting because it possesses significant form, rather than for some other reason?

Often formalists attempt to repair this shortcoming by saying that significant form is such that it causes a special mental state in the minds of viewers. But this is not a helpful suggestion unless the formalist can define that state of mind. Otherwise we are left with one undefined concept posing as a definition of another, which is effectively equivalent to having no definition at all. Nor can the formalist say that significant form is that which causes the peculiar state of mind in percipients that is the apprehension of significant form, since such a definition is circular. We would already have to possess the concept of significant form in order to tell whether the mental state was indeed an apprehension of significant form.

It is impossible here to review all the different proposals—in terms of notions like aesthetic emotion and aesthetic experience—that formalists have attempted to craft in order to characterize the putative mental state that significant form is alleged to afford. To date, none of these has been anything less than controversial. Thus, at this point in time, the burden of proof falls to the formalist since, on the face of it, it appears unlikely that there is a distinctive state of mind elicited by all and only artworks. That is, since there are so many different kinds of artworks that require all sorts of mental responses, it is doubtful that there is just one mental state which they all induce. Does a feminist novel really engender the same kind of mental state as a Fabergé egg? Is there really some uniform aesthetic experience elicited by all artworks? Until that question is answered positively, precisely, and persuasively, the idea that significant form can be explicated by reference to aesthetic experience remains moot. But, without such an answer, the notion of significant form is too vague to be credible.

Perhaps the most incendiary corollary of formalism is the idea that representational properties in artworks, whenever they appear in artworks, are strictly irrelevant to their status as art and to our appreciation of them as artworks. According to formalists, we must appreciate artworks in terms of their purely formal relationships, divorced from the claims and concepts of daily life. But this is a very unlikely doctrine, for the simple reason that what is called significant form frequently supervenes on the representational content of artworks.

In order to access the form of a novel—to track its unity and diversity, to appreciate its intensity or its lack thereof—we must attend to its representations of actions, places, and characters. We must generally bring to the novel the kinds of schemas, scripts, and folk psychology that cognitive scientists tell us we bring to the affairs of ordinary life. But if in order to admire the structure of oppositional relationships among the characters in a novel we must deploy the categories of ordinary life (such as what are called person schemas) to the states of affairs the novelist represents, then the notion that representation and its connection to ordinary experience is strictly irrelevant is grievously mistaken.

Furthermore, it is not difficult to extend observations like this to our apprehension of form in many historical, mythological, religious, and otherwise narrative paintings and sculptures, since there too form often comes to light only in the shadows of representational content.

As a heuristic, formalism may be a useful pedagogical standpoint. It reminds us that it is important not to overlook the formal dimension of artworks. Artists spend an immense amount of energy designing the structures of artworks, and attending to the intelligence disclosed by the form of a work can be a rewarding source of satisfaction for readers, viewers, or listeners. However, transforming this near-truism into a philosophy of art, as the formalist does, impoverishes rather than enriches our understanding of art.

REFERENCES AND FURTHER READING

Bell, C. 1914. *Art*. London: Chatto and Windus.

Carroll, N. 1985. "Formalism and Critical Evaluation," in P. McCormick, ed., *The Reasons of Art*. Ottawa: University of Ottawa Press, pp. 327–35.

—— 1989. "Clive Bell's Aesthetic Hypothesis," in G. Dickie, R. Sclafani, and R. Roblin, eds, *Aesthetics: A Critical Anthology*. New York: St Martin's Press, pp. 84–95.

—— 1991. "Beauty and the Genealogy of Art Theory." *Philosophical Forum*, 22: 307–34.

Danto, A. 1981. *The Transfiguration of the Commonplace*. Cambridge, MA: Harvard University Press.

Dickie, G. 1984. *The Art Circle*. New York: Haven.

Fry, R. 1956. *Vision and Design*. New York: Meridian.

Greenberg, C. 1961. *Art and Culture*. Boston, MA: Beacon.

Hanslick, E. 1986. *On the Musically Beautiful*, transl. G. Payzant. Indianapolis, IN: Hackett.

Lemon, L. T., and Reis, M. J., eds. 1965. *Russian Formalist Criticism*. Lincoln, NB: University of Nebraska Press.

Levinson, A. 1991. "The Spirit of the Classical Dance," in J. Acocella and L. Garafola, eds, *André Levinson on Dance*. Middletown, CT: Wesleyan University Press, pp. 42–8.

Riegl, A. 1992. *Problems of Style*, transl. F. Kain. Princeton, NJ: Princeton University Press.

Weitz, M. 1956. "The Role of Theory in Aesthetics." *Journal of Aesthetics and Art Criticism*, 15: 27–35.

Wolfflin, H. 1950. *Principles of Art History*, transl. M. D. Hottinger. New York: Dover.

3

Definitions of Art

A range of related topics are gathered together under the title "The Definition of Art." These include: (1) metaphysical questions, such as "Is there a set of necessary properties whose possession is conjointly sufficient for a candidate to qualify as an artwork?" and, if so, "What are they?" And (2) the epistemological issue of how we go about establishing that a candidate is an artwork. Traditionally the default assumption among many philosophers has been that there are necessary and sufficient conditions for classifying things as artworks; that these conditions can be assembled into a real or essential definition of art; and that the application of the aforesaid definition provides us with the means to establish that this or that candidate is an artwork. The trick with this approach is to specify successfully the pertinent necessary and sufficient conditions.

Needless to say, this enterprise has turned out to be more challenging than one might have anticipated. And the difficulties encountered in successive attempts to carry off this endeavor have left some philosophers either skeptical or agnostic regarding the prospects of the metaphysical project of defining art. Instead, they have tried more modestly merely to identify the epistemological grounds for classifying candidates as artworks without resorting to real definitions.

The search for a definition of art was not something that taxed ancient philosophers like Plato and Aristotle. For Aristotle, art was skill with respect to any practice or craft. There was an art of poetry and an art of painting, but also the art of medicine, navigation, warfare, and so on. Though Plato, Aristotle, and Horace compared poetry and painting, they did not presume an overarching framework that groups certain of the arts (in their sense) together in the category that we now call the Fine Arts or Beaux Arts, or maybe more simply just Art with a capital "A"—roughly, poetry (literature), painting, sculpture, music, theater, dance, architecture, and, nowadays, photography, film, and video.

The system of the arts was not stably consolidated until the eighteenth century (Kristeller, 1992). Thus, it comes as no surprise that Aristotle felt no inclination toward defining the conditions for membership in the category, though he did analyze the nature of some of the things—like tragedy—that would later be subsumed under the concept of (fine) art. For the ancients, there were arts that were tied to certain functions—quite often religious, political, or otherwise social ones—and these artforms were defined and evaluated in light of that function.

For example, Aristotle maintained that the function of tragedy was to educate the emotions by clarifying pity and fear.

When Aristotle and Plato single out *mimesis* or imitation as a necessary feature of drama—both tragedy and comedy—and painting respectively, it is immensely unlikely that they were attempting to isolate the essence of art in our sense of fine art. It is more plausible to suppose that they were merely singling out a necessary condition of the relevant artforms that is particularly revelatory of the point and purpose of these practices. If you want to understand what poetry and painting are about—if you want to know what it is appropriate to expect from them—the concept of imitation is central. However, when Plato speaks of *mimesis* in poetry and painting, he is not offering an analysis or definition of what we mean by (fine) art or even a real or essential definition of poetry or painting. Rather, he is merely pointing to a general feature of these artforms that is especially useful to have in mind, if one hopes to comprehend them and to gauge their value.

The pressure to define Art (with a capital "A") does not arrive on the scene until the subset of arts mentioned above are separated from the rest and treated as an exclusive confraternity. Perhaps the reason for the emergence of this grouping has to do with the rise of the bourgeoisie who, with leisure time on their hands, turned to these particular arts to fill their hours and days. But, of course, once this grouping took hold, a question arises concerning what property or properties a prospective member needs in order to join the category.

At least initially, it seems that the first gambit for answering this question was that a candidate for membership in the Fine Arts had, harkening back to Plato and Aristotle, to be an imitation, but, more specifically, an imitation of the beautiful in nature. This view is explicitly advanced in Abbé Charles Batteux's 1746 treatise *The Fine Arts Reduced to the Same Principle*, in which the eponymous principle is none other than the imitation of beautiful nature (Beardsley, 1966). For something to count as art, then, in the relevant sense of that which the eighteenth century called the Fine Arts or the Beaux Arts (and what we simply call Art with a capital "A"), something had to be the imitation of the beautiful, though it seems that sometimes this requirement was slackened to no more than that the artform in question had to be representational. If the artform in question was representational, then a work made in accordance with this propensity of the pertinent artform was an artwork. That is, a painting that is a picture is, all things being equal, a work of art.

This definition of art—often called the representational theory of art (Carroll, 1999: Ch. 1)—was certainly ill-suited for the developments in the arts to come, for example: an abstract expressionist painting is not a representation of anything and especially not an imitation of something beautiful in nature. So the definition was fated to be accosted by counterexamples incessantly in the future. But, perhaps more to the point, the representational theory of art was not even viable in its own day.

Dance, for instance, belonged to the system of the Fine Arts; it had its own muse, Terpsichore. However, not all dance, even in the eighteenth century, was

representational. Much dance involved no more than cadenced steps, gracefully executed. In fact, in order to legitimatize a place for dance in the newly anointed system of the arts, choreographers, like Jean-Georges Noverre, had to invent the *ballet d'action*—the ballet that told a story. But, in cases like this, the definition of art as a matter of representation, in fact, functioned prescriptively rather than descriptively.

But an even greater embarrassment for the representational theory of art than dance was the emergence of absolute music—that is to say, pure orchestral music. When opera and song were the dominant forms of music, music could be counted as implicated in representation, since the words that accompanied the notes referred. But, once absolute music took pride of place in the order of Calliope, it became very strained to think of the imitation of nature as the essence of art status. Indeed, as absolute music came in the nineteenth century to be praised for its possession of a condition to which all the other arts aspired, it became less and less credible that imitation was a necessary condition for entry into the citadel of art. Though some swatches of Beethoven's *Pastorale* are imitative, most of the rest of his purely musical oeuvre is not. If for no other reason than the ascendancy of absolute music, the representational theory or definition of art was clearly inadequate. Another approach was needed.

Consonant with the reigning artistic movement of the day, Romanticism, one alternative approach to the representational theory of art was the expression theory—the view that something is an artwork only if it is the expression of an emotion or a feeling (Carroll, 1999: Ch. 2). Variations of this view have been defended by figures such as Leo Tolstoy (Tolstoy, 1985) and R. G. Collingwood (Collingwood, 1938).

If the representational theory of art emphasized the representation of the outer world, the expression theory of art stressed art as the presentation of the inner world of the affective life. Wordsworth asserted that poetry is "the spontaneous overflow of powerful feelings," and this was also thought to be applicable to the other arts. It certainly appeared to fit the absolute music that we now call Romantic. Isn't that why we call it Romantic? Moreover, the expression theory seemed to resist counterexamples insofar as it might be supposed that any human artifact would unavoidably carry an expressive trace of the affects of its maker.

Nevertheless, counterexamples appeared in droves starting in the early twentieth century. One source of these counterexamples were various sorts of aleatoric art; the Dadaist Tristan Tzara composed poems by cutting out words from a newspaper, placing them in a hat, and drawing them out randomly—thus thwarting the possibility of any causal connection with what he was feeling. Related chance techniques were mobilized by the Surrealists and artists like John Cage and Merce Cunningham. Another kind of counterexample to the expression theory derived from found artworks—an ordinary comb presented as an artwork by the likes of Marcel Duchamp projects no expressive properties, let alone the trace of anything felt by Duchamp.

Nor could these counterexamples be blocked by appealing to the idea that every human product bears an emotive residue from its maker. For the preceding

strategies incontrovertibly sever the emotional link between the artist and the art object. Moreover, the expression theory of art would not only be challenged by the artists of the twentieth century. The theory was undermined by certain forms of art already in existence in the heyday of Romanticism, including art that aspired simply to beauty, as in the case of decorative art, and perhaps some absolute music, and art that aimed to represent the look of the world objectively.

Defenders of the expression theory might attempt to fend off these examples by invoking the claim that there is an inevitable and manifest emotive tie between any artifact and its creator. However, not only does this appear controversial, but, if it were so, then the theory would be far too broad to be a satisfactory definition of art, since it would fail to differentiate an artwork from any other artifact.

Around the same time that expression theories begin to make their appearance, so too do alternative accounts of art which derive from Kant's *Critique of Judgment*. These theories can be called the formalist theory of art (Carroll, 1999: Ch. 3) and the aesthetic theory of art (Carroll, 1999: Ch. 4). Formalism, as presented by someone such as Clive Bell (Bell, 1914), maintains that something is an artwork if and only if it is designed primarily to possess a formal design (called significant form) that is worthy of contemplation for its own sake. That is, the form of the work is intended, first and foremost, to afford an aesthetic experience (which is sometimes called an experience of disinterested pleasure pursuant to contemplating the work's design).

The aesthetic theory of art (Beardsley, 1983) is like formalism, except that it leaves the object of experience unspecified by making no reference to the form of the work. On this view, something is an artwork if and only if it is made primarily with the intention to support an appreciable amount of aesthetic experience (aka experience valued for its own sake). Both the formalist theory of art and the aesthetic theory of art make essential reference to intentions in order to differentiate artworks from natural scenes that might give rise to aesthetic experience. With their emphasis on experiences valued for their own sake, both these views may actually articulate the motive behind the modern category of art as a grouping of the things suitable for leisured contemplation and/or diversion.

Neither formalism nor the aesthetic theory of art provides necessary conditions for classifying candidates as artworks. For it is implausible to suppose that most religious artworks were created with the primary intention of abetting experiences valuable for their own sake. Rather, like so many other premodern artworks, they were produced to perform a function. They were created with the primary intention of advancing religious purposes. Paintings of Christ's crucifixion were intended to instill reverence; they were not meant to be occasions for intrinsically valuable experiences of painterly form. And the designs on the shields of the Sepik warriors of New Guinea were not drawn in order to engender experiences valued for their own sake, but with the instrumental aim of frightening the enemy. Nor is experience valued for its own sake a sufficient condition for art status. Games of chess may be said to promote experiences valued for their own sake, but games of chess are not artworks, not even performance artworks.

 The successive failures of attempts to define art disposed many philosophers
to skepticism about the very venture itself. By the mid-twentieth century,
the suspicion, generally encouraged by the writings of Ludwig Wittgenstein,
that art could not be defined became popular. Philosophers like Morris Weitz
argued that, since artmaking is an arena in which experimentation, innovation,
and novelty are prized, the notion of defining art is incompatible with the
practice of artmaking (Weitz, 1956). For to define art in terms of necessary and
sufficient conditions would putatively somehow shackle the essential openness
of art to invention and creativity. Philosophers of this ilk, often called neo-
Wittgensteinians, maintained that to define art was to contradict the concept
of art as that which contained the permanent possibility of art to expand its
horizons in new directions. Consequently, they rejected the metaphysical project
of identifying for artworks a set of necessary conditions that were conjointly
sufficient. Moreover, with respect to the epistemological question of how we
establish that something is an artwork, they suggested that it was a matter of
family resemblance; something A is an artwork when it resembles an artwork B
in some respects, artwork C in other respects, and so on for further paradigmatic
artworks.

 Though initially quite influential, the spell of the neo-Wittgensteinian brief
began to wane by the 1970s. On the one hand, the argument that specifying the
conditions according to which a candidate counted as an artwork is inconsistent
with the innovative nature of art could be seen to rest on an equivocation. For
even if the *practice* of art is always in principle open to innovation, and, therefore,
supposedly inhospitable to definition, it is not clear why this would stand in
the way of defining the concept of an artwork, since individual artworks are not
typically open to the permanent possibility of change. It just does not follow that
if *art* (in the sense of the practice of art) is an open concept, then *art* (in the
sense of an individual artwork) is an open concept. Moreover, this open concept
argument, as it was called, was also challenged by the appearance of definitions
of art by people like Arthur Danto (Danto, 1981) and especially George Dickie
(1974) which, though stated in terms of necessary conditions, provided more
than ample room for artistic invention, accommodating the entire gallery of
works of Dada and its legacy.

 And, finally, the epistemological wing of neo-Wittgensteinianism also came
under fire. Because it relied upon similarity to establish art status and because
everything is like everything else in some respect, by means of the family
resemblance method, one could in fairly short order establish that any candidate
is an artwork. For example, Rodin's *Gate of Hell* and an I-beam about to be
shipped from a steel mill are both physical objects, both metallic, both shaped by
human designs, both weigh over one hundred pounds, both over two feet long,
and so on. But all these similarities and more are not enough to warrant calling
the I-beam an artwork. Though it may be that in the wake of the found artwork
anything can be art, it is not the case that everything is art. Nevertheless, the
family resemblance method for classifying artworks would appear to force us to
conclude that everything is art now.

A common failing of the theories of art as representation, as expression, as form, as well as the family resemblance model for identifying art is that in each case art status rests upon some discernible or manifest feature of the object—such as the possession of anthropomorphic or expressive properties, significant form, or similarities with antecedently acknowledged artworks. Perhaps, it was suggested, by philosophers, like Arthur Danto, that art status rested in some property of art that the eye could not descry. Duchamp's *In Advance of a Broken Arm* and an ordinary snow shovel are putatively indiscernible. Thus, a theory of art that relies on discernible features of artworks cannot hope to cut the difference between them. Rather, the property (or properties) that are constitutive of art status is something indiscernible.

For Danto, like Hegel, the relevant feature here is *about-ness* in a double sense. Something will be an artwork, on this account, only if (1) it is about something and (2) its mode of presentation says something about, makes some comment upon, or advances a point of view concerning whatever it is about (Danto, 2000). However, this formula is, on the one hand, too exclusive—there are artworks that may be about nothing, but that are simply beautiful or delightful to the senses. On the other hand, Danto's theory may be too inclusive. Though Danto means it to tell us the difference between Andy Warhol's artwork *Brillo Box* and an allegedly indiscernible though inartistic one from Procter and Gamble, surely the ordinary soap pad container in the grocery store meets both of the conditions of Danto's theory of art.

Like Danto, George Dickie is impressed by the thought that the defining features of art might be indiscernible. This has disposed him to look toward the context that surrounds and frames the work for clues about its status as a work of art. That is, the work does not wear its artistic status on its face; rather, its position in a social framework or institution is the source of its pedigree. This insight has motivated Dickie to develop a series of what have been referred to as Institutional Theories of Art, the latest version of which he has christened The Art Circle (Dickie, 1984).

According to Dickie, our concept of art can be captured by five interlocking definitions: (1) an artist is a person who participates with understanding in the making of a work of art; (2) a work of art is of a kind created to be presented to an artworld public; (3) a public is a set of persons the members of which are prepared in some degree to understand an object which is presented to them; (4) the artworld is the totality of all artworld systems; and (5) an artworld system is a framework for the presentation of a work of art by an artist to an artworld public.

Even a cursory examination of the preceding set of definitions reveals that it is circular. One needs the concept of an artworld to define what counts as a work of art, but the concept of a work of art figures in the definition of an artworld system which, in turn, is an element in the definition of an artworld. Dickie is aware of this circularity but claims that it is not problematic. Yet it appears to leave the crucial notion of *art* undefined, though a definition of art was what Dickie was aiming for.

Dickie's framework does articulate the structure of any communicative practice with its emphasis on mutual understanding. However, what makes art the very communicative practice it is rather than some other, like philosophy, has not been clarified by Dickie's analysis. Moreover, some, like Jerrold Levinson, suspect that the model does not even offer a set of necessary conditions for art status, since it does not allow for art made by a solitary artist for himself—for example, some Neolithic wanderer who arranges a pile of colored stones in front of his fire because they are delightful to look at as the flames illuminate them variously (Levinson, 1979).

Instead of social context, Levinson locates the defining feature of art in the intention of the artist. On Levinson's view, a candidate is an artwork if and only if it is created by a person (1) who has a proprietary right over the work in question and (2) who non-passingly intends the work for regard as a work of art—i.e., in one or more of the ways that artworks have been correctly regarded historically (Levinson, 1979). Like Danto and Dickie, Levinson deploys a non-manifest property of the work—a certain kind of intention—as the crux of his definition. Because this intention must be linked to the history of art, Levinson entitles his approach *defining art historically*.

It is not clear why Levinson feels compelled to require that artists must have a proprietary right over the work in dispute. Surely if Brancusi constructed a sculpture out of stolen materials, there would be no question that he had created a work of art, even if the ownership of the object was in question. Moreover, the second condition of Levinson's definition is also fraught with difficulties. Though it is called a historical definition, it is historically insensitive. It overlooks the possibility that some historical art regards may become obsolete. For example, appreciating the verisimilitude of a picture was an art regard for centuries, but it is arguably no longer decisive, lest many ordinary family snapshots made with the intention to be appreciated integrally and non-passingly for their accuracy would, counterintuitively, count as artworks. Unfortunately, Levinson makes no provision for anachronistic art regards.

Like Levinson, Robert Stecker appeals to history in order to define art. He labels his view *historical functionalism* (Stecker, 1997). It is a disjunctive definition of art. Stecker claims that something is an artwork if and only if it is in a central artform at time *t* and it is made with the intention of fulfilling functions standardly or correctly recognized for that form OR it is an artifact that achieves excellence in fulfilling one of the functions of the central artforms at *t*.

This definition seems far too inclusive. According to Pierre Bourdieu, one of the functions of our artforms is to produce social capital or status or identity. Thus, a Cadillac convertible would be a work of art in virtue of the second disjunct in Stecker's formula. The problem here is that Stecker has not limited the functions he countenances to exclusively artistic functions, but, of course, it is not evident that he can do that readily without inviting circularity.

Historical functionalism is also too exclusive. It cannot assimilate as artworks the initial avant-garde entries of radical art movements. For these works may not

belong to a central form of art and they may be designed expressly to repudiate the recognized functions of art at time *t*. Consider the cases of found objects (Duchamp), found music (Cage), and found movement (Yvonne Rainer and Steve Paxton) when they first emerged. They were not obvious examples of a central form and, in any event, they repudiated the functions correctly associated with the forms to which they were related adversarily. Yet certainly any definition of art at this late date must accommodate works like these.

Perhaps the historical functionalist will attempt to negotiate this shortfall in the theory by saying that once art movements like Postmodern Dance are successful they become—say at time $t + 1$—central forms of art with correctly recognized functions; thus, in virtue of the second disjunct of the theory, the originating works of the movement from time *t* can be reclaimed as art. Yet this gambit comes with costs, since it has the avant-garde works in question only becoming artworks due to our appreciation of them long after their creators produced them. But surely a dance like *Satisfyin' Lover* or a composition like *4' 33"* were artworks from the very moment of their inception. And it is their actual creators who imbued them with art status and not some other folks at time $t + 1$.

Due to the recurring difficulty with constructing an adequate conceptual analysis of art, some contemporary philosophers are agnostic about the metaphysical prospects of discovering a set of necessary properties that are conjointly sufficient for identifying artworks. Instead they focus their energies upon articulating epistemically satisfactory methods for identifying candidates as artworks—methods which are not real definitions.

Berys Gaut, mining Wittgenstein again for inspiration, resurrects the notion of a cluster concept, arguing that it is sufficient for classifying a candidate as an artwork that the candidate scores well against the following 10 criteria: (1) it possesses positive aesthetic properties; (2) it expresses emotion; (3) it is intellectually challenging; (4) it is complex and coherent; (5) it has the capacity to express complex meanings; (6) it exhibits an individual point of view; (7) it is an original exercise of the imagination; (8) it is the product of skill; (9) it belongs to an established form of art; and (10) it is made with the intention to be a work of art (Gaut, 2000).

This is not a real or essential definition of art, since none of these properties are necessary conditions for art status. Anything that is a work of art will have at least one of these features; a work that has more and more of these features provides us with more and more reasons to categorize it as an artwork. On this view, a cluster account of a concept is true of that concept just in case it isolates properties whose possession by the work in question necessarily counts toward its belonging to that category. However, though Gaut provides us with this list of the components of the cluster concept, he does not believe that the cluster concept approach to identifying art stands or falls with his particular sketch of it. He asserts that even if problematic cases for his formulation exist, that should not lead us to distrust in general the cluster concept approach to identifying artworks.

But is Gaut's assertion here convincing? Clearly, there are problem cases with respect to his dissection of the putative cluster concept. I see no reason why a delicious meal made by a master chef to express his devotion to his beloved and to recall their life together by means of culinary references could not instantiate every component of Gaut's list save obviously (9). Indeed, since the preparation of food occasionally figures in certain theatrical works, and especially in examples of performance art, maybe a case could even be made that it satisfies (9), generously construed. It should, therefore, count as a work of art, though this is certainly at least a very controversial case and, for many, a decisive counterexample to Gaut's proposal. But, if Gaut's proposal is defeated, why believe that there is some other model of the cluster concept of art that will do the job? If it is inadmissible to maintain that the definitional approach to the concept of art will succeed despite the lack of evidence so far, why should we have faith in the cluster concept approach, when the best version of it so far misses the mark?

Another non-definitional approach to answering the epistemic question of how we might establish that a candidate is an artwork is that we do so by employing historical narratives (Carroll, 1993, 2001). According to what we may call narrativism, establishing that a candidate is an artwork involves telling a certain kind of story about the work in question, namely an accurate historical narrative about the way in which the candidate came to be produced as an intelligible response to an antecedently acknowledged art-historical situation. That is, in order to corroborate the claim that something is an artwork, we standardly mobilize a narrative explanation of how the work emerged coherently from recognized artistic modes of thinking, acting, composing, decision-making, and so forth already familiar to the practice.

Usually the pressure to establish that something is an artwork arises when there is some dispute over its art status, as frequently occurs with works of the avant-garde. The narrativist observes that these imbroglios are typically managed by recounting art historical narratives that demonstrate the connection between the disputed work and some earlier artworks whose membership in the order of art is uncontested.

If, for example, the distorted figuration of German Expressionist painting is rejected as art properly so-called on the grounds that it departs from the canons of accurate pictorial representation, the narrativist traces its lineal descent from styles of art, such as the medieval art of Grunewald, where distortion was a strategy for signaling the sentiment of the artist toward his subject. Even if German Expressionist art repudiated prevailing styles of realism, the narrativist argues that there is still reason to count the works in question as art because they harken back to earlier forms of artmaking, discharging functions, such as the expression of feelings, that are abroad, alive, and acknowledged in their contemporary artworld.

One objection to narrativism is that it is circular. However, though circularity is a defect in definitions, it is not clear that it raises any problems for narratives. It is also charged that narrativism confronts the same problem that perplexed the family resemblance approach to identifying art. But this is not the case, since

narrativists do not merely cite similarities between earlier and later works, but also seek to establish a network of causal relations between them. It is not merely that German Expressionist paintings resemble some medieval art that supports their art status; it is also the case that the German Expressionist painting was influenced and inspired by the antecedently recognized medieval art.

Insofar as the narrative approach relies upon tracing lines of descent within historically situated, artistic practices, the question arises as to how the narrativist intends to identify artworks in alien traditions. A first response is: by tracing the emergence of later works in that tradition from earlier works. But how can the narrativist identify the first works in alien traditions of art—something he needs to do in order to establish the bona fide origin of subsequent artworks from genuine precedents? Here, the narrativist needs to concede that narrativism is not the only way in which artworks may be identified. With works in alternative traditions of artmaking, we frequently need to fix the earliest instances of art in those practices by isolating the works that in that culture are meant to perform the same functions—such as representation, expression, symbolization, decoration, signification, etc.—that the earliest, already recognized artworks execute in our own culture. This, of course, admits that narration is not our only means of identifying candidates as artworks; sometimes we must depend on functional considerations. Moreover, though historical narration may be sufficient for establishing that a candidate is an artwork, it is not a necessary condition for art status, if only because with certain cases of art, notably from ancient and remote civilizations, it may not be possible to retrieve a narrative account of their provenance.

REFERENCES AND FURTHER READING

Beardsley, Monroe. 1966. *Aesthetics: From Classical Greece to the Present*. New York: Macmillan.
——1983. "An Aesthetic Definition of Art," in Hugh Curtler, ed., *What is Art?* New York: Haven, pp. 15–29.
Bell, Clive. 1914. *Art*. London: Chatto and Windus.
Carroll, Noël. 1993. "Historical Narratives and the Philosophy of Art." *Journal of Aesthetics and Art Criticism*, 51: 313–26.
——1999. *Philosophy of Art: A Contemporary Introduction*. London: Routledge.
——2001. *Beyond Aesthetics*. Cambridge: Cambridge University Press.
Collingwood, R. G. 1938. *Principles of Art*. Oxford: Clarendon Press.
Danto, Arthur. 1981. *The Transfiguration of the Commonplace*. Cambridge, MA: Harvard University Press.
——2000. "Art and Meaning," in Noël Carroll, ed., *Theories of Art Today*. Madison, WI: University of Wisconsin Press, pp. 130–40.
Davies, Stephen. 1991. *Definitions of Art*. Ithaca, NY: Cornell University Press.
Dickie, George. 1974. *Art and the Aesthetic*. Ithaca, NY: Cornell University Press.
——1984. *The Art Circle*. New York: Haven.

Gaut, Berys. 2000. "*Art* as a Cluster Concept," in Noël Carroll, ed., *Theories of Art Today*. Madison, WI: University of Wisconsin Press, pp. 25–44.

Kristeller, Paul Oskar. 1992. "The Modern System of the Arts," in his *Renaissance Thought and the Arts* (Princeton, NJ: Princeton University Press, 1990), pp. 163–221.

Levinson, Jerrold. 1979. "Defining Art Historically." *British Journal of Aesthetics*, 19: 232–50.

Stecker, Robert. 1997. *Artworks*. University Park, PA: Pennsylvania University Press.

Tolstoy, Leo. 1985. *What is Art?* transl. Almyer Maude. Indianapolis, IN: Hackett.

Weitz, Morris. 1956. "The Role of Theory in Aesthetics." *Journal of Aesthetics and Art Criticism*, 15: 27–35.

4

Art, Creativity, and Tradition

1. THE PREJUDICE AGAINST TRADITION

Tradition has had a bad odor among artists of the twentieth century. And, as anyone who has ever taught in an art department knows, anti-tradition rhetoric has seeped into the consciousness of many an undergraduate journeyman (and woman). When I taught film history, a required course for fledgling moviemakers, I was frequently asked by them why they had to take my course—why did they have to study film history? After all, Hitchcock never enrolled in such a course, and he turned out okay. Their basic presupposition seemed to be that somehow learning the tradition of their artform would impede or hamper or stultify the flowering of their natural creativity. This article of faith, moreover, is well precedented in the writings of many twentieth-century artists. Perhaps the Futurists are the best-remembered proponents of virulent anti-traditionalism. In the manifesto entitled "The Futurist Synthetic Theatre," Filippo Tommaso Marinetti, Emilio Settimelli, and Bruno Corra proclaim:

The Futurist Theatre is born of the two most vital currents in the Futurist sensibility . . . which are: i) our frenzied passion for real, swift, elegant, complicated, cynical, muscular, fugitive, Futurist life; 2) our very modern cerebral definition of art according to which no logic, no tradition, no aesthetic, no technique, no opportunity can be imposed on the artist's natural talent; he must be preoccupied only with creating synthetic expressions of cerebral energy that have THE ABSOLUTE VALUE OF NOVELTY.[1]

So convinced were the Futurists that tradition threatened the creative potential of their natural talent that they urged: "Set fire to the library shelves! Turn aside the canals to flood the museums! . . . Oh, the joy of seeing the glorious old canvases bobbing adrift on those waters, discolored and shredded."[2] One suspects (and

The author wishes to thank Berys Gaut, Sally Banes, Dale Jamieson, P. Adams Sitney, Philip Harth, Annette Michelson, and Lester Hunt for their help in the preparation of this chapter.

[1] Filippo Tommaso Marinetti, Emilio Settimelli, and Bruno Corra, "The Futurist Synthetic Theater," in *Let's Murder the Moonshine: Selected Writings of F. T Marinetti*, ed. R. W. Flint, transl. R. W. Flint and Arthur A. Coppotelli (Los Angeles: Sun and Moon Classics, 1991), p. 135. This manifesto was initially issued in 1915.

[2] Filippo Tommaso Marinetti, "The Founding and Manifesto of Futurism," in *Let's Murder the Moonshine*, p. 51. This was first published in the Parisian newspaper *Le Figaro* in 1909.

hopes) that this rhetoric was intentionally hyperbolic. However, the message is clear: tradition, as accumulated in libraries and museums, is the enemy. The enemy of what? Creativity.

Nor were the Futurists alone in their animus against tradition. Nunism (Nowism), as its very name indicates, also eschewed any connection with the past. In 1916, its polemicist Pierre Albert-Birot wrote:

Do we worship Isis, Jupiter, Janus, Jehovah, Christ, Boudha, Moloch? No. Do we wear tunics, peplums, or armor? No. Do we speak Egyptian, Greek, Rumanian, Hebrew . . . Roman or Chinese? No. So why should our arts be Egyptian, Greek, Rumanian, Gothic, Chinese, or Japanese?

Our idea, our costume, our language, is it the same as in the time of Louis XIV, Louis XV, Louis XVI? No. Why should our arts be the same? Is our ideal, our way of dressing or of speaking, the same as last century's? Does our time resemble that of our parents? No. So let's do as each people has done in each period of time, LET'S BE MODERN; let our works be the expression of the time in which they were born, these works alone are living.

ALL THE OTHERS ARE ARTIFICIAL
TO EACH TIME ITS ART.[3]

Moreover, this sentiment is, albeit more succinctly and more colorfully, echoed by Vladimir Mayakovsky, who recommends, "Throw the old masters overboard from the ship of modernity."[4]

It is hard not to detect a residue of earlier ideas about creativity in these twentieth-century manifestos. With their references to the modern, Albert-Birot and Mayakovsky, perhaps unconsciously, recall to mind the famous debate between the Ancients and the Moderns—that is, the eighteenth-century debate between those who emphasized the emulation of ancient models as the road to artistic excellence, versus those who championed originality and natural genius.[5] Intimated by Addison, but then elaborated in greater detail by Edward Young, the Moderns' position contrasted imitation of traditional models with reliance on artistic spontaneity, leaving little doubt of the superiority of the latter approach.

Young writes:

An *Imitator* shares his crown, if he has one, with the chosen object of his imitation; an *Original* enjoys an undivided applause. An Original may be said to be of a *vegetable* nature; it rises spontaneously from the vital root of genius; it *grows*, it is not *made*: *Imitations* are often a sort of *manufacture* wrought up by those *mechanics, art* and *labour*, out of pre-existent materials not their own.[6]

[3] Pierre Albert-Birot, "Banality," in *Manifesto: A Century of Isms*, ed. Mary Ann Caws (Lincoln: University of Nebraska Press, 2001), p. 195.

[4] Vladimir Mayakovsky, "A Drop of Tar," *Manifesto*, p. 234. Mayakovsky's manifesto dates from 1915.

[5] For an excellent discussion of this debate, see Peter Kivy, *The Possessor and the Possessed* (New Haven, CT: Yale University Press, 2001), Ch. 3.

[6] Edward Young, "Conjectures on Original Composition," in *A Collection of English Prose: 1660–1800*, ed. Henry Pettit (New York: Harper and Brothers Publishers, 1962), p. 394.

And: "[L]et not great examples, or authorities browbeat thy reason into too great a diffidence of thyself. Thyself so reverence, as to prefer the native growth of thy own mind to the richest import from abroad; such borrowed riches makes us poor."[7] Indeed, imitation of the tradition not only makes us poor, but proud, "makes us think little, and write much."[8] Though born original, Young says, we die copies.[9] That is, by emulating the canon, artists alienate themselves from their own sources of genius, and originality.

These ideas, of course, were then seized upon eagerly by the Romantics with their extreme emphasis on individuality and, through them, relayed to the twentieth century, when the notion that tradition is inimical to creativity, spontaneity, and originality became a recurring commitment, inspiring wave upon wave of avant-gardists with the conviction to overcome tradition and, as Ezra Pound says, "to make it new."

Undoubtedly, the tendency of nineteenth-century artists to model their own, allegedly Promethean creativity on God's[10] also reinforced the prejudice against tradition. For, if God creates *ex nihilo*, so must the artist; but if artistic creation emerges from tradition, it comes from somewhere and is not *sui generis*. Moreover, God is a creator, not an imitator, where imitation is conceived to be essentially tradition-bound. So a godlike artist should not be tethered to tradition, no matter how sterling the exemplars gathered together in the canon of that tradition be. Likewise, the separation of the artist from systems of patronage placed a premium on the individuality of the artist. No longer charged by commissions from Church and state, the artist was free to pursue his or her own aims—ones that expressed his or her own individuality—and to search out consumers with like interests in the marketplace. What the artist had to sell was her own individuality, her own subjectivity, and originality became her calling card. But to be genuinely individual, to be an authentic original, was to be autonomous, not a slave to a tradition, bound to it by imitation. Perhaps that is why Schopenhauer characterizes genius as akin to childishness—as uncorrupted by the acculturation process which tradition represents. Maybe that is why Mozart is so often represented as a prodigy who remained perennially childlike.[11]

Insofar as the modern myth of creativity is tied up with ideas of originality, spontaneity, freedom, exorbitant claims to individuality, and the notion of artistic genius as thoroughly self-determining, it has little patience for the idea of an artistic tradition. Tradition stands in the way of creativity and artistic freedom by introducing something putatively not of the artist's own into the mix. If artistic creativity, properly so called, is the spontaneous outpouring of the authentic self uncontaminated by anything else, then tradition is its nemesis.

Instead of freedom, tradition is seen as a form of bondage to the past. Instead of spontaneity and utter self-determination, sympathy for tradition marks the

[7] Ibid., p. 402. [8] Ibid., p. 400. [9] Ibid.
[10] George Steiner, *Grammars of Creation* (New Haven, CT: Yale University Press, 2001), p. 22.
[11] Kivy, *The Possessor*, Chs 5 and 6.

artist as a person with a past, a past to which she is beholden. And whereas artistic creativity is associated with consummate originality, unconstrained by anything, the notion that the artist is beholden to tradition undermines his godlike individualism, his supposed power to give the rule to nature. On this view, appeals to tradition are always, essentially, at root *academic* (in the pejorative sense of that term).

Something like this view of artistic creativity is widely abroad even today. It is probably the Ur-theory of artistic creativity in our culture, often masquerading under the name of self-expression. Undoubtedly, connected to this prejudice is the commonplace that art cannot be learned and that artists are born to their vocation rather than trained. And, though never stated quite so baldly by professional philosophers, some of these tenets lie submerged in their theories as well. The purpose of this chapter is to challenge the opposition that the Ur-theory presupposes between artistic creativity and tradition. I shall argue not only that its metaphysical conceits are outlandishly excessive, but that, in point of fact, tradition is and must be an important ingredient in artistic creativity, properly so called.

2. THE CASE FOR TRADITION

For the purposes of this chapter, there are at least two senses of the notion of artistic creativity: the descriptive sense and the evaluative one. In this section, I will discuss the descriptive sense and argue that tradition is indispensable to artistic creativity of this sort. In the next section, I will briefly examine the evaluative sense of artistic creativity.

In the descriptive sense, artistic creativity is simply the capacity to produce new artworks that are intelligible to appropriately prepared and informed audiences. A creative artist is someone who is able to carry on—to continue to produce new artworks. An uncreative artist, in this light, is someone who lacks the ability to go on producing new works of art—for example, a novelist with writer's block or a plagiarist. In this sense of creativity, the artworks in question need not be especially valuable. When we use the word "creative" to praise an artist or a work of art, we are employing it in the evaluative sense.

In the descriptive sense, an artist is creative if she is able to produce new artworks that elicit uptake from suitably prepared viewers, listeners, or readers; she is creative in the evaluative sense if those works possess a certain type of value (to be discussed later). But, clearly, to be called creative in the evaluative sense requires being creative in the descriptive sense, since, if nothing is produced, then there is nothing to praise.

The pressure to create new artworks comes from several sources. First, inasmuch as art is intended to stimulate, command, and absorb the attention of audiences, some variation and novelty is requisite, lest the artist's work start

to blend, as they say, into the woodwork.[12] The artist renews attention to his production through change. The artist is also drawn to variation insofar as she is involved in a conversation with other artists—in effect, a conversation about the techniques and purposes of her artform—and, as in any conversation, she feels the pressure to add something new to the dialogue.[13]

Furthermore, the artist is virtually impelled toward change, because, as Hegel pointed out, as time goes on, the concerns, emotions, ideals, and so on of her culture evolve, and she must find new ways to express them. And, last, the challenge to innovate also arises recurringly as new media and technologies for expression and representation become available. For these reasons, and others, art gravitates toward differentiation, variation, and innovation. Change is the name of the game; artistic creativity in the descriptive sense is the price of entry for the individual artist.[14]

This is not to say that every artist is a revolutionary. The kind of variation expected can come in small increments as well as large ones. An artist's output need not mutate enormously from work to work. Nevertheless, some variation from work to work is the norm. Thus, artistic creativity appears to be presupposed by the very vocation of the artist. But whence does this spring?

Because he denied that artists possess knowledge, Plato hypothesized that the source of artistic creativity is divine madness—the artist inspired by the gods or muses. But this conjecture is of little use to us, since there are no gods, and, in any case, Plato forgot to discount the possibility that artists, even if they lack knowledge about war, statecraft, and navigation, nevertheless possess knowledge of their artform. That is, though poets are not generals, as Socrates reminds Ion, they know how to represent generals. As Shakespeare shows in *Henry V*, they know how, for example, to portray the way in which a warrior-leader might go about rousing his troops. Moreover, there is no need to plump for a supernatural explanation of this knowledge. From a perfectly naturalistic viewpoint, one may hypothesize that the artist learns how to do this by studying the tradition of her artform.

Historically, a more palatable explanation than Plato's for the source of artistic creativity appeared in Longinus's *On Sublimity*. Whereas Plato/Socrates situated artistic creativity outside of the artist—in a genie, so to speak—Longinus relocated it inside the artist, in his natural, inborn genius. The artist, in other words, is her own genie. Genius, furthermore, is not taught, and this natural

[12] Colin Martindale, *The Clockwork Muse: The Predictability of Artistic Change* (New York: Basic Books, 1990).

[13] The notion of art as a conversation derives from Jeffrey Wieand, "Putting Forward a Work of Art," *Journal of Aesthetics and Art Criticism*, 41 (1983): 618.

[14] Some artistic traditions may encourage more change than others. Some may even discourage change. My point is that, given the considerations rehearsed above, some change in all artistic traditions is virtually inevitable. The evidence for this is that even traditions that devalue change exhibit variation from work to work, from generation to generation, and so on. The preceding two paragraphs attempt to explain why this is.

endowment is the prime cause of at least great art.[15] In Longinus, then, we find the germs of the avant-gardist repudiation of tradition rehearsed above, transmitted to the twentieth century through the influential writings of people like Edward Young and then, momentously, by Immanuel Kant.

Longinus's problematic was to weigh the competing claims of natural genius versus rules and precepts as sources of artistic creativity. In this, he was a trimmer. Though giving natural genius an edge in the matter, he also conceded a role for rules and precepts in the process of artistic creation—notably as curbs or brakes on natural excess. However, as the discussion ensued over the centuries, the rivalry between natural endowment versus rules and precepts as the source of artistic creativity turned into a zero-sum game. The font of artistic creation was either nature or the rules, inspiration rather than perspiration, genius rather than the artificial or mechanical application of precepts. Moreover, this opposition of natural talent to rules of art explains in large measure the deprecations of tradition in the name of creativity that we hear from avant-gardists and undergraduate art students alike, since tradition, in their minds, is squarely associated with allegiance (generally assumed to be blind) to the rules and precepts of art.

The first argument against rules of art is fairly straightforward. There are no rules of art—no algorithms of composition that guarantee success in every instance. One cannot create artworks by numbers. So it cannot be that artistic creativity is a product of tradition, conceived of as a body of rules, because there are no rules in the relevant sense. That is why artistry cannot be taught. Artistic creativity must hail from elsewhere. This, then, prompts the hypothesis that it originates in the artist's natural endowment, which should never be hemmed in by alleged, phantom rules.

A second argument looks to the history of art and notes that tradition, with its vaunted rules, has often been an impediment to creativity. Had Shakespeare abided by the so-called Aristotelian unities, we would not have had *King Lear* to enjoy today. Tradition, in this respect, is an obstacle to creativity. It chokes it and attempts to contain it. But history shows that great works of art, like those of Shakespeare and Beethoven, originate in the defiance of tradition and its supposed rules and instead rely upon natural genius, which today might also go under the name of the unconscious.

Both these arguments rest on what I will argue are misconceptions concerning the nature of artistic tradition. Both arguments associate artistic tradition with rules. But if there are no rules, the first argument, which we may call the no-rule argument, maintains, then there is nothing to learn from tradition and no way for tradition to nurture creativity. Moreover, the second argument, which we may call the genius-argument, adds that the things which are advanced as rules, like

[15] Admittedly, Longinus was concerned with art of a high level of accomplishment and not routine creativity. However, since many people tend to use the notion of art honorifically, regarding as art only works of palpable achievement, it is understandable that the genius account is often appropriated as a description of the processes of ordinary artistic creation.

the Aristotelian unities, are really parochial norms that, as they become obsolete, shackle real creativity.

With respect to the no-rules argument, several things need to be said. First, there do seem to be some rules of art, or, at least, fairly reliable rules of thumb, such as Hume's recommendation that if an author wants to hold the reader's attention, he should make sure that there is a secret in the story—that is, something the reader desires to learn—which keeps her turning the pages. In each artform there are rules of this sort that an artist may learn that will enable her to secure certain routine effects. Of course, these rules do not have scientific precision. Since artworks are very complicated, such rules have to be subtly coordinated with other factors. The rules cannot be applied mechanically. Their application requires finesse and judgment. But, arguably, these talents themselves are acquired by studying the tradition and its canon of exemplars.

Of course, the rules the skeptic has in mind may not be rules such as those for promoting effects, like suspense. What the skeptic denies is that there are rules that guarantee the production of masterpieces. This may be correct, and, in any case, no one knows what those rules might be. However, this is irrelevant to a descriptive account of artistic creativity. For such an account is only concerned with the contribution that tradition makes to the creation of new works, whether they be masterpieces or not. And it may be the case that sometimes, even often, traditional rules of thumb, supplemented by judgment, is what enables artists to produce new work—that is, to be creative in the descriptive sense. That is, after all, why visual artists learn color theory.

The no-rule argument may be right in its contention that there are no rules of art that are algorithmic, but this is also true in other arenas, such as morality and the law, where we are not disposed, in consequence, to deny there are rules. Of course, the skeptic may concede this and go on to modify his position by saying that if there are such rules, there are not very many of them, and, in any event, they are not very important. So, even if tradition is a matter of such rules, tradition's contribution to artistic creativity dwindles to insignificance.

Now the skeptic may or not be correct about the number and import of such rules. However, even if he were right, his conclusion does not follow from this, because it is not clear that the only thing an artist learns from her tradition is a body of rules. That is, the conflation of tradition with rules, especially algorithmic ones, is invidious. For, as I will attempt to show in what follows, artists learn something more than rote formulas from their tradition and it is this something more that is indispensable to artistic creativity.

However, before turning to this issue, a few points need to be made about the second skeptical argument, the genius-argument. Like the no-rule argument, it uses masterpieces—works by Shakespeare and Beethoven—as its primary intuition pumps. Thus, it is really concerned with artistic creativity in the evaluative sense, not routine artistic creativity in the descriptive sense. It may be the case that certain masterpieces defy period-specific rules, but that does not imply that period-specific rules do not sometimes abet the creation of new artworks, some of which may be very good, even if others are not.

Moreover, again like the no-rule argument, the genius-argument supposes that artistic traditions are to be construed as a body of rules, indeed, particularly rigid, static, and inflexible rules, rules that stand in the way of creativity as a logjam holds back the torrential, altogether sublime river. But this is the wrong way to conceive of an artistic tradition.

Artistic practices evolve for reasons we have already suggested. This evolutionary process involves expansion in new and future directions and the retention of past aims, values, and strategies that make evolving artistic practices of a piece with their predecessor practices. Tradition obviously plays a role in this process in terms of retention. But tradition also contributes to the expansion of the practice by informing artists about which variations in artistic production are intelligible ones, given the background of the practice.

That is, artistic creativity is not a matter of random variations. Artists need some sense of which variations will count as intelligible or relevant expansions of the same practice. That sense, in large measure, derives from their immersion in a tradition. Tradition, in this respect, is what negotiates the transition between the past and the future of artistic practice.

Tradition, in short, is not an inflexible barrier to change and creativity. It is a flexible resource for initiating relevant and intelligible changes within artistic practices—a resource that enables artists to create new work that remains within the boundaries of the self-same practices. In this regard, it is mistaken to view artistic tradition as an obstacle to creativity; rather it is an engine or catalyst that enables it to unfold.

So far I have criticized the two skeptical arguments that impugn the role of tradition with respect to artistic creativity. I have done so primarily by denying that their conceptions of tradition are accurate. But, if this is to be more than a logical gambit, the burden of proof is upon me to suggest an account of artistic tradition that supports the claim that it is an indispensable contributing factor to artistic creativity in the descriptive sense.

In his book *Ulysses Unbound*, Jon Elster points out that artistic creativity requires a way in which to delimit the number of options that confront the artist.[16] Too many options lead to paralysis rather than creativity: too many possibilities, without some way of narrowing down the field of alternative choices, will stop the artist in her tracks rather than promoting the production of new work. Elster emphasizes the importance of constraints, especially self-elected ones, for performing this filtration function. This is true enough. However, artistic traditions, which are not always best spoken of in terms of constraints, also operate as filtration devices. That is, filtration is requisite for artistic creativity, but self-elected constraints are not the only source of filtration. Tradition is another, indeed, a generally more pervasive one.

Tradition is the living past of a practice. It is indispensable for creativity in the descriptive sense, because it serves to fix the horizon of possibilities that

[16] Jon Elster, *Ulysses Unbound* (Cambridge: Cambridge University Press, 2000), pt. 3.

lie before the artist. It focuses the artist's attention upon those options that will be intelligible—to both the artist and her audience—against the historical background of a practice.

Call these options live options. Artistic change and innovation emerge in the course of history. The artistic choices that will be intelligible at time T_5 are made possible, in part, by earlier choices in the practice. Presenting an upside-down bathroom fixture as a new work of art would not have been intelligible—would not have been a live option—in the court of Louis XIV, even if it had been signed by an artist. For such a gesture to be intelligible requires a background of doing and saying—of making and theory (or, at least, lore, history, and shoptalk).

That is, for a readymade like Duchamp's *Fountain* to be intelligible as an artwork, it had to fit into the conversation of art in a way that was relevant,[17] and relevance, in this sense, is in large measure a function of previous stages in the conversation, which stages we may refer to as tradition. Moreover, the tradition not only serves to filter out live options, but since there is generally an array of live options, the artist's understanding of the tradition also enables him to assess them in terms of which ones are most apposite, given his circumstances. The tradition, that is, not only performs a filtration function with regard to artistic creation, but an assessment function as well.[18]

Artists acquire knowledge of the tradition in the process of learning their profession. They begin by imitating the past—not only models from the past, but routines, strategies, conventions, rules of thumb, past solutions to recurring problems, and so on. Imitation is the means by which artists are initiated into their vocation. Aristotle pointed out that imitation is a key source of learning, something readily confirmed by contemporary psychology. This is true not only for things like language, morals, and etiquette, but for artmaking as well.

Artists could not become artists unless they had something to emulate. This is not to deny that natural endowment may make a difference in the degree of facility they achieve. However, it cannot be a matter of natural genius "all the way down," as the anti-tradition rhetoric sometimes suggests, since such genius would remain empty and inert without models, strategies, conventions, and

[17] See Wieand, "Putting Forward a Work of Art," following Grice, on conversation.

[18] Tradition performs a filtration function for the artist by sorting live options from non-options. For example, painting in the manner of Bouguereau—that is, non-ironically, non-reflexively, or "straight"—is not a live option for a painter entering the artworld today; it is an option foreclosed by the evolution of the tradition. However, the same tradition allows that appropriating Bouguereau's work allusionistically or reflexively is a live option; though this, of course, is not the only live option (the only non-non-option) available to the contemporary artist.

In this regard, the tradition presents an artist with a gamut of live options at any given moment. In order to proceed, the artist must elect some of those live options over others. A contemporary artist may ask herself, "Should I explore postmodern pastiche or painterly abstraction?" To answer that question, the artist must reflect upon which live alternatives best serve her interpretation of the tradition. That is, the tradition enables the artist to assess which live artistic options most suit her understanding of and commitments to the tradition. The filtration function selects out live artistic options; the assessment function then enables the artist to weigh those live options in terms of what she finds most worthy of pursuit.

routines to imitate. And, of course, the source of these exemplars is the relevant tradition. To suppose otherwise is to buy into a metaphysical view of genius that is frankly exorbitant. It relies on a romantic myth of the individual self apart from society and socialization.

Artists begin to learn how to go on in their practice by imitation. There is, it appears, no other way. But here tradition, it should be noted, is not primarily a body of rules applied mechanically, as the anti-traditionalists suggest, but rather a collection of exemplars that include not only artworks as models, but also routines, techniques, solutions to recurring problems, conventions, effects, and so on. That there may not be any algorithmic rules of art does not preclude the importance of tradition to artistic creativity, as the no-rule argument contends, since the tradition is primarily a diverse assortment of models to be imitated, with increasing finesse and judgment, and sometimes to be surpassed as the artist becomes more familiar with her trade. Even revolutionary choreographers begin by learning how to dance, often in the very style they will eventually come to oppose.

The enemies of tradition, of course, deny it a creative role exactly because they are suspicious of imitation. For them, however, the guiding notion of imitation is that of slavish or blind imitation. So, they conclude, if tradition is to a large extent a matter of imitation, then it is more of a manacle on creativity than an enabling factor. If journeymen (and women) are enlisted in their artform by means of imitation, putatively they will never be creative. The tradition will function like a cast-iron template stamping out copies. But this is where the skeptic's error lies—in the assumption that an artistic tradition is rigid rather than flexible, strictly imperatival rather than suggestive, cast iron rather than plastic.

But how is this possible, if the imitation of exemplars plays such a large role in artistic education? Because an artist is not simply inducted into her practice by the imitation of models and routines. The artist learns more than that. She learns about the rationales behind those routines, techniques, conventions, and strategies, about the history of her artform; about those whom her teachers regard as illustrious predecessors to be emulated (and about those to be despised as disreputable); about the nature of their accomplishments (and transgressions) and the aims and values they embody; about what are taken to be significant breakthroughs and turning points in the practice, and about why those are important; as well as hearing about what are regarded as blind alleys and regressive tendencies in the practice, along with explanations of why this is so. She hears a great deal of criticism, positive and negative, and not only heeds what it says, but takes on board many of its implications and presuppositions.

The blossoming artist, that is, not only learns certain techniques of composition, initially through imitation, but that process is surrounded by talk—often less theory than a mix of history, folklore, art criticism, and practical rumination, though sometimes explicit theorizing as well. In learning about the techniques and routines of an artform, the artist, often indirectly though sometimes overtly,

learns about the aims and values of her practice. As she learns, through imitation, the means of her practice, she also comes to understand its purposes, problematics, and points, as those are embodied in exemplars and commented upon by other artists in her circle, including both peers and mentors. Her education is not merely an affair of doing—of imitating exemplars. The doing is also accompanied with sayings, sayings which she hears from her teachers, or reads in commentary if she is an autodidact, and which she learns to say herself and to herself in the process of coming to understand the practice.

In acquiring knowledge of her tradition in this way, she not only learns about a plurality of different means for making artworks, but she learns about the plurality of various aims and values that these diverse means can serve. Different strategies may secure different aims of an artform. For example, some strategies may promote harmony in music, while others arouse feeling. It is then up to the artist to attempt to amalgamate these disparate purposes, weighing them in variable combinations, or to pursue exclusively one aim rather than the other in her work. These are judgment calls the artist must make, guided, but not mandated, by her understanding of the tradition.

Thus, the artist need not slavishly imitate the past, but rather finds in the past as it is handed on (in Latin, *traditio*) to her a plurality of related but different aims, means, exemplars, and histories—networks of association—that she may employ in order to determine the way in which she will carry her practice and the practice forward. It is from this background of knowledge that she is able to recognize live options in the practice (the filtration function of tradition) and to assess which ones are most appropriate to her context (the assessment function). As she acquires knowledge of the tradition and command of its plurality of means and ends, the possibility of new combinations and new points and purposes opens up. If the artist is able to create spontaneously—automatically and seemingly without effort—that is because she has imbibed the tradition, making it her second nature.

Practices, artistic and otherwise, are "self-propagating histories of activities."[19] The vehicle for the propagation of artistic practices is the artist who in the process of learning and comprehending her tradition acquires habits—habits of making and habits of mind—that enable her to go on, to continue making new artworks.[20] However, since these habits can be acquired variably from different parts of the tradition by different artists, and since even the same artist's habits may be influenced by different strands of the tradition—strands that may even clash—the practice can and is likely to change, not despite its traditions, but because of them. Artistic practices do not issue forth the same old thing again and again, because the tradition itself is complex, often resounding with clashing voices and examples, and because those voices and examples must be interpreted

[19] Theodore R. Schatzki, *Social Practices: A Wittgensteinian Approach to Human Activity and the Social* (Cambridge: Cambridge University Press, 1996), p. 137.

[20] See Stephen Turner, *The Social Theory of Practices: Tradition, Tacit Knowledge and Presuppositions* (Chicago, IL: University of Chicago Press, 1994), p. 121.

by different artists, making different judgment calls, often while attending to different strands in the tradition.

Artistic creation involves the production of new works that are intelligible. Intelligibility here faces in two directions. The work must be intelligible to the artist and to his intended audience. In both cases, intelligibility, to a substantial degree, is achieved by connecting the new work to the tradition—to antecedent exemplars, techniques, conventions, conversations, and purposes. This is most obvious in terms of securing audience uptake. If artworks were absolutely novel, as the Futurists urged, they would be incomprehensible to audiences.[21]

The artist must make contact with the audience in some common place, and that common place is the antecedent history of the practice, aka tradition.[22] But the tradition is also where the artist must look for her own self-understanding of her work, because that is where her habits of making and thinking come from, not from gods and muses as Socrates conjectured (or was he merely joshing Ion?).

Moreover, the artist's sense of the tradition is typically apt to converge with her intended audience's, since the artist is not only a maker: she too is a member of the audience—both with respect to the work of other artists, but also with respect to her own work, where she functions as its first viewer, reader, or listener. Stepping back from her own work, she surveys her choices and, using herself as a detector, contemplates its intelligibility and fitness for other audience members like herself, and then adjusts, assesses, criticizes, and corrects her work with these judgments in mind.[23]

[21] The claim that the intelligibility of artworks depends upon a backdrop of tradition raises the question of how the first artworks could have been intelligible, insofar as, *ex hypothesi*, there was no antecedent artistic tradition. I am very uneasy speaking about "first art," since I suspect that it is a logical fiction. However, supposing there was a moment when art first appeared on the scene, how would it have been intelligible, given the preceding account?

It does not seem controversial to conjecture that art, as we know it, emerged from related practices, such as ritual. These proto-artistic, overlapping practices—involving symbolism, representation, expression, decoration, and so on—themselves possessed traditions of making and thinking. Consequently, it is in virtue of the traditions of these proto-artistic practices that first art, if there was such a thing, would have been understood. See my "Art, Practice, and Narrative," in *Beyond Aesthetics* (New York: Cambridge University Press, 2001).

[22] This is why artistic creativity cannot be simply a matter of self-imposed constraints. Self-imposed constraints can be completely arbitrary, like Georges Perec's avoidance of the letter "e" in his novel *La Disparition*; but the more arbitrary the self-imposed constraint is to the audience, the less likely will be its intelligibility to audiences. Inasmuch as audience intelligibility is involved in artistic creativity, common bonds need to be established, and shared traditions are the most natural means of securing them. Consequently, insofar as such bonds are necessary, and insofar as they are not available solely through arbitrary, self-imposed constraints, tradition is indispensable for artistic creativity. Nor does it seem correct to assimilate the notion of tradition to that of a constraint, since constraints are primarily negative, whereas traditions are generative.

[23] The notion that the artist has a special aptitude for communicating intelligibly with her audiences by doing something that they do, only more effectively, appears in the theories of genius of Dubos, Gerard, and arguably Kant. But, whereas they think that this communication is universal in its reach, I would relativize it to prepared or informed audiences—the target audiences of the author, who, because they are like the author in pertinent respects, including sharing a tradition, enable the author to use her own responses to anticipate theirs.

In the process of becoming an artist, one introjects a tradition, incorporating some subset of its means, ends, techniques, rules of thumb, norms, stories, routines, exemplars, conventions, and so on, which then cross-pollinate and incubate[24] in often unique ways, and which afford the necessary background for artistic creativity.[25] With regard to some artists, this cognitive and emotive stock may be somewhat systematic and fairly explicit. But for most artists it will be a loose network of habits (of making and thinking), often only tacitly or unselfconsciously understood, and accessed fluidly and selectively as called for by contextual considerations. That is the reason why, as commentators have pointed out,[26] artists typically use the language of correctness—"That's right," "It feels right," or "It clicks"—to explain their choices, rather than adverting to rules applied algorithmically.

Tradition is indispensable to the creation of new artworks. This is most evident when artists work in inherited styles and genres in which they redeploy tried and true structures, varying only the content. For example, in the genre of the buddy film, one may vary or permutate the cast of characters in terms of their professions, races, genders, educational backgrounds, and so on, while still keeping the basic generic structure of contrasting personalities (the odd-couple format) intact. This clearly counts as artistic creation in the descriptive sense, since it involves the production of new work that is intelligible. But it is also obviously creation within a by-now established tradition whose structural données the filmmaker repeats. Call this type of artistic creativity repetition.

At the same time, this is not slavish imitation, for with each repetition the filmmaker will have to make local adjustments, deciding what to emphasize, exaggerate, connect, diminish, balance, foreground, compare, subtract, contrast, and so on. Moreover, this sort of creation by repetition is not only present in the Cineplex, but in the avant-garde biennale as well, where politicized installation pieces deploy a panoply of recurring devices—such as lists, videos, quotations, photos—for the same critical (often political) effect. However, the fact that artists often repeat stylistic and generic données need not count against the quality of the new artwork, since those traditional données can be reworked with varying degrees of ingenuity, insight, grace, facility, and pointedness.

It is also possible for an artist to repeat the traditional content of a genre or style while varying its structures. One of Stephen King's accomplishments has been to take the traditional material of his genre, as typically found throughout much of the twentieth century in the short story and comic book, and to reconfigure

[24] If creativity is vegetative, as Young suggests, then tradition provides the seeds.

[25] What Gotz calls the preparation and incubation stages of creativity are clearly bound up intimately with the artist's immersion in her tradition. Insofar as these stages are necessary to the creative process, tradition is indispensable to artistic creativity. See Ignacio L. Gotz, "Defining Creativity," *Journal of Aesthetics and Art Criticism*, 39 (1981): 299–300.

[26] Ludwig Wittgenstein, *Lectures and Conversations on Aesthetics, Psychology and Religious Belief*, ed. Cyril Barrett (Berkeley, CA: University of California Press, nd), and Monroe C. Beardsley, "On the Creation of Art," *Journal of Aesthetics and Art Criticism*, 23 (1965): 291–304.

and expand it to the length of a full-scale novel by employing extended characterization and iterated suspense sequences. His book *Pet Sematary*, for example, is basically "The Monkey's Paw" made contemporary and replete with much more character psychology and color—not to mention over 200 more pages. *Pet Sematary* is an instance of artistic creativity, but one that exploited King's knowledge of the traditional canon of his artform, while at the same time reinventing its prevailing structure.

Artistic creativity, then, may proceed from repetition—the repetition with variation of the structures and/or themes found in the antecedent tradition. But another process of artistic creativity is hybridization, the yoking together of two or more heretofore distinct styles or genres. For example, in *Apollo*, George Balanchine mixed together movements from jazz dance and from classical ballet, discovering through juxtaposition qualities and possibilities of movement previously unimagined in either dance form. Likewise, much postmodern gallery art involves melding vernacular imagery with artworld critique. Clearly, artistic creativity of this sort requires understanding not only one's own immediate tradition but adjacent ones as well.

Hybridization is also relevant to the case of Shakespeare, the hero of the genius-argument. Skeptics rightly point out that he did not follow the Aristotelian unities. But he was steeped in theater tradition, from which he borrowed freely, mixing elements drawn from Roman models, including Seneca and Plautus, medieval theater (in terms of its episodic structures), and Italian commedia dell'arte. Shakespeare was exposed to these different genres and styles in his apprenticeship, and after a sufficient incubation period they matured into the magnificent hybrids that, howsoever much they defy the rules, would not have been possible without the input of the theatrical tradition.

Of course, an artist may not only look at the range of different styles and genres in her own artform for creative inspiration; she may also look to the other arts and their traditions. Often artistic creativity results from interanimating artforms—from importing strategies, aims, and values from one artistic tradition (not necessarily of one's own culture) into another, in the way that postmodern choreographers attempted to implement the program of modernist painting in dance. We can label this process of creation "artistic interanimation." Moreover, artistic interanimation and hybridization are frequently recurring strategies when artists feel the pressure to rejuvenate their tradition. This is why, for example, Soviet theater artists in the twenties incorporated silent-film techniques in live performances.

In addition to repeating their generic données with variations, hybridizing their artforms by mixing styles, and interanimating artforms, artists also produce new work and transform their tradition creatively by amplifying it—by finding new solutions to enduring problems within the tradition. For centuries, Western artists were preoccupied with the problem of capturing the appearance of things; artistic creativity revolved around finding new ways to approximate the way the world looks. The artists who contributed to this project *amplified* the tradition by providing new means to secure aims already recognized within the tradition.

Likewise, in the film *M*, Fritz Lang solved the problem of how to integrate the fluidity of silent-film technique with the new technological possibility of sound recording. He achieved this by using offscreen sound asychronously or contrapuntally—by showing us one thing while we hear something else unseen. In this, he was using an editing principle, namely, montage juxtaposition, which had been perfected in the silent-film period as a way of organizing the relation between the image track and the sound track. Lang thus solved a problem that was recognized as such within his practice, while also finding a way of expanding the resources of that practice that continues to influence filmmakers today.

Like repetition, hybridization, and interanimation, artistic creation by amplification also depends on tradition, since the problem and its criteria of solution are relative to the historical background of the practice. That is, tradition is where the problem and the criteria of what would count as its solution come from. In the case of Lang, the importance of tradition was double-barreled, since he not only inherited the problem from his practice, but found the solution there too, in his creative rethinking and extrapolation of the poetics of montage.

Thus far, the creative processes canvassed—repetition, hybridization, artistic interanimation, and amplification—all emphasize ways in which artistic practices evolve in a continuous fashion. It should come as no surprise that tradition plays a constitutive role in this regard. But what about artistic revolutions—especially revolutions like Futurism—that claim to repudiate tradition? If tradition is, as I allege, indispensable to artistic creativity in the descriptive sense, doesn't that hypothesis have to accommodate revolutionary artistic eruptions as well? For, certainly, artistic revolutions count as instances of artistic creativity. Indeed, for some they are paradigmatic cases. And yet many artistic revolutions are heralded as utter breaks from tradition—defiant repudiations of what has gone before.

It is undeniable, as we saw in the opening section of this chapter, that revolutionary artists often repudiate tradition. Yet it is a curious fact about these repudiations that they generally repudiate only a selected portion of the tradition, usually the ensemble of techniques and values that congealed in and dominated the artworld immediately prior to their own attempted revolution. Moreover, in repudiating that formation of the practice, revolutionaries generally claim the authority of other portions of the tradition—either specific earlier practices or enduring aims or values of the practice—as a basis for their revolt. The Russian Formalists referred to this as "the knight's move."

That is, artistic revolutionaries hypostasize a period-specific coalescence of the tradition as The Tradition and repudiate it under that label, while, ironically, citing other strands of the tradition in their brief for artistic rebirth. This is analogous to the cultural reformer who denounces bourgeois morality as Morality for the sake of actually defending his own preferred recommendation for moral regeneration (such as the call for less sexual repression).

Yet it is not really tradition *tout court* that is being denounced in these cases, but rather a particular configuration of artistic choices. And, in fact, that

configuration itself is typically attacked in the name of renewing the tradition, of returning to options and values that have allegedly and lamentably been suppressed, neglected, or forgotten under the dispensation of the reigning style. Thus, German Expressionists appealed to the precedent of expressive distortion found in medieval artists in their war with realism.

As previously noted, artistic traditions are complex in terms of their aims, means, and values. That is, artistic traditions may possess a multiplicity of aims, means, and values. To simplify drastically, theater involves both text and spectacle, word and image. In certain periods, one of these elements, and the values associated with it, may be perceived to have the upper hand, to the virtual exclusion of the other element. That is how Antonin Artaud saw the theater of his time. He regarded it as text- and word-dominated, Apollonian rather than Dionysian. Thus, he called for a theater of images to reinvigorate theater, citing earlier theatrical practices, like Balinese dance. Though vituperating the tradition of theater, his revolt can be better understood as an attempt to get in touch with vital elements of the tradition that he was convinced had been repressed under the regime of the well-made play.

Despite the fury of his manifestos and spectacles, Artaud invokes past practices of theater, and the traditional ends and values he finds embodied in them, to advance his radical innovations. Every avant-garde repudiation brings to light a legacy of ancestors. Often the avant-gardist names these predecessors explicitly, as Artaud did with reference to the Balinese.

But sometimes the invocation of the past is more general, taking the form of an appeal to an enduring, but still live, aim or value of art. Thus, Duchamp resorted to readymades to disrupt the artworld's overvaluation of manual skill and sensuous beauty for the sake of re-establishing the artistic tradition's commitment to the intellect—to being thought-provoking—an enduring aim of art that Duchamp believed had been forgotten, or at least woefully undervalued.[27]

Moreover, this sort of process of repudiation and innovation often appears at junctures where a prevailing style or genre is believed to have exhausted its potential for further development. At that point, the artist looks backward—to the tradition—for a way forward.[28] But this results, not in a slavish replication of the past, but in a reinvention, since the artist will reinterpret the significance of the enduring aims and values of the tradition in light of recent history and his own circumstances.

Although it may seem oxymoronic to suggest that tradition contributes even to the radical revolutionary artistic process of repudiation, it should come as no surprise. For even avant-garde creativity requires intelligibility—both for the artist and her audience. There is no absolute novelty, again *pace* the Futurists, that is also comprehensible. In order to be understood, the relevant avant-garde

[27] Perhaps the interest of contemporary artists in exploring beauty once again is a reciprocal reaction to the success of Duchampian anti-aesthetics and intellectualism.
[28] As Artaud did with *Les Cenci*, through which he attempted to restore the Jacobean revenge play as a way of revitalizing the theater of his time.

innovation must be connected to something familiar to both the artist and the audience. In order to make sense, it must be an innovation relative to a familiar background, and that background, of course, is the artistic tradition. That avant-gardists themselves are aware of this is evinced by the way in which they speak out of both sides of their mouths: tongue-lashing tradition, but then citing traditional precedents and values in support of their cause.

Tradition plays an indispensable role in such processes of artistic creation as repetition, hybridization, artistic interanimation, amplification, and revolutionary repudiation. This entails that the notion that tradition is inimical to artistic creativity is false, since in these cases tradition is a constitutive ingredient in artistic creation in the descriptive sense. Thus, in its strongest version, the Ur-theory of artistic creativity is a romantic myth. The artistic tradition need not be an obstacle to creativity. It is a resource for engendering creativity that enables artists to filter out live options and to assess them. Because the tradition is rich—comprised of many projects and voices—it is a flexible resource, not a cage.

I cannot claim with certainty that the list of creative processes I have provided is exhaustive. There may be others. So I have not conclusively demonstrated that the tradition is an essential ingredient in *every* sort of artistic creativity. But my list is comprehensive enough, I think, to warrant provisionally the hypothesis that tradition is indispensable to artistic creativity across the board. The burden of proof, then, is on the skeptic to adduce some process of artistic creation that operates without any input from the artistic tradition. Until then, it is reasonable to presume that artistic traditions are indispensable for artistic creativity in the descriptive sense.

3. ARTISTIC CREATIVITY IN THE EVALUATIVE SENSE

In the descriptive sense, the artist is creative when she produces a new work that is intelligible to the relevant audience. Probably most intended artworks are creative in this sense—that is, they have been created. However, this is not the only sense in which an artwork is said to be creative. The other sense is commendatory. To say an artwork is creative is not just to say that it has been created; it is to say that it is valuable in some respect. "Creative" is evaluative in this sense, because it tracks value.

Perhaps sometimes people use the word "creative" as a synonym for "good"—"The piece is so creative" just means "The piece is so good." But I presume that "creative" is generally a more specific accolade than "good." It is an attribution that would appear to have more descriptive content than "good" *simpliciter*. In its evaluative usage, "creative" connotes value. To say an artwork is creative is to claim that it should be highly valued. But for what reason? I suggest that it is the value the artwork has for the tradition in which it has been created.

We call innovations like Lang's deployment of asynchronous sound in *M* creative in the evaluative sense because of its contribution to the history of

film (and TV). It was a particularly fecund intervention in the practice because of the resources it made available to subsequent generations of filmmakers. It was creative in the procreative sense—it was generative, it was fertile, it gave rise to many progeny. It was creative, in part, because its influence is so widespread. Lang perfected a technique that the vast majority of filmmakers have relied upon at one time or another in their careers. From a merely quantitative point of view, its significance has been immense. But it is also important from the qualitative perspective, for it made possible wondrous experiments in the use of asynchronous sound, such as those of Godard. One thing, then, that we mean when we applaud an artwork as creative is that it has been bountiful—its consequences have been both copious and beneficial for the practice to which it belongs. This sort of creativity is obviously calculated retrospectively.

But, of course, this cannot be the whole story, since we are often disposed to call artworks creative in the evaluative sense before we are in a position to estimate their consequences for the tradition. In the case of historical achievements that had plentiful influence on the future that evolved in their wake, we estimate their creativity by attending to the branching lines of development they motivated. But what of works in the present, whose future is necessarily obscure to us, which we are also prepared to call creative? I want to propose that these evaluations too, are, in an important way, also tradition-relative.

When we call a recent artwork "creative," we mean that it has recombined elements and concerns of the tradition in an especially deft, original, or insightful way. In this, it shows us the tradition and its possibilities more clearly, expansively, and perspicuously than earlier works. By boldly economizing his means of expression—paring down his cinematic resources primarily to a reliance on point-of-view editing—in *Rear Window*, Alfred Hitchcock disclosed to us in striking relief the central vertebrae of the classical mode of Hollywood narration. When *Rear Window* was first released, people were ready to call it creative. They did so, I submit, because it enabled them to see the tradition of filmmaking in a new light. It revealed to us how powerful a device the taken-for-granted structure of point-of-view editing really is.

One would not call *Rear Window* creative simply because it was effective in promoting suspense. Many suspense films do that without meriting the appellation "creative" in the evaluative sense. Nor was it creative in the evaluative sense because it reconfigured the tradition (by subtraction, so to speak); that alone would only warrant calling it creative in the descriptive sense. Rather, *Rear Window* possessed some added form of value. It illuminated a power of cinema that was there all along in the tradition for anyone to see, but which only Hitchcock had the simplifying nerve and discernment to spotlight. After *Rear Window*, we are wont to say that earlier film history never looked the same again. That is why it is appropriate to call *Rear Window* creative. It not only reassembled the cinematic tool-kit in a novel way, but it made the structure of the tool-kit newly manifest. What was creative about *Rear Window*, indeed breathtaking, was that it enabled us to see afresh the tradition we thought we knew so well.

From the vantage point of historical hindsight, we call past artworks creative in the evaluative sense retrospectively as progenitors of subsequent developments, in terms of both the extent and the quality of what they have influenced. With contemporary artworks, we say they are creative when they recollect the means and/or purposes of the tradition in a way that clarifies the tradition—in a way that brings its latent possibilities, commitments, and structures into the foreground. Works that stand the test of time with respect to both these criteria are the most worthy of the title "creative" in the evaluative sense. Perhaps when we call contemporary works creative, we are issuing a promissory note—a bet that they will be fruitful—given the clarity they have already brought to the tradition. We suppose, reasonably, that that clarity will have consequences. Though we may be wrong in this, that expectation is not without grounds. Nor need we withdraw the label "creative" from such works if they are genuinely brilliant re-conceptions of the tradition, albeit infertile ones.[29]

The conception of artistic creativity in the evaluative sense that I have proposed centers on the place of the art object in an evolving practice.[30] Creativity is relative to the tradition in two different, though frequently related, ways. This view of artistic creativity contrasts with the perhaps more common view that creative artworks are the ones that flow from genius. That conception of creativity correlates it with certain inner, psychological processes—whatever

[29] One case I have not explicitly discussed is that of artwork which, because it is ahead of its time, goes unappreciated in its own day and, consequently, has little or no influence on subsequent developments. Given what has been said so far, must we deny that it is creative in the evaluative sense? I think not.

There may be two different cases here. Let me take them up one at a time. The first case is when the innovative work in question is a precursor of some other work (or works) that does (do) have a significant influence on what follows. In this instance, the relevant work is creative in the evaluative sense, because it is fecund, though its fecundity may be somewhat indirect. Nevertheless, it has a pertinent causal role in bequeathing the tradition benefits that were popularized by one of its descendants.

The second case occurs when the innovative artwork has no influence whatsoever. Such a work may still be called creative just in case it reworks the tradition and illuminates its possibilities in a particularly perspicuous manner. This may happen even if these possibilities are not exploited by subsequent artists. That the work is not appreciated in its own time does not preclude our calling it creative in the evaluative sense, if, with historical hindsight, we can see that it was, unbeknownst to its contemporaries, a particularly discerning reworking of the tradition. But, of course, it must be at least this. An unintelligible "original," both in its own time and ours, hardly counts as creative.

That is, I propose that we call this example creative on the same grounds that we call contemporary works creative whose consequences are yet unknown to us. Moreover, I prefer this solution to the case at hand—rather than going counterfactual and saying that the work is creative on the grounds that it would have had great influence if only it had had a sympathetic audience—because the complexity of the variables in play in art history render any such predictions little more than arm waving.

[30] Other approaches that emphasize the value of creativity in terms of the place of the object in evolving practices include those of L. Briskman and Dale Jamieson; however, the weight given to the value of the object in relation specifically to tradition is my own. See L. Briskman, "Creative Product and Creative Process in Science and Art," in D. Dutton and M. Krausz, eds, *The Concept of Creativity in Science and Art* (The Hague: Martinus Nijhoff, 1981); and Dale Jamieson, "Demystifying Creativity," a lecture given at the NEH Institute on Philosophy and the Histories of the Arts, San Francisco State University, 1991.

happens when genius does its work. My conception of artistic creativity has more to do with the place of the artwork in outwardly observable social and historical processes—the evolution of the relevant artworld. In this regard, my conception seems more plausible, since we have little access to the inner workings of genius. Indeed, our only way of locating artistic genius seems to be to begin by isolating creative works in my sense, and then to go looking for the psychological processes that coincide with them. I am not very sanguine that we would find any distinctive regularities here. But the fact that such an investigation would be parasitic on the conception of artistic creativity in my sense should be enough to take the most ambitious form of the romantic notion of genius out of the race as a significant competing account of artistic creativity, even in the evaluative sense.

4. SUMMARY

Tradition and artistic creativity are often thought of as contraries by avant-garde artists and art students alike. I have argued that this is a mistake both with respect to artistic creativity in the descriptive sense and in the evaluative sense. Tradition is, I contend, indispensable to the day-to-day artistic creativity we see everywhere around us—the constant production of new works that are intelligible to prepared and informed audiences. As an artist prepares for her vocation, she submerges herself in her tradition, and what she takes from it incubates in ways that enable her to produce new works, works never before seen under the sun, which are, nevertheless, intelligible to her intended audiences.

Where the artist grapples with prevailing problems of the tradition, her creativity is flexibly controlled by critically interacting with prior products of the tradition so as to put herself in contact with recognizable problems and norms for their solution.[31] Where the artist seeks to revitalize her tradition by repudiating domineering predecessors and setting out in a new (generally *re*discovered) direction, she does so by appealing to aims and purposes abroad, alive, and acknowledged in the tradition, albeit as interpreted or reinterpreted, and given determinate content by her in virtue of her concrete circumstances.

Artists use the tradition to locate which options are live options for them to pursue, and to assess which of the possible live options make the most sense for them, given their context. Without such guidance as to how to continue to proceed, there would be no artistic creativity. That is why tradition is indispensable for artistic creativity and not its antagonist, as romantic propaganda might have it.

But tradition is not only relevant to artistic creativity in the descriptive sense. It is also relevant to artistic creativity in the evaluative sense—the sense where we intend to commend a work not simply for having been created rather than plagiarized, but for being an extraordinary creation. For the value of a creative

[31] Briskman, "Creative Product and Creative Process," p. 148.

artwork is the contribution it makes to the tradition either by its influence, quantitatively and/or qualitatively speaking, or through the way in which it clarifies the tradition, or both. Artistic creativity is not identified in terms of the effectively occult operation of genius, but by how the artwork behaves against the background of tradition.

It may be hard to convince the art student communing with his own inner spark, like my filmmaking students of yesteryear, of this. But that spark will set nothing aflame unless it is fueled by tradition. So, if any of my former students are reading this chapter, let me repeat: "You have to take my film history course. That's the bottom line. It's what you need, even if you don't believe it."

PART II

AESTHETIC EXPERIENCE

5

Aesthetic Experience: A Question of Content

1. INTRODUCTION

For many philosophers, the notion of aesthetic experience is so central to the philosophy of art that they are inclined to call the entire field of inquiry "aesthetics." They believe that art can be defined in terms of aesthetic experience—for them, an artwork just is something produced with the intention to promote aesthetic experience. And they believe that the degree of excellence found in an artwork can be measured in virtue of aesthetic experience—that is, an artwork is good exactly in proportion to the amount of aesthetic experience it affords. For such philosophers—called aesthetic theorists of art—aesthetic experience is the philosopher's stone, the charm that discloses all the secrets of the philosophy of art. But, obviously, before those mysteries can be unlocked, one must first offer an account of the nature of aesthetic experience. So in those precincts where the aesthetic theory of art presides, the first order of business for the philosopher of art is to deliver such an account.

Of course, not all philosophers of art regard aesthetic experience as so utterly central to the field as do aesthetic theorists. I, for example, do not. Nevertheless, inasmuch as artists, art lovers, and philosophers are constantly talking about aesthetic experience—in ways that are generally converging and reciprocally intelligible—it seems likely that they have something definite in mind, rather than something chimerical or mythic—something, moreover, alluded to so frequently that it is significant enough to warrant the attention of any philosopher committed to elucidating the prevalent concepts of the artworld. That is, even if one does not believe, as aesthetic theorists do, that aesthetic experience is the philosophical cornerstone of the artworld, insofar as one is a philosopher of art, one has an obligation to attempt to clarify the concept of aesthetic experience.

The purpose of this chapter is to do just that—to characterize aesthetic experience, notably with respect to the aesthetic experience of artworks. In this regard, questions about whether the notion of aesthetic experience can be dragooned to define art or to calculate artistic value will be put to one side.[1] Similarly, the issue of the aesthetic experience of nature will be deferred, for

[1] For the record, I do not believe that art can be defined in terms of aesthetic experience or that artistic value is reducible to the promotion of aesthetic experience.

the most part, until after I have sketched a positive account of the aesthetic experience of art.

The notion of *aesthetic experience* has two components: the aesthetic and experience. Assuming that we have some inkling of what comprises an experience, the pressing issue for us is what to make of "the aesthetic." The word was introduced in the eighteenth century by Alexander Baumgarten, initially to stand for sensitive knowledge, knowledge delivered by the senses, or sensations which, following Descartes, Leibniz, and Wolfe, Baumgarten regarded as a matter of clear but indistinct ideas. However, even in Baumgarten's hands, the aesthetic came to be associated with the experience of artworks, where artworks appeared to be objects paradigmatically directed at sensitive cognition. This may seem strange to us, considering that literature or poetry is a leading artform, but one that is not primarily addressed to the senses. Yet, insofar as the reigning theories of art in the eighteenth century were representation theories, and insofar as literature/poetry could be thought of provoking inner images (percepts for the imagination) by means of their representations/descriptions, literature could be construed as affording sensitive knowledge at one step removed, so to speak.[2]

However, even if much of what we call aesthetic experience corresponds to what is sensed—either perceived outwardly or "sensed" inwardly—the way the concept has come to be applied exceeds its original usage. For example, the discovery and apprehension of the complex form of a novel like Joyce's *Ulysses* is today regarded as an exemplary instance of having an aesthetic experience, but it barely counts as a robust instance of the exercise of our powers of sensation.

Consequently, in order to develop an adequate account of aesthetic experience, we need to look beyond Baumgarten. In the period since Baumgarten, four major approaches to defining aesthetic experience have emerged. They can be called: the affect-oriented approach, the epistemic approach, the axiological approach, and the content-oriented approach. Historically, elements of these approaches have been combined in various ways, resulting in a diversity of theories of aesthetic experience. In this chapter, however, I will be concerned exclusively with these approaches in their pure forms, asking whether any of them can provide an adequate account of aesthetic experience. For, clearly, if one of these approaches is satisfactory in its pure form, then there is scant reason to cobble together a combinatory theory.

In what follows, then, we will assay the strengths and weaknesses of these four approaches to characterizing aesthetic experience. Nevertheless, before

[2] That is, inasmuch as literature addresses the imagination, it could be regarded by eighteenth-century theorists as functioning rather like painting with regard to the senses. For the senses and the imagination were thought to be very much alike. Kant writes: "sense is the power of intuiting when the object is present; imagination, that of intuiting even when the object is not present." Both faculties, that is, intuit images. See Kant (1978: Ak. vii, p. 153). Similarly, Aquinas regards the imagination as something like the counterpart of the senses; images passively apprehended by perception are actively created by the imagination. Perhaps the poet's imaginative suggestions are then grist for the reader's imaginative construction. See Thomas Aquinas (1945), *Summa Theologica*, 1, 85, ad. 3.

proceeding any further, it is perhaps only fair to admit that I prefer a version of the content-oriented characterization of aesthetic experience. Thus, the shape this chapter takes is fundamentally that of a disjunctive syllogism, setting out the four alternative approaches as the basic options in this arena of debate and then finding the content-oriented approach to be the last one standing.[3]

2. THE AFFECT-ORIENTED APPROACH

Affect-oriented approaches to the characterization of aesthetic experience take it to be marked by a certain experiential quale, or pulsation, or peculiar feeling tone which is sometimes referred to gingerly in the French tradition by the circumlocution *je ne sais quoi*: Clive Bell thought of it as a highly distinctive feeling with which every true lover of art is intimately familiar. Undoubtedly, the affect-oriented approach derives from Baumgarten's correlation of the aesthetic with sensitive knowledge—perception, sensation, and, in short, feeling. Thus, on this view, aesthetic experience is thought to be a sort of feeling or affect.

This suggestion, needless to say, provokes an inevitable question—namely, "what sort of feeling?" There are so many different kinds of feelings that might attend an experience of a work of art—claustrophobia and a sense of oppressiveness in response to a film noir or elation while watching Ruth St Denis's choreography for *Soaring*, and so on. Perhaps at one time or another virtually every feeling that a human can undergo might figure as an ingredient in some aesthetic experience. But then saying that aesthetic experience is marked by some feeling is of no use, unless the field of relevant feelings can be appreciably narrowed. Simply having feelings, in other words, will not differentiate aesthetic experiences from other sorts.

At this point, it is often suggested that whatever other feelings aesthetic experience involves, it is always comprised of pleasure—either pleasure undiluted, or pleasure in response to or in combination with the other feelings in play in the experience. That is, something, it might be said, is an aesthetic experience if and only if it is pleasurable.

Yet obviously pleasure is not a sufficient condition for aesthetic experience, since sex, drugs, drink, and food, among other things, elicit feelings of pleasure, though indulging in these delights are not typically regarded as aesthetic experiences. Indeed, they are sometimes treated as the very antitheses to aesthetic experience. So it is unlikely that if an experience involves pleasure, then it is automatically an aesthetic experience, rather than some other kind of experience.

But maybe pleasure is a necessary condition for aesthetic experience. However, the proposal that something is an aesthetic experience only if it involves pleasure is suspect from several directions. First, many aesthetic experiences, even though they involve feelings, need not be defined by feelings of pleasure. As one circulates

[3] I have also attempted to defend this position in Carroll (2000, 2001a, 2002).

around the statue of *The Prince of the World* in St Sebald in Nuremberg, one sees that behind his comely facade is a mass of decay; beneath that surface handsomeness, the opening in the back of his cloak reveals the corruption of the flesh. Normal viewers do not feel, nor are they intended to feel, pleasure at this manifestation of bodily decomposition. They are meant to be disgusted which, in turn, is intended to remind them that earthly existence is both fleeting and foul, and that corporeal delights are futile and vain. The statue is a *memento mori*. This is also the intended or mandated affect of the death's heads that appear on tables laden with luscious comestibles throughout the *vanitas* tradition of painting, as well as the design behind many contemporary works by artists like Damien Hirst, who compose works that encourage the contemplation of mortality.

In such cases, the feelings of disgust have a legitimate claim to the title of aesthetic experience, since the disgust in question is connected to the percipient's detection of and immersion in the salient aesthetic properties of the pertinent works. But disgust is not pleasurable; nor is it plausible to suggest that the informed viewer of *The Prince of the World* takes pleasure or is intended to take pleasure in being disgusted, since not only is the feeling of disgust displeasurable, but delight in the statue would, from the artist's point of view, defeat the mandated purpose of his design. Similar kinds of observations can be made about the affect elicited by many instances of transgressive art of the modern period. Consequently, it is extremely improbable that pleasure is a necessary condition for having aesthetic experience.

Moreover, not only are there artworks that are intended to engender aesthetic experiences involving affects inconsistent with pleasure; displeasure is also the result of many artworks that are originally designed to delight. Here I have in mind defective artworks. For example, the performance of the sonata might have been intended to cause pleasure; but the execution is so inept that it engenders boredom and even pain. What are we to call the experience of sitting through such a performance, attempting to follow its formal and expressive development, but being defeated in the process? Surely the experience of following or trying to follow the form of an artwork is an aesthetic experience. What else would it be? But inasmuch as an incompetent work may frustrate our efforts to derive pleasure from its formal design, and yet the experience still has a claim to being called aesthetic, then pleasure cannot be an essential feature of aesthetic experience.

To the extent that pleasure is regarded as *prima facie* good, to stipulate that pleasure is a necessary condition of aesthetic experience makes the concept of aesthetic experience a commendatory concept; aesthetic experience in this view would be valuable by definition. However, aesthetic experience is arguably a descriptive concept—attending to the form of an artwork, whether it is pleasurable or valuable or not, is ostensibly an aesthetic experience. How else would we classify it? So the commendatory use of the concept is not its primary use; the descriptive usage would appear to be more fundamental. Thus, again, it seems that pleasure is not a necessary condition for having an experience categorized as aesthetic.

So far, the notion that pleasure is a necessary condition for aesthetic experience has been challenged on the grounds that aesthetic experiences, properly so called, may involve feelings other than pleasure—indeed, feelings that preclude pleasure. However, an even deeper objection to the thesis is that there may be aesthetic experiences that involve no feelings or sensations at all. That is, some aesthetic experiences may not only be bereft of pleasure, but may lack affect altogether. For example, one might take note of the angularity of Katharine Hepburn's body, her gestures, her facial structure, and her way of speaking and, in addition, realize how this all "fits" with the "edginess" that her characters are meant to project; and yet one may take no pleasure, nor suffer any other affect while doing so. On what grounds would it be denied that this is an aesthetic experience? And if it is not an aesthetic experience, what sort is it?

The objection that aesthetic experiences may be affectless cuts more deeply than our previous objections, since it not only undermines the hypothesis that pleasure is a necessary condition for aesthetic experience; it contests the very presupposition of affect-oriented approaches to aesthetic experience. For, if there are aesthetic experiences without feeling, sensation, or affect, as there seem to be, then visceral commotion of any sort is neither a necessary nor sufficient condition for aesthetic experience.

One, of course, might claim that in cases of aesthetic experience that appear affect-less, there really always are feelings, but very minute ones. However, that gambit gives every indication of being egregiously ad hoc. Similarly, the suggestion that simply apprehending the aforementioned properties of Katharine Hepburn, and grasping their coherence together, requires affect is empirically false and, in any case, begs the question.

It might be said that seeing how these properties go together—that is, "getting it"—can be an occasion for pleasure. I would not wish to deny that possibility. But suppose that someone scrupulously discerns the relevant properties and makes out the appropriate relationships here, and yet does not feel pleasure? This is certainly a possible case. Why deny that it is an aesthetic experience? And if it is not an aesthetic experience, what other kind of experience might it be?

By this point in the discussion, the proponent of the affect-oriented approach might complain that the view that pleasure is the mark of aesthetic experience is not being given a fair shake. For this strategy for characterizing aesthetic experience does not make pleasure *simpliciter* the criterion of aesthetic experience, but, rather, something more complex—namely, *disinterested* pleasure. Perhaps this special sort of pleasure can evade some of the objections posed so far. This, of course, will depend upon what the notion of disinterested pleasure signifies. Unfortunately, it signifies different things for different theorists. Nevertheless, I do not think that, on any of its better-known variants, it lends any credence to the affect-oriented approach to aesthetic experience.

The idea of disinterest, as propounded early on by Lord Shaftesbury, meant "not motivated by self-concern." On this understanding, a pleasure is disinterested if its object is not my own well-being, but something else. I take pleasure in the look of the landscape and not in the fact that my ownership of it is worth millions

to me. In this sense of disinterested pleasure, the pleasure at issue is not the sort of peculiar feeling tone that the affect-oriented approach is searching for. The high I derive from seeing the property and the high derived from the recognition that I own something valuable as sensations of euphoria are pretty much the same. So the concept of disinterested pleasure does not locate a specific feeling, categorically distinct from other feelings of pleasure, and, therefore, capable of hiving off aesthetic experience, parsed as a phenomenologically discriminable affect, from other sorts of pleasures and their corresponding experiences (e.g., gustatory or sexual experiences).

Historically, the conjunction of aesthetic experience with pleasure appears to occur initially in the context of discussions of judgments of taste or positive aesthetic judgments, of which "This rose is beautiful" is paradigmatic. Here the experience of pleasure is regarded as the ground for the judgment of beauty. This pleasure should be disinterested in the sense that it should not be biased personally. But three things need to be noticed about disinterested pleasure here.

First, though it may be plausible (though possibly false) to conjecture that a feeling of pleasure is required in order for a percipient to advance a legitimate judgment of beauty, not all aesthetic experiences are reducible, without begging the question, to experiences of beauty. Thus, there may be aesthetic experiences that do not track beauty and, therefore, do not require feelings of pleasure—thereby eliminating the affect-oriented approach's best candidate for the quale that constitutes a necessary condition for aesthetic experience.

Second, aesthetic experiences should not be conflated with aesthetic judgments. Though aesthetic judgments may presuppose aesthetic experiences, the two are different. So, even if positive aesthetic judgments mandate some feeling of pleasure (a dubious hypothesis in my book), it would not follow that aesthetic experiences do. That the tedium of the concert is an unpleasurable aesthetic experience is not contradicted by the fact that a positive judgment or assessment of such a concert might be said to require some palpitation of pleasure in the breast of the percipient. For aesthetic experiences are not the same as positive aesthetic judgments. That is, even if positive aesthetic judgments (or, at least, those involving attributions of beauty) must rest upon a pleasurable aesthetic experience, an experience can be aesthetic without being pleasurable.

And, lastly, as we've already seen, disinterest is not, in its primary usage, an affect; it has no phenomenological tone of its own. A self-interested pleasure does not feel any differently than a non self-centered one. Consequently, saying that aesthetic experience is marked by disinterested pleasure does not supply the wherewithal to distinguish these sorts of experiences from others. The pleasure taken in looking at the orchard cannot be differentiated in virtue of qualia from the twinge of pleasure born of owning the orchard.

Of course, within the tradition that speaks of disinterested pleasure, the idea of disinterestedness became more extensive than merely "not to one's own advantage"; it came to stand for the disavowal of any advantage whatsoever—moral, political, social, religious, and so on. Yet, even with this expansion, the concept of disinterested pleasure is still of no use to the affect-oriented approach

to characterizing aesthetic experience, since it does not discriminate between pleasures at the level of feeling. The sensation of exultation felt in response to a striking sunrise is not, in terms of its tonal qualities, discriminable by introspection from exultation in response to the resurrection of Christ or to the victory of the oppressed. Since disinterest in its primary use does not specify any particular affective tingle or tremor, disinterested pleasure is not going to supply the theorists who aspire to define aesthetic experience by means of certain felt affective qualities (especially ones thought of in terms of phenomenologically discriminable kinds of pleasure) with what they need to achieve their purposes.

There is, however, within the tradition, at least one way of developing the idea of disinterest that does intersect with a discernible quality of feeling. For Kant, disinterested pleasure is pleasure not caused by the prospect of advantage. It is a way of describing from whence the pleasure comes. It comes free of considerations of advantage for either self or society. But, perhaps beginning with Schopenhauer, there emerges the view that aesthetic experiences are those in which in the very process of having them we are freed or liberated from the cares of self and society, that is, from every ordinary concern to which flesh is heir. This is a particular kind of pleasure—one with its own affective tone. It is a feeling of release from the everyday—a sense of relief. For Clive Bell, it is the experience of being lifted out of the quotidian; for Edward Bullough, it is a feeling of being distanced; Monroe C. Beardsley calls it felt freedom. In this way of thinking, aesthetic experience does come suffused with its own variety of affect, a specifiable modality of pleasure, namely, a sense of release from mundane, human preoccupations with respect to oneself, one's tribe (both narrowly and broadly construed), and humanity at large.

This suggestion, of course, faces some of the difficulties already encountered with other variations of the affect-oriented approach. Is release from worldly concerns a sufficient condition for aesthetic experience? Wouldn't the state of nirvana count as aesthetic experience then? But that seems wrong.

Moreover, if release of any sort is taken to be a necessary condition for aesthetic experience, then we are back to the problem of flawed artworks—for instance, the infelicitous performance of the Wagnerian opera that leaves us feeling trapped in the concert hall. In such a case, we feel no pleasure, let alone relief. But once again this experience is certainly an aesthetic one, unless we unadvisedly stipulate that aesthetic experiences are always necessarily rewarding affectively—always occasions of pleasure, delight, or enjoyment in terms of release. But surely most of the life of aesthetes willing to explore the wide range of the art on offer is spent encountering artworks whose forms and qualities leave them either indifferent or disgruntled. Yet to discount as aesthetic most of the experience of those who approach the formal and aesthetic properties of artworks correctly smacks of arbitrariness.

Another problem with the present extension of the notion of disinterested pleasure is that it appears unlikely that the appropriate aesthetic experience of successful artworks always involves an episode of felt release—not even release from moral and political concerns. Sartre's *No Exit* (*Huis Clos*), as its title

suggests, is not intended to, nor does it, engender a sense of release in the prepared spectator, but rather the feeling of inescapability it invites contributes to an aesthetic experience of the play, since that sense of hopelessness is an appropriate response to both the form and the expressive qualities of the play, a way of detecting or apprehending and then assessing them (or appreciating them).[4]

Likewise, rather than abetting an air of release, an artwork might call forth burdensome feelings with practical, moral, *and/or political overtones. If performed correctly,* Friedrich Durrenmatt's *The Visit* should leave audiences with the recognition that they would have behaved as the villagers in the play behaved. That is, a sense of guilt and a felt weight of moral responsibility is mandated by the play; the experience is not one of being lifted out of the everyday world, but a feeling of being brought down to earth and confronted with who we really are and are not, and of whom instead we should become morally. In other words, the play does not engender release from our everyday lives; it returns us to our everyday lives and reminds us of our moral obligations, while, at the same time, the sense of guilt it instills puts us in touch with the dominant expressive qualities of the play.

Similarly, Kafka's *The Trial* imparts a sense of being irredeemably lost within the snares of bureaucracy in a way that encourages socially significant reflection on the inhuman systems of (ir)rationalization we endure under modernity. That frustrating experience of being mystified and the fear and indignation that comes with it involve neither a feeling of liberation in particular nor pleasure more generally; they register soberingly our sociopolitical plight. But they are no less legitimate ingredients of our aesthetic experience for their implication with real world concerns, since these affects, though not the sort typically favored by affect-oriented theorists, connect us with salient formal and expressive features of *The Trial.* Indeed, these feelings of imprisonment (rather than release) disclose essential artistic structures and properties of *The Trial* to us, enabling us to apprehend, interpret, and weigh them.

In short, supposing that the idea of release from the everyday (including the practical, the moral, and the political) is an intelligible one, it does not appear to be the hallmark of every aesthetic experience. For we have seen examples of aesthetic experience that are at odds with the putative fugues from the ordinary concerns that affect-oriented theorists often advance as necessary conditions of aesthetic experience. Moreover, there are also, I would maintain, cases of aesthetic experience where no palpitation of relief obtains—I note, for instance, how solidly the pyramid sits on the horizon with no flash of buoyancy in my chest, or I take in how sharply articulated the musculature of the statue is with no glimmering of a transition within my inner states whatsoever. These seem unquestionably to be aesthetic experiences. Therefore, aesthetic experiences can obtain without attending feelings of liberation.

[4] For a discussion of this sense of appreciation, see Carroll (2001b).

Of course, at this juncture, the affect-oriented theorist of aesthetic experience may attempt to water down the notion of release from the everyday to the point where it amounts to nothing more than that the percipient, while experiencing an object aesthetically, is not distracted by everyday concerns like the mortgage payments or ecological disaster. But, in such cases, it does not seem apposite to describe the percipient's focus in terms of an emotional liberation or emancipation from everyday concerns. This is not a special process of release; it is a matter of simply paying attention on a par with the way in which we bracket thoughts about our mortgage payments from our minds when we carefully attend to the steps in a recipe while carrying out the practical task of preparing a meal.

Though I have not canvassed every candidate an affect-oriented aesthetic theorist might put forward, my review of some of the most recurrent ones provisionally indicates that aesthetic experience does not necessarily possess unique experiential qualia that set it off from other sorts of experience. If there is such a quale, then the burden of proof falls to the affect-oriented theorist to produce it, though let us not hold our breath while waiting, since the diversity of the objects of aesthetic experience and the wide variety of the responses they are designed to elicit would seem to be so heterogeneous as to resist summary in terms of a single affect; surely the odds are stacked precipitously against the likelihood of there being a common perturbation, tickle, or feeling tone that runs through every aesthetic experience. And if it is improbable that aesthetic experience can be identified in terms of a distinctive affective property, then such experiences must be identified either in terms of the way they are known, or in terms of the distinctive form of value they embody, or in terms of their content.

3. THE EPISTEMIC APPROACH

Like the affect-oriented approach to characterizing aesthetic experience, the epistemic approach[5] is also connected to the original idea that the realm of the aesthetic is that of sensitive knowledge or apprehension by the senses or perception. For the epistemic approach to aesthetic experience presupposes that an aesthetic experience involves coming to know its object in a specific way, namely, directly. To encounter an object aesthetically is to perceive it—to hear it or to see it—or, if it is a work of literature, one must nevertheless inspect it directly. One does not have an aesthetic experience of an object, on this view, unless one peruses the particular object in question for oneself. You cannot have an aesthetic experience on the basis of a report about the object by some second party. The particular object at issue must be the immediate source of an aesthetic experience, properly so called. This approach to aesthetic experience

[5] The notion of an epistemic approach to aesthetic experience is derived from Iseminger (2003).

can be called epistemic, insofar as it requires that what qualifies an experience as aesthetic is the manner in which one is required to come to know or otherwise cognitively engage the relevant objects of said experience: one's experiences must be object-directed; one must experience the particular object of that experience directly. This is a necessary condition of aesthetic experience.

The deep association of the aesthetic with the perceptual shows the influence of this tradition. This sometimes surfaces in talk that links the aesthetic exclusively with appearances. Also, the notion that the aesthetic is tied to the particular rather than to the general or the conceptual belies the link between thinking about the aesthetic and the perceptual, since the object of perception is most naturally thought of as a particular. But, of course, the putative correlation of the aesthetic with the perceptual is inadequate as long as one wishes to grant that there are aesthetic experiences of literature and especially poetry, since one does not encounter the objects of these representations by looking (that is, *perceptually* in the requisite sense) but by reading. So in order to sustain some link to perception, the requirement needs to be weakened to no more than that for an experience to be aesthetic, the percipient must examine the pertinent object directly for himself or herself. One does not have an aesthetic experience based on the second-hand testimony of others. An experience is aesthetic only if it is governed by a close encounter of the third kind with the pertinent object.

Sometimes this epistemic requirement may be stated in terms of the idea that the experience is being pursued for its *own sake* or that it is directed at *intrinsic properties of the object.* This language can be confusing, since very similar locutions also figure in axiological characterizations of aesthetic experience. However, when these locutions appear in epistemic accounts, they boil down to the notion that aesthetic experiences are restricted to the direct experience of something—the experience of the intrinsic properties of the object (those available by direct inspection)[6] pursued for the sake of encountering or perceiving those properties "in the flesh," so to speak, rather than as an optional pretext for daydreaming or free-floating fantasies.[7] The aesthetic experience, properly so called, must be directed by an object that is literally present to the aesthete and its literal presence mandates the way in which it is to be negotiated by the percipient.

The notion of object-directedness is central to the epistemic approach to aesthetic experience. This appears to have two ideas built into it: that one must directly encounter the object of such an experience and that one's response be governed by the object. In all likelihood, there is also the assumption that in order to guarantee that one's response to the object is governed by it, one must be experiencing the object directly. However, that does not seem to me to be the case. One's response to the object may be governed by the object in a normatively appropriate way—that is, one's cognitions with respect to the object can be precisely those mandated by the object—without requiring one's direct inspection of the object. But if this is the case, then the crux of

6 See, for example, Eaton (2001), Ch. 1.
7 Iseminger (2003), p. 110.

the epistemic approach to aesthetic experience—the claim that something is an aesthetic experience only if it involves the direct inspection of its objects—is false, and, in consequence, aesthetic experience does not necessarily demand a specific type of knowledge, namely, knowledge by personal acquaintance.

Evidence for the claim that one can have normatively appropriate, aesthetic experiences, of objects such as artworks without directly encountering the works in question abound in the arena of artmaking often referred to as *conceptual art*. One of the most famous examples of this kind of art is *Fountain* by Marcel Duchamp. This work, in its various manifestations, has been widely discussed by artists, philosophers, critics, art historians, and innumerable members of the lay audience who follow the artworld. But one wonders whether all those who speak of it have seen it or even a photograph of it. Of course, that they speak of it shows nothing. Yet I conjecture that quite often commentators who have not directly encountered *Fountain* have nevertheless made insightful remarks about it or, at least, have thought them to themselves when they have heard or read about *Fountain* second hand—that is, they have, so to say, "gotten it," but without eyeballing it. Have they not then had an aesthetic experience?

At this point, the proponent of the epistemic account is apt to cry "foul!" The kind of responses to *Fountain* to which I have just adverted, it may be charged, cannot be called aesthetic experiences, save by begging the question against the epistemic theorist of aesthetic experience. For, on this view, an experience cannot be aesthetic unless it is "face-to-face." Moreover, the epistemic theorist of aesthetic experience may also claim further support in this matter from the conceptual artists themselves, including Duchamp. For those artists maintain that their work is anti-aesthetic (Duchamp intended to undermine the retinal or *perceptual* claims of painting); and their understanding of the way in which their work is "anti-aesthetic" is that it does not support aesthetic experience either in terms of yielding visual pleasure or, crucially, in the present case, in terms of requiring a direct encounter with the artwork (thereby supposedly undermining the alleged commodity value of the artwork). So if the theorists of aesthetic experience and the conceptual artists themselves agree that the experiences to which I am alluding are not aesthetic experiences, on what grounds can I use responses to conceptual art, or, at least some of them, as counterexamples to the epistemic approach?

My argument is this: the identification and/or appreciation of the form of an artwork is perhaps the paradigmatic example of an aesthetic experience. This view finds voice in the work of Bell and can arguably be traced back to Kant. I take it that every participant in the discussion accepts this premise, even if he or she does not limit aesthetic experience to the experience of form. Nevertheless, it is not the case that one must inspect an artwork directly in order to identify and/or appreciate the form of an artwork.

The form of an artwork is the ensemble of choices intended to realize the point or purpose of an artwork.[8] Furthermore, one may be able to grasp the pertinent

[8] This conception of artistic form is defended in Carroll (1999), Ch. 3.

choice or ensemble of the choices and the corresponding interrelationships that enable an artwork to secure its point or purpose without inspecting the work directly. From a photograph, or, even more importantly for my argument, from a reliable description of *Fountain*, someone informed about art history can glean the subversive purpose of the piece and see how the choice of a urinal and its inversion ingeniously challenges various presuppositions about art; one can, again simply from a reliable description of the work, savor how suitable—how diabolically apposite—Duchamp's choices and minimal artisanship advance the point of the work: that anything, even something remote from the imprint of the artist, can be an artwork.

Calling the work *Fountain*, for example, connects it with the sort of Renaissance marvels that decorate Rome and which no one would deny are artworks. Duchamp's found object explores the same territory as more ornate fountains, trading, as it does, in running water. Likewise, as is the case of other recognized artworks, Duchamp's *Fountain* has a subject, namely, the nature of art, and it may even afford for some either the aesthetic pleasure of a witty jest, a Hobbesian chuckle of superiority at the apoplexy of the outraged philistine, or a sense of satisfaction at the elegance with which Duchamp has combined his materials so economically to make his points.

That is, one can contemplate the form of *Fountain* from afar, from a photograph, but, again more significantly, from a reliable description as well. One need not see *Fountain* to grasp and/or to appreciate the form of the work—that is, the way its elements interact cleverly to carry its purpose. A reliable description will do.

At this point, it may be alleged that one cannot have a full aesthetic experience of the work without seeing it. But apart from the question of what would constitute a *full* aesthetic experience, all that is required to show that the epistemic approach to aesthetic experience is false is that some quantum of aesthetic experience is possible without directly confronting the relevant object. And clearly one can derive an accurate sense of the form of many conceptual artworks—for example, of their structures of rhetorical address—and perhaps even come to admire them on the basis of a reliable description.[9] Moreover, if this is true of the experience of the formal structures of conceptual artworks, might not it also be true of other kinds of art?[10]

Similar stories can be told of further works by Duchamp, such as *In Advance of a Broken Arm*, and of works by his followers, including Language Artists, performance artists, and conceptual artists in general. One of the animating ideas of much conceptual art is that, even if it exists as a performance or a specific object, it is primarily as a concept that it is to be approached; one

[9] Though I would not require admiration for the experience to count as aesthetic, since, as I argued earlier, I take the concept to be descriptive and not essentially commendatory.

[10] Perhaps one could apprehend the basic structures of dramatic conflict in a literary work from a reliable description of its plot and even, though this would not be necessary for the encounter to count as aesthetic, be pleased by its ingenuity.

may cogitate about the design of such objects—their point, their subtending rhetorical construction, and the interrelation of the two—without being in their presence. Photographs, other forms of documentation, and, in the most pertinent case for our purposes, reliable descriptions, suffice. In many instances, this very feature of the conceptual artwork is of central importance, since it is putatively intended to subvert the alleged commodity fetishism of the artworld. But, be that as it may, one can experience the formal design of many conceptual artworks as it is relayed to us by a reliable description. So, insofar as an experience of the formal design of an artwork is an aesthetic experience, it is not necessary to inspect such an object directly in order to have an aesthetic experience of it.

Often it is said that one cannot have an aesthetic experience of an artwork on the basis of a description because features of the artwork—like the precise thickness of a line—may be omitted from the best imaginable description, and yet, inasmuch as that feature may influence our perception of the object subtly, any experience based on such a description will be defective. Here, of course, one wonders whether we are talking about aesthetic experiences of objects or aesthetic judgments of objects. The real anxiety seems to be that if we are judging the object aesthetically, we cannot judge (in the sense of evaluate) its perceptual effects fairly unless we see it. But even if one disagrees with my contention that aesthetic experiences are distinct from aesthetic judgments, considerations like this will not deflect the conceptual art case, since the conceptual artworks we have in mind, like Duchamp's readymades, are designed and/or selected in such a way that such perceptible variations are irrelevant to the formal structure of the work. When one thinks of form in terms of features like symmetry and balance, fine differences in line and shading can be decisive to one's experience. But the formal design of many conceptual works does not require the eye to descry it; it can be retrieved through a description. Therefore, direct inspection is not necessarily a condition for aesthetic experience.

One objection to the preceding argument might be that the "close encounter" requirement is just built into the notion of an experience of X of any sort, including an aesthetic experience. If that were true, it would, of course, under-mine any attempt to use the epistemic account as a sufficient condition for aesthetic experience.[11] But, in any event, it does not seem convincing to regard every experience as necessarily direct; if they were, why would we speak of "direct experience" as if it contrasted with some other kind of experience? Furthermore,

[11] Marcia Eaton seems to me to hold an epistemic view of aesthetic experience. She maintains that "An aesthetic response is a response to the aesthetic properties of an object or event, that is to intrinsic properties considered worthy of attention within a particular culture." Here "intrinsic properties," those verified by direct inspection, mark her commitment to the epistemic approach. The added stipulation—that the properties in question be considered worthy within a particular culture—I speculate is her way of securing sufficiency for her definition. I challenge her intrinsic-properties requirement above. But, in addition, I do not see how she hopes the "worthy of attention" clause will succeed, since a culture might consider the patriotism of a work that wears it on its sleeve to be worthy of attention (perception or reflection) but an experience of patriotism, however appropriate given the function of the work, is not what is typically thought of as an aesthetic experience. See Eaton (2001), p. 10.

it does not seem to be the case that even the aesthetic experiences the epistemic theorist countenances must be direct in all instances. For surely an epistemic theorist will regard as an aesthetic experience a reflection on the form of a poem once read (once experienced directly) in memory.

A second response to my denial that direct experience of the relevant object is necessary for aesthetic experience may involve a reconstrual of the requirement on the part of the epistemic theorist. Instead of demanding that the aesthete must inspect the object directly in order to experience it aesthetically, it might be proposed that in order to verify that the object has the property upon which the aesthetic experience is putatively focused, one must engage in the activity of direct inspection; thus, in order to have a flawless aesthetic experience, direct inspection of the object of said experience is requisite.

But, again, the identification of the formal design of certain conceptual artworks and their associated formal properties need not require direct inspection in order to verify that the works in question possess the imputed properties, so long as one has access to a reliable description of the work; indeed, some conceptual works may be designed in such a way that one cannot directly inspect them. Needless to say, the epistemic theorist may maintain that one cannot know that one is relying on a reliable account of the work, unless one has directly experienced the work. But why should that be true of accounts of artworks when it is not true of accounts of other sorts of things? This is something the epistemic theorist would have to establish in a way that does not beg the question. After all, scientists do not have to run every experiment themselves in order to presume that the findings reported by respected authorities in reputable journals are reliable.[12]

4. THE AXIOLOGICAL APPROACH

The axiological approach to characterizing aesthetic experience identifies it in terms of the kind of value it is thought to secure, typically intrinsic value or value for its own sake. This is perhaps the most common way of regarding aesthetic experience today. It probably is a descendant of the view that aesthetic experience is essentially pleasurable. For, if one regards pleasure as its own reward, as many philosophers do, then aesthetic pleasure is consequently valuable for its own sake. That is, it is a short step from the belief that pleasure is valued for its own sake to the view that aesthetic experience, conceived as essentially pleasure, is something valued for its own sake.

[12] Paisley Livingston has offered a series of arguments against what he tags as the "apparent truism" that an aesthetic judgment requires a close encounter of the third kind with the pertinent artwork. Inasmuch as this truism is closely related to the epistemic approach to aesthetic experience, some of Livingston's objections are germane to the present discussion. At the same time, I wonder whether counterexamples from the realm of conceptual art won't undermine the successor that Livingston proposes to the "apparent truism." See Livingston (2003).

The concept of disinterested pleasure, beloved of the tradition since at least Kant, moreover, intensifies the association of aesthetic experience with intrinsic value, since the very idea of "disinterestedness" tends to be defined as "not instrumentally valuable." Thus, the view that aesthetic experience is valuable for its own sake emerges from two converging lines of thought: that it is essentially pleasurable *and* disinterested.

Of course, we have already seen that the correlation of aesthetic experience with pleasure is inadequate. But the axiological approach, though probably a mutation of the affect-oriented approach, does not connect aesthetic experience to pleasure essentially. It requires rather that the aesthetic experience be valued for its own sake. Perhaps in some cases, the alleged intrinsic value of the experience in question is rooted in the pleasure it imparts. But inasmuch as the axiologists maintain that an experience can be valued for its own sake without being pleasurable, they can agree that there are aesthetic experiences that are not pleasurable. Thus, the axiological approach is not vulnerable to certain of the counterexamples that were raised against the affect-oriented approach, such as the experience of paintings predicated on eliciting revulsion toward the delights of the flesh. For if such experiences of mortification are valued by percipients for their own sake, they are aesthetic experiences, albeit unpleasant ones.[13]

By the same token, however, valuation for its own sake cannot be a sufficient condition for aesthetic experience, since, if one believes in intrinsic value, one is likely to countenance other sorts of purportedly autotelic activities,[14] such as playing chess, as equally valuable for their own sake. Consequently, the safest version of the axiological approach claims no more than that being valued for its own sake is at most a necessary condition for aesthetic experience.

When speaking of the aesthetic experience of artworks, it is important to locate in the right place that which is being valued for its own sake. One must be careful not to confuse the artwork with the experience of the artwork. For, if one values the artwork because it affords an experience valued for its own sake, then, without further qualification, the artwork would not appear to be valued for its own sake, but rather to be valued instrumentally as something that makes an intrinsically valuable experience available to the percipient.

Furthermore, a great many of the artworks of the past, especially the premodern past, are religious—religious in content and religious in virtue of the sorts of experiences they are supposed to engender. One wonders whether the reverence for the artwork—that experience said to be valued for its own sake—as putatively evinced by modern aestheticians is not merely a displacement of the religious

[13] Of course, this feature of the axiological approach may also have a downside. For percipients may subjectively value for their own sake experiences that would not be characteristically regarded as aesthetic. If one values for its own sake the absorption of what one takes to be the spiritual insight of an artwork, then that will count as an aesthetic experience for the axiologist; but this is precisely the sort of experience that the tradition typically refuses to regard as aesthetic. Can the axiologist claim to be capturing the prevailing concept of aesthetic experience, or do cases like this indicate that the axiologist has actually changed the subject?

[14] See Csikszentmihalyi (1975).

reception of previous art. Has the experience of the numinous, putatively valuable for its own sake, been confused with the response to the artwork as the vehicle that makes the holy manifest? Is that why museums are sometimes called our contemporary cathedrals?

Though the axiological approach does not have all the liabilities of the affect-oriented approach, it does share some of them. It too appears to conflate having an aesthetic experience with rendering an aesthetic judgment. For surely to assign intrinsic value to an experience is to evaluate it positively. But this then raises the problems of unrewarding experiences of bad art, on the one hand, and indifferent experiences of routine artworks, on the other hand.

One may follow the formal permutations of a musical theme as it moves from one section of the orchestra to another and yet judge the experience as without value, either intrinsic or otherwise, because the artwork itself is unintentionally grating. Or perhaps the formal structure is respectable enough, but uninspired in a way that gives rise to indifference. In such cases, where one's attention is directed in the right way at the formal design of the work, it seems appropriate to call the aforesaid responses aesthetic experiences (how else should we categorize them?), but they are not valued for their own sake, since they are not valued at all.

It may be true that an aesthetic judgment *qua* evaluation must contain a positive value element (intrinsic or instrumental), or maybe just some value element (positive or negative). But, undoubtedly, there are aesthetic experiences that are negative or indifferent. One cannot deny this, save by confusing aesthetic judgments with aesthetic experiences—that is, by conflating a form of commendation and/or evaluation with experiencing the object aesthetically.

It might be said in response to the case of the unrewarding experience elicited by bad artworks that the relevant aesthetic experiences are not necessarily valuable for their own sake, but only that they must be intended to be so. Yet this seems false: the experience of terror that certain tribal masks are supposed to provoke in the enemy is not intended by the artificers of such designs to be valued by foreign onlookers for their own sake. The experience promoted by such masks is intended to elicit flight, something that the makers of the images value not for its own sake, but for the security of their tribe.

Another problem with the axiological approach is that it is stupendously uninformative. It provides no guidance about how to go about having an aesthetic experience. Probably the reason for this amazing absence of specificity has to do with the fact that the axiologist, in effect, defines aesthetic experience almost exclusively in negative terms. Aesthetic experience is valuable intrinsically—that is, it supposedly has no instrumental value of any sort. It is an experience *not* valued for its service to morality, politics, religion, and so on. It is something one values for its own sake. But how precisely does one go about doing that?

The axiologist's concept of aesthetic experience is woefully empty in terms of informational content; it leaves someone interested in having such experiences with no directions about how to proceed. Perhaps a corollary of this problem is that if one wishes to do empirical research on the subject of aesthetic experience, one would have no idea, on the basis of the axiological account, of what features

of our interactions with artworks to scrutinize; the pertinent variables of aesthetic experience that the psychologist might interrogate are left completely blank and undefined by the axiologist.

Nevertheless, despite the axiological theory, we do know how to teach children ways in which to have aesthetic experiences—we know to tell them to look at certain aspects of artworks and in certain ways. Having an aesthetic experience can be specified in terms of certain concrete operations, like listening for recurring themes and echoes in music, which can be taught explicitly and also observed by psychologists. But this would hardly seem feasible, if aesthetic experience is to be simply defined as that sort of experience which is valued for its own sake. Who could instruct anyone else in how to have such an experience or to find one on the basis of the exceedingly thin account the axiologist offers?

There is also an important ambiguity that lies at the heart of many axiological characterizations of aesthetic experience; it pertains to the way in which we are to understand the qualification "for its own sake." Is the aesthetic experience one that is said to be necessarily valuable for its own sake from an objective point of view (the view from nowhere) or from the subjective point of view (from the perspective of the percipient's own belief system). That is, is aesthetic experience, on the axiologist's conception, good in a non-instrumental way, an aspect of human flourishing rather than a cause or means to flourishing, *or* is aesthetic experience merely such that those who have it believe it to be non-instrumentally valuable (where so believing is compatible with the said experiences really being instrumentally valuable)? In other words, when it is claimed that aesthetic experience is valuable for its own sake, is the axiologist saying the experience actually is, in some sense, valuable for its own sake, or only that this is what the people who undergo such experiences, necessarily, typically believe of them?

The contention that aesthetic experience is objectively valuable for its own sake—that it possesses no instrumental value whatsoever—is difficult to fathom. Cultures, both literate and tribal, have spent large resources, sometimes on a grandiose scale, in order to secure the conditions for aesthetic experience, such as artworks. But this would be a mystery were it true that aesthetic experience yields no instrumental value whatsoever. It confounds the naturalistic perspective to imagine that so many sacrifices, both individual and social, have been made in order to facilitate experiences that have no beneficial or adaptive consequences. The view that aesthetic experiences are objectively valuable for their own sake does not fit with what secularists generally presume about human nature. Typically, where humans make great efforts, those endeavors are rewarded with advantages, even if they are not initially obvious ones (but only "known" by our naturally selected hard-wiring). That, at least, is certainly our best framework for explaining long-standing human (and animal and vegetable) regularities.

But this makes the notion that aesthetic experience is objectively valuable for its own sake anomalous. Why would natural selection tolerate such an expensive evolutionary attribute without some sort of instrumental advantage?

Moreover, this query is not merely methodological, since there are numerous and even attractive hypotheses that connect what are uncontroversial examples

of aesthetic experience to beneficial or adaptive consequences. Surely these hypotheses are extremely plausible rivals to the naturalistically deficient view that aesthetic experiences are simply intrinsically valuable objectively.

For example, aesthetic experiences are generally shared amongst audiences—theatergoers, filmgoers, concertgoers, dance aficionados, and the like—who find themselves in congruent emotive states. This is clearly an advantage from an evolutionary point of view, since it nurtures a feeling of group cohesion.[15] This suggests one way in which aesthetic experience is objectively valuable instrumentally and explains, at least in part, why societies cultivate it—why it appears to be a focus of important activity universally or nearly universally.

In a related vein, aesthetic experience involves the detection of expressive properties in the actions and products of conspecifics, sometimes by, as already mentioned, arousing parallel emotional states in us or by means of triggering our other capacities for recognizing the emotive states of others. Aesthetic experiences in this way make possible the transmission of a common culture of feeling—with obvious benefits for both the group and the individual. Inasmuch as aesthetic experience involves the detection of expressive properties, having such experiences exercises our powers for determining the emotive states of conspecifics as well as for expressing our own, while contemplating the form of artworks also refines our abilities to comprehend the purposes and intentions of others. These powers are clearly advantageous to social beings such as ourselves.[16]

Aesthetic experience, it is generally conceded, also enhances our perceptual powers of discrimination, thereby facilitating our capacities for recognizing, cataloguing, and re-identifying objects, capabilities whose sophistication can make one better able to navigate the world.[17] Furthermore, by engaging audiences in the play of their emotive, sensuous, and intellective potential, typically simultaneously, aesthetic experiences of art redundantly encode useful cultural knowledge about conspecifics and the environment across several faculties, thereby rendering it both more entrenched in memory and easier to access than it might otherwise be.

[15] Dissanayake (1992, 2000).

[16] Though we have been emphasizing the instrumental value for social existence of the pursuit of aesthetic experience, it should also be noted that aesthetic experience may afford significant benefits for the individual as well. By exercising certain of our powers of perception, association, comparison, contrast, and so on, having aesthetic experiences enhances mental fitness by tuning our cognitive organizational powers. Aesthetic experience helps develop the mind's capacities for organization and discrimination, while also sharpening and refining them. See John Tooby and Leda Cosmides (2001).

[17] Many early artworks and the structures they employ, such as rhyme, were mnemonic devices that facilitated the recall of information, especially culturally significant information. The aesthetic experience involved in response to these structures undoubtedly served an instrumental purpose in keeping the relevant information alive for the relevant peoples. Moreover, the information was not only exclusively cultural; songs can encode geographical information. In such cases, the aesthetic experience of the song may serve the practical purpose of making important information more accessible than it would otherwise be. See, for example, Bruce Chatwin's fact-based fiction, *The Songlines* (1987); similarly, the African-American song "The Drinking Gourd," encoded information about traveling on the underground railroad.

Admittedly, these hypotheses require much more substantiation than one has space for in a chapter of this sort. Nevertheless, even in their abbreviated form they or comparable biologically oriented accounts would appear to command more initial plausibility from the naturalistic point of view than what the axiologist can muster by way of explaining why aesthetic experiences of art have been sought by every known culture in every period of history. For what kind of explanation is it to say that these experiences just are objectively valuable for themselves? That seems virtually tantamount to saying that one simply does not know why they are valuable.

Impressed by the sort of evolutionary accounts suggested above, the axiologist, of course, might try to accommodate them by means of a compromise: namely, by saying that aesthetic experiences are valuable *both* for their own sake and for the sake of the instrumental benefits various evolutionary hypotheses suggest that they afford. But this solution raises certain questions. First, if aesthetic experience is to be defined in this manner, how will the axiologist differentiate aesthetic experience from other types of experience? Isn't this how the axiologist understands most other sorts of experience? So, even if this were, in some sense, a convincing resolution, wouldn't it signal the uselessness of the axiological approach for characterizing aesthetic experience?

Yet one wonders if this gambit can be persuasive in the least, since once the axiologist agrees that aesthetic experience is valued both instrumentally and intrinsically, one wants to ask what additional explanatory work the notion of intrinsic valuation contributes to our understanding of the persistence of the aesthetic experience of art. The instrumental value of aesthetic experience alone, it would appear, gives us what we need—our simplest explanation. Adding to the story that aesthetic experience is also intrinsically valuable brings no further insight into why human societies systematically pursue aesthetic experience. From an explanatory viewpoint, the notion that aesthetic experience is valuable for its own sake appears to be a gear that is extraneous to turning any other part of the mechanism. That is, it is not needed to explain why humans have the capacity for aesthetic experience, once the evolutionary advantages of that capacity are adumbrated.[18]

[18] At this point, the axiologist may say that here aesthetic pleasure has a role to play. People pursue the aesthetic experience because of the pleasure it yields. Pleasure is the device that natural selection has elected to insure that humans pursue the benefits that aesthetic experience has to offer. Moreover, pleasure is valuable for its own sake. So adverting to something in aesthetic experience that is valued for its own sake does have explanatory value. One problem with this response is that, as we have seen, pleasure is not a feature of every aesthetic experience. However, a deeper problem here is that, on the preceding story, pleasure is not objectively valuable for its own sake. It is objectively valuable for the evolutionary job it facilitates. Thomas Aquinas speaks of delight or pleasure that is conducive to the operation of an end—as carnal pleasure is conducive to the end of procreation. But this sort of pleasure is not objectively valuable for its own sake; it is valuable for what it brings about. Thus the evolutionary psychologist may argue that aesthetic pleasure, where it obtains, does not force her to make room for intrinsic value in her account. See Thomas Aquinas, "The End of Man," *Summa Contra Gentiles*, Book 111, in *Basic Writings of St. Thomas Aquinas* (1945).

So challenged, the axiologists may modify their thesis: instead of contending that aesthetic experiences are objectively valuable for their own sake, they may only claim that they are subjectively valued for their own sake. That is, the subject who has such an experience regards it as valuable for its own sake. This belief may be either the cause or motivation that leads the subject to pursue aesthetic experiences, or it may be how he or she assesses the experience retrospectively. In either case, what is being claimed is not that aesthetic experience is intrinsically valuable, but only that those who have these experiences think they are valuable for their own sake.[19]

Perhaps needless to say, that subjects believe aesthetic experiences to be intrinsically valuable cannot provide a sufficient condition for aesthetic experience, since subjects prone to believe in intrinsic value will declare other sorts of experience as well to be valuable for their own sake, as will the axiologists themselves. Thus, the cautious axiologist will claim nothing more than that an experience is aesthetic only if it is believed to be valuable for its own sake by the person who has it. That is, a belief in the intrinsic value of the experience by the person who undergoes it is a necessary condition for aesthetic experience.

Undeniably, there are people like this—people who would sincerely report that they read poetry for the intrinsic value of the experience it affords. Nor is there any reason to suspect that they are self-deceiving or incoherent in this matter. But even if there are some, or even a great many, who hold such convictions, it is not the case that a belief in the intrinsic value of an experience is essential to having an aesthetic experience.

In order to see why, consider the following case: a believer in the intrinsic value of aesthetic experience (whom we shall call "an aesthete") and an evolutionary psychologist both attend to the same piece of music. The evolutionary psychologist believes that this sort of aesthetic experience is instrumentally valuable objectively, perhaps for the kinds of reasons sketched above. Nevertheless, the evolutionary psychologist is alert to the same features of the music that the aesthete contemplates: the evolutionary psychologist tracks the same developments, recognizes the same expressive and aesthetic properties in the work, and discerns the same formal relationships that the aesthete does. Everything the aesthete surmises about the way in which the music modulates his attention, the evolutionary psychologist surmises; everything the aesthete feels, the evolutionary psychologist feels; both are cognitively and affectively tuned to the music in the same way; they both notice the same things about the structure of the music and its impact on their cognitive-perceptual-emotive system.

In short, we are imagining the possibility that the succession of computational states in these two individuals are type-identical with each other. They attend to the same artistic stimulus in the same ways, ways furthermore that are canonical within the traditions of reception within the relevant culture. Nor is there anything self-contradictory about imagining this sort of parallel.

[19] This belief is, of course, compatible with it really being the case that aesthetic experience is instrumentally valuable, objectively speaking.

Both percipients, then, are processing the artwork in the same ways, correctly noticing the same formal articulations and the same expressive and aesthetic properties. The only difference is that the aesthete believes this experience is valuable for its own sake, whereas the evolutionary psychologist believes it is instrumentally valuable.

According to the axiologist, this difference in belief is enough to discount the evolutionary psychologist's experience as aesthetic. But isn't this simply arbitrary? If the evolutionary psychologist is following the formal and expressive evolution of the music correctly and perceptively—indeed, precisely as the aesthete does—why should her beliefs about the value of the experience compromise the aesthetic standing of her experience? After all, there is no reason to suppose that the evolutionary psychologist's beliefs in the instrumental value of the experience would lead her to misidentify a formal pattern or to ignore an expressive property, or to deviate in any way from the same pathways of thought and attention mobilized by the aesthete. Surely the evolutionary psychologist is processing her experience aesthetically, if the aesthete is, since the two processes are step-by-step identical. Moreover, how else, other than as aesthetic experience, would we describe searching for formal designs with understanding or detecting expressive properties? Thus, inasmuch as those activities can be discharged successfully, irrespective of one's beliefs about the nature of the value of such experiences, there is no reason to regard the evolutionary psychologist's experience as any less aesthetic than the aesthete's. If anything is an aesthetic experience, grasping with comprehension the formal design of an artwork is. But one can do that effectively whether one's beliefs correspond to our aesthete's or our evolutionary psychologist's. Thus, both are having aesthetic experiences. Therefore, a belief in the intrinsic value of the experience in question is not a necessary condition for having an aesthetic experience.

Some axiologists have gone so far as to claim that critics cannot have aesthetic experiences insofar as they attend to artworks with an avowed, self-acknowledged instrumental interest in finding material for their next article. But good critics are paradigms of the way in which we should respond to and experience artworks. Thus, the axiologist's position has the paradoxical consequence that the critic whose experience of an artwork serves as a model for the aesthete is not having an aesthetic experience, whereas the aesthete whose receptive behavior strictly parallels the critic's, but who believes his or her experience is intrinsically valuable, is having an aesthetic experience. As in the case of the comparison of the evolutionary psychologist and the aesthete, this conclusion seems arbitrary and unacceptable.

Though our thought experiment involved an evolutionary psychologist, it is not necessary to the argument for the believer in the instrumental value of aesthetic experience to be a scientist. Like Ralph Waldo Emerson, the instrumentalist might believe that the aesthetic experience of art is instrumentally valuable as a propaedeutic exercise that prepares or trains us for seeing the

wonders that surround us in the natural world.[20] Or the instrumentalist might
be: a Hindu who regards aesthetic experience as an avenue to or foretaste of the
bliss of emancipation;[21] a Sufi who thinks of the experience of outward beauty
as a gateway to spiritual beauty;[22] a Daoist who pursues aesthetic sophistication
as a means of self-improvement, a way of cultivating in oneself the harmonious
patterns immanent in the natural order;[23] and so on. Holding any of these
beliefs or comparable ones about the instrumental value of experiencing the
form and expressive properties should be no impediment to having aesthetic
experiences of artworks so long as the percipient is attending to the appropriate
features of the object in terms of proper strategies, patterns, and techniques of
reception.

Indeed, it is not even required that the instrumentalist's beliefs about the value
of the experience be true in order for the experience to be aesthetic, so long as it
focuses on the right things in the right ways for the right reasons. Daoists may be
wrong in believing that attending to artistic harmony instrumentally promotes
personal harmony, and yet be experiencing the relevant artwork aesthetically, so
long as they are noticing the formal equilibrium in it and intuiting its serenity.
There is no reason to think experiences like these are aesthetically foreclosed if the
agent holds beliefs, whether true or false, in the instrumental value of undergoing
such experiences.[24] Thus, it cannot be the case that a belief in the intrinsic value
of the sort of experience under discussion is a necessary requirement in order for
said experience to be classified as aesthetic.

Moreover, in order to motivate this objection it is not even necessary to
postulate subjects who have doctrinal or theoretical commitments, like the
evolutionary psychologist, about the nature of all aesthetic experience. Without
any general views about the relation of aesthetic experience to instrumental value,
someone may pick up a novel in order to satisfy the very instrumental end of
getting a handle on recent social developments. One might read Jay Cantor's
Great Neck to get a clearer understanding of the politically tumultuous 1960s and
1970s; Jane Smiley's *Good Faith* for insight into the realty boom of the 1980s;
or Don DeLillo's *Cosmopolis* for his take on the financial bubble of the 1990s.
In all these cases, readers may carefully attend to formal structures—such as
the contrasts between various character types—in order to see how the relations
and tensions between these incarnated abstractions illuminate the interplay of
concrete social forces. But if readers track formal relations, even if they do
so in pursuit of instrumentally valuable knowledge about the lay of society, I
see no reason to deny that their experience is aesthetic, since, once again, we

[20] Emerson (1936), p. 246. Similarly, Russian Formalists thought of their paradigmatic aes-
thetic experience of art—what they called *ostranenie* (defamiliarization)—as being valuable for
reinvigorating our powers of perceiving the world.
 [21] Gerow (1997), p. 317. [22] Nasr (1997), p. 455.
 [23] Goldberg (1997), p. 228.
 [24] Moreover, since the subjective version of the axiological approach is framed in virtue of beliefs,
it is irrelevant to having an aesthetic experience, on this view, if the percipient's conviction that
aesthetic experience is intrinsically valuable is false.

would not deny that title to the aesthetes who spend their time and energy doing exactly the same thing—contemplating the same structures and their relations.

A frequent axiological riposte to cases like the preceding ones is to ask us to imagine what would happen if the kinds of subjects we've described came to believe their conjectures about the instrumental value of aesthetic experience were not viable. Would they still pursue aesthetic experience? The axiologist asserts that, of course, they will. Moreover, the axiologist then goes on to explain this putative response by hypothesizing that subconsciously these so-called instrumentalists really believe in the intrinsic value of aesthetic experience. Why else would they continue to pursue aesthetic experience, once their beliefs about the extrinsic value of aesthetic experience have fallen by the wayside?[25]

I, however, am not so sure that the imagined experiment will turn out as the axiologist presumes. If someone pursues aesthetic experience as part of a spiritual regime, but then comes to suspect its transcendental efficacy, I see little cause to predict that the true believer will continue to say "yes" to aesthetic experience. Religionists can be quite stern about what they come to regard as irrelevant or frivolous. Remember Puritanism?

Furthermore, even if our instrumentalists continue to pursue aesthetic experience in the face of the defeat of their pet theories and beliefs, that does not entail that they have a subconscious belief in the value of aesthetic experience for its own sake. It might equally support the hypothesis that they continue to believe that aesthetic experience is instrumentally valuable—that it is good for them—despite the embarrassing fact that their best account of why this is so has just been refuted. That is, instrumentalists may concede that their best account of why aesthetic experience is beneficial has been problematized, but remain convinced in their hearts that such experiences are (instrumentally) good for them in a way that future research will eventually reveal and clarify. Such a response could, for example, be sustained by an evolutionary psychologist, who, on theoretical grounds, maintains the reasonable expectation that it is only a matter of time before the adaptive advantages of aesthetic experience are finally pinpointed. Alternatively, such a view could be held by someone who experiences the hankering for aesthetic experience as satisfying a drive—perhaps a subsidiary of the curiosity drive—and speculates, quite rationally, that where there is drive, there is an ulterior purpose.[26] Or it may be that the subject holds to the common

[25] Perhaps the axiologist will try to bolster this conjecture by claiming that the alleged instrumentalists will continue to pursue aesthetic experience in this case because they believe it will yield pleasure where pleasure, it will be maintained, is something that everyone values for its own sake. On the other hand, perhaps like Aristotle, they believe that pleasure is a sign that the pertinent faculties—in this case, the cognitive, emotive, and perceptual faculties engaged in aesthetic experience—are functioning well. They seek pleasure, if they do, as a means of ascertaining that the system is running optimally. Surely such a perspective is coherent.

[26] Richard Miller regards aesthetic experience as a learning-like response. For him, it is only learning-like because it supposedly is divorced from a concern with truth. Nevertheless, the characteristic behaviors associated with the aesthetic experience of art do mirror those of learning

notion that having aesthetic experience improves one—a tenet of many cultures and classes—even if one cannot articulate exactly how; for that reason he or she continues to pursue aesthetic experience, even while the philosophical jurists are out (betting, all the while, that sooner or later they will figure out why what is good for us is good for us).

Moreover, since the subjective variation of the axiological approach trades essentially in beliefs, a perhaps ignominious counterexample to the theory would be the case of the subject who irrationally believes that aesthetic experience is instrumentally rather than intrinsically valuable. For certainly we can consistently entertain the possibility of an art lover who believes some truly insane theory about the instrumental value of the aesthetic experience of art (that it builds strong bodies 12 ways), but who is, at the same time, astoundingly adept at detecting the formal patterns and expressive qualities of artworks. If, immersed in an experience of an artwork, this person is preoccupied with unraveling its intricate relationships and resonating with its expressive effects, then there is certainly more reason to categorize his or her experience as aesthetic rather than as any other sort. This is not the sort of counterexample that someone, like myself, who is sympathetic to instrumentalism, reaches for with relish, but logically it is another nail in the coffin of the axiological approach to aesthetic experience.

acquisition. They include inspecting, comparing, contrasting, grouping, discriminating, and so on. Having an aesthetic experience of an artwork is not a matter of staring at it vacantly; it involves an active investigatory or exploratory stance. Thus it is not amiss to regard it as connected to what some psychologists see as our curiosity drive, something of the utmost instrumental value in the human appropriation of nature. Perhaps, in this light, aesthetic experience is fitness-enhancing in that it hones both the mind's appetite for curiosity along with its abilities to develop talents for satisfying it.

Furthermore, if aesthetic satisfaction is related to the satisfaction of a drive, one wonders whether we should say that it is valuable for its own sake? Consider the following: humans and some animals possess the curiosity drive. Animals without the capacity to form conscious beliefs explore under its pressure. We do not explain their behavior as a result of their belief in the intrinsic value of such activity. If humans are behaving as a result of the same kind of instinctual mechanism, why should we say that they are doing so because they believe in the intrinsic value of the experience? Even if they have such a belief (and they may not), it does not seem to be what is causing their behavior. The curiosity drive is. Thus, if the imputation of a belief in the intrinsic value of something is ultimately meant to isolate a proximate cause of a person's behavior, then it is not clear that the alleged belief in the intrinsic value of aesthetic experience is doing any explanatory work here. Moreover, since we would not attribute an intrinsic valuation of exploration to a non-belief-forming animal responding to the pressure of the curiosity drive, maybe for consistency's sake, it would be advisable to withhold it from the human case as well. This is not to deny that people may have such beliefs about aesthetic experience, but only that, inasmuch as they have no explanatory value with respect to the agent's behavior, they are not beliefs in the value of the experience for its own sake in the most robust sense.

Indeed, what these beliefs come down to seems to be the subject's admission of having no idea of why he or she really values the aesthetic experience of art. But if the notion of valuing the aesthetic experience of art for its own sake actually amounts to no more than a confession of ignorance, then the idea is much less exalted than it is usually imagined to be. It is at least questionable as to whether or not someone should proudly advertise holding such a belief.

See Miller (1998). On the curiosity drive, see Panksepp (1985), pp. 273–4.

5. THE CONTENT-ORIENTED APPROACH

We have so far examined the claims that all aesthetic experiences involve affective arousal, or direct engagement, or valuation for their own sake (at least subjectively). But, though there may be a great many cases that exemplify each of these claims, we have seen that none of these theories obtains universally.

Nevertheless, there appears to be one aspect of the aesthetic experience of artworks that does hold across the board, namely: all such experiences take objects. All aesthetic experiences of art have content. This, in turn, suggests that this particular experiential state may be definable, at least partially, in terms of its content—that is, in terms of the kinds of objects toward which it is directed. For obvious reasons, we call this research program the content-oriented approach to characterizing the aesthetic experience of art.

But what comprises the content of aesthetic experience? When speaking of art, the most commonly mentioned candidates include the form of the work of art and its aesthetic properties, of which expressive properties comprise a very large and especially noteworthy subclass. The form and the aesthetic and expressive properties of the artwork also interact in various ways. Sometimes form gives rise to aesthetic properties, such as unity, while the succession, evolution, or juxtaposition of expressive properties can constitute the form of the artwork. Form, expressive and aesthetic properties, and the interaction between these elements, are the most commonly indicated objects of aesthetic experience, as well as being the ones about which there is the least controversy.

In addition, aesthetic experience is also often directed at the way in which these elements engage and mold our attention to and awareness of them. So to observe aperceptively the way in which the perspective draws our eye to the narrative center of the picture is an aesthetic experience. Consequently, another object of aesthetic experience is the relation of the form, expressive properties, aesthetic properties, and/or the interaction thereof to our response to them—to the way in which they shape and guide our reactions. Thus the content-oriented theorist of aesthetic experience conjectures that if attention is directed with understanding to the form of the artwork, and/or to its expressive or aesthetic properties, and/or to the interaction between these features, and/or to the way in which the aforesaid factors modulate our response to the artwork, then the experience is aesthetic.

This account of aesthetic experience, in other words, provides us with a disjunctive set of sufficient conditions for categorizing aesthetic experiences of artworks. That is, a specimen of experience is aesthetic if it involves the apprehension/comprehension by an informed subject in the ways mandated (by the tradition, the object, and/or the artist) of the formal structures, aesthetic and/or expressive properties of the object, and/or the emergence of those features from the base properties of the work, and/or of the manner in which those features

interact with each other and/or address the cognitive, perceptual, emotive, and/or imaginative powers of the subject.[27]

Admittedly, there may be further objects of aesthetic experience that could be added to this list. However, given the tradition, these are the most recurrent, non-controversial ones. So, on the basis of the tradition, we can say that at least the satisfaction of one or more of these conditions is the most straightforward way of determining whether or not an experience of an artwork or a feature thereof is aesthetic.[28] This list has the virtue of excluding some of the more controversial candidates for aesthetic experience. For example, the simple recognition of what a representation, such as a picture, is of does not traditionally count as an aesthetic experience; seeing-in, as it is called, is not an aesthetic experience. So it is not on the list.

The list was assembled by thinking about the features of artworks, attention to which are most likely to elicit consensus and least likely to spur controversy among people who talk about aesthetic experience. The consideration of the moral consequences as such of an artwork for the commonweal is typically said not to be germane to aesthetic experience, so it is not on the list. This makes the content-oriented approach superior to the axiological approach, inasmuch as someone might intrinsically value reflecting on the moral consequences of an artwork; but that would make such contemplation an aesthetic experience, thereby contradicting the tradition. On the other hand, form is taken to be a *prima facie* object of aesthetic experience by everyone, even if they do not believe that it is the only object of aesthetic experience. Therefore, it is high on the content-oriented theorist's list.

Moreover, though form is being treated as a *prima facie* object of aesthetic experience, this should not be rejected as what is often referred to as formalism. Those who criticize formalism do so because they reject the attempt to solve the demarcation problem by defining art in terms of significant form. However, by invoking form to define aesthetic experience partially, nothing is being said about whether or not form is any sort of criterion for art status. Moreover, those who

[27] As the emphasis on apprehension/comprehension in this formulation might suggest, I regard the cognitive dimension of aesthetic experience as its primary locus of value.

[28] Some commentators have asked: what makes this list hang together? Is there some essence, like valuation for its own sake, that groups these objects together? Why is it that the tradition treats the apprehension of formal, aesthetic, and expressive properties as of a piece? My own suspicion is that this is best explained genealogically. When the notion of the aesthetic was first introduced, people thought of form in terms of something that could be seen or heard—something manifest—like the geometric alignment of figures in a painting or the echo of a theme in music. Similarly, they thought of aesthetic and expressive properties as things that could be seen or heard (either outwardly by the senses or as some sort of internal representation intuited by the imagination). Strictly speaking, as we have seen, this does not provide us with adequate conceptions of either form or of aesthetic and expressive properties. Nevertheless, it is this mistaken prejudice that led the tradition to lump these things together under the rubric of objects of aesthetic experience. The content-oriented theorist deals with this by preferring to treat each type of experience (such as the experience of form) specifically on its own terms and to continue to regard them as a package only in the deflationary sense that they are a disjunctive enumeration of sufficient conditions for what has been nominally bequeathed to us under the title of aesthetic experience.

object to the notion that attention to form is a necessary condition for aesthetic experience have no quarrel with me, since I have only advanced it as one of a disjunctive set of sufficient conditions.

If attention with understanding is directed at the form of an artwork, then it is an aesthetic experience. As mentioned earlier, by the form of an artwork is meant the ensemble of choices intended to realize the point or the purpose of the artwork. To consider an organism biologically is to consider the features of the organism that are relevant to its biological operation; to consider an artwork formally is to consider the features of the work relevant to its formal operation—that is, to consider the features of the work (and their coordination) that realize the point or purpose of the work. Attention to the form of a work is attention to its design—to the way the work is intended to work. Noticing how the spacing of the last line of A. R. Ammons's poem "Beautiful Woman" visually reinforces the puns he means to wring out of the word "fall" is an example of attention to the form or design of a work.[29]

Aesthetic properties are another source of aesthetic experience. Some examples include: detecting the sadness in the music, the apparent massiveness of the building, the balance in the sculpture, and the lightness of the dancer's step. These are all aesthetic experiences. Furthermore, as this brief, incomplete inventory suggests, there are various different kinds of aesthetic experience, insofar as aesthetic experiences may take a variety of objects. Some are sensuous properties like massiveness and lightness; others—like balance—could be called Gestalt properties. Sadness, on the other hand, is an expressive or anthropomorphic property. Moreover, one might discern or detect expressive properties by at least two different, though not mutually preclusive, routes: either by having a comparable feeling aroused in one or by recognizing certain emotive configurations (that is, one can take note of the sadness of the drooping weeping willow tree without feeling sad oneself).

There are, of course, even more types of aesthetic and expressive properties than enumerated so far. What they have in common is that they are response-dependent insofar as their existence depends on creatures like us with our sensibilities and imaginative powers. These properties supervene on the primary and secondary properties of the relevant objects of attention, as well as upon certain relational properties, including art-historical ones, such as genre or category membership. Aesthetic properties emerge from these lower order properties; they are dispositions to promote impressions or effects on appropriately backgrounded creatures with our perceptual and imaginative capabilities.[30]

[29] "Beautiful Woman" by A. R. Ammons (1997), p. 150:

> The spring
> in
> her step
> has turned to
> fall.

[30] Levinson (2001).

Because aesthetic properties are response-dependent, some may argue that defining aesthetic experience in light of them is circular. But one does not need to use the concept of aesthetic experience to define such things as form or aesthetic properties. These can be defined without explicit or implicit reliance on the notion of aesthetic experience. We have already defined form in this way; the aesthetic properties of artworks, then, are dispositions to promote impressions or effects, notably of expressivity, mood, figuration (metaphoricity), synesthesia or cross-modal correspondence, perceptual salience, Gestalt organization, and/or qualitative intensity, which emerge from the base properties of the works at hand in relation to suitably informed percipients with standard-issue human sensibilities and imaginative powers. It is true that this account makes reference to human capacities for experience, but inasmuch as no appeal is made to *aesthetic* experience, there is no circularity here.

In visual and sonic artworks, aesthetic properties are predominantly involved in promoting the ways in which the work appears phenomenally, over and above the operation of its primary and secondary properties. In literary works, aesthetic properties are typically less a matter of direct address and primarily emerge from the descriptions in the text in relation to the imagination. Though scarcely an exhaustive accounting of aesthetic properties, these brief remarks should nevertheless suggest that an aesthetic experience can be identified in terms of its content, without reference to affective states like pleasure, disinterested or otherwise, or to evaluative postures, such as finding the experience of such properties to be valuable for their own sake.

Whereas the axiological approach to aesthetic experience is remarkably unin-formitive, the content-oriented approach can begin to tell aspiring aesthetes what they should do in order to have an aesthetic experience—to wit: attend to the form, to the aesthetic properties, and so forth of artworks. Of course, this must be done with understanding—that is, in terms of certain strategies and techniques reception. But these strategies and techniques, though they may vary from artform to artform and from genre to genre, can also be described with a high degree of specificity and without circular appeal to aesthetic experience. For example, if one is reading poetry, one is well advised to attend to where the line breaks—to invest it with a special pause and then to listen for its expressive reverberations.

Likewise, anyone who wishes to study aesthetic experience rigorously should be drawn to the content-oriented approach, since it zooms in with some precision on the leading variables—the properties and techniques of reception—that give rise to it.

Friends of the epistemological approach may think that, by including under-standing in the content-oriented approach to aesthetic experience, we have encroached on their territory. For it is clear that the content-oriented theorist does not countenance just any encounter with the form and/or aesthetic prop-erties of the artwork as aesthetic experiences, but only epistemically appropriate ones. This is true, but I think that this is not the distinctive domain of the epistemic approach. Rather, I think it is shared by every approach to aesthetic

experience. All require that the subject engage the artwork with understanding. What is distinctive about the epistemological approach is that it demands a close encounter of the third kind with the artwork. But since this is not necessary—one can apprehend the form of a readymade without seeing it—and since the content-oriented approach is not committed to it, the content-oriented approach seems superior to the epistemological approach as the latter is distinguishable from other approaches to aesthetic experience.

Some will charge that, by limiting the aesthetic experience of artworks to attention with understanding to the work's formal and aesthetic properties and their interaction with each other and with our sensibilities and imagination, I have made the range of aesthetic experience unduly restrictive. For, they will say, there are other legitimate responses to artworks than these, such as deriving moral insight from them. However, the presupposition underlying this criticism is that the concept of aesthetic experience should be large enough to incorporate every legitimate response to an artwork, whereas I maintain, on the basis of traditional usage, that aesthetic experiences constitute only one family of responses, albeit an important one, that we may appropriately mobilize with respect to artworks.

Call the larger category of legitimate responses to artworks "art responses." Aesthetic experience is one kind of art response; moral learning is another. This way of treating the matter, I think, accords better with how the concept is commonly applied. It certainly fits better with the tradition than versions of the axiological approach that would count as an aesthetic experience any occasion where a reader, viewer, or listener subjectively valued for its own sake his or her experience of acquiring moral insight from an artwork.

It is frequently noted that aesthetic experiences are not only characteristically derived from artworks, but also from nature. In fact, some might contend that an adequate account of aesthetic experience must have something to say about responses to both art and nature. Though the content-oriented account defended above has concentrated on the aesthetic experience of art, it also has suggestive ramifications for the analysis of the aesthetic experience of nature. Clearly, nature lacks form in the way that we apply that concept to artworks. Nevertheless, inasmuch as form is to be understood functionally, we can note an analogous way of engaging nature to apprehending the formal design of artworks. Specifically, one can attend to nature functionally, sizing up the ways in which the contours of an ecological system have evolved from natural processes, pressures, and constraints. Allen Carlson has called this mode of attending to nature "the natural environmental model."[31] Attention to form in works of art, then, has an analogue in the aesthetic experience of nature in the naturalistically informed attention to the apparent teleology of natural processes and prospects.

Similarly, attention to aesthetic and expressive properties in artworks has close analogues to the aesthetic experience of nature, insofar as nature often moves

[31] Carlson (2000), Part 1.

us feelingly or arouses us in ways that engage our sensibilities and imagination, so that, in consequence, we attribute aesthetic and expressive properties to it.[32] Thus, if it is a requirement of a satisfying account of the aesthetic experience of art that it have some connection to the aesthetic experience of nature, then the content-oriented approach can meet this desideratum in that attention to the formal and expressive properties of artworks has strong analogues in the prominently acknowledged varieties of the aesthetic experience of nature.

If it is a virtue of affect-oriented, epistemic, and axiological approaches to the aesthetic experience of art that they can also say something comparable about the aesthetic experience of nature, then this too is a virtue of the content-oriented approach.

6. SUMMARY AND CONCLUSION

The affect-oriented, epistemic, axiological, and content-oriented approaches appear to offer our most promising accounts of aesthetic experience. In favor of the affect-oriented approach, it is indisputable that many aesthetic experiences of art engender pleasure (or displeasure). However, the experiential qualia of aesthetic experiences are quite diverse, too diverse in fact to be assimilated to a single formulaic, phenomenological characterization, such as pleasure, and, in fact, to make matters worse, some aesthetic experiences may have no accompanying affect, feeling tone, or quality.

Likewise, aesthetic experiences may or may not issue in any evaluation of their own worth, including taking it to be something that is valuable for its own sake. For example, I note that a poem has a unifying A/B/A/B rhyme scheme, but this does not lead me or other appropriately informed readers to find it valuable, either intrinsically or instrumentally. Nor, in such a case, need one assess such an experience negatively. I may regard some aesthetic experiences indifferently, as neither good nor bad, intrinsically or instrumentally, just as I may be indifferent affectively to such an experience.

Finally, *pace* the epistemic account of aesthetic experience, I may have a response to the form of certain artworks—such as some examples of conceptual art—without directly encountering the work in question. Thus the distinctive claim of epistemic accounts—that direct acquaintance with the relevant stimulus is a necessary condition of aesthetic experience—is false.

Therefore, insofar as the content-oriented account of the aesthetic experience of artworks shares none of these liabilities with its competitors, has no evident liabilities of its own, and even possesses certain strengths, notably in terms of its informativeness, the content-oriented account is at present our best bet—the odds-on favorite in this particular horse race.

[32] Carroll (2001c).

REFERENCES AND FURTHER READING

Ammons, A. R. 1997. *Brink Road: Poems.* New York: W.W. Norton.
Anderson, J. C. 2000. "Aesthetic Concepts of Art," in N. Carroll, ed., *Theories of Art Today.* Madison, WI: University of Wisconsin Press, pp. 65–92.
Aquinas, T. 1945. *Basic Writings of St. Thomas Aquinas,* ed. A. C. Pegis. New York: Random House.
Carlson, A. 2000. *Aesthetics and the Environment: The Appreciation of Nature.* London: Routledge.
Carroll, N. 1999. *Philosophy of Art: A Contemporary Introduction.* London: Routledge.
—— 2000. "Art and the Domain of the Aesthetic." *British Journal of Aesthetics,* 40/2: 191–208.
—— 2001a. "Enjoyment, Indifference, and Aesthetic Experience." *British Journal of Aesthetics,* 41/1: 81–3.
—— 2001b. "Emotion, Appreciation, and Nature," in N. Carroll, *Beyond Aesthetics.* New York: Cambridge University Press, pp. 384–94.
—— 2001c. "On Being Moved by Nature," in N. Carroll, *Beyond Aesthetics.* New York: Cambridge University Press, pp. 368–84.
—— 2001d. "Beauty and the Genealogy of Art Theory," in N. Carroll, *Beyond Aesthetics.* New York: Cambridge University Press, pp. 20–41.
—— 2001e. "Four Concepts of Aesthetic Experience," in N. Carroll, *Beyond Aesthetics.* New York: Cambridge University Press, pp. 41–62.
—— 2002. "Aesthetic Experience Revisited." *British Journal of Aesthetics,* 42/2: 145–68.
Chatwin, B. 1987. *The Songlines.* New York: Viking.
Csikszentmihalyi, M. 1975. *Beyond Boredom and Anxiety.* San Francisco, CA: Jossey-Bass.
Dickie, G. 1964. "The Myth of the Aesthetic Attitude." *American Philosophical Quarterly,* 1: 56–65.
—— 1965. "Beardsley's Phantom Aesthetic Experience." *Journal of Philosophy,* 62: 129–36.
—— 1973. "Psychical Distance: In a Fog at Sea." *British Journal of Aesthetics,* 13: 17–29.
Dissanayake, E. 1992. *Homo Aestheticus.* Seattle: University of Washington Press.
—— 2000. *Art and Intimacy.* Seattle: University of Washington Press.
Eaton, M. M. 2001. *Merit: Aesthetic and Ethical.* New York: Oxford University Press.
Emerson, R. W. 1936. "Art," in R. W. Emerson, *Essays.* Reading, PA: Spencer Press, pp. 239–50.
Gerow, T. 1997. "Indian Aesthetics: A Philosophical Survey," in E. Deutsch and R. Bontekoe, eds, *A Companion to World Philosophies.* Oxford: Blackwell, pp. 315–25.
Goldberg, S. J. 1997. "Chinese Aesthetics," in E. Deutsch and R. Bontekoe, eds, *A Companion to World Philosophies.* Oxford: Blackwell, pp. 225–36.
Gregor, M. J. 1983. "Baumgarten's Aesthetics." *Review of Metaphysics,* 37: 357–85.
Guyer, P. 1998. "Baumgarten, Alexander Gottlieb," in M. Kelly, ed., *Encyclopedia of Aesthetics,* vol. I. Oxford: Oxford University Press, pp. 227–8.
Iseminger, G. 1981. "Aesthetic Appreciation." *Journal of Aesthetics and Art Criticism,* 39: 389–97.
—— 1999. "The Aesthetic Function of Art," in K. L. Stoehr, ed., *Proceedings of the Twentieth World Congress of Philosophy,* Vol. 4, *Philosophies of Religion, Art, and Creativity.* Bowling Green, OH: Philosophy Documentation Center, pp. 169–76.

Iseminger, G. 2003. "Aesthetic Experience," in J. Levinson, ed., *The Oxford Handbook of Aesthetics*. Oxford: Oxford University Press, pp. 99–116.

——2004. *The Aesthetic Function of Art*. Ithaca, NY, and London: Cornell University Press.

Kant, I. [1798] 1978. *Anthropology from a Pragmatic Point of View*, transl. V. L. Dowell. Carbondale, IL: University of Illinois Press.

Korsgaard, C. M. 1983. "Two Distinctions in Goodness." *Philosophical Review*, 92: 165–6.

Kripke, S. 1970. *Naming and Necessity*. Oxford: Blackwell.

Kristeller, P. O. [1951] 1980. "The Modern System of the Arts," in P. O. Kristeller, *Renaissance Thought and the Arts*. Princeton, NJ: Princeton University Press, pp. 163–227.

Levinson, J. 2001. "Aesthetic Properties, Evaluative Force, and Differences in Sensibility," in E. Brady and J. Levinson, eds, *Aesthetic Concepts: Essays After Sibley*. Oxford: Oxford University Press, pp. 61–80.

Livingston, P. 2003. "On an Apparent Truism in Aesthetics." *British Journal of Aesthetics* 43/3: 60–278.

Meskin, A. 2001. "Review of *Theories of Art Today*," ed. Noël Carroll. *Journal of Aesthetics and Art Criticism*, 59: 219–20.

Miller, R. 1998. "Three Versions of Objectivity: Aesthetic, Moral and Scientific," in J. Levinson, ed., *Aesthetics and Ethics*. Cambridge: Cambridge University Press, pp. 26–58.

Mithen, S. 1996. *The Prehistory of the Mind: The Cognitive Origins of Art and Science*. London: Thames and Hudson.

Nasr, H. S. 1997. "Islamic Aesthetics," in E. Deutsch and R. Bontekoe, eds, *A Companion to World Philosophies*. Oxford: Blackwell, pp. 448–59.

Panksepp, J. 1985. "Mood Changes," in P. Vinken, C. Bruyn, and H. Klawans, eds, *Handbook of Clinical Neurology*, 1/45: 271–85. Amsterdam: Elsevier.

Sober, E. 2002. "Intelligent Design and Probability Reasoning." *International Journal for the Philosophy of Religion*, 52: 65–80.

Stecker, R. 2001. "Only Jerome: A Reply to Noël Carroll." *British Journal of Aesthetics*, 41: 76–80.

Tooby, J., and Cosmides, L. 2001. "Does Beauty Build Adapted Minds? Toward an Evolutionary Theory of Aesthetics, Fiction and the Arts." *Substance*, 30 (1 and 2): 6–27.

6

Non-Perceptual Aesthetic Properties: Comments for James Shelley

1. INTRODUCTION

In his excellent and important article "The Problem of Non-Perceptual Art,"[1] James Shelley advances the discussion of the relation of art and aesthetic properties by probing the question of whether certain kinds of art—notably the sort of conceptual art often referred to as anti-aesthetic—truly lack aesthetic properties. This view is often supported by presupposing that aesthetic properties necessarily depend on properties perceived by the five senses. But many conceptual works do not require being perceived in order to be understood and processed appropriately; indeed, this may even be an essential feature of the design of the work in question. As a result, some aesthetic theorists of art, such as Monroe Beardsley, deny that conceptual works of this type are art. Instead, Shelley rejects the assumption that aesthetic properties must be perceptual, thereby opening up the possibility that the disputed conceptual works may possess aesthetic properties, and, therefore, be assimilated under an aesthetic conception of art.

Throughout much of his essay, Shelley treats me as a foil to his position. And though this is apposite on several counts, our disagreements are not as stark as it might appear.[2] For in a forthcoming essay, I too argue, although by a different route than Shelley's, that aesthetic properties are not necessarily such that in

[1] James Shelley, "The Problem of Non-Perceptual Art," *British Journal of Aesthetics*, 43/3 (October 2003): 363–78.

[2] Shelley regards me as an opponent to his position because in the past I have often deployed examples of conceptual art of the anti-aesthetic variety as counterexamples to aesthetic theories of art. And I do not deny that I have done so. However, I have in large measure taken this tack in response to aesthetic theorists, such as Monroe Beardsley and Marcia Eaton, who have argued against the art status of the relevant conceptual works on aesthetic grounds, *and* I have regarded them, especially for dialectical purposes, to be authoritative concerning the extension of their own theories. But recently—even before reading Shelley's fine article—I had come to be convinced that the pertinent conceptual works could possess aesthetic properties, notably formal properties, and that they could, in consequence, support aesthetic experiences. I raise this prospect explicitly in a forthcoming article in the process of challenging what Gary Iseminger calls epistemic accounts of aesthetic experience. Thus, at this point in time, Professor Shelley and I agree that many of the usual suspects—when it comes to conceptual though not necessarily perceptual art—may possess aesthetic properties. Nevertheless, Professor Shelley and I still part company on the issue of whether

order to engage them properly one must have a "close encounter of the third kind" with the objects that possess them.[3] That is, we can traffic with aesthetic properties without perceiving them, so to speak, face to face; aesthetic properties need not be directly perceptual. However, despite my agreement with Shelley that some aesthetic properties may not be perceptual, I do not believe that this shows that art is "essentially aesthetic"—at least as that phrase is typically parsed by aesthetic theorists of art.

In what follows, I will present my argument for thinking that aesthetic properties need not be perceptual and then I will compare my approach with Shelley's. Next I will try to show that neither of our views entails anything like the aesthetic theory of art. And lastly I will conclude by addressing the differences between my interpretation of Francis Hutcheson and Shelley's.

2. AESTHETIC PROPERTIES ARE NOT NECESSARILY PERCEPTUAL

2.1. The Argument from Form

Elsewhere I have argued that an experience of an artwork is aesthetic, if it involves attention to the form of the work or to its expressive or other aesthetic properties. I call this the content-oriented approach to aesthetic experience.[4] It contrasts with a number of other views, including the epistemic account of aesthetic experience.[5] According to the epistemic account, an experience of an artwork is aesthetic only if it involves coming to know its object directly; to encounter an object aesthetically is to perceive it—to hear it or to see it—or, if it is a work of literature, one must nevertheless inspect it directly. You cannot have an aesthetic experience on the basis of a report about the object by some second party.[6] You must perceive the relevant properties—including the

art is essentially aesthetic. Below, I attempt to sift through our agreements and disagreements as they currently stand.

[3] Noël Carroll, "Aesthetic Experience: A Question of Content," in *Contemporary Debates in Aesthetics*, edited by Matthew Kieran (Oxford: Blackwell, forthcoming). Unfortunately, this article was completed prior to the publication of Shelley's, thereby making it impossible to take account in it of Shelley's observations.

[4] See Noël Carroll, "Art and the Domain of the Aesthetic," *British Journal of Aesthetics*, 40/2 (October, 2000): 191–208; "Aesthetic Experience Revisited," *British Journal of Aesthetics*, 42/2 (2002): 145–68; "Four Concepts of Aesthetic Experience," in my *Beyond Aesthetics* (Cambridge: Cambridge University Press, 2001), pp. 41–62.

[5] The epistemic account to aesthetic experience is sketched by Gary Iseminger in his "Aesthetic Experience," *Oxford Handbook of Aesthetics*, edited by Jerrold Levinson (Oxford: Oxford University Press, 2003), pp. 99–116.

[6] Paisley Livingston calls this the "apparent truism"—the view that aesthetic judgment requires a close encounter of the third kind with the pertinent artwork. He attempts to replace it with a more defensible successor notion. However, I think that using the argument from form with examples from the realm of conceptual art will undermine the successor that Livingston proposes to the

aesthetic properties—directly. The epistemic view, in other words, presupposes that the aesthetic properties of an artwork and/or the base properties upon which they supervene must be directly perceptual ones.

I have challenged the epistemic view of aesthetic experience by considering the case of conceptual art where, I argue, one can experience the formal properties of works such as John Cage's *4'33"* on the basis of a reliable report without ever encountering—and, therefore, without perceiving—them directly.

This argument depends on a certain conception of the form of the artwork—what I call the functional account. On my view, the artistic form of the artwork is the ensemble of choices intended to realize the point or purpose of the artwork.[7] With respect to *4'33"*, the form of the work crucially involves the choice of notational silence—the pianist enters, opens the score, and does nothing, thereby virtually compelling the audience to attend to whatever ambient sounds occur in the ensuing interval of four minutes and thirty-three seconds. The point of the work—Cage's great project, one might say—is to deconstruct the privileged position of *music* in the music/noise couplet and to alert the listener to the aural richness that surrounds her at any given moment.

But one can grasp the point of *4'33"* without ever attending a performance of it; one can understand its design—how it is intended to work in order to fulfill its purpose—without hearing anything. That is, one can divine the form of the work or a significant part of it—its use of silence as a framing device, for example—*and* the concept it subserves from a reliable description of the piece. When I attended *4'33"*, I may have heard a cement mixer churning on the sidewalk outside; perhaps you encountered the work in a pastoral setting with birds chirping. Whatever we heard is not indispensable to isolating the structure of the work; the structure of the work can be understood and the suitability of its design to its point or purpose can be discerned without one being directly acquainted with the piece. A description is enough to set the wheels turning for the informed connoisseur of the avant-garde who can, by dwelling on the concept of the piece, recognize the way in which Cage's choices in the presentation of *4'33"* have been contrived in order to herald the utopian theme of the dissolution of the boundary between art and life.

"apparent truism." See Paisley Livingston, "On An Apparent Truism in Aesthetics," *British Journal of Aesthetics*, 43/3 (2003): 260–78.

Similarly, Malcolm Budd has recently attacked what he calls the "acquaintance principle," arguing, successfully I think, that knowledge of an artwork's aesthetic properties *can* be transmitted by a reliable description received second hand. Budd goes on to maintain, however, that an appreciation and its associated attitudes toward the aesthetic properties of a work of art cannot be derived from someone else's description of the piece. Nevertheless, if the argument from form with respect to conceptual artworks that is articulated in the section above is correct, there is no reason to imagine that we could not develop a thoroughly informed appreciation and even an admiring attitude toward the formal properties of some conceptual artworks. See Malcolm Budd, "The Acquaintance Principle," *British Journal of Aesthetics*, 43/4 (October, 2003): 386–92.

[7] Noël Carroll, *The Philosophy of Art: A Contemporary Introduction* (London: Routledge, 1999), p. 143.

It may seem perverse, given Cage's avowed commitments to deepening our aural experience of the world, to cite one of his works as an example of possessing various aesthetic properties that need not be directly perceived. But, be that as it may, avant-garde works like Cage's have a structure of rhetorical address whose intended operation can be apprehended from, so to say, afar. One can understand how something like 4'33'' has been designed to put its audience through certain predictable paces—one can see the way in which the work is supposed to work—and even perhaps admire the ingenuity of the structure without sitting through a live or recorded performance of it.[8]

Cage's piece has been widely discussed by artists, musicians, composers, philosophers, critics, historians, and innumerable members of the lay audience who are conversant with postmodern art. But I wonder whether all those who speak of it have heard a performance of it. Of course, that they talk about it shows nothing. Yet, I speculate that quite often commentators who have not directly encountered 4'33'' have nevertheless made insightful remarks about its structure and/or its implications or, at least, they have thought those "remarks" to themselves when they have read about it second hand. That is, they have "gotten it," but without hearing it directly. They have had an aesthetic experience of it because they have had it reliably described in sufficient detail to contemplate its *form*—to comprehend the way in which the elements that comprise it suit (indeed facilitate) the purpose of the whole.

Everyone would appear to agree that the formal properties of a work of art belong among its aesthetic properties. The formal properties of an artwork are the ensemble of choices that realize the point or purpose of the work. Works of conceptual art can have formal properties. One can grasp the ways in which the formal properties of a work of conceptual art realize its point or purpose without experiencing them directly, but on the basis of a reliable description of them. Therefore, some aesthetic properties of artworks—notably the formal properties of conceptual artworks—can be non-perceptual. Or, as Shelley might prefer to put it: conceptual artworks can have non-perceptual aesthetic properties. On the present argument, this is possible because formal properties are aesthetic properties which need not be perceptual, and conceptual artworks may possess them.[9]

[8] Here, I hasten to add that I do not require admiring the formal properties at hand as a necessary condition for the experience in question to be an aesthetic one. On my view, this experience will be aesthetic only if attention with understanding is directed at the relevant formal properties.

[9] The argument from form may be extended beyond merely works of conceptual art. Perhaps one can apprehend the basic structures of dramatic conflict in a moving picture from a reliable description of it rather than from a perceptual encounter with it. Yet, arguably, one is still having an aesthetic experience. Likewise, one might grasp the dramatic structure of a work of literature from a reliable description; this would indicate that it need not be a perceptual property of the work. In these cases, it might be said that these are not examples of *complete* aesthetic experiences. But this proposal faces at least two hurdles: first, the challenge of saying what a complete aesthetic experience would be; and, second, the recurring suggestion that no genuine aesthetic experience can ever be exhaustive.

One of the central motivations behind much conceptual art is that even if it exists as a performance or as a specific object, it is primarily as a concept that it is to be approached; one may cogitate about the design of such objects—their point, their subtending rhetorical construction, and the interrelation of the two—without being in their presence. Photographs, other forms of documentation, and, in the most pertinent cases for our purposes, reliable descriptions suffice. Not infrequently, this is the only available access to such works. In many instances, this very feature of the conceptual artwork is of great significance, since these works are putatively intended to subvert the alleged commodity fetishism of the artworld. That their formal structures can be adequately conveyed by means of reliable descriptions—that is to say non-perceptually—is, of course, itself part of the way in which these artworks have been designed to realize their anti-commodity, anti-gallery, anti-art market animus. So there are artworks that need not be perceived by means of the five senses, which nevertheless possess aesthetic properties—formal properties whose contemplation serves as the targets of aesthetic experiences. And for some of these artworks the fact that they cannot be perceived by the five senses is the most important design feature (or formal property) they possess.

2.2. The Argument from Sensation

The preceding represents my account of how it is possible for conceptual artworks to possess non-perceptual aesthetic properties. James Shelley has another line of attack, though it should be stressed that both these approaches can be, and probably are, true. Shelley notes that a number of conceptual pieces, like Duchamp's readymades, lack the sort of readily perceptible aesthetic properties that paintings customarily exhibit, but nevertheless have what would appear to be aesthetic properties like wit and humor. One might not literally see humor when one looks at *Fountain*; it may not be detectable by sight. But it is *felt*. One is *struck* by the cleverness of the piece. It is a satiric gesture. If this is not something detected directly by our outer senses, its risibility is something that triggers an "inner sense," the sense of humor. Thus, if we take aesthetic properties to encompass not simply properties dependent on the operation of the five senses, but also those that are merely felt—that are registered in sensation sans percepts—then we have no reason to deny that conceptual pieces may possess aesthetic properties. Moreover, as Shelley's discussion of Sibley indicates, there are grounds to believe that some of the leading commentators on aesthetic properties have thought of them in terms of an intimate relation with feeling broadly construed, rather than only as associated with perception narrowly conceived as a product of the five senses. So the humor of *Fountain* may strike us palpably—might even elicit a laugh—though we need not have seen the work or even a photograph thereof.[10] Being told about it may be sufficient to

[10] As a biographical aside, I think that it might be interesting to mention that, when the late Monroe Beardsley informed me that he did not recognize *Fountain* as an artwork due to its lack

provoke a smile. As long as the wit is connected to some inner sensation, it should have a claim to being an aesthetic property, an object of sensitive (as Baumgarten might put it) apprehension. Thus, a conceptual piece like *Fountain* may be said to possess aesthetic properties—properties intimately connected with feeling—even though they need not be literally perceived by one of the five senses.

Of course, Shelley does not claim that the only relevant, not necessarily perceptual, feeling with respect to such works is amusement; he also suggests that we might merely be struck or excited by the properties in question. These sensations are enough. That is, the relevant properties are non-perceptual but they are not divorced from sensation; they are linked to our feelings of being excited or of being struck by them. Perhaps we are struck or excited by the elegance and ingenuity of the design of Cage's *4′33″*. We do not have to hear the work to be moved thusly; nevertheless, in being so moved, the connection with feeling marks the property as aesthetic. Moreover, there is no reason to suppose that we cannot be moved by conceptual pieces conducted in remote locales for which our only sources of access are reliable reports. So, once again, it appears that there may be works of art, notably conceptual works, that have aesthetic properties that are non-perceptual.

As far as I can see, there is no pressure to opt for the argument from form over the argument from sensation. Some examples can be adduced in favor of each. Maybe some examples involve a combination of the two approaches—as when someone is awestruck by the non-perceptually accessed form of a conceptual piece. Both arguments head toward the same conclusion. Artworks may have non-perceptual aesthetic properties. In that regard, both arguments establish that a great deal of what has been called anti-aesthetic art might have been more accurately called "anti-*perceptually* aesthetic art." To that extent, the arguments are not rivals.

But perhaps Shelley might contest this. He might argue that an experience of the formal design of a conceptual artwork is not a genuine aesthetic experience unless it is accompanied by some sensation, say excitement, and/or that such

of aesthetic properties, I pressed him about the obvious humor of the piece—a feature of *Fountain* that I have frequently alluded to in my writings. Beardsley remained unmoved, though I was never sure why. Perhaps he did not count being amusing as an aesthetic property. But, in any event, given Beardsley's status as one of the leading aesthetic theorists of art, I have not previously been completely confident that claiming humor as an aesthetic attribute of *Fountain* and comparable works is fair game. However, Shelley has persuaded me otherwise.

In footnote 16 of his article, Shelley suggests that I am inconsistent in maintaining that *Fountain* is an example of anti-aesthetic art, whereas I say that Duchamp's *In Advance of a Broken Arm* and *Paris Air* possess comic aesthetic properties. This apparent inconsistency appears in my book *Philosophy of Art*, especially page 181. Unfortunately, my remarks about *Fountain* have been taken out of context. *Fountain* is used as a counterexample to what I call the ordinary sense of aesthetic experience (p. 180), which in the same paragraph is associated with perceptibility. It is perfectly compatible to regard *Fountain* as a counterexample to that view, while agreeing that it engenders sensations of amusement separate from perception in the same manner that the other cited works by Duchamp do. Isn't that what Shelley himself is claiming? I see no inconsistency here.

allegedly formal properties are not truly aesthetic unless they elicit some sensation. That is, some quanta of sensation as a requisite response to it is a necessary condition for something to count as an aesthetic property. Or, in other words, when push comes to shove, only the argument from sensation is decisive.

Should Shelley have this move in mind, I think that it is ill-advised. There are conceptual works—such as those by Joseph Kosuth and other Language Artists—that neither invite nor elicit any palpitations or sensations (not even a snicker), but instead encourage the *dispassionate* contemplation of their design concepts. Moreover, in such cases, that the contemplation of the form of the work be dispassionate in a way that precludes the sorts of feelings Shelley underscores is often essential to the point of the works in question. But surely one cannot deny that the properties at issue here are aesthetic properties, since, from all sides, formal properties have perennially been regarded to be paradigmatic aesthetic properties. Thus, I think that Shelley should agree that conceptual artworks may possess non-perceptual aesthetic properties because they possess non-perceptual formal properties, or properties that elicit other than perceptual sensations, or combinations of the two.[11]

[11] Another problematic move that Shelley may be tempted to make would be to require that not only is a connection to sensation a necessary condition for being an aesthetic property but, even more radically, to require that the pertinent sensations be positively charged ones. Shelley's examples of the non-perceptual feelings that may come into play when encountering aesthetic properties include excitement, pleasure, and, of course, amusement. Does Shelley hold that the non-perceptual feelings that the aesthetic properties of conceptual artworks engender must be of the order of attractions rather than aversions, of being inclinations toward rather than against? If that is what Shelley intends, it seems to be a mis-step for several reasons.

First, if we are considering responses to the formal properties of conceptual artworks, there will be those, as mentioned above, that mandate a dispassionate response, not a passionate one (whether positive or negative). Yet formal properties are aesthetic properties and attending to them with understanding is an aesthetic experience.

Second, by correlating aesthetic properties with positive responses, it would appear that aesthetic defects are no longer aesthetic properties. But surely the sloppy asymmetries in a work that aspires to geometric clarity (and that is *displeasing* precisely for its failure to do so) are aesthetic properties? Whatever else would these blemishes be? And an experience of said properties, however unpleasant, would be an aesthetic experience. What else would it be? Indeed, some inept art—such as the preceding example—may leave us indifferent rather than upset. But, though there be no affect at all in such a case, the sloppy asymmetries are still aesthetic properties.

Of course, cases involving bad art also remind us of the danger of turning our concept of aesthetic properties into a category of positive commendation. For, if such a value-laden concept of the aesthetic is inserted into an aesthetic theory of art, then bad art, it would appear, becomes impossible by definition.

Needless to say, I am not certain that Shelley means to turn the notion of the aesthetic into a generically laudatory one by associating it exclusively with positive affective responses. He does appear to advert only to felicitously charged non-perceptual feelings in his argument from sensation. And he tends to use the idea of appreciation in a way that connotes *liking* rather than merely sizing-up. But, on the other hand, I may be reading too much into this.

In a related vein, Shelley suggests that my approach suggests a spectator who contemplates artworks but who is not excited by them. Instead, I would claim that my approach allows for the case where spectators are excited, but also for cases where they respond dispassionately, indifferently, and even unhappily. This seems to me a more comprehensive canvassing of our aesthetic responses than one that might, by definition, limit aesthetic responses to only those charged with positive affect and aesthetic properties to only those that support such responses.

But, even if agreement prevails this far, there still remains a question concerning the ramifications of this finding for the aesthetic theory of art. If conceptual artworks are no longer denied aesthetic status—and are no longer invoked as counterexamples to the theory—has it been reanimated?

3. IS ART ESSENTIALLY AESTHETIC?

The view that art is necessarily aesthetic is often challenged by the existence of conceptual artworks that are said to lack aesthetic properties, which lack, in turn, entails that they are incapable of supporting aesthetic experiences. Shelley has observed that this argument depends on presupposing that aesthetic properties must be susceptible to perception in terms of the five senses. But this view of aesthetic properties is too limited, as should be obvious from the case of literature. Shelley's argument from sensation gives a better sense of the range of aesthetic properties, as does, I would add, my argument from form. Both suggest that conceptual artworks can have aesthetic properties and support aesthetic experiences. That would appear to remove a whole, rather sizeable family of counterexamples from the brief against the view that art is essentially aesthetic. Do the argument from sensation and the argument from form put the aesthetic theory of art back in business? That is really what is at stake in the question of whether artworks, especially conceptual ones, can have non-perceptual aesthetic properties.

If what is meant by the claim that art is essentially or necessarily aesthetic is that something is an artwork only if it has aesthetic properties—allowing, of course, that these may be non-perceptual ones—then I think the answer must be no. For there may be artworks that are formless—artworks whose ensemble of choices fails to realize their points or purposes (and any other points or purposes, for that matter)—and there may be artworks that fail to strike us in any way, that leave us indifferent when it comes to feeling.[12] The argument from form is no help when it comes to formless artworks; the argument from sensation is useless with respect to the art that leaves us unmoved. Both sorts of art, however, are widely available. They are what we call *bad* art; but it is important to remember that bad art is still *art*. Even if Shelley has shown that much conceptual art is not a threat to the aesthetic conception of art, the aesthetic approach still seems ill-suited for dealing with bad art.

At this juncture, it may be suggested that this particular problem may be handled easily by amending the theory to read: something is an artwork only if it is intended to focus attention upon its aesthetic properties. In this version, bad works of art are intended to support attention to various aesthetic properties, but fail to deliver them. Yet this rewriting has its own problems. For it seems

[12] For further argument, see my "Enjoyment, Indifference, and Aesthetic Experience," *British Journal of Aesthetics*, 41/1 (2001): 81–3.

as though there are things that we standardly regard as artworks that are not presented with the intention to support attention to their aesthetic properties. Though Mel Gibson's *The Passion of the Christ* has a form, it hardly seems likely that it is intended to focus attention on its formal design. Of course, with this example, one might concede that it is not intended to encourage attention to its formal design, but to other of its aesthetic properties, such as the brutality of the world it portrays so expressively.

Yet I suspect there are some artworks of which it would be strained to suggest they are intended to focus or to support attention to their aesthetic properties—whether those properties be formal, expressive, or gestalt-like features. I have in mind the kinds of tribal artifacts that we classify as representational art, which are not intended to invite contemplation of their aesthetic properties but rather to frighten off onlookers and enemy warriors. Of such works, the aesthetic theorist of art may contend that they are not at the moment of their creation artworks, for they are not made to invite the requisite sort of attention but only become artworks later when we use them as opportunities to explore their inadvertent aesthetic properties. It is only then, it might be said, that they are being appreciated *as artworks*. However, the phrase "as artworks" here sounds suspiciously legislative; surely a statue of a demon, even if it is intended to send you running instead of to start you contemplating, is an artwork in any descriptive sense of the term.

Thus, though I concur with Shelley that conceptual art—especially conceptual art of the defiantly anti-perceptual sort—may possess aesthetic properties and support aesthetic experience, appropriately understood, I do not believe that this significant finding lends credence to the persuasion that art is essentially or necessarily aesthetic. For one will still have to show that all artworks are designed with the primary intention of focusing attention upon their aesthetic properties. And this seems to me, for historical and anthropological reasons, to remain implausible.

4. INTERPRETING HUTCHESON

Shelley rejects my claim that in Article XII of Section I of his *Inquiry Concerning Beauty, Order, Harmony, Design*, Francis Hutcheson brackets knowledge as a source of the kind of pleasure that he associates with the experience of beauty.[13] There Hutcheson says: "we are struck at the first with the Beauty: nor does the most accurate Knowledge increase this pleasure of Beauty, however it may superadd a distinct rational Pleasure from Prospects of Advantage or may bring along that peculiar kind of Pleasure which attends the Increase of Knowledge." I take this to signal that deriving knowledge from the object in question, though pleasurable (that peculiar kind of Pleasure), does not enhance the sort of pleasure

[13] Noël Carroll, "Beauty and the Genealogy of Art Theory," *Beyond Aesthetics*, pp. 20–40.

that Hutcheson connects with beauty. Hutcheson's distinction here is historically important because it represents a separation between aesthetic experience and cognition (understood as the acquisition of knowledge/truths).

Shelley feels I have overstated the case here since Hutcheson thinks of theorems and universal truths as things of beauty (Section III). But it is not clear to me that Hutcheson counts these as things of beauty because they impart knowledge, which is the issue under dispute. Rather, I think that for Hutcheson, inasmuch as we already know the truth of these theorems, we are then able to take pleasure in our apprehension of the way in which they unify a vast amount of data—as, for example, a Euclidean theorem applies to an infinite number of triangles of a certain sort. Knowledge is not a source of aesthetic pleasure, but a condition for its occurrence in the case of theorems, axioms, physical laws, metaphysical truths, and so forth. I believe that just as Hutcheson's friend David Hume thought that the operation of good sense was requisite for the operation of taste without being part of the relevant experience of beauty reception, so Hutcheson thinks that the cognitive possession of knowledge is not what yields the pertinent species of pleasure, though we may need that kind of knowledge in order to enjoy things like theorems. Knowledge is a precondition rather than an occasion of beauty. Furthermore, this distinction, so different from the way in which the Greeks saw things, stands at the beginning of the tradition that comes to regard the acquisition of knowledge as not germane to the proper experience of art where art is characterized in terms of the aesthetic theory of art.[14]

[14] I am not sure that I completely understand what larger issues hang on the difference between Shelley and me on the interpretation of Hutcheson. If Shelley wants to block my interpretation of Hutcheson because he fears that I will try to use it to say that the argument from sensation imposes a conception of the aesthetic that is not grounded in the history of that concept, he need not worry. I think that his invocation of non-perceptual sensations has a long lineage. As Hegel says at the outset of his *Introductory Lectures On Aesthetics* (New York: Penguin Press, 1993, transl. Bernard Bosanquet; orig. 1886): "'Aesthetic' means more precisely the science of sensation or feeling." At the same time, I think that the notion of formal properties that I exploit in this chapter is equally well-entrenched in the tradition. On the basis of the historical usage of the idea of aesthetic properties, both conceptions are available to us. We need not choose one over the other.

7

Aesthetic Experience, Art, and Artists

1. INTRODUCTION

This chapter examines the dominant characterization of aesthetic experience among anglophone philosophers for the purpose of replacing it. To that end, I will begin by speculating about why the standard concept of aesthetic experience came to play and continues to play such an important role for the philosophy of art. Next I shall argue that function is by now obsolete. Indeed, perhaps the standard characterization of aesthetic experience never really was as effective in discharging that function as its defenders imagined. I will also attempt to reveal other inadequacies of the dominant concept of aesthetic experience, especially in terms of the ways in which it appears to exclude certain kinds of artistic creativity from its domain, while, at the same time, I shall introduce an alternative conception of aesthetic experience which I call the *content-oriented* approach.

2. ON THE EMERGENCE OF THE STANDARD CONCEPT OF AESTHETIC EXPERIENCE

The dominant notion of aesthetic experience with respect to art, as it is generally articulated in the Western tradition, comes to the fore and begins to be consolidated in the eighteenth century.[1] It evolves from, among other things, Francis Hutcheson's characterization of the experience of beauty and Immanuel Kant's analysis of the aesthetic judgment. In both authors, the requirement of *disinterested pleasure* is paramount, though, since not all aesthetic experiences are *pleasurable*, in the usual sense of that word, this condition has been subsequently sometimes modified to the more minimal condition that aesthetic experiences are valued for their own sake.

The preceding conjecture is not intended to imply that elements or, even arguably, versions of what might be called "aesthetic experience" were not available in the tradition prior to the eighteenth century. Rather, my point is that until somewhere between the mid-points of the eighteenth and nineteenth

[1] Henceforth, throughout this chapter, unless explicitly alerted otherwise, the reader should presume that I am always talking about aesthetic experience in relation to artworks.

centuries, aesthetic experience, parsed as pleasure, was not taken to be the end all of the arts, nor was it given anything like the significance with which it came to be invested by modern philosophers of art.

In the *Hippias Major*, Socrates entertains, but ultimately rejects, an account of *kalon* (the beautiful, the fine, or the excellent) that sounds like a partial forerunner to the dominant characterization of aesthetic experience in the Western tradition; he correlates the beautiful to that which pleases or delights by means of sights and sounds. This conception of an experience that is defined by its relations to the senses (seeing and hearing) and sensation (pleasure, delight) undoubtedly reverberates in Baumgarten's eighteenth-century neologism "aesthetics." But this conception is not finally an idea that Plato shares with Baumgarten, since Plato goes on to criticize it soon after he introduces it into the dialogue.

The definition of beauty that Socrates embraces, though not without obvious unease, in the *Hippias Major* is that *kalon* is connected to beneficial pleasure. Indeed, in Book X of his *Republic*, Plato demands of the friends of poetry that they demonstrate that poetry affords beneficial pleasure, if poets are to be allowed re-entry into the ideal *polis*. Undoubtedly, the correlation between poetry and pleasure here influences the characterization of aesthetic experience that is assembled in the modern period. However, Plato is not endorsing anything like the modern view, since he is talking about *beneficial* pleasure—pleasure tied to interests—and not disinterested pleasure. Of course, he is not denying that such pleasure is to be had; rather, he does not value it very highly. In fact, he distrusts it.

In his *Poetics*, Aristotle indicates that there are two kinds of pleasures with respect to the pertinent arts. There is the pleasure to be accessed from imitation, which is cognitive in nature, and, therefore, beneficial or interested (thereby meeting Plato's challenge to the lovers of poetry). But there is also a second sort, which, though unlabeled, appears to be connected to formal features like color, melody, and rhythm.[2] Yet Aristotle scarcely bothers to examine this kind of pleasure. So, though Aristotle may acknowledge the existence of something like a predecessor-notion of aesthetic experience, or, at least, a part of one, he does not appear to accord it much importance.

It is not until the eighteenth century that the dominant characterization of aesthetic experience begins to become focal. As already noted, it was in the eighteenth century that Baumgarten coined the category of *aesthetics*, by which he intends sensitive or sensuous knowledge—that is, knowledge that comes by way of outer senses (such as sight and hearing) and/or by way of the inner sense of imagination (which responds to things like descriptive poetry by producing mental images). Although Baumgarten introduced "aesthetics" for the purposes of epistemology in general—where, in the terminology of Descartes and Leibniz, it exemplifies the category of clear but indistinct ideas—so many

[2] Of course, it remains unclear in the text whether these pleasures are tied to benefits, since Aristotle may hold that the pleasures these features instill are in the service of abetting or, at least, reinforcing the kinds of cognitive engagement he believes to be central to the imitative arts.

of Baumgarten's examples derived from poetry that the notion of aesthetics came to be closely associated with the address that artworks make upon the senses. In this regard, aesthetic experience became connected in philosophical thinking with the pleasurable sensations imparted by artworks and other beautiful things, such as landscapes and clothing, as they thrill and caress the senses.

Though explored under the rubric of "aesthetics" in Germany, similar preoccupations surfaced in the British Isles under the heading of "taste," and in France under the sobriquet of *le gôute*, a faculty whose activation engendered a virtually ineffable sensation of pleasure describable only vaguely as *je ne sais quoi* ("I know not what").[3]

In Britain, the very influential idea, popularized by Shaftesbury and Hutcheson, evolved that beauty itself was precisely an experience of disinterested pleasure excited, according to Hutcheson, by the stimulation of unity amidst diversity in a seventh and inner sense called taste. This thought, with modification, then found its way into Kant's theory of aesthetic judgments of free beauty, which locates said judgments in feelings of a certain species of subjective pleasure (namely, the disinterested kind). Perhaps the French too contributed to Kant's formulation of the nature of aesthetic judgment insofar as their notion that such judgments are founded upon an "I-know-not-what" experience appears to correspond to Kant's idea that the experience cannot be subsumed under concepts.

Kant's *Critique of Judgment* has probably had the greatest influence on subsequent formulations of the most popular versions of aesthetic experience. Although Kant's treatise concerned aesthetic judgments rather than aesthetic experiences, it is easy to see how Kant's successors could skip so easily from the former to the latter insofar as, for Kant, the grounds for issuing aesthetic judgments are, in large measure, a matter of having certain kinds of experiences, namely, feelings of disinterested pleasure (which are, of course, otherwise known as aesthetic experiences).

Echoes of Kant's theories can be heard in the works of philosophers as diverse as Arthur Schopenhauer, Clive Bell, and Monroe Beardsley. Though the accounts of aesthetic experience proffered by these theorists are rarely as complicated as Kant's—they are not only less complicated and thinner, but also sometimes diverge in details—they nevertheless typically hold onto, albeit with modifications, the notion of disinterestedness. However, as observed previously, since not all the experiences we wish to count as aesthetic—including, for

[3] It should be noted that for Hutcheson *disinterestedness* amounts to little more than impartiality—that is, the pleasure in question is not a consequence of the pleasing recognition that the object of the stimulus serves one's *personal* interests. But since Hutcheson, like Shaftesbury, thinks that virtue evokes the pertinent kind of pleasure, their versions of disinterestedness are not utterly divorced from serving social, specifically moral, purposes. Kant, as we shall see, will champion a far more encompassing concept of disinterestedness, one that separates the pleasure in question not only from personal, selfish, or egoistic purposes, but from any social, moral, religious, political purposes as well. It is in Kant that disinterestedness and purposelessness come together.

example, the experience of the sublime—are unequivocally pleasurable, it has become common to drop the stipulation that aesthetic experiences are necessarily pleasurable and instead to suggest only that such experiences must be valued for their own sake and not for the sake or purpose of something else (which, needless to say, is another, perhaps more precise way, of saying that these experiences are to be engaged disinterestedly).

Bell's conception of the aesthetic emotion is clearly a descendant of Kant's idea of disinterestedness, since the aesthetic emotion—Bell's name for aesthetic experience—is defined as discontinuous with any other sort of experience, most notably any of the kind that contributes usefully to the life of individuals and/or of society. Bell's aesthetic emotion, however popular and influential the idea was, suffered from being overly threadbare. It turned out to be very hard to put one's finger on it, given that so little that is positively informative is said about it in Bell's account. A somewhat more informative and representative account of aesthetic experience, nevertheless, can be extrapolated from the writings of Jerome Stolnitz.[4]

For Stolnitz, an aesthetic experience is one that is had under the direction of an aesthetic attitude. And an aesthetic attitude, in turn, involves essentially the "disinterested and sympathetic attention to and contemplation of any object of awareness whatever, for its own sake alone." Consequently, an aesthetic experience is a matter of the disinterested and sympathetic attention to and contemplation of an object for its own sake. This view of aesthetic experience, moreover, is probably the one shared, either consciously or subconsciously, by a very large number of philosophers of art.

In what follows, I intend eventually to interrogate its adequacy. Nevertheless, before embarking upon that project, it will be instructive to speculate about why this characterization of aesthetic experience took hold in the first instance. And, furthermore, why does it continue to exercise a grip upon the imaginations of so many philosophers of art? What needs did it serve? What functions does it perform? What is ultimately at stake in the persistent commitment to this conception? Answering these questions may help shed light upon the shape of the notion, as well as upon its tenacity.

I conjecture that the dominant notion of aesthetic experience that has taken hold since the eighteenth century performs two overlapping functions—one intellectual or, perhaps more accurately, philosophical, and the other social. Both these functions, moreover, are related to the consolidation—again in the eighteenth century—of what has come to be called the Modern System of the Arts.[5]

During the eighteenth century, a series of practices—including poetry, painting, sculpture, music, dance, and drama—were collected under the category of

[4] See Jerome Stolnitz, *Aesthetics and the Philosophy of Criticism* (New York: Houghton Mifflin Co., 1960), Ch. 1.
[5] This discussion is based on Paul O. Kristeller, "The Modern System of the Arts," in his *Renaissance Thought and the Arts* (Princeton, NJ: Princeton University Press, 1990), pp. 163–221.

the Beaux Arts, or the Fine Arts, or simply the Arts with a capital "A."[6] These are, along with certain additions (including film and photography), what we refer to as the arts nowadays; they are the practices huddled onto the arts quad on campuses and they are the activities funded by governmental agencies such as the National Endowment for the Arts in the United States. However, though we find it "natural" to group the arts, or rather the *Arts* in this way, it wasn't always so. Instead it is a product of the modern era.

In the classical period, for example, the arts were any practice involving skill. Navigation was an art, as was charioteering. Medicine was an art; it was underwritten by knowledge that was teachable. Some of our Fine Arts were grouped together with other arts (that is, teachable skills), but not always in the way that we would do so today. Music might be grouped together with mathematics rather than poetry, while poetry might go with rhetoric. Painting could even sometimes be classified alongside of chemistry and pharmacology, inasmuch as painters and chemists and apothecaries belonged to guilds that ground things (such as pigments and pills) down. In short, the category of art with a capital "A"— which we presume to be perfectly obvious—is a historical invention.

For example, Aristotle was not a philosopher of *Art* with a capital "A"; he was the philosopher of a particular artform, tragedy, though, of course, he also made some brief asides about painting.[7] There were no philosophers of art with a capital "A" until the eighteenth century, because we did not yet have that category self-consciously in play. In the Renaissance, painting and poetry might be compared, but primarily in order to win for painting the esteem in which poetry was already held. There was not the attempt to assemble all of the practices we call Art under one big tent. Our category appears to have arrived on the scene in the eighteenth century or thereabouts. Though the collection of practices listed in the catalogues of our present-day art schools strikes us as transparent, it is the result of a historical conjuncture.

Perhaps needless to say, once the category of *Art*, or Fine Art, or the Beaux Arts took hold, the pressure—the intellectual or philosophical pressure—arose to say what constituted grounds for membership in this new order of the Muses. A first attempt to answer this question, undoubtedly inspired by Aristotle, was to postulate that representation, especially the representation of the beautiful in nature, was that which gained work entry into the Modern System of the Arts. Thus, in order to win membership in this most elevated company, dancing masters, like Jean-Georges Noverre, called for choreography that *represented* dramas, and the *ballet d'action* was born.

But this proposal could not long withstand a seminal development in the history of music—the rise to ascendancy of pure orchestral or absolute music.

[6] It is interesting to speculate that calling these arts alternatively the Beaux Arts or the Fine Arts might be connected to the ambiguity in the notion of *kalon* discussed earlier, since *kalon* too can be translated alternatively as "beautiful" or "fine," as well as "excellent."

[7] Of course, Aristotle spoke of music and dance briefly too, but he thought of them as primarily accessories to drama.

For, aside from some desperate attempts to claim that such music represented something (birdsongs, thunderstorms, and the like), it appeared wildly implausible to characterize most pure orchestral music as a representation of anything particular. Yet the membership of absolute music in the Modern System of the Arts was hard to gainsay. Indeed, for some in the nineteenth century, such music exhibited a condition toward which every other artform aspired. Thus, philosophically, the need for a new paradigm to replace representation as the criterion for membership in the Modern System became urgent. And that, I hypothesize, is where Western culture's dominant characterization of aesthetic experience enters the picture.

Of course, several alternative paradigms offered themselves. But one of the most enduring and most significant, especially for our purposes, is that artworks, properly so called, are objects and performances designed to afford a certain kind of pleasure—namely, the sort of disinterested pleasure that was emphasized previously.[8] Most often, this sort of pleasure was thought to be derived from attention to the form of the artwork. Thus, this position is sometimes referred to as formalism or aesthetic formalism.

However, this philosophical tendency can be further modified. For reasons expressed earlier, the theorist may choose to replace the notion of pleasure with the valuation of the experience for its own sake and, furthermore, add that that value need not be connected to the form of the work, so long as it is grounded upon attention to some pertinent aspect of the work. Because this approach uses aesthetic experience as its means to define a work of fine art, it is often called the aesthetic theory of art. The theory can be as thin as: something is an artwork if and only if it is intended or designed to promote an appreciable degree of aesthetic experience. Stolnitz's theory, introduced earlier, is clearly a variation upon this patent.

The aesthetic theory of art is a putative solution to the question of why the practices assembled under the rubric of the Fine Arts belong together as a group. *Ex hypothesi*, they are all designed to afford aesthetic experiences. Moreover, this proposal has the further philosophical attraction of implying—in one fell swoop—a fundamental disassociation of the Fine Arts from all the other arts. For the Fine Arts, understood as works prized exclusively for the intrinsically valuable experiences they encourage, can be thought to stand apart, virtually automatically, from all the other arts—such as agriculture, rhetoric, and engineering—since the other arts are valued primarily for their utility and not for the sake of the intrinsically valued experiences they engender. If aesthetic experience is the mark of *Art*, properly so called, and aesthetic experience is divorced from serving any ulterior purpose, then *Artworks*, properly so called, thereby have no essential truck with any aims, interests, or purposes other than that of providing intrinsically valued experiences.

[8] A very important rival to this paradigm is the expression theory of art that has been influential throughout the modern period. It will not, however, be discussed in this chapter.

That is, since the end of *Artworks* is a mental state that is separate from every other practice, it would appear to follow almost immediately that the means *qua* Art to attaining that state should be equally distinct from every other category of activity. If the end state is to be untainted by practical, selfish, or social interests and purposes, it stands to reason that the means to that mental state must be undiluted as well, lest interest and purpose seep into the vaunted mental condition. Perhaps that is one of the reasons why Kant argued that aesthetic pleasure not be connected to concepts, since concepts tend to be bound up with interests, purposes, and activities.

But, in any event, the conception of art as the intended promotion of *sui generic* value neatly cleaves Art (i.e., Fine Art) from every other human enterprise with a single stroke and, by definition, since something that is aimed at producing an experience that is categorically unalloyed with the interests and purposes attached to other human practices must be, it seems fair to surmise, a thing apart. Thus, the aesthetic theory of art elegantly suits the philosophical task of essentially defining membership in the Modern System of the Arts: it defines membership in terms of the intention to engender an experience valuable for its own sake, or, in other words, an experience that has no inherent or necessary connection to any ulterior purposes and the practices.

Furthermore, the aesthetic theory of art has a number of corollary philosophical attractions. If a work of art, properly so called, is such in virtue of its function to support aesthetic experience, then the artistic value of the work can be measured in terms of the degree to which it promotes or impedes aesthetic experience. Likewise, the theory gives us a way to establish what reasons are relevant to commending a work *qua* its status as Art—namely, any aspect of the work that enhances its capacity to deliver aesthetic experience can be adduced as a good-making feature of the work. In short, the aesthetic theory of art in connection with the standard characterization of aesthetic experience is such a serviceable and unified theoretical package that a great many philosophers are loathe to give up on it.

Of course, with respect to many of the individual members of the recently convoked *Modern* System of Arts—for example, poems, sculptures, or pieces of music—the aesthetic theory of art was quite highly revisionist. In the *premodern* period, poetry was frequently valued for, among other things, its educative power, especially in terms of morality. Horace did not deny that poetry delights, but the pleasure it induced was harnessed to its usefulness. Poetry involved pleasure, but the sort of beneficial pleasure of which Plato dreamt.[9] Poetry and its associated pleasures served a social purpose by making the lessons of the ethos of cultures eminently accessible to their citizenry.

Likewise, sculpture told the history and embodied the virtues of nations, while music accompanied rituals—religious and civic—modulating feelings to synchronize with the events it accompanied. These works were not intended to

[9] Surely Horace's *dulce et utile* is descended from Plato's call for beneficial pleasure.

be occasions for the cultivation of experiences valued for their own sake. The arts were designed as a means of deepening the experiences and activities of the religious, cultural, and political practices they subserved. In premodern times, to regard especially the artworks deemed to be the most significant culturally as simply or even primarily opportunities for aesthetic experiences—such as swoons of disinterested pleasure—vastly distorted that which the works in question were designed to achieve.

Most patriotic songs were likely to have been intended to raise the kind of pride that would lead to courageous efforts. The mental states these songs excited were not supposed to be valuable for their own sake, but for the activity they promoted. To regard a song of this sort as an occasion for having a contemplative experience valuable for its own sake was to use the song in a way for which it was not expressly designed. Though not all, nor perhaps even most, of the objects and performances enlisted in the Modern System of the Arts—and particularly those created in the premodern period—were meant essentially to be instruments of aesthetic delectation, it was their alleged capacity to be used as such, even where this was at odds with their very nature, that supposedly warranted their incorporation in the kingdom of Art.

The aesthetic theory of art, albeit a revisionist theory, then, appeared, at least to many, as a solution to the problem of membership in the Modern System of the Arts. Moreover, insofar as the aesthetic theory of art depended upon a certain conception of aesthetic experience—namely, as contemplative and sympathetic attention for its own sake—this particular characterization of aesthetic experience became deeply entrenched. That is, it is my hypothesis that, to a large extent, this version of aesthetic experience has come to have the authority it does because of the conceptual role it promises to play in the identification of artworks *qua* Art.

In brief, what we have labeled the standard concept of aesthetic experience sustains its influence because of the function it is supposed to perform in the rationalization of the Modern System of the Arts via the aesthetic theory of art. That is the intellectual need to whose satisfaction the standard concept was thought to contribute in the first instance and it remains the question to which many philosophers still believe it supplies the most compelling answer. Furthermore, I suggest, the essentially negative cast of the characterization—as having nothing to do with ulterior interests or purposes—assumes its conceptual shape given the burden of the aesthetic theory of art to hive Art off from everything else. To assure the autonomy of art from everything else, aesthetic experience is defined as something utterly apart from every conceivable purpose. The aesthetic theory of art and the standard concept of aesthetic experience fit each other like a hand in a glove. Together they recommend themselves intellectually or philosophically as the best solution to the Enlightenment (and post-Enlightenment) problem of the discovering the rationale of the Modern System of the Arts.

But the aesthetic theory of art did not arise in a social vacuum. There were important cultural developments that worked in its favor and, consequently,

in favor of the acceptance of the standard conception of aesthetic experience that came in tandem with it. This package of theories emerged in a period where patronage of the arts was evolving in noteworthy ways. In earlier times, the primary patrons of the representational arts had been political or religious. Generally, art was commissioned to serve the functions of the Church or the state (or the dukedom, or whatever other civil authority). Such art was explicitly tied to social purposes—to command reverence, to show forth the power of the king, or his magnificence, to aggrandize the court, to teach ethics or doctrine, to memorialize the past, and so on. During the Counter-Reformation, for example, the Council of Trent recommended that art be used as an emotional stimulus to piety and that "by means of stories of the mysteries of our Redemption portrayed by paintings or representations, the people be instructed and confirmed in the habit of remembering, and continually revolving in mind the articles of faith."[10]

However, as the bourgeoisie appeared, a new market for art dawned as well. The bourgeoisie used art as a way of enlivening the leisure time that was increasingly at their disposal. As Gadamer observed, the value of art became subjectivized.[11] That is, instead of serving objective social purposes, art began to be esteemed for the subjective pleasures it sustained.

Whereas previously art was very frequently incorporated into the portentous affairs of culture—for example, in the form of civic or religious statues of moral exemplars or historic heroes at the appropriate institutional sites, or in the form of music, song, and pageants as parts of religious or political rituals—the arts under the emerging dispensation were re-conceived as a kind of play, a contemplative play in response to the form of the work, irrespective of the cognitive, political, social, spiritual, and/or moral content and/or utility of the work. Moreover, as time wore on and the demands of this new market became better defined, artworks and, indeed, even entire art movements began to cater to it.

The bourgeoisie sought beautiful things to brighten their lives, including not only furniture, tableware, carriages, and gardens, but also pictures, exquisite writing, and the like. Taste became a marker of social capital for the rising middle class. Art became more and more an object of bourgeois consumption. As Hegel noticed, artworks began to migrate from sites of public intercourse, where they had contributed to the various purposes of the culture at large, into museums where they became "purposeless" (as Kant would have it) objects of contemplation.[12] A critical estate began to flourish whose spokespersons, like Joseph Addison, tutored the leisured classes in the best ways to spend their time

[10] Quoted in Rudolf Wittkower, *Art and Architecture in Italy, 1600–1750* (Harmondsworth: Penguin, 1958), Ch. 1.

[11] Hans-Georg Gadamer, *Truth and Method*, transl. Sheed and Ward Ltd. (New York: Seabury Press, 1975).

[12] Indeed, as art begins to exit living social practices and emigrates into its own hermetic domains, like the concert hall, the gallery, and the museum, it abdicates its highest vocation, as Hegel notes, though perhaps not for the precise reasons that he suggests.

in pursuit of the pleasures of the imagination.[13] Moreover, the directives of these critics were soon codified in the theories of taste and aesthetics advanced by philosophers such as Hutcheson, Hume, and Kant.

Though the participants in this emerging practice would probably not have described the situation in this way, the artwork was becoming a commodity[14] whose purpose, to speak paradoxically perhaps, was exactly—usually by means of its form—to engender disinterested pleasure, also known as aesthetic experience, or, even more obscurely, as the purposeless play of one's contemplative powers. The aesthetic theory of art neatly fit the bourgeois practices of connoisseurship and consumption, undoubtedly because, in this case, the theory and the practice were mutually informative.

Furthermore, that the standard characterization of aesthetic experience, which is itself the *sine qua non* of the aesthetic theory of art, is an essentially contemplative affair suited the bourgeois practice of art consumption perfectly, since the standard concept is above all a *spectatorship* model of aesthetic experience. It is as if it is simply assumed that the subjects of aesthetic experience will be onlookers—readers, viewers, and listeners (consumers)—rather than, say, also artists. Aesthetic experience is, in other words, conceived as an experience for audiences (indeed, leisured audiences). It is a matter of reception rather than production.

The standard concept of aesthetic experience, then, took hold in the eighteenth century for at least two, interrelated, reasons. There was the intellectual or philosophical task of rationalizing membership in the Modern System of the Arts in terms of some criterion, on the one hand, and the social pressure to arrive at a criterion that reflected the emerging bourgeois practices of consuming the Fine Arts, on the other hand. The aesthetic theory of art appeared to fit the bill on both counts. And, inasmuch as the standard concept of aesthetic experience is the cornerstone of any aesthetic theory of art, this conception of aesthetic experience became deeply embedded in the tradition.

Nevertheless, there remains the two-pronged question of whether the theory ever really succeeded in defining Art in the first place and of whether it continues to do so. These issues will be taken up in the next section. Specifically, we want to know: does the standard characterization of aesthetic experience live up to the role that has made it dominant?

3. INTERROGATING THE AESTHETIC THEORY OF ART

It is my conviction that aesthetic experience has such pride of place in discussions amongst philosophers of art because of the indispensable role it is thought to

[13] See, for example, Joseph Addison, "Taste and the Pleasures of the Imagination," in *Critical Essays from The Spectator*, ed. Donald Bond (Oxford: Clarendon Press, 1970), pp. 409, 411–21.

[14] John Brewer, *The Pleasures of the Imagination: English Culture in the Eighteenth Century* (Chicago, IL: University of Chicago Press, 1997), p. 92. See also Paul Mattick, "Art and Money," in Paul Mattick, ed., *Eighteenth-Century Aesthetics and the Reconstruction of Art* (Cambridge: Cambridge University Press, 1993).

play in one of the most seductive definitions of art, namely, the aesthetic theory of art. By mobilizing the standard characterization of aesthetic experience, the aesthetic theorist of art appears to provide the sort of rationale necessary to make sense of the Modern System of the Arts.

In short, I suspect that many philosophers are tempted to hold onto the standard characterization of aesthetic experience just because they are convinced that it plays this role in their web of beliefs. Consequently, in order to persuade them to abandon the standard characterization of aesthetic experience, it is not enough to show its internal weaknesses. They must also be convinced that it, in tandem with the aesthetic theory of art, cannot deliver the systematic results that they desire. Thus, our first order of business is to challenge the aesthetic theory of art.

Though the aesthetic theory of art relies centrally upon the notion of aesthetic experience, it is not sufficient to say that something is a work of art if and only if it affords aesthetic experience. This is not a sufficient condition for art status, since fully natural vistas may also afford what adherents of the aesthetic viewpoint count as aesthetic experiences; but natural vistas are not artworks, since they need not be artifacts. Nor does the preceding formula provide us with a necessary condition for art status, since presumably there are artworks which we regard as failures precisely because they cannot deliver aesthetic experiences in the standard sense but which we nevertheless still count as artworks. A god-awful statue is still an artwork even if the artist's mother can wring no pleasure from it.

One straightforward way in which to repair the theory in order to avert these kinds of counterexamples is to invoke the concept of intention. Revising the aesthetic theory, then, we can say that something is an artwork if and only if it is *intended* to afford aesthetic experience. Since natural vistas are not the products of intention, this version of the theory defeats the first of the previous objections. And, second, failed artworks, like our god-awful statue, are putatively intended to support aesthetic experiences, even if they do not do so. So they are still artworks, albeit bad ones.

Nevertheless, the theory is still not as tight as it should be. It remains too inclusive. For so many objects that we do not regard as artworks are nevertheless designed or intended to support aesthetic experiences. Stroll down the aisle of any supermarket or variety store. The shelves are full of items in packages designed or meant to support at least some quotient of aesthetic experience. But, even if Warhol's various packages are art, these everyday packages are not. In the modern industrial world, it is rare to come upon an artifact that has not been fashioned with some, however minimal, intention to engage aesthetic experience in the presiding sense of that phrase. But Walmart is not some bargain basement Louvre. In order to block this objection, the aesthetic theory of art must be revised even further.

One option is to say that the objects must be intended to deliver an appreciable (perceptible) amount of aesthetic experience. But how will the threshold be established here in a way that both is non-arbitrary and avoids inviting a slippery

slope? And, in any event, surely the designers of the lowliest cereal box *intend* it to ferry an appreciable degree of aesthetic experience.

Another option is to require that the objects and performances in question be created with the *primary* intention to afford aesthetic experience. This formulation, moreover, fits well with the consumerist orientation of the modern artworld. And yet it would seem to fail as a generalization about everything the Modern System of the Arts is supposed to embrace.

This should be patently obvious for reasons already discussed—to wit: the aesthetic theory of art is highly revisionist. Historically, most of what we now call art, both in Western culture and elsewhere throughout the world, was not made with the primary intention to afford aesthetic experiences of the disinterested variety. Most art, particularly in the premodern period, was made with the primary intention to serve various social purposes—religious, political, moral, cognitive, communal, and so forth. Villages did not erect cathedrals primarily in order to have something folks might enjoy looking at for the sheer fun of it.

Likewise, tribal peoples did not decorate their shields with fearsome visages in order to invite their adversaries to contemplate them sympathetically in autotelic acts of attention valued for their own sake. Not only was this not the primary intention behind the art of the pertinent shield makers; it was not even a tertiary intention either. In fact, it was no intention of theirs at all. Were the enemy to value the experience of these shields for their own sake that would surely have defeated the intentions of their designers who made these shields to frighten off rival tribesmen. The last thing these shieldmakers could have wanted would be for the enemy to hunker down in their lands because they enjoyed ogling their shields.

In brief, though the shields in question would count as art for most of us today, they cannot be so on the grounds that they were created with the primary intention to curry aesthetic experience. Moreover, so much traditional art is analogous to these shields in having ulterior purposes as central purposes that the aesthetic theory of art has questionable applicability when it comes to a staggering amount of premodern art.

The friend of the aesthetic theory of art, of course, will point out that *we* can ignore the original intention behind works such as these and savor them disinterestedly. But then are we really contemplating the works sympathetically—that is, on their own terms? And, in any case, if that is what we are doing, it certainly cannot be captured by saying that these are works created with the primary intention that they afford aesthetic experience. Furthermore, if it is *our* intention to treat said works as objects of aesthetic experience that make the works art, won't the theory become overly inclusive? Can't I intend to treat snowflakes and myriad other natural phenomena that way? But they are not artworks.

Perhaps the defender of the aesthetic theory of art will grant that the theory has problems with premodern art, but claim adequacy for it in the modern period. Nevertheless, even this modification of the scope of the theory is extremely controversial. For, though we may live in the so-called *Modern* period of art, not

all art in the modern period is modernist. Much remains committed to premodern notions of art as connected to purposes—religious, political, cognitive, moral, and so on.

According to A. O. Scott, the major American novels of the last twenty-five years—including Toni Morrison's *Beloved*, Philip Roth's *American Pastoral*, Cormac McCarthy's *Blood Meridian*, John Updike's *Rabbit Angstrom* series, and Don DeLillo's *Underworld*—are all concerned with history: with figuring out and illuminating both how Americans as a people have gotten to this stage of their history and what perilous tensions that passage has compounded and exacerbated.[15] These authors write with the primary intention of clarifying our national identity—to enable us to see who we are by showing us how we became that way and to bid us to use those insights to influence who we shall become.

These novelists have interests that are cognitive, moral, and political all at once. Their works are not devoid of social purpose, nor are they dedicated primarily to affording some disinterested experience valued for its own sake. These writers have a sense of civic responsibility and urgency; they stand, broadly speaking, in a prophetic tradition. For these authors are striving to achieve a transformative understanding not only for themselves but for their readers—a transformative understanding which may have subtle ramifications for both our private and our public lives.

These novels are but one case in point of art in the modern period that remains committed to being valuable primarily for the purposes—cognitive, moral, and social—they advance. More examples are readily available. But these should suffice to establish that the aesthetic theory of art is not an adequate definition of art, even for the so-called modern period. Moreover, if we look further afield—historically and transculturally—it becomes quickly apparent that a great deal of (most of?) that which we are disposed to call *Art* in our current parlance does not accord with the aesthetic theory of art (understood as requiring that something is art if and only if it is intended primarily to afford aesthetic experience (in the dominant variant of the notion of the aesthetic)).

Thus, if it is true that the dominant characterization of aesthetic experience derives its authority from the contribution it makes to the aesthetic theory of art, then the characterization does not deserve any special points for its intimate relationship to that theory, since the aesthetic theory of art itself is highly dubious.

Undoubtedly, the defender of the aesthetic theory of art will not give up the ship in the face of the preceding fusillade of counterexamples. She will remain loyal to the aesthetic theory on the grounds that she believes that it is our

[15] A. O. Scott, "In Search of the Best," *New York Times Book Review*, May 21, 2006, pp. 17–19. Aesthetic theorists of literature and other formalists sometimes dismiss articles like Scott's on the grounds that the kinds of considerations that concern him are really extra-literary—not really a proper move in the literary language game. However, I don't see how—without begging the question—one can rule as out of bounds the sorts of criticism Scott, a fully credentialed commentator, makes; if Scott doesn't count as a member in good standing in the practice of literature who does, and, more to the point, why them and not Scott?

best shot at rationalizing the Modern System of the Arts. She has faith in the proposition that all that is called for is a bit more tinkering with the fine points of the theory before the coherence of the Modern System of the Arts will finally be disclosed.

I, on the other hand, do not think that the Modern System of the Arts is coherent. Arguably, it may have made sense when it was first assembled under the rubric of the representational theory of art. When music was primarily song, hymn, and opera, it was plausible to group it alongside of poetry. But, as art mutated in various directions, whatever initial coherence obtained unraveled. With each passing decade and each successive art movement, the aims of art evolved diversely, and even very encompassing theories like the aesthetic theory of art and the expression theory of art could not accommodate its every variation.

What connects the various works we now count as belonging to the realm of art are historical narratives that link contemporary candidates for the status of art with past artworks in the right way. The Modern System of the Arts is no longer a system, but a tradition, a work in progress with a past, rather than something unified by a principle like the function of imparting aesthetic experience.

4. BUT WHAT ABOUT AESTHETIC EXPERIENCE?

I have argued that philosophers of art cleave to the standard characterization of aesthetic experience because they mistakenly believe that it will make an honest category out of the Modern System of the Arts. I have challenged this supposition; indeed, I seriously doubt that anything at this late date can conceptually put the Modern System of the Arts back together again. However, even if I have shown this much, the friend of the standard characterization of aesthetic experience will immediately remind me that I have not shown that there is anything wrong with the standard characterization of aesthetic experience. At best, I have demonstrated that philosophers persevere with it for the wrong reason.

Yet I also maintain that the standard characterization of aesthetic experience is inadequate on its own terms. To begin with, the standard characterization is stunningly uninformative. Try to operationalize the notion that it is the contemplative and sympathetic attention to an object for its own sake, or, even more vaguely, the notion that it is an experience valued for its own sake. Clearly, neither of these formulations represents sufficient conditions for aesthetic experience, since I can contemplate sympathetically the construction of the habitat of a community of naked mole rats and putatively value for its own sake my experience of coming to understand their adaptive behaviors, without that counting as an aesthetic experience. It is more aptly described as an ethological experience. Thus, the most the standard characterization could deliver is a necessary condition for aesthetic experience.

But the aforesaid conditions, construed as necessary, provide virtually no guidance either concerning how I might go about having an aesthetic experience,

or how I might instruct someone else to do so, or, if I am engaged in research, what behaviors or mental processes I should observe in order to investigate aesthetic experience. Presumably the concept of a certain form of experience should contain information about the way in which one has the experience in question. Yet the standard characterization of aesthetic experience says next to nothing about what goes into such an experience except to say that the experience is valued for its own sake.

Moreover, in a period where philosophers of art are beginning to enrich their inquiries by joining hands with cognitive scientists, the standard characterization of aesthetic experience is effectively useless from the point of view of empirical research. It gives one precious little by way of the variables one would need to focus upon. Saying that an aesthetic experience is one which the percipient values for its own sake fails to differentiate it from what many enthusiasts are likely to say of the chess experience.

Not only is the notion of intrinsic valuation insufficient to discriminate aesthetic experience from other intrinsically valuable ones (supposing you go in for that kind of talk); it is also hard to imagine how anyone could use this meager description concretely to initiate having an aesthetic experience of an artwork. To be told (1) to peruse sympathetically some painting and (2) to value the perusing for its own sake is not a recommendation—especially with respect to the second condition—that I find very helpful to act upon. I, at least, need to know more about the way in which to proceed.

Part of the problem is that the notion that an aesthetic experience is one valued for its own sake is primarily negative. It tells one what you shouldn't be doing—namely, valuing the experience instrumentally—and not how to go about what you should be doing. Nor does it tell you very much about the way in which to study subjects who are allegedly undergoing such experiences in response to artworks. What would your questionnaire look like: "Are you valuing this experience for its own sake?" You won't find out very much that way.

Perhaps the standard characterization of aesthetic experience is partly motivated by grander architectonic considerations about the categories of large-scale types of experiences. Certainly, Kant wanted to work out distinctions between certain classes of judgments. Maybe his successors wish to accomplish the same level of categorization with respect to various forms of experience. Whether or not this cartography is useful in other domains of philosophy, I question its utility with respect to the philosophy of art. For being told that the aesthetic experience of art falls under some big category of experiences valued for their own sake, tells one nothing about exactly what such experiences comprise.

Furthermore, this apparent reticence seems to me to be utterly at odds with what customarily happens in the actual artworld as we know it. For, in the ordinary course of affairs, we are far more forthcoming about telling people about the ways in which to have aesthetic experiences than the standard account allows. We tell them to be on the lookout for various formal structures (like symmetries and contrasts) for vividly instantiated aesthetic properties (such as

lightness, elegance, or brittleness), or for more anthropomorphic or expressive qualities (including sadness or joyousness). In short, we tell them that which is the appropriate focus or *content* of such experiences.

Of course, the percipient's attention to factors like these—aesthetic properties all—must be informed by the ways mandated in the artistic traditions in question in terms of the pertinent strategies of reception. That is, typically, we instruct the potential subjects of aesthetic experience about what the content of their experience should be—we tell them what to look for in accordance with the relevant conventions, strategies, and traditions of attention for the genres and artforms at hand.

Moreover, these instructions are something that people can readily get the hang of, in contrast to the more elusive suggestion that one cherish one's experience for its own sake. Thus, insofar as this sort of *content-oriented* characterization of aesthetic experience is more informative than the standard characterization, with its obscure talk of valuing the experience for its own sake, the standard characterization should not be our preferred version of aesthetic experience. The content-oriented approach should be.

That is, instead of identifying aesthetic experiences with those valued necessarily for their own sake, it is far more enlightening to maintain that an experience is an aesthetic one if it involves informed attention to the formal, expressive, or otherwise aesthetic properties of the artwork in ways that are consistent with the norms and strategies of detection prescribed for that type of work by its conventions, genre, and tradition. An experience of an artwork, in other words, is aesthetic if the content of the experience is aesthetic—a matter of formal, expressive, or otherwise aesthetic properties and relations—and if that content is negotiated in the appropriate or correct manner.

At this point in the dialectic, the friend of the standard characterization of aesthetic experience may suggest that his approach and the content-oriented approach are not really at odds. They can be amalgamated thusly: an aesthetic experience involves (1) informed attention to the aesthetic properties of an artwork (2) which attention is valued for its own sake. However, I dispute whether appending the clause—"valued for its own sake"—is really necessary.

In his "Of the Delicacy of Taste and Passion," David Hume claims that "nothing is so proper to cure us of this delicacy of passion as the cultivating of that higher and more refined taste" which, among other things, is that talent which enables us to discern discriminately artistic compositions.[16] Here, Hume explicitly regards delicacy of passion as a defective character trait that can be combated by exercising our powers of noticing fine distinctions, which powers Hume labels the "delicacy of taste."

Exercising delicacy of taste in response to an artistic composition—detecting an expressive or otherwise aesthetic property of an artwork—is what Hume

[16] David Hume, "Of the Delicacy of Taste and Passion," in his *Selected Essays* (Oxford: Oxford University Press, 1993), p. 11.

would, had he our vocabulary, have called an aesthetic experience. But, note, it is an aesthetic experience that he recommends for being instrumentally valuable—that is, valuable as an antidote to our violent passions.

Nor is this a one-off remark by Hume. In his "Of Refinement in the Arts," Hume again observes that the refined (delicate, tasteful) experience of the arts softens tempers and counteracts barbarism.[17] Thus, on Hume's view, it would appear to be possible to undertake and value an aesthetic experience—the perception of an aesthetic property—without valuing said experience intrinsically, but rather instrumentally.[18]

Moreover, since Hume's position is not obviously self-contradictory, we have no reason to think that an experience of the aesthetic content of an artwork, sans valuing the experience for its own sake, is not a genuine aesthetic experience. Indeed, how else should we characterize it?[19] Consequently, valuing the pertinent experience of delicate discernment for its own sake is not a necessary condition for having an aesthetic experience.

Of course, we need not rest the argument here solely upon Hume's testimony. For it is perfectly possible to imagine that someone, who never read Hume, might indulge in aesthetic experiences involving the delicate discernment of aesthetic properties on the belief—which may not be true—that it can rein in his choleric tendencies. Maybe his grandfather recommended this nostrum; maybe he hatched it on his own. Nevertheless, so long as the percipient is attending to aesthetic properties of the artwork in the right way, shouldn't we count his experience as a legitimate aesthetic experience, even if his reasons for doing so are instrumental? How else should we categorize it? But, if we agree to classify it as an aesthetic experience, then valuing said experiences for their own sake is not a necessary feature of aesthetic experience.

To have a grammatical experience of a stretch of writing, attend to its grammatical properties. Similarly, in order to have an aesthetic experience of an artwork, attend to its aesthetic properties in the ways mandated by the relevant practice. It is not clear why adding "and value the experience of detecting those properties for its own sake" is necessary. It really does not tell us anything further about what one must do in order to peruse the object (or performance) in a specifically aesthetic fashion.

How does one go about instructing someone else to value something for its own sake? What does being told to do so add to the operations/computations one undertakes? And what if one performs the requisite acts of attention, but not for their own sakes, but for some instrumental purpose, such as softening

[17] David Hume, "Of Refinement in the Arts," in *Selected Essays*, pp. 169, 171.

[18] It should be obvious that Hume has no allegiance to the notion that an aesthetic experience is a matter of disinterested pleasure as it is understood in the post-Kantian tradition, since Hume is willing to count moral defects in artworks as blemishes with regard to their beauty. See his "Of the Standard of Taste," in *Selected Essays*, pp. 152, 153.

[19] It is remarkable that the proponents of the standard characterization of aesthetic experience never tell us how we are to categorize cases like this. Will they propose a special category? That seems ad hoc and, in any event, hardly economical conceptually.

one's passions? Isn't it just arbitrary to suppose that one could be attending to the aesthetic content of the work in the right way, but not be having an aesthetic experience? Indeed, as what kind of other experience should it be classified?

In order to appreciate the arbitrariness of tacking on the requirement of intrinsic valuation to the content-oriented conception of aesthetic experience, imagine someone who, inspired by Hume's essay, seeks out aesthetic experiences in order to calm his savage breast. He reads Addison and Steele with interest and works on his native capacity to make delicate discriminations; but he does so in order to put his more robust passions in check. Moreover, he takes the pleasure he feels in making such fine distinctions as he does as a sign that his powers of delicate discernment are on the rise and that he is, thereby, conquering his violent tendencies. In other words, he values the pleasure in question instrumentally. Clearly, such a person is conceivable.

Imagine, at the same time, that he has a younger twin brother who engages the same artworks the elder twin does, with the same delicacy of discernment, and who tracks the self-same features of the works as his elder does, using the same techniques of detection. But the younger twin values the experience for its own sake, whereas the older brother values it instrumentally. Certainly, such a situation is a possible one. But wouldn't it be patently arbitrary in such a situation to say one is having an aesthetic experience and the other is not? Is the prostitute not having a sexual experience because she values it solely instrumentally, whereas the libertine, engaged in precisely the same activities, is having a sexual experience because she values it as an end in itself?

Another liability with the standard notion of aesthetic experience is particularly evident in Stolnitz's formulation of it. For, as noted earlier, it seems excessively biased toward the consumption or reception side of the artistic interaction. As the artist attends to his piece, working out, for example, its formal design, his activity is hardly describable as "contemplative." Think of Jackson Pollock feverishly dripping paint on the picture plane of his canvas. He is intimately attending to and knowingly related to the form of his painting, discovering it splash by splash; but it strains the English language to call what he was doing *contemplative*. Recall that Harold Rosenberg dubbed it "action-painting" and the label stuck for good reason.

Perhaps it will be observed that, on occasion, Pollock paused to survey what he had accomplished. In those moments, it might be said that he is contemplating the work, and, therefore that, in those intervals, he was having full-fledged aesthetic experiences of the work. But that seems overly contrived. Surely, Pollock was as engaged attentively with the form of the work while he was creating it as when he was inspecting it. It is not as though he was slipping in and out of a string of intermittent states of aesthetic experience.

And what of artists who do not pause midway to size-up their results? Think of a dancer improvising to a piece of music; as she attends to the forms in the music, she invents movement patterns to interpret the sonic ones. She doesn't pause to look at a video of what she's done; she just keeps dancing, continuously attentive to the formal relationships between the music and her movement throughout.

Nor need the dancer be a professional. Imagine you are freely adapting your move—à la the seventies—to a piece by the Rolling Stones. This example and the preceding ones all seem to me to be paradigmatic aesthetic experiences. But they do not involve contemplation. Thus, they will not fit Stolnitz's version of aesthetic experience. On the other hand, they pose no problem for the content-oriented approach, since the performers in each case are attending to the aesthetic properties of their artistic activities even as they generate them.

In response to objections like these, the advocate of the standard characterization of aesthetic experience may opt to part company from Stolnitz by dropping any mention of contemplation and by committing himself simply to the requirement that an experience is aesthetic only if it is valued for its own sake. But even this version of the standard account appears to fail to accommodate the activities of at least some conceivable artists. Imagine the artist who is in it for the money or the fame. He designs his pieces adroitly; he molds their formal structures with great care and understanding. But he values his own achievements exclusively for the glory and/or the riches they bring him.

Had he had the acumen to be an investment banker, he would have pursued that career. But, as it happens, he has the eye of an artist rather than that of a financier. So he plies his art in order to secure the lifestyle he covets. He strives for perfection in the form of his artworks for ulterior or instrumental ends. When he looks upon the formal ingenuity of his artworks, he feels pleasure as dollar signs dance in his head. He does not value his engagement with form for its own sake, though his handling of the aesthetic dimension of his pieces is by all accounts quite masterful, knowing, and sure—in fact, it is far more estimable than that of the starving artist down the street who values his own formal engagements with his own work for its own sake.

There is, I submit, no reason to protest that the preceding case is not a possible one. Artists can be as venal as anyone else. But perhaps the defender of the standard view will attempt to claim that the example is not truly conceivable on the grounds that our mercenary artist will have to stand back from his work from time to time in order to establish that the form is working as he intends; he will have to use himself as a detector in order to assure that his formal design will deliver the experience he wants. And when he does this, in those moments, it may be suggested, he will have to undergo an aesthetic experience in the standard sense in order to realize his more instrumental ends.

In response, first I wonder if valuing something intrinsically as a sub-routine in valuing it instrumentally counts, in the last analysis, as genuinely valuing something for its own sake. But, that not withstanding, I would also challenge the idea that in order to assess the efficacy of the work, the artist must undergo an aesthetic experience in the standard sense. If I am constructing a suspense movie, I merely need to stand back from the rushes and notice whether or not I am feeling the palpitation of suspense. I need not value having that sensation for its own sake. I may cherish it precisely because it convinces me that I've got a blockbuster in the can. Nor does it make much sense to suppose that I must have a feeling that my experience is valuable for its own sake. There is no such feeling.

Nor need we focus merely on the case of the mercenary or social-climbing artist in order to make the point here. Many artists, including cloistered monks in the Middle Ages, produced artworks, such as stained-glass windows, sculptures, and illuminated texts, in order to express their reverence for the divinity. As they perused the intricate formal designs with which they decorated, for example, the pages of sacred texts, it is reasonable to think that many, or at least some, of them valued them solely as humble offerings to God. We need not infer that they appreciated these designs for affording intrinsically valued experiences. If these works yielded satisfaction, that was not its own reward but a sign that they might be pleasing in the eyes of the Lord.

Moreover, with regard to some artist-monks, they valued their formal inventions not for the putative, associated, intrinsically valuable experiences, but instrumentally as a means to salvation An early twelfth-century inscription reads: "The monk Amandus alone wrote this book/for whom it may obtain the rewards of perpetual life."[20]

According to the standard characterization, the experience of artists like these, though concentrated relentlessly and with understanding upon the form of their artworks, counterintuitively, does not qualify as aesthetic experience. It is some other, mysteriously unclassified experience of the aesthetic properties of an artwork.

Of course, similar problems can arise with respect not only to artists, but to critics as well. Suppose a critic keenly scrutinizes a work of art in order to write an article about it for which she will be handsomely paid. She piths the complex formal design of the work with breathtaking brilliance and understanding. Perhaps she even makes it possible for some of her readers to claim that she has enabled them to have an experience of the work that they value for its own sake.

But she does not value her experience of the formal structure of the work for the sake of having had that experience. To her, criticism has just become a job—one she does well, one that puts food on the table, but not one that she still relishes. The standard characterization will have to reject her experience as aesthetic. Yet that is a perplexing result, since critics, even jaded ones like this, often serve as exemplars of what it is to have an aesthetic experience. We turn to them to guide us in the ways of aesthetic experience—to show us where to look and how to connect the various features of the work that capture our attention.

Of course, the content-oriented approach has no problem ascribing aesthetic experiences to the artists and critics just canvassed, so long as they are attending appropriately and with understanding to the formal, expressive, or otherwise aesthetic qualities of the relevant artworks. It is true that the content-oriented approach will be of little value in solving the demarcation problem—in helping us to sort the art from the non-art—since the content-oriented approach presumes

[20] Andrew Martindale, *The Rise of the Artist in the Middle Ages and Early Renaissance* (New York: McGraw-Hill Book Company, 1972), p. 67.

that we have some independent way, sans reference to aesthetic experience, to establish when we are dealing with an instance of *Art* with a capital "A." But this should not be counted as a failure of the content-oriented approach to aesthetic experience. For, as I hope I have shown, it has always been a serious philosophical misunderstanding to suppose that the standard characterization of aesthetic experience, when coupled with the aesthetic theory of art, could solve the demarcation problem.

PART III
ART AND VALUE

8

Art and Alienation

1. INTRODUCTION

The topic of this volume, art and ethics, conjoins two concepts whose close association would have been utterly unobjectionable philosophically for almost every major Western thinker from Plato to Hume. In his *Preface to Shakespeare's Plays*, Samuel Johnson asserts that "the end of poetry is to instruct by pleasing," where the instruction he has in mind is, first and foremost, moral instruction.

In what might be labeled the premodern period,[1] traditional art was an integral part of its cultural milieu, transmitting, but also in the process shaping, the shared ethos of its intended audience—conveying and clarifying, refining, reinforcing and galvanizing the religious, ethical, political, and otherwise cultural values of those it addressed. Art tutored peoples in pertinent norms of interpersonal relations, in their societal obligations and expectations; it imparted information about folk psychology, and especially about moral psychology with respect to virtue, vice, the connection between motives and action, and so forth. Art showcased the customs of the relevant groups, illustrating models of desirable and undesirable character traits, concretizing society's conceptions of duty, and advancing the preferred attitudes toward historical and contemporary events and even eschatological ones. Art also functioned as a site for pointers about correct manners and carriage, and endorsed ideas about personal style in general, including suggestions about one's style of movement, mode of gesture, deportment, and so much more.

Premodern art, in short, functioned as one of the—if not the most—powerful disseminators of the ethos of a people *and* it was widely recognized to possess this capacity. Art was a *comprehensive* source of enculturation in the sense that it very frequently engaged the whole person—simultaneously setting in motion one's mind and one's body (one's senses, emotions, desires, and pleasures). Furthermore, precisely due to this comprehensive appeal to the multiple aspects of the whole person—its potential to function as a sensuous universal—art was

The author would like to take this opportunity to thank Sally Banes, Diarmuid Costello, Dominic Willsdon, Nigel Warburton, and Adrian Piper for their suggestions regarding this chapter. However, they are not responsible for any remaining errors.

[1] Karol Berger, *A Theory of Art* (New York: Oxford University Press, 2000).

a particularly effective means for instilling the mores of a culture in every fiber of the very being of its citizenry.

Virtually no one denied this for two thousand years in the West. Indeed, it is probably true that much art in our own time still performs this role. However, since the eighteenth century, it has become at least controversial to suppose that moral instruction, even broadly construed, is the mission of art properly so called. Mass art, it might be conceded, may still traffic in morality—projecting exemplars of virtue and vice (as does the recent Chinese film *Hero*)—but the qualification will quickly be voiced that such is not the legitimate ambition of serious art (otherwise known as *genuine* art). That is, at least since the mid-eighteenth century, the seemingly untroubled conjunction of art and ethics has been problematized in ways that continue to incite fierce debate even in these allegedly postmodern times in which categorical boundaries everywhere are supposedly evaporating.

The purpose of this talk is to diagnose how we have arrived at a point at which for many a link between art and ethics seems anomalous. To that end, I will sketch what I take to be parallel developments in the artworld, on the one hand, and in the philosophy of art, on the other hand, which have resulted in the modern—or perhaps more aptly the *modernist*—prejudice that art and ethics are irretrievably twain. I will also attempt to undermine the presuppositions and the reasoning that recommend the separation of art and ethics. And I will conclude with some programmatic advice about what artists and philosophers of art might do at the present conjuncture.

Although the relevant developments in artistic practice and philosophical theory intersect—both historically and conceptually—in various ways, it is also the case that the artworld figures and philosophers who share a mutual suspicion of the legitimacy of connecting art and ethics could have arrived at their conclusions by independent routes without in any way availing themselves of the considerations that energize their allies in the other estate (respectively the artworld and philosophy). Thus, in what follows, I will begin with an admittedly broad outline of what disposed the artworld to abandon the premodern conviction of an obvious linkage between art and ethics, and then I will go on to review philosophy's case against the connection. Though there are points of tangency between these briefs, they also, as might be expected, often rest upon different concerns. Since the artworld case for the separation of art and ethics is in many ways practical, I will limn its shortcomings by underscoring the unhappy consequences this policy has had for the relevant artworld practices. But, insofar as the philosophical position in favor of a categorical separation between art properly so called and ethics is theoretical, it will require a philosophical refutation. Indeed, just because the philosophical conviction is theoretical, it may be more difficult to dislodge than the artworld prejudices in question. But I shall try, before concluding with some broad prognostications about how artists and philosophers might profitably negotiate the relation between art and ethics in the future.

2. THE ARTWORLD DECLARES ITS INDEPENDENCE

The disposition to deny any intimate bond between art and ethics is the consequence of a larger artworld endeavor to hive off art from other social practices and to establish art as an autonomous realm unto itself. That is, if the artworld is a domain independent from the external concerns of any other social institution, then it straightforwardly follows that art is something distinct from ethics and certainly not beholden to it.

As modernization took hold in the eighteenth century, processes of specialization began to accelerate. Among other divisions, the Weberian triplet contrasting rationality (theoretical reason and knowledge acquisition), instrumental and practical reason, and aesthetics evolved, enshrined in such intellectual monuments as Kant's three critiques.[2] Within the context of a changing society, the artworld found itself, or, at least, imagined itself, to be embattled on several, sometimes overlapping, fronts of which each, in turn, called for damage control, if the reputation of art was to survive in the way the friends of art desired in the emerging division of labor. In each case, the defensive strategy that attracted the artworld involved issuing a declaration of autonomy—an affirmation of the independence of art from other sorts of interests—in an effort to insulate art from the claims of other, putatively encroaching, social initiatives.[3]

These defensive maneuvers included, among other things, the assertion of the separation of art from utility. On the one hand, utility could be construed as a euphemism for the crude mercantile inclination of an emerging bourgeoisie to reduce all value to market value. To affirm that artistic value was something else—something categorically different than market value—not only claimed autonomy for art but did so in the name of acknowledging that there was more value to be had in the world than one could find summarized on a price tag.

However, the declaration of the separation of art from utility could not only serve as code for the animus against vulgar materialism. It also affirmed the independence of art from social utility in general. Art was no longer to be demoted to the status of an instrument in the service of religion and/or politics and/or any other larger social project. The artist was becoming a free agent in the same marketplace he suspected, and what he had to sell was his own vision unencumbered by the commissions of patrons such as the Church and the state. With employers like that, art had been expected to discharge social functions, often in the form of moral instruction. But the artist as a free market agent declared himself liberated from any obligation to be socially useful. Where what was on sale was self-expression, the artist agitated for de-regulation. Art,

[2] This trichotomy still holds sway today. See Jurgen Habermas, "Philosophy as Stand-in and Interpreter," in James Bohman and Thomas McCarthy, eds, *After Philosophy* (Cambridge, MA: MIT Press, 1987), pp. 296–318.

[3] See Iredell Jenkins, "Art for Art's Sake" in Philip P. Wiener, ed., *Dictionary of the History of Ideas* (New York: Scribners, 1973), vol. I, pp. 108–11.

its advocates clamored, had to be free to pursue its own purposes, *sui generis* purposes on a par with, if not more important than, those of neighboring social practices.

But what were the purposes of art? In premodern times there had not been the notion of art with a capital "A"—*Art* as a concept that defined a certain cluster of practices, including painting, sculpture, music, poetry, drama, and architecture. Rather, "art" connoted a skill; it was a term that signified mastery in doing something. Thus, one spoke of an art of this or that—an art of painting as the skill of painting and an art of war as skill in battle. In this context, it was the object of the preposition in the formulation "the art of —" that gave the phrase its content.

But, in the eighteenth century, a subset of the arts—the so-called Fine Arts or Beaux Arts—were gathered together in an alleged system.[4] This presented the lovers of fine art with the task of establishing the criteria for membership in the newly anointed institution of the Beaux Arts. At first, undoubtedly extrapolating freely from Aristotle, representation, or, more specifically, the representation of the beautiful in nature was proposed as the litmus test for citizenship in the republic of the arts. But with the rise of absolute music—pure orchestral music—representation became a scarcely credible requirement for the status of art properly so called. Something else had to be found to credential a candidate as art. And the alternative that still commands wide acceptance is that a genuine artwork is something produced with the intention that it facilitate disinterested contemplation. Disinterested contemplation of what? Of the artwork itself, usually in terms of its design or form for its own sake.

This conception of the artwork corresponded with the growing use of art by the developing bourgeoisie as a means of enriching through connoisseurship the leisure time that was increasingly at their disposal. Whereas previously art was most frequently encountered incorporated in the serious business of culture—for example, in the form of civic or religious statues of moral exemplars at the appropriate institutional sites or in the form of music, song, and pageant as parts of political or spiritual rituals—art became reoriented as a form of play, contemplative play free of social interests and needs. The purpose of art—the feature that won something entry into the Modern System of the Arts—was said to be precisely that it was not essentially useful for anything other than the exercise of the free (that is to say *disinterested*) play of one's contemplative powers.[5]

Ironically, this enabled art to function as a sign of conspicuous consumption—a badge of social distinction for the bourgeois consumer—at the same

[4] Paul Oskar Kristeller, "The Modern System of the Arts," in his *Renaissance Thought and the Arts* (Princeton, NJ: Princeton University Press, 1990), pp. 163–221.

[5] See M. H. Abrams, "Art as Such: The Sociology of Modern Aesthetics," and "From Addison to Kant: Modern Aesthetics and the Exemplary Art," in Michael Fisher, ed., *Doing Things with Texts: Essays in Criticism and Critical Theory* (New York: Norton, 1991), pp. 135–58, 159–90. See also: Jane Forsey, "The Disenfranchisement of Philosophical Aesthetics," *Journal of the History of Ideas*, 64/4 (October, 2003): 581–97.

time that the severance of art from utility was supposedly a gesture of resistance against crass materialism. And yet it provided the nouveau riche with the wherewithal to don aristocratic airs.

But, in any event, a direct consequence of the conception of art as a locus of distinterested contemplation (especially of form) was to remove art from the domain of ethics, since the very notion of disinterested contemplation was itself a pleonasm[6] that came to signal the exclusion of financial, political, religious, and, of course, ethical purposes with respect to an art object properly so called.

The artwork was to be contemplated as an artistic design for its own sake, not as moral instruction. Its purpose was to be, not to do—not even to do good. To assess the artwork in terms of ulterior social purposes, such as moral edification, was tantamount—on the evolving construal—to a category error.

Furthermore, by asserting that art is its own socially autonomous realm of value, the artworld not only claimed cultural capital for itself; it also attempted to fortify itself against censorship. When officials of the Church or the state mobilized to squash art they believed to be offensive—generally morally offensive—the artworld could respond, at least rhetorically, that art as such is not in the service of morality, even if that is how it appeared in premodern times. Indeed, art was immune to the claims of morality insofar as it sustained a distinctive sort of value peculiar unto itself. Attempts to police art morally were categorically out of bounds. Admittedly, this rhetoric was not always successful in the past. However, it has gradually come to influence the law and has in fact begun to serve as a firebreak against censorship, as in the Mapplethorpe case in Cincinnati.

Lastly, in addition to serving as a defense against the perceived threats of market materialism, utilitarianism, and moralism, the assertion of the autonomy of art also removed art from competition with science. When art was conceptualized as representation, it was natural to think of it as engaged in an activity comparable to science—that of describing the world. But from the seventeenth century onwards, art seemed to be a less and less likely peer to science in terms of the discovery of facts. Quite simply, science appeared to outclass art as a source of the acquisition of objective knowledge. If the arts were thought to be engaged in the same enterprise as the sciences, art undoubtedly would appear to be the weaker vessel. So, within these circumstances, clearly an advisable gambit was to withdraw from the field of competition and to declare that one's contribution lay elsewhere. Where? In providing opportunities for disinterested contemplation, which experiences, in turn, were said to be valuable for their own sake. That is, art was not valuable for the knowledge it could supply, as one might have wrongly supposed with respect to genres like historical painting, but for the experiences, primarily of formal design, art afforded—experiences alleged to be valuable in and of themselves.

It perhaps goes without saying that this withdrawal from the field of knowledge also severed the relation of art and ethics. For, in a culture where it was commonly

[6] Miles Rind, "The Concept of Disinterestedness in Eighteenth Century British Aesthetics," *Journal of the History of Philosophy*, 4/1 (2002): 85.

believed that objective moral knowledge was not only available but that it could be taught, taking art altogether out of the knowledge game—aka science, broadly conceived—was, in effect, to surrender one of art's primary claims upon society's attention. Plato had envied Homer's reputation as the educator of the Greeks where the education in question was primarily moral. Plato attempted to erode Homer's standing by arguing that, inasmuch as Homer and the poets had no knowledge, they had nothing to teach. Those who celebrate the autonomy of art in terms of its independence from cognitive pursuits thereby grant Plato's point without a fight; but in abdicating all claims to knowledge whatsoever they relinquish any prerogative to educate the populace ethically and thus forgo their former place of pride at the nerve center of the culture at large. By claiming autonomy and disavowing service to broader social projects, art ironically loses its authority in society instead of establishing it on a firm footing.

In order to defend the arts from materialism, utilitarianism, censorship, and an invidious competition with science, along with perhaps the desire on the part of the artist as free market agent to sell without constriction his wares—notably, self-expression with the onset of Romanticism—the artworld asserted its autonomy from the rest of society and its purposes. This tendency is manifested historically in the nineteenth century in slogans like "art for art's sake," which apparently arose via Benjamin Constant through a misunderstanding of Kant's third critique,[7] and then gained wider currency through movements such as aestheticism which enlisted followers such as James Whistler, Walter Pater, and, of course, Oscar Wilde.

Moreover, at the same time that the artworld declared its independence polemically, it was also changing itself physically in ways that reinforced the notion of art's autonomy. Whereas premodern music accompanied rituals of power and faith, absolute or pure music in the modern era was composed for a newly invented institutional site, the concert hall, which was a machine for concentrating contemplation upon musical form apart from distracting social purposes, like religious commemoration.[8]

Likewise, the art museum, another emerging institution, was a way of abstracting artworks from contexts in which they performed social, political, and/or religious functions so that their form rather than their social meaning became the most salient thing about them. The Louvre, for example, assembled the politically charged paintings and statues of the *ancien régime* from the locations in which they symbolized Bourbon power for the express purpose of defanging these representations—placing them instead in a museum setting where they would no longer perform their intended social function but would become merely decontextualized objects for contemplative appreciation.[9] The museum and the galleries modeled upon it have a decontextualizing and, therefore, desocializing

 [7] John Wilcox, "The Beginnings of L'art pour L'art," *The Journal of Aesthetics and Art Criticism*, 11 (1953): 363.
 [8] Larry Shiner, *The Invention of Art* (Chicago, IL: University of Chicago Press, 2001).
 [9] Ibid.

tendency, which, among other things, can cause anxiety when photographs, such as those of the Abu Ghraib atrocities, are displayed on the whitened walls of galleries where their form glows forth, as opposed to what strikes us when we find them in newspapers where they are juxtaposed to suitably accusatory headlines.

If the architecture of the artworld under the dispensation of art's autonomy seems almost cathedral-like, it is an echo of the religiously derived language of the self-sufficiency of art and of its value for its own sake—terminology originally coined by Plato and Plotinus to characterize the absolute, and later appropriated by the Catholic Church to speak of God.[10] It is almost as if after centuries of using art as an instrument of worship, people became so accustomed to praying before religious paintings and statues that they came to take the artworks themselves as the objects of adoration and began to worship them. How else would one make sense of the curious conviction of certain modern aesthetes that art could save the world?

The aestheticism of the nineteenth century turned into the formalism of the twentieth, capably defended by polemicists like Clive Bell and Roger Fry who tutored generations in the appreciation, understood as the distinterested contemplation, of a species of pictorial value, called significant form, that was allegedly independent of any social concerns, perhaps most obviously ethical ones. To attend to the moral content of a picture—its political or religious significance—was to be looking in the wrong direction: at the world, and, therefore, away from what one should be looking at, namely, the picture and its structure. In other words, it was to be focused wrongly on those Spaniards being massacred by the French firing-squad and not on the painting by Goya.

Likewise modernism, à la Clement Greenberg, continued the theme of the autonomy of art, reinterpreting the notion of art for art's sake epistemologic-ally—asserting that genuine art was *about* art in the sense that its task was to reveal and acknowledge its own nature, specifically the nature of painting as a two-dimensional thing. By making self-reflection the goal of art, the modernists sustained the separation of art from other social practices initiated in the late Enlightenment and early Romantic period, the notion of reflexivity translating into the contemporary variant of the idea of art for art's sake. Moreover, this framework for conceptualizing ambitious artmaking continued to be unquestionably the hegemonic one through minimalism, which, despite Greenberg's disapproval, used the model of critique he had fashioned as its primary means of self-understanding. Consequently, it was still the case as late as the 1970s that the assertion of the autonomy of art was a generally accepted article of faith across much of the artworld, including its most powerful domains.

However, there is a serious question about whether the separation of art from the rest of the culture, including the ethical realm, achieved the desired effect or whether it was the victim of what Hegel called the cunning of reason (better

[10] M. H. Abrams, "Kant and the Theology of Art," *Notre Dame English Journal*, 13 (1981): 75–106.

known as history). If my abstract characterizations of the various artworld motives behind its declaration of independence are correct, the notion of the autonomy of art was intended to bolster the prestige of the artworld, and to raise it to an equal, if not greater status, than adjacent social enterprises. But, in the long run, this strategy appears to have failed.[11] Ambitious art has become marginal to the life of the culture. The artist has made great strides in winning his/her freedom, at least in principle, from moralism, commercialism, utilitarianism, and so forth by flying the flag of autonomy. But the other side of the coin of that autonomy has been a corresponding degree of alienation from the wider society. For, inasmuch as the artist spurns engagement with broader social interests, such as enculturation, the surrounding society loses interest in the activities of artists. Only those with highly specialized concerns take an interest in art for art's sake. Once artists remove themselves from the ongoing concerns of the culture, the culture predictably loses interest in the arts, except on those occasions where the artworld provokes some scandal, the sensation momentarily commandeering the public spotlight.

The cost of the kind of freedom the artworld has aspired to in the name of autonomy has been an ever-accelerating diminution of attention toward ambitious artmaking, even among the educated elite. It is no accident that alienation—especially alienation from everyday society—has been the recurring theme of the stories about the artist in the era of the autonomy of art. It symbolizes—through the particular—the plight of an artworld that demands freedom from society on its own terms. The alienation of the artworld, in other words, is largely self-inflicted, and the abandonment of the role of transmitter of the ethos of its intended audience is arguably the deepest wound the artworld has perpetrated upon itself.

If this diagnosis is convincing, then it seems obvious that the separation of art from ethics, however well-intentioned way back when, has been a self-destructive policy on the part of the artworld. In order to reverse the alienation of the artworld, the artworld needs to reclaim its function as a source of promoting—both critically *and* sympathetically—the ethos of the people it intends to address. The novel, even in our own times, has consistently proven itself to be a resilient force in the life of the culture. As new segments of the society empower themselves—persons of color, women, gays, postcolonial peoples—the novel serves as a vehicle for articulating their concerns and values and for celebrating while also constructing their emerging ethos. The literature of these groups, like the literature of the Jews and the Irish before them, encourages attention for being engaged in the community, not by standing outside the community and declaring itself a community of interest unto itself. The challenge for the Fine Arts, it seems to me, is to discover its own way of reinserting itself into the social process.

[11] Crispin Sartwell, "Art for Art's Sake," in Michael Kelly, ed., *The Encyclopedia of Aesthetics* (Oxford: Oxford University Press, 1998), vol. I, pp. 118–21. The isolation of art in our civilization is also noted by John Dewey in his *Art as Experience* (New York: Perigee Books, 1934), p. 337.

In Philadelphia, for example, there is a thriving mural arts program. Begun in 1984 as a way of combating graffiti, the program now comprises more than 2,400 indoor and outdoor murals. These murals celebrate local neighborhood heroes, values, and activities. Some of them commemorate victims of crime and express the desire that such will never occur again. Some sketch the ethnic history of the people in the community. Others symbolize the hope that different neighboring ethnic groups can reconcile and tolerate diversity. Some picture pastoral scenes, providing a glimpse of serenity in the midst of the bustle of urban life. But all address what the adjacent communities value, including ethically value, and for that reason are much beloved, are objects of comment and discussion, and part of the life of the streets that they emblazon.[12]

For instance, the mural on Fabric Row includes the image of an elderly couple showing a child—perhaps their grandchild—a piece of cloth. They are talking about it. One presumes they are telling the infant what it is and how it is made, while also expressing their pride in their trade and its ethos. Such murals are embraced by the people of Philadelphia because they are integrated into the pulse of the community as emblems of the everyday life and values of the neighborhoods whose history, aspirations, tragedies, folkways, and values they enshrine. These artworks are not, after the fashion of much performance art, merely *symbols* of the continuity of art and daily living. These artworks are embedded in the ebb and flow of the culture in a way that might be instructive to the reigning artworld that has imprisoned itself behind the blindingly white walls of the gallery and museum.

Before turning to the reasons that philosophy has separated art from ethics, let me briefly review three objections that might be leveled at the very sketchy account that I have just offered of the alienation of the artworld. The first observes that my characterization of the influence that the notion of the autonomy of art has exerted over the artworld for the last two centuries is vastly exaggerated, even if we narrow our purview to avant-garde art. For, in opposition to the lineage that extends from the proponents of art for its own sake, through the Greenbergian modernists there is an alternative tradition that has sought to dissolve, as they say, the boundaries between art and life. Here, one may have in mind Dada and its heritage, including conceptual art, Fluxus, early postmodern dance, Joseph Beuys, happenings, readymades, and so on. How can I say that the artworld has separated itself from society when these highly visible gestures against the autonomy of art have been undertaken expressly in order to reunite art with the everyday life of the culture?

My answer is simply that these movements, which I think are both fascinating and important, nevertheless are essentially part of an internal debate within the artworld. A dance composed of ordinary movement may symbolize a continuity between everyday life and art, but it does not influence everyday life outside the concert hall. It engages an artworld dialectic, albeit on behalf of the heteronomy

[12] Jane Golden, Robin Rice, and Monica Yant Kinney, *Philadelphia Murals and the Stories They Tell* (Philadelphia, PA: Temple University Press, 2002).

of art, but it does not intersect with any more concrete social issues. If it projects egalitarianism, it does so in the most etiolated fashion, and, if it claims for itself the property of being ordinary movement, then it is self-refuting, since ordinary movement is not intended to symbolize a dissolution between art and life. Such dance requires an artworld atmosphere in order to live; it does not live in the wider culture.

A second objection to my account is to recall that the assertion that art is autonomous need not be understood as a denial of ethical or political significance. The affirmation of the autonomy of art is itself a political or ethical act—an act of defiance in the face of the reductive tendencies of instrumental reason, on the one hand, and the all-devouring market, on the other. Such is broadly the view of some of the leading figures of the Frankfurt School of Critical Theory.

However, this, like the not unrelated polemics of Dada and its progeny, is largely an in-house debate within the artworld. The autonomy of art becomes a political symbol or allegory for those who know how to decipher it—which is to say predominantly denizens of the avant-garde artworld. This is not to suggest that this is not a legitimate activity or to deny that it is a worthwhile debate to enter. But neither can it be regarded as an avenue for reconciling art with society, since, of course, it regards the alienation of art from society as a moral badge of courage. It conceives the ethos of existing society to be too utterly fallen to be worthy to enlist the services of art. Art is not only conceptually opposed to other social practices; it must be politically and morally opposed as well. Yet this stance, even if it were intellectually defensible, would hardly relieve the alienation of art nor would it restore a role for art in the everyday ethical life of society.

Finally, I anticipate that many will reject my diagnosis on the grounds that it is obsolete. Though the idea of the autonomy of art may have been ascendant through the minimalist moment, with the arrival of politicized postmodernism in the late seventies and its consolidation in subsequent decades, it will be proposed, faith in the autonomy of art has become an artifact of the past. Art is no longer regarded as autonomous, nor is the ambitious art of the present self-alienated from the rest of the culture. It is patently engaged, primarily in social criticism.

Here I want to make two brief comments. Though there is a great deal of politicized postmodernist art on offer, including the work of Barbara Kruger, Jenny Holzer, and Mary Kelly, it has not neutralized the effect of two centuries in which the ideology of the autonomy of art held sway. For that reason, the appearance of politicized art in the venues where ambitious art is exhibited is still controversial. Influential critics continue to wonder aloud whether artists have lost their way and rail that they have forgotten about pleasure and beauty and other formal qualities. The notion of the autonomy of art has not been banished by any means. It remains in constant reserve. Only time will tell whether it or politicized postmodernism will win the hearts and minds of prospective artists. That is, the future of the artworld is still up for grabs.

Second, politicized postmodernism and autonomism both appear to have one thing in common: an adversarial relation to the rest of the culture. The autonomist declares art to be separate from everything else and categorically

contrasts artistic value to other sorts, sometimes even suggesting that it is superior. Politicized postmodernism does not place art completely outside of the culture, but it does assume that the artist occupies a privileged position, namely, that of social critic.

Indeed, in debates about government funding of the arts, artworld advocates often claim that it is the essential role of the artist to be a social critic and that this is what warrants government funding. But not only is this claim completely without any historical warrant—was even one medieval master builder a social critic, or, for that matter, was Leni Riefenstahl?—but it also reiterates the idea of the art as somehow distanced from the rest of the culture, a stance that is guaranteed to perpetuate the alienation of art if it is pursued as the exclusive vocation of ambitious art.

My point here is not to suggest that art should not engage in social criticism. That is one thing that art should do. That is one way in which the artworld needs to reclaim its connection to ethics. But social criticism is only one aspect of the ethical role of art. Ambitious art also needs to get back into the activity of articulating, transmitting, and celebrating all that is positive in the ethos of its audience. Artists cannot simply stand above the rest of the culture and rain down admonitions like Old Testament prophets. If its only relation to society at large is negative, this will have the practical effect of its marginalization as a scold. Art must engender a more intimate relationship with its viewers by creating symbols of the positive ethical values of the culture that people find worthwhile as guides to and ways of making sense of their lives.[13] In that way, social criticism will be recognized to hail from within a wellspring of the society and not from an unelected position on high.

3. PHILOSOPHY AND THE AUTONOMY OF ART

Like the artworld, philosophy has also defended the thesis that art is autonomous from other cultural endeavors, most notably, ethical instruction and leadership. Philosophy's sometimes subconscious acceptance of the notion of the autonomy of art, moreover, has blinkered philosophical research into the arts, proscribing entire areas of inquiry—including the relation of art to the broader society, politics, morals, personal relations, and to knowledge and even to philosophy itself. Philosophy's espousal of autonomy has not only reinforced the alienation of art from a theoretical perspective, it has also marginalized the philosophy of art. For, if philosophical theory reconfirms the sentiment that art is of no interest outside the artworld, then why should philosophical aesthetics attract anything more than insider interest?

However, whereas the artworld's affirmation of autonomy arose, one hypothesizes, as a solution to the perception of various practical predicaments, philosophy,

[13] See Noël Carroll, "Art and Recollection," *Journal of Aesthetic Education* (forthcoming).

at least in part, is drawn to the autonomy thesis for reasons having to do with a certain conception of the nature of the project of the analytical philosophy of art.

That philosophy parallels or echoes certain dominant artworld themes is not surprising. Some, of a Hegelian bent, will maintain that philosophy is predictably always the reflection of a form of life (such as the artworld), while those who like their Hegel spiced with Marx will claim that both the artworld and its philosophy are merely converging reflections of deeper economic forces. Correspondingly, those of a more anglophone persuasion are apt to argue that inasmuch as the philosophy of anything aspires to be the rational reconstruction of the conceptual frameworks and modes of reasoning of whatever practice it is the philosophy of, needless to say, the philosophy of art will tend to rehearse the presuppositions of the artworld. I think that each of these conjectures has a great deal of plausibility and adds to the explanation of why the philosophy of art gravitates so readily toward the autonomy thesis and, thus, in its own way, contributes to the alienation of art. Nevertheless, I also believe that there is a further motive operating here that makes the notion of the autonomy of art particularly seductive to philosophers of art, especially those of an analytic disposition.

Earlier, I noted that the so-called Modern System of the Arts only emerged in the eighteenth century. Before that it was just as "natural" to classify music with mathematics, while painters could belong to the same guild as chemists, since both ground pigments. But, in the eighteenth century, the practices we now find gathered together on the arts quad of the campus became a canonical grouping. And this provoked a conceptual or theoretical question, namely: what criterion or criteria must be satisfied in order to qualify for membership in this system? Or, in other words: what is art?

Answering this question became the philosopher's task; specifically, it was the job of the philosopher of art. This project was conceived as the enterprise of discovering the essence of art—that property or combination of properties that any artform would have to possess for any instance of that artform to count as an artwork and not as something else. Note that this construal of the goal calls for the disclosure of something that all artworks properly so called possess necessarily, but which is not possessed by non-artworks. The search for an essence of art—let us call it essentialism—dictates the kind of answer that will be attractive to philosophers. Furthermore, I suspect that it is the very kind of answer that this brand of essentialism anticipates that makes the notion of the autonomy of art enduringly attractive to philosophers of art. That is, the notion of the autonomy of art is compelling to philosophers of art for reasons internal to their theoretical project, given their essentialist leanings.

Why? Because if one can demonstrate that art has some generic value that is by definition different from and in contrast to every other sort of value—including every other sort of personal and/or social value—then one will have located a necessary feature of art sufficient to differentiate at a stroke art from everything else. If one can isolate an autonomous value for art—one separate from and even contrary to every other kind of value—then one has the conceptual resources

adequate to demarcating virtually automatically the border between art and artworks and every other social practice and its products.

Essentialism and the thesis of the autonomy of art have, I want to say, a natural affinity. This is not to imply that an essentialist with respect to art must accept the autonomy thesis, but that, for the reasons just given, the autonomy thesis is a permanently fatal attraction for philosophers of art of this ilk. And yielding to this temptation, of course, is a major factor, among others, that accounts for the scant interest said philosophers have shown concerning the intersection of art and ethics, not to mention other social practices, throughout the twentieth century.

Needless to say, it is not enough for the philosopher of art to assert that art has autonomous value and to leave it at that. Nor can he defend this view by advertising that it solves his problems ever so conveniently. The philosopher must specify the allegedly necessary property of art that grounds the unique sort of value that, in turn, differentiates and categorically separates art from everything else. Moreover, one must characterize that feature in such a way that it is evident why both that property or set of properties and its associated value are distinctive of all and only art.

Historically, the feature that it seems to me philosophers smitten by the autonomy thesis return to again and again is that of form valued for its own sake and not for the sake of anything else.[14] That is, it is the form as such of the religious statue and not the form of the statue as a means of promoting reverence that we appreciate when we appreciate the statue as art, or *qua* art (to revert to the standard way of speaking in discussions like these). Essentially valuing form for its own sake, it is thought, distinguishes art from everything else, just because in every other realm of value, we value things for their consequences. For example, however much we may be said to admire knowledge for its own sake, we also value the enterprise of knowledge acquisition for its proven pragmatic potential.

But, when it comes to art, it is hypothesized that we value art *qua* art solely for its affordance of the disinterested contemplation of form for its own sake—something that, by definition, is separate from (or autonomous from) the concerns of every other social practice. This kind of philosophical formalism, of course, need not deny that historically art has been dragooned into the service

[14] In order to substantiate this claim, take note of perhaps the most impressive recent defense of the autonomy of literature from the claims of truth, namely, *Truth, Fiction, and Literature* by Peter Lamarque and Stein Haugom Olsen (Oxford: Oxford University Press, 1994). Though it may not be immediately apparent, the position that this book defends is formalist. For the way in which its authors maintain literary artworks deploy concepts that apply to the world is not in order to propound truths, moral or otherwise, but to organize or colligate the disparate episodes, characters, descriptions, and so forth of the text under overarching conceptions—like destiny. That is, artists and critics use such concepts in order to unify the text (or, at least, large parts of the text) where *unity* is a formal feature of a work of literature. According to Lamarque and Olsen, the practice of literature is such that writers employ concepts not to advance truths, but to structure their fictions. This is alleged to be a premise of the institution of literature. But, above, I argue that with respect to some genres, literary and otherwise, it is part of the practice of the artmaking under consideration to do more than present *unified* formal designs.

of other social practices, like moral instruction, but only maintains that these supposedly ulterior functions are at best irrelevant to art's distinctive value as art—though, at worst, these entanglements are lethal distractions.

Yet why believe that form valued for its own sake is the one and only value to be heeded when approaching art *qua* art? The argument is an essentialist one; it goes like this. What does everything we call art have in common? Some artworks are political; some are religious. Some engage in moral instruction, but others simply abet experiences of delight, and apprehensions of beauty. Some artworks raise terror; others soothe. And so on. The local purposes of artworks, styles, movements, and genres are various. Artists undertake many briefs. But is there something they have in common? Yes, suggests the formalist: *ex hypothesi*, they all aspire, no matter their medium or genre, to find a form appropriate to the point or purpose of the work in question.

As an artist, one is a maker. Artists are makers with skills in manipulating and organizing the means that belong to their media and genres—makers who find forms that suit whatever the artwork is about whether it be the salvation of humanity or, maybe less exaltedly, the provocation of visual pleasure. Artists, in the sense relevant to the Modern System of the Arts, are always the creators of form, and when we attend to their creations *qua* art we attend to the forms they have invented as forms and not as the means to something else. For that is their distinctive contribution; they are at the very least artificers of form, if nothing else.

That is, what we value in art *qua* art are the forms the artists have made for their own sake. Why? Because this is what the artist *qua* artist has done; she has created forms. We admire their ingenuity, coherence, and elegance, and not their contribution to, for example, social or psychological knowledge or to ethical insight or education. Those achievements do not putatively belong essentially to the artist. Indeed, the formalist may claim that other sorts of experts are better at securing those ends. The artist is an expert in the creation of form and, for that reason, we should contemplate his designs as designs—inspect them from the inside, so to speak, and not in terms of the ostensibly external purposes they may serve. What any artist achieves *qua* artist is the form or structure that embodies the point or purpose of the work. It is not the point or purpose of the work that is artistically significant or valuable but the way in which it is made manifest formally.

Furthermore, the friend of formalism adds, there is no feature other than form that obtains with comparable generality across the practices and objects we call all and only art. Admittedly, other practices evince form, but only in the realm of art properly so called is the sole locus of worthiness form itself irrespective of the purposes, if any, that it might serve. Only artistic form is autonomously valuable.

Put succinctly, the argument begins with a question: what *qua* art, in the sense relevant to the Modern System of the Arts, is it that artists (all artists) do? Supposedly, the only feasible answer is: they create forms. No other property reaches so generally across the arts. Thus, the exhibition of form for its own

sake must be *the* value of art, since beyond the universal creation of form, the aims of artworks are too diverse and, indeed, often too conflicting to provide a comprehensive and consistent source of value. This conclusion, moreover, fits nicely with the view that art affords the opportunity for disinterested contemplation, since it specifies, in a way that makes the notion of disinterested contemplation concretely intelligible and operational, that upon which one should focus—the form of the artwork on its own terms or for its own sake. Furthermore, insofar as one is to attend to the form for its own sake, thinking about the object disinterestedly comes to seem natural, since we are to concentrate on the form independently of its purpose. For little effort would appear required to contemplate the object disinterestedly if what we are tracking is the form of the work in isolation from its allegedly non-aesthetic purposes.

Given what I hope are obvious reasons, we can call this the common-denominator argument. It is very compelling, particularly for anyone committed to the kind of essentialism I have characterized so far. However, the argument is not irresistible.

One thing to notice about this argument is the way in which it presupposes that art and artistry can be informatively and exclusively identified and assessed independently of the context and content of the art in question. As observed previously, prior to the advent of the Modern System of the Arts, art was simply the skill of x, where x, say medicine or sculpture, and the aims thereof, informed one of the values and standards of excellence that pertained to the activity in question. To modify a saying of Gombrich's, there were arts; there was no art as such.[15] But, in the eighteenth century, the notion of a category that incorporated certain arts under a single, uniform concept won wide acceptance. And formalism, as the most enticing variant of the autonomy of art thesis, gained traction as that subsection of the arts was hypostasized as ART. Formalism performed the service of rationalizing this collection of the arts as a system by proposing that the kind of thing that Art (with a capital "A") is, is the exhibition of form for its own sake.

But, even granting that there is something so abstract, called Art, and that the discovery of appropriate forms is a concern of every practitioner who belongs to this enterprise, it should also be clear that practitioners of the various artforms, genres, styles, and movements who are citizens of this republic may have further commitments, given the kinds of artists they are, in addition to the creation of form. In other words, due to the particular type of artist one is, one may be responsible *qua* that sort of artistry for more than the creation of form. The formalist asserts that one must appreciate an artwork on its own terms, but he wrongly assumes that the terms of a given artwork must be specified exclusively in terms that are common to every artwork—namely, just formal terms. However, artworks belong to specific kinds that possess their own terms that are more pertinent to the appreciation of the specific artwork *qua* artwork—that is, *qua* the kind of artwork it essentially is—than are generic considerations of form. To

[15] E. H. Gombrich, *The Story of Art* (Englewood Cliffs, NJ: Prentice Hall, 1995), p. 4. Also quoted by Jane Forsey "The Disenfranchisement of Philosophical Aesthetics," p. 596.

be truly respectful of the artwork on its own terms, then, requires acknowledging the kind of work it is. And the kind of artwork it is may demand that one attend to it as something other than a *sui generis* formal design.

For example, a realist novelist, given the nature of the realist novel, is not merely expected to create a coherent novelistic form. She is also typically expected to be a penetrating and accurate observer of society, or, at least, of the social milieu she describes. She is expected to distill these observations into, among other things, characters that readers can use in a way that is analogous to how concepts function in order to comprehend social conditions.[16] This is not an extraneous or dispensable responsibility for the category of realist novelist. It is a constitutory element of what it is to be a realist novelist. It is part of the art of the realist novel. The realist novelist, as the kind of artist she is, not only creates a consistent, probable, narrative-dramatic structure, but also strives to provide astute and clarifying commentary about the society she depicts. It would be simply ad hoc to protest, as the formalist might, that that aspect of creating realist novels is merely journalism or reportage, whereas the genuinely artistic part is the way in which the variety of characters and actions are unified formally or colligated by an overarching concept or theme.

To split in half in this way the role of the realist novelist *qua* the kind of artist she is falsifies the way in which this form of art is understood both by those who write novels in this genre and those who read them. Neither side of this relationship regards the social commentary as nothing but a pretext for formal invention. That is why aspiring novelists of this sort are told to develop their skill (the art) of observation. Both sides of the exchange—both readers and writers—believe that the art of the realist novel as such aspires to the illumination of social reality, which elucidation may include the promotion of a moral perspective—perhaps original with the author—concerning the state of affairs represented in the story.

Moreover, such novelists are not only expected to be social observers. They are encouraged by the tradition of their practice to be psychologists as well. When, in *House of Mirth*, Edith Wharton surmises, on the basis of a carefully crafted character study, that "it is less mortifying to believe oneself unpopular than insignificant and vanity prefers to assume that indifference is a latent form of

[16] For example, Tom Wolfe's recent novel *I Am Charlotte Simmons* has been roundly criticized for its presentation of prefabricated rather than penetrating and closely studied observations of the contemporary styles of collegiate life, the ostensible subject of his book. Such criticisms must be especially rankling for Wolfe, since he has expressly agitated for a return to the sort of realist novel that takes account of the conditions of social reality as they unfold. Nevertheless, for our purposes, the criticism of Wolfe's novel is pertinent apart from its accuracy because it shows that, with respect to the practice of certain kinds of art, there is the institutional expectation that knowledge, including knowledge of mores, be something the author deliver. And where the author fails to dispatch that charge, he/she is justifiably deserving of criticism. The case of Wolfe merely confirms that this is a donnée of the language game in which realist novels are created, consumed, and evaluated.

unfriendliness,"[17] she is discharging a central function of the realist novelist—the revelation of psychic scenarios and syndromes that govern everyday life. The task of the realist novelist is not simply to exhibit in a formally perspicuous fashion the findings of others, but to discover, illustrate, and explain what makes people tick. And this includes the keeping track of new personality types, interpersonal strategems, anxieties, virtues, and vices as they emerge and mutate with changing times. We admire novelists because of their ability to distill the scripts that determine and explain behavior. This, as well as finding a suitable formal design, is part of the charge of the novelist. Indeed, in many cases we are willing to overlook the formal lapses of a novelist if her social and/or psychological and/or moral insights are estimable. Moreover, we count these observations as part of her achievement as a novelist and not as something else.

It is not clear that the task of social and/or psychological and/or moral exploration is of a secondary or inessential interest to the reader or the writer of the realist novel, since both may in fact regard the purpose of the form of a novel to be justifiably subservient to advancing as forcefully as possible the novel's social and psychological insights, and/or its moral perspective. That is, even if form is a concern of every artist *qua* artist, there is no reason to suppose that in any individual artwork, given the kind of thing it is, that it is form for its own sake that is of central importance to it for either the artist or the audience, as both are informed by the practice. Think, for example, how we talk about Dostoyevsky.

Also, the form of a tribal mask designed to terrify outsiders is something that occupies the native artist, but not so that interlopers savor it for its own sake. Were they to do that, the mask would be self-defeating, since it is not intended to transfix foreigners in aesthetic ecstasy but to send them off in flight. Likewise, the visions of hell in our own culture—such as those by Bosch and Breughel—were not designed to encourage contemplation for its own sake. They are meant to frighten the viewer—to call her back to the straight and narrow path out of fear of eternal damnation. These spectacles are not intended to be consumed disinterestedly. Nor is it the case that the viewer regards her terror of hellfire as valuable for its own sake; it is valuable for the way in which it encourages pious living. In these examples, it is quite evident that though the artist is concerned with the form of the work, the form for its own sake is neither the mandated focus of the work, nor the focus for the intended audience.

At best, the common-denominator argument might establish that in general artists are concerned with form—that a commitment to formal invention is a general feature of art. But this falls far short of what the autonomy thesis requires and for two reasons. First, it is logically consistent with the assertion that a formal dimension is a necessary condition of all artworks, that artworks have other, non-extraneous dimensions, given the kinds of things they are, which may be

[17] Edith Wharton, *House of Mirth* (Harmondsworth: Penguin, 1995), p. 122. Also cited in M. W. Rowe, "Lamarque and Olsen on Literature and Truth," in his *Philosophy and Literature* (Aldershot: Ashgate, 2004), p. 133.

purposive and contentful, and, furthermore, these dimensions may be equally or even more essential than the formal dimension with respect to the type of art at hand.

Second, even if we agree that every artwork has a formal dimension, there is no reason to imagine that it is the formal dimension for its own sake that should *qua* artwork preoccupy us. For with respect to certain sorts of artworks, form may be merely a transparent gateway, albeit an indispensable one, for facilitating the audience's absorption in a larger point or purpose (such as social, psychological, and moral insight as in the case of the typical realist novel). This is not to say that there are not artworks for which the contemplation of form for its own sake is not apposite, but only that, even if appropriate or suitable form were aimed at by every artwork, it does not follow that it is the intended focus of every artwork. Moreover, the realist novel is not the only artform where this is so. Similar points with respect to the visual arts might be made regarding the genre of caricature. Hogarth, Daumier, and Grosz are surely as, if not more, esteemed for their discernment, both social and moral, as they are for their formal prowess.

Philosophical formalism is the best hope for the thesis that the art is autonomous, for it lights upon a feature of art that appears to be not only arguably generic but detachable from other realms of social value, namely, form for its own sake. However, as we have seen, it is not form for its own sake that is of general concern across the arts in the Modern System but just form, often for the sake of something else, and, in any event, in a way that is consistent with artworks possessing other aims, such as ethical instruction, that are as artistically essential to the kinds of artistic practices they instantiate as is the commitment to formal efficacy.

Without formalism, the strongest case for the philosophical endorsement of the autonomy thesis founders. For formalism gives the philosopher something positive that art is about, namely, form for its own sake. Without that, the thesis becomes simply negative and hollow in a way that is ultimately uninformative and, therefore, intellectually unsatisfying. But without the common-denominator argument, it is hard to see how to get formalism off the ground.

That, of course, will not stop philosophers from trying, since the notion of the autonomy of art fits so neatly with their essentialist ambitions. However, here it must be emphasized that essentialism at the level of Art with a capital "A" is purchased at the price of ignoring the natures of many of the artforms, genres, movements, and styles that fall under that umbrella concept but which, due to their own essential aims, are inextricably and heteronymously enmeshed in such enterprises as the discovery of knowledge (psychological, social, and moral); the promotion of insight and understanding (personal, political, ethical, religious); the clarification and dissemination of the ethos of a culture or subculture; and so on. Autonomism for the sake of essentialism about *Art* with a capital "A" obscures getting clear about the natures of the *arts* (beginning with a minor

case "a" and ending with a small "s"). It is an instance of the philosophy of art standing in the way of the philosophies of the arts.[18]

The autonomy thesis in the philosophy of art has served to alienate philosophical inquiry into the relation of art with other social practices in a way that parallels the withdrawal of modern art, under the aegis of autonomism, from the life of the broader culture. In the philosophy of art, this has resulted in an unduly constricted, even distorted, view of art, one that has been virtually blind to many of the dimensions, such as its ethical address, that make art important. But, in addition to the violence done to the data, this approach has also inflicted damage to the field of the philosophy of art. It has turned it into an area of barely marginal interest. For in allegedly discovering that art serves no interests but its own—aka form for its own sake—philosophy "proves" that no one outside the artworld need take any interest in it. By embracing the autonomy thesis, the philosophy of art alienates both art and itself from the wider culture.

Of course, in philosophy, untoward practical consequences alone do not refute a thesis. But, given the long history of art, the burden of proof belongs to the autonomy theorist.[19] Apparently, his best argument is the common-denominator argument. Therefore, if it fails, as I hope I have shown it does, we are free to reopen the kind of inquiries about the arts that Plato and Aristotle initiated, inquiries that attempt to ascertain the intimate relation of the arts to the emotions, morals, politics, and so forth of the communities they serve.

4. CONCLUSION

For nearly two centuries, the artworld and the philosophy of art have to a surprising degree defended the viewpoint that art is autonomous from other social practices. An immediate consequence of this has been a decoupling of art and ethics, despite their longstanding affiliation heretofore. The hegemonic trend of ambitious art through much of the modern period has been to stress the independence of art from morals not only as a hedge against censorship, but also as a way of removing self-perceived constraints upon the self-expression of the artist. The serious artist through most of this period has not respected moral instruction and exploration as a worthwhile vocation, but as topics that belong to children's authors, to the creators of animated cartoons, and maybe the producers of soap operas. However, the cost of the self-alienation of art from the broader culture has been the pervasive marginalization of ambitious art that is only sporadically relieved on the heels of some or another scandal.

The marginalization of serious art is a practical problem that I believe flows from the artworld's continued affirmation of autonomy and the policies that

[18] See Peter Kivy, *Philosophies of the Arts: An Essay in Differences* (New York: Cambridge University Press, 1997).

[19] For an overview of recent philosophical discussions of the relation of art and ethics, see Noël Carroll, "Art and Ethical Criticism," *Ethics*, 110 (2000): 350–87.

stem from it. The antidote, broadly stated, is that artists once again have to become involved in the life of the culture, taking up many of the responsibilities that modern art has shed under the sign of the autonomy of art. This includes re-entering the ethical realm, not only, I stress, in the role of social critic, but also as transmitter and shaper of that which is positive in the ethos of their audience. The ambitious artists present will undoubtedly challenge me to say how this is to be done. I do not know exactly; and, anyway, it is their job to figure this one out. But let me suggest that they might start by thinking about the Constructivists.

The philosophy of art is lured toward the autonomy thesis for theoretical rather than practical reasons. The influence of the autonomy thesis, even where it is not explicitly embraced, is everywhere apparent in the philosophy of art as currently practiced. That is why so few of the textbooks in the analytic tradition have sections devoted to the relation of art to society, to politics, to national identity, to racism, to morality, and so on. For, under the presupposition that art *qua* art is autonomous and that the philosopher of art examines only those aspects that are essential to his object of study, such relations are not on his radar screen.

This myopia has not only reduced the extent to which the philosophy of art is taken seriously—how important or pressing can the study of something that is connected to nothing else really be?—but it has skewed philosophical research in its obliviousness to the fact that most art, including art of today (even if you want to deny that it is ambitious art) has been and is involved with ongoing social concerns. Thus, by abandoning the commitment, both explicitly and implicitly, to the autonomy thesis and by attending to art's involvement in society, politics, and ethics, the philosophy of art could not only provide a truer account of its object of study, but it would begin to reverse the opinion, shared even among other philosophers, that it is as useless and extraneous as it has attempted to demonstrate, wrongly to my mind, that art is.

9

Art and Recollection

Undoubtedly, as the discussions about how to commemorate the events of 9/11 have shown, we need to think seriously about memorial art—those statues whose often forgotten heroes molder in public parks and town squares everywhere. But perhaps that neglect is no more pronounced in any relevant domain of inquiry than it is in the philosophy of art, since memorial art is art expressly designed to perform cultural functions and there remains in modern aesthetics a strong tendency to withhold the title of art, properly so called, from works noteworthy for their social utility. Such art is, for a great many aestheticians, below their theoretical radar screen.

The culprit here is the aesthetic theory of art which maintains, roughly speaking, that something is an artwork if and only if it is designed with the primary intention of affording or having the capacity to afford experiences valuable for their own sakes.[1] The aesthetic theory of art might be diagnosed as a philosophical reflection of that wing of modernism called aestheticism. Artists in the nineteenth and twentieth centuries, so the story goes, sought to resist the assimilation of all value to utilitarian and especially market value by attempting to create works that had no other value than that available through the contemplation of the work itself, isolated from whatever useful, including socially useful, purposes such works might be expected to serve.[2]

Philosophers then, like the owl Minerva, spread their wings over this artistic tendency, protecting it with formidable argumentation until it became one of the most deeply ingrained biases of the philosophy of art—or, at least, the default assumption of a great many of those who practice said philosophy. Perhaps some evidence of this lingering, almost automatic or subconscious prejudice is that the

The author wishes to thank Peter Kivy, Hugh Felix Carroll III, Laurie Beth Clark, Michael Peterson, and Gary Iseminger for their help with the preparation of this chapter. However, only the author is responsible for its shortcomings. This chapter was originally presented as a talk during the session on memorial art at the Annual Meetings of the American Society for Aesthetics in Miami, Florida, in October 2002.

[1] For a representative presentation of this view, see Monroe Beardsley, "An Aesthetic Definition of Art," in Hugh Curtler, ed., *What Is Art?* (New York: Haven Press, 1983), pp. 15–29.

[2] For philosophical objections to the aesthetic theory of art, see Noël Carroll, *Philosophy of Art: A Contemporary Introduction* (London: Routledge, 1999), Ch. 4.

scholarly societies in the English-speaking world that specialize in the philosophy of art bear names such as the American Society for *Aesthetics*, the British Society for *Aesthetics*, and so on.

But if art, properly so called, must be intended primarily to deliver aesthetic experience—experience valued for its own sake and not for social utility—where does that leave memorial art, art dedicated first and foremost to discharging social functions, art that would not succeed on its own terms if indeed it was valuable primarily or exclusively for the intrinsic value of the experience it afforded? It leaves it off the theoretical map of the philosopher of art, unless the philosopher is prepared to argue, somewhat in the face of the facts, that such artworks, despite the convictions of those closest to it, were undertaken with the primary intention of affording aesthetic experience, appearances notwithstanding.

Of course, another option is for the philosopher to deny that such work is art at all, consigning it to the category of kitsch. And perhaps a parallel observation to that of taking note of the philosopher's discomfort with memorial art is that high modernism, of which I maintain the aesthetic theory of art is a reflection, has been, for the most part, singularly unsuccessful historically in producing major art of this sort, the Vietnam Memorial being an exception to this generalization of which there are only a few others. Fundamentally, both high modernism and the aesthetic theory of art appear constitutionally inhospitable to memorial art.

Of course, the theoretical cost of cashiering memorial art from the order of the muses is potentially quite high, since so much art traditionally has had a memorial function or, at least, a significant commemorative dimension.[3] For that matter, one might even be tempted to claim that most traditional art has had a memorial dimension as part of its essential address, though I do not require such a strong assertion to be true in order to make my argument. It is enough that a vast amount of traditional art is memorial for the argument to proceed. And that much is undeniable.

The *Iliad* and the *Mahabharata*, along with countless other epics, commemorate the founding struggles of their respective peoples. The depiction of Christ's crucifixion, the motif of an indefinitely large number of Christian paintings and sculptures, is basically commemorative in purpose as are the cathedrals, churches, and monasteries in which many of these representations are housed, often taking their names from the saints or holy events in whose memory they have been erected. As we stroll through the churches and temples of Europe and Asia on our summer tours of the great art of the world, most of the art we are seeing is commemorative in nature. But religion has no corner on memorials. Politics in the form of representations of great leaders, law givers, generals, founding fathers, important and unimportant battles, historic oaths, and other events decorate with remarkable frequency the walls of museums and public buildings, while also populating thoroughfares and town squares far and wide. This, of course, comes

³ Nicholas Wolterstorff, "Why Analytic Philosophy of Art Cannot Handle Kissing, Touching, and Crying," *The Journal of Aesthetics and Art Criticism*, 61/1 (winter 2003): 17–28.

as no surprise, since, for much of the past, the Church and state were leading patrons of art.

Poetry has several genres that specialize in remembering: the epitaph, the elegy, and, to some extent, the eulogy. So many novels in the modern period have been remembrances of wars past. In film, the former Soviet Union commissioned Pudovkin's *The End of St. Petersburg* and Eisenstein's *October* to commemorate the 1917 revolution, while *Potemkin* was a celluloid monument to the 1905 revolution. As well, much music is memorial. This is obviously the case with music composed to commemorate special events, like royal weddings and funerals, and with music that accompanies religious observances, such as the Passion; but there is also music that celebrates historic events, like Mozart's *Coronation Mass*, Liszt's *Hungarian Coronation Mass*, and Tchaikovsky's *1812 Overture*. Even the portraits of once thriving burghers were undertaken for the sake of memory, and then posterity. In short, it is difficult to deny that much art, especially much traditional art, is memorial in nature, designed essentially to recollect the past for various ulterior purposes, that is, purposes ulterior to engendering aesthetic experiences valuable for their own sake.

What is the aesthetic theorist of art to do with this "monumental" fact? He may try to bite the bullet and contend that these examples are not art. But that would render the theory suspect for most. Losing the *Aeneid*, the *Winged Victory of Samothrace*, the *Bayeaux Tapestry*, and the *Arch of Triumph* as artworks is too steep a price to pay for any theory. Alternatively, the aesthetic theorist may allege that, though the pertinent works in question appear to be aimed primarily at acquitting social functions, that is not really the case. Artists merely used the opportunities granted them by the Church and other patrons to make works that were meant to induce aesthetic experiences, while pretending to do something else—glorifying Christ's sacrifice, the king's beneficence, or the courage of the common soldier.

Not only does this hypothesis appear far too cynical; one also doubts that it could be sustained empirically. The historical record will bear out that most of the relevant artists did intend primarily to glorify God and that they would be appalled to have their works taken as simply pretexts for aesthetic experience.

On the other hand, the aesthetic theorist might suggest that we have misconstrued what is meant by an aesthetic experience valued for its own sake. This need not be thought of only in terms of the play of the imagination in response to the forms of an artwork. Rather, if the experience of Christ's love, engendered by the artwork, is valued for its own sake, then the experience in question is aesthetic. However, this solution, it seems to me, has the whiff of equivocation about it. For the notion of an aesthetic experience as one valued for its own sake was introduced traditionally to mark a contrast with social or religious utility. To maintain that such utility itself or the experience thereof can be valued for its own sake evaporates the contrast. Thus, the aesthetic theorist may appear to have repaired the damage the examples I've discussed inflict, but only at the cost of giving up the point of his theory.

Admittedly, at this juncture, the aesthetic theorist of art, of whom there are a growing number nowadays,[4] may feel a bit exasperated with what I have said, regarding it as somewhat of a caricature. She may observe that the kind of aesthetic theory that I have been hammering is a thing of the past. The contemporary aesthetic theorist is well aware of these sorts of objections and, it may be said, has armored his theory against them. Some, like Alan Goldman[5] and Malcolm Budd,[6] might respond that they are not in the business of defining art. They are only concerned with what is very valuable in great art or with what has artistic value, properly so called. That is, what they think attention to the production of experiences valuable for their own sake tracks is not whatever we are willing to call art, and certainly not everything for which artworks can be appropriately, though not artistically, valued. This response, however, merely invites reframing some of the preceding objections. For certainly some memorial art is highly valuable, indeed artistically valuable, exactly because it implements so well the social functions for which it was designed.

Another sophisticated response is suggested by Gary Iseminger.[7] According to Iseminger, art is aesthetic, by which he means that it is the function of art, presumably *qua* art, to afford what he calls aesthetic transactions.[8] Aesthetic transactions appear to be roughly synonymous with what are traditionally called aesthetic experiences, experiences of the sort intended to be valued for their own sake, experiences said to be intrinsically good. Art may have other functions, but its function *qua* art is to afford aesthetic experience. It is in this sense that art is essentially aesthetic. Though Iseminger does not explicitly say this, it appears to follow that something that does not have this function is not functioning as art.

Iseminger advances two considerations on behalf of the thesis that art is essentially aesthetic: that affording aesthetic transactions is something that art does better than any other practice *and* that affording aesthetic transactions is what art does best of all the things it does. These premises, then, encourage Iseminger, following Daniel Dennett's Principle of Artifact Hermeneutics, to infer that art is intended to afford aesthetic transactions.[9]

Neither of these claims seems to me decisive. Whether the practice of art is better at affording aesthetic experiences than the practice of nature appreciation

 [4] For example: James C. Anderson, "Aesthetic Concepts of Art," in Noël Carroll, ed., *Theories of Art Today.* (Madison, WI: University of Wisconsin Press, 2000), pp. 65–92; Nick Zangwill, *The Metaphysics of Beauty* (Ithaca, NY: Cornell University Press, 2001); and Gary Iseminger, "The Aesthetic Function of Art," in Kevin L. Stoehr, ed., *Proceedings of the Twentieth World Congress of Philosophy: Philosophies of Religion, Art, and Creativity*, Vol. 4., Philosophies of Religion, Art and Creativity (Bowling Green, OH: Philosophy Documentation Center, 1999), pp. 169–76.
 [5] Alan Goldman, *Aesthetic Value* (Boulder, CO: Westview, 1995).
 [6] Malcolm Budd, *Values of Art* (Harmondsworth: Allen Lane; Penguin Press, 1995).
 [7] Gary Iseminger, "The Aesthetic Function of Art," pp. 169–76.
 [8] This terminology is contained in a letter sent on September 5, 2002, to the author from Iseminger.
 [9] Iseminger, "The Aesthetic Function of Art," pp. 169–76.

appears undecidable. Iseminger attempts to deal with this issue by arguing that inasmuch as nature lacks an artificer, it does not afford as complete an aesthetic experience as art does. However, I remain unconvinced by this because I am not clear that appreciating the skill of an artist is what the tradition usually counts as an aesthetic experience. On the one hand, it would have been disallowed by aesthetic theorists like Monroe Beardsley who worried about the genetic fallacy, while, on the other hand, there would appear to be a straightforward way of regarding the artist's contribution as merely instrumentally valuable for producing in audiences the consequent aesthetic experiences that are valued for their own sake.

But, in any event, it is Iseminger's second claim that is more relevant to the issue of memorial art—namely, that of all the things that art does, affording aesthetic transactions is what it does best. Admittedly, Iseminger moves between stronger and weaker claims here. Sometimes he claims that affording aesthetic transactions is something art does quite well and, at other times, he says it is what it does best or does best now. The weaker claim is not germane to the artistic status of memorial art, since it is compatible with art as such doing several things well and having several functions—including both memorializing and promoting aesthetic transactions. And this seems completely unobjectionable to me.[10]

The more ambitious claim provides the grounds for Iseminger's conclusion that art as such is intended to afford aesthetic transactions and is, for that reason, essentially aesthetic. Since *ex hypothesi*, of all the functions art has (or has now), affording aesthetic experience is what it does best, we are putatively entitled to infer that this is *the* function of art *qua* art, that is, art construed as a natural kind. Though the inductive reasoning here seems open to dispute, I will not quibble with it now. Rather I want to focus on the premise that of everything art does, the affordance of aesthetic experience is what it does best. For it seems to me that the functions performed by memorial art at least rival and arguably surpass the aesthetic function of art.

In order to substantiate this claim, however, something must be said of the function of memorial art. Memorial art, of course, has several functions. But one function of public memorial art is to commemorate the past for the present—to recall to mind exemplary events and persons and to limn their significance to the ongoing culture, contributing thereby to the definition of cultural identity and indicating the direction in which the culture should continue. Memorial art transmits the ethos of a culture. It celebrates the honored dead, underscoring their virtues, and calls upon the living to emulate them. The praise it lavishes on the deceased is intended to encourage later generations to be like them.[11]

[10] At least, if you construe aesthetic experiences as I do. See: Noël Carroll, "Aesthetic Experience Revisited," *British Journal of Aesthetics*, 42/2 (April 2002): 145–68.

[11] Of course, some memorial art, such as memorials to the Holocaust, may have the purpose of reminding viewers of significant, but dark, historical episodes and of reminding spectators of the vices that gave rise to them and the need to combat them. Perhaps needless to say, discouraging the pertinent vices is, as well, an essential part of the enculturation process.

Memorial art is a key participant in the continuous reconstruction of the social order. It reminds present generations of who they have been and of the virtues and values that have made them what they are, and it encourages them to persist in the same direction. Art in general, in this respect, of which memorial art is a prime example, is fundamental to the reproduction of culture and society. It educates and enlists succeeding generations in the ethos of the culture, its defining ensemble of beliefs and values. That is what Homer did and that is why he was called the educator of the Greeks.

Moreover, art, including memorial art, executes this social function exceedingly well. By simultaneously addressing, often, but not always, pleasurably, the perception, imagination, memory, emotions, and cognition with concrete images—that is, by engaging so many faculties of the whole person at once—it deeply embeds the ethos of the culture in appropriately prepared recipients. By mixing sense and sentiment, feeling and information, art renders the ethos of the culture accessible to its citizens and eminently retrievable for memory insofar as it has been encoded across multiple faculties. It makes values perceptible or, in the case of literature, it describes them in powerful, arresting, memorable images.

It is not obvious that any other practice transmits the ethos of a culture as well as art does. Art is clearly advantaged in this regard because it does not merely address cognition with abstract information but engages audiences by way of the sensuous, the feelings, including frequently feelings of pleasure, the emotions, perception, memory, and the imagination. Thus, the ethos it imparts is redundantly imprinted across several dimensions of its recipients' being, thereby enhancing access and retrieval. Art can educate the whole person by involving many of our powers at the same time and in interrelated, mutually reinforcing ways. This makes art an immensely expeditious and probably indispensable instrument for the transmission of culture, one far superior, I suspect, to any other cultural practice.[12]

Nor is it evident that art performs any other function quite so well as it does this one.[13] Indeed, it is scarcely conceivable that the costly—in terms of time and resources—institution of art would have survived through the ages and across cultures had it not been effectively performing a crucial social function such as the dissemination of the values and beliefs of the societies in which it formed an integral practice.[14] Given these observations, the view of aesthetic theorists

[12] In arguing that art is aesthetic because it affords aesthetic experience better than any other practice, Iseminger does not consider the possibility that there may be some other function, such as transmitting the ethos of a culture, that art performs better than any other practice. This would seem to be a major gap in his argument.

[13] Admittedly, the very notion of comparing the efficacy of different functions of art is difficult to operationalize. However, since it is something on which the aesthetic theorist relies, any inadequacies with this way of proceeding should be counted as liabilities of the aesthetic approach presently under examination.

[14] Historically speaking, things like commemorative art may have a better claim than aestheticism to implementing the founding function of art inasmuch as the earliest art has been frequently discovered in burial mounds.

of art—that the affordance of aesthetic experience, understood as independent from social utility, is *the* function of art—appears dubious, since what art does best, in the two senses Iseminger countenances, is arguably to enculturate and reinforce the ethos of social groups in a way that promotes their cohesion and continuance. Art, among other things, is engaged in the continuous reproduction of the social order.

At the very least, it must be stressed, aesthetic theorists of art have failed to show why art's contribution to enculturation is not the thing it does best, not only of all the things it does, but also what it does better than any other practice. The aesthetic theorist of art appears to presuppose almost complacently that the affordance of aesthetic experience is what art does best without ever considering competitors like enculturation. Moreover, when one weighs the role of art in enculturation, it is difficult to deny the centrality of this function. Is this not why the practice of art commands support in every known culture and is an integral part of our educational institutions? Surely this is why art as a generic practice or type came into existence. And the fact that much art continues to discharge this function is a substantial part of the account of why art continues to exist.

This function of art—to enculturate—is especially apparent in memorial art, whether in the form of statues, monuments, murals, pageants, processions, paintings, dances, songs, poems, films, and so on. Memorial art functions vividly to remind its audiences of culturally important events and persons and of the commitments, values, virtues, and beliefs for which they stand. By celebrating the past, and the ethos they represent, memorial artworks attempt to facilitate the reproduction of the relevant social group by inspiring emulation. They function to recall the past, and, through the process of recollection, to encourage continued imitation. Such artworks enliven perhaps forgotten or neglected commitments and ideals (whose full seriousness and relevance is often overlooked) through its sensuous appeal and they attempt to project them onto the future by inspiriting posterity to remain true to its heritage.[15] Memorial art often expresses national pride, pride in the national ethos whose continuance it abets.

Greek memorials to the battle of Marathon, for example, celebrated it as the victory of the value of civilization over barbarism, while Christian depictions of the crucifixion function to call to mind Christ's sacrifice, not only to reverence it, but to encourage believers to imitate it in their lifestyle. English epitaphic poetry of the seventeenth century, whose purpose Samuel Johnson claimed was to teach the "bulk of mankind,"[16] emphasized as key the importance of living a life in terms of virtues like honesty over the importance of an aristocratic birth, thereby promoting emerging humanist values through engendering the recollection of what makes life significant, which recollection, in turn, was intended to encourage

[15] See Noël Carroll, "Aesthetics and the Educative Powers of Art," in Randall Curren, ed., *A Companion to the Philosophy of Education* (Oxford: Blackwell, 2003), pp. 365–83.

[16] Samuel Johnson, "An Essay on Epitaphs," in Donald Greene, ed., *Samuel Johnson* (Oxford: Oxford University Press, 1984), p. 96.

emulation.[17] The Pantheon in Paris is a collection of exemplars of virtue designed to showcase the culture of France in a manner that invites viewers to carry the tradition forward.[18] The Lincoln Memorial commemorates not only the man, but also the values for which he stood, and reminds onlookers of that to which Americans are committed.[19]

The function of memorial art is to depict what is significant about what it memorializes, to recollect the past in order to galvanize a commitment in the hearts and minds of viewers to following the example of the virtues and ideals enshrined in the memorial artwork. In this way, memorial art discharges one of the central functions of art—namely, instilling the ethos of the culture in its members. Unveiling the memorial at the Leys School in Cambridge, which has a statue of St George as a central figure, the Duke of York explicated its meaning: "It will stand for all time, a pivot of the school's history and tradition and the inspiration of those ideals of chivalry, self-sacrifice, and patriotism which are essential to the highest conduct and character."[20] That is, the function of the sculpture is to inculcate the culturally prized virtues of chivalry, self-sacrifice, and patriotism.

At present, war memorials and monuments, given the events of 9/11, are of particular interest. They, like memorials in general, can serve the purposes of enculturation in terms of promoting desired virtues, a sense of duty, and the ideals that call for sacrifice. French World War I memorials, of which there are over 38,000, celebrate republican virtues. Rather than being shrines to generals, more often than not, they are dedicated to common soldiers, thereby underscoring the republican virtue of equality. Recurring themes also include obedience, devotion to duty, sacrifice freely given, and patriotism—all virtues recollected in order to be honored, but also to be emulated. Such monuments extol the fallen dead for their contribution to the defense of liberty and tolerance.[21] In this way, abstract and legalistic republican virtues are given a concrete, perceptible form in a manner that makes the ethos comprehensible and attractive to viewers.

[17] Joshua Scodel, *The English Poetic Epitaph: Commemoration and Conflict from Johnson to Wordsworth* (Ithaca, NY: Cornell University Press, 1991), Ch. 5.

[18] Mona Ozouf, "The Pantheon: The École Normale of the Dead," in *Realms of Memory: The Construction of the French Past, vol. III, Symbols*, under the direction of Pierre Nora, transl. Arthur Goldhammer, English edn, ed. Lawrence D. Kritzman (New York: Columbia University Press, 1998), p. 330.

[19] Indeed, one might claim that the Vietnam Memorial, given its vaunted interpretive openness, ultimately celebrates tolerance of differing opinions, arguably a central virtue in a society like that of the United States that conceives of itself as fundamentally pluralistic.

[20] Alan Borg, *War Memorials from Antiquity to the Present* (London: Leo Cooper, 1991), p. 100. This book will be cited as *WM* in the text for all subsequent references.

[21] On French war monuments, see Antoine Prost, "Monuments to the Dead," in *Realms of Memory: The Construction of the French Past, vol. II, Traditions*, under the direction of Pierre Nora, transl. Arthur Goldhammer, English edn, ed. Lawrence D. Kritzman (New York: Columbia University Press, 1997).

Of course, the ethos of one culture may differ in significant ways from that of other cultures. Thus, German World War I memorials differ from those of the French by emphasizing Protestant piety and German national consciousness,[22] while Italian monuments of the period often employ gladiatorial imagery to commemorate war as the supreme test of manhood and male camaraderie.[23] But, in each case, the memorial performs the function of disseminating the cultural values esteemed by the pertinent society and regarded as essential to the construction of its future.

For example, the Canadian memorial at Vimy Ridge, designed by Walter S. Allward, contains symbolic figures representing Peace, Justice, Truth, and Knowledge, implying these values are what motivated those who sacrificed their lives and what posterity should be prepared to fight for as well (*WM:* 99). In a less allegorical vein, the Royal Artillery Memorial at Hyde Park Corner shows a shell carrier exuding determination and force, while the presiding captain evinces calm power, underscoring the manly virtues and the specific kind of heroism believed to be required to protect British civilization (*WM:* 121–2). Other British memorials convey an affirmation of cheerful optimism in the face of adversity (*WM:* 1).[24] This kind of exemplary iconography, moreover, is not a thing of the past, as witnessed by what might be called the media memorials to the police and firefighters of 9/11. Their deeds are recounted and recollected as much to transmit cultural values, including its ideas of virtue, as they are simply to remember the heroes.

So far I have been dwelling at length on one function of memorial art—the recollection of the past for the purpose of reproducing the ethos of a culture in the future. I have emphasized this function because it seems to me to exemplify one of art's most central functions, *pace* aesthetic theories of art. But memorial art has other functions. Many ancient war memorials celebrate strength, functioning both to terrify prospective enemies with the power of the ruler and to reassure the native populace that he has what it takes to defend them. The narrative relief in the palace at Nineveh, commemorating the defeat of the Elamites at the Battle of the Ulai River begins with the inscription "I am Ashurbanipal, King of the Universe, King of Assyria, Conqueror of my enemies," followed by violent battle scenes (*WM:* 25–6). Clearly, this is meant to frighten visiting emissaries and to convince Assyrians of the invincibility of

[22] George L. Mosse, *Fallen Soldiers: Reshaping the Memory of the World Wars* (Oxford: Oxford University Press, 1990), p. 35.

[23] Ibid., p. 104.

[24] Also certain monuments erected in Britain, Australia, and New Zealand early on during World War I commemorated the call to arms, celebrating ordinary citizens gladly volunteering to go to war, thereby asserting the moral character of the nation in a way predicated upon exciting others to recall their patriotic commitments and to enlist likewise. See Jay Winter, *Sites of Memory, Sites of Mourning: The Great War in European History* (Cambridge: Cambridge University Press, 1995), p. 80.

their leader. For neither audience is it intended to afford an experience valued for its own sake.

Another function of war memorials, especially more modern ones, is to promote consolation and healing.[25] The memorial consoles the bereaved—both his immediate loved ones and fellow citizens who share their sense of loss—by reminding them that the fallen did not die in vain and that the living remain connected to them in the sense of owing them a genuine debt. This provides the friends and families of the dead with a way of remembering that "quietens embitterment and alleviates despair."[26] Memorials and the ceremonies that attend them give articulate focus to the unease the loss has caused and allow for the reassessment of the event in retrospect; this enables mourners to manage their emotions, to move from shock to healing inasmuch as the memorial enables them to digest and process what has happened in a focused way.[27] That is, through the emotionally clarifying agency of the memorial, sorrow becomes more controllable and tolerable.[28] Moreover, as with the other socially useful functions of memorials, it would be strange to assess these experiences of consolation and healing as non-instrumentally valuable ones.

Of course, by emphasizing the social utility of memorial art as a way of recalling that much art functions in the service of social utility in the ways I have sketched—and by stressing that this has a fair claim to the title of what art does best—I do not intend to suggest that the function of art as such is exclusively something like the transmission of the ethos of a culture. That is one function; promoting aesthetic experience, suitably construed, is another.[29] Each type of art should be evaluated in terms of the functions it serves, both in terms of how well it discharges that function and how worthy that function is.[30]

Memorial art reminds us that much art is embedded in cultural practices and addresses social needs. Thus, it is incumbent on philosophers of art to develop conceptual frameworks that are theoretically sensitive to art that is part and parcel of "interested" human practices and that serves social purposes. If the era

[25] This, of course, is not only a function of certain war memorials; it is also the purpose of commemorative works like the AIDS Quilt.

[26] Jay Winter, *Sites of Memory*, pp. 115–16.

[27] Georgia Witkin, "9/11 Anniversary Observances Can Rekindle Hope," *USA Today*, August 14, 2002, 13a.

[28] This seems to be the motivation behind Bruce Springsteen's recent album *The Rising*.

[29] See Carroll, "Aesthetic Experience Revisited."

[30] This allows, needless to say, that some memorial art can be bad; it can discharge its function poorly and discharging that function may be disvalued. Perhaps the Martyrs Memorial in Baghdad, commemorating the Iraq–Iran war, deserves low marks on both counts. Evaluating art, in part, in terms of its performing its intended function is also recommended by Daniel A. Kaufman, in "Normative Criticism and the Objective Value of Artworks," *The Journal of Aesthetics and Art Criticism*, 60/2 (spring 2002): 151.

of high modernism is finished, and artists are returning to social engagement, then perhaps the moment has arrived to retire the aesthetic theory of art, that doppelgänger of high modernism, and for philosophers of art to resume thinking about the social function of art, or, at least, certain kinds of art, namely, the kinds of art whose role in various social practices is an integral part of its identity. We need to begin to develop a theory of the social practices of art as those are connected to broader cultural practices and purposes.[31] And memorial art seems like a good place to start.

Moreover, linking art to broader social practices also has relevance to educational policy. It is difficult to motivate artmaking under the dispensation of modernist aesthetic theories, like formalism. People in general and students in particular are practical beings. Putting artmaking in the service of a social purpose, like memorialization, has the advantage of supplying the imagination with a concrete problem with which to grapple. And this is more likely to start the creative juices of students flowing than are abstract mantras about the intrinsic value of aesthetic experience. Reconnecting artmaking with social concerns, that is, will revitalize it for students, while, and at the same time, underscoring the services art can perform for other social practices will probably encourage more generous investments in arts' education programs than art-for-art's sake rhetoric is apt to elicit.

Aestheticians frequently complain that they get no respect—that their subject is regarded as marginal—by the general public and by other philosophers. It is time to consider the possibility that the reason for this lies with the aestheticians themselves. Many of them have preached the doctrine that the value of art is dependent upon its promotion of aesthetic experiences that are valuable for their own sake and for nothing else. Perhaps those who ignore aesthetics have been convinced by aesthetic theorists of art. They too regard the value of art as separate from every other kind of value. This then leads them to dismiss art and aesthetics as marginal. And why should this be surprising? Aestheticians and modernist artists maintain that art inhabits its own discrete niche, celebrating specialized values apart from everything else. Those who fail to take art and aesthetics seriously have simply taken modernist aestheticians at their word and then gone on to surmise that if art is not connected to other interests, then it is of little or no interest either to the general public or to philosophers, like moral and political philosophers, who are not aestheticians.

Undoubtedly, this is not what modernists and aestheticians predicted. In all likelihood, they expected that the consequence of assigning autonomous value to art and the aesthetic would have engendered a sort of reverence rather than

[31] A similar recommendation regarding the direction of the philosophy of art can be found in Wolterstroff, "Why Analytic Philosophy of Art Cannot Handle Kissing."

studious obliviousness. But their own rhetoric of separatism invites an attitude of at best benign neglect toward art and aesthetics, if not one of hostility and dismissiveness. Thus, re-embedding art and aesthetics in broader social projects, such as memorialization, will not only be good for society and art, but for aesthetics as well.

10

Art and the Moral Realm

The relation of art and morality is enduring and complex. Indeed, it is so complex that it is better to speak of the relations of art and morality, rather than to talk as though there were only one relation here. In all probability, art and morality arrived on the cultural scene at roughly the same moment, inasmuch as the earliest tribal moralities and values of the race were articulated and disseminated through the songs, poems, dances, narratives, and visual arts of our early forebears. In the *Iliad*, for example, Homer taught the Greeks the virtues and vices of vengeance (French 2001: Ch. 1). Much early art, as well, was a vehicle of religious expression and belief which involved tutoring audiences in the obligations and ideals of their cultures, while also, at times, criticizing them, as Christ does in many of his parables in the New Testament (Parker 1994: 48).

In the West, medieval art and much of that to follow was devoted to expressing the tenets of Christianity in almost every imaginable medium, including words, song, sculpture, architecture, stained glass, painting, and so on. So many cathedrals are, in effect, encyclopedias of Catholic culture, repositories of Christian values expressed in visual narratives that serve to recall exemplary moments. And the same doctrinal function occurs in the artifacts of non-Western cultures. In short, there can be little doubt that one of the primary functions of art through the ages has been the presentation and exploration of morality.

Art is a primary means for enculturating peoples in the ethos of their society—where that ethos has, as one of its central components, morality narrowly construed. Art introduces us to that ethos and its morality, reinforces and clarifies our commitments to it, often through exemplary stories and characters; art inspires us morally by equipping us with ideals, and it can even suggest ways of criticizing prevailing forms of moral blindness.

Of all the services that art performs, none seems more longstanding than its involvement in the ongoing enculturation of its audiences, which process encompasses their moral education in diverse ways. This is not to say that moral education is the only significant thing that art does. But imprinting and interrogating the ethos of a people, including its morality, for its audiences is one of the tasks art excels in discharging; perhaps it does this as well as anything else it

does. Moreover, this is not only a function of the art of yesteryear; it continues in the literature, drama, film, dance, fine art, and song of artists everywhere today.

For these reasons, it is not surprising that much art is discussed and evaluated in terms of morality. It is not odd, for example, to read a critic chiding Philip Roth's recent novel, *The Dying Animal,* for its apparent inability to think of women as other than sexual beings (Scott 2001). This sort of criticism seems to be an appropriate response to the kind of novel *The Dying Animal* is.

Admittedly, not all art is equally suitable for moral evaluation. Some absolute music and some abstract painting may be bereft of moral content altogether, thereby rendering moral criticism inapposite in such cases. However, so much art traffics in moral matters and presents moral viewpoints that when moral considerations are raised with respect to the relevant artworks, nothing seems amiss—at least to the plain reader, viewer, or listener.

But common sense and philosophy often diverge. And when it comes to assessing the pertinence of art to morality and of morality to art, that divergence can be quite pronounced. On the one hand, since Plato, some philosophers have disparaged art's epistemic credentials as a source of moral education, suggesting that art has little to offer by way of instruction concerning the moral life. That is, art is not relevant to morality. On the other hand, many philosophers, especially since the eighteenth century, have argued that the realm of art is essentially independent from the realm of morality. Thus, moral criticism is not germane in evaluating artworks as artworks. Or, in other words, morality is not truly relevant to art. Indeed, some even might say that it makes no sense, ontologically speaking, to criticize artworks morally, since only agents can be criticized in this way and artworks are not, strictly speaking, agents.

We can organize these arguments against the common-sense view—that art or, at least, some art can be evaluated morally—under three headings: cognitive or epistemic arguments; ontological arguments; and aesthetic arguments. In order to appreciate what is at stake in the debate between philosophy and common sense on the issue of the ethical criticism of art, something needs to be said about each of these challenges.

The cognitive or epistemic arguments against the moral evaluation of artworks challenge the notion that artworks can serve as vehicles for moral education. Such arguments raise concerns about whether artworks are such that they possess the capacity to provide genuine ethical instruction. For, if artworks lack the resources to provide genuine ethical instruction, it makes no sense to commend them for doing so. Moreover, if artworks are really outside the instruction game altogether, then there is little point in criticizing them for failing to do what they cannot do anyway.[1]

[1] This is not the only conclusion the philosopher can opt for at this juncture. For instance, Plato maintained that artworks could not provide knowledge, ethical or otherwise, but this did not lead him to conclude that artworks should not be criticized morally. For Plato, artworks could not afford ethical knowledge, but they could—indeed they necessarily did—promote immorality, and, therefore, they could be disparaged morally. However, since the Platonic position about art in this regard has already been subjected to mountains of criticism, I will not dwell on it in this chapter.

The sorts of considerations that lead some philosophers to challenge the capacity of artworks to contribute to ethical learning include the following: that the ethical knowledge supposedly dispensed by artworks is too trivial to count as real knowledge acquisition (so it is scarcely reasonable to say audiences learn from artworks); that the putative knowledge claims in artworks are empirically unsubstantiated (fictions, for example, are made up; they are hardly evidential); and third, that the moral implications attributed to artworks are not supported by the kind of argumentation and analysis that one typically expects to accompany and to authenticate ethical claims in the realm of moral debate and contestation.

That is, according to what we can call the banality argument, the moral insights attributed to, for instance, literary fictions are too threadbare to count as something a novel teaches its readers. In most cases, the readers must already grasp the relevant truisms—such as that gratuitous cruelty toward innocent victims is evil—in order to understand the novel. Thus, it strains credibility to suggest that the novel teaches this to readers. You cannot teach someone what they already know. Moreover, since the so-called knowledge that most artworks allegedly impart is of this truistic variety, the claim that art contributes to moral education is vastly, if not entirely, exaggerated.

Furthermore, if moral education requires something to teach, namely, know-ledge, then some philosophers worry that art is not up to the job at hand. For knowledge, properly so called, is not simply a matter of belief, but involves belief warranted by evidence, argument, and analysis. And, though artworks may imply or presuppose many beliefs, they do not substantiate them by evidence, argument, or analysis. Most artworks (excepting certain avant-garde attempts) do not include experimental or observational data in support of their claims (Beardsley 1981: 379–80); nor do they contain the sort of explicit argumentation and analysis in support of their moral views that one finds in newspaper editorials, policy statements, sermons, and philosophical treatises, and on the other platforms from which moral claims are advanced.[2]

Thus, though one finds common sense incessantly recommending artistic achievements for their contributions to moral enlightenment, the philosoph-ical skeptic insinuates that this is so much blather, uplifting perhaps, but ultimately empty-headed. For epistemic reasons, art cannot be praised for its cognitive additions to moral knowledge, because what it brokers is neither knowledge (*justified*, true beliefs) nor even new beliefs (rather than merely tru-isms). Nor, the philosopher may add, should artworks be criticized for failing to provide moral education, if that is not something they were ever equipped to do.

But epistemic objections are not the only ones philosophers raise with regard to the relation of art to morality. The epistemic line of attack supposes that it makes no sense to evaluate artworks morally, where such evaluation rests on

[2] This argument against the claims of art to supply knowledge has been identified by Kivy (1997–8), p. 22.

the presumption that artworks have the capacity to afford moral education. But suppose, contra the epistemic arguments just rehearsed, that artworks could be shown to facilitate moral education, and that, in consequence, it does make sense to evaluate them morally. In that event, many skeptical aestheticians will say: "OK, evaluate the relevant artworks morally, but the moral evaluation of said artworks is strictly independent of and irrelevant to their aesthetic evaluation." That is, an artwork may be evil, but that evil need not figure at all in the question of whether it is aesthetically good or bad.

Suppose that Nero incinerated Rome because he thought it would be an enthralling spectacle for the eye (and for the ear, too, since he was fiddling all the while). Though the resulting spectacle was unquestionably evil, it does not follow, so the philosophical skeptic suggests, that it was not also beautiful, for aesthetics and ethics are twain. Thus, even if the epistemic arguments against the ethical criticism of art fail, there are aesthetic arguments that may also be introduced to challenge the common-sense assumption that some, indeed many, artworks can be intelligibly evaluated ethically.[3]

Of course, the epistemic arguments and the aesthetic arguments against the ethical criticism of art make different points. The former claim that artworks cannot be evaluated morally, whereas the latter claim that, even if artworks can be evaluated morally, their moral evaluation is never relevant to their aesthetic evaluation. Thus, one might reject the epistemic arguments, while accepting the aesthetic argument. But there is also another option: one might accept the epistemic arguments as a way of reaching the aesthetic conclusion by contending that, since artworks do not really involve moral knowledge, assessing them, qua artworks, in that light is never appropriate. Rather, they should only ever be assessed aesthetically, despite the commonsensical inclination to suppose that the moral viewpoint of an artwork, at least sometimes, might have something to do with its artistic merit or demerit.

Lastly, the philosopher might charge common sense with speaking nonsense when we talk of artworks as being moral or immoral. People, it might be said, are moral or immoral, not things. This is the aesthetician's variant of the notion that "guns don't kill, people do." Likewise, "artworks are not immoral, people are." It is a category error to think otherwise. Thus, on ontological grounds, the skeptical philosopher bridles at the basic assumption of ethical criticism, however entrenched the idea appears in our artistic practices.

Whether our commonsensical assumptions about the ethical criticism of art can be defended against these philosophical arguments is the question that this chapter addresses. In what follows, I will examine, in turn, the epistemic, ontological, and aesthetic arguments against the ethical criticism of art. By way of preview it is only fair, in the interests of full disclosure, that I confess before the ball starts rolling that I belong to the party of common sense.

[3] The French poet Laurent Tailhade, hearing of an anarchist bomb thrown into the Chamber of Deputies, said: "Who cares for the death of vague human beings, if the gesture be beautiful?" Quoted by Guerard (1963), p. 71.

1. THE EPISTEMIC ARGUMENTS

Because of the multifarious roles that art appears to play in the enculturation of value, a natural first thought about the relation of art to morality is that art participates in the process of moral education. This, then, suggests a basis for the ethical criticism of the arts. Put schematically, art that enhances moral cognition, to the extent that it does so, is morally good; whereas art that distorts moral cognition, to the extent that it does so, is morally defective. This is the commonsensical presumption that the epistemic arguments seek to undercut.

First, it is argued that it is mistaken to suggest that art educates audiences morally, since the beliefs it conveys to audiences—even if true—are so banal that it makes no sense to say that it teaches them to anyone. No one needs a novel as intricate as *Crime and Punishment* to learn that murder is wrong.[4] In fact, knowing that murder is wrong is probably a precondition for understanding the novel. Thus, it is implausible to allege that readers learn this by reading Dostoyevsky.

Second, if artworks are genuinely educative, it is alleged, they must not only be transmitting new, hitherto unrecognized, interesting, non-trivial beliefs; those beliefs must also amount to knowledge—they must be true and justified. But artworks characteristically neither supply the kind of evidence that would be required to warrant the empirical claims they often presuppose, nor support their moral claims with arguments and explicit analysis. Thus, the beliefs proffered by artworks do not constitute genuine knowledge, since they are not justified.

Underlying these epistemic arguments is, of course, a view of what genuine moral education would require. It takes as its paradigm the transmission of a kind of propositional knowledge. If art is educational, it is presumed, it would convey to audiences propositions that are of the order of discoveries—that relay new, interesting (non-trivial), general information—which, in turn, the art in question supports with evidence, argument, and analysis. If art does not communicate propositional knowledge of this sort, either overtly or by implication, then it is not genuinely educative. Moreover, it is argued that art does not characteristically afford propositional knowledge of this sort. So it is not genuinely educational.

Perhaps the first thing to note about this set of epistemic arguments is that its conception of moral education appears unduly constricted. Let us temporarily grant, for the purposes of argument, the skeptic's assertion that art does not

[4] It should be clear that in using this intuition pump about *Crime and Punishment*, I am representing the position of the philosophical skeptic. It is not my position that this is the only thing that *Crime and Punishment* might have to teach. Rather, I only intend to be advancing the skeptic's point in a rhetorically effective and well-precedented way. Unfortunately, some commentators, like Connolly and Haydar, have misinterpreted my expositional deployment of such intuition pumps as my considered view of works like *Crime and Punishment*. Throughout this chapter, I attempt to portray the skeptic's arguments as forcefully as I can in order to attempt to defeat them on their own terms. This should not be taken as a sign that I agree with all the presuppositions of the skeptical arguments. See Connolly and Haydar (2001), p. 122.

characteristically afford knowledge of the sort that he has in mind. Does this preclude the possibility that art is morally educative? Surely it does not, if there are dimensions of moral education that this model excludes which, as well, can be exemplified by artworks. Furthermore, it is not the case that there is just one type of moral education of this variety that the skeptic's model neglects. There are many.

For example, artworks may expand our powers of moral judgment. Many moral rules are of a highly abstract nature and may be very difficult to apply in practice. Artworks, especially narrative ones, can enable us to begin to apply them. Jane Austen gives flesh to the principle that we should refrain from treating others merely as means to our own ends through the concrete case of Emma's meddling in Harriet's love life. In Austen's encouraging us to see what is wrong in Emma's behavior—in being encouraged to judge it wrongful—we are brought to see the relevance of such abstract principles in everyday affairs in such a way that we can become more adept at issuing comparable judgments in real life. In this regard it is the process that engagement with the novel encourages that is educative rather than the product construed as a newly acquired moral maxim.

Narrative artworks require audiences to become involved in a continuous process of making moral judgments about characters, situations, and even the points of view of artworks as a whole. In this, they provide occasions for practice in the application to particulars of abstract moral principles and concepts, such as those of virtue and vice. Without such practice in matching concrete cases to our moral abstractions, moral judgment would remain impoverished, if not inert (Carroll 1998a).

Though art is not the only opportunity we have for acquiring such practice, it remains a culturally important, as well as a sanctioned, one. Indeed, narrative artworks may enlarge our awareness of the range of variables pertinent in making moral judgments—in applying moral principles and concepts to concrete particular cases. In this way, artworks, or at least some of them, may hone our overall skills in making moral judgments.

The enhancement of skills—of our knowing how to do something, such as issuing moral judgments—should count as education on anyone's view of learning. It may not be reducible to the skeptic's paradigm of the acquisition of a certain sort of propositional knowledge, but that is no reason to discount this kind of moral learning as a contribution that art can make to moral cognition. One of the morals of *Emma*—treat others as ends, not means—may in some sense be a truism. But coming to see that that principle can apply to the circumstances Austen portrays—and to similar situations in everyday life—may enrich one's capacities of moral perception and even enable one to increase one's command of the principle in such a way that one sees its applicability to cases unimagined by Austen.

Integral to the ability to make sound moral judgments is the capacity to scope out situations sensitively—to be alert precisely to variables, often not immediately obvious ones, that carry moral significance. Art, especially narrative art, is a leading

cultural vehicle for developing this talent. Thus, in *David Copperfield*, the reader
(with Charles Dickens's help) detects, when first encountering Steerforth, a note
of callous manipulation beneath his superficial charm and congeniality. It may
be close to a truism that charm can cloak opportunism, but it need not be the
acquisition of that proposition upon which the case for the educative value of
David Copperfield, in part, rests. Rather, what Dickens helps the reader acquire is
finesse in sussing out characters like Steerforth—in perceiving the telltale signs
of moral flaws in a concrete context, one that is complex in the sense that it
admits of mixed[5] messages.

Indeed, arguably, art, especially narrative art, can improve our overall atten-
tiveness to the kinds of nuanced behavioral details that are relevant for delivering
accurate moral judgments. Just as exercising our capacity to hit a ball against a
variety of pitchers develops our batting skills, notably in terms of flexibility and
adaptability to new circumstances, so reading novels may expand the acuity of
our moral perceptions.

Augmenting our skills in moral judgment and perception, then, is a contri-
bution to moral education that artworks can make that is not defeated by the
skeptic's banality argument. Thus, where artworks enlarge our powers of moral
judgment, common sense will adjudge them, all things being equal, to be morally
good (or morally bad, should the artworks in question befuddle or confuse or
otherwise impede our powers of moral judgment). Moreover, there are other
sorts of skills besides those just mentioned that art may nurture which are also
morally educative, despite the skeptic's objections.

Art, for example, engages our emotions, including our moral emotions, such
as righteous indignation.[6] Furthermore, our emotions are educable. A large part
of enculturation involves, following Aristotle, learning to mobilize the right
emotion in response to appropriate objects with the suitable level of intensity.
By exercising our emotions, including our moral emotions, artworks may tutor
them—through directed practice—to love and hate the right things for the right
reasons and with the right quotient of energy.[7]

Among the emotions that artworks, especially narrative ones, shape are our
sympathies. In this regard, artworks have the power to enlarge our sympa-
thies—to elicit our concern for people whom we might otherwise ignore, such as
peoples of other races, genders, ethnicities, nationalities, sexual preferences, the
physically and mentally disabled, the elderly, and so on. Much contemporary lit-
erary fiction, theater, film, and TV is dedicated to this project, for instance Athol
Fugard's *"Master Harold"* . . . *and the Boys*. It is hard to see why the cultivation

[5] The capacity of literature to refine moral perception is a major theme of Martha Nussbaum's.
See especially her (1990).

[6] Views of the ways in which art might engage the emotions educatively can be found in Currie
(1995); Walton (1990).

[7] The capacity of art to educate our emotions, of course, is not necessarily distinct from its
capacity to enhance our skills with respect to moral perception, since the emotions and perception
are linked in important respects. Likewise, the refinement of our moral emotions is also connected
to our powers of moral judgment.

of moral feelings through commerce with artworks should not count as moral education.

The skeptic cannot accept it as such, because the narrow view of education he presupposes entertains as education only the acquisition of novel, general, epistemically warranted propositions. But this seems too limited. Moreover, if the skeptic defends this viewpoint by arguing that education is tied to cognition, and that the emotions are not cognitive, then this can be countered from two directions.

First, it may be pointed out that making a sharp distinction between emotion and cognition is too draconian. Emotions, inasmuch as they are generally guided by reasons, possess a cognitive dimension; indeed, audiences may be made aware by their emotional reactions of some of their hitherto unacknowledged beliefs through exposure to certain artworks. And, second, even if the emotions are not cognitive in the narrow sense of being tied to the relevant sort of propositions, education—such as learning to swim or to ride a bicycle—need not be narrowly cognitive in the skeptic's sense.

Thus, contra the skeptic, it makes sense to evaluate artworks that enlarge our emotions or that reinforce our authentic moral sentiments as *pro tanto* morally good, and those that corrupt said emotions as *pro tanto* morally defective. That is, the skeptic's epistemic arguments do not cut against this sort of moral evaluation of—at least some—artworks.

Related to the enhancement of our emotional repertory, especially our talent for sympathy, is another skill that some artworks can promote. Many narrative artworks excel in giving us access to alien points of view. They enable us to understand others from the inside, so to speak. They give us moral insight into behaviors that we might not otherwise comprehend and, for lack of comprehension, morally condemn out of hand. Toni Morrison's *Beloved*, for instance, puts readers in a position to see how the slave-mother's destruction of her own child is not an act of moral depravity, but is motivated by genuinely compelling reasons.

And, apart from the specific moral insights that such novels afford, engaging with works of this kind also, arguably, may in general enhance our moral sensitivity to unfamiliar points of view. That is, immersion in this sort of art can make us more practiced at appreciating the viewpoints of others—can make us more empathetic—thereby dislodging us from our natural inclination toward egocentric and/or ethnocentric partiality. Artworks, then, can augment our powers of moral reflection, not only by undermining specific prejudices through the exploration of alien viewpoints, but by cultivating a general attitude of impartiality in the sense of an openness to the moral claims of others.

So far the kinds of moral skills that we have claimed that some artworks can cultivate are moral in the very narrow sense. That is, they pertain primarily to judgments that employ concepts of right and wrong, obligation and duty, virtue and vice, especially with regard to others or with regard to ourselves in relation to our conduct toward others. However, there is a broader conception of morality, sometimes denominated by the term *ethics*, which concerns questions of the

nature of the good life or the meaningful life.[8] Such ethical concerns—while canvassing narrow moral preoccupations with obligations to others, with justice and fairness, with right and wrong—ask, more broadly, what makes a life worth living.

Clearly, an answer to this sort of question is not reducible to a history of our rightful actions in our conduct toward others. Our lives encompass so much more than following the Ten Commandments or some other, suitably expanded, moral code. But how are we to begin to approach the existentially pressing, ethical (in the broad sense) issue of assessing the worthiness or significance of our lives as a whole?

That is, for many, the question of the meaningfulness of their lives arises unavoidably. In our culture, there is scant guidance as to how to negotiate this challenge, outside religious guidance. In fact, it may be that in our culture artworks—certain kinds of artworks, notably certain kinds of literature—have the best claim to mentorship in this regard. For to answer the question of whether our life is worthy, we need a holistic sense of it, and that holistic sense is best captured by narrative—an incomparable device for organizing or colligating or collecting the diversity of our experiences into a unity. To see our lives as significant requires at least an ability to configure them as meaningful stories. But whence do we learn the skill of rendering or configuring our lives as meaningful stories?

Of course, we hear others recount their lives; and the various roles we inhabit have subtending, if sketchy, scenarios. And, for believers, religious traditions offer narrative paradigms. But for secularists, the most sophisticated narrative exemplars for exploring the unity of lives we have are, in the main, to be found in literary fictions, movies, dramas, and the like. Such narratives can give a holistic sense of a life, exploring it from the inside and the outside, and from beginning to end (or, at least, from nodal turning points to life-determining choices and events).[9]

Genres like the *Bildungsroman* are predicated upon telling life stories. In novels such as *The Magic Mountain, A Portrait of the Artist as a Young Man,* and *Nausea,* we encounter stories of characters deciding the course of their lives as those decisions emerge from a barrage of jostling alternatives. What we learn from these stories, I submit, is not so much a template of a life story to be slavishly emulated as a sense of how to narrate or to structure or to configure the evolution of a life into a unity. That is, mindful exposure to sophisticated life narratives communicates to us the knack of how to begin to tell our own life stories, if only to ourselves, and, in that way, they augment our capacity to find holistic significance and unity in what otherwise may feel like the rush of one

[8] Goldberg labels this distinction between two senses of morality as the conduct-centered sense versus the life-centered sense. See Goldberg (1993), p. 113.

[9] Goldberg points out that there is a dimension of moral judgment that involves taking lives as a whole. This is a matter of seeing their unity. This, moreover, is a dimension of moral judgment that literature excels in modeling. He says: "Literature has always been concerned with making moral sense of lives" (1993), p. 113.

god-damned, desultory thing after another.[10] And acquiring and/or refining this skill for divining the significance or meaning of a life through our intercourse with the relevant sorts of fiction, then, puts us in position—supplies a necessary condition—for ascertaining whether that life-structure is a worthwhile one.[11]

Some artworks, especially narrative ones, contribute to moral education by developing important moral skills with respect to moral judgment, perception, emotional responsiveness, sympathy, empathy, and the capacity to narrate our lives (and those of others) as significant unities. These claims on behalf of the educative potential of art are not defeated by the skeptic's banality argument. Rather, they outflank that argument by finding sources of moral education available in some artworks—notably, in terms of the development of skills (know-how)—that the skeptic, at his own peril, ignores, because of his requirement that moral education afford the acquisition of a certain sort of propositional knowledge (knowledge *that*). However, it is not simply on the basis of skills that one may defend the commensensical notion that (some) art may be defended as a source of moral education.

The skeptic denies a cognitive role to art on the grounds that the propositions obtainable through art are truisms, generally known by audiences in advance of the artwork. Suppose we grant that this is the case (though later we will find reason to contest it). Nevertheless, this dismisses, in effect, the possibility that artworks may function to recall to mind truths the audience already knows, in some sense, but has forgotten or neglected, or truths whose full seriousness and relevance they have not retained or do not access or have suppressed, or that they simply never realized completely to begin with. That is, artworks may serve to remind audiences of what they already know by posing it vividly and concretely.

The poor and the oppressed, for example, may always be with us, and though we know it, it is quite easy to lose sight of this and of its moral implications. Artworks like the activist performances of Dario Fo, the San Francisco Mime Troupe, and Bread and Puppet Theater may not only recall our attention to such mundane facts of life, but also remind us of their moral weight vis-à-vis our responsibilities. Abetting recollection is a leading function of (much) art, while recovering what is already known and bringing back to mind its significance is undoubtedly a contribution to cognition. Thus, even if artworks only traded in moral truisms, that would not show that artworks could not be enlightening, if it could also be demonstrated that frequently artworks function to activate memory

[10] Literature educates us in the ways of structuring not only our own lives as unities, but also the lives of others. And, as Goldberg notes, one dimension of moral insight involves "the capacity to make sense of people's lives in a holistic way . . . a capacity to find terms appropriate to each particular life." This species of moral insight might also be called the moral imagination, due to its capacity to construct unities. See Goldberg (1993), p. 109.

[11] Of course, the importance of narrative art for exhibiting life stories is not only relevant for introducing audiences to ways of beginning to configure their own life stories. By displaying lives, often lives very different from our own, narratives provide access to information about possible lives—what Mill referred to as life experiments. Fictions, in this regard, might be construed as life–thought experiments, cost-free opportunities to contemplate alternative lifestyles. This is an approach emphasized especially by Putnam (1978).

and to recall to mind what is already known, but negligently or remissly so, in a way that underscores its importance.

This, it would appear, has been a major function of art through the ages, and it does not seem appropriate to disparage art as a form of education on the grounds of the alleged triviality of what is presented. For we are often unmindful or forgetful of simple moral truths learned long ago, and, however banal those truths may be said to be, to be reminded of their relevance is hardly trivial. Call this art in the service of memory, which, by anyone's account, should be regarded as an element of cognition.

Artworks may serve cognition not only by promoting recollection of moral knowledge already known, if only dormantly or passively, but also by deepening our understanding of that which we already know. That is, we may possess many beliefs in isolation, or serially, so to speak, but fail to see the interconnections between them. We may know, for instance, that all persons should be treated equitably and that women are treated differently than men, but fail to realize that this differential amounts to a violation of the principle of equal treatment.[12]

In this regard, a feminist novel, such as Marilyn French's *The Women's Room*—by vividly portraying how this differential treatment adversely affects a person, a woman, shown to have justifiable aspirations and needs just like ours (if we are males or male-identified females) and about whom we are encouraged to be concerned—can remove the scales from our eyes, thereby prompting us to reorganize our cognitive stock, to see or to comprehend, where we were previously blinkered, the plight of women as falling under the principle of the equality of persons.

In this way, an artwork can render our belief set more coherent by making the implications and connections between what we know more explicit, perspicuous, and consistent. This sort of gestalt shift in our grasp of what we already know may be best described not as the acquisition of the sort of proposition the skeptic privileges—since the generalization about equal treatment is putatively already in our cognitive stock—but as a deepening of our understanding of a principle we already possess, as an insight into the implications of and interconnections between that which we already know, in short, a remembering of our moral mapping.[13]

[12] Oliver Connolly and Bashshar Haydar contend that this sort of function of novels has greater application to political cases than to personal moral cases. But this is not correct. One could regard the case of *Emma*, discussed earlier, as also vividly underscoring and deepening the principle that persons should be treated as ends, not means, in the personal moral realm. See Connolly and Haydar (2001), p. 121.

[13] I first advanced this response to the skeptic's banality argument in my (1998a). Since then, Oliver Connolly and Bashshar Haydar have criticized that article by presupposing that I claim that only moral understanding of this sort can be derived from narratives, and that propositional knowledge, of the kind recommended by the skeptic, cannot be so derived. This is a misinterpretation of my original article and of my view. In my (1998a), p.158, n.16, for example, I explicitly admit, citing *Native Son*, that some narrative artworks supply the kind of propositions the skeptic requires. And in the body of the text, when I talk about the "standard case" and "the vast majority" of narratives (1998a), p. 141, the implicit hedge is meant to acknowledge that there are cases of

That the relevant principle may be of the order of a truism would appear to provide no reason for dismissing the insight in question as unenlightening. For the novel at issue serves to reorganize our conceptual map, drawing links where before there were none in a way that enables the reader to find new connections in his knowledge stock, thereby engendering new understanding. "Education," we should remind ourselves, comes from the Latin root *educere*, which means to draw forth or bring out or lead out, often in terms of what is latent or potential. Hence, artworks that educe deeper understanding of what is in some sense already known should have a fair claim to being educative.

If the preceding considerations permit us to challenge the allegation that art cannot be educative because it merely rehashes general propositions that, since they are already known, are trivial and, therefore, not appropriately regarded as something that requires learning, we still have not yet addressed the epistemic arguments that maintain that art has no claim to be morally educative, since the beliefs it allegedly advertises do not amount to knowledge, lacking, as they typically do, warrant in terms of evidence, argument, and/or analysis. Zola, for instance, believed that his novels supported the theory of inherited traits. But how could they? His cases were made up—indeed, they were made up expressly to serve his purposes. Would that biologists had it so easy. Likewise, *The Cabinet of Dr Caligari* is said to show that authority breeds madness. But where is the argument?

This set of objections against the educative potential of art is rooted in a very demanding requirement as to what shall count as communicating knowledge, namely, that the relevant knowledge claim carry with it its own warrant, on its sleeve, so to speak. As we shall see, this may be an unrealistic demand. But that notwithstanding, it can be shown that at least some artworks can meet even this very exacting criterion for knowledge communication. In order to see this, it pays to remember that much of the art that we have in mind when we are talking about moral education is fiction. This has led some philosophers to deny that it lacks the wherewithal to warrant the claims it advances. However, it is strange that philosophers should field this objection, since they use fictions all of the time in order to secure their claims.

That is, standard fixtures in the philosopher's repertoire are thought experiments, examples, and counterexamples that are fictional in nature. Thus, if philosophical thought experiments produce knowledge—warranted belief—why cannot it be the case that artistic fictions, conceived of as thought experiments, function analogously?[14]

learning from fiction that meet the skeptic's requirements. Connolly and Haydar confuse my giving the skeptic his strongest case for the purpose of refuting it with my own position, despite the fact that I implicitly and explicitly part company with the skeptic's claim that narrative art cannot provide access to non-trivial, propositional, knowledge claims. See Connolly and Haydar (2001), pp. 109–24.

[14] The notion that some artworks may be conceived of as thought experiments is defended at length in my "The Wheel of Virtue." Subsequent to writing that article, I have discovered that

Philosophical thought experiments can be fictional because the knowledge they aim to produce is conceptual, not empirical. Confronting the doctrine that justice requires never lying, Socrates imagines the case where the question arises of whether it is just to tell an enraged friend, bent on revenge, where he can find his sword. It makes no difference that the case is made up, since on hearing the case, one realizes that it is a possible one, and that its possibility refutes the universal prohibition against lying—it shows that such a universal constraint is not consistent with our concept of what justice demands. The knowledge unearthed by this thought experiment is perhaps something we already knew, but the thought experiment recalls it to mind and makes its pertinence shine forth. Moreover, since the knowledge in question is conceptual—concerning our concept of justice and its conditions of application—it need not rest on empirical evidence.

Clearly, many artistic counterexamples function like this one from Plato. Perhaps Bertolt Brecht's *Galileo* can be interpreted as a refutation of the axiom "never lie," while Martha Nussbaum convincingly reads Henry James's *The Ambassadors* as a challenge to the conception of rule-dominated moral reasoning (Nussbaum 1990). Such cases force us to amend initially attractive or commonplace conceptions of morality by confronting us with eminently possible cases through which the content of our concept of what is moral is interrogated and clarified. Since we are dealing with conceptual knowledge here, it makes no difference that the cases are fictional, thus rendering as beside the point the skeptical allegation that artworks always lack sufficient empirical warrant.

Moreover, since the thought experiment itself is an argumentative strategy—in literature no less than philosophy—the skeptic cannot maintain that art lacks the appropriate argumentative resources, since it shares the thought experiment with philosophy. That is, a thought experiment functions to excavate conceptual knowledge by pointing to neglected possibilities in such a way that listeners come to the relevant conclusions on their own, so to speak. The thought experiment moves the argument or analysis into the minds of the audience, where they make the pertinent connections. Such knowledge may be propositional—propositional knowledge about the conditions of application of our concepts—thereby meeting the skeptic's most stringent demands. Furthermore, there is no reason to suppose that literary counterexamples cannot function as effectively in refuting generalizations as those found in purely philosophical texts, since, among other things, philosophers sometimes uncontroversially use literary examples in this way; considering the Socratic doctrine that a person who knows the good cannot choose to do evil, a philosopher can reach for Milton's Satan, Shakespeare's Iago, and Melville's Claggart as counterexamples.

a similar view is advanced by Zemach (1997), pp. 198–200. Likewise, Helen Reed, the novelist in David Lodge's recent novel *Thinks*, suggests that "novels could be called thought experiments," after she hears various thought experiments from the character Ralph Messenger, the director of the Holt Belting Center for Cognitive Science. "The Wheel of Virtue" appears in this volume.

Literary thought experiments do not only yield propositional knowledge about our concepts negatively, by way of imagined counterexamples to general claims. They may also function to afford positive knowledge of concepts. Philosophical thought experiments are often designed to promote conceptual discrimination by setting forth a polarized, graduated array of contrasting fictional cases that systematically vary the factors that contribute to enabling us to identify conceptual distinctions, dependencies, and other relations. Kant, for example, imagines two merchants—one who counts out the correct change because it is right to do so and another who performs the same action so as to avoid incurring a bad reputation—in order to limn the distinction between moral action and prudent action. The reader, contemplating Kant's contrasting examples against the background of her own conceptual stock, sees the point and performs the analysis on her own; the argument, to the extent that there is one, is supplied by the reader.

Similarly, fictions are often designed in such a way that they can provoke comparable exercises in conceptual discrimination by means of structured arrays of contrasting cases. Dickens's *Great Expectations*, for example, explores the concept of virtuous parenting by constructing a gallery of varied parental figures who instantiate the concept of virtuous parenting to greater, or more often lesser, degrees; Pip's sister, her husband Joe Gargery, Miss Havisham, and Abel Magwitch. Reflecting on this array, we are able to clarify our concept of virtuous parenting. Only Joe qualifies under the concept, since he alone shows selfless love in relation to his charge. Moreover, his possession of this qualification is illuminated by contrast to the other parental figures, who, in varying ways, suggest defective and even vicious modes of parenting.

Pip's sister fails to meet the criterion of virtuous parenting, since she regards Pip as a chore, simply to be disciplined "by hand," as she says. Miss Havisham and Magwitch, in turn, are defective parental figures, since they treat their wards as a means to satisfy their own fantasies—Estella and Pip are not ends in themselves, but means to achieve vicarious wish-fulfillments for Magwitch and Miss Havisham respectively.

The structure of character contrasts in *Great Expectations* enables us simultaneously to clarify our concept of virtuous parenting—it allows us to reflect upon the conditions where we would apply or withhold it—and to sharpen our sense of when the concept is defectively or even viciously instantiated.[15] The text makes these conceptual discoveries available to us, if not as we read along, then in the reflective afterlife of the text or in conversation with others about our reaction to it. In this way a literary fiction may serve the purposes of conceptual discrimination by means of employing a structure analogous to the philosophical thought experiment.[16] And, inasmuch as the philosophical thought experiment

[15] Marshall Cohen and Eileen John have pointed out to me that my use of the notion of conceptual knowledge may be too strained here. Perhaps it might be better to call the kind of knowledge I have in mind philosophical knowledge.

[16] Some literary thought experiments may serve to identify necessary conditions for the application of a concept, as *Great Expectations* zeroes in on selfless love as a condition for virtuous

is warranted by the argument and analysis it elicits in the thinking of the reader, so should we regard at least some artistic thought experiments as warranted in the same way in terms of argument and analysis.[17]

Thus, even allowing the skeptic his extremely exacting requirement of what it would take for an artwork, such as a literary fiction, to communicate knowledge, it can be shown that some artworks possess the wherewithal to do so. For some artworks, construed as counterexamples and/or thought experiments, have the capacity to engender the sort of reflection that yields propositional knowledge about the conditions of application of our concepts in the same way as philosophical thought experiments do. That is, the force of the skeptic's epistemic arguments is too strong. They can only succeed by denying the enlightening potential of thought experiments, a gambit that would consign too much philosophy to the flames.

Up to this point, we have played along with the skeptic's supposition about what would be required for art to communicate knowledge. We have shown that even under this somewhat austere conception, some art, notably some fiction, can pass the test. However, it is important to note that the skeptic's demands are unrealistic, and, once we see that, of course, then even more art than has so far been reclaimed for moral education can be shown to have a legitimate title to communicating knowledge, especially moral knowledge.

Pace the skeptic, we do not characteristically require that knowledge claims come with all the relevant empirical evidence, argument, or analysis written on their sleeves. Claims are typically advanced in newspaper editorials, science textbooks, and even philosophical texts without marshalling all the pertinent documentation or argumentation. Authors rely on readers to bring a stock of empirical and conceptual knowledge to the text and to use that stock to assess the claims they make. Most arguments in historical works, for instance, are enthymematic, notably in terms of the presuppositions about human psychology upon which they depend. Authors, in such cases, rely on their audience to use what they already know about the subject at hand and their understanding of the world to test their conclusions.

We do not epistemically disparage a newspaper editorial about the national budget because it comes unaccompanied with yards of graphs and footnotes; nor do we discount, as potential knowledge, claims about the motivations of world traders because said articles lack experimental data, argument, and/or conceptual analysis. In fact, it is extremely rare that knowledge claims are advanced with anything near full documentation and argumentation. But if this is how we treat knowledge communication in general, why should the standards shift when it comes to art?

parenting. Other literary thought experiments may function to remind us of the importance of certain properties as variables to consider when rendering moral judgments. For an example of the latter case, see my treatment of *Howards End* in "The Wheel of Virtue."

[17] Another function of philosophical thought experiments is to set up a problem, as Plato does with the myth of Gyges in his *Republic*; perhaps needless to say, this can also be a function of literary fictions.

The skeptic, in short, has set the epistemic bar higher for artistic knowledge communication than for ordinary, including most formal, discourse. Once we see that, we realize that the scope for deriving moral knowledge from art is even more ample than we have canvassed so far. Fictions can be a source of information about our obligations without exhaustive documentation and argumentation, just as op-ed page articles can be.

Fictions, as well, can be especially useful as sources of insight concerning moral psychology. Mary Shelley's *Frankenstein* presents us with a scenario of the way in which the denial of affection gives rise to a kind of raging envy best understood as a species of revenge. We do not need mountains of data on developmental psychology to appreciate Shelley's perceptiveness, nor an argument. We can discern the inner logic of the Frankenstein Monster's behavior by reflecting on our own feelings.

Such insight into moral psychology is one of the staples of great fiction. It provides us with knowledge relevant for moral self-understanding and for understanding and judging others morally. That it originates in art should not stop us from helping ourselves to it, since comparable knowledge claims are frequently and reliably derived from non-artistic sources without the benefit of full empirical documentation, argumentation, and analysis. That is, despite the skeptic, art is not, in principle, worse off than most of our other venues of knowledge communication.

Thus far, I have rushed through an inventory of ways in which art may function as a source of moral knowledge. It is a large and varied list, because, as I mentioned at the outset, the relations of art and morality are complex and varied.[18] I have not discussed every way in which art may be morally educative, but only those that address the skeptic's arguments against the very possibility that art can deliver moral knowledge. Many of my examples have involved the ways in which art can develop pertinent moral skills, since knowledge of how to conduct moral reflection demarcates an area of moral education that the skeptic, with his emphasis on the acquisition of a certain sort of propositional knowledge, has ignored altogether.

However, we have seen, as well, that it is also possible for art to deliver even this sort of knowledge, once we recall that artworks can function as thought experiments that either refute universal generalizations or abet conceptual discrimination. Moreover, we have pointed out additionally that the skeptic's epistemic arguments may rest on too high a standard of what is required to advance knowledge claims. And, if that is true, then common sense has all the

[18] It is not my contention that the types of moral education rehearsed above are utterly discrete and mutually exclusive. For example, our emotional responses to fiction may be enlisted in the process of encouraging us to make finer conceptual discriminations. And there are other ways of combining the activities sketched above. My purpose here is not to erect a rigorous, iron-clad taxonomy of moral responses to art, but only to remind the reader of the various ways in which our experience of art contests the skeptic's epistemic arguments. Furthermore, it should go without saying that I do not pretend that my brief list of possibilities here is an exhaustive one.

more reason to expect moral insight from artists—to commend them when they afford it and to chide them when they mislead or confuse us.

2. THE ONTOLOGICAL ARGUMENT[19]

Though there may not be epistemic obstacles to evaluating art morally, it appears that there may be a metaphysical one. For artworks are things, albeit artifacts, and we do not ordinarily morally evaluate things as such. Moral judgment is reserved for persons or beings with the right sort of psychological capacities. Thus, it is a category mistake, so the skeptic might argue, to call artworks morally good or bad. Perhaps this is the thinking that motivates Oscar Wilde, in his preface to *The Picture of Dorian Gray*, to say famously: "There is no such thing as a moral or an immoral book. Books are well written or badly written. That is all."[20]

Stated less elliptically, the argument would seem to be this:

1. If artworks can be evaluated morally, then they must be the kinds of things that can bear moral properties, namely, persons or person-like entities to whom the relevant mental properties apply.
2. Artworks are not the kinds of things that can bear moral properties; they are not persons or person-like entities to whom the relevant mental properties apply.
3. Therefore, artworks cannot be evaluated morally.

Let us grant the first premise, for purposes of argument. The question then becomes whether artworks are the sorts of things that can bear mental properties. Certainly, parts of some artworks appear to be the right sort of thing, namely, characters. Nothing seems out of place in judging Dr No to be evil. Of course, here the skeptic is apt to respond that, typically, when we evaluate novels morally, it is not the characters whom we are judging—for evil characters can inhabit morally upright fictions—but it is the novel as a whole, so to say, that is the object of evaluation. And, furthermore, the novel, unlike a character, is not a person-like thing.

Nevertheless, the recognition that characters can be evaluated morally suggests the way in which it may be appropriate to assess novels as such morally. For novels are narrated from points of view. As discussed above, Philip Roth's *The Dying Animal*, for example, characterizes women in a certain way, as primarily, indeed almost exclusively and mythically, sexual beings, and encourages readers to view them similarly. This point of view, moreover, belongs either to a person (the actual author) or to a person-like thing (the implied author) or, most probably, to both. And, of course, either the actual author and/or the implied author is the

[19] This argument was identified by Devereaux (2001). The response that I develop to this argument here parallels Devereaux's, though where she speaks of posited authors, I prefer to speak of points of view, due to my reservations about the notion of posited authorship.

[20] Devereaux cites Oscar Wilde as a representative of this position.

appropriate object for the application of the mental properties relevant to moral attributions.

Consequently, there should be no problem in morally evaluating the author(s)' point of view.[21] Where that point of view affords moral insight, to that extent, a novel can be said to be morally good. Where a novel unreflexively obscures moral perception, as *The Dying Animal* arguably does, it is to that extent morally bad.[22] There does not seem to be a category error here, since points of view are necessarily attached to persons (actual authors) or person-like things (implied authors). Therefore, at least artworks that possess points of view would appear to evade the preceding ontological argument. And that amounts to quite a few works of art.

It might be said that if it is the point of view of the actual artist that is at issue, then we are not really morally evaluating the artwork, but the artist. This does not seem right, however, for two reasons. First, the point of view is something that the novelist has constructed and, therefore, is part of the artwork proper. Second, though intimately related, even in everyday life, we can distinguish between moral judgments of a person and his point of view. Thus, we can render differential judgments of the moral character of a conscientious Brahmin who is unacquainted with other views about caste-relations. Similarly, we may in principle distinguish between our judgments of a novelist's moral character and his viewpoint, even if these often do converge.

It might also be objected that the implied author is not really the kind of thing to which moral predicates can be applied. However, if characters can be judged morally, then implied authors should be as well. For the implied author, where he or she diverges from the real author, is really a persona or role or mask that the actual author invents or takes on, much as an actor plays a character. Though of a different order, an implied author may be a fictional character of sorts. Hence, if fictional characters can be judged morally, so can implied authors. Moreover, just as fictional characters can be criticized morally where they provide attractive exemplars of moral viciousness, so can implied authors be criticized where they present depraved points of view as lustrous. Nor can it be denied that implied authors qua characters and their related points of view are part of the artwork proper, since they compose, in large measure, what the novelist has constructed.

Oscar Wilde alleges that books can only be written well or badly; that they are not moral or immoral. However, inasmuch as that writing is involved in the construction and expression of points of view, it may be susceptible to moral evaluation. Moreover, artworks other than literary fictions also possess points of view. Thus, in a vast number of cases, common sense has little to fear from the skeptic's Ontological argument.

[21] This argument parallels that against expressive properties being necessarily metaphorical that I make in my (1999), pp. 959.

[22] The hedge "unreflexively" is included here in order to accommodate the possibility that a novelist might project an evil viewpoint ironically or reflexively for the purpose of unmasking it.

3. THE AESTHETIC ARGUMENT

If successful, our rejoinders so far to the philosophical skeptic show that it can be appropriate to evaluate some art morally. But the skeptic may be quick to note that even if an artwork is morally bad, it may still be aesthetically good, just because moral goodness does not guarantee aesthetic quality or preclude aesthetic awfulness. A movie that exalts the career of a remorseless jewel thief may still be aesthetically exciting, while one that commends the teachings of a paragon may be aesthetically boring.

This is hard to deny. However, the skeptic frequently extrapolates a rather expansive principle from these commonplaces, namely that the moral blemishes in an artwork never count against its aesthetic merit and that the moral worthiness of an artwork never counts toward aesthetic worthiness. That is, aesthetic value and moral value are strictly independent or autonomous from each other. This position can be called autonomism.[23]

Obviously, the autonomist's argument is based on the presupposition that the aesthetic realm and the moral realm are utterly discrete, with no possibility of substantive interaction between them. But whether this hypothesis can be sustained, of course, depends on how we are to understand the notion of the aesthetic presumed in the aesthetic argument.

One way to construe this vexed notion is to regard the aesthetic as pertaining to experience—the experience of the artwork—and to hold that that experience is aesthetic only if it is valued for its own sake. An element in an artwork is aesthetically valuable, then, if it promotes aesthetic experiences. This may be thought to exclude moral insight as an aesthetic element in an artwork, furthermore, on the grounds that moral insight is not valued for its own sake, but for other reasons, such as its conduciveness to good conduct.

However, this will not do. For if one believes that experiences are valuable for their own sake, surely one must concede that moral insight can be. Can a proponent of such value deny that learning that the social practices of an extinct civilization were evil can be appreciated (in his sense) for its own sake, even though it has no possible ramifications whatsoever for the appreciator's present conduct? If purely theoretical, mathematical insights can be valued for their own sake, why can't moral insights be so valued? Consequently, the conception of aesthetic value that ties it simply to experiences valued for their own sake cannot do the job of hiving off the aesthetic from the moral, in the way the aesthetic argument requires, undoubtedly because this view of the aesthetic is not sufficiently contentful.

[23] Elsewhere I have referred to this position as moderate autonomism. Radical autonomism maintains that it is never appropriate to evaluate artworks morally. The preceding two sections of this chapter are intended to undermine radical autonomism. Moderate autonomism—which I am now simply calling "autonomism" for expositional purposes—holds that moral evaluation of artworks is possible but is never to be confused with aesthetic evaluation. See my (1996, 2000).

A perhaps more promising way of crafting the concept of the aesthetic for autonomist purposes is to associate the aesthetic with the formal. On this view, an aesthetic experience has a certain content—the form of an artwork—and aesthetic value is calibrated in terms of the capacity of the formal structure of the work to engage aesthetic experience productively. As William Gass puts it: "Artistic quality depends upon a work's internal, formal, organic character, upon its inner system of relations, upon its structure and its style, and not upon the morality it is presumed to recommend or upon the benevolence of its author, or its emblematic character, when it is seen as especially representative of some situation or society" (1993: 113).

Of course, the autonomist cannot deny that many artworks contain moral content, often forcefully presented. But she contends that this content is only ever relevant to the aesthetic evaluation of an artwork insofar as it relates to the form or structure of the work—does it contribute to the unity or coherence of the work, or does it detract from it? Arnold Isenberg says: "Any issue of moral ideas may be an aesthetic object. But a didactic poem is a work of art—which means that ethical material is not merely utilized but is worked into a structure. Now there are structures built of other than ethical materials; and there it is common enough for critics to employ such criteria as 'unity' and 'coherence'" (1973: 280). Likewise, Isenberg implies, ethical features of artworks play into aesthetic evaluation to the extent that they contribute to the form of the artwork. That is, the evil viewpoint that a work sponsors, no matter how morally noxious, is not an aesthetic demerit, unless it renders the work formally incoherent, as it would if it inadvertently endorsed inconsistent moral views (1973: 281).

Whether or not the identification of aesthetics with form is to serve the autonomist's agenda, needless to say, rests on the notion of form—a notoriously difficult concept to define—that the autonomist adopts. Some notions of form will clearly be inadmissible—such as that the form of an artwork comprises only its non-representational elements—since they would appear false from the outset to the scope of aesthetic experience. But perhaps a clue to the relevant notion of form is our widespread tendency to associate form with the *how* of an artwork—how it is phrased, how it is painted, how it is constructed. The form of the work pertains in some way to the manner in which it has been contrived. But in what way?

Not just any answer to a how-question about an artwork will suffice to instruct us about the form of the work. Being told that the words on the page of a novel got there by printing does not identify a formal aspect of the novel. Rather, the how-questions that are pertinent to the formal structure of the work have to do with the elements and relations in the work that function to realize the point(s) and/or purpose(s) of the work.[24] As Louis Sullivan said, "Form follows function."

It is a formal feature of a narrative painting that it leads our eye to the subject of the picture, since the point of the work is to encourage our contemplation of,

[24] This view of artistic form is defended in my (1999), pp. 142–8.

say, the Madonna and child. Likewise, the rapid montage of the Odessa Steps sequence of the film *Potemkin* is a formal element, because it visually enhances the chaos of the scene which the director, Sergei Eisenstein, wishes to communicate to the audience. That is, artworks possess points or purposes—themes they are designed to convey or mental states, like emotions, moods, or even visual pleasure—that they seek to engender in viewers, listeners, and readers; and the elements and relations in the work that realize those points and purposes constitute the formal structure(s) of the work. Like the human form, the form of the work is its outward manifestation (of its point[s] and purpose[s])—the way in which it presents or embodies them.

In constructing an artwork, the artist chooses how to proceed relative to the point or purpose of the work—to make the line thick or thin, to alliterate or not, to opt for a major or minor key, to portray a character as harsh or gentle in view of the point or purpose of the work (or of a part thereof). The sum of these choices embodies the relevant how of the work, its form, the manner in which it pursues its end. Or, to state the matter formulaically: the form of an artwork is the ensemble of choices intended to realize the point(s) or purpose(s) of the artwork.

Supposing this to be an idea of form that the autonomist acknowledges, then we can state the conclusion of her aesthetic argument thus: a moral defect in an artwork is never a formal defect in a work and a moral virtue in an artwork never counts as a formal virtue. Admittedly, the autonomist may be correct in observing that not every moral defect is a formal one, just as not every moral virtue is a formal one. But is she correct in alleging that moral properties of artworks are never relevant to their formal, that is to say, their aesthetic, evaluation?

One very common purpose of artworks is to arouse our emotions. The emotions, of course, are criterially governed. In order to fear something, a percipient must regard it as harmful. Moreover, the criteria that govern many emotions are moral; to be angry, I must regard the object of my state as someone who has done wrong to me or mine. And, there are straightforwardly moral emotions, such as righteous indignation. Thus, in order to arouse certain emotions, the relevant artworks must design the characters and situations they portray in a way that is morally appropriate to the emotion they are meant to elicit. It would be an error in the design, *ceteris paribus*, in an artwork predicated on raising a sense of injustice in normal audiences, were it to represent as utterly saintly the commandant of a heinous slave camp. That is, it would be a formal error insofar as the way in which the commandant has been designed impedes the work's functioning as intended.

Similarly, had Nero ignited Rome with the intention of engaging emotions like the awe that occasions the display of fireworks, his conflagration would have been a failure from the perspective of normal viewers, who, aware of the grievous costs to life and property involved, would have greeted it with horror rather than wonder. The error here would have been formal, since Nero's design choices, notably roasting people, did not serve the putative purpose of the incineration. But it is also, needless to say, a moral outrage. Moreover, it is the fact that it is

a moral outrage that, in large measure, accounts for its incapacity to function to realize its purpose, since it is the perception of the moral outrageousness of Nero's action that blocks the intended response in the normal audience member. That is, the moral defectiveness of Nero's fire is intimately connected to its compromised aesthetic design; the immoral or evil nature of Nero's choice is the major reason that his fire-work failed to secure its purpose.

For a case closer to home, consider again Philip Roth's *The Dying Animal.* The novel aims to paint the life of male desire in a morally heroic, albeit melancholy, light. But the manipulative central character, David Kepesh, is transparently a predator, and his apparent view of women as essentially sexual beings, while said to be complimentary (even mystically so), is morally impoverished. The defects in the character and the novel's point of view are apt to thwart the sensitive reader's enthusiastic response to this paean to libertinage, which locked into a sixties time warp, somewhere between *Playboy* and the Woodstock nation. If there is a way to craft the representation of Kepesh's *modus vivendi* in a way that would secure the sought-after effect of admiration, Roth has not found it.

Furthermore, the formal flaw in Roth's design is traceable, to a great degree, to the morally defective point of view he invites and encourages morally sensitive readers to embrace. That they cannot embrace it because of its immorality is the central reason for the ultimate emotional unintelligibility of the book (Kieran 2001: 34). The reason it is formally incoherent is primarily due to its moral defectiveness.[25] That is, part of the design of many artworks is their moral-emotive address. Where that capsizes, for reasons of moral defectiveness, the design of the work is likewise flawed.

Thus, in cases like this, ethical criticism and aesthetic criticism merge. Our best explanation of why *The Dying Animal* is aesthetically defective is that it is morally blemished. That is, the design of the work misfires because the moral shortsightedness it proffers is unacceptable to the morally sensitive audience. Therefore, sometimes a moral defect in an artwork is relevant to evaluating it aesthetically, inasmuch as the moral address of the work can be an integral part of its design. Moreover, in cases where the moral defect *qua* moral defect in the work explains the failure of the work to discharge its purposes, the moral defect is also a bad formal choice, which is to say, contra autonomism, an aesthetic

[25] The sense of incoherence here is different from that suggested by Arnold Isenberg in the quotation above. Isenberg appears to think that moral elements in an artwork are formally incoherent when they jar with each other (1973), p. 281; that they are evil is not important, so long as they are consistent. That is why Isenberg appears to think that ethical and aesthetic evaluation can always be kept separate.

However, the kind of incoherence I have in mind is pragmatic—that the immoral viewpoint of the work undermines the prescribed uptake to which the work aspires. The reason it misfires can only be explained by calling attention to the fact that the moral viewpoint it advocates is too defective to enlist the cooperation of the morally sensitive audience member. Thus, the reason it fails aesthetically in terms of actualizing its purposes is that it is morally defective. Its aesthetic failure and its moral failure are explained by reference to the same feature of the work—its moral defectiveness. Thus, in these cases, unlike Isenberg's, the kind of incoherence in question does not support the idea that ethical and aesthetic evaluation can always be kept apart.

defect (Carroll 1998b). That is, the reason that explains the formal failure of the work is a moral one—for example, that it is too immoral to be countenanced by a morally sensitive audience.[26] Hence, sometimes a moral defect in a work can also figure as an aesthetic defect.

This argument does not show that every moral defect is an aesthetic defect, but only that some are—namely, those that compromise the design of the work. Some moral defects in a work may be insignificant or adventitious to the presiding purposes of the artwork. Furthermore, artworks can be immensely subtle and complex in terms of their moral commitments and implications. Moral defects in such works may only be identified by sustained and recondite interpretations. Consequently, some moral defects may elude even morally sensitive and informed audiences, due to the work's subtlety, obscurity, and/or intricacy. Where that happens and, as a result, the moral defect in question is not likely to retard the morally sensitive reader, viewer, or listener's emotive uptake of the work, the moral defect will not count as a formal or an aesthetic defect, though, of course, it remains a moral defect.[27]

Additionally, it should be clear that even where an artwork contains a moral defect—that is also a formal or aesthetic defect—that does not entail that the work overall is necessarily bad aesthetically, since the work may contain, as well, compensating aesthetic virtues that render the work, on balance, aesthetically good. And this, along with the considerations from the previous paragraph,

[26] Here it needs to be added that we must understand the morally sensitive audience in counterfactual terms. The reason for this is that we expect artistic merit to stand the test of time. Thus, genuine aesthetic evaluations track the reactions that morally sensitive audiences would have to the work, not the reactions that the actual audience has to the work. For a contemporary audience to a work—such as Nazi audiences to Riefenstahl's *Triumph of the Will*—may, in the heat of the ideological/patriotic moment, be blinded to the moral defects of the artwork.

[27] It is for this reason that in the past I have referred to this position as moderate moralism. This view contrasts with Gaut's position, which he calls ethicism, which contends that every moral defect in a work is, *pro tanto*, an aesthetic defect. My argument covers less ground than Gaut's does and, though I am not completely unsympathetic with Gaut's inclinations, my argument explicitly does not go as far as his.

However, several commentators—including Connolly, Harold, and Kieran—have argued that my position collapses into Gaut's. Their reason for this is that since the morally sensitive viewing I consider relevant for tracking moral defects is to be understood counterfactually—in terms of how a morally sensitive viewer would respond to a work—then any moral defect in a work will, allegedly, disturb its implementation of the work's point and/or purpose. I deny this for the reasons stated above: not every moral defect—for example, an off-hand ageist aside—will be structurally undermining of the presiding purposes of the work, and some moral defects will not be obvious enough in a work to attract the attention of even the morally sensitive audience member.

Perhaps Connolly, Harold, and Kieran think that it is impossible for a viewer, reader, or listener, construed counterfactually, to count as morally sensitive, if some moral defect would elude them. However, this seems to me to be talking about morally hypersensitive audiences, not just morally sensitive ones. One can be morally sensitive and still not pick up on very subtle or recessive moral defects in a complex artwork. Morally sensitive audiences should not be conceived of as ethical superpersons. Thus, moderate moralism does not collapse into the stronger position, ethicism, though like ethicism it must be thought of in terms of the counterfactual responses of morally sensitive audiences, since, ideally, aesthetic evaluations are expected to converge on the results of the test of time. See Gaut (1998); Connolly (2000); Kieran (2001); Harold (2000).

rather than autonomism, accounts for the commonplace observation that it is possible for a work that contains moral defects to be aesthetically successful.

If we have shown, against the aesthetic argument, that sometimes a moral blemish in an artwork amounts to a formal or aesthetic flaw, it remains to be pointed out that sometimes the positive moral features of an artwork can contribute to the aesthetic value of a work. Narrative artworks especially are constructed in such a way as to engage readers, viewers, and listeners in virtually continuous processes of moral judgment—moral assessments of characters, situations, and points of view. Obviously, then, if these elements are designed in a way that makes it possible for audiences to make insightful and enlightening connections between the moral variables in the story, the story, all things being equal, will be better for it—that is, more absorbing. And, inasmuch as it is a purpose of most art to be absorbing, design choices of this sort will be aesthetically good, just because they stimulate the audience's moral imagination in productive activity that the audience finds rewarding.

We saw earlier that artworks may be adjudged morally good for exercising our moral powers. Insofar as this can also contribute to absorbing the audience in the work, it can also be an aesthetic virtue of the work for morally sensitive audiences. Moreover, for such audiences, the moral insights must be reasonably authentic, if they are to mobilize said audience's participation and not deter it. Thus, making apposite moral observations can be part of the design of an artwork. Oscar Wilde was just wrong if he thought that good writing, as it is normally assessed, is always utterly divorced from moral content.

The autonomist's aesthetic argument maintains that a moral defect in an artwork is never an aesthetic defect and that a moral virtue is never an aesthetic virtue. Perhaps this argument has been attractive for so long because it functions like a firebrake against aggressive moralists who would counterintuitively brand every moral defect an aesthetic defect and declare all right-thinking artworks aesthetic masterpieces. Nevertheless, however serviceable in the struggle against puritanism and censorship, the aesthetic argument is too ambitious. For sometimes, *pace* autonomism, aesthetic and ethical evaluation converge.

4. CONCLUSION

Art and morality have been linked together for so long and in so many ways that it appears commonsensical for plain readers, viewers, and listeners to assume that it is natural—at least some of the time—to treat the latter as a source of enlightenment about the former, and—again, at least some of the time—to suppose that sometimes the moral evaluation of an artwork may be relevant to its aesthetic evaluation. Maybe that is one reason why ordinary critics typically feel so free to move without comment between the moral evaluation of the point of view of an artwork and its artistic evaluation.

However, as we have seen, there are formidable philosophical objections to this practice—particularly epistemic objections, ontological objections, and aesthetic

objections. These philosophical arguments raise important questions about our practices with regard to art. Nevertheless, the considerations they advance are not insurmountable, as I have attempted to demonstrate. In fact, these objections serve as a salutary pretext for attempting to clarify what we are doing and why we are doing it when it comes to speaking about art. In that sense, philosophy needs to be thought of as not inimical to common sense, but as an impetus to its greater refinement and sophistication.

REFERENCES AND FURTHER READING

Beardsley, Monroe C. 1981. *Aesthetics: Problems in the Philosophy of Criticism*. Indianapolis, IN: Hackett.

Carroll, Noël. 1996. "Moderate Moralism." *British Journal of Aesthetics*, 36: 223–37.

—— 1998a. "Art, Narrative, and Moral Understanding," in Jerrold Levinson, ed., *Aesthetics and Ethics*. Cambridge: Cambridge University Press, pp. 128–60.

—— 1998b. "Moderate Moralism versus Moderate Autonomism." *British Journal of Aesthetics*, 38/2: 419–24.

—— 1999. *Philosophy of Art: A Contemporary Introduction*. London: Routledge.

—— 2000. "Art and Ethical Criticism." *Ethics*, 110: 350–87.

——"The Wheel of Virtue: Art, Literature, and Moral Knowledge." In this volume.

Connolly, Oliver. 2000. "Ethicism and Moderate Moralism." *British Journal of Aesthetics*, 40/3: 302–16.

Connolly, Oliver, and Haydar, Bashshar. 2001. "Narrative Art and Moral Knowledge." *British Journal of Aesthetics*, 41/2: 109–24.

Currie, Gregory. 1995. "The Moral Psychology of Fiction." *Australasian Journal of Philosophy*, 73: 250–9.

Devereaux, Mary. 2001. "Moral Judgments and Works of Art." Paper at conference on Art and Morality, University of California at Riverside, April.

French, Peter A. 2001. *The Virtues of Vengeance*. Lawrence, KA: University of Kansas Press.

Gass, William H. 1993. "Goodness Knows Nothing of Beauty: On the Distance between Morality and Art," in John Andrew Fisher, ed., *Reflecting on Art*. Mountain View, CA: Mayfield.

Gaut, Berys. 1998. "The Ethical Criticism of Art," in Jerrold Levinson, ed., *Aesthetics and Ethics*. Cambridge: Cambridge University Press.

Goldberg, S. L. 1993. *Agents and Lives*. Cambridge: Cambridge University Press.

Guerard, Albert L. 1963. *Art for Art's Sake*. New York: Schocken Books.

Harold, James. 2000. "Moralism and Autonomism." Talk at Central Division Meetings of American Philosophical Association, Chicago, April.

Isenberg, Arnold. 1973. "Ethical and Aesthetic Criticism," in *Aesthetics and the Theory of Criticism: Selected Essays of Arnold Isenberg*. Chicago, IL: University of Chicago Press.

Kieran, Matthew. 2001. "In Defence of the Ethical Evaluation of Narrative Art." *British Journal of Aesthetics*, 41/1: 26–38.

Kivy, Peter. 1997–8. "On the Banality of Literary Truths." *Philosophic Exchange*, 28: 17–27.

Nussbaum, Martha. 1990. *Love's Knowledge*. Oxford: Oxford University Press.

Parker, David. 1994. *Ethics, Theory and the Novel*. Cambridge: Cambridge University Press.

Putnam, Hilary. 1978. "Literature, Science, and Reflection," in H. Putnam, *Meaning and the Moral Sciences*. London: Routledge and Kegan Paul.

Scott, A. O. 2001. "Alter Alter Ego." *New York Times Book Review* (May 27): 8.

Walton, Kendall. 1990. *Mimesis as Make-Believe: On the Foundations of the Representational Arts*. Cambridge, MA: Harvard University Press.

Zemach, Eddy M. 1997. *Real Beauty*. University Park, PA: Pennsylvania State University Press.

11

The Wheel of Virtue: Art, Literature, and Moral Knowledge

In Chapter 12 of his autobiography, Anthony Trollope writes:

> By the common consent of all mankind who have read, poetry takes the highest place in literature. That nobility of expression, and all but divine grace of words, which she is bound to attain before she can make her footing good, is not compatible with prose. Indeed, it is that which turns prose into poetry. When that has been in truth achieved, the reader knows that the writer has soared above the earth, and can teach his lessons somewhat as a god might teach. He who sits down to write his tale in prose makes no such attempt, nor does he dream that the poet's honour is within his reach—but his teaching is of the same nature, and his lessons all tend to the same end. By either, false sentiment may be fostered; false honour, false love, false worship may be created, by either vice instead of virtue may be taught. But by each, equally, may true honour, true love, true worship, and true humanity be inculcated; and that will be the greatest teacher who will spread the truth the widest.[1]

Now I suppose that not all of Trollope's assertions here will meet with common consent. Some will find the comparison with poetry strained, perhaps archaic, and maybe invidious. Many more may bristle at the notion that literature "inculcates" virtue, since, unqualified, that may strike them as too "causal" a way of speaking. Nevertheless, I suspect that a great many plain readers would accept the germ of Trollope's view, once it is suitably modified to claim no more than that literature, and, by extension, art can play a role in moral education.

This chapter was originally presented as the Presidential Address to the American Society of Aesthetics in Reno, Nevada, in October, 2000. The author would especially like to thank Peter Kivy, Sally Banes. Philip Harth, David Lowenstein, Elliott Sober, Lester Hunt, Francis Schrag, Harold Scheub, Lorrie Moore, Stephen Davies, Dominic Lopes, David Bordwell, Ulrich Langer, and the audience at the Institute for Research in the Humanities at the University of Wisconsin-Madison for their help and encouragement in the preparation of this chapter. Of course, only I am responsible for the errors herein.

[1] Anthony Trollope, *An Autobiography* (London: Williams and Norgate, 1946), p. 196 (originally published in 1883). A similar sentiment is voiced by Leibniz, who says, "The chief end of history, as also of poetry, should be to teach prudence and virtue by examples, and then to display vice in such a way as to create aversion to it and to prompt man to avoid it, or serve towards that end." See G. W. Leibniz, *Theodicy*, transl. E. M. Haggard (London: Routledge and Kegan, 1951), p. 217.

But, of course, ever since Socrates met Ion, this has been the crux of the great quarrel between poetry and philosophy. For in his momentous effort to depose Homer as the educator of the Greeks in favor of his own tutor, Plato was at pains to argue that neither literature nor art could teach anyone anything, since teaching requires something to teach, namely, knowledge, moral or otherwise; and knowledge, according to Plato, was something that neither literature nor art had to offer. Moreover, this Platonic tradition, albeit with modern variations adapted for different epistemological convictions, still persists.

From an empiricist viewpoint, Monroe Beardsley in his treatise *Aesthetics* challenges the claims of art and literature to serve as a legitimate source of knowledge,[2] while, more recently, Peter Lamarque and Stein Haugom Olsen in their magisterial *Truth, Fiction, and Literature*—surely the most comprehensive philosophy of literature in the analytic tradition to date—advance a no-truth conception of literature that, among other things, rejects the relevance of literature as a font of genuine enlightenment.[3]

In this chapter, then, I would like to address what I believe are the most compelling epistemic arguments against the notion that literature (and art more broadly) can function as an instrument of education and a source of knowledge.[4] I will attempt to suggest and to defend *one* way of answering the aforesaid challenges, though, of course, I readily acknowledge that there may be more than one way to meet these arguments (perhaps simulation and empathy may provide other routes).[5] Moreover, since it is generally thought that if literature and art can function in the service of knowledge and education, the most likely sort of enlightenment available from them would be moral, psychological, and social knowledge, I will try to build my case by focusing on the ways in which literature and art can impart knowledge of virtue and vice (true and false, as Trollope would say). Specifically, I want to convince you that some—not all, but still much—literature, especially, and art can function and is designed to function as a source of moral knowledge (notably, for my purposes, knowledge of virtue and vice).

Let me begin by rehearsing the leading epistemic arguments against the view that literature and art can function as a genuine source of knowledge and education. The first objection can be called the banality argument. Here the idea is that the significant truths that many claim art and literature afford—that is,

[2] Monroe C. Beardsley, *Aesthetics: Problems in the Philosophy of Criticism* (Indianapolis: Hackett, 1981). This text was originally published in 1958 by Harcourt, Brace & World.

[3] Peter Lamarque and Stein Haugom Olsen, *Truth, Fiction, and Literature: A Philosophical Perspective* (Oxford: Clarendon Press, 1994).

[4] In this chapter, I will only be concerned with epistemic arguments against the possibility of art and literature serving as vehicles of moral education and knowledge. There are also aesthetic arguments that maintain that art and literature should not be viewed from a cognitive point of view, whether moral or otherwise. I will not be concerned with the aesthetic arguments here, since I have dealt with them elsewhere.

[5] Indeed. I do think there are other ways, but I focus on the one examined in this chapter because I think it has been underexplored so far and because I think it is particularly effective against epistemic anxieties about literature as a source of knowledge and education, especially moral education.

general truths about life, usually of an implied nature (as opposed to what is "true in the fiction")—are, in the main, trivial. Richard L. Purtill writes, "the general truths about human nature which . . . the protagonists of fiction are supposed to illustrate seem so platitudinous and threadbare as to raise serious questions about the importance of artistic truth. We need no ghost risen from the grave to tell us that every villain is a knave."[6]

Unlike the other objections to come, the banality argument grants that art and literature may imply some general truths, particularly about human life. Thus, on this argument, one might concede that nominally art and literature can contain or imply knowledge, moral and otherwise. However, that knowledge hardly counts for much, amounting to little more than truisms, such as that patricide is evil. Therefore, insofar as education presupposes informativeness, the knowledge, so called, to be had from art and literature *teaches* no one anything. Compared to the natural and social sciences, and to history, art and literature do not produce new knowledge; they do not make discoveries. They recycle truisms that readers already know. Consequently, since it makes little sense to claim that people learn the truisms they already know from literature and art, there is little point in regarding the arts as educational.

The banality argument can also be strengthened by recalling that most of the implied general truths said to be available in the arts are of the nature of conversational or pragmatic implicatures.[7] They are presuppositions that the reader or spectator must bring to the artwork in order to understand and respond to it appropriately. To be prepared to exonerate the character Werner Heisenberg in Michael Frayn's play *Copenhagen*, one must already be convinced that, in the long run, the invention of the atomic bomb was a bad thing. The play does not teach this to the suitably prepared viewer. She must presuppose it as a condition of the work's intelligibility in order to comprehend the play appropriately.

But if such implied themes are the best candidates for the title of artistic truth *and* if they are characteristically such that audiences must know them in advance, then it is bizarre to say that audiences learn these truths from the relevant artworks. You cannot learn what you already know. That much, putatively, is built into the concept of education. So, even if art and literature can be said to traffic in truths and, in that respect, to afford knowledge nominally, the knowledge is so familiar that no one who is ready to appreciate the art in question can be thought to acquire it from the artwork. Art and literature are not sources of moral knowledge, but, at best, occasions for activating antecedently possessed knowledge.

The banality argument questions whether art and literature can be educative, though it concedes that they may pragmatically imply general truths, albeit those of a trivial sort with which audiences are already long familiar. That is, it is the

[6] Richard L. Partin, "Truth in Fiction" (photocopy, Western Washington University, nd, p. 4). Cited in Ira Newman, *Fiction and Discovery: Imaginative Literature and the Growth of Knowledge*, PhD diss., University of Connecticut, Storrs, 1984, p. 38.

[7] Christopher New, *Philosophy of Literature: An Introduction* (London: Routledge, 1999), p. 110.

claim that art and literature *educate* that the banality argument targets, not the claim that they may communicate general truths. The next set of arguments, however, rejects the thesis that art and literature provide anything worth calling knowledge at all.

Monroe Beardsley argues that:

in common speech, the statement, "His behavior at the party revealed something to me," would usually mean that the behavior afforded observational data that not only (a) suggested a new hypothesis to me, but (b) constituted fairly strong and direct evidence for that hypothesis. I do not think we would ordinarily speak of an event or object as revealing something unless it did both of these things.[8]

Beardsley then goes on to apply this principle to a case where someone alleges that Elia Kazan's film *Baby Doll* reveals the shocking condition and abuse of retarded women in the South.

Beardsley says:

Even this way of speaking stretches the term from its ordinary use, for though the movie may suggest the hypothesis that retarded Southern girls are frequently kept in unconsummated wedlock, it does not present a single authenticated case history (being fiction), and therefore it certainly is not strong or direct evidence for the hypothesis. . . The distinction between suggesting a hypothesis and giving evidence for it—that is, confirming it—is crucial here, but I assume it to be generally understood and accepted. To give an extreme example, a man may dream that his wife is unfaithful, and this dream, vividly and sharply recalled, may suggest to him for the first time in his married life the hypothesis that she is unfaithful. Here we are speaking of the source, or genesis of the hypothesis, though it may be evidence for another hypothesis, namely that he unconsciously wishes to be unfaithful himself.[9]

In a similar vein, Christopher New argues:

The novel may well imply that the views are true, and do so very forcefully, but it cannot itself authenticate the view it conveys—whether the view is a sound one depends on what the (moral and religious) facts are, not on how the author's fiction represents them. So, while fiction literature may imply such truths, it cannot guarantee them. This does not mean, of course, that we cannot gather truths from fiction, only that they are not shown to be truths by virtue of being persuasively conveyed in a novel, story, poem, film or play. In this sense, claims that fiction has some kind of special route to moral (or any other) truth must be rejected as fanciful.[10]

This line of objection can be called the no-evidence argument. Whereas the banality argument challenges the belief that art and literature can be properly subsumed under the concept of education, since audiences already standardly possess whatever knowledge they imply, the no-evidence argument contests the notion that what art and literature possess or imply by way of general truths can be subsumed accurately under the concept of knowledge. For knowledge, properly

[8] Beardsley, *Aesthetics*, p. 379. [9] Ibid., p. 380.
[10] New, *Philosophy of Literature: An Introduction*, pp. 120–1.

so called, must not only be true, but warranted. Thus, if the knowledge in question is empirical, it must be supported by evidence. However, few artworks, save perhaps some postmodernist installation pieces, contain evidence on behalf of the knowledge claims—the hypotheses—they advance.[11]

Most artworks that allegedly contain generalizations only present a single case—or a handful of cases—on behalf of the generalizations they suggest, but this is scarcely adequate evidence for generalizations, for example, about human nature.[12] Moreover, this problem of evidence is particularly vexing in cases of fiction, where the case studies that accompany the hypotheses are made up. A reader would be foolish to take a fiction as evidence for an empirical claim about the South or about human nature, just because he could never be certain which parts of the fiction were spun of whole cloth and which parts were not.[13]

Fictions that are intended to advance theses, furthermore, are typically designed in such a way that the story content supports its putative truth claims. From the epistemic point of view, they are always already tainted; the evidence, if that is what the story is, is, so to speak, cooked from the get-go. The story cannot confirm or authenticate its thesis, where it has one. So the fiction, when it is underwritten by some general truth, cannot afford genuine knowledge, since, however true its claims may be, they are never justified. Fiction is not a reliable source of evidence. So fiction cannot educate, since it has no knowledge (no *justified* true belief) to dispense. Thus, by a different epistemological route, the contemporary philosopher of literature arrives at the same conclusion Plato reached in Book X of his *Republic*.

The proponent of the no-evidence argument concedes that art and literature may be sources of hypotheses about the world that audiences may then go on to attempt to confirm.[14] But the concession here is at best grudging, since it will

[11] In a similar vein, John Hospers writes, "it cannot be one of the functions of literature to state facts, nor can a literary work rightly be valued, wholly or in part, for the truth of the factual statements it contains, since authors of literary works do not employ the scientific techniques necessary for the establishing of facts," and "most of the statements in poems are not documented enough for us to be able to verify them." See John Hospers, *Meaning and Truth in the Arts* (Chapel Hill, NC: University of North Carolina Press, 1949), p. 157. More recently, Bruce Russell argues, "No one can establish on the basis of, for instance, *A Simple Plan* that people will probably get caught or that their lives will be made miserable if they commit a heinous deed. It is the actual rate of being caught and the actual percentage of people who are made unhappy after committing a horrible act, that determines whether it is reasonable to believe that 'crime doesn't pay.'" "A film might remind us of the evidence we know of already, but it cannot supply the relevant evidence itself. Imaginary situations cannot supply real data." See Bruce Russell, "The Philosophical Limits of Film," *Film and Philosophy* (Special Edition, 2000): 166–7.

[12] Beardsley, *Aesthetics*, p. 416.

[13] In the novel *The Name of the World* by Denis Johnson, when Seth complains to the novelist Kit that his (Kit's) characters are not morally instructive, Kit replies, "Hey, come on, Seth. They're fictional. Do you really hope to get your moral lessons from people who don't exist?"

[14] Defenders of the hypothesis/confirmation approach include Peter Mew, "Facts in Fiction," *The Journal of Aesthetics and Art Criticism*, 31 (1973): 329–37: and David Novitz, *Knowledge, Fiction, and Imagination* (Philadelphia, PA: Temple University Press, 1987). Likewise, Ira Newman argues that literature can provide models for understanding in his *Fiction and Discovery: Imaginative Literature and the Growth of Knowledge*.

also be pointed out that the hypotheses available from art and literature are, in general, woefully vague. How are we to understand their scope? If Brett Easton Ellis's *Less Than Zero* is meant to represent adolescent life in Los Angeles, how comprehensive is this hypothesis supposed to be?[15] Does it pertain to all LA youths or only some—to all members of a certain social class, or most, many, or just a few? For, if we are unable to ascertain how far the hypothesis reaches, then talk of confirming the hypothesis seems so much arm waving. Indeed, since extracting hypotheses from art and literature generally involves interpretations, and interpretations themselves may often be indeterminate and contestable the hypothesis/confirmation model may rarely provide us with a hypothesis solid enough even to attempt to confirm.[16]

A third position against the notion that art and literature can function as a source of knowledge and education has been identified by Peter Kivy;[17] we can call it the no-argument argument. Stated succinctly, it maintains that even if artworks contained or implied general truths, neither the artworks themselves nor the critical discourse that surrounds them engages in argument, analysis, and debate in defense of the alleged truths.

The no-argument argument advances two claims. The first is that artworks, where they contain or suggest general truths, do not argue in their behalf; at best they merely assert or imply them. The second point is that the critical discourse that greets artworks does not typically lavish attention on arguing for or against the truths allegedly disclosed in the artwork. This indicates that assessing the truth or falsity of general claims is not a feature of the literary institution, since neither authors nor critics appear much concerned with it. But, if authors and critics are not much concerned with assessments of truth or falsity, it would seem that the authentication of truth claims is not a function of literature. And if the authentication of truth claims is not part of literary practice, then that practice cannot have much to do with the production of knowledge, properly so called.

The first part of the no-argument argument resembles the no-evidence argument. It denies that artworks can be regarded as sources of knowledge, since artworks typically spend little or no effort in attempting to justify whatever general beliefs they advance. Whereas the no-evidence argument notes that artworks do not offer genuine evidence for the general beliefs they contain or imply, the no-argument argument faults art and literature for their lack of argumentation, analysis, and debate.

Kivy also notices a possible connection between the banality argument and the no-argument argument.[18] In philosophical discussions, people often advance what appear to be truisms, such as "there is an external world." We do not dismiss discussions like this on the grounds that they are banal, however, because they are generally defended by often-sophisticated argumentation. It is the argumentation

[15] Beardsley. *Aesthetics*, p. 385. [16] Ibid., p. 416.
[17] Peter Kivy, "On the Banality of Literary Truths," *Philosophic Exchange*, 28 (1997–8): 22.
[18] Ibid.

that saves philosophical views such charges of banality. If one simply says, "there is an external world" and leaves it at that, we would regard the assertion as a truism. But, when supported by argumentation, the position can become interesting, novel, and informative. Artworks can contain and imply moral and philosophical beliefs of the order just mentioned. However, since artworks, including literary works, putatively trade in those beliefs without argumentation or analysis, their avowals never amount to the banal. In this way, the first part of the no-argument argument lends support to the banality argument.

The second part of the no-argument argument concerns the lack of argumentation in our literary practices regarding the truth value of the general beliefs contained and implied in artworks. Lamarque and Olsen allege that it is a striking fact about literary criticism and literary conversations that we do not debate the truth or falsity of the claims we find in literary works.[19] Critics may identify the moral or philosophical commitments in a work, but they do not go on either to dispute them or to supplement them with further argumentation and analysis. This indicates to Lamarque and Olsen that questions of truth and falsity are not part of the literary institution.

Moreover, this evidence, derived from literary criticism (which, in turn, might be regarded as a model of the appropriate response to literature), suggests that the assessment of the general claims in literary works is not part of the reader's appreciative practices with respect to a literary work *qua* literary work.[20] And, if the assessment of truth or falsity is not part of the reader's appreciative activities, then the idea that the reader gains knowledge or learns from literary works appears unlikely. Lamarque and Olsen do not deny that literary works may contain or imply general beliefs. However, they do deny that the purpose of said beliefs in the works that advance them is to impart knowledge and education. The general beliefs in literature, they contend, serve a different function. They are there to organize the text, inasmuch as the general themes in literary texts subsume or colligate the incidents and descriptions therein for the sake of imbuing the whole with unity. Critics point to these themes in order to disclose the coherence of the text. Like latter-day Russian Formalists, Lamarque and Olsen regard the thematic content as only what motivates and organizes writing. Such themes do not occur in literary texts for the purpose of promoting knowledge and learning.

The banality argument, the no-evidence argument, and the no-argument argument are three of the leading philosophical objections to the notion that art and literature can function as sources of knowledge and education. Insofar as they are general objections, they preclude any artistic pretensions to knowledge and education, whether about society, psychology, philosophy, morality, and so on. In order to probe these general claims, I will focus on the possibility that art, and especially literature, can function as a source of moral knowledge and education. For, inasmuch as these skeptical arguments are universal (or nearly universal) in scope, this should be enough to defeat them.

[19] Lamarque and Olsen, *Truth, Fiction, and Literature*, pp. 332–3. [20] Ibid., p. 320.

Rather than confronting these skeptical arguments one at a time, I would like to introduce a consideration that simultaneously problematizes each of these arguments in different ways. These arguments, we must remember, are philosophers' arguments. And yet it is extremely peculiar that philosophers should raise these particular objections against literature, since philosophy employs a gamut of techniques to produce knowledge and learning that are analogous to those found in literature. What I have in mind here specifically are thought experiments, examples, and counterexamples that are often narrative and generally fictional in nature. Such devices are frequently employed by philosophers to defend and/or to motivate their claims, moral and otherwise. Thus, if these strategies are acceptable forms of knowledge production in philosophy and if literature contains comparable structures, then if philosophy conducted by means of thought experiments is an adequate source of knowledge and education, then so should literature be.

The thought experiment is embraced across philosophical schools. The phenomenologist Edmund Husserl referred to it as "free variation,"[21] the pragmatist Charles Sanders Peirce called "it ideal or imaginary experimentation,"[22] the logical empiricist Ernst Mach is said to have coined the term *gedankenexperimente*,[23] and the logical behaviorist Gilbert Ryle speaks of "imaginative variation."[24] Of course, thought experiments lie deep in the Western philosophical tradition: Plato's tale of the Ring of Gyges and Descartes's tale of the Evil Deceiver are both thought experiments. And thought experiments abound in contemporary philosophical literature, including: Quine's Gavagi, Putnam's Twin Earth, Searle's Chinese Room, Nozick's Experience Machine, Putnam's Brain in a Vat, Rawls's Original Position, Thomson's Ailing Violinist, Danto's Gallery of Indiscernible Red Canvases, and so on. Since virtually no philosophical technique is utterly beyond controversy, some criticisms of thought experimentation have been voiced. Yet thought experimentation continues to be an acceptable philosophical practice.

Before turning from the relevance of philosophical thought experiments to the arguments against the cognitive prospects of literature and art, it is first useful to remind ourselves of some of the features of philosophical thought experiments. Speaking very broadly, Roy Sorensen defines thought experiments as those "that purport to deal with their questions by contemplation of their design rather than by execution."[25] Thought experiments frequently take the form of narratives, but, at the same time, they also function as arguments. In order to refute utilitarianism, one tells a story about the execution of an innocent loner by a police force bent on maintaining public order. A philosophical thought

 [21] Edmund Husserl, *Ideas*, transl. W. R. Boyce Gibson (London: Allen and Unwin, 1932), pp. 57 and 198–201.
 [22] Charles Sanders Peirce, *Collected Papers* (Cambridge, MA: Harvard University Press, 1931–58), 3.527 and 3.516.
 [23] Roy A. Sorensen, *Thought Experiments* (New York: Oxford University Press, 1992), p. 51.
 [24] Gilbert Ryle, *Philosophical Arguments* (Oxford: Oxford University Press, 1945), p. 6.
 [25] Sorensen, *Thought Experiments*, p. 6.

experiment is not a device for reaching empirical discoveries but for excavating conceptual refinements and relationships.[26]

Philosophical or analytical thought experiments aim at mobilizing conceptual knowledge—a priori knowledge and/or the knowledge that underwrites our ability to apply concepts competently—in order to reach certain conclusions. In other words, thought experiments rely upon what we, as competent users of a concept, already in some sense know, in order to clarify our understanding.[27] Ideally, from our antecedent knowledge of how to apply certain concepts, the analytical thought experiment can shift our conceptual map in such a way that the results bring to the surface propositional knowledge about our concepts and their interrelationships.[28]

That is, given the specifics of an imagined case, we can be led to consider how we would or would not describe it or size it up in a way that may prompt us to contemplate, possibly clarify, and even reconfigure our conceptual commitments, thereby rendering our concepts newly meaningful.[29] Among other things, thought experiments provide us with the opportunity to observe the results of the imaginative employment of our antecedently possessed verbal and conceptual know-how in such a way that we become aware of what we already know.[30]

Analytic philosophers frequently use thought experiments, examples, and counterexamples for the purpose of the sort of clarification associated with conceptual analysis—for the purpose of framing, probing, and/or challenging definitions, for testing ways of setting up a question or a problem, for making precise distinctions, revealing adequacy conditions, tracing entailments and inference patterns, proposing possibility proofs, and assessing claims of conceptual necessity.[31] Fictional philosophical narratives of these sorts are considered arguments, albeit enthymemes. They rely on listeners to fill them in. They operate on the listener's antecedent conceptual knowledge, exploiting her or his ability to apply concepts in order to clarify that knowledge and to bring it out into the open, or to dispel or unmask conceptual vagueness and/or confusion. The listener reflects on the design of the thought experiment in such a way that her intuitions are brought explicitly into the foreground.

[26] C. Mason Myers, "Analytical Thought Experiments, " *Metaphilosophy*, 17 (1986): 109.

[27] Ernst Mach claimed that thought experiments exploit our fund of unarticulated experience. See Sorensen, *Thought Experiments*, p. 4.

[28] C. Mason Myers refers to this as the transformation of ability knowledge into propositional knowledge. He describes the process thusly: "We can reflect on our exercise of an intellectual ability in a way resulting in the formulation of rules or principles governing the proper exercise of that ability and this way we become aware of certain conceptual relations" ("Analytical Thought Experiments," p. 109).

[29] Tamar Szabo Gentler, *Thought Experiment: On the Powers and Limits of the Imaginary Cases* (New York: Garland, 2000), pp. 12 and 25.

[30] C. Mason Myers, "Thought Experiments and Secret Stores of Information," *International Philosophical Quarterly*, 13 (1968): 191.

[31] Sorensen, *Thought Experiments*, p. 15.

When my students tell me that any list of virtues is arbitrary, I ask them to imagine that they are parents endowed with the singular ability to invest magically their offspring with any package of personality traits they wish. As they contemplate this exercise with a commitment to the aim that their offspring be equipped to flourish or to do well in unpredictable circumstances, they invariably arrive at a list of traits many of which would certainly be recognized by Aristotle. And these results then lead them to reconsider critically the notion that every list of virtues is purely arbitrary or subjective. The fictional thought experiment functions argumentatively, enthymemetically, to shake their skepticism by mobilizing and reorganizing knowledge they already possess.

Now it should be clear that philosophical thought experiments, examples, and counterexamples are not vulnerable to the banality argument, the no-evidence argument, and the no-argument argument. They are not susceptible to the no-evidence argument, since philosophical thought experiments are not aimed at discovering empirical knowledge, knowledge already possessed by listeners intuitively, often inhering in their ability to apply concepts. Since philosophical thought experiments aim at the conceptual reorganization of antecedent knowledge, rather than empirical discoveries about the world, they can be fictional; imaginary cases suffice to get the mind moving over its conceptual map.[32] Actual cases are not required to produce conceptual knowledge. Thus, it is no failing of a philosophical thought experiment that it wants for the kind of evidence requisite for the production of empirical knowledge. Confronted with the proposition that it is always morally wrong to lie, a possible case concerning the return of a sword to its irrational owner is enough to unhorse the universalization.

Likewise, since philosophical thought experiments, examples, and counterexamples function by mobilizing and reorganizing what the listener already knows, the banality argument is irrelevant. Philosophical thought experiments may be dragooned in the service of banalities, and they are predicated on provoking reflection on what is already known, especially in terms of the application of concepts; nevertheless, we still regard them as productive of knowledge, since they make what in some sense is already known accessible and salient. They make connections—that were hitherto recessive or obscure—between what is already known and other parts of our cognitive stock. They illuminate the relevance of what is already known to the question at hand by refocusing that knowledge in a novel way. This counts as knowledge production, because it clarifies linkages between parts of our cognitive map. But, even if someone were to discount this as genuine knowledge production, on the grounds that all that has been achieved by the thought experiment is to draw forth what is already known (or what is

[32] Such as the stories J. L. Austin retailed in order to move readers to see distinctions between accidental doings, inadvertent doings, and mistakes in his "A Plea for Excuses," in *Philosophical Papers*, ed. J. O. Urmson and G. J. Warnock (Oxford: Oxford University Press, 1979), pp. 175–204. Similarly, law schools employ a profusion of hypothetical cases in order to teach students the conceptual contours, implications, and conceptual dependencies of the law. (See Gendler, *Thought Experiment: On the Powers and Limits of Imaginary Cases*, p. 14.)

implied by what is already known), it cannot be denied that thought experiments contribute to learning. For, granting that the slave in Plato's *Meno* already knows what Socrates elicits from him, it is still unquestionable that Socrates teaches him geometry.

The banality argument, then, leaves philosophical thought experiments unscathed. What of the no-argument argument? Construed very narrowly—say, in the terms of a logic textbook—thought experiments are not deductive arguments. They are incomplete. But they still function as arguments. For what is missing on the page is filled in by the reader's reflection on the thought experiment, example, or counterexample. Told the story about the shopkeeper who always counts out change scrupulously so as not to be stigmatized as a cheat, the reader grasps the point of the narrative and draws the distinction between prudent action and moral action on her own. The analysis occurs, so to speak, in her own mind, operating on her or his antecedent conceptual stock, and need not be spelled out on the page. Thought experiments are enthymemetic in this respect. But they are nonetheless arguments, often functioning maieutically. Thus, philosophical thought experiments do not fall afoul of the no-argument argument, at least where the concept of argument is applied as liberally as it is in philosophical discourse.

Philosophical thought experiments, then, which are often both narrative and fictional, cannot be rejected on the grounds of banality, lack of evidence, or lack of argument. Consequently, if some artworks, especially literary ones, are sufficiently analogous to philosophical thought experiments, examples, and counterexamples, then they too should be immune to these objections. But is there any reason to suppose that any artworks are sufficiently analogous to philosophical thought experiments?

One reason, of course, is that examples drawn from fiction are frequently put into service by philosophers. Rather than concoct their own thought experiments, that is, sometimes philosophers borrow them from literature. Encountering the Socratic doctrine that a person who knows the good cannot choose to do evil, the philosopher may respond by drawing attention to the literary cases of Milton's Satan, who declares, "Evil be thou my good," as well as to Shakespeare's Iago and Melville's Claggart.[33] The reader, using her conception of what is humanly possible, recognizes that such personality types could obtain and then goes on to take these literary inventions as counterexamples to the Socratic position. Thus, insofar as philosophers can use literary thought experiments argumentatively, there should be no objection, in principle, to authors and artists behaving comparably.

Undoubtedly, it will be pointed out that when philosophers appropriate literary examples as thought experiments, there is little question about how they intend them to be used; whereas, it might be said, the literary authors who invent them have no intention to use them argumentively. They invent characters, such

[33] See S. I. Berm, "Wickedness," in *Ethics and Personality: Essays in Moral Psychology*, ed. John Deigh (Chicago, IL: University of Chicago Press, 1992), pp. 201–5.

as Claggart, to entertain, not to make an argumentative point. But whether this is so depends on the text in question.[34] Some artworks and literary fictions are intended to make argumentative points, and where a convincing interpretation of the text renders that interpretation plausible, there should be no reason, in principle, to treat the artist's thought experiments—with respect to conceptual knowledge—differently from the philosopher's.[35]

A further reason to regard some artistic and literary fictions, or parts thereof, as comparable to philosophical thought experiments, examples, and counterexamples is that, when interpreted suitably and contextually, they can be seen as performing the same kinds of functions that philosophical thought experiments do. Some of the primary functions of philosophical thought experiments include: defeating alethic claims concerning possibility or necessity or deontic claims of what ought or ought not be done, or of what is or is not obligated; advancing modal claims about what is possible; and, finally, motivating conceptual distinctions—that is, refining conceptual space, rendering what was vague more precise by promoting what Wittgensteinians might call exercises in the grammar of concepts or grammatical analysis. But, if we grant that these are among the leading functions of philosophical thought experiments, then we must also grant that some artworks, under eminently plausible interpretations, can discharge the same functions.

The function of a great many philosophical thought experiments is to raise counterexamples to universal claims. The same can be said with justice about some (even many) of the narrative fictions found in literature. In 1938, E. M. Forster wrote:

Personal relations are despised today. They are regarded as bourgeois luxuries, as products of a time of fair weather which is now past, and we are urged to get rid of them, and to dedicate ourselves to some movement or cause instead. I hate the idea of causes, and if I had to choose between betraying my country and betraying my friend, I hope I should have the guts to betray my country.[36]

One straightforward way of understanding Forster's remarks here is as an endorsement of the moral maxim, "When loyalty to a friend conflicts with loyalty to a cause, one ought to choose in favor of the friend." But suspicion of this maxim seems precisely what animates Graham Greene's 1949 screenplay for *The Third Man*.[37]

[34] There can be little doubt that Ursula Le Guin's short story "The Ones Who Walk Away from the Omelas," is a thought experiment designed to challenge utilitarianism. Indeed, one could assign it to a class with that very purpose in mind.

[35] Moreover, it is important to remember that sometimes philosophical thought experiments require interpretations in order to be located, identified, and understood. Should the skeptic complain at this point that the preceding argument depends upon interpreting the artwork, that will not compromise my point unless the skeptic also argues that truthful and/or plausible interpretations of the sort required are, in principle, impossible. Perhaps, needless to say, I do not find such a position persuasive, though discussion of this dialectical counter would require another article.

[36] E. M. Forster, "What I Believe," from *Cheers for Democracy* (New York: Harcourt Brace, 1967).

[37] I owe this example to Lester Hunt.

Though Harry Lime is Holly Martins's best friend and old school chum, as the evidence mounts that Lime's black-market drug dealing has destroyed thousands, including children, Martins is finally compelled morally to sever the bonds of friendship and to assist the Allies in tracking Lime down. Finally, Martins himself shoots Lime, appropriately enough in a sewer (which is where the story suggests people like Lime belong). As a counterexample to Forster's maxim, it makes no difference that the story is a fiction, that Lime never existed, and that, consequently, he poisoned no one. For the viewer or reader recognizes that a situation like the one imagined by Greene is a possible one, and, using our already in-place cognitive/moral stock, we, along with Martins, realize that Forster's maxim is untenable.

Some might be skeptical of this example on the grounds that it is the case of a philosopher, namely, me, using a fictional example to do my work for me. That is, I am using Greene's screenplay because I am too lazy to invent a thought experiment of my own design. It is, in effect, my thought experiment, juxtaposed to Forster's maxim, and not Greene's thought experiment. However, a cursory examination of the text makes clear that the issue of personal loyalty is at the very heart of Greene's thriller—that Martins's conversion to the Allied cause is its central dramatic conflict. This dramatic transformation is, in fact, highlighted by an important contrast in the fiction, since Anna Schmitt, Lime's lover, refuses to be disloyal to Lime, thereby casting Martins's metamorphosis into bold relief.[38] Another reservation about my use of *The Third Man* might involve a reversion to the banality argument. That Martins should side with the Allies in their pursuit of a vicious racketeer, it might be said, is a no-brainer. Who needs a counterexample, especially such an elaborate one, to persuade any decent person of this? Later, I will make some comment on the elaborateness of literary thought experiments. For the moment, let me concentrate on the accusation of banality.

Though for most moral philosophers, the notion that a just cause should trump friendship may seem self-evident, nevertheless for ordinary people caught in the web of daily life, Forster's maxim has seductive resonance. It may strike many, especially given certain circumstances, as a piece of commonplace wisdom—a reliable, even noble, guide to life's decisions. It is certainly the sort of consideration that anyone caught between friendship and a cause will take very seriously, even if not as ultimately decisive.

Literature, moreover, enters public discourse at the level of ordinary experience. Novels and plays are not, in the main, directed at moral philosophers, but at plain readers who deliberate about living problems by consulting maxims derived from what passes as commonplace wisdom. In that context, the falsity of Forster's maxim is not self-evident; indeed, it has even been attractive to many of Forster's admirers in the intellectual elite. So, given the context in which the

[38] Also, Martins struggles palpably with the question of loyalty. At one point, Anna sways him in the direction of abiding by his friendship for Lime. It is only after that that he decides for the Allies, when Callahan shows him documentation of Lime's victims.

Forster/Greene debate is staged, the conclusion *The Third Man* elicits is hardly banal, if by banal one means a redundant, foregone conclusion.[39]

In reviewing the banality argument, it is worthwhile to notice that it raises the question of "banal for whom?" Art and literature are customarily directed at communities broader in scale and background than the philosophy colloquium. Conclusions that might appear utterly banal or obvious for experts in ethics may not be banal or obvious to non-professional audiences, especially where the maxims in question figure in pitched, contextually motivated, debates about pressing issues abroad in the culture.[40] What the philosopher discounts as trivial may in fact be revelatory for the plain reader and, for that very reason, can have a fair claim to being informative and educative for the intended audience.[41]

The potential of art to challenge the standing ideas of a culture—moral, political, and even theoretical ideas—is a feature emphasized by many defenders of literature's claim to be a source of knowledge and education.[42] Art and literature, by destabilizing reigning ideas, often elicit social debate by functioning as counterexamples, undercutting, subverting, and disconfirming common belief by designing thought experiments, such as *The Third Man*, whose possibility the reader recognizes, upon reflection, refutes prevailing opinion. In such cases, no evidence is required for the thought experiment as argument to find its mark. Thus, the fact that *The Third Man* is fictional is no impediment to its yielding knowledge, and, even if that yield could be described as merely a reorganization or refocusing or even recollection of knowledge already possessed, it need not be dismissed as banal for its intended audience. For an already known but neglected truth reinserted strategically into a debate can afford insight; sometimes education can involve remembering, recalling, reconfiguring, or applying in a pertinent context what one already knows. Much artistic criticism of social convention operates like this: through imagining eminently possible cases that contradict conventional wisdom, authors prompt readers to recognize the limitations of the maxims and concepts they live by as well as their implications.

[39] Furthermore, if philosophical defenses of theses already known are saved from charges of banality in virtue of their philosophical thought experiments, then the argumentative thought experiment posed by *The Third Man* should exonerate as well.

[40] Mark Kingwell suggests that Forster's maxim is still a live issue. See Mark Kingwell, *In Pursuit of Happiness* (New York: Crown, 2000), pp. 310–11.

[41] That charges of banality must be relativized to intended audiences—rather than supposing the relevant audience is always comprised of all and only sophisticated philosophers and advanced thinkers—is noted in Peter Kivy, "On the Banality of Literary Truths," p. 20, and Noël Carroll, "Art and Ethical Criticism," *Ethics*, 110 (2000): 365.

[42] See, for example: Hilary Putnam, "Literature, Science, and Reflection," in his *Meaning and the Moral Sciences* (London: Routledge, 1978), pp. 83–96; Catherine Wilson, "Literature and Knowledge," *Journal of the Royal Institute of Philosophy*, 58 (October 1983): 489–96; R. W. Beardsmore, "Literary Examples and Philosophical Confusion," in A. Phillips Griffiths, ed., *Philosophy and Literature* (Cambridge: Cambridge University Press, 1984), pp. 59–73; Bernard Harrison, *Inconvenient Fictions: Literature and the Limits of Theory* (New Haven, CT: Yale University Press, 1991); John Passmore, *Serious Art* (LaSalle, IL: Open Court, 1991); and Richard Eldridge, "Reading for Life," *Arion*, 2 (1992): 187–97. This approach is also discussed in Noël Carroll, "Art and Ethical Criticism," p. 364; and Martin Warner, "Literature, Truth, and Logic," *Philosophy*, 74 (1999): 51–4.

Such literary thought experiments function to refute beliefs about what is necessary or universal or morally required by imagining possibilities, thereby promoting reflection from audiences in the same way that Plato does in his *Philebus* when he confronts the hedonist with the prospect of living the life of a contented oyster. The example energizes thought, throwing one back on one's antecedent cognitive resources, probing them, and eliciting a conclusion. If this counts as argumentation in Plato's case, then so should it in Graham Greene's. Therefore, inasmuch as the no-argument argument does not pertain to philosophical thought experiments, neither must it preclude comparable literary thought experiments. For the relevant argumentation and analysis is elicited in the mind of the reader, either in the process of reading or in what Peter Kivy has elegantly christened the reflective afterlife of the work—our mulling over the significance of the story and its characters after we have put the book down, or even perhaps our reflection during subsequent discussions with other readers.[43]

Moreover, literary thought experiments, like philosophical thought experiments, need not function only negatively as counterexamples. They too can function positively to clarify concepts, to dispel vagueness, and to illuminate the criteria that lead us to apply concepts one way or another. Arthur Danto, for example, imagines a gallery of nine, indiscernible, red-covered canvases in order to map the concept of art, while also juxtaposing the *Don Quixote* of Cervantes with the *Don Quixote* of Menard in order to isolate certain of the conditions in accordance with which we individuate works of art.[44] This is a very standard use of philosophical thought experiments in the service of conceptual analysis: to array a structured series of carefully chosen, contrasting, graduated examples in order to provoke reflection on concepts whose conditions of application remain otherwise elusive and/or vague. Call this function of philosophical thought experiments conceptual discrimination. It should also be evident that literary thought experiments can also promote conceptual discrimination in just this way, since, of course, Danto himself appropriates the Cervantes/Menard juxtaposition from the story by Jorge Luis Borges entitled "Pierre Menard, Author of the Quixote."

It is my contention that conceptual discrimination occurs in art, especially in literature, quite frequently, or, at least, much more than heretofore suspected, and that this justifies our speaking of certain literary thought experiments as analogous enough to philosophical thought experiments that we may wave to one side the banality argument, the no-evidence argument, and the no-argument argument.

[43] Kivy introduces this notion in his "The Laboratory of Fictional Truth," *Philosophies of Art: An Essay in Differences* (New York: Cambridge University Press, 1997), pp. 121–39. There he argues that it is part of the practice of literary appreciation that readers confirm (or at least contemplate?) the truths advanced in literary works during said afterlife. See Kivy's "On the Banality of Literary Truth," where he argues that the argumentation and analysis alleged to be lacking in literature by proponents of the no-argument argument are supplied by the reader in the reflective afterlife of the text (see pp. 22–3).

[44] Arthur Danto, *The Transfiguration of the Commonplace: A Philosophy of Art* (Cambridge, MA: Harvard University Press, 1981), Chs 1 and 2, respectively.

For, though literary thought experiments of this variety tread conceptual terrain that in some sense we already inhabit, they cultivate our grasp of what is known with finer distinctions. Even if such knowledge is already known, it is not banal, since literary thought experiments refine it. Moreover, since what they produce is conceptual knowledge rather than empirical knowledge, they are immune to the no-evidence argument.[45] And, lastly, insofar as the thought experiment is itself an instrument of argumentation, broadly but fairly construed as a device for stimulating and guiding reflection and analysis in the mind of the reader, the literary thought experiment is no more vulnerable to the no-argument argument than the philosophical thought experiment is.

One particularly rich topic that is explored by literary and artistic thought experiments concerns our concepts of virtue and the conditions according to which we apply them. To defend this claim, let me spend some time examining Forster's novel *Howards End*. As you may recall, it involves, most importantly, the interactions of two families—the Schlegals and the Wilcoxes. The trait that marks the Schlegals is imagination, signaled by their interests in art, literature, music, culture, and political idealism.[46] The Wilcoxes, in contrast, are practical people, strong on duty and convention, and committed to the life of business affairs and acquisition. There are other important characters, such as Leonard Bast, but, as we will see, he too figures in the organizing contrast between imagination and practicality.

The epigraph of the novel is "Only connect . . ." What must be connected? As Margaret Schlegal, the protagonist, makes explicit, what must be connected are passion and prose—imagination and practicality—in a complete, unfragmented life, i.e., in a flourishing or virtuous life. The central problematic of the novel is the appropriate coordination of the virtues of the imagination and of practicality. To pursue this question, the novel parades before us a series of characters who instantiate these virtues in varying degrees, inviting us to compare and contrast these instantiations—to determine whether, for example, the characters possess the virtues of imagination and practicality in appropriate or defective ways—and to reflect upon which manner of connecting these traits adds up to what we would be willing to call a suitably complete and virtuous way of living.[47]

[45] Here my use of the notion of conceptual knowledge should not be confused with Putnam's use in "Literature, Science, and Reflection." Putnam appears to mean the notion to refer to knowledge of possible lives, arguing that this is a way in which literature can function as a source of knowledge (knowledge of life possibilities). I use "conceptual knowledge" in a more prosaic and traditional manner, namely, as "knowledge of concepts." However, I do not dispute Putnam's strategy for defending literature as a source of knowledge. It is another way of getting the job done, though a different way from the one pursued in this chapter.

[46] Their name, Schlegal, of course associates them onomastically with German Idealism and its emphasis on the imagination, since the sound of their name reminds one of Friedrich and August Wihelm Schlegel.

[47] Fictions are often preoccupied with the question of balancing one's commitments virtuously. Jane Austen's *Persuasion*, for instance, examines the danger of letting oneself be persuaded unduly by the claims of prudence and the practical advice of one's elders.

To promote and guide this reflection, the novel deploys a structure—which I believe is quite frequent in art, especially narrative art and literature—that we might call the virtue wheel or virtue tableau. A virtue wheel or virtue tableau comprises a studied array of characters who both correspond and contrast with each other along the dimension of a certain virtue or package of virtues—where some of the characters possess the virtue in question, or nearly so, or part of it, while others possess the virtue, but only defectively, or not at all, even to such an extent that their lack of the virtue in question amounts to the vice that corresponds to the virtue. In this way, a virtue wheel is a comparable structure to the studied, polarized array of contrasts found in philosophical thought experiments, such as Danto's, that by systematically varying possible contributing factors enable us to identify conceptual dependencies and other relations.[48]

For example, in Dickens's *Great Expectations*, we find a structured array of contrasting parental figures who instantiate the virtues of parenthood to greater, but, more often, lesser degrees: Pip's sister, her husband Joe Gagery, Miss Havisham, and Abel Magwitch. Reflecting on this array, we are able to clarify our concept of virtuous parenting. Only Joe qualifies under the concept, since he alone shows selfless love in relation to his charge. Moreover, his possession of this virtue is illuminated by contrast to the other parental figures who, in varying ways, suggest defective and even vicious modes of parenting. Pip's sister fails before the criteria of virtuous parenting, since she regards him as a chore, simply to be disciplined "by hand," as she says.[49] Miss Havisham and Magwitch, in turn, are defective parental figures, since they regard their wards as ways to satisfy their own fantasies—Pip and Estella are not ends in themselves, but means to achieve vicarious wish-fulfillment for Magwitch and Miss Havisham, respectively. The virtue wheel in *Great Expectations* enables us simultaneously to clarify our concept of virtuous parenthood—it allows us to reflect upon the conditions where we would apply or withhold it—while also sharpening our sense of when the concept is defectively or even viciously instantiated. The text makes these conceptual discoveries available to us, if not as we read along, then in the reflective afterlife of the text or in conversation with others about our reaction to the text.[50]

Similarly, *Howards End* is structured in terms of a rather elaborate virtue wheel. Not only are the Schlegals and the Wilcoxes as families contrasted with each other; there are further contrasts among the major players that suggest better and worse ways of possessing the relevant character traits. On the Schlegal side of the divide, there are Margaret, her sister Helen, and her brother Tibby. They

[48] Gendler, *Thought Experiment*, p. 27.
[49] Indeed, her notion of parenting reduces simply to discipline.
[50] Virtue wheels occur not only in novels; they can also occur in films and other art forms. For an analysis that does not use the concept of a virtue wheel explicitly but nevertheless finds a structure analogous to the one in *Great Expectations*, see Joseph Kupfer's "The Virtues of Parenthood," in his fascinating book *Visions of Virtue in Popular Film* (Boulder, CO: Westview Press, 1999), pp. 91–122.

are all imaginative, though only Margaret seems to be imaginative in a virtuous way, since only Margaret perceives the necessity of tempering imagination with practicality; only Margaret can see that there is something virtuous about people like the Wilcoxes.

Helen and Tibby, in turn, illustrate, as Aristotle might have predicted, *two* ways in which the virtue of imagination can be defective. Helen's imagination is almost pathological; so overwhelmed by imaginative empathy for others, notably the Basts, is she that she harms the people closest to her and herself; whereas Tibby is so preoccupied with the life of the imagination—conceived of in terms of aesthetic/scholarly distance—that he is almost completely indifferent to others. As we reflect on the novel, we come to realize that only Margaret is a real candidate for the virtue of imagination, properly so called. We not only learn that, but also we become conscious of why we ought to withhold ascription of the virtue from people such as Helen and Tibby. They have either too much imaginative empathy or too little. Only Margaret is able to strike a balance.

Likewise, the Wilcoxes suggest a series of gradations on the theme of practicality. Henry, the paterfamilias and eventual husband of Margaret, is a practical man, but he appreciates the imagination in a limited way; it is her imagination that attracts him to Margaret. His elder son, Charles, has no inkling of imagination, but lives utterly by convention, a trait that not only blinds him to imaginative reflection, but leads him to kill Leonard Bast accidentally; whereas his sister Evie is completely a figure for material or physical (as opposed to spiritual) existence, associated as she is almost exclusively with sports and rearing pets. She is all "body," and scarcely a mind.

However, even though Henry represents the best—with respect to his family—of the practical approach to life, he is still wanting, precisely, as we see through the contrast with Margaret Schlegal, because of his lack of imagination. He is unable to grasp the analogy between his previous illicit relation to Mrs Bast and Helen's transgression of conventional morality; he is unable to see that as Margaret forgave him, so should he forgive Helen. Also, he lacks any imagination of the sort Helen has in unfortunate overabundance; he lacks empathy.

His lack of empathy, in turn, brings Margaret to an awareness of the proper balance between imagination and practicality in the virtuous life. Realizing that the claims of the practical and the conventional cannot reasonably extinguish the claims of imaginative empathy, Margaret defies Henry's refusal to allow Helen to stay over at Howards End. Thus, Margaret illustrates the proper coordination of practicality with imagination, of conventional morality with empathy, in a way that also sheds light upon defective and even vicious ways of inhabiting the traits of imagination and practicality. To the extent that virtue involves placing a brake on excessiveness, the example of Margaret Schlegal suggests that while practicality is a needed brake on imaginative excess, imagination is a needed brake on practical or conventional excess.[51] And,

[51] The idea of virtues as brakes can be found in G. H. von Wright, *Varieties of Goodness* (New York: Humanities Press, 1963), and Robert C. Roberts, "Will Power and the Virtues," in Robert

inasmuch as the reader concurs with Margaret's behavior (and reflects on why he does so), the reader can be said to come to see or, at least, to recollect the relevance of these considerations to his application of the concepts in question.

Other characters in the novel also occupy various points on the virtue wheel. Leonard Bast, for example, attempts to compartmentalize the imagination and practicality—he fails to connect. Because of this, he never really appears to deserve being thought of in terms of either virtue.[52] However, rather than proceeding by locating every significant character in the novel on the virtue wheel, I suspect that I have said enough to draw the relevant conclusions I need about how the virtue wheel serves as a structure that enables *Howards End*, conceived of as a thought experiment, to discharge the function of concept discrimination.[53]

As in many literary works, films, plays, narrative paintings, ballets, and so on, in *Howards End* we do not simply find a bunch of characters willy-nilly. Rather, the cast of characters bears notably strong, highly structured, systematically varied, and subtly polarized relations of comparison and contrast to each other, particularly along the dimension of virtue. In this respect, virtue wheels recall the structures of studied variations and contrasts found in philosophical thought experiments dedicated to concept discrimination.

B. Kruschwitz and Robert C. Roberts, eds, *The Virtues: Contemporary Essays on Moral Character* (Belmont, CA: Wadsworth, 1987), pp. 121–36.

[52] Another character who perhaps deserves mention here is the first Mrs Wilcox. In terms of the virtue wheel, she would appear to belong on the side of imagination, not merely for her almost mystical relation to nature, but also for her impressive empathetic understanding. She is able to know what is going on with others—note how she knows about Helen's engagement at the beginning of the book—though no one understands how she does so. One also supposes that she has chosen Margaret as her successor just because she realizes that the Wilcox family needs imagination. The first Mrs Wilcox is not an ideal fusion of imagination and practicality, however, since she lacks, as Margaret does not, the forcefulness to stand up to the worst tendencies of her family. The Schlegals' aunt, on the other hand, functions as a comic contrast on the virtue wheel: she prides herself on her practicality, but she has none; likewise, she is without imagination.

[53] For another example of a complex virtue wheel, consider this description of *Tom Jones* by L. J. Potts: "The plot of Tom Jones is a comic plot, based on the grouping of the characters rather than on the sequence of the events. The centre of the picture is the contrast between Tom and his half-brother Blifil; between man as a spontaneous animal, and man as a calculating machine. But that by itself would not say more than a quarter of what Fielding has to say. The book is not a defense of animalism; so Fielding gives us two more 'animals' to contrast with Tom. Squire Western and Molly Seagrim, the one deprived of his wits by coarse habits, and the other deprived of honesty and self-respect by her bad heredity and environment. They throw into further relief Tom's character, which is both sensitive and honest; and on the other side there is Sophia, who has Tom's naturalness without his faults. Again, in the Blifil camp there are two minor rascals. Thwackum and Square; they are as selfish and dishonest as he is, but they make him look blacker both because they lack his cool-headed cunning, and because they have some sort of principles; and they are themselves contrasted and receive different treatment in the end, for Square is at least free from the cruelty and ill-nature of Thwackum and Blifil. There is also the contrast of Sophia's liveliness and breeding with the rather corrupt liveliness of Mrs. Fitzpatrick and the superficial breeding of Lady Bellastom and yet another contrast between the selfish fecklessness of Partridge and the disinterested fecklessness of Tom." See L. J. Potts, *Comedy* (New York: Capricorn, 1966), pp. 133–4.

In literary fictions, such as *Howards End*, these comparisons and contrasts are apt to strike any moderately attentive reader, who, in addition, is aided in this by what the author and the characters say. These variations—these comparisons and contrasts—prompt the audience to apply concepts of virtue and vice to the characters, thus exercising and sharpening their ability to recognize instances of these otherwise often vaguely defined or highly abstract concepts.[54] In this, such virtue wheels serve the purposes of moral education by enabling readers to recognize better, as Trollope might say, things like true honesty and false love. Moreover, this is clearly a contribution to our moral lives, since a large part of our moral lives is not simply concerned with how to act, but with issuing moral judgments about others.[55]

But virtue wheels can do more than cultivate our capacities for moral perception; they can also call attention to the criteria we depend upon in judging the moral character of others. Thus, not only do virtue wheels exhibit a comparable structure to philosophical thought experiments; they may also perform the same function. That is, not only do thought experiments of the virtue-wheel variety exercise and refine our skills of moral judgment; they can also help to make explicit the conditions upon which those judgments rest by studiously varying the similarities and differences between the various characters situated on the same virtue wheel. If we withhold the concept of imagination, properly so called, from Helen, who possesses it at best neurotically, but award it to Margaret, we may (and may even be likely) to ask ourselves, "Why is that?" The virtue wheel then enables us to highlight that a sense of practicality—including care and concern for those who are closest to us—is a constituent of genuine imaginativeness in our commerce with others.

That is, a virtue wheel can provide the opportunity for initiating a guided conceptual analysis or grammatical investigation into the notion of true

[54] On the idea that literature aids the understanding of highly abstract conceptions of the virtues by matching the virtues with concrete cases—and thereby enhancing our capacity for making judgments of character—see Noël Carroll, "Art, Narrative, and Morality," in Jerrold Levinson, ed., *Aesthetics and Ethics* (New York: Cambridge University Press, 1998), p. 147.

[55] Philosophers, such as Onora O'Neill, have argued that literary examples should not play a role in ethics, because they are too indeterminate. What appears to concern her is that a literary example cannot be instructive about the way in which to act in a specific real-world situation, because we cannot be certain that it matches the real-world situation in all morally relevant respects. Whether or not that is true, however, is not pertinent to our proposal, since we are not talking about deploying literary thought experiments for the purpose of making reliable decisions about whether to act one way or another. Rather, we are talking about clarifying our moral concepts. Even if literary thought experiments are not reliable guides to action in concrete situations, that does not detract from their potential for moral education where that education does not involve their use as props for decisions about action, but involves sharpening the concepts we use in the judgments we make about the behavior of others, and even ourselves, as well as understanding the conditions upon which these judgments rest. Not all moral deliberation, I wish to stress, is a matter of deciding how we should act in a situation. Much moral deliberation is about ascribing virtues and vices. This sort of judgment is as much a part of morality as deciding about the way in which we shall act. Moreover, it is here that literary thought experiments are particularly attractive. Nor, for the reasons just sketched, do O'Neill's anxieties suggest that we must resist said attractions. See Onora O'Neill, "The Power of Example," *Philosophy*, 61 (1986): 5–29.

imagination, or true honesty, or false loyalty. In this way, the literary thought experiment can, like the philosophical thought experiment, function as an argument in the service of conceptual discrimination, and it is able to do this, in part, because it possesses a comparable structure.

As in the case of many philosophical thought experiments, literary thought experiments such as *Howards End* rely on the audience to note the relevant conceptual discriminations and to reach the pertinent conclusions. In this sense, they are rhetorical—they call upon the antecedent resources of the reader—but they are rhetorical in a way that is not divorced from argumentation (since a *rhetorical* question, for example, can be argumentative).[56] The argument, however, occurs in the mind of the reader, either while processing the text, or, more likely, during its reflective afterlife (whether pursued in conversation with ourselves or with others). Thus, literary thought experiments are not bereft of argument and analysis; rather, they set up the argument, while pointing the way to certain conclusions, and they prime the analysis that is completed in the mind of the reader. In this respect, they are doubly educative: not only do they afford knowledge of concepts of virtue, but they guide the reader through the process of conducting a grammatical investigation of the virtues by arraying in a structured way imagined examples that point toward pertinent distinctions.

When a literary thought experiment is summarized in the way in which I have just explicated *Howards End*, it is likely to sound preachy rather than maieutic. However, *Howards End* is not experienced as a catechism.[57] Rather, one senses that there is something wrong with Helen, for example, and then tries to put one's finger on what it is. This often occurs not while reading, but when reflecting on it either between chapters or after one has finished the book.[58] In this context, the contrasts available through the virtue wheel come into play and help clarify the nature of Helen's flawed imagination, which, in turn, inclines one to consider what it is about Margaret that makes her variation on the theme of imagination appropriate. That this sort of reflection about characters is a natural part of reading novels is, I think, undeniable. But it needs to be understood that this reflection not only exercises our capacities for recognizing what falls under the concept of a given virtue, but also for contemplating the kinds of characterological properties that lead us to apply the concept in question or to deny it.

Literary fictions, then, can afford knowledge of concepts, such as concepts of virtue, by stimulating the reader to an awareness, through reflective self-analysis,

[56] Some works combine the virtue wheel and the structure of the rhetorical question. For example, in "The Great Stone Face" by Nathaniel Hawthorne, the requisite virtues are inferred by the reader in response to a series of failed candidates. This, in turn, leads the reader to anticipate that it is Ernest who possesses the relevant qualities.

[57] Anthony Palmer worries about the use of literature merely to illustrate theoretical doctrines. This, I surmise, he regards as an offense against literature. But I hope that my treatment of *Howards End* indicates that literary thought experiments need not function as thinly as Palmer fears. See Anthony Palmer, "Philosophy and Literature," *Philosophy*, 65 (1990): 151–66.

[58] An experience I trust that no one will deny is part of interacting with literature. No one, I believe, can imagine that literary experience is simply a matter of the experience of reading what is on the page.

of the conditions, rules, and criteria for her application of said concepts.[59] Although in some cases a literary thought experiment might suggest a necessary or sufficient condition for the application of such concept, if you are wary of the existence of such criteria, you need not abandon this line of defense of literature as a source of conceptual knowledge of our existing cognitive map; since even the skeptic about principles such as these can grant that what we may learn from fictional thought experiments are reminders of the sort of importance that a property can have in the relevant concepts in suitable situations.[60] That is, for example, Henry's case from *Howards End* may serve as a reminder that in certain situations, if practicality is to be considered virtuous, it needs to be tempered or supplemented by imagination.

Indeed, in reflecting on the scope of our conceptual discoveries—in determining whether we have found an invariant condition for some concept or only a reminder of an important variable in certain contexts—the worry about the vagueness (with respect to quantification) of literary implications can be allayed somewhat on the grounds that encouraging the reader to determine the generality or specificity of the grammatical disclosures in question is also part of the educative function of literature and art.[61]

So far I have been urging against the no-argument argument that virtue wheels in literature and art (or at least some of them) can be regarded as thought experiments because they possess comparable structures (a polarized set of contrasts) and perform comparable functions (such as eliciting conceptual discrimination), as do certain philosophical thought experiments.[62] But is there

[59] Although in this chapter I have been emphasizing the potential of artworks and particularly literature to promote knowledge of virtue through concept discrimination, I think other forms of conceptual knowledge can also be obtained in this way. The potential for literature to stimulate grammatical analyses of the emotions has been explored by Alex Neill in his "Fiction and the Education of the Emotion," a paper delivered at the Annual Meetings of the American Society for Aesthetics in Kansas City, October 30, 1987. And Eileen John has examined the way in which Grace Paley's story "Wants" initiates a conceptual analysis of wanting (see Eileen John, "Reading Fiction and Conceptual Knowledge: Philosophical Thought in Literary Context," *The Journal of Aesthetics and Art Criticism*, 56 [1998]: 331–48).

Fictions can also illuminate the relation of certain virtues to connected character traits and their rationales, affording thereby insight into moral psychology. For an interesting example of this with regard to popular Western fictions, see Peter French, *Cowboy Metaphysics* (Lanham, MD: Rowman and Littlefield, 1997). Colin McGinn also illustrates the power of literature to explore the conceptual relations underpinning the moral psychology of virtues and vices—for example, the relation of existential envy to pure evil—in his *Ethics, Evil and Fiction* (Oxford: Oxford University Press, 1997). Literary thought experiments also afford insight into moral metaphors of the sort explored by Mark Johnson in his *Moral Imagination* (Chicago, IL: University of Chicago Press, 1993).

[60] Jonathan Dancy, "The Role of Imaginary Cases in Ethics," *Pacific Philosophical Quarterly*, 66 (1985): 150.

[61] In terms of my examples, I think that *Great Expectations*, conceived of, in part, as a thought experiment about the virtues of parenting, identifies selfless love as a necessary condition of the virtue, whereas *Howards End* serves merely to remind us that considerations of practicality are relevant when determining whether an instance of empathy should be counted as falling under the concept.

[62] In his Nobel Prize address, Joseph Brodsky said, "On the whole, every new aesthetic reality makes man's ethical reality more precise." I like to think that one thing Brodsky had in mind by

any reason to believe that virtue wheels really operate this way? There should be no problem in admitting the existence of virtue wheels in much art, notably narrative art, including not only literature, but also theater, film, TV, narrative painting and sculpture, ballet, modern dance, and so on. The virtue wheel is a structure that we encounter again and again in artworks, particularly narratives with more than one character. But why believe that it can function to promote the kind of conceptual discrimination I have been advertising as one of its potentials?

Perhaps some evidence for this hypothesis can be found in the typical response of plain audiences to narrative artworks. What do ordinary folk (or even academics when they leave the classroom and conference hall) talk about after they see a play or a film, or the morning after the airing of a TV show, or when they discuss a new novel? They talk about characters. Though the discussion of character is not a major concern in contemporary theoretical approaches to the arts,[63] it is usually the first order of business in informal discussions of narrative artworks.[64]

Frequently, people begin by discussing their likes and dislikes regarding the characters. But this, where opinions differ, soon leads to a consideration of the character attributes that ground those assessments. Here we point to the features of the characters that warrant our judgments, pro and con. And this, in large measure, involves pointing to the virtues and vices of the characters. As we compare and contrast what we have observed about the characters with the views of others, and as we weigh our judgments against what others have to say, we are, of course, engaging in a process of reflective equilibrium about the aptness of our applications of concepts of virtue and vice that, among other things, brings to the fore or makes available to us an awareness of the conditions in accordance with which we make those applications and issue our judgments.

Often informal conversation and debate of this sort explicitly interrogates disputants' use of this or that virtue in describing this or that character.

this was the virtue wheel and its potential for sharpening conceptual discrimination. For a more extended analysis of Brodsky's speech, see Marcia Muelder Eaton's presidential address, "Aesthetics: The Mother of Ethics?," *The Journal of Aesthetics and Art Criticism*, 55 (1997): 355–64.

It may be thought that my exploration of virtue wheels grants too much to the no-argument argument. It may be observed that we do not require as a condition of knowledge communication and education in non-literary fiction that putative insights be accompanied by argumentation, analysis, and debate. We will consider such writing a vehicle of knowledge as long as the reader is able to come up with supporting argument and evidence for the relevant claims on her or his own. Thus, the no-argument argument is too stringent in its presuppositions. I agree with this, but have proceeded as I have in order to give the no-argument argument its best shot. Also, what I have said about the virtue wheel is in the same spirit as the present observation, since on my account what the virtue wheel does is supply the reader with the analytic tools for constructing the pertinent conceptual discriminations.

[63] Murray Smith, *Engaging Characters* (Oxford: Oxford University Press, 1995), pp. 17–20.

[64] And if it is not always the first order of business—because sometimes folks start talking about the probability or improbability of the narrative—then it is the second order of business (though, of course, discussions of probability themselves are frequently connected to the probability of a certain character behaving one way or another given her or his various virtues or vices).

Is so-and-so correct in calling such-and-such a character shy rather than aloof,[65] arrogant rather than magnanimous, reckless rather than courageous? Does the ingénue have character, properly so called, or merely personality? This then can quickly escalate into questions about what it means to call a behavior or a character truly courageous, or cowardly, or reckless.[66] And at this point—in what I conjecture is a representative scenario of informal discussions of narrative art—our conversationalists have embarked upon something that can be unequivocally described as a form of conceptual analysis.

I believe that philosophers and theorists do not pay enough heed to the ordinary transactions that transpire between artworks and their audiences, despite the fact that this is an obvious place to look for the lineaments of our artistic practices. Instead, they often build their theories in response to certain epistemological constraints that have little to do with the actual reception of art. Perhaps this is why philosophers and theorists have so little to say about characters, often referring to them gingerly by means of technical phrases such as "character functions." But this is not how typical consumers of art and literature regard them. Not only do they very often read for character—read because of their interest in characters—but they understand these characters in terms of virtually the same person schemas they use to understand each other in everyday life.

Literature and narrative art, then, become a means of exploring those person schemas in conversations (with either oneself or others) in the reflective afterlife of the text. Moreover, large portions of those person schemas are constituted by our concepts of virtue and vice—for what is it to be or to have a character, in art or life, other than to possess an ensemble of virtues and vices?[67] Indeed, it is probably no accident that we use the same word—"character"—to refer to fictional beings and the ensemble of virtues of existing persons. Thus, the ordinary tendency to read for character leads ineluctably to a contemplation of virtue and vice as well as, quite frequently, to reflection upon our application of those concepts in everyday life.[68]

It may seem strained on my part to attempt to derive evidence for the conceptual discrimination putatively evoked by the virtue wheel from ordinary conversations after a movie or a play. Those conversations, as I have indicated, typically begin with the expression of likes and dislikes, preferences and aversions to characters. However, these preferences, I submit, are connected to our

[65] R. E. Ewin argues that this is a central preoccupation of Jane Austen's *Pride and Prejudice*. Although Ewin does not speak of thought experiments or virtue wheels, it should be evident that his approach to *Pride and Prejudice* parallels my approach to *Howards End* as a type of conceptual analysis. See R. E. Ewin, "Pride, Prejudice and Shyness," *Philosophy*, 65 (1990): 137–54.

[66] Here it is hard to imagine that the dispute could proceed, unless it is supposed that people are talking about what it really means to call someone courageous, rather than merely what one of the disputants means by the concept. Thus, the requirements of the debate itself pushes it onto the territory of conceptual analysis and discrimination, properly so called.

[67] N. J. H. Dent, *The Moral Psychology of the Virtues* (Cambridge: Cambridge University Press, 1984), p. 10.

[68] Such reflections are often prompted by anomalies, disturbances, or incongruities raised by the text itself, often through the dialectic that underwrites the virtue wheel.

perception and contemplation of virtues and vices, since alluding to the presence of virtue or vice serves as among our central reasons for preferring or disapproving of human qualities (in ourselves and others) in daily affairs.[69] Thus, when challenged (by others or ourselves) about our preference for this or that character, it is natural for us to cite virtues in support of our judgments. And, where the debate continues (as it often does), this then naturally leads to the contemplation of the virtues in question in terms of the ways in which they are manifested and identified (in both life and art).

That is, the distance between our ordinary reactions to narrative artworks and reflection on our concepts of the virtues (and vices) is a short one and one that is frequently and naturally traversed, given the structure of the social arena in which we communicate our responses to artworks. Moreover, inasmuch as the dialectical formats of our public responses to art serve as models for our solitary acts of interpretation and appreciation—inasmuch as the outside is taken and re-staged inside—I feel confident in speculating that the vector toward conceptual discrimination that flows naturally, prompted by the virtue wheel (and comparable devices), in the public contemplation of characters, is often mirrored or replicated inwardly in the mind of the reader, viewer, or listener.[70]

So one piece of evidence that virtue wheels function as thought experiments that elicit conceptual discrimination is the easily observed course of informal discussions of narrative artworks that, in addition, I hypothesize provide reasonable access to solitary modes of appreciation. But there is further evidence for my case about virtue wheels in the history of our artistic institutions in general and literature in particular. For, unquestionably, in many of the artistic traditions of Asia, Africa, and Europe, art from time immemorial has served as a means for teaching about and meditating upon virtue and vice, often by example.[71]

In our own tradition, not only do Greek plays such as *Antigone* feature virtue wheels—or perhaps more aptly "vice wheels"—for this purpose, but medieval art is generally didactic to this effect. The mystery play *Mankind* limns the contrast between Mercy and its antipodes allegorically, while Chaucer's "The Pardoner's Tale" explores avarice by means of an exemplar.[72] There can be no

[69] See Edmund Pincoffs, *Quandaries and Virtues: Against Reductivism in Ethics* (Lawrence, KS: University of Kansas Press, 1986), p. 97. Pincoffs defines the virtues functionally as "those qualities that serve as reasons for preference in the ordinary and not-so-ordinary exigencies of life." Although I am not convinced that this is an ultimately adequate definition of virtue, I do agree that this is at least an accurate characterization of how virtue talk operates in much ordinary discourse.

[70] For a discussion of the way in which public deliberation serves as a model for private deliberation, see Stuart Hampshire, *Justice is Conflict* (Princeton, NJ: Princeton University Press, 2000).

[71] For an example of this from the Indian tradition, consider the wall drawings of the life of Buddha on the great cave temples of Ajanta; in part, these serve to illustrate his virtues upon which viewers are intended to meditate and then, ideally, emulate. African traditions of oral storytelling also emphasize the virtues. Consider, for example, "A Man Who Hides Food from his Family," by Nongenile Masithetha Zenani, in Harold Scheub, ed., *The World and the Word: Tales and Observations from the Xhosa Oral Tradition* (Madison, WI: University of Wisconsin Press, 1992), pp. 417–37.

[72] Similarly, Ben Jonson's *Volpone* explores the vice of avarice through several gradations. Indeed, the entire genre of the comedy of humors is predicated on inviting reflection on vice. And, in

doubt that the function of this sort of literature is to engender the contemplation of virtue and vice. Moreover, this practice did not end with the Middle Ages but continued into the eighteenth century, when the most popular English play of the period was *The London Merchant: Or, The History of George Barnwell* by George Lillo, an allegory contrasting the virtue of industry with the vice of idleness, clearly for the purpose of inviting (coercing might be a better word) viewers to ponder these traits and their vicissitudes. This play was still well known in the nineteenth century, as Dickens's allusion to it in *Great Expectations* bears witness, and its influence may, in part, account for the continued use of virtue wheels in the work of Dickens.

In Dickens, of course, the virtue wheel is more submerged in realistic detail than it is in *The London Merchant*, just as in *The London Merchant* the allegory is more naturalized than it is in *Mankind*.[73] However, the structure is still apparent in the nineteenth-century novel, and, I suggest, there is no reason to suppose that the structure is not still acquitting the same role in Dickens that it did when it was invented. That is, what seems to have occurred historically is that, over time, the virtue wheel, though remaining a recurrent literary structure, has, so to speak, moved progressively into the background, the author refraining from explicitly hammering its lesson home to the reader, but nevertheless leaving it there for the reader to find and to explore on her or his own.[74]

By the time of a modern novel such as *Howards End*, the presence of the virtue wheel is far more subtle than it is in Dickens. There are undoubtedly many reasons for this, including the displacement of the importance of religion in Western civilization, the development of a taste for participatory readership, and mutations, due to different circumstances, in our conceptions of the virtues.[75]

the non-comedic vein, *Pilgrim's Progress* and *Fairie Queene* are further famous examples of works designed to engender meditation on the virtues.

[73] To refer to another art form than literature, a similar trajectory can be discerned in visual art. Not only medieval art, but Renaissance fine art, such as Paolo Veronese's *Mars and Venus*, invites contemplation of the virtues and their coordination (in Veronese's case, the coordination of warlike virtue and the virtues of love) in a highly allegorical mode. Likewise, Donatello's *Judith and Holofernes* originally bore the inscription "Behold the neck of pride severed by the hand of humility," thereby encouraging viewers to meditate on the relevant virtues through an allegorical representation. This is the case with much religious, mythological, and historical painting and sculpture. However, one still discerns the presence of comparable virtue wheels, albeit submerged in greater naturalistic detail, in the works of Hogarth. The twelve plates of his *Industry and Idleness* are virtually an adaptation of Lillo's *The London Merchant*.

Dance, as well, can invite reflection on vice and virtue. The title of George Balanchine's *The Seven Deadly Sins: Sloth, Pride, Anger, Gluttony, Lust, Avarice, Envy* is undoubtedly self-explanatory. Likewise, the virtues can become the subject of a dance, as in the fairies' variations in *The Sleeping Beauty*. For an explication of this choreographic sequence, see Sally Banes, *Dancing Women* (London: Routledge, 1998), p. 52.

[74] It is not my contention that every artwork that contains a virtue wheel does so in order to promote conceptual analysis, but only that a significant number do. In order for us to ascribe to a virtue wheel in a given artwork the function of conceptual discrimination, we must provide a plausible interpretation of the work—one that shows the attribution is likely.

[75] It is undoubtedly due to the fact that time and circumstances change—and along with them conceptions of what constitutes virtue—that art and literature continue to employ virtue wheels and

However, again, I see no reason, despite the evolution of the virtue wheel in literary practice (both with regard to readers and writers), to suppose that it does not often perform the same function in the modern works (where it appears) that it performed in earlier works, namely, as a contrastive structure that abets meditation upon and contemplation of the virtues.[76] Thus, on the grounds of literary history and precedent, I argue that, given the historical nature of our practices, the virtue wheel remains a potential source of thought experimentation concerning virtue and its conceptualization. To say that this is not part of our literary institution is historically mistaken.[77]

Further evidence on behalf of my account of the virtue wheel lies in our practices of inducting children into the appreciation of narrative art, whether written or

to promote meditation upon the virtues. Literature and art will stay in the business of elucidating the virtues, I predict, as long as the virtues and their conditions of application evolve and subtly alter with changing circumstances. In this way, art performs one of its most culturally significant services.

[76] Structures of contrasting characters can also be found in modernist and postmodernist works from Musil's *Man Without Qualities* (the contrast between Ulrich and Arnheim) to Rushdie's *Satanic Verses* (the mutating contrasts between the two central protagonists).

[77] The skeptic might admit that although the virtue wheels that I have described were once a feature of the arts, they no longer are. This challenge merits two responses. First, this concedes that sometimes, at least with reference to past art, virtue wheels function as I have outlined and, therefore, with respect to the relevant works, interacting with them in the way sketched above is a legitimate mode of response. But, second, I am not convinced that one can say that virtue wheels of the sort we have been discussing have disappeared from the scene. They are certainly widely in evidence in contemporary mass art. John Ford's film *The Man Who Shot Liberty Valence* is structured, in terms of character contrasts, around three versions of the virtue of manliness: Senator Stoddard's, Tom Doniphon's, and, of course, Liberty Valence's. Especially in terms of the contrast between the Senator and Doniphon, the spectator is asked to deliberate about who is more truly virtuous, which, in turn, I think compels the alert viewer to clarify what is and is not at stake in our concept of manliness.

Of more recent filmmaking, David Bordwell has pointed out that Hong Kong action films have become a public forum for carrying on a cultural debate about the nature of heroism. Sometimes this question is pursued by means of the deployment of virtue wheels as described above. In *Once Upon a Time in Triad Society II*, for example, criminal figures like the Dinosaur and Dagger are contrasted to the policeman (called Dummy) in order to argue that the genuine hero is the man of commitment rather than the flashy swordsman or the wily gambler/confidence man. This argument, however, though initiated and guided by the film, finally needs to be completed by the viewer who compares the candidate-examples to her or his concept of heroism.

Closer to home, it should be obvious that virtue wheels are rampant in television. In the first *Star Trek* series, Spock exemplified the virtue of rationality, Dr McCoy (tellingly nicknamed "Bones") stood for the virtue of authentic emotion, while it was left to Captain Kirk to coordinate these virtues in an integrated, complete, and flourishing life. Likewise, the HBO situation comedy *Sex and the City* employs a virtue wheel in order to probe the nature of the right combination of dispositions that modern courtship demands. Miranda represents the intellect, Samantha the body and sexual pleasure, and Charlotte a mixture of sentimentality and convention, while Carrie attempts to amalgamate the strengths and avoid the defects the aforesaid traits entail. In this way, *Sex and the City* explores the mores of Manhattan romance, while inviting the audience to reflect on the virtues it demands. I would also argue that virtue wheels also appear in contemporary "serious" literature. However, this brief inventory of mass artworks should reassure skeptics that the virtue wheel is still alive and well.

For information concerning my claims about Hong Kong filmmaking, see David Bordwell, *Planet Hollywood* (Cambridge, MA: Harvard University Press, 2000), p. 42.

oral. We tell or read them things such as fairy tales, which are often structured, in part, in terms of virtue wheels designed explicitly to encourage moral education.[78] Stories like Charles Perrault's classic, self-consciously moralistic "Cinderella, or the Little Glass Slipper," with its studied contrast between the selfless, modest, generous, honest, ever-patient Cinderella, on the one hand, versus her selfish, vain, grasping, deceptive, and impulsive sisters, on the other hand, lay before the child a rudimentary scheme of virtues and vices in order to engage in a guided exploration, often in conversation with an adult, of the application of the relevant trait-terms to particular cases. Thus, the moral elucidation of character comes part and parcel with one's initiation into the practice of reading narrative fiction.[79]

Nor is this simply an artifact of the seventeenth century. The contemporary children's best-seller, the *Harry Potter* series, employs virtue wheels in this manner not only to differentiate characters, such as Harry and Draco, but even the major divisions of their school, Hogwarts. As we are told in *Harry Potter and the Goblet of Fire*, Gryffindor, Harry's house, is associated with the trait of bravery, Ravenclaw with cleverness, Hufflepuff with hard work and conscientiousness, and Slytherin with ambition. That modern parents still have an abiding interest in introducing their children to reading and to the contemplation of virtue simultaneously is readily borne out by the popularity of books such as *The Book of Virtues*,[80] *The Moral Compass*,[81] *What is Man: 3,000 Years of Manly Virtue*,[82] and *The African American Book of Values*;[83] each of these books contains stories overtly indexed to specific virtues, inviting young readers to master the application of the relevant abstract concept through an encounter with a concrete case.

There can be little doubt that the intention of these books, like so many other children's books, is to introduce youngsters at one and the same time into the practice of reading fiction and that of reading character. Reading stories and contemplating virtue are, in a manner of speaking, intertwined from the outset, not only in the history of literature, but also in the experience of beginning readers. We are recruited into the practice of reading fiction from the start, so to speak, under the presumption that tracking virtue is an appropriate aspect of appreciating fiction. There are no grounds to think that this alertness to virtue ever disappears in our reading or that it should disappear. In fact, there is every reason to think that it does not, since authors appear

[78] In earlier times, the lives of the saints also often functioned in this way.

[79] Martha Nussbaum writes: "When a child and a parent begin to tell stories together, the child is acquiring essential moral capacities." Martha Nussbaum, *Cultivating Humanity* (Cambridge, MA: Harvard University Press, 1997), p. 89.

[80] William Bennet, ed., *The Book of Virtues: A Treasury of Great Moral Stories* (New York: Simon and Schuster, 1983).

[81] William Bennet, ed., *The Moral Compass: Stories for Life's Journey* (New York: Simon and Shuster, 1985).

[82] Waller R. Newell, ed., *What is a Man: 3,000 Years of Manly Virtue* (New York: Regan Books, 1999).

[83] Steven Barboza, ed., *The African American Book of Values* (New York: Doubleday, 1998).

to persist in addressing it by producing fictions replete with virtue wheels every day.[84] Nor does it make much sense to claim that reading in order to contemplate virtue, where the text supports it, is not a proper part of our literary institution, since it seems to be such a fundamental feature of our literary education.

Before concluding, I should at least comment briefly on some of the more predictable lines of objection to the position I have sketched. The first protests that I have left little room for the emotions in this account; I have made reading sound too much like a rarefied exercise in grammatical analysis, on the one hand, and too much like pedagogy, on the other. But it is even more obviously an affair of the passions. And where is that acknowledged in my story?

Clearly, this objection would be troubling, if my account excluded any role for the emotions. But, of course, it does not, since the emotions play a role in our discerning, refining, and identifying the virtues. That is, the way in which we react emotionally to the characters variously placed on the virtue wheel is an integral part of our reflection on what, for example, counts as a virtue or a vice of parenthood or of true imaginative empathy.[85] Our emotional responses not only draw us to attend to certain character traits rather than others, but also enter into our reflective weighting of certain character traits vis-à-vis others. Or, to say it differently, emotional responses are part of the mix of factors that are engaged in deliberating about the application of virtue concepts in reaction to fictional thought experiments. In that sense, grammatical analysis does not preclude the relevance of emotion.[86]

In a related objection, one might argue that the defense of the possibility of literature and art as a source of knowledge and education about the virtues is too remote from pleasure. We read for pleasure. The idea that reading is connected to moral education is too puritanical. But, as with the emotions, it is a mistake to presume that pleasure and the sort of reflection that I have emphasized are

[84] One reason to believe this is that writers are still taught in creative writing classes and in instruction manuals to differentiate characters in terms of the sorts of sharp contrasts that sustain virtue wheels. In his manual of dramatic writing, Lajos Egri calls this kind of differentiation "orchestration," and, though not every orchestration yields what I have called a virtue wheel, it is clear how virtue wheels will evolve naturally out of this structure. Egri points out that orchestration is necessary for dramatic conflict and interest. To the extent that this is so, we can continue to anticipate virtue-wheel-type structures into the foreseeable future, where they will not only support dramatic conflict, but also, sometimes, promote conceptual discrimination. See Lajos Egri, *The Art of Dramatic Writing* (New York: Simon and Schuster, 1960), pp. 114–24.

[85] That literary thought experiments are character-centered—rather than principle-centered—makes them more suitable objects of emotional response than philosophical arguments. This, in turn, is connected to the need for literary thought experiments to enlist a great deal of concrete detail in comparison with philosophical argument, since emotional responses require concretely realized cases. Yet this accumulation of detail, as will be argued shortly, is not a reason to reject the literary thought experiment as a philosophical instrument, but only to acknowledge that its means vary with its ends. On narrative concreteness and the emotions, see Robert C. Roberts, "Is Amusement an Emotion?," *American Philosophical Quarterly*, 25 (1988): 273.

[86] And, of course, in any event, my discussion does not preclude that artworks may also enlist emotional responses for reasons other than concept clarification.

necessarily alien. For, if pleasure correlates with the unimpeded exercise of the faculties,[87] then there is no cause to suspect that the maieutic acquisition of conceptual knowledge of the virtues from literature must lack pleasure, since it may exercise our powers of reflection and discovery appreciably. It affords self-knowledge about our conceptual scheme, and social knowledge of our mores, and it refines our cognitive map of the world for the purpose of judging others. All this occurs in a participatory fashion that may not only be rewarding, but absorbing and exciting. Moreover, there is scant reason to imagine that this pleasure is not artistically relevant, since, as I have shown, the contemplation of virtue is a long-standing aim of the arts.

From another direction, it might be objected that my argument depends essentially on an illicit analogy between philosophical thought experiments and artistic ones. Artistic thought experiments are not akin to philosophical ones, it might be said, because: (1) they are not directed at addressing problems explicitly; (2) they have purposes other than argumentation; and (3) they are too elaborate.[88] But these apparent disanalogies are not decisive.

Artistic thought experiments may have purposes other than argumentation, such as entertainment, but entertainment may also have, and often does have, a role in the construction of philosophical thought experiments;[89] often the funnier and more intriguing the philosophical thought experiment, the better. Moreover, whether or not an artistic thought experiment is addressed to a problem can be determined by an interpretation of the pertinent text and, in fact, some literary texts explicitly indicate the problem that motivates them, as does *Howards End*. On the other hand, it is also the case that sometimes philosophical thought experiments require interpretation before one is sure of precisely the problem they are addressing.[90]

And, furthermore, there is a reason why literary texts concerned with the conceptual clarification of the virtues are more elaborate than typical philosophical thought experiments. Determining whether an action is virtuous often depends in part on the hidden motives and feelings of the agent.[91] One must have access

[87] Aristotle, *Nichomachean Ethics*, 1174a–1177a.

[88] Sorensen, *Thought Experiments*, pp. 222–3.

[89] Moreover, it will not do to say that conceptual discrimination is the essential goal of philosophical thought experiments whereas entertainment is the central goal of art, conceptual discrimination being merely a subsidiary or peripheral goal. For, in some cases, conceptual discrimination may be the primary aim of an artwork (and this can be revealed by an interpretation). Indeed, in such examples, it may be the case that the entertainment value of the work in question serves the purpose of involving the audience in conceptual tasks (as is also true of the entertainment value of some philosophical thought experiments).

[90] Many of Wittgenstein's thought experiments, for example, require interpretation. Furthermore, the case of Wittgenstein also shows that genuine thought experiments need not be accompanied by self-explicating commentary. The thought experiment—alone and unglossed—may stand as the argument in philosophy. There do not seem to be principled grounds for withholding the same license from literature.

[91] Jerome B. Schneewind, "Moral Problems and Moral Philosophy in the Victorian Period," in S. P. Rosenbaum, ed., *English Literature and British Philosophy* (Chicago, IL: University of Chicago Press, 1971), pp. 196 and 203.

to them in order to assess the action. This is something that literature is especially good at providing, though, in order to do so, far more exposition is required than what one typically finds in a philosophical thought experiment.[92] Indeed, this is related to a frequent source of complaint about philosophical thought experiments in ethics, namely, that they are too abbreviated.[93]

Moreover, virtues often need to be coordinated with other virtues and traits in order to obtain in a complexly individuated situation.[94] All this requires an immense amount of stage-setting, because so many variables are involved, including not only the situation and its background, but also the relevant hidden motives and feelings of the characters, the complicated interplay of many virtues and traits, and so on. Thus, it is the complexity of the task that justifies the elaborateness of the literary thought experiment;[95] the elaborateness is not evidence that such inventions are not, at least in part, thought experiments. Indeed, literature is so effective a tool for illuminating our concepts of virtue just because, like virtue itself, it is context sensitive.

It is often said that literary examples are far more effective in eliciting ethical understanding than are abstract philosophical arguments.[96] One reason for this

[92] Perhaps this is why John Wisdom says, "Hate and love we knew before Plato, Flaubert or Proust wrote about them. Nevertheless, these men and others have given us a greater apprehension of the varieties of hatred and of love, of their entanglement with each other, and of their relations with honesty, honour, degradation, war and peace." See "Tolerance," in *Paradox and Discovery* (Oxford: Blackwell, 1965), p. 139.

[93] Another reason that a fictional exploration of a virtue would, perforce, have to be elaborate is that the factors that warrant the attribution of a virtue are often complex and subtly interacting. For example, bravery, according to Aristotle, involves facing and fearing the right things, for the right motive, in the right way, at the right time, and to the right extent. Articulating such a concept by means of a virtue wheel then calls for nuanced and deep variations in terms of objects, motives, occasions, responses, and degrees of response. To do this with sensitivity obviously requires much more detail than a breezy intuition pump would allow.

[94] As Lester Hunt says, there are subterranean connections between the virtues. See his *Character and Culture* (Lanham, MD: Rowman and Littlefield, 1998), p. 79. It is these kinds of connections that literature excels in disclosing.

[95] Part of the task of a fictional thought experiment often involves establishing the possibility of something. But, as David Lewis notes, this calls for elaborate detail. He says: "Fiction might serve as a means for discovery of modal truth. I find it very difficult to tell whether there could be such a thing as a dignified beggar. If there could be, a story could prove it. The author of a story in which it is true that there is a dignified beggar would both discover and demonstrate that there does exist such a possibility. An actor or a painter might accomplish the same. Here the fiction serves the same purpose as an example in philosophy, though it will not work unless the story of the dignified beggar is *more fully worked out* than our usual examples." See David Lewis, "Fiction in the Service of Truth," *Philosophical Papers*, vol. I (New York: Oxford University Press, 1983), p. 278 (emphasis added).

[96] One source of this complaint is that philosophical arguments lack sufficient detail to make us feel comfortable that we have enough information about the issue at hand. Marilyn Friedman notes, "Hypothetical dilemmas have no social or historical context outside their own specifications: lacking any background information, we require *longer stories* in order to feel comfortable that we know most of the pertinent information that can be expected in cases of this sort. What matters is having *enough* detail for the case at hand." Thus, the reason that literary thought experiments possess as much concrete detail as they do is to reassure readers that enough of the situation has been articulated for the moral imagination to proceed. Of course, where significant variables have

is that, though more simplified and structured than actual cases,[97] they are much richer in detail—about motives, feelings, circumstances, social relations, and interconnected personality traits—than typical philosophical arguments and thought experiments. They are, in a word, more concrete than routine philosophical thought experiments, and this concreteness, in turn, is connected to their effectiveness in stimulating ethical understanding.[98] Thus, the elaborateness of literary examples is not grounds for disqualifying them as thought experiments, but rather grounds for appreciating them as thought experiments that have special cognitive requirements and advantages.

One final objection pertains to my use of virtue wheels in this argument. On my account, these structures function argumentatively to promote conceptual analysis and discovery for their intended audiences. Philosophers such as Lamarque and Olsen are likely to agree that the evidence for virtue wheels in literature is overwhelming, but to deny that they ever perform the function that I have assigned to them. For Lamarque and Olsen, virtue wheels, i.e., subtly contrasting character traits, are really formal or organizational devices constructed by authors to imbue their texts with unity. The virtue wheel in *Howards End*, for example, contributes to keeping the story together as a complex series of variations on a theme. Isolating the virtue wheel is part of an interpretation of the work, but only insofar as it enhances our appreciation of the structured coherence of the novel.

But this seems to me to be unconvincing for several reasons. The first is that working out the contours of the virtue wheel itself requires that we reflect on our virtue concepts not only descriptively but normatively. That is, we cannot reconstruct the virtue wheel without realizing that *genuine* empathy requires—as it obtains in real life—a subtle mixture of imagination and practicality. But, to do this, we must go outside the text and its formal structures. If we do not do so, we will not be able to chart the relation of true virtue to defective and vicious instantiations of neighboring traits. To appreciate the organizing work the virtue wheel performs, in other words, requires the kind of conceptual reflection that brings with it enlightenment. In fact, it is hard to see how getting clear about the

been obscured in the type of situation depicted fictionally, that may well count as a moral failing in the work. See Marilyn Friedman, "Care and Context in Moral Reasoning," in Eva Feder Kittay and Diana T. Myers, eds, *Women and Moral Theory* (Totowa, NJ: Rowman and Littlefield, 1987), p. 201 (emphasis added).

[97] Ryle notes, "The fact that the examples are faked tends to render them all the better as illustrations of the general principle in question. For irrelevant and conflicting characteristics can he omitted or left in the shade." See Gilbert Ryle, "Imaginary Objects," *Aristotelian Society*, suppl. vol., 12 (1933): 42. This is a feature of all thought experiments, and it pertains to literary ones as well. See also Gendler, *Thought Experiment*, pp. 15–17.

[98] Of course, this concreteness is leavened by unifying strategies, like virtue wheels, thus enabling literature to provide readers with complexes of events ordinarily beyond our ability to track and to hold together in our minds cognitively and perceptually. Thus, it is the power of literature to marry unity with rich detail that allows it to serve so well as an invitation to moral deliberation, especially in terms of learning how to make sense of the behavior of others and ourselves through the exploration of our concepts of virtue and vice.

virtue wheel can proceed without reflection upon the ways in which the relevant virtues stand in everyday life and not just with reference to the text at hand, since we will have to go outside the text, comparing fictional cases to real ones, in order to arrive at conclusions about whether characters do or do not really instantiate the virtues and vices in question.

Once the reader has begun to contemplate the pertinent virtues and their putative status in a given literary work, it is natural for her or him to reflect on how the characterizations implied by the text apply outside the text. How are we to determine which virtues are true and which are false without considering the application of the relevant concepts outside the text'? Moreover, not only does this happen with great frequency; there is no justification in thinking that it is not a warranted response, since, as I have shown, the use of literature as a vehicle for contemplating the virtues is a historically well-precedented and deeply ingrained function of our practice.[99]

In conclusion, then, despite the banality argument, the no-evidence argument, and the no-argument argument, I do not feel compelled to believe that literature and art cannot provide a source of knowledge and a contribution to education, especially moral knowledge and education with respect to the virtues. One way of establishing this conclusion is to notice that literary works can be regarded as thought experiments that encourage conceptual discrimination of our virtue schemas through the imaginative deployment of structures of studied contrasts that function argumentatively. Since the knowledge in question is conceptual, it makes no difference that the cases are fictional. Since the education involved concerns the refinement of our grasp of virtue concepts, it is not best described

[99] Lamarque and Olsen maintain that this sort of cognitive value is not part of the literary institution because, they allege, argumentation and debate about the substantial assertions of literary works are not part of the literary institution. This is the second part of the no-argument argument—that critics do not debate the truth or falsity of the themes they find in literary works. But I think Lamarque and Olsen are just wrong about this. Marxist, feminist, gay, postcolonial, and otherwise politically minded critics often include in their reviews and explications attempted refutations of the supposedly reactionary themes they uncover in canonical works. For example, in her review of Philip Roth's *The Human Stain*, Lorrie Moore challenges the accuracy of Roth's characterization of what is called "political correctness" on American campuses. See Lorrie Moore, "The Wrath of Athena," *New York Times*, May 7, 2000. p. 7. And, for a less politicized example, consider Daniel Mendelsohn's review of Tom Stoppard's *The Invention of Love*, in the *New York Review of Books*, vol. 47 (August 10, 2000): 58–64. Here, *pace* Lamarque and Olsen, we find sustained historical criticism of the fidelity of Stoppard's depiction to the life of A. E. Houseman. Likewise, in his "The Greatest Generation (Revised)," a review of Gore Vidal's novel *The Golden Age*, Andrew Sullivan takes Vidal to task for his allegedly misguided historical conjectures; see the *New York Times Book Review* (October 1, 2000): 14–15. Thus, the second part of the no-argument argument is insupportable, unless Larmarque and Olsen maintain that such criticism falls outside our practices. But that would be tantamount to begging the question.

By the way, it should also be acknowledged that the first part of the no-argument argument is not, strictly speaking, true. There are some artworks that do contain explicit argumentation and/or analysis. Examples include Dostoyevsky's *Brothers Karamazov*, Mann's *Magic Mountain*, Shaw's *Man and Superman*, and Frayn's *A Landing on the Sun*. And there are many others. However, since proponents of the no-argument argument are correct in observing that such cases are far from the norm, it still seems advisable to produce demonstrations of less overt argumentation, such as the ones in this chapter, in order to put the no-argument argument decisively to rest.

as banal or platitudinous, but rather as affording added insight into that which we already know. This need not always be taken as a mere repetition of familiar knowledge but can be an amplification or refinement thereof. Admittedly, much of the work of argument and analysis served up by art, especially art that employs virtue wheels, transpires in the mind of the audience. But, in that respect, artworks function no differently from philosophical thought experiments.[100] Thus, in the great and ongoing quarrel between philosophy and poetry, philosophy cannot win without undermining itself.

[100] Throughout this chapter, I have assumed that there is such a thing as moral knowledge and that it can be taught. If someone denies there is moral knowledge, that would have to be addressed in terms of considerations that go far afield of the scope of this chapter. However, even if there is no moral knowledge, the strategy employed in this chapter would still be available to show that literature and art can be viewed as thought experiments that yield knowledge, since the kind of concept discrimination I maintain that literature encourages with respect to the virtues still could be shown to be relevant to eliciting conceptual analyses of not necessarily moral concepts, such as those of desire and emotion.

Another objection to my approach might be that it assumes that knowledge of virtue is to be derived by conceptual analysis. But suppose that knowledge of virtue ultimately belongs to the province of science, perhaps evolutionary psychology. Can we then claim to derive knowledge of virtue from things like literature?

Whether science will ever inherit the study of virtue is too large an issue to address here. However, supposing that moral psychology becomes more scientific, it still may require the folk psychology of virtue in order to isolate the phenomenon whose determining mechanisms scientific research goes on to explain. In this respect, literature, by illuminating folk psychology, still may have a contribution to make to our knowledge of virtue and, in that sense, be said to be knowledge tracking. Literature may not be able to tell us the whole story about virtue, but I have not claimed that it does, nor do I think one needs to be so extravagant in order to meet the skeptic.

Furthermore, I should note that throughout this chapter I have chosen examples where I think the case can be made that the conceptual discrimination afforded by artworks is approximately correct—that is, the examples are ones where the results of fictional thought experiments either hit their mark or, at least, nearly do. This should not be taken as an indication, however, that I believe that literary and artistic ventures of this sort are always successful. Surely fictions, as they shape and guide our perception of the ongoing story, can lead us into error by either (1) framing an immoral course of action or a character trait as if it were not morally problematic, or (2) drawing our attention away from morally significant aspects of a situation and displacing it elsewhere—perhaps onto something morally insignificant (or deflecting attention from an immoral aspect of a course of action or a trait by overemphasis on some moral aspect that is far less important than the effectively camouflaged immoral aspect). When these sorts of things happen, they are bad-making features of the work from the perspective of moral evaluation.

Moreover, that literary fictions may mislead, as well as lead, the reader with respect to the contemplation of virtue should not compromise my argument about the epistemic and educative potentials of literary thought experiments, since the same observations can be made about philosophical thought experiments. That is, we do not disavow philosophical thought experimentation as a source of knowledge and learning because it *sometimes* results in error. Rather, we check it to reassure ourselves that it has canvassed all the relevant variables. Ditto, artistic thought experiments. And this is why explorations of literary thought experiments that employ virtue wheels set us thinking about the virtues in everyday life.

On the ways that moral error can arise, see Joel Kupperman, *Character* (New York: Oxford University Press, 1991), p. 72.

12

Art and Ethical Criticism: An Overview of Recent Directions of Research

1. INTRODUCTION

Ironically, though the philosophy of art emerged initially as part and parcel of Plato's ethically motivated criticism of art, the ethical criticism of art has received scant attention from analytic philosophers for most of the twentieth century. Influenced by Kant's aesthetic theory, especially as that was interpreted (or misinterpreted) by subsequent movements—including, for example, aestheticism ("art for art's sake") and formalism—and ostensibly reinforced by certain consequential critical practices (such as the New Criticism with respect to literature), many twentieth-century philosophers of art have not only neglected the topic of the ethical criticism of art, but have also regarded the ethical criticism of art as either irrelevant or conceptually illegitimate.

Of course, despite the effective moratorium on ethical criticism in philosophical theories of art, the ethical evaluation of art flourished in the critical estate. Indeed, with regard to topics like racism, sexism, homophobia, and so on, it may even be the case today that the ethical discussion of art is the dominant approach on offer by most humanistic critics, both academics and literati alike. Nor have plain readers, viewers, and listeners of art been deterred by the absence of either philosophical acknowledgment or enfranchisement. Their assessments of artworks remain steadfastly linked to ethical considerations, as can be readily confirmed by listening to what ordinary folk talk about after seeing a film or a play or TV show, or when they trade opinions about the latest novels.

There has been, in other words, a gap between theory and practice with respect to the ethical criticism of the arts throughout the twentieth century—a gap intensified by philosophy's silence about the relation between ethics and art. This gap, moreover, is a recent one, since philosophers from Plato through Hume supposed that the pertinence of ethical criticism to art was unproblematic. It is only since the late eighteenth century that the view took hold that the aesthetic realm and the ethical realm are each absolutely autonomous from the other. Needless to say, some philosophers of art, such as Tolstoy, bucked this tide. But, in the main, philosophical discourse about the arts has steered clear of the topic

of ethical criticism, except, on occasion, to argue that it is logically inadmissible or beside the point.

Lately, however, this consensus itself is beginning to be challenged. Perhaps impressed by the pervasiveness of ethical criticism in our ongoing practices, philosophers are re-evaluating traditional arguments against the ethical criticism of art, and they are also attempting to discover the premises upon which such criticism might rest. The purpose of this chapter is to survey some of the recent debates that address the ethical criticism of art. In order to organize thinking about this subject, I will start by sketching the leading traditional arguments against the ethical criticism of art, and then in subsequent sections I will explore contemporary responses to these arguments as a way of introducing various new approaches now available for defending the prospects for ethical criticism.

2. OBJECTIONS TO ETHICAL CRITICISM: AUTONOMISM, COGNITIVE TRIVIALITY, AND ANTI-CONSEQUENTIALISM

As already indicated, before the modern era (before philosophers of art were influenced by the writings of Hutcheson and Kant), the notion that art could and should be criticized ethically was generally unexceptionable. Since that time, however, several powerful arguments have taken shape that have called that practice into question philosophically. Since much current philosophical thought about the ethical criticism of the arts has taken shape against the background of those arguments—attempting either to show said arguments are dubious or that they can be outflanked logically—it is useful to initiate our discussion by reviewing the leading traditional objections to the ethical criticism of art. These can be called, respectively, the "autonomism" argument, the "cognitive triviality" argument, and the "anti-consequentialist" argument.

2.1. The Autonomism Argument

This argument concludes that art and ethics are autonomous realms of value and, thus, criteria from the ethical realm should not be imported to evaluate the aesthetic realm. Artworks, it is said, are valuable for their own sake, not because of their service to ulterior purposes, such as moral enlightenment or improvement. The epitome of this sentiment can be found in Oscar Wilde's slogan: "There is no such thing as a moral or an immoral book. Books are well written or badly written. That is all."[1]

This viewpoint is sometimes called "aestheticism." Several sociological accounts have been advanced for its popularity. One is that the doctrine is an

[1] Quoted by Booth (1988), p. 382.

artworld maneuver to protect artworks from censorship; in response to Plato and his puritanical descendants, it is asserted that, logically, art is its own locus of value and should not be assessed in terms of alien sorts of value, such as morality.

A more historically specific hypothesis is that aestheticism is a response to the triumph of bourgeois culture in the nineteenth century, at which time the dominant tendency was to reduce all value to instrumental and/or commercial value. Bourgeois culture put a price tag on everything, including art. And the popular arts that emerged in tandem with the rise of mass urban society "cheapened" the arts, made them too "easy" as well as inexpensive. Aestheticism in this context, then, was a gesture of cultural resistance. It characterized art (or what is sometimes called "high art") as a source of esoteric value, separate from the everyday values of commercialism, morality, and any other sort of instrumental or practical purpose. Aestheticism attempted to seal off art hermetically from the surrounding bourgeois and mass cultures by declaring art to be autonomous.[2]

Aestheticism in particular and autonomism in general were not merely a matter of cultural polemics. The view could also be supported by formidable argumentation. One argument against the ethical criticism of art—which we may call the "common denominator argument"—takes note of the undeniable fact that much art has nothing to do with morality. Much pure orchestral music as well as many abstract visual designs and decorations count as art, but they promote no ethical viewpoints and, therefore, are not susceptible to ethical evaluation. If they have value, it must be other than ethical value, and, consequently, they need to be assessed in terms of criteria other than ethical criteria. Furthermore, whatever we identify as the value of art should be such that every artwork can be assessed in accordance with it. That is, art *qua* art should be beholden to standards that are universally applicable to all art. But, since not all art concerns ethical matters, the standard cannot be ethical. The relevant value must reside elsewhere.

Where? Here the notion of aesthetic experience often comes to the fore. All artworks are supposedly intended to promote aesthetic experience; thus, the capacity to promote aesthetic experience is the proper criterion for evaluating art. Moreover, since aesthetic experience is explicitly defined in terms of disinterestedness—disinterested pleasure or disinterested attention—aesthetic experience is strictly independent of ethics. Thus, the appropriate standard to raise with respect to any artwork concerns its capacity to afford aesthetic experiences. For some autonomists, called, predictably enough, "formalists," aesthetic experience revolves solely around the appreciation of the formal aspects of artworks, though other autonomists are somewhat broader in their conception of aesthetic experience, regarding it as any experience prescribed by an artwork that is valued for its own sake (and not for the sake of anything else, including moral enlightenment or moral improvement).

Autonomism also finds a sympathetic audience with those who incline toward an essentialist view of the value of art. That is, if one is disposed to the opinion

[2] For a historical account of aestheticism, see Bell-Villada (1996).

that whatever the value of art is, it is a value unique to art (and shared by no other human practice), then autonomism appears to offer a very compelling hypothesis, since art seems to be the only human practice whose products are uniformly intended primarily to afford aesthetic experiences. Sermons and ethical treatises may be aesthetically satisfying, but that is not the primary intention that motivates them. Only artworks are primarily intended to promote aesthetic experiences. Artworks should be evaluated in terms of that to which they uniquely aspire. That is not the production of moral insight or moral improvement; other things are primarily intended to do that. Only artworks (all artworks) are uniquely dedicated to the production of aesthetic experience. Thus, aesthetic experience, not ethics, provides the appropriate evaluative grid for art.

The notion of aesthetic experience, of course, is attractive to the essentialist because it, by means of the very definition of disinterestedness, excludes art from every other source of value—whether practical, cognitive, or ethical. Thus, in a single stroke, by invoking the notion of experiences of aesthetic disinterestedness, the essentialist automatically guarantees that the value of art will be divorced from that of every other human practice, including, for our purposes, ethics.

Autonomists also have some very powerful intuitions on their side. Most informed lovers of art are likely to agree that there are certain immoral works of art that are excellent, whereas, at the same time, they are loathe to count an artwork as good simply because it is (morally speaking) pure of heart. Indeed, many ethically sterling artworks turn out to be execrable when all is said and done. But these intuitions do not appear consistent with ethical criticism. One would, for example, expect the ethical critic to condemn immoral art, whereas the informed art lover maintains that some immoral art is superlative.

The art lover fears that the ethical critic is prone to reduce artistic value to something else, namely, ethical value. This is what makes the notion of art for art's sake attractive to the art lover who worries that ethical criticism is a reversion to the kind of Victorian moralism that Oscar Wilde abhorred.

2.2. The Argument from Cognitive Triviality

As frequently practiced, the ethical criticism of art proceeds by isolating a moral thesis associated with or implied by an artwork and then goes on to commend the artwork in light of its moral commitments. Perhaps the moral of *Emma* is that people (such as Emma) should not treat persons (such as Harriet) simply as means. Ethical critics typically abstract theses like these from artworks, treat them as moral insights, and applaud them as such. This practice certainly makes it sound as though what the artist has done that is worthy of our approval is to have made some moral discovery, thereby contributing to our fund of ethical knowledge in such a way that attending to the artwork educates us in this or that moral truth.

But the opponent of ethical criticism balks at this, pointing out that, in general, the moral theses associated with artworks are usually in the nature of truisms. Suppose that Käthe Kollwitz's *Municipal Lodging* is taken to reveal that

the poor are oppressed. That hardly counts as a moral discovery; it was surely well known before the picture was made. In fact, it makes little sense to say that the picture "revealed" this truism. Rather, the picture appears to presuppose it. That is, the picture requires viewers already in possession of this viewpoint in order to recognize its articulation in the picture and to be moved to indignation by it.

This line of attack is really a subsidiary of an even broader complaint about art criticism.[3] Art critics often write as though artworks were contributions to knowledge, including, in the case at hand, moral knowledge. In this way, critics treat art as if it were comparable to science—a mode of inquiry. However, the skeptic maintains that the putative cognitive accomplishments of art are paltry, especially when compared to science. Artworks, more often than not, presuppose articles of common knowledge or philosophy, recycling them, perhaps imaginatively, but hardly discovering them. If artworks are to be commended for their contribution of genuinely original insights to our body of knowledge, very few artworks would be worthy of our esteem. And what applies to artworks with respect to knowledge in general, applies equally to artworks with respect to moral knowledge. If James's *Ambassadors* shows the importance of acute perceptual discrimination for moral reflection, well, Aristotle already demonstrated that.

Furthermore, if many of the moral "discoveries" cited in the literature not only are known, but need to be known for readers, viewers, and listeners to recognize them, then the idea that we learn from art appears altogether without substance. For how does one learn what one already knows? The claim of the ethical critic that art is a source of moral education, then, rings hollow; art does not teach us what we already know and, indeed, must know if we are to grasp that a certain artwork is associated with a particular moral precept.

Not only can art not be said to impart knowledge, since the knowledge at issue is generally common knowledge, but art's epistemic prowess can also be disputed by pointing out that even if artworks can be said to advance knowledge claims, they supply no evidentiary support for them. Fictions, for example, provide no grounds for the knowledge claims they allegedly imply, since, after all, fictions are made up. Consequently, the claims to knowledge associated with artworks are merely notional, since no one can be said to know that such and such is the case merely by, say, reading a novel.[4]

Aspects of the cognitive triviality argument are also attractive to essentialists. The discovery of knowledge, including moral knowledge, cannot be the unique value of art, since many other human practices, including science, social science, history, and philosophy, are also engaged by it, and, in fact, are arguably even better suited to imparting authentic knowledge than art is. Thus, the revelation of new knowledge, including moral knowledge, cannot be the distinctive source of value in all art and, therefore, moral insight of the sort prized by ethical critics cannot be the appropriate standard for evaluating artworks.

[3] For a general discussion of this debate, see Lamarque and Olsen (1994), pp. 289–321.
[4] Arguments like this can be found in Beardsley (1958), p. 429; and Putnam (1978), p. 90.

2.3. The Anti-Consequentialist Argument

Like the preceding argument, anti-consequentialism is a response to the way
that ethical critics talk. It queries what ethical critics appear to presuppose as
altogether uncontroversial. In both commending and condemning works of art,
ethical critics speak as though they know what the ethically relevant behavioral
effects of an artwork are likely to be. A film such as *In and Out* is approved
not only because it advances the salutary moral insight that gays are persons
deserving of moral respect, but also because broadcasting this message is likely to
change people's behavior toward them. In contrast, the film *Con Air* is criticized
because, it is thought, it will encourage violent behavior.

The autonomist will, of course, challenge such assessments, because rather than
evaluating the works in question in terms of the unique values of art (in this case
cinema), here critics are evaluating artworks for the sake of something else—the
alleged moral/behavioral consequences of these films for society at large. But
the anti-consequentialist's objection to these examples of ethical criticism is
somewhat different from the autonomist's. The anti-consequentialist asks: how
does the ethical critic know that the works in question will have the behavioral
consequences that are imputed to them?

Since Plato, commentators have criticized art, usually negatively, by presuming
that they know what the behavioral effects of the artworks in question would
be. However, they have never had anything like sufficient evidence to back up
these claims. Contemporary pundits, for example, maintain that media violence
is a major causal factor in violence today. And yet crime rates in industrially
developed countries have been falling recently, at exactly the same time that
media violence appears to be on an upsurge. If there is, as alleged, such a strong
causal correspondence between media violence and social violence, how will
ethical critics account for divergences like these? Of course, usually they don't
bother, but this, the anti-consequentialist chimes in, is just the problem with
ethical criticism.

Though the correlation between violent media and violent social behavior
seems obvious to ethical critics, the empirical support for these hypotheses is
famously wanting. Despite seemingly endless studies of the consequences of the
media for violent behavior, there is little conclusive evidence for any claims, save
the most empirically trivial and uninteresting ones (such as: excessive exposure
to violent media on the part of violently predisposed subjects *may* lead to violent
behavior).

Against such observations, the ethical critic is likely to respond that, sans social
science, we know that art, especially literature, influences people. We have ample
testimony that art has changed people's lives; some people say they tried smoking
dope after reading *On the Road* (Booth 1988: 227–63). However, such examples
are too indeterminate and spotty to serve the ethical critic's purposes. What
ethical criticism requires is knowledge of regularly recurring patterns of behavior
that predictably follow from exposure to fiction (or certain kinds of fiction). The
occasional anecdotal evidence to which the ethical critic appeals in order to affirm

that art and fiction influence life is too vague to support the inferences the ethical critic wants to make. That art has a diversity of (unpredictable) consequences for everyday affairs is too broad a premise from which to infer that this type of novel causes anti-social behavior on the part of a significant number of readers.

For centuries, ethical criticism of the arts has proceeded confidently, as if we knew the behavioral effects of art on its audiences. However, no one really possesses reliable knowledge of the relevant order of specificity concerning art's behavioral consequences, nor do we have any dependable means for predicting the regularly recurring pattern of social behavior that any artwork will elicit—either in the short or the long run—from normal viewers, listeners, and/or readers. Anyone who claims to have access to this information, as participants in this debate often do, is simply bluffing. Inasmuch as ethical criticism of the arts rides on the possession of such knowledge about the behavioral consequences of art, the project is doubtworthy.

An even more extreme form of anti-consequentialism might go so far as to suggest that, insofar as there is no conclusive evidence concerning the behavioral consequences of art, the most prudent stance is to suppose that, until contrary evidence arises, art has no determinate, regularly recurring behavioral consequences. And, if we adopt the view that art has no such behavioral consequences, then there is little point, it could be said, in attempting to evaluate art ethically. Thus, by a different route, anti-consequentialism joins forces with autonomism in the conviction that ethical standards should not be imported into the aesthetic realm.

The arguments from autonomism, from cognitive triviality, and from anti-consequentialism are well known and often repeated. In what follows, we will review various responses to them in order to explore a number of developments and debates currently evolving in this area of the philosophy of art.

3. RESPONSES TO AUTONOMISM

The strongest autonomist argument is the common-denominator argument. It presupposes that the appropriate criterion for evaluating art must be one that is applicable to all the arts. But, since it is the case that much art does not concern morality directly, ethics cannot be the appropriate criterion for evaluating art.[5] This argument equivocates. That some art is not concerned with

[5] The motivation for adding the qualification "directly" here is that some ethical critics might maintain that even if an artwork does not contain ethical content, as an abstract visual design might not, it will still have ethical consequences, since the making and consuming of it will spend social resources which might be spent elsewhere. This, at least indirectly, makes it a candidate for ethical evaluation—has it contributed to or subtracted from overall social utility or to the common good? But even here the autonomist is likely to respond that still some art—e.g., an abstract design by a Sunday painter composed solely for herself—is, for all intents and purposes, neutral on this score. And, in any case, the autonomist might add, appealing to our intuitions, that it seems irrelevant to evaluate such a work not in terms of its design, but for its contribution to the commonweal.

morality directly—that it lacks ethical content or implications—may indicate that some art is not an appropriate object of ethical criticism. But from this it does not follow, as the common-denominator argument suggests, that ethical criticism is not appropriate for any art. For some art, given the kind of art it is, does have ethical dimensions, and, therefore, with respect to that kind of art, ethical criticism has a *prima facie* claim to appositeness.

Sharpness and heft are appropriate criteria for evaluating meat cleavers, though sharpness and heft are not appropriate criteria for every kind of cutting instrument. They are irrelevant with respect to butter knives. One could say that sharpness and heft are not appropriate criteria for all cutting instruments. But it would not follow from this that they are not appropriate criteria for certain kinds of cutting instruments, namely, meat cleavers.

Similarly, certain kinds of art—for instance, Greek tragedies—possess an ethical dimension, not adventitiously but constitutively. Authors composed their work with this understanding; readers, comprehending the author's intentions, read them for ethical significance. The constitutory social contract that founds the consumption and production of many of our artistic genres encourages artists and audiences alike to focus on ethical concerns.[6] George Grosz's caricatures, consistent with the genre in which they occur, make an ethical address which prescribes an ethical response from viewers. Ethical criticism, whether commendatory or not, of this kind of work is appropriate, even if ethical criticism is inappropriate with regard to a Handel concerto grosso.[7]

Of course, the common-denominator argument also presupposes that there must be a singular criterion of value for all art. Thus, the preceding conclusion—that ethical criteria are appropriate for some art—will not do. The ethical critic's response to this is twofold. First, even if there were a single global criterion of value for all art, that would not have to preclude the possibility that there are not also multiple, local criteria of evaluation for certain genres of art, consistent with whatever the global criterion turns out to be. But, second, the ethical critic is entitled to be skeptical about whether there is a single global criterion of aesthetic value, or even a set of such criteria, applicable to every kind of art. There are so many different kinds of art which mandate so many different kinds of audience responses. What of any significance do the Sex Pistols, the Egyptian pyramids, and Rembrandt's *Girl Sleeping* have in common? Why imagine that there is a single global criterion of evaluation applicable to all arts?[8]

[6] Earlier I noted that autonomism is attractive to essentialists. But the case is not unmixed. For, as the argument above indicates, if one is an essentialist about certain genres and agrees that said genres possess an ethical dimension as part of their nature, then with respect to those genres, the essentialist in question will side with ethical criticism.

[7] Responses to autonomism can be found in Carroll (1998a). See also Booth (1988), pp. 3–22.

[8] For skepticism about the existence of such a criterion, see Marshall Cohen (1977), pp. 484–99. This line of questioning, of course, is meant to deter the essentialist attracted to autonomism. For even if essentialism is initially a good working hypothesis with which to approach a philosophical inquiry, it may have to be abandoned when the phenomenon under examination becomes too unruly.

Needless to say, in the face of such skepticism, the autonomist is apt to weigh in with a proposal—there is such a criterion, namely, the intended capacity of the work in question to promote aesthetic experience. This proposal, however, is itself a vexed one, since the notion of aesthetic experience is highly controversial.[9] What is an aesthetic experience? If the autonomist says that it is an experience of significant form, then it will not serve as a global evaluative criterion, since there is some art, given the kind of work it is, that is designed to thwart such experiences. Arguably John Cage's *4′33″* is intended to subvert the apprehension of what is called (not very informatively) "significant form."

Another initially more promising route for the autonomist is to define aesthetic experience as any experience valued for its own sake. This construal not only supplies the autonomist with a candidate for the global criterion of art evaluation, but also ostensibly excludes even the possibility of additional ethical criteria, since ethics raises issues of practical rather than intrinsic value.

On this reading of aesthetic experience, then, any artwork can be assessed in terms of its intended capacity to afford an experience valued for its own sake. But, again, this criterion is not universally applicable to all art, since some art is not created with the intended capacity to afford aesthetic experiences so defined. For example, tribal images of demons are meant to scare off intruders, not to enthrall them with pleasurable experiences valued for their own sake. And, of course, if in order to avert counterexamples like this, autonomists drop the requirement that artworks are intended to afford aesthetic experience (and merely require that they afford aesthetic experience), then they lose a criterion of value unique to art, since, putatively, waterfalls and songbirds afford the kind of experience they are talking about.[10]

So far, the autonomist has failed to come up with a plausible contender to serve as the unique, global criterion of evaluation for all and only art. This entails that, at least until the autonomist shows otherwise, the ethical criticism of some art is viable. And this, it seems to me, is all we need for the practice of ethical criticism as it commonly occurs—with reference to the kinds of works to which it is appropriate—to continue with a philosophically clean bill of health.

But what of the autonomist's other arguments? The claim that art is for art's sake and not for the sake of anything else is at best misleading, since "art's sake" (the interest for which an artwork is made) is frequently for purposes beyond the creation of captivating forms and/or aesthetic delight. The great cave paintings in the Buddhist temples of Ellora were intended to commemorate important events in the life of Gautama and to enable devotees to recollect their significance. In those cases, "art's sake" is religious and ethical. Indeed, the formal invention in these paintings is not for its own sake, but for the sake of facilitating concentration on the Buddha's message. The supposition that "art's sake" (art's interest) can only be concerned with form or disinterested experience is really just the flag of one partisan tendency in art history.

[9] For a taste of the controversy, see Dickie (1974).
[10] For further discussion, see Carroll (1999), Ch. 5.

Similarly, the fear that ethical criticism, applied in appropriate circumstances, reduces all artistic value to something it is not is a red herring for three reasons. First, the ethical critic need not presume that all art is susceptible to moral criteria. Second, in the case of genres that have an ethical dimension, evaluating an artwork in terms of the quality of its moral perception (or misperception) is not invoking criteria alien to its value as the kind of artwork it is; it is a matter of evaluating the work in terms of the norms (genre norms) of the kind of artform to which it belongs. And, third, the ethical critic need not claim that ethical considerations are the only ones to be brought to bear on an artwork; even artworks that are appropriate to evaluate ethically may have formal dimensions that call for independent evaluation. So, if what one means by saying that ethical criticism reduces art solely to ethical value is that this neglects formal values, the claim is mistaken, since a critic may assess a given work with respect to both kinds of value.[11]

Moreover, this last comment suggests one way that the ethical critic can deal with the case of immoral art that is nevertheless excellent: such a work may, when all things are considered, contain ethical defects that are vastly outweighed by its other merits, such as formal ones. Likewise, an artwork that is morally upstanding but formally inept and experientially barren may, all things considered, be eminently dismissible.

Contemplating these remarks, the autonomist may be willing to concede that the ethical criticism of some art, given the kind of art it is, is valid. However, she will hasten to add that ethical criticism is nevertheless categorically distinct from something called "aesthetic criticism." Some art is made to be sold and can be assessed in terms of its marketability, but its market value is strictly independent from its aesthetic value. Similarly, the autonomist might agree that some art addresses ethical issues and may be assessed morally in terms of its ethical address, but this dimension of the work's value (or disvalue) is, the autonomist asserts, independent of its ethical value. Ethical criticism is logically feasible, but one should not confuse the ethical value of artworks with their aesthetic value.

This viewpoint can be called "moderate autonomism." It disavows the stronger autonomist claim that the ethical criticism of art is somehow a category mistake. It allows that artworks can be criticized ethically, but goes on to contend that the ethical value or disvalue of an artwork has no bearing on its aesthetic value or disvalue. No ethical defect makes an artwork aesthetically worse; no ethical virtue makes an artwork aesthetically better.

This position, moderate autonomism, introduces issues not yet broached. Thus far, in this section and the preceding one, we have only reviewed the arguments in behalf of what might be called "radical autonomism"—the view that the ethical evaluation of artworks is always conceptually confused. In the final section of this chapter, we will explore responses to moderate autonomism.

[11] That artworks can be evaluated in terms of multiple dimensions, including ethical ones, is discussed in Dickie (1988), pp. 126–8.

4. RESPONSES TO THE ARGUMENT FROM COGNITIVE TRIVIALITY

Thus far we have only spoken of the possibility of ethical criticism. But, granted that it is possible, what exactly does ethical criticism criticize—what features of artworks serve as the locus of ethical criticism and on what grounds does ethical criticism criticize them? As already indicated, ethical critics typically abstract moral theses from artworks, generally by means of interpretations,[12] treating them as knowledge claims (in terms of truth or falsity; aptness or inaptness) and, in the most favorable cases, often commending them as moral insights such that readers, viewers, and listeners can learn them from the works in question. Ethically good artworks afford the opportunity to gain moral insight; ethically suspect artworks palm off defective moral views as if they were insights. Such criticism, then, appears to regard the potential educative value of artworks as the grounds for ethical criticism.

But this picture of ethical criticism, of course, invites the objections from cognitive triviality rehearsed earlier. Where artworks presuppose, imply, or express outright ethical theses, the viewpoints are generally truisms; nor should this be surprising, since in order to be understood widely, artworks must trade in viewpoints that audiences recognize. Standardly, audiences use what they recognize to be the moral viewpoint of the work in order to organize what they are seeing, hearing, or reading.

But, if audiences already know the pertinent truisms, it is silly to say that they learn such "insights" from artworks. One must already know that hypocrisy is noxious in order to appreciate Tartuffe's come-uppance. And it is such common knowledge that everyone can share in the laughter. We don't learn this maxim from Molière's play, but bring it to the theater with us. So there seems little reason to regard moral education as a plausible ground for ethical criticism.

Previously, I noted that this line of objection not only pertains to the possibility that art affords moral education, but is, more broadly, an objection to general claims about the cognitive value of art. Art cannot be regarded as valuable for the production of new knowledge claims, ethical or otherwise, and statable as propositions, because art, for the most part, engages in truisms. Even if the theses found in certain artworks are true, they are, in the main, hardly original, so it cannot be that they are insights. If ethical criticism is in the business of commending moral insights in art, there will be about as much call for it as for a fire department in a desert. So ethical criticism is, at best, largely beside the point. For the most part, it lacks an object.

One line of response to this argument is to claim that the model of knowledge employed by the skeptic here is too narrow. The skeptic, albeit encouraged by

[12] For one, albeit controversial, account of how this is done, see McCormick (1982), pp. 399–410.

the apparent practice of many ethical critics, thinks that the knowledge that is relevant to ethical criticism takes the form of propositions—propositions such as "that hypocrisy is noxious"—and goes on to say that where such propositions are abstractable from artworks they are generally overwhelmingly trivial. But some ethical critics counter that there are more forms of knowledge than "knowledge that." Ryle spoke of "knowledge how." Ethical critics add to the list "knowledge of what it would be like," which itself is a form of knowledge by acquaintance.[13]

If one says that the moral knowledge available in *Uncle Tom's Cabin* is that slavery is evil, then the skeptic can say: (1) that was already known by morally sensitive readers before the book was published; (2) it was knowledge that was or could have been stated in other than artistic forms, such as treatises, pamphlets, and sermons; and (3) the novel scarcely proved the case, since all its examples were made up. The ethical critic, however, might agree with all these points, but then continue by saying that the novel still afforded knowledge, namely, knowledge of what slavery was like. By providing richly particularized episodes of cruelty and inhumanity—of families callously sundered and savage beatings—the novelist engages the reader's imagination and emotions, thereby giving the reader a "feel" for what it was like to live in slave times.

It is one thing to be told that roadways in Mumbai are massively overcrowded; it is another thing to be given a detailed description full of illustrative incidents, emotively and perceptively portrayed. The first presents the fact; the second suggests the flavor. The first tells you that the streets are congested; the second gives you a sense of what that congestion is like. The ethical critic, or at least some ethical critics, then, answer skeptics by first agreeing that the propositional knowledge available in art is often trivial or platitudinous; art is not competitive with science, philosophy, history, or even much journalism in supplying "knowledge that." But this is not the only type of knowledge there is. There is also "knowledge of what such and such is or would be like." And this is the kind of knowledge that art excels in providing and that the best ethical critics look for, or at least should look for.

Moreover, this kind of knowledge is especially relevant for moral reasoning. In entertaining alternative courses of action, there is a place for the imagination. To take an extremely dramatic example, if one is contemplating murder, one should, among other things, reflect on what it would be like to live as a murderer. Reading a novel such as *Crime and Punishment* can give one an inkling of this. It engages the imagination and the emotions in a way that yields a feeling for what being a killer is like that one can consult in one's imaginative reflections on this alternative line of action. Furthermore, this kind of information is not only relevant to deliberating about how one should act; it is also pertinent to making

[13] The notion that literature trades in "knowledge of what X would be like" first appears, I believe, in Walsh (1969). It also is used in Scruton (1974). Neither of these authors applies the idea specifically to the claims of art and/or literature to moral knowledge. However, that move can be found in Putnam (1978); Palmer (1992); Currie (1995, 1998).

judgments about others. Having a sense of what slavery is like contributes to the indignation we feel toward surviving instances of it in the world today.[14]

Supposing that there is ethically relevant "knowledge of what X would be like," ethical critics can assess works that pretend to it: positively, when said works convey such knowledge accurately, and negatively, when the works in question falsify or distort what such and such a situation would be like (e.g., by portraying antebellum plantation life as idyllic for all concerned). Furthermore, though art and literature are not the only means for conveying knowledge of what X would be like, this is one of their leading specialties, and they have developed and continue to develop an astonishing number of strategies to this end (an end to which a substantial number of artists and writers have been and still are primarily committed). And, of course, the artist can offer us "knowledge of what X is like," which is unprecedented, and which, therefore, has a claim to being educative.

This approach to art's claims to moral knowledge, which we might call the "acquaintance approach," is promising, though it faces certain challenges. One would appreciate hearing a lot more than is currently available in the literature about the nature of "knowledge of what X is like." What precisely does it take to be a certifiable instance of it? What conditions must obtain for a candidate to count as "knowledge of what X is like?" And, once those conditions are spelt out, will this sort of knowledge really turn out to be categorically distinct from "knowledge-that" or will it be reducible to long conjunctions of propositional knowledge? More needs to be said about this intriguing, though still vague, proposal.

Even among proponents of this view, there seems to be an ambiguity about the object of this knowledge—does it focus on characters or situations? That is, in reading a novel, do we learn what it would be like to be a certain character in a certain kind of situation, or do we learn what the situation is like from the perspective of an onlooker? Some theorists in this vein suggest that what we learn is not what a situation is like, but what it would be like to view the situation as the real or the implied narrator does—to learn, for instance, what it is like to see the world as loveless, as Céline does.

Which of these alternatives does the acquaintance theorist have in mind when talking about knowledge of what X is like? And, if the answer is that it could be any one of them, how does a critic know which one is relevant with respect to a particular artwork? There are also questions about the nature of the pragmatic mechanisms that underlie the communication of knowledge of what X would be like, though as we will see in the next section, some work on this problem has been undertaken by simulation theorists.

Perhaps a more troublesome problem for the acquaintance approach than the preceding requests for more detail is that the ethical critic who adopts the acquaintance approach appears to presuppose that the kind of situations

[14] On the relevance of this sort of knowledge to moral reasoning, see especially Currie (1995).

and characters about whose haecceity we learn from art and literature are sufficiently like those we might encounter in everyday life to be morally relevant to practical and moral reasoning and judgment. But are they really? We almost always know more about situations and characters in literature than we do about the situations and people with whom we must interact morally. Also, novelists and dramatists can enter the minds of characters, disclosing their motives and feelings, and they can omnisciently limn factors that no one could suspect.

How often do we find ourselves in situations with such epistemic mastery? Furthermore, given the frequent epistemic disparity between the situations and characters in fiction and what we are likely to find in everyday life, how can we match the information accessed through fiction to our own circumstances? And, finally, even if we could, an earlier skeptical complaint returns: why would we rely on a novel's portrayal of what some situation would be like, since it is made up? The fiction does not provide any evidence that comparable situations really are like this.[15]

Another response to the cognitive triviality argument is what might be called the "subversion approach." On this view, ethically commendable artworks present readers, viewers, and listeners with depictions or descriptions that call into question or subvert our (lamentably) settled moral views.[16] Novels that reveal conventional sexual mores to be the agency of sickness and oppression, or that show ethnic minorities undemonized and worthy of common human respect, undermine complacent stereotypes and maxims and invite the reader to revise his moral opinions and adopt a superior moral perspective. These are the sorts of things that artworks can do effectively, and ethical critics are keen to praise them when they do.

Of course, the subversion approach can be combined with the acquaintance approach,[17] since the way in which an artwork or fiction might challenge complacent moral views is by bringing home experientially to audiences, through imaginative examples, how degrading, alienating, or unjust are the kinds of situations that follow from conventional morality. That is, a harsh work ethic toward the poor might be subverted by showing what it is like to worry about one's next meal on a day-to-day basis. Or, a morally condescending, though socially enfranchised, view of women might be shaken by narrating what it is like to be a woman in a man's world.

[15] Perhaps an answer to this objection is to concede that the fiction does not present knowledge, but rather hypotheses—hypotheses which we may then bring to the world for confirmation or disconfirmation. This is what we do with much non-fiction, like diet advice. The article offers a hypothesis for which we may then seek evidence (sometimes in our own case, but usually not mine). Similarly, the proponent of the acquaintance approach could suggest that what fictions do is offer us hypotheses about what X would be like, where such hypotheses can be of cognitive and ethical value. For further discussion, see Novitz (1987), esp. pp. 130–2.

[16] Variations on the subversion approach include Putnam (1978); Wilson (1983); Beardsmore (1984); Harrison (1991); Passmore (1991); Eldridge (1992b).

[17] Indeed, in Putnam (1978), the subversion approach and the acquaintance approach blend into each other.

On the other hand, artworks like Eisenstein's film *Potemkin* may place more weight on argument than empathy in overthrowing entrenched, though dubious, moral convictions. But whether by example or argument or an admixture of the two, it seems that there can be little doubt that artworks have contributed to the social transformation of moral values. Think of all those stories about young lovers who defy parentally arranged marriages; such tales are very romantic, but they also represent confrontations with conventional moral hierarchies for the sake of asserting the autonomy of individuals. In our own times, much avant-gardism has been predicated on unsettling moral pieties, while, throughout the ages, this has been the terrain of satire. Whether through acerbic ironic assertion after the fashion of Brecht's *Threepenny Opera*, or through showing what colonialism was like à la Forster's *Passage to India*, artworks have functioned as opportunities or occasions for revising moral conceptions, even at times facilitating ethical conversion experiences.

At this point, the skeptic is likely to chime in with a familiar refrain: the challenges to complacent morality advanced in artworks are almost never original to the artwork or artist in question. The moral insight in question is most often an illustration or rhetorically effective reframing of something derived from already existing social criticism, or philosophy, or religion, or whatever. It is still at best recycled knowledge. The artist has not discovered it, but only re-tooled it.

Yet this argument seems irrelevant. It is one thing to claim that most artworks are not genuinely insightful or educative because they usually broker truisms. But it is strange to say that they cannot be conduits of innovative knowledge because they disseminate moral views heretofore shared only among small coteries of progressive thinkers. Given the context in which artists operate—given their audiences—it does seem correct to say that, relatively speaking, they are introducing new moral insights, and, to the degree that those insights justifiably challenge accepted moral wisdom and clear the path for audiences to revise their moral beliefs, it seems perfectly natural to describe the value of the relevant artworks as educative. The kinds of artworks the subversion approach commends are not telegraphing truisms; they are impugning truisms for the sake of moral ideas that are new and informative for the relevant audiences, even if they are already known to savants.

Thus, the subversion approach provides the ethical critic with an answer to the charges of cognitive triviality. Some art affords what, relative to its audiences, counts squarely as moral insight, including even propositional knowledge. This provides the ethical critic with grounds to praise the relevant art in terms of its educative value. Maybe the subversion approach also suggests a way to evaluate some art negatively, namely, the art that tends to reinforce settled moral convictions that are pernicious.

But, though the subversion approach has several advantages, it also has certain shortcomings. It is rather limited in scope. It is best suited to deal with artworks that undermine complacent moral views. This biases the ethical critic's attention to radical works. But most artworks, including most fictions, are not morally radical. A great many artworks, notably fictions, operate within established moral

frameworks and are not morally pernicious, though they may yet possess an ethical dimension. The subversion approach leaves the ethical critic nothing to say about work like this. It enables the ethical critic to commend the morally revolutionary and to deplore the morally reactionary. But won't the ethical critic also want to have a way of talking about artworks that do not push the moral envelope, yet which are still nevertheless morally praiseworthy? Thus, the subversion approach makes the case for ethical criticism with respect to some art, but it is not comprehensive enough.

A third response to skeptical objections concerning the educative powers of art can be called the cultivation approach.[18] Whereas defenders of the acquaintance approach contend that the skeptic's conception of knowledge is too narrow, defenders of the cultivation approach maintain that the skeptic's conception of education is too narrow. For the skeptic, education is the acquisition of insightful propositions about moral life. For the advocate of the cultivation approach, education may also involve other things, including the honing of ethically relevant skills and powers (such as the capacity for finer perceptual discrimination, the imagination, the emotions, and the overall ability to conduct moral reflection), as well as the exercise and refinement of moral understanding (that is, the improvement and sometimes the expansion of our understanding of the moral precepts and concepts we already possess). As the label for this approach indicates, the educative value of art resides in its potential to cultivate our moral talents.

Most fiction, for example, engages audiences in a constant process of ethical judgment, encouraging readers, viewers, and listeners to form moral evaluations of characters and situations virtually on page after page, and in scene after scene. Though the call for rendering moral judgments is intermittent in everyday life, in fiction it is generally pervasive. Thus, through constant exercise, narrative fiction can keep our powers of moral judgment lubricated.

Much art mandates emotional responses from audiences. The emotions, in turn, are typically governed by criteria, and with respect to many emotions, like anger and pity, the appropriate criteria for having the emotion are moral (perceived justice with respect to anger; perceived undeservedness with respect to pity). Thus, exposure to certain art can sensitize us to, as Aristotle would say, the right reasons and objects for the emotions in question. In the best cases, artworks can also expand our emotional powers of discrimination by appealing to our imagination in such a way that we come to apprehend some objects, say AIDS victims, as worthy of emotions such as sorrow, where previously we had been oblivious or even hostile toward them. Where artworks cultivate our moral emotions by exercising and/or expanding them, the ethical critic can commend them. But, of course, many artworks encourage audiences to indulge in morally

[18] Some recent examples include: Kieran (1996), p. 351; Carroll (1996, 1998a). The view is also suggested in passages in: Murdoch (1970, 1992); Palmer (1992); Booth (1988). I would also interpret Martha Nussbaum as a representative of this approach; see, e.g., (1996, 1998). I call my own version of the cultivation approach "clarificationism."

flawed emotional responses for the wrong objects and/or the wrong reasons. In those cases, the ethical critic is in a position to castigate them.

The cultivation approach can be wedded to the acquaintance approach. An encounter with a fiction, for instance, encourages audiences to imagine what working in a sweatshop would be like, thereby not only perhaps expanding the focus of our emotion of indignation, but augmenting our imaginative resources. Insofar as the imagination (the capacity to entertain contrary-to-fact situations) is integral to moral judgment, fictional explorations of what such and such would be like are, in general, relevant to keeping our powers of moral judgment in working order, while specific fictions may enrich the scope of our imaginations by giving us more food for thought. Here, the cultivation approach need not fall afoul of the problem confronting the acquaintance view, since on the former view it is only claimed that exposure to fictional situations may cultivate our imaginative powers and reach, and not that we take fictional situations as exemplars that correspond and are directly applicable to living cases. On the cultivation view, the ethical critic can regard artworks as object lessons in moral reflection in general; they need not take artworks to be lessons for dealing with certain specific kinds of situations.

Art can also amplify our morally relevant powers of perceptual discrimination. Fictions, for example, present us with characters, such as Mr Skimpole in *Bleak House*, who, we come to realize, are not what they initially appear to be—beneath the charm, for instance, we may gradually discover heartless egoism. Fiction, that is, can train us to be—and how to be—on the lookout for telltale signs of character. Moreover, as we read certain fictions, we often simultaneously run through a process of moral reflection—one that is coincident with one conducted by the real and/or implied author or some character. In the best cases, this tutors us in how to attend to and weigh details, and in the appropriateness of casting our reflective net broadly. This exercise enhances our ability to reflect on further moral situations, just as running through logic exercises prepares us to solve theorems we have never seen before. Here, once again, we are not talking about treating specific fictional reflections as models for real-life cases, but only of the way in which fictions exercise and potentially augment our general powers of moral reflection. Thus, once again, the cultivation approach evades the charges leveled at the acquaintance approach.[19]

Art, especially fiction, can contribute to the enlargement of our capacity for moral understanding. We learn many moral rules and concepts, but they are very abstract and, as a result, we may not be able to connect them to particular situations. By providing detailed examples, fictions help us evolve a sense of how to employ these abstractions intelligibly and appropriately. Aesopian fables provide a simplified example of this. But even more complex works like Marlowe's *Doctor Faustus* and Melville's *Moby-Dick* can be read as vivid prototypes for admonitions about pride. Experience with such vivid prototypes enables us to employ abstract

[19] The themes of perception and reflection are especially central in Nussbaum (1986).

moral maxims with greater facility when we are called upon to make moral judgments.

In addition to abstract maxims, we also possess abstract moral concepts, such as those pertaining to virtue and vice. By providing concrete examples, art can advance our understanding of how to apply them to particular cases. Shakespeare's *Henry VI*, for instance, provides an array of contrasting characters that enable us to clarify our understanding of the nature of political virtue and vice. Moreover, that the specimens of virtue and vice found in fiction are often more clearcut than those found in life does not compromise their educative serviceability. Like the use of heuristic devices, such as diagrams, in the education of medical students, the fact that literary examples are generally less messy than real-life cases aids the refinement of our practice of moral judgment.

The skeptic denies that art and literature provide a resource for moral education because the ethical maxims and propositions found there generally are already known by audiences and, indeed, usually must be known if the audience is to recognize their connection to the artworks in question. Under the cultivation approach, the ethical critic can concede that this is most often the case, but then adds that this is no objection to the educative potential of art and literature. For what art teaches us generally is not new maxims and concepts, but rather how to apply them to concrete cases, engaging and exercising our emotions and imagination, our powers of perceptual discrimination, moral understanding, and reflection, in ways that sustain and potentially enlarge our capacity for moral judgment.

The proponent of the cultivation approach can also take on board the insights of the subversion approach. Though agreeing with the skeptic that most often artworks instantiate already known moral propositions and concepts, the ethical critic need not concur that this is always the case. Sometimes artworks do introduce innovative moral perspectives or reorient moral emotions and understandings in unexpected ways. This often occurs by showing that our moral convictions apply more broadly than reigning prototypes suggest or by bringing our attention to hitherto ignored, but morally significant, variables. But this is just a special case of the cultivation of our moral powers, the enlargement of our imaginative, perceptive, reflective capacities for moral judgment.

Most of our preceding examples have been ones in which art and literature enhance our moral powers. But, of course, there are also many cases in which art ill serves morality. For example, there is a particularly nasty short story by F. Paul Wilson, entitled "The Wringer," which blinkers the reader's reflection on the story (concerning a revenge kidnapping) in such a way as to encourage the reader to assent to the proposition that torture is sometimes not only permissible, but required, oddly enough to buoy family values.

From the perspective of the cultivation approach, it is easy to see how the ethical critic deals with cases such as this. Since the cultivation approach commends artworks that exercise and enlarge our moral powers by clarifying our moral understanding, it will deplore artworks that encourage confusion by misdirecting

moral perception and emotion and by proffering distorting instantiations of moral maxims and concepts.

Earlier it was argued, against the autonomist, that ethical criticism is possible. The cultivation approach gives a sense of what the ethical critic looks for in order to commend or to censure artworks. Here the educative potential (or lack thereof) of art figures centrally, while skeptical charges about the cognitive triviality of art are circumvented by appealing to the cultivation of moral powers. Thus, the cultivation approach appears to be a feasible avenue of research for ethical criticism, though admittedly one whose chief concepts—moral perception, reflection, understanding, imagination, and judgment (as engaged by artworks)—require further elaboration.[20]

5. RESPONSES TO ANTI-CONSEQUENTIALISM

The consequentialist suspects that ethical criticism rests on presuming knowledge that, in truth, no one has. Ethical critics appear to commend artworks morally because they maintain the relevant artworks will abet morally admirable behavior; they seem to condemn artworks because they suppose the works in question will bring about anti-social behavior. And, admittedly, ethical critics sometimes talk this way. But, the anti-consequentialist observes, we know next to nothing about the regularly recurring effects of artworks, and, therefore, the predictions on which the ethical critic feigns to rely are ultimately groundless.

However, ethical criticism need not depend on spurious behavioral predictions. If one endorses certain variations of the cultivation approach, one may argue that one's moral assessments of artworks are based not on forecasts of the behavior that the artworks are likely to elicit, but on the quality of the moral experience that the artwork encourages as the audience engages with it.

As we have seen, fictions generally invite or prescribe ongoing processes of moral judgment. We can ask of the ongoing processes that the fiction encourages or mandates whether they exercise our moral powers appropriately and/or deepen them, or whether they confuse or distort moral understanding, blind moral perception, stunt reflection, and/or misdirect moral emotions. Questions about the direct behavioral consequences of the artwork need not arise in order for the ethical critic to be in a position to approve or reprove an artwork. Rather, the ethical critic can focus on the probity of the moral experience that an artwork shapes or prescribes as a condition for correctly assimilating it. Do those interactions cultivate our moral powers, or do they deform them?[21]

[20] One aspect of recent writing germane to issues of the cognitive triviality of art not canvassed in this section is Martha Nussbaum's contention that certain kinds of novels are indispensable to moral philosophy. This viewpoint is advanced frequently in the essays in Nussbaum (1986). For discussion and criticism of it, see Kalin (1992).
[21] For example, Wayne Booth writes: "even when we do not retain them, the fact remains that insofar as the fiction has worked for us, we have lived with its values for the duration; we have been

As we read, view, or listen to an artwork with a significant ethical dimension, our consciousness is occupied by content that has been shaped in a certain way—that prescribes and facilitates certain moral responses. Without claiming anything about the likely behavioral effects of the work, we can nevertheless still comment on the moral value of the pathways that we are invited to follow. Thus, ethical criticism can proceed, as it has for millennia, without claiming knowledge of behavioral generalizations that it has not got. Instead of attending to the putative behavioral consequences of artworks, ethical criticism, properly so called, takes the experience the work is designed to engage as its object of scrutiny.[22]

Since so much emphasis is being put on the experience of the artwork, at this point it will be instructive to look at the most precise account of that experience put forth by an ethical critic so far. Developed by Gregory Currie (henceforth called "the simulation theorist"), it derives inspiration from the notion of simulation that figures currently in debates about the philosophy of mind.[23]

Like most contemporary philosophers of fiction, the simulation theorist presupposes that fiction mandates audiences to imagine the states of affairs the author lays before them. The simulation theorist, however, has a very specific notion of imagination; for him, imagination is simulation. That is, the experience of reading a novel is a simulation of how a person like us (equipped with beliefs and desires like ours), under the guidance of the author, would respond to the discourse, if it were assumed to be narrated as true.

When simulating—when imagining—we take ourselves "off-line" (we de-couple the connection of our belief/desire system to the world) and use our standing repertoire of emotional and cognitive responses to fill in the story with what we know and feel in order to make sense of it. All fictions require that audiences complete them by supplying background presuppositions about the world of the fiction as well as appropriate affect. How does this come about? The simulation theorist says that the mechanism is simulation, the same process that we use to understand conspecifics in everyday life.

Furthermore, experiencing a fiction involves two kinds of simulation: primary and secondary imagining. Primary imagining is a matter of simulating belief in the propositions advanced in the text. If the story says "the house was made of stone," then the reader makes believe the house was made of stone, along with whatever we normally think goes with that. Secondary imagining, however, involves simulating the experience of characters. Since secondary imagining is what is most relevant to ethical criticism, we will now turn to that.

that kind of person for at least as long as we remained in the presence of the work" (1988, p. 41). See also Carroll (1998a).

[22] Determining the experience that the work is designed to engage, of course, is a matter for critical interpretation. This is why ethical criticism is generally interwoven with interpretation.

[23] For a more extensive discussion of this view, see Carroll (1998b), pp. 342–56.

According to simulation theory, in ordinary life we understand others not on the basis of some folk-psychological theory, but by simulating them, by taking our own belief-desire system off-line (by disconnecting it from the disposition to act) and by putting ourselves in their shoes. Why is Jones speaking in such a strangely guarded manner? Put yourself in his place—the boss has just insulted him. Using your own beliefs about the world and your own emotional inclinations, simulating his predicament will disclose to you that he is probably angry and yet simultaneously fearful of saying something that will get him in deeper trouble with the boss. You now understand why he is so circumspect. You know, through your simulation, that this is how you would be too, were you to find yourself in his circumstances.

Encountering characters in fiction, the simulation theorist suggests, is not so very different. In order to understand them—a project that occupies a large amount of our experience when attending to fictions—we simulate their situations. Why is the character walking so cautiously down that dark alley? Simulate his situation—he is being pursued by the SS—and his caution becomes evident. Moreover, it is our secondary imagining—our simulation of the mental states of characters—that makes fictions feel vivid, rather than dull and lifeless.

But what does character simulation have to do with ethical criticism? Our capacity to imagine—to simulate—is adaptive. It enables us to scope out the intentions and other inner states of our conspecifics. But we are not only able to simulate others; we are also able to simulate our own future selves. Simulation of our future selves is an indispensable element of practical deliberation.

It is an aid to planning, a way of engineering cost-free trial runs. In contemplating a future line of action, we can simulate it. Before we decide to embezzle, we can simulate what it would be like to be an embezzler. The simulation will yield information about whether we could live comfortably being an embezzler or rather be stricken by the pangs of conscience. And this sort of information is relevant to deciding to embezzle or not.

What does this have to do with fiction?

Good fictions give us, through the talents of their makers, access to imaginings more complex, inventive and instructive than we could often hope to make for ourselves. Constructing my own imaginings would also require of me a prodigious capacity to stand aside from my own immediate desires, since a natural tendency is to rig the narrative so as to get from it the lesson we want to hear. Better on the whole to listen to the narrative of another, more competent teller of tales. In this way we can think of fictions as just further examples of endogenously supplied survival mechanisms.

(Currie 1998: 171)

So the simulation of fictional characters yields information of what it would be like to undertake certain lines of action, and this is pertinent to practical and moral reasoning.

Simulation theory is a worked-out version of the acquaintance approach discussed in the previous section. Through secondary imagining (the simulation

of fictional characters), we learn what it would be like to be a nun or a pickpocket. Could we stand being a murderer? Simulate Raskolnikov and see. Because of the role that the simulation of fictional characters can play in moral reasoning, the ethical critic negatively evaluates fictions that distort our imaginings in such a way that we come to value what is not valuable, while positively evaluating fictions that promote imaginative experiences that predispose us to value what is valuable.

Simulation theory is an attractive account of the moral relevance of our experience of artworks, notably fiction, because of the way in which it ties together aesthetic issues with the philosophy of mind and evolutionary psychology. However, at least two kinds of questions must be raised about it. On the one hand, does it provide anything like a plausible, comprehensive account of our experience of fictional characters? And, on the other hand, do fictions really play the role in moral reasoning that the simulation theorist suggests?

In answer to the first question: there is little call for character simulation, construed as secondary imagining, when reading fiction, since novelists, dramatists, short-story writers, and so on typically give us access to what the characters are thinking and feeling, most frequently by omnisciently narrating their inner states. Even in popular films and TV programs, characters usually tell us what is on their mind. There is small cause to simulate them, and so, I propose, we don't. There are, of course, modernist examples, like the film *The Eclipse*, where the characters are opaque and enigmatic, but such films do not give us enough background information for simulation to get off the ground (and that is probably part of their point—that the springs of human action are impenetrable).

Character simulation is just not as pervasive as the simulation theorist suggests. If it occurs at all, it is a marginal feature of the process of experiencing fiction. For that reason alone, it is hard to believe that the phenomenon could play the central role for ethical criticism that the simulation theorist assigns to it.

Similarly, the role in moral reasoning that the theorist claims for simulating fictional characters appears strained. With the possible exception of literature professors, how many consult fictions when contemplating how to act? This is not to deny that simulation is important to moral reasoning. But it is the simulation of our future selves that is relevant here, not the simulation of fictional characters. Indeed, recalling a criticism of the acquaintance approach, I am prone to suspect that we would not be very likely to rely heavily on simulations of characters in moral reasoning, even if we did simulate them more than we do, because we realize that such characters are artificially contrived and their situations made up.[24]

[24] Currie seems aware of this criticism, which he frames in terms of skepticism about fiction as an epistemically reliable process for generating moral knowledge. His response is rather obscure. He appears to say that fiction can be a reliable process for acquiring moral knowledge where the person who employs it as such knows how to use it (knows how the genre in question works, understands its rhetorical resources, and comprehends how to reflect vividly and imaginatively on literature). But this seems to suggest that it is critics or people under the tutelage of critics who

Simulation theory, though presently the most rigorous account of the moral significance of our experiential engagement with fiction, is extremely controversial. This is not to say that the ethical critic's emphasis on the moral quality of our experience to artworks does not, in principle, suffice to evade the anti-consequentialist's objections, but only makes apparent the need for more exact thinking and theorizing about the express contours of that experience.

6. RESPONSES TO MODERATE AUTONOMISM

In Section 3, we examined the case for radical autonomism—the view that the ethical criticism of art is always inappropriate or irrelevant. Argument showed this is false; sometimes ethical criticism is appropriate, depending on the kind of artwork in question. Some artworks, given the kind of work they are, may be appropriate objects of ethical criticism. But we also noted previously that this line of argument may only result in the autonomist's adoption of a new tack, which we called "moderate autonomism." Qualifying autonomism, the moderate autonomist agrees that some art may be evaluated ethically, but adds that ethical criticism should not be confused with artistic criticism. A favorite example is the film *Triumph of the Will*, of which it is alleged that, though it deserves negative ethical evaluation, it is artistically good. The negative ethical evaluation has no impact on its artistic evaluation.

Hume claimed that where artworks contain ethical defects, "they confound the sentiments of morality, and alter the natural boundaries of vice and virtue. They are therefore eternal blemishes" (Hume 1993: 153). That is, an ethical blemish counts as an artistic (or aesthetic) one. This is what moderate autonomism denies. An artwork may contain ethical blemishes and be legitimately criticized for that reason. But an ethical blemish is conceptually distinct from an artistic or aesthetic blemish. An artwork is not aesthetically less for being ethically degraded, even though it may be incumbent on a critic to deplore its moral failings. Nor is an artwork better for being morally correct. Ethical evaluation and artistic evaluation with respect to artworks are always necessarily independent.

Two recent challenges to moderate autonomism are ethicism and moderate moralism.[25] Ethicism maintains that certain kinds of ethical failings in an

use secondary imagining in moral reasoning in the way he describes. Both prospects strike me as unlikely. Criticism, even less than fiction, is rarely, if ever, consulted by plain moral reasoners as they deliberate. And I would be surprised if it turned out that a significant number of critics make moral decisions by simulating fictional characters. I wouldn't say that it never happens. But I speculate that if it does, it is too idiosyncratic to serve as the keystone in a theory of ethical criticism.

[25] Ethicism is defended in Gaut (1998a). Kieran (1996) also calls his position ethicism, but since Kieran appears to be primarily concerned with refuting radical autonomism, I will focus on Gaut's view. Moderate moralism is defended in Carroll (1996, 1998c). Ethicism and moderate moralism are criticized in Jacobson (1997); and Anderson and Dean (1998).

artwork are always aesthetic defects and should be counted as such in an all-things-considered judgment of the work *qua* artwork. Moderate moralism contends only that some of the relevant ethical defects in artworks can also be aesthetic defects and must be weighed that way in all-things-considered judgments. Since ethicism is the stronger position, we will turn to it first.

As we have already seen, many artworks prescribe or mandate certain responses, including emotional responses, from their audiences. Structuring such an artwork so that it gets the response it prescribes is part of the artistic or aesthetic design of the work. Amusement is one of the responses that *Guys and Dolls* prescribes. If an audience has some problem, due to the way the work is structured, with complying with the work's prescribed response, that is a problem with the artistic or aesthetic design of the work.

Prescribed responses to a work can be merited or unmerited. A mystery story may prescribe that readers be gripped by curiosity about whodunit, but if the culprit is transparent from the get-go, the story does not merit the prescribed response of curiosity. Failure to support a work's prescribed responses is an artistic or aesthetic flaw in an artwork. That is, where an artwork does not merit the responses it prescribes, that is an aesthetic flaw in the artwork *qua* art. An artwork may be, on balance, considered good, even if it fails to merit some of the responses it mandates. However, such failures to merit some of its prescribed responses must be assessed as debits in contrast to whatever other of its virtues are also placed on the scale.

Moreover, if an artwork prescribes a response that is immoral, such as a pro-attitude toward torture, then that response is unmerited. Why? Because immoral responses are unmerited, and this gives the audience a reason to refrain from responding to the work in the way the work mandates. But failures to design a work in such a way that the work's mandated responses are not prey to countervailing reasons is a failure in the artistic design of the work—an aesthetic flaw. So moral defects in a work, notably prescribing immoral cognitive-affective responses, are aesthetic flaws, contrary to moderate autonomism.[26] This has been called the "merited response argument."

A central problem that critics of the merited response argument raise concerns the notion of an unmerited response. What is built into it? All immoral responses are alleged to be unmerited in a way that is relevant to aesthetic response. But are they? Drawing an analogy with immoral jokes, the critic points out there are many jokes that are immoral, but which are nevertheless humorous—not funny despite their immoral appeal, but sometimes because of it. Laughter at such jokes may be unethical, but it seems strange to say that it is, from the point of view of humor, unmerited, at least if "unmerited" means "unwarranted." For surely the laughter is well warranted by the structure and content of the joke. So, if aesthetic

[26] Gaut writes: "If these responses [to an artwork] are unmerited, because unethical, we have reason not to respond in the way prescribed. Our having reason not to respond in the way prescribed is a failure of the work. So the fact that we have reason not to respond in the way prescribed is an aesthetic failure of the work, that is to say, is an aesthetic defect" (1998a, p. 195).

effectiveness is analogous to humorousness, then indulging a prescribed though immoral response to an artwork may be warranted, as in the case of humor, even if it is evil. And being aesthetically moved is like being amused.[27]

We may be warranted in conceding that an immoral joke is funny at the same time as we agree that it is evil. In many cases, it would be wrong to say that such a joke is not funny—that it does not warrant amusement. We simply say that it is evil. Perhaps we think that it would be wrong to repeat such a joke—suppose it is a racist joke. But that is not because it is defective as a piece of humor, but because we think it is morally bad. Yet this has no bearing on its status as an aesthetically effective specimen of humor. The joke *qua* humor is well designed and, to the extent that it is well designed, our laughter is warranted by it. So, by parity of reasoning, if the ethicist means by "unmerited" "unwarranted," then the claim with respect to artworks that all prescribed, though immoral, responses are unmerited is false, since, like a joke, the structure and content of an artwork may warrant a prescribed response that is immoral. On the other hand, if the ethicist protests that by (aesthetically) "unmerited" he means to include "morally unmerited," then he can be charged with begging the question.

With regard to jokes, the ethicist points out that amusement, like other emotional states, has certain criteria of appropriateness, and, therefore, can be evaluated in terms of whether it is appropriate (that is to say, merited). However, the anti-ethicist responds that those criteria of appropriateness are amoral, involving factors like incongruousness. An evil joke can be incongruous—in fact, its incongruity may be connected to its evil—and, thus, appropriate in the relevant sense. To suppose that cognitive-affective appropriateness in a joke must involve appropriateness in the moral sense is an equivocation. Similarly, artworks may meet the appropriate conditions for engendering a powerful aesthetic response—for example, they may be viciously humorous—and this response may be well warranted, even if morally regrettable. The only way to avoid this conclusion is to build moral propriety into the criteria of appropriateness for being aesthetically moved, but that, of course, courts circularity.[28]

Critics of the merited response argument, then, maintain that not all ethically unmerited responses to artworks are unmerited aesthetically. Some artworks that prescribe ethically unmerited responses may be aesthetically powerful, not despite the ethically unmerited responses they prescribe, but because of them. This debate remains to be played out in the literature. Nevertheless, however it eventuates, there is a weaker position to which the ethical critic can revert in order to oppose moderate autonomism. It is moderate moralism.

Moderate moralism is less sweeping than ethicism. Against moderate autonomism, it claims only that sometimes a moral defect in an artwork can be an

[27] The analogy between jokes and artworks at the expense of the merited response argument is pursued at length by Jacobson (1997).

[28] Though Gaut has addressed the relation of ethicism to humor at length, he has not confronted an argument exactly like this one. See Gaut (1998b). Though Gaut does not seem prone to take this option, questions could be raised about the aptness of the art/joke analogy. For example, see Carroll (1991).

aesthetic flaw and that sometimes a moral virtue can be an aesthetic virtue. Like ethicism, moderate moralism begins the case for moral defects being aesthetic defects by reflecting upon the ethically relevant responses prescribed by artworks.

Securing audience uptake to the responses a work prescribes is a leading feature of any artwork's agenda. Failing to secure uptake, then, is an aesthetic defect in an artwork, and, as such, needs to be balanced against whatever other, if any, aesthetic virtues the work possesses. Many (most?) artworks prescribe emotional responses. Some of these emotional responses contain, among their warranting conditions, moral considerations (in the way that anger requires the perception of injustice); and some of these emotional responses are moral through and through (for example, a feeling of social indignation). An artwork that fails to secure emotional uptake is aesthetically defective on its own terms. Moreover, an artwork may fail to secure the emotional responses it mandates because its portrayal of certain characters or situations fails to fit the moral-warranting criteria appropriate to the mandated emotion. And one way it can fail to do this is by being immoral.

Imagine a novel that calls upon audiences to deliver the moral sentiment of admiration for a sadistic colonizer who cruelly and relentlessly tortures every Indian he encounters, not only braves but women and children. He presumes the moral rightness of his actions on the grounds that his victims are vermin and the point of view of the novel concurs. The graphic violence and the malevolence of the work are impossible to miss. The work would be criticized for its evil; it is morally defective. But also it would come as no surprise if audiences were unable to feel admiration for the colonizer. That is, *ex hypothesi*, they would not be able to respond emotionally in the prescribed manner, since he not only fails but contravenes the morally relevant criteria for admiration.[29] All things being equal, this is an artistic defect, a failure to design the character in accordance with the warranting conditions for the emotional response prescribed.

But the reason the work is aesthetically defective is that it is morally defective. Though the work prescribes admiration as part of its aesthetic agenda, it fails to secure it, precisely because it is evil. The relevant explanatory reason the work fails aesthetically is the same as the reason it is ethically defective. It is evil. Nor are cases like this recherché. We often have problems mustering the prescribed affect for fictional characters and situations just because they are inappropriately sympathetic from a moral point of view. Thus, contra moderate autonomism, sometimes a moral defect in a work is an aesthetic defect. Presuming that typically artists intend to address their works to morally sensitive audiences, then where characters and situations are portrayed in ways that block said audiences from responding in the prescribed manner, due to an immoral instantiation of the appropriate warranting conditions, an ethical defect can also be an aesthetic defect.

[29] The view that audiences cannot just suspend their moral beliefs in such cases is defended in Walton (1994).

Moderate moralism does not claim that every moral defect in an artwork is an aesthetic defect. Artworks can be immensely subtle in terms of their moral commitments. Morally defective portrayals may elude even morally sensitive audiences and may require careful interpretation in order to be unearthed. Of course, once they are excavated, they can be ethically criticized. But the moderate moralist will not, in addition, criticize them aesthetically, if they are so subtle as to escape a morally sensitive audience. Moderate moralism is not, then, committed to the proposition that every moral defect in an artwork is an aesthetic defect.

Of course, sometimes actual audiences may fail to be deterred by a moral defect in a work because, given the circumstances, they are not as morally sensitive as they should be (as opposed to as hermeneutically sensitive as they could be). Perhaps in the midst of a war, audiences who are ordinarily morally sensitive will miss the inhumanity portrayed in the treatment of enemy soldiers in a propagandistic artwork. Ethical critics will, needless to say, criticize the work on moral grounds. But moderate moralists may also criticize the work as aesthetically defective, if it is such that it would daunt the work's prescribed responses for ideally morally sensitive audiences because it is ethically defective.

Against moderate autonomism, the moderate moralist also claims that some-times an ethical virtue in an artwork can also count as an aesthetic virtue. A central aesthetic aim of most artworks is to absorb the attention of the audi-ence. Providing genuine, eye-opening moral insight; exercising and enlarging the audience's legitimate moral powers of perception, emotion, and reflec-tion; challenging complacent moral doxa; provoking and/or expanding the moral understanding; calling forth educative moral judgments; encouraging the tracing out of moral implications or the unraveling of morally signifi-cant metaphors that have import for the audience's lives can all contribute to making an artwork absorbing. Thus, sometimes an ethical virtue is also an aesthetic one.

One criticism of moderate moralism concerns the idea that it should count as an aesthetic defect that, due to the immorality of the artwork, the ideally morally sensitive audience is reluctant to join a prescribed response. For, if the reluctance here is akin to that of a person who turns off when encountering a racist joke and refuses, in principle, to laugh, then it seems that this person has simply made whatever the work has to offer inaccessible to himself. And if what the work has to offer is inaccessible to this person, he is in no position to judge the work aesthetically, since he has not experienced it fully.[30] It is not as bad as someone who pronounces on the dreadfulness of an artwork without ever having seen it. But it is in that ballpark.

Yet the reluctance that the moderate moralist has in mind is not that the ideally sensitive audience member voluntarily puts on the brakes; rather, it is that he can't depress the accelerator because it is jammed. He tries, but fails. And he fails because there is something wrong with the structure of the artwork. It has not been designed properly on its own terms.

[30] This seems to be the objection that Jacobson has in mind in (1997), p. 189.

Nor need the work be inaccessible to the ideally sensitive viewer in any way that compromises an aesthetic judgment of the work. The ideally sensitive viewer, or the critic speculating about his reactions, may understand (find accessible) what is intended by the work and go on to note that the work fails to realize its intentions, perhaps due to its moral structure. One does not say of a critic who realizes both how the music is trying to move him and that it fails that what the work is trying to do is inaccessible to him in a way that calls into question his credentials as a critic. Similarly, a moderate moralist with reasonable claims to being sufficiently, but not neurotically, sensitive morally, using himself as a detector, can attribute an aesthetic defect to an artwork on the basis of being discouraged in a fair attempt to enact a prescribed response due to its evil.

Another complaint about moderate moralism is that, though it allows that artworks can be morally defective without being artistically defective, it is nevertheless committed to the view that whenever morality is relevant to aesthetic evaluation, then the relation is such that the pertinent moral defects will only count as artistic defects, and the moral virtues will only count as artistic virtues. That is, moderate moralism, like ethicism, does not allow that a moral defect in an artwork might sometimes contribute to the positive aesthetic value of an artwork.[31]

It is not clear that the moderate moralist has explicitly made such a claim, nor is it clear that he is committed to it.[32] But, that notwithstanding, the issue of the praiseworthiness of immoral art is sufficiently interesting and important to merit discussion in the closing paragraphs of this chapter.[33]

Are there immoral artworks that are aesthetically commendable because of their moral defectiveness? Few, if any, examples come to mind.[34] One that is often discussed is Leni Riefenstahl's *Triumph of the Will*. It seems aestheticians need Hitler for an intuition pump as much as ethicists do. Personally, I have always found the proposition that *Triumph of the Will* is an aesthetically good

[31] This, I take it, is the leading theme in Jacobson's (1997).

[32] Speaking as a moderate moralist, I note that I've always used examples of moral defects that are aesthetic defects because my argument has been with the moderate autonomist. The thesis that a work might be aesthetically good because it is morally defective is obviously not an autonomist viewpoint, moderate or otherwise, and so it introduces a new issue that requires moderate moralism to explore heretofore unexamined options. But I'm not convinced that a moderate moralist must be antecedently committed one way or another on this issue on the basis of what the moderate moralist has said so far.

[33] One issue in contemporary ethical criticism that I have not introduced in this chapter is the notion that works of fictions are like friends and that our relation to things like novels should be assessed ethically as we assess friendships. This view is advanced by Booth (1988).

[34] Jacobson suggests three. The first is a poem by Emily Dickinson of which I think he rightly believes that it only could appear immoral to some, but they would be wrong. Second, he seems to suggest that parts of *Macbeth* might be immoral, possibly because it elicits sympathy for the regicide. But, if this is what he has in mind, I think the case is unconvincing because it is sympathy for a good man gone bad. The play does not prescribe that viewers exculpate Macbeth. Perhaps Aristotle could argue that the tragedy works in accord with his predictions, since Macbeth raises the fear in us that ambition could blind us thusly. Jacobson's last example is *Triumph of the Will*, which I will deal with below.

film problematic. Seen in its entirety and not in the edited versions that are usually screened, it is immensely boring, full of tedious Nazi party speeches. But, rather than quibble about examples, let us suppose that *Triumph of the Will* is an aesthetically commendable film.

Given this, the moderate moralist can tell a story about why it is aesthetically valuable, if it is. The film has some cinematically stunning scenes. The opening image of Hitler (Hitler's plane) flying through the clouds, and then his descent, as if from heaven, is cleverly imagined and edited with flawless grace. And there are other parts of the film that in terms of their camera work and editing are fluid and arresting. The moderate moralist can say that if *Triumph of the Will* is aesthetically good, it is because, on balance, its cinematic virtues vastly outweigh whatever aesthetic costs its moral defectiveness incurs.[35] You could say that, if you thought it was a good film.

But now we will be told that *Triumph of the Will* is not good in spite of its moral defectiveness, but because of it, and moderate moralism cannot account for this. Perhaps. Yet, at this point, we have to ask: why one would think so? What's the argument? It seems to be this: we live in a world where there are a plurality of beliefs. Many of these beliefs are in error, including, notably, moral error. Nevertheless, we need to know about these beliefs and why people hold them (Jacobson 1997: 193–4). Thus, we need to have these perspectives presented to us as vividly as possible. *Triumph of the Will* does that. Thus, its energetic portrayal of a morally defective position contributes essentially to its praiseworthiness.

Some artworks may present morally defective perspectives for scrutiny with the intention of informing us in the way sketched in the preceding paragraph. But works like this are generally not morally defective, since the distorted moral viewpoints in question are housed in larger structures that mark them as specimens, like Bigger Thomas's or Mack the Knife's conceptions of life, rather than exemplars. But *Triumph of the Will* is not like that; its portrait of Nazism is that of an advocate. Yet why should its advocacy count as an aesthetic virtue?

Whoever praises *Triumph of the Will* for its artistic value owes us an explanation here. That it can be made to serve educative needs in a pluralistic society does not sound like an artistic value in any traditional sense. It sounds like a strategic value from a certain, perhaps liberal, point of view. If indeed it is an artistic value, more needs to be said to connect it with better-known sources of artistic or aesthetic value.

If *Triumph of the Will* is heuristically valuable, one wants to know why it or Leni Riefensthal deserves praise, either ethical or aesthetic, for a use by us that it

[35] Jacobson thinks that stories like this belie an untenably formalist conception of aesthetic value at the heart of moderate moralism. But I don't see why. Regarding things like elegant cutting, admittedly a formal value, does not imply a commitment to the notion that aesthetic value is solely a matter of formal value. Formal value is one aspect of aesthetic or, perhaps better, artistic value, but that is not the only type of artistic value the moderate moralist acknowledges. As we have seen, the moderate moralist thinks that securing uptake on prescribed responses can be aesthetically valuable and even that moral defects in artworks can be aesthetic blemishes.

was never designed to serve. The virtually Millian heuristic value that has been advanced in its defense perhaps provides a reason that immoral art should not be censored, but not a reason why it should be praised. Of course, I suspect that these remarks will not end the discussion. But maybe they predict the next chapter in the debate about the ethical criticism of art—the question of the value, if any, of immoral art.

REFERENCES AND FURTHER READING

Ackerman, Felicia. 1991. "Imaginary Gardens and Real Toads: On the Ethics of Basing Fiction on Actual People." *Midwest Studies in Philosophy*, 16: 142–51.

Anderson, James, and Dean, Jeffrey. 1998. "Moderate Autonomism." *British Journal of Aesthetics*, 38: 150–66.

Anderson, John. 1941. "Art and Morality." *Australasian Journal of Philosophy*, 19: 253–66.

Barrett, Cyril. 1982. "The Morality of Artistic Production." *Journal of Aesthetics and Art Criticism*, 41: 137–44.

Beardsley, Monroe. 1958. *Aesthetics*. New York: Harcourt, Brace & World.

Beardsmore, R. W. 1971. *Art and Morality*. London: Macmillan.

—— 1983. "The Censorship of Works of Art," in Peter Lamarque, ed., *Philosophy and Fiction*. Aberdeen: Aberdeen University Press, pp. 93–107.

Bell-Villada, Gene. 1996. *Art for Art's Sake: How Politics and Markets Helped Shaped the Ideology and Culture of Aestheticism, 1790–1990*. Lincoln, NB: University of Nebraska Press.

Bontekoe, Ron, and Crooks, Jamie. 1992. "The Interrelationship of Moral and Aesthetic Excellence." *British Journal of Aesthetics*, 32: 209–20.

Booth, Wayne. 1988. *The Company We Keep: An Ethics of Fiction*. Berkeley, CA: University of California Press.

—— 1991. Critical review of Martha Nussbaum's *Love's Knowledge*. *Philosophy and Literature*, 15: 302–10.

—— 1993. "On Relocating Ethical Criticism," in Salim Kemal and Ivan Gaskell, eds, *Explanation and Value in the Arts*. Cambridge: Cambridge University Press, pp. 71–93.

—— 1998. "Why Banning Ethical Criticism is a Serious Mistake." *Philosophy and Literature*, 22: 366–93.

Bradley, A. C. 1959. "Poetry for Poetry's Sake," in *Oxford Lectures on Poetry*. London: Macmillan, pp. 4–32.

Brooks, David. 1993. "Taste, Virtue, and Class," in David Knowles and John Skorupski, eds, *Virtue and Taste*. Oxford: Basil Blackwell, pp. 65–82.

Brudney, Daniel. 1998. "Lord Jim and Moral Judgement: Literature and Moral Philosophy." *Journal of Aesthetics and Art Criticism*, 56: 265–81.

Buckman, Kenneth. 1997. "Gadamer on Art, Morality, and Authority." *Philosophy and Literature*, 21: 144–50.

Budd, Malcolm. 1995. *Values and Art*. London: Penguin.

Carroll, Noël. 1990. "The Image of Women in Film." *Journal of Aesthetics and Art Criticism*, 48: 349–60.

—— 1991. "On Jokes." *Midwest Studies in Philosophy*, 16: 280–301.

—— 1993. "Film, Rhetoric, and Ideology," in Salim Kemal and Ivan Gaskell, eds, *Explanation and Value in the Arts*. Cambridge: Cambridge University Press, pp. 215–37.

—— 1996. "Moderate Moralism." *British Journal of Aesthetics*, 36: 223–37.

—— 1997. "Simulation, Emotion and Morality," in Gerhard Hoffman and Alfred Hornung, eds, *Emotion in Postmodernism*. Heidelberg: C. Winter, pp. 382–99.

—— 1998a. "Art, Narrative and Moral Understanding," in Jerrold Levinson, ed., *Aesthetics and Ethics*. Cambridge: Cambridge University Press, pp. 128–60.

—— 1998b. *Philosophy of Mass Art*. Oxford: Oxford University Press.

—— 1998c. "Moderate Moralism versus Moderate Autonomism." *British Journal of Aesthetics*, 38: 419–24.

—— 1999. *Philosophy of Art: A Contemporary Introduction*. London: Routledge.

Casey, John. 1966. "Art and Morality," in *The Language of Criticism*. London: Methuen, pp. 179–97.

Cavell, Marcia. 1974. "The Good and the Beautiful: Considerations of Morality and Art." *Philosophical Forum*, 4: 360–71.

Cebik, L. B. 1995. *Nonaesthetic Issues in the Philosophy of Art: Art as a Social Real Realm*. Lewiston, PA: Edwin Mellen Press.

Cohen, Marshall. 1977. "Aesthetic Essence," in George Dickie and Richard Sclafani, eds, *Aesthetics: A Critical Anthology*. New York: St Martin's Press, pp. 474–99.

Cohen, Ted. 1983. "Jokes," in Eva Schaper, ed., *Pleasure, Preference and Value*. Cambridge: Cambridge University Press, pp. 120–36.

Currie, Gregory. 1995. "The Moral Psychology of Fiction." *Australasian Journal of Philosophy*, 73: 250–9.

—— 1998. "Realism of Character and the Value of Fiction," in Jerrold Levinson, ed., *Aesthetics and Ethics*. Cambridge: Cambridge University Press, pp. 161–81.

Danto, Arthur. 1986. *The Philosophical Disenfranchisement of Art*. New York: Columbia University Press.

—— 1994. *Embodied Meanings*. New York: Farrar, Straus & Giroux.

Devereaux, Mary. 1991. "Can Art Save Us? A Meditation on Gadamer." *Philosophy and Literature*, 15: 59–73.

—— 1998. "Beauty and Evil: The Case of Leni Riefenstahl's *Triumph of the Will*," in Jerrold Levinson, ed., *Aesthetics and Ethics*. Cambridge: Cambridge University Press, pp. 227–56.

Diamond, Cora. 1983. "Having a Rough Story about What Moral Philosophy Is." *New Literary History*, 15: 155–70.

—— 1988. "Losing Your Concepts." *Ethics*, 98: 255–77.

—— 1993. "Martha Nussbaum and the Need for Novels." *Philosophical Investigations*, 16: 128–53.

Dickie, George. 1974. *Art and the Aesthetic: An Institutional Analysis*. Ithaca, NY: Cornell University Press.

—— 1988. *Evaluating Art*. Philadelphia, PA: Temple University Press.

Diffey, T. J. 1975. "Morality and Literary Criticism," in *The Republic of Art and Other Essays*. New York: Peter Lang, pp. 105–24.

—— 1991. "Aesthetics and Aesthetic Education (and Maybe Morals Too)," in T. J. Diffey, *The Republic of Art and Other Essays*. New York: Peter Lang, pp. 217–24.

Diffey, T. J. 1991. "Art and Goodness: Collingwood's Aesthetics and Moore's Ethics Compared," in T. J. Diffey, *The Republic of Art and Other Essays.* New York: Peter Lang, pp. 139–57.

Dubin, Steven. 1992. *Arresting Images: Art and Uncivil Actions.* New York: Routledge.

Dutton, Denis, ed. 1983. *The Forger's Art.* Berkeley, CA: University of California Press.

Dwyer, Susan, ed. 1995. *The Problem of Pornography.* Belmont, CA: Wadsworth.

Eagleton, Terry. 1990. *The Ideology of the Aesthetic.* Oxford: Blackwell.

Eaton, Marcia. 1989. *Aesthetics and the Good Life.* Madison, NJ: Fairleigh Dickinson University Press.

—— 1992. "Integrating the Aesthetic and the Ethical." *Philosophical Studies,* 67: 219–40.

—— 1997. "Aesthetics: The Mother of Ethics?," *Journal of Aesthetics and Art Criticism,* 56: 355–64.

Eldridge, Richard. 1988. *On Moral Personhood: Philosophy, Literature, Criticism and Self-Understanding.* Chicago, IL: University of Chicago Press.

—— 1992a. "How Is the Kantian Moral Criticism of Literature Possible?," in Bjorn Tysdahl et al., eds, *Literature and Ethics.* Oslo: Norwegian Academy of Science and Letters, pp. 85–98.

—— 1992b. "'Reading for Life': Martha Nussbaum on Philosophy and Literature." *Arion,* 3d ser., 2/1: 187–97.

—— 1993. "Narratives and Moral Evaluation." *Journal of Value Inquiry,* 27: 385–90.

—— 1994. "How Can Tragedy Matter for Us?," *Journal of Aesthetics and Art Criticism,* 52: 287–98.

Ellos, William. 1994. *Narrative Ethics.* Aldershot: Avebury.

Feagin, Susan. 1983. "The Pleasures of Tragedy." *American Philosophical Quarterly,* 20: 95–104.

Fenner, David, ed. 1996. *Ethics and the Arts.* New York: Garland.

Freeland, Cynthia. 1997. "Art and Moral Knowledge." *Philosophical Topics,* 25: 11–36.

Gardner, John. 1978. *On Moral Fiction.* New York: Basic Books.

Gaskin, Richard. 1989. "Can Aesthetic Value Be Explained?," *British Journal of Aesthetics,* 29: 329–40.

Gass, William H. 1958. *Fiction and the Figures of Life.* Boston: Godine.

Gaut, Berys. 1998a. "The Ethical Criticism of Art," in Jerrold Levinson, ed., *Aesthetics and Ethics.* Cambridge: Cambridge University Press, pp. 182–203.

—— 1998b. "Just Joking: The Ethics and Aesthetics of Humor." *Philosophy and Literature,* 22: 51–68.

Glidden, David. 1991. "The Elusiveness of Moral Recognition and the Imaginary Place of Fiction." *Midwest Studies in Philosophy,* 16: 123–41.

Goldman, Alan. 1990. "Aesthetic versus Moral Evaluation." *Philosophy and Phenomenological Research,* 50: 715–30.

Gordon, Graham. 1996. "Aesthetic Cognitivism and the Literary Arts." *Journal of Aesthetic Education,* 30: 1–17.

Grossman, Morris. 1973. "Art and Morality: On the Ambiguity of a Distinction." *Journal of Aesthetics and Art Criticism,* 32: 103–6.

Guyer, Paul. 1993. *Kant and the Experience of Freedom: Essays on Aesthetics and Morality.* Cambridge: Cambridge University Press.

Haines, Victor Yelverton. 1989. "No Ethics, No Text." *Journal of Aesthetics and Art Criticism*, 47: 35–42.

Hall, Robert. 1990. "Art and Morality in Plato: A Reprisal." *Journal of Aesthetic Education*, 24: 5–13.

Ham, Victor. 1940. "Literature and Morality." *Thought*, 15: 268–80.

Hampshire, Stuart. 1970. "Logic and Appreciation," in Morris Weitz, ed., *Problems of Aesthetics*. London: Macmillan, pp. 818–25.

Hanson, Karen. 1998. "How Bad Can Good Art Be?," in Jerrold Levinson, ed., *Aesthetics and Ethics*. Cambridge: Cambridge University Press, pp. 204–26.

Hare, R. M. 1963. *Freedom and Reason*. Oxford: Oxford University Press.

Harrison, Bernard. 1991. *Inconvenient Fictions: Literature and the Limits of Theory*. New Haven, CT: Yale University Press.

Heinrich, Natalie. 1993. "Framing the Bullfight: Aesthetics vs. Ethics." *British Journal of Aesthetics*, 33: 52–8.

Hepburn, R. W. 1956. "Vision and Choice in Morality." *Proceedings of the Aristotelian Society*, suppl., vol. 30: 14–31.

Hjort, Mette, and Laver, Sue, eds. 1993. *Emotion and the Arts*. Oxford: Oxford University Press.

Hume, David. 1993. *Of the Standard of Taste*. In *Selected Essays*. Oxford: Oxford University Press, pp. 133–54.

Hyman, Lawrence. 1971. "Literature and Morality in Contemporary Criticism." *Journal of Aesthetics and Art Criticism*, 30: 83–6.

—— 1978. "Moral Attitudes and the Literary Experience." *Journal of Aesthetics and Art Criticism*, 38: 159–65.

—— 1984. "Morality and Literature: The Necessary Conflict." *British Journal of Aesthetics*, 24: 149–55.

Isenberg, Arnold. 1973. *Aesthetics and the Theory of Criticism*. Chicago, IL: University of Chicago Press.

Jacobson, Daniel. 1996. "Sir Philip Sidney's Dilemma: On the Ethical Function of Narrative Art." *Journal of Aesthetics and Art Criticism*, 54: 327–36.

—— 1997. "In Praise of Immoral Art." *Philosophical Topics*, 25: 155–99.

—— 1999. Review of McGinn's *Ethics, Evil and Fiction. Philosophical Quarterly*, 49/195 (April): 247–9.

Janaway, Christopher. 1995. *Images of Excellence: Plato's Critique of the Arts*. Oxford: Clarendon Press.

Jenkins, I. 1968. "Aesthetic Education and Moral Refinement." *Journal of Aesthetic Education*, 2: 21–39.

John, Eileen. 1995. "Subtlety and Moral Vision in Fiction." *Philosophy and Literature*, 19: 308–19.

—— 1997. "Henry James: Making Moral Life Interesting." *Henry James Review*, 18: 234–42.

—— 1998. "Reading Fiction and Conceptual Knowledge: Philosophical Thought in a Literary Context." *Journal of Aesthetics and Art Criticism*, 56: 331–48.

Kalin, Jesse. 1992. "Knowing Novels: Nussbaum on Fiction and Moral Theory." *Ethics*, 103: 135–51.

Kieran, Matthew. 1996. "Art, Imagination, and the Cultivation of Morals." *Journal of Aesthetics*, 54: 337–51.
—— 1997. *Media Ethics: A Philosophical Approach*. Westport, CT: Praeger.
—— ed. 1998. *Media Ethics*. London: Routledge.
Korthals, Michiel. 1989. "Art and Morality: Critical Theory about the Conflict and Harmony between Art and Morality." *Philosophy of Social Criticism*, 15: 241–51.
Kuczynski, Alicja. 1980. "Art and Morality." *Dialectics and Humanism*, 7: 40–9.
Kuhns, Richard. 1975. "That Kant Did Not Complete His Argument Concerning the Relation of Art to Morality and How It Might Be Completed." *Idealist Studies*, 5: 190–206.
Kupfer, Joseph. 1983. *Experience as Art: Aesthetics in Everyday Life*. Albany, NY: SUNY Press.
Lamarque, Peter. 1978. "Truth and Art in Iris Murdoch's *The Black Prince*." *Philosophy and Literature*, 2: 209–22.
—— 1995. "Tragedy and Moral Value." *Australasian Journal of Philosophy*, 73: 239–49.
Lamarque, Peter, and Olsen, Stein Haugom. 1994. *Truth, Fiction, and Literature*. Oxford: Oxford University Press.
Levinson, Jerrold. 1996. "Messages in Art," in *The Pleasures of Aesthetics*. Ithaca, NY: Cornell University Press, pp. 224–41.
Lipman, Matthew. 1975. "Can Nonaesthetic Consequences Justify Aesthetic Values?," *Journal of Aesthetics and Art Criticism*, 34: 119–23.
Lloyd, Genevieve. 1982. "Iris Murdoch on the Ethical Significance of Truth." *Philosophy and Literature*, 6: 62–76.
Machamer, Peter, and Roberts, George W. 1968. "Art and Morality." *Journal of Aesthetics and Art Criticism*, 26: 515–19.
Markowitz, Sally. 1992. "Guilty Pleasures: Aesthetic Meta-Response and Fiction." *Journal of Aesthetics and Art Criticism*, 50: 307–16.
McCormick, Peter. 1982. "Moral Knowledge and Fiction." *Journal of Aesthetics and Art Criticism*, 41: 399–410.
—— 1988. *Fictions, Philosophies, and the Problems of Poetics*. Ithaca, NY: Cornell University Press.
McGinn, Colin. 1997. *Ethics, Evil, and Fiction*. Oxford: Oxford University Press.
—— 1999. "The Meaning and Morality of Lolita." *Philosophical Forum*, 30: 31–41.
Miller, Richard. 1979. "Truth in Beauty." *American Philosophical Quarterly*, 16: 317–25.
—— 1998. "Three Versions of Objectivity: Aesthetic, Moral and Scientific," in Jerrold Levinson, ed., *Aesthetics and Ethics*. Cambridge: Cambridge University Press, pp. 26–58.
Mooji, J. J. A. 1992. "Literature and Morality: The Primacy of Ethic," in Bjorn Tysdahl et al., ed., *Literature and Ethics*. Oslo: Norwegian Academy of Science and Letters, pp. 99–114.
Moore, Ron. 1995. "The Aesthetic and the Moral." *Journal of Aesthetic Education*, 29: 18–27.
Moran, Richard. 1994. "The Expression of Feeling in Imagination." *Philosophical Review*, 103: 75–106.
Murdoch, Iris. 1970. *The Sovereignty of the Good*. London: Routledge & Kegan Paul.
—— 1977. *The Fire and the Sun*. New York: Viking.
—— 1992. *Metaphysics as a Guide to Morals*. London: Chatto & Windus.

Natanson, Maurice. 1983. "The Schematism of Modern Agency." *New Literary History*, 15: 13–25.

Nehamas, Alexander. 1988. "Plato and the Mass Media." *Monist*, 71: 214–34.

Newton, A. Z. 1995. *Narrative Ethics*. Cambridge, MA: Harvard University Press.

Novitz, David. 1987. *Knowledge, Fiction and Imagination*. Philadelphia, PA: Temple University Press.

Nussbaum, Martha. 1990. *Love's Knowledge: Essays on Philosophy and Literature*. Oxford: Oxford University Press.

—— 1996. *Poetic Justice: The Imagination and Public Life*. Boston, MA: Beacon Press.

—— 1998. "Exactly and Responsibly: A Defense of Ethical Criticism." *Philosophy and Literature*, 22: 343–65.

Olafson, Frederick. 1988. "Moral Relationships in the Fiction of Henry James." *Ethics*, 98: 294–312.

Olson, Elder. 1977. "Morality and Art." *Religious Humanism*, 11: 69–77.

Palmer, Frank. 1992. *Literature and Moral Understanding: A Philosophical Essay on Ethics, Aesthetics, Education and Culture*. Oxford: Oxford University Press.

Parker, David. 1994. *Ethics, Theory and the Novel*. Cambridge: Cambridge University Press.

Passmore, John. 1991. *Serious Art*. LaSalle, IL: Open Court.

Phillips, D. Z. 1982. *Through Darkening Glass: Philosophy, Literature and Cultural Change*. Oxford: Oxford University Press.

—— 1992. "Ethics and Anna Karenina," in Bjorn Tysdahl et al., ed., *Literature and Ethics*. Oslo: Norwegian Academy of Science and Letters, pp. 69–85.

—— 1999. "Nussbaum on Ethics and Literature: A Cool Place for Characters?," in *Philosophy's Cool Place*. Ithaca, NY: Cornell University Press, pp. 131–56.

Plato. 1956. *Republic*. Harmondsworth: Penguin.

PMLA. 1999. *Special Topic: Ethics and Literary Study*. Vol. 114.

Pole, David. 1983. "Morality and the Assessment of Literature," in *Aesthetics, Form and Emotion*. London: Duckworth, pp. 193–207.

Posner, Richard. 1997. "Against Ethical Criticism." *Philosophy and Literature*, 21: 1–27.

—— 1998. "Against Ethical Criticism: Part Two." *Philosophy and Literature*, 22: 394–412.

Putnam, Hilary. 1978. "Literature, Science and Reflection," in *Meaning and the Moral Sciences*. London: Routledge & Kegan Paul, pp. 83–96.

—— 1983. "Taking Rules Seriously: A Response to Martha Nussbaum." *New Literary History*, 15: 193–200.

Raphael, D. D. 1983a. "Can Literature Be Moral Philosophy?" *New Literary History*, 15: 1–12.

—— 1983b. "Philosophy and Rationality: A Response to Cora Diamond." *New Literary History*, 15: 171–8.

Ridley, Aaron. 1992. "Desire and the Experience of Fiction." *Philosophy and Literature*, 16: 279–91.

—— 1993. "Tragedy and the Tender-Hearted." *Philosophy and Literature*, 17: 234–45.

Robinson, Jenefer. 1995. "L'Education Sentimentale." *Australasian Journal of Philosophy*, 73: 212–26.

Robinson, Jenefer, and Ross, Stephanie. 1993. "Women, Morality, and Fiction," in Hilde Hein and Carolyn Korsmayer, eds, *Aesthetics in Feminist Perspective*. Bloomington, IN: Indiana University Press, pp. 105–18.

Rorty, Richard. 1989. *Contingency, Irony, and Solidarity*. Cambridge: Cambridge University Press.

Rosebury, Brian. 1988. *Art and Desire: A Study in the Aesthetics of Fiction*. London: Macmillan.

Rousseau, Jean-Jacques. 1968. *Politics and the Arts*, transl. Allan Bloom. Ithaca, NY: Cornell University Press.

Ryle, Gilbert. 1966. "Jane Austen and the Moralists." *Oxford Review*, 1: 5–19.

Salmagundi. 1996. *Art and Ethics: A Symposium*. 111: 27–145.

Sankowski, Edward. 1988. "Blame, Fictional Characters and Morality." *Journal of Aesthetic Education*, 22: 49–61.

—— 1992. "Ethics, Art, and Museums." *Journal of Aesthetic Education*, 26: 1–15.

Schier, Flint. 1983. "Tragedy and the Community of Sentiment," in Peter Lamarque, ed., *Philosophy and Fiction*. Aberdeen: Aberdeen University Press, pp. 73–92.

Scruton, Roger. 1974. *Art and the Imagination: A Study in the Philosophy of Mind*. London: Routledge.

—— 1983. *The Aesthetic Understanding: Essays in the Philosophy of Art and Culture*. London: Methuen.

Seabright, Paul. 1988. "The Pursuit of Happiness." *Ethics*, 98: 313–31.

Seamon, Roger. 1989. "The Story of the Moral: The Function of Thematizing in Literary Criticism." *Journal of Aesthetics and Art Criticism*, 47: 229–36.

Sharpe, R. A. 1992. "Moral Tales." *Philosophy*, 67: 155–68.

Shaw, G. B. 1957. *The Quintessence of Ibsenism*. New York: Hill & Wang.

Sidorsky, David. 1983. "Modernism and the Emancipation of Literature from Morality." *New Literary History*, 15: 137–54.

Siebers, Tobin. 1992. *Morals and Stories*. New York: Columbia University Press.

Silvers, Anita. 1993. "Aesthetics for Art's Sake." *Journal of Aesthetics and Art Criticism*, 51: 141–50.

Sircello, Guy. 1989. *Love and Beauty*. Princeton, NJ: Princeton University Press.

Solomon, Robert. 1991. "On Kitsch and Sentimentality." *Journal of Aesthetics and Art Criticism*, 49: 1–14.

Sorell, Tom. 1992. "Art, Society, and Morality," in Oswald Hanfling, ed., *Philosophical Aesthetics: An Introduction*. Bristol: Open University, pp. 297–347.

Steiner, Wendy. 1995. *The Scandal of Pleasure: Art in the Age of Fundamentalism*. Chicago, IL: University of Chicago Press.

Stolnitz, Jerome. 1992. "On the Cognitive Triviality of Art." *British Journal of Aesthetics*, 30: 191–200.

Tanner, Michael. 1976–77. "Sentimentality." *Proceedings of the Aristotelian Society*, n.s., 78: 127–47.

Tilghman, Ben. 1991. *Wittgenstein, Ethics, and Aesthetics: The View from Eternity*. London: Macmillan.

Tirrell, Lynne. 1990. "Storytelling and Moral Agency" *Journal of Aesthetics and Art Criticism*, 48: 115–26.

—— 1998. "Aesthetic Derogation: Hate Speech, Pornography and Aesthetic Contexts," in Jerrold Levinson, ed., *Aesthetics and Ethics*. Cambridge: Cambridge University Press, pp. 283–314.

Tolstoy, Leo. 1994. *What Is Art?* London: Duckworth.

Vadas, Melinda. 1987. "A First Look at the Pornography/Civil Rights Ordinance: Could Pornography Be Subordination of Women?" *Journal of Philosophy*, 84: 487–511.

Van Peer, Willie. 1995. "Literature, Imagination, and Human Rights." *Philosophy and Literature*, 19: 276–91.

Walsh, Dorothy. 1969. *Literature and Knowledge*. Middletown, CT: Wesleyan University Press.

Walton, Kendall. 1990. *Mimesis as Make-Believe: On the Foundation of the Representational Arts*. Cambridge, MA: Harvard University Press.

—— 1994. "Morals in Fiction and Fictional Morality." *Proceedings of the Aristotelian Society*, suppl. vol., 68: 1–24.

Waugh, J. M. Beil. 1986. "Art and Morality: The End of an Ancient Rivalry." *Journal of Aesthetic Education*, 20: 5–17.

Whitebrook, Maureen. 1995. *Real Toads in Imaginary Gardens: Narrative Accounts of Liberalism*. Lanham, MD: Rowman & Littlefield.

Wilson, Catherine. 1983. "Literature and Knowledge." *Philosophy*, 58: 489–96.

Wittgenstein, Ludwig. 1965. "Lecture on Ethics." *Philosophical Review*, 74: 3–11.

—— 1967. In *Lectures and Conversations on Aesthetics, Psychology, and Religious Belief*, ed. Cyril Barrett. Berkeley, CA: University of California Press.

Wollheim, Richard. 1983. "Flawed Crystals: James's *The Golden Bowl* and the Plausibility of Literature and Moral Philosophy." *New Literary History*, 15: 185–92.

—— 1993. *The Mind and Its Depths*. Cambridge, MA: Harvard University Press.

Zemach, Eddy. 1971. "Thirteen Ways of Looking at the Ethics/Aesthetics Parallelism." *Journal of Aesthetics and Art Criticism*, 29: 391–8.

Zuidervaart, Lambert. 1990. "The Social Significance of Autonomous Art: Adorno and Bürger." *Journal of Aesthetics and Art Criticism*, 48: 61–77.

13

Politics and Aesthetics

1. HISTORICAL AND CONCEPTUAL OVERVIEW

Historically, art and politics have been linked for almost as long as there have been political entities. Throughout the civilizations of antiquity, we find poems, statues, and structures commemorating the rulers, warriors, and battles that past peoples believed contributed to the course of history. Moreover, that art still has this practical function for politics can be seen in evidence ranging from lowly postal stamps to the Vietnam War Memorial in Washington, DC, and to structures projecting the aura of state power, such as the Pentagon. Likewise, philosophically, the nexus between art and politics is long-standing. In Plato's *Republic*—the earliest sustained theoretical treatment of art in the Western tradition—political censorship of the arts is defended for reasons of state.

Because the practical as well as the theoretical linkage between art and politics has been perennial, it should come as no surprise that the range of relationships between art and politics is quite diverse. For the purpose of giving some order to this collection of functions, we can organize our thinking around two primary relationships, namely, support and opposition. This yields four basic (non-exhaustive and not mutually exclusive) categories: art in support of politics, art in opposition to politics, politics in support of art, and politics in opposition to art. Using these categories, it is possible to organize the most fundamental functional relationships between art and politics.

2. ART IN SUPPORT OF POLITICS

If we begin by taking the extension of *politics* narrowly—that is, as pertaining to formal political entities, such as the state, and political organizations, such as political parties—then the first role of art with respect to politics is that of service. Under this category, art explicitly advances the cause of the state, the ruling monarchy, and class or political factions. Art that celebrates military prowess, such as the monuments on Freedom Square in Budapest, is political art in the service of the state. Triumphal arches; victory steles; the paintings of historic lawgivers, generals, civic founders, battle scenes; and epic poems all commemorate the past of a people, often linking present regimes with fondly

remembered ones. The imagery on stamps and currency functions this way as well, whereas governments use architecture to erect an appropriate vision of themselves—such as august courthouses and suitably solid, central banking offices. Art can make government buildings feel creditable.

Art in the service of the state often has a legitimating function. Artistic images may correlate a contemporary government with a past regime in order to claim the authority of history for the present. Such was Benito Mussolini's appropriation of the sign of the fasces. For this reason, art in the service of government often trades in idealizations. That is why the workers are so much more muscular in Socialist Realist paintings than they are in actual factories. Artists can also endorse specific political programs, as did those Depression artists in the United States who portrayed social welfare as justifiable.

Political regimes and movements require commitments from their citizens and followers. Customarily, art provides the symbols around which solidarity can take root and flourish. Even liberal democracies require allegiance to certain core values, such as equal respect and tolerance. Thus, liberal art generally aspires to promote and to rhapsodize the sentiments of equality.

In the twentieth century, attempts have been made to transform art in the service of politics into a quasi-science. This endeavor is called propaganda. The notion of propaganda itself has at least two senses—a pejorative sense and a non-pejorative one. The pejorative sense of propaganda construes propaganda as always a matter of deception. On this account, propaganda is the dissemination of what its creators know to be lies for the purpose of intentionally misleading the public for political ends. Falsely depicting enemy aircraft allegedly strafing civilian populations would be an example here.

Alternatively, the notion of propaganda may simply apply to any explicit attempt to persuade by means of artful rhetoric. Thus, the opening shots of Leni Riefenstahl's *Triumph of the Will*, portraying Adolf Hitler as a demigod and savior alighting from the clouds, would count as propaganda in the non-pejorative sense so long as Riefenstahl believed this to be a fair account of Hitler. But, if Riefenstahl thought otherwise and was merely cynically manipulating her audience, then the sequence would count as propaganda in the pejorative sense. Although it is hard to be certain in this matter, nowadays "propaganda" appears to be used most frequently in the pejorative sense.

So far, we have been concerned with art in the service of politics narrowly construed. Some critics and theorists, however, think of "politics" more broadly—not in terms of specific political formations (regimes, factions), but in terms of society at large. Art performs a service to society at large, of course, inasmuch as it acts as a conduit for social values and beliefs. Call this the reflection theory of art.

Art presupposes many of the beliefs and values of the society from which it emerges, and readers, listeners, and viewers must fill in these presuppositions in the process of assimilating the artworks in question. In this way, artworks may come not only to reflect but also to reinforce the beliefs and values of the larger culture. Art, for example, may reflect and reinforce prevailing social ideals of

leadership even in fictions and pictures not expressly concerned with politics. Many critics, especially since the 1960s, have come to regard the role of art in the transmission of culture as a political function.

Of course, one can take a more circumscribed view than this. One may not find it advisable to suppose that every aspect of art is involved in politics. One might want to focus one's attention on only those artworks that are concerned with disseminating false (or otherwise epistemically defective) thoughts, beliefs, attitudes, emotions, and desires for the purpose of sustaining some practice of social domination. This is to be concerned with the *ideological* function of art.

This approach tracks the service of art to political formations less formally individuated than regimes and parties. It allows one to speak of racist, homophobic, and patriarchal ideologies. At the same time, this approach is more specific than the reflection theory of art, since it does not regard every topic as politically significant. The ideologue also differs from the propagandist (in the pejorative sense) because, although both traffic in deceptions, the propagandist does so intentionally and in the service of an overt political institution, whereas the ideologue need not meet either of these conditions. In this respect, it may be profitable to regard propaganda (in the pejorative sense) as a subcategory of ideology.

Our discussion of the services art performs for politics has emphasized content rather than form. In the twentieth century, however, questions have arisen, not only about the use of art's content to promote political ideas and emotions, but also about the means that art employs to do so. Revolutionary movements, such as Soviet Marxism, have spawned artistic fellow travelers who aspire to create new revolutionary forms in order to express appropriately and to emblematize heralded transformations of revolutionary consciousness—hence, Soviet Constructivism. Nevertheless, at the same time, such endeavors have often been denounced as formalist by other political radicals, who defend realism as the proper form of socialist art on the grounds that, though it is admittedly bourgeois in origin, it is what the people understand and, therefore, the politically appropriate means of serving them. Bertolt Brecht and Sergei Eisenstein are famous representatives of the formalist line. György Lukács is a leading theorist of Socialist Realism. In dance, for example, this contrast can be marked by Nikolai Foregger's machine dances, on the one hand, and ballets like *White Haired Girl* and *Red Detachment of Women*, on the other.

3. ART IN OPPOSITION TO POLITICS

Of course, art can oppose foreign regimes and factions, although, in this sense of political opposition, opposition to one regime can just as easily be re-conceived as political service to another regime. Thus, in considering art in opposition to politics, it is most useful to focus on art's opposition to the political unit with which it is affiliated, as is the case with Bill T. Jones's *Last Supper at Uncle Tom's*

Cabin/The Promised Land. In this light, Francisco José de Goya's *Execution of May 3, 1808* is primarily in the service of Spanish patriotism, while Erich Maria Remarque's *All Quiet on the Western Front* opposes war as a political instrument in general, including the German war machine. Art in opposition to politics can also be referred to as protest art, subversive art, or social criticism.

Art as social criticism may be explicit or implicit, and it may be targeted broadly or narrowly. Social criticism is narrowly targeted where its domain of concern comprises formally individuated entities like states and political parties. It is broadly targeted where it is directed at society or culture at large (or, at least, at substantial portions thereof, such as bourgeoisie culture or patriarchal ideology).

An example of explicit social criticism, targeted narrowly, is a film like *El Norte*, which focuses expressly on US immigration policy and makes its concern with the injustice of that policy evident. Similarly, John Steinbeck's *Grapes of Wrath* explicitly addresses an identifiable social problem. Honoré Daumier's drawing "The Third Class Carriage," on the other hand, while clearly critical, does seem critical, not of isolable social practices, but of the treatment of the poor in general. In a similar vein, the choreographer Kurt Jooss's *Green Table* criticizes war throughout the ages. Likewise, much German Expressionist painting appears to be critical of the existing social world as such, rather than of this or that policy of any specific political regime.

Indeed, throughout the twentieth century, many avant-garde artists have come to conceive of art as a form of social criticism. Dada is overtly critical, but of everything (or everything bourgeois), rather than of anything in particular. Much contemporary art commentary—as well as practice—presumes that art, or, at least, ambitious art, is always subversive social criticism of such large-scale social phenomena as capitalism, racism, sexism, and homophobia. This is not to say that contemporary artists may not focus on criticizing specific policies and identifiable official regimes, but that their conception of the political is frequently much broader than one restricted to particular governments and self-conscious parties. Sometimes artists will attack Senator Jesse Helms—as in Paul Schmidt's play *The Bathtub*—but "Amerika" is a more likely, explicit target for most of them.

Social criticism may also be implicit in art. An artist may reveal the machinations of a society while being unaware that he or she is doing so. Lukács maintains that the conservative Honoré de Balzac actually portrayed French society in his *Comedie humaine* in a way congenial to socialism. Certain structuralist theorists, such as Pierre Macherey and Louis Althusser, perhaps imitating Claude Lévi-Strauss's analysis of myth, have even argued that it is the role of art to reflect social contradictions, as if art were essentially a Marxist social critic.

Some theorists, like Herbert Marcuse, argue that art itself is essentially (rather than contingently) a form of progressive social criticism, since the artwork, by means of such core artmaking structures as fiction and representation, provides alternatives to what exists and, thereby, effectively argues for the possibility of social change (although this argument appears to overlook the possibility

that certain artworks may at the same time be in the service of ignoble social alternatives).

Similarly, Theodor W. Adorno allegorizes Modernist art's quest for autonomy as an implied criticism of the tendency in capitalist society to reduce all value to market or instrumental value. Modernist art does not succeed in this quest, but its honorable defeat shows us in microcosm—from a critical perspective—the operation of capitalist society writ large. For Adorno, this is only true for Modernist art. Mass art, on the other hand, is complicit with the marketplace and functions to sustain the political domination of the population by capitalism.

Arguments that suppose that it is of the nature of art to belong to the general species of social criticism err either by being too loose in what they think of as social criticism (e.g., Marcuse) or by speaking of art in an honorific rather than in a classificatory or descriptive sense of the term (Adorno). Art is not essentially social criticism. Too much of it is either critically mute politically or involved in uncritical political advocacy. Nevertheless, social criticism and protest represent one avenue of art, an avenue increasingly traveled since the eighteenth century (as art came to be more independent of religious and political patronage) and one especially popular toward the end of the twentieth century.

4. POLITICS IN SUPPORT OF ART

As we have already seen, artmaking itself can be a form of political activity. Governments hire artists to design stamps, currency, monuments, and uniforms; to compose music; to sing anthems; to play marches; to organize parades and spectacles; and so on. Where governments or official parties pay the bills or otherwise support artistic activity, politics plays the role of employer with respect to art. In the past and across different cultures, many artists were employed by sovereigns, nobles, and churches in this manner. Nevertheless, even in modern times in the industrial world, artists are employed to secure political ends.

Despite being a source of revenue for artists, government commissions can also result in a conflict between the claims of artistic autonomy and claims about the common good. This happened with respect to the publicly financed monument titled *Tilted Arc*, by Richard Serra. Serra's claim to a right to express freely his belief in the oppressiveness of modern life by means of a sculpture that oppressed spectators was challenged by citizens who claimed the right not to be oppressed by a public edifice. After extended court hearings, a judge ordered that *Tilted Arc* be dismantled, indicating that political backing of the arts, insofar as it is political, can be a risky source of support.

Artists are employed by political units when they are commissioned or salaried to produce specifiable artworks for use by political entities (narrowly construed). There is another form of government support of the arts, however. We might call this "patronage" (where this means that artists are given government support

to pursue their own ends, rather than the ends of the commonwealth). That is, whereas government employment involves hiring artists to produce specifiable artworks for public use—such as a mayoral seal—patronage involves extending money or benefits, directly or indirectly, to artists so that they can carry out their own aims. Indirect support for the arts involves things like tax benefits to museums, non-profit accreditation of arts organizations, and federal grants to art schools. Direct support for the arts involves outright cash payments or benefits in kind (land, buildings, etc.) to artists or to arts organizations to produce their own work.

Government patronage of the arts is widespread throughout the industrial world. It is, however, a practice that has recently become controversial in the United States. A particular source of debate concerns monies granted by government organizations, such as the National Endowment for the Arts, to individual artists in order to produce original art. The recent furor began over federally funded artworks—like *Piss Christ* by Andres Serrano—that offended the sensibilities of many taxpayers, especially those of a religious and right-wing bent. Nevertheless, the theoretical concerns here are not simply conservative; they cut to the heart of liberalism as well. For if liberalism is the doctrine that the state should be neutral between competing conceptions of the good life, and if there are significant numbers of citizens who doubt whether the pursuit of art is anything but a sectarian perspective on the good, then the question arises whether a liberal state can, on its own terms, legitimately extract taxation on behalf of the artworld from non-consenting citizens.

Political entities, like governments, may also benefit the arts through their licensing and regulatory activities by creating venues for artistic creativity. Government regulatory activities can also, however, impede the autonomous development of art in a number of ways.

5. POLITICS IN OPPOSITION TO ART

Political bodies, whether formally constituted or informal, may oppose the arts through criticism. Public officials, party leaders, and the representatives of social movements may speak out against the political content, putative cultural repercussions, social significance, and alleged moral consequences of artworks. Political entities, such as states, typically, however, have even more powerful levers than criticism for opposing art. They standardly have the prerogative to regulate and, ultimately, to prohibit artworks. That is, formal political entities, like states, have the capacity to censor art. The theoretical grounds for censorship were established long ago by Plato. Censorship rests on the presumption that the function of art is to serve the political ends of the state. Where art fails to advance those ends, or where it even appears to subvert those ends, censorship is apposite.

From the eighteenth century until quite recently, a typical Western response to the Platonic viewpoint was that art is autonomous—it is not an instrument

of politics or of anything else. Art, so the story went, has its own ends and functions, irrespective of and independent from those of politics. Art, that is to say, is disinterested. This position, however, has come to sound rather empty by the end of the twentieth century, which is perhaps why the case against political censorship seems more embattled now than at any other time since the 1960s.

Political censorship can be motivated by opposition to the political content of the relevant artworks. Artworks containing explicit or implied criticism of certain sets of political arrangements or of regnant philosophies may be suppressed—as they were in the former Soviet Union. But political censorship can also be motivated by fear of the behavioral consequences of certain types of artworks. This seems to be the direction that movements in favor of censorship have taken recently in the United States.

Violent programming on television and in the movies, as well as aggressive song lyrics, are opposed on the grounds that they will lead to violent behavior. Pornographic art, likewise, is condemned, and banning it is advocated because it is said to lead to rape or to other sex crimes. These allegations are extremely difficult to test. One obvious reason for this is that any experiments that possessed the potential of causing criminal activity would probably themselves be illegal and would certainly be immoral.

The emphasis on behavioral consequences in American debates about censorship undoubtedly signals a commitment in the United States to the liberal notion of the harm principle. That is, for government censorship to be legitimate, certain burdens of proof must be met. Specifically, the state must show that the artworks in question are likely to cause harm to innocent, non-consenting bystanders. This desideratum can be met—at least in principle—by claiming that the artworks in question are likely to bring about untoward consequences to the interests of third parties. Whether they do so, however, is in the end an empirical question, one to which no one has yet found a conclusive answer.

REFERENCES AND FURTHER READING

Adorno, Theodor W. 1997. *Aesthetic Theory*, ed. by Gretel Adorno and Rolf Tiedemann, translated by Robert Hullot-Kentor. Minneapolis, MN: University of Minnesota Press.

Adorno, Theodor W., and Max Horkheimer. 1972. *Dialectic of Enlightenment*, transl. by John Cumming. New York: Seabury.

Althusser, Louis. 1971. *Lenin and Philosophy and Other Essays*, transl. by Ben Brewster. London: New Left Books.

Barrell, John. 1986. *The Political Theory of Painting from Reynolds to Hazlitt: "The Body of the Public."* New Haven, CT: Yale University Press.

Brecht, Bertolt. 1964. *Brecht on Theatre: The Development of an Aesthetic*, ed. and transl. by John Willett. New York: Hill and Wang.

Carroll, Noël. 1987. "Can Government Funding of the Arts Be Justified Theoretically?" *Journal of Aesthetic Education*, 21/1 (spring): 21–35.

——— 1998. *Philosophical Problems of Mass Art*. New York and Oxford: Oxford University Press.

Copp, David, and Susan Wendell, eds. 1983. *Pornography and Censorship*. Buffalo, NY: Prometheus Books.

Eagleton, Terry. 1976. *Criticism and Ideology: A Study in Marxist Literary Theory*. Atlantic Highlands, NJ: New Left Books.

Edelman, Murray. 1995. *From Art to Politics: How Artistic Creations Shape Political Conceptions*. Chicago, IL: University of Chicago Press.

Johnson, Pauline. 1984. *Marxist Aesthetics: The Foundations within Everyday Life for an Emancipated Consciousness*. London and Boston, MA: Routledge.

Lukács, Georg. 1964. *Realism in Our Time: Literature and the Class Struggle*, transl. by John Mander and Necke Mander. New York: Harper Torchbook.

Macherey, Pierre. 1978. *A Theory of Literary Production*, translated by Geoffrey Wall. London and Boston, MA: Routledge.

Marcuse, Herbert. 1978. *The Aesthetic Dimension: Toward a Critique of Marxist Aesthetics*. Boston, MA: Beacon Press.

National Television Violence Study: Scientific Papers, 1994–1995. 1995. Studio City, CA.

Plato. 1974. *Republic*. Transl. by G. M. A. Grube. Indianapolis, IN: Hackett.

Sorrell, Tom. 1992. "Art, Society and Morality," in Oswald Hanfling, ed., *Philosophical Aesthetics*. Oxford and Cambridge, MA: Blackwell, pp. 297–347.

Williams, Raymond. 1977. *Marxism and Literature*. Oxford and New York: Oxford University Press.

PART IV
ART AND AFFECT

14

Art and Human Nature

1. INTRODUCTION

The concept of human nature unavoidably implies the existence of nearly universal regularities across the human species—regularities, like language use, most probably explicable in terms of biology and evolutionary psychology. Thus, linking the arts to human nature implicitly promises to connect the arts to long-term, enduring, nearly universal features of the human frame. That is, if art is rooted in human nature, then it is a response, at least in part, to elements of our evolved cognitive, perceptual, and emotive architecture that are either necessary for social life, or conducive to it, or that are side-effects from features that are.

For some, this will sound scarcely exceptionable, since we are prone to say that virtually every known human culture has what we call arts, including narrative (oral and written), image-making, carving, whittling, sculpting, chanting, dance, song, decoration, acting, mime, and so on.[1] And inasmuch as this is a feature of human societies, exemplified across the species, we would expect to find that its explanation—like the explanation of our linguistic capacities—goes rather deep, to something inherent in human nature.

Although every known culture appears to possess art, it is improbable that this can be explained in terms of art's originating in a single location at one time and then being disseminated gradually therefrom. Rather, art seems to have sprung up independently in different locales and at different times, often apart from outside influences. But if the worldwide distribution of art cannot be explained by cultural diffusion, then the alternative that recommends itself is that art has its origins in something common to humankind, something bred in the bone, so to speak.

The reasoning here is straightforward, namely, that the same global effect is apt to have the same cause. If that cause is not ultimately cultural diffusion from a single source, then we must look elsewhere—to enduring features of the human

I would like to thank Elliott Sober, Jerrold Levinson, and the audiences at St Norbert's College and Wayne State University for their helpful comments in response to this chapter. Of course, only the author is responsible for any errors herein.

[1] Stephen Davies, "Non-Western Art and Art's Definition," in Noël Carroll, ed., *Theories of Art Today* (Madison, WI: University of Wisconsin Press, 2000), p. 199.

organism as it has evolved to engage recurring adaptive challenges.[2] Or, to put the matter more simply, we must look to human nature as at least part of the explanation of why we have art as we know it.

Moreover, it is not just the fact that we find art distributed globally that suggests a consideration of its evolutionary heritage. There is also the related phenomenon that people of different cultures are able to recognize, at rates that are hardly random, the products of other cultures as artworks. As Stephen Davies notes, "I am impressed by how accessible to Westerners is much sub-Saharan music, Chinese painting, and woven carpets from the Middle East."[3] And the same sort of cross-cultural recognizability can be observed of non-Westerners in regard to our art; Western mass culture could not be so easily exported were it otherwise.

This, of course, is not to say that the citizens of disparate societies grasp the significance in their full cultural complexity of artworks from other societies. Rather, the point is that, to an arresting degree, Europeans can recognize a statue of Ganesha as an artwork without being able to know its symbolic import. Appreciating the meaning of such a figurine, needless to say, requires contextual or background knowledge of the sort that is available to the untutored Westerner only from a participant of the relevant culture, or by way of an anthropologist, or an art historian. Nevertheless, it remains a striking fact that we can recognize—to a perhaps surprising extent—the artworks of other cultures, as other peoples can recognize ours, even where we are unable to decipher them or discern their historical significance.[4] But how is this possible?

Again, a very attractive hypothesis is that we have an inbred capacity to detect the expressive behavior of our conspecifics as it is inscribed in the sensuous media of the traditional arts. We may not know what a tribal decoration means, but we know that, by means of it, its maker intends to communicate something special, something that is worth remarking on.[5]

Of course, it is not my contention that every artwork is recognizable as such by anyone from any culture. We would not predict that just anyone from anywhere could recognize many of Duchamp's readymades as artworks. Many from our own culture have been tripped up by these examples, though, it should be noted, that their manner of display ought to have given onlookers food for thought.

[2] Of course, even if art was diffused culturally from several different independently arising sources, the resort to evolutionary explanations would still recommend itself.

[3] Davies, "Non-Western Art and Art's Definition," p. 199.

[4] It may be said that some cultures have no concept of art and, therefore, their members will not be able to recognize our artifacts as artworks. The view that some cultures have no concept of art is usually advanced where it is said that they do not have our concept of art. I will deal with this objection shortly. Where it is alleged that cultures lack any concept of art whatsoever, I speculate that they will nevertheless be able to recognize matchings between much traditional Western art and the products of comparable practices of representation, decoration, and expression in their own societies. This, of course, is a speculative response. We will need actual empirical studies here if indeed there are cultures without anything remotely akin to the sorts of globally recurrent concepts of art limned by Davies and Dutton. See: Denis Dutton, "But They Don't Have Our Concept of Art," in Carroll, *Theories of Art Today*, pp. 217–38.

[5] Ellen Dissanayake, *Homo Aestheticus* (New York: Free Press, 1992), Ch. 13.

Still, to a rather surprising degree, the artworks of foreign societies are cross-culturally recognizable as artworks and that calls for explanation. And since the phenomenon is cross-cultural, and not readily explicable in terms of merely cultural diffusion, the invocation of human nature appears irresistible. Moreover, since this recognizability, where it occurs, seems most likely with what can be called the traditional arts, the suggestion that human nature plays an important role in our explanation here appears apposite, since the relevant, enduring features of our cognitive, perceptual, and emotive architecture were in place when the more traditional forms of art and expression emerged.

Nevertheless, despite the *prima facie* case that can be made that art has something to do with human nature—conceived of in terms of our enduring, evolved cognitive, perceptual, and emotive architecture—it is also true that for over two decades, researchers in the humanities have resisted universalizing modes of analysis, such as evolutionary psychology and cognitive science, preferring, almost exclusively, to historicize artistic phenomenon in the conviction that, as they say, "it's culture all the way down."

In contrast, in this chapter I want to stress that biologically informed research and cultural-historical research on the arts need not be seen as locked in a zero-sum struggle. Both kinds of research have important contributions to make to our understanding of art and aesthetic experience, not only in the sense that sometimes one of these perspectives is better suited than the other to explain certain aspects of the phenomena, but also in the sense that sometimes these perspectives can mutually inform one another. Indeed, I hope to show that in some cases psychology, including evolutionary psychology, may enrich historical explanations. In order to motivate this claim, I will try to indicate how aspects of the development of certain mass artforms, such as film and TV, can be fruitfully discussed psychologically in terms of the ways in which they address human nature.

2. THE CASE AGAINST HUMAN NATURE

Before attempting to substantiate the usefulness of discussing art in relation to human nature, it will perhaps be instructive to review briefly some of the reasons that specialists in the humanities have had for resisting this approach.[6] Here my purpose is not to reject the many deep insights that cultural-historical approaches have yielded. Nor is it to urge that cultural approaches be supplanted across the board by ones informed by evolutionary psychology and cognitive

[6] In this chapter, I am concerned with the rejection of human nature by academics in the humanities. Resistance to the notion of human nature in the social sciences has been documented and attacked by: Leda Cosmides, John Tooby, and Jerome H. Barkow in "Introduction: Evolutionary Psychology and Conceptual Integration," in Jerome H. Barkow, Leda Cosmides, and John Tooby, eds, *The Adapted Mind: Evolutionary Psychology and the Generation of Culture* (New York: Oxford University Press, 1992), pp. 3–15; and Steven Pinker, *The Blank Slate: The Modern Denial of Human Nature* (New York: Viking, 2002).

science. Rather, my point is that cultural-historical approaches may be profitably supplemented, especially in the explanation of *certain* artistic phenomena, by talking about human nature.

Earlier, I claimed that the appeal to human nature seems unobjectionable on the face of it, since it appears that almost every known culture possesses art. Undeniably, this art comes in many different forms. However, the diversity of art across different societies should no more discourage us from looking for a common cause here than the diversity of different languages deters us from attempting to locate the human capacity for language in our common human nature. That is, where we are dealing with cognate phenomena, it pays to look for a common cause.

But many in the humanities today are apt to question my first premise. They will deny that art is universal, thereby vitiating the grounds for an appeal to human nature. They may point out, for example, that many cultures lack a word for "art" that is equivalent to our usage. However, this is not a very compelling consideration, since, though certain cultures do not have a word for "economics" in their vocabulary, this does not encourage us to think that the pertinent societies lack economies. Nor should the fact that art shows such astounding cross-cultural variation overly impress us, since, as already noted, the diversity of different languages does not lead us to suspect that the nearly universal capacity for language is not a biological endowment.

A perhaps more sophisticated way of denying that what we call art is universal, or nearly so, is to allege not that other cultures lack a word for art, but that they lack a concept for it, or, at least, that their concepts are so wildly different from the Western concept that they mark different phenomena. That is, once we recognize that the concepts that underwrite different artistic practices in different cultures are wildly non-converging, we will realize that the phenomena we boldly suppose belong to the same class—and for that reason, we say, call for the same explanation—are really only a series of disjunct practices, best explained culturally and historically with attention to local detail, rather than something global, like our purportedly common humanity.

For example, it might be said that what we call art is very different from what we find in many other societies. What we call art is putatively designed for disinterested contemplation, a source of pleasure divorced from the prospect of practical or utilitarian advantage, including social or religious benefit. This conception of art has been especially influential in Western culture since the eighteenth century, notably due to certain interpretations of the aesthetic theories of Immanuel Kant. However, this is not how the comparable expressive, decorative, and representational artifacts of many other cultures are regarded. For those cultures, the artifacts in question are often practical.

The designs on the shields of Sepik highlanders are intended to frighten off their enemies, not to invite them to savor their expressive design. Likewise, what we would regard as representations of the gods in many cultures are not

representations in our sense—that is, statues that *stand* for the gods—but rather are taken to be the very gods themselves, incarnate in stone or wood, in whose presence worshipers avow their reverence and advance their desires. That we place these objects in our museums where we contemplate them in a supposedly disinterested manner is a matter of wresting these objects out of their cultural context and using them for our own purposes. It is a matter of projecting our concept of art onto artifacts that belong to an entirely different category altogether.

For, it is said, art in our sense is not universal. Indeed, art in our sense is parochial. It is historically specific, as are the ostensibly comparable practices of other cultures. Thus, there is not a single class of behaviors here that warrants an explanation in terms of generic human nature. There is rather a series of non-converging practices best accounted for in light of the histories of the cultures in which they obtain.

Though admittedly seductive, this argument is not finally conclusive.[7] For it rests upon identifying an arguably skewed concept of art as the canonical one in Western culture. Though there is a tradition that has been influential for just over two centuries in Western culture that identifies artworks as things designed for disinterested, non-utilitarian contemplation, this a controversial view. It is not universally endorsed, even in the relevant precincts of Western culture. It is a *theory* of our concept of art, often called "the aesthetic theory of art" or sometimes "aestheticism," but it is a theory that many, specialists and non-specialists alike, reject, even in Western culture. One reason for this rejection is the observation that this theory does not encompass all the objects and performances that we are prepared to categorize as art in our own culture. For, even in our own culture, we are happy to classify works designed, intended, and used for their practical consequences as artworks.

For example, much Western art was created to serve religious and/or political purposes, rather than for the sake of disinterested contemplation. The stained-glass windows of churches were originally, first and foremost, vehicles for teaching articles of faith and doctrine to the illiterate. Equally, many war monuments and victory arches are intended to commemorate historic events and to remind the populace of their political heritage and civic responsibilities.[8]

That is, despite the cultural authority of the theory that art is an occasion for disinterested contemplation, the theory does not really track even the way in which Westerners, as a group, actually categorize things as artworks. And when we look at how we in fact go about doing this, we notice far more correspondences between what other cultures count as artworks and what we do, which, of course, suggests that our prevailing, de facto concept of art is not as different from theirs as we have been asked to believe.

[7] Both in setting out and refuting the arguments about the nearly universal reach of the concept of art, I have benefited greatly from Denis Dutton's "But They Don't Have Our Concept of Art," in Carroll *Theories of Art Today*, pp. 217–38.

[8] See Noël Carroll, "Art and Recollection," *Journal of Aesthetic Education*, 39/2 (summer 2005): 1–12.

Like the Sepik highlanders, we too consider armor designed to intimidate and terrify the enemy to be art.[9] And it should be noted that within our own tradition the notion of representation has not always been parsed in terms of something like the relation "x stands for y" (as in "the portrait of Wellington stands for Wellington"). We too find in our own heritage artworks where the operative notion of representation is better understood as akin to incarnation. It was, for example, believed that Byzantine icons put one in the presence of the saints, and, as well, one of the celebrants of the Eleusinian Mysteries, from which Greek tragedy is descended, was thought to become the embodiment of Dionysus himself. Moreover, both these conceptions of certain types of representational art were, of course, in the service of larger purposes than art for art's sake. Thus, once we cease to allow ourselves to be misled by the eighteenth-century theory that art is exclusively an affair of disinterested contemplation, we find that our operative conception of art coincides approximately to what we find elsewhere in other cultures.

In short, those who complain that other cultures do not share our concept of art and, therefore, that art, so called, is not universal err because they take an impoverished view of what counts and has counted as art in Western culture. They have uncritically accepted a blinkered conception of art, hypostasizing it as the Western viewpoint, and this has led them to ignore the fact that many of the things categorized as art within Western culture have unequivocal correlates in the supposedly incommensurable art of other cultures. The contention that Western art is essentially different in kind from the art of other cultures is fundamentally the result of not looking closely enough at what we count as the art of our own culture and of how we are prepared to count it. For, once we look closely at the art of our own culture and that of others, it seems that a great many of the relevant practices are universal, or nearly so.

This, of course, is not to say that every sort of art can be found transculturally; we do not expect to find conceptual art flourishing in tribal cultures. Nevertheless, there are certain very frequently recurring features in a great deal of what are called artworks across cultures, including their embodiment in a sensuous medium that calls for an imaginative response to their decorative, representational, emotive, and symbolic properties. Also, these things are typically the product of the application of skills, acquired from a tradition, and they address both feeling and cognition, often affording pleasure. Though there may be artworks that elude all these criteria, at the same time, things of this sort are to be found in every culture, and, to that extent, art is universal. Moreover, it is exactly this dimension of art that warrants being thought about in terms of human nature.

Another reason that contemporary representatives of the humanities resist talking about art and human nature is that they do not think that there is

[9] Some might argue that in our culture if the armor in question were designed solely with the intention to intimidate the enemy, we would not count it as art. However, I think that if it were a truly frightening expression of menace—which presumably is the means by which it terrifies the enemy—then we would count it as art. Certainly, skilled, intentional expression is a characteristic and prevailing purpose of art in our culture.

such a thing as an enduring human nature. Or, if they do, they believe that it is the nature of human life at any rate to be utterly plastic or malleable. From Hegel and Marx, they have inherited the idea that it is the nature of humankind to create itself through its practices, especially the practices through which humans secure their means of existence, notably their material existence. Moreover, as liberals, many humanists have learned to distrust the language of human nature, since it has often been invoked to resist social change, while talk of biological endowments gives them the shivers, because it raises the specter of racism. In order to stave off these undesirable political consequences, they are disposed to regard humans as open to the permanent possibility of improvement.

It is hard not to be sympathetic to these very humane concerns. However, it is not clear that these legitimate worries mandate a complete blackout of reference to human nature and obliviousness to cognitive science and psychology. With regard to the discussion of art and our biological endowment that I have broached, the issue of racism does not arise, since I am talking about universal or nearly universal features across the *entire* human species, and not about invidious contrasts between different racial groupings.

Furthermore, though talk of human nature is always worthy of suspicion for its potential reactionary bias, it does not seem realistic for people committed to improving social conditions to ignore the possibility that the space in which they operate may be constrained by our biological make-up. Surely, in designing public policy with regard to social problems, such as obesity, it is more socially enlightened to realize that many are afflicted with this disability because natural selection, in certain locales, favored those who were capable of storing large amounts of fats and sugars, rather than thinking it to be simply an issue to be solved by counseling, motivation, and willpower.

We are bodies, and our bodies were shaped by an evolutionary history in response to environments often very different from the ones presently inhabited in the industrial world. Much of our cognitive, perceptual, and emotional make-up, including our associative dispositions, are legacies of that process. Hegel and Marx were correct in observing that, in large measure, humans create themselves through their cultural and material practices, but we do not start from nowhere; we are not empty receptacles; we come onto the scene with certain biological endowments. (It is certainly a great irony that contemporary "cultural materialists" in the humanities—who relish speaking of the "body" metaphorically—seem to have a genuine aversion to talking about the actual bodies produced by natural selection.)

There is a diversity of cultures because we bring our endowments, our biological resources, to diverse environmental challenges, and because these initial differences themselves then generate diverse histories. But cultural diversity does not entail the utter plasticity of the human frame, since that variation occurs within the parameters of possibility set by our biological make-up—which includes the evolved cognitive, perceptual, and emotive hardware that we share cross-culturally. This is not a plea for political conservatism, but only a reminder

that the emancipatory projects we pursue need to be adjusted to the human materials we hope to improve.

It is not "culture all the way down" then, because the living, human stuff from the process of evolutionary natural selection invests us with a certain cognitive, perceptual, and emotive architecture. That this is so is especially significant in coming to understand important features of art and aesthetic experience. For much art, especially of the traditional, transcultural variety, addresses our evolved sensibilities, feelings, emotions, and perceptual faculties in a fairly direct manner, while also depending on activating relatively basic cognitive and imaginative capabilities, such as the ability to follow narratives and to entertain fictions.

Art involves more than this, of course, and much of that "more" may be best explained in light of cultural history. But that art addresses these transculturally distributed human powers as well, in fairly straightforward and important ways, indicates that we would be remiss in neglecting the contribution that thinking about human nature can make to our understanding of art and aesthetic experience.

3. ART AND EVOLUTION

So far the discussion has been extremely abstract. I have been trying to defend the plausibility of thinking of art, or, at least, of some art, in terms of human nature. But, apart from defending this as a conceptual possibility, I have not given the reader much reason to think that this is a promising line of inquiry. Let me try to do that in two ways: first, by suggesting how certain of the recurring features of art as we know it may serve universal adaptive purposes that account for the emergence and continuance of art; and, second, by showing how certain forms of historically specific art, such as film and TV, have become mass artforms because of the ways in which they engage our evolved cognitive, perceptual, and emotive architecture.[10]

Though there is a tradition that holds that art and aesthetic experiences are only valuable for their own sakes, this is open to dispute on at least two fronts. On the one hand, as a matter of fact, the arts seem to have emerged primarily from unquestionably purposeful cultural practices, such as religion, ritual, the transmission of social and political values and mores, the reinforcement of cultural identities, the reproduction of social relations and world-views, the dissemination of ideas and understanding, the mobilization of sentiment, and so forth. On the other hand, for millennia, people transculturally have invested a great deal of time and energy in producing and consuming art, often making genuine sacrifices to do so; it is difficult to explain adequately why this could be the case were art only valuable for art's sake.

[10] Which, in turn, makes them ripe for naturalistic analysis in terms of cognitive science and psychology.

That is, art taxes human resources. One wonders how societies, especially where life is arduous, can afford to pay the price, if art really has no adaptive benefits.[11] Were that truly so, would we not expect to find history littered with cases of societies swept away because they had too much art? Of course, it could be just dumb luck that societies that have lavished sizeable subsidies on artistic activities have never been called upon to pay the piper. But, given the extent of the investment by so many societies over so much history, that would be an amazing run of good luck.

At the same time, the notion that art is valuable simply for its own sake does not provide a very satisfactory explanation for its emergence and continuance. The idea that art and aesthetic experience are valuable for their own sakes does not fit neatly within our best theoretical frameworks for understanding nature, including human nature. That art could be a universal or nearly universal feature of human societies but afford no adaptive advantages would be a mystery. It would be as if art were not at all part of the rest of the mechanism, a wheel that neither turned anything else nor was turned by anything else. To say that art is only valuable for its own sake sounds less like an explanation than a confession of ignorance.

Furthermore, it is unlikely that the universal or nearly universal distribution of art across time and place can be explained in virtue of its diffusion from a single source. Artistic practices appear to have sprung up independently in isolated societies where the possibility of outside cultural communication seems remote. Thus, it is natural to hypothesize that in all likelihood the appearance of artistic practices across the board negotiates certain recurring human exigencies. What could that involve? Here are some speculations.

One generalization that is uncontroversial is that art and aesthetic experience have something to do with feeling, at least in an astronomically large number of cases. Much art, in other words, addresses feelings. Moreover, the feelings engendered by artworks are very frequently shared by audiences.[12] That is, art standardly elicits converging feelings among viewers, listeners, and readers.

Sitting in a theater, in the best of cases, we all laugh at the same time, for roughly the same reasons. Sitting in a concert hall, the audience anticipates the crescendo at approximately the same rate of expectation and then thrills to its arrival all at once. The flight of the ballerina makes us simultaneously forget the pull of gravity momentarily, and, even when reading a novel at home alone, we generally do so with the confidence that others will weep at the same parts we do.

Artworks, in this respect, coordinate feelings; they attune audience members to each other. In this regard, one might say, along with Tolstoy, that artworks

[11] The proposition that art has no adaptive benefits, of course, becomes even more curious once one recalls that many of the animating functions of art listed above, such as the reinforcement of cultural identities, are still operating at full throttle after thousands of years.

[12] Ellen Dissanayake, *Art and Intimacy: How the Arts Began* (Seattle: University of Washington Press, 2000).

cultivate fellow feeling; artworks have the power to build communities of sentiment in their audiences and/or participants. In this, artworks have the capacity—at a fairly elemental level—to promote cohesion among groups.[13] Among other ways, they do this by engendering cognate feelings amongst spectators in response to the same subject, which may be of especial cultural, political, or religious significance. But, even where the subject is not of the utmost importance, the social cohesiveness borne of fellow feeling is still functional. It still supplies social cement.

Quite clearly, this is an aspect of the aesthetic experience of artworks of value to any human group. Furthermore, it is a potential that we see exploited everywhere—people bound together in feeling by religious ritual, images, and architecture, by folk songs, patriotic songs, and even by the songs of their youth; people bonded together in movement in national and ethnic dances, and often, quite literally, marching to the same drummer, perhaps around the same commemorative monument; and also there are the people gathered together to hear or to see the same stories and to share common feelings with regard to their cultic origins (Indian villagers gathered to hear the *Ramayana*) or to the plight of contemporary society (e.g., us viewing a performance by the San Francisco Mime Troupe or maybe an evening of *West Wing* or *Law and Order*).

Not all art does these things, but so much of it does that it is difficult to think that this is not one of the reasons that art is universal, since every society benefits from social cohesion.[14] Art, of course, can also promote dissension and cohesion simultaneously—pitting one group against another. However, from inside the relevant groups, the capacity of art to quicken the social glue of fellow feeling is an advantage that has no obvious substitute. Art is a lever on human nature that enhances sociability. If humans are social beings, it is, in part, because art is conducive to this. And, insofar as art promotes social cohesion, it has adaptive value. Nor is this an advantage that belongs only to the group, since it is also an advantage to individuals enfolded emotionally in social entities.

Though art is not universally expressive, the possession of expressive properties and the appreciation thereof is a feature of art across cultures. Expressive properties are the anthropomorphic qualities that we attribute to artworks when we say that the music is sad or that the architecture is majestic. They are the human profiles we find in artworks that remind us of emotive states, such as

[13] Dissanayake, *Art and Intimacy: How the Arts Began*.

[14] In this regard, it is interesting to consider the relation of art to religion. Many early religions derive their identity through ritual rather than theology. Religions that are ritual rather than theological obviously serve to coordinate their followers—quite literally, they do the same things and are, consequently, apt to share the kinds of feelings the relevant rituals are designed to promote, often through the deployment of artistic processes such as representation, figuration, expression, emotional arousal, enactment, song, music, dance, and so on. Especially where the artistic dimension of the ritual is participatory, shared feelings are predictable. But even where rituals are observed by audiences, the common effect on them can still be quite strong. In this way, ritual religions and religious rituals contribute to social cohesiveness. It is probable that artistic processes both as originally components of religious rituals, and then as descendants of ritual discharged, and still continue to perform the generative functions of ritual.

joyfulness, or character traits, such as nobility. Detecting properties like these occupies a large part of our traffic with artworks. We work hard at trying to discern the plaintiveness of the dancer's gesture or the ire in the actor's voice.

But, if this is so, then it seems reasonable to suppose that artworks enable us to refine and enhance our sensitivities for discriminating the emotive states of our conspecifics, which, among other things, is advantageous to us, since scoping out the emotive states of others is a living necessity for social beings such as ourselves. Likewise, many artworks call for interpretations, thereby exercising our abilities for deciphering the intentions of others, which is a related skill for conducting human affairs. Art, in short, is one of the most important cultural sites we have for training our powers for detecting the emotions and intentions of others. And in this regard it would appear to be unquestionably adaptive. For "mind-reading" is the cornerstone of human sociability—one modeled and refined by artworks.

In addition, much art addresses the imagination. This is no more apparent than in the practice of fiction, which receives its fullest elaboration in the realm of art. From the earliest stories that we hear as children, art teaches us to think counterfactually—to think of how things might be otherwise than they are. Our capacity to imagine is, of course, an inestimably valuable adaptive asset.[15] It enables us to plan, to envision alternatives, to take heed of warnings of dangers not immediately at hand, to run in our minds, so to speak, cost-free trials of future events, and to configure chains of events into meaningful wholes.[16] The practice of fiction, especially narrative fiction, augments the range of our imaginative powers, including, notably, our capacity for empathy—the

[15] Though skeptical of the adaptive value of art in general, Steven Pinker appears to concede that narrative fiction has adaptive benefits. He regards the consumption of such fictions as a training regime whereby we familiarize ourselves about what to do and what not to do in myriad life situations. Just as a chess player studies the scenarios of a great many games in order to gain knowledge about what works and does not work in a wealth of concrete board situations that he has not yet encountered but may, so we consume fictions in order to store up a repertoire of possible moves and countermoves for the game of life and, in the process, refine our understanding of how to maneuver in diverse social and personal circumstances. We read *Bildungsromans*, for instance, in order to garner a sense of how lives might go. Perhaps the notion that narratives provide a way of mulling over responses to life situations finds support in the activity of early Greek choruses who comment by drawing multiple comparisons between the circumstances of central characters and parallel cases from the lives of the gods. What seems to be going on is the development of a catalogue of recurring situations along with information about reactions to them; these detail-sensitive scenarios can then be stored for possible future use. Narratives (written and spoken) might, in this regard, be thought of as virtual conversations—virtual information transfers—about problems, situations, and strategy. For Pinker on narrative fiction, see his *How the Mind Works* (New York: Norton, 1997), pp. 538–43.

[16] This last item, configuring chains of events and states of affairs into wholes, is the capacity to make narratives, which, of course, is logically independent from the capacity for fiction, even though many of the most important cultural narratives are fictional. As well, the kind of imaginative activity required by narrative per se and that required by fiction—both in terms of production and reception—differ. One is the power to construct or to configure wholes, the other to suppose counterfactually. Nevertheless, both tend to find their most elaborate and best-known manifestations in artworks and, for this reason, art may be designated a primary tutor of both sorts of imagination, each of which brings with it its own adaptive advantages.

imaginative understanding of others—which, like the ability to detect the emotions and intentions of our conspecifics, is an aspect of mind-reading that is indispensable for virtually every sort of human intercourse.

Undoubtedly, there are more ways than these that art serves the exigencies of human nature.[17] But mention of these selected few should at least lend succor to the hypothesis that there is a connection between art and human nature that can begin to limn the reasons why art is universal. For these are the kinds of reasons we would have had, were we cosmic engineers, for designing human life in such a way that art is a component of virtually every human culture. By reverse engineering, that is, we may postulate that these are the kinds of factors that abetted the survival of societies with art through the blind processes of natural selection.

Of course, evolutionary scenarios, such as the ones canvassed above, often provoke the worry that they are "just-so" stories, unconstrained by any canons of proof. In order to ensure that one has not simply concocted a just-so story or a whole series of them, some, like Elliott Sober, have suggested that for any instance where one claims that such-and-such an attribute is adaptive for a group, one should be able to point to a contrasting group that lacks the attribute in question and that did not survive.[18] I am not persuaded that we always need to find such a contrasting group in order for an evolutionary hypothesis to be satisfactory. Is not common sense enough to assure us that an organism's faster speed relative to all the available predators is a naturally selected adaptation? And might not the same be said with respect to the features of artistic and aesthetic experience that foster social cohesion? That is, is it not, analogously, pretty much a no-brainer?

However, if a skeptic rejects this appeal as too facile, we might nevertheless be able to satisfy him or her by producing the desired contrast-group. Cro-Magnon peoples possessed art; the Neanderthals, it appears, did not. Neanderthal social units were small, whereas Cro-Magnon social units were much larger, enabling Cro-Magnons to engage in more ambitious economic activities and a greater scale of warfare. Whether by more effectively exploiting the environment or by conflict, the Cro-Magnons bested the Neanderthals in the competition for survival. Cro-Magnon social organization was undoubtedly an important ingredient in how this came about. Insofar as the experience of art contributes

[17] Though I have been emphasizing the adaptive value for social existence of artworks and the experience thereof, it should also be noted that significant benefits may accrue to the individual as well. By exercising certain of our powers of perception, association, comparison, contrast, and so on, interacting with artworks enhances cognitive fitness by tuning our organizational powers. Characteristic experiences of art help develop the mind's capacities for organization and discrimination, while also sharpening and refining them. See John Tooby and Leda Cosmides, "Does Beauty Build Adapted Minds? Toward an Evolutionary Theory of Aesthetics, Fiction and the Arts," *SubStance*, 30 (2001): 6–27.

[18] S. Orzack and E. Sober, "Adaptation, Phylogenetic Inertia, and the Method of Controlled Comparisons," in S. Orzack and E. Sober, eds, *Adaptationism and Optimality* (Cambridge: Cambridge University Press, 2001), pp. 45–63; and E. Sober, "Intelligent Design and Probability Reasoning," *International Journal for the Philosophy of Religion*, 52 (2002): 65–80.

to social cohesion, as conjectured above, it is probably an evolutionary plus, permitting, as it would, more extensive social organization. Consequently, the anxiety that ours is merely a just-so story may be alleviated somewhat by pointing to the contrasting case of the Neanderthals who do not appear to have had the advantage of the aesthetic experience of artworks and who, therefore, lacked an important means for fostering and expanding social cohesion.[19]

Needless to say, to postulate the operation of such factors does not conclusively prove their relevance to the emergence and continued existence of art, though it does alert us to the kinds of things that we need to think about confirming or disconfirming in arriving at an explanation of art—its emergence and its persistence on a global or nearly universal scale.

Art celebrates human powers. We all move, but dancers test the limits of human movement possibilities.[20] We all speak, but poets and dramatists refine verbal communication exponentially. We are interested in artists because they show us things about what we all do at higher levels of accomplishment and, by doing so, they inspire us to do better, thereby enhancing our capacities for expression, communication, representation, and signification[21] (talents, all of which contribute to more effective sociality). The exemplary feats that artists perform undoubtedly occur in culturally specific contexts, but it is important not to lose sight of the fact that these cultural variations are rooted at base in recurring human exigencies, albeit modified, as responses to concrete and diverse situations and environments.

Possibly all this talk of human nature and natural selection in relation to art will sound too deterministic for some. In contrast, it may be urged that the great diversity of art and artforms across cultures and within cultures attests to art's freedom. Indeed, in our own culture, art is often taken as the very emblem of freedom. Nevertheless, the link between art and human nature is consistent with the cultural diversity of art, since that diversity is a matter of so many local responses, culturally specific responses, to the enduring, regularly recurring claims of human life on organisms like us, including the benefits of social bonding, planning, and mutual understanding, both cognitive and emotive.

Different cultures, responding from different contexts, including the availability of different materials, arrive at different artistic adaptations, just as they evolve different ethoses and world-views, which, moreover, are often—to an important

[19] The information about Neanderthal and Cro-Magnon social organization and art is derived from Steven Mithen, *The Prehistory of the Mind: The Cognitive Origins of Art and Science* (London: Thames and Hudson, 1990). Marshaling that information so as to claim that art and aesthetic experience can be seen—by contrasting the Neanderthals and the Cro-Magnons—to be an evolutionary bonus is my own doing.

[20] Alan Lomax has hypothesized that the dance movement of a given culture is actually a celebration of the kinds of work-movements that are essential for the material existence of a society. Fancy stepping, for example, correlates with agricultural cultures that demand swiftness and dexterity moving through furrowed fields. And so on. In this regard, virtuoso dancers would be exemplary movers with respect to culturally exemplary movements of a sort engaged by most of the workers in a particular society. See Lomax's film *Dance and Human History*.

[21] Paul Hemadi, "Literature and Evolution," *SubStance*, 30 (2001): 56.

extent—conveyed by art. In fact, perhaps nothing transmits cultural values better than art, for inasmuch as art may engage feeling, emotion, perception, imagination, and cognition all at once, it encodes, so to say, cultural information redundantly across a number of faculties, thereby embedding it more deeply in memory and making it more readily available for retrieval than it would otherwise be. Thus, it is the way in which art engages our cognitive, emotive, and perceptual architecture—our human nature—that makes it so serviceable for culture. This is the reason why art is the preferred currency for dispensing the shared understandings of a society. Nothing else is as effective in inculcating the individual in the byways and main thoroughfares of his or her folk. Culture, art, and human nature, in consequence, are indissolubly intertwined and will continue to be, unless and until evolution takes a radically unexpected turn.

4. MASS ART AND HUMAN NATURE

The considerations advanced so far suggest that human nature may have something to tell us about why art has emerged and taken root cross-culturally. However, it may be thought that once art becomes a going concern, human nature has nothing else to add to the story. Societies may have and sustain artistic activities for some of the reasons given, but understanding the inner workings of those activities once they are in play is a matter of cultural history, not natural history. There is little cause to refer further to human nature—to our enduring cognitive, perceptual, and emotive architecture. Art history and cultural studies rather than cognitive science and psychology are all we know and all we need to know.

This may be in large measure true. Nevertheless, although art is primarily a cultural affair, aspects of its history may still be elucidated by reference to human nature and the disciplines that study it. For the specific, historically motivated projects that a culture elects for artistic development may succeed exactly because they *exploit*, and not merely presuppose, some of the cognitive, perceptual, and emotive capacities bequeathed to us by human nature. That is, at specific historical junctures, artists may turn to human nature to find solutions to their problems. In order to evaluate this conjecture, let us take a brief took at film and TV.

These artforms were not destined to arise by a process of natural selection. They emerged at specific points in history, due to social processes, such as urbanization (and then sub-urbanization), in order to perform a social function, the entertainment of large numbers of disparate people, often with very different cultural backgrounds. That is, history supplied the opportunity—large numbers of people with growing amounts of leisure time in search of aesthetic amusement. The problem was how to exploit this opportunity. Film, which later passed its achievements on to TV, was one solution to the problem. Moreover, its solution,

along with the historically contingent discovery of the requisite technologies, to a surprising degree, involved taking advantage of our cognitive, perceptual, and emotive make-up.[22]

One way to appreciate this is to recall that the basic symbol in film and TV is the moving image. Though a symbol, the moving image is not the sort of symbol upon which semiologists dote; its relation to what it is a picture of is not arbitrary. The word "dog" is arbitrarily correlated with dogs. But a picture of a dog, say, Lassie, is the result of a causal process in which Lassie actually pranced before a camera, and, more importantly for our purposes, the moving picture of Lassie will be recognized as an image of a dog by any sighted human being familiar with dogs. That is, anyone capable of recognizing a dog in, as they say, "real life," will be able to identify a moving image of a dog.

There are at least two reasons to believe this. The first is that children not raised with pictures are able to recognize what pictures are pictures of, at rates well above random, without prior training. This indicates that whatever hardwired perceptual capacities are engaged in object recognition are also engaged in picture recognition, including moving picture recognition. And, second, moving pictures are understood cross-culturally with amazing alacrity—at least in terms of people's ability to comprehend at the level of recognition of what is represented, the basic symbols of the artform, that is, the moving images. Unlike language, the basic symbols in film and TV do not require a protracted process of learning in order to decode or decipher them. We simply look at a picture of a bearded man, and we recognize what it is a picture of without any subtending processes of inferring, translating, decoding, or deciphering. Moving pictures access our natural recognitional capacities, capacities shared across the species, and this is one reason why they are able to engage mass audiences around the world, audiences often lacking common cultural backgrounds or any special training in how to determine what a moving image is an image of.[23]

This is a simple fact, but it is important not to underestimate its significance. The moving image is the *sine qua non* of film and TV as we know them. It is the fundamental symbol in these artforms. That it operates on innate recognitional capacities implies that, at a certain level of comprehensibility, these artforms are accessible to nearly everyone without background training. Thus, though the project of engaging mass audiences was a historically specific one, its success, to a significant degree, relied upon capitalizing on nearly universal cognitive and perceptual features of human nature of the sort best elucidated by cognitive/perceptual psychology. Had film and TV been used only to project words, rather than pictures, they would not have succeeded as mass artforms on a global scale. Nor is this merely a fanciful, cooked-up counterfactual, since part of the technology that would become television was developed with the intention

[22] Noël Carroll, *Philosophy of Mass Art* (Oxford: Clarendon Press, 1999), Ch. 3.
[23] Noël Carroll, "The Power of Movies," in *Theorizing the Moving Image* (New York: Cambridge University Press, 1996), pp. 78–93.

to communicate information across the Atlantic Ocean by wire.[24] Had film and TV developed simply as delivery systems for script, their aesthetic best would have been as some sort of language-bound literary art. But, in fact, they were able to travel cross-culturally to the extent that they do, in large measure because they tap into our common human nature.

Moreover, a related aspect of the success of motion-picture communication has to do with the fact that not only are we able to recognize automatically the objects moving pictures portray; from infancy, we are also able especially to recognize human faces *and* the basic emotions they express, including (most probably): enjoyment/joy, surprise/startle, distress/anguish, disgust/contempt, anger/rage, shame/humiliation, and fear/terror.[25] This nearly universal, evolved capacity is, of course, extremely adaptive, as it enables us to derive information from and about our conspecifics. But also, to a large extent, a striking amount of the basic information that we derive about the characters in moving-picture narratives is communicated facially. This is why the close-up (of faces) and point-of-view editing are such staples of film and TV.[26] We know that the gun shown in the first shot is threatening, even without further narrative contextualizaton, because it is coupled with a close-up of someone's terrified visage—rather than with the face of one of those folks who laugh at danger. We know that one character has said something very stupid, even if this is not immediately obvious, because there is a reaction shot of someone else looking contemptuous.

As early as the 1920s, the film theoretician Béla Bélasz announced the centrality of the face to film communication, claiming that, through the close-up of the face, the new medium afforded special access to the soul. But, of course, it did not take an explicit theory to alert filmmakers to the power of facial close-ups. They had already discovered that in the previous decade, perfecting the point-of-view shot, the reaction-shot, and the glamour close-up to a degree that the passage of decades has added little to what was already available, formally speaking, in the period of silent filmmaking, whence these devices continue to impart indispensable narrative information about what characters are feeling and sometimes even facilitate empathy with them. Moreover, the facial close-up remains essential to television: not simply because the talking head fits so neatly into the box (after all, the box is getting bigger and flatter), but because the way in which natural selection has designed the human frame, as has been revealed by contemporary psychological research, makes the human face one of our greatest sources of information about others—indeed, sometimes a source that we value

[24] David E. Fisher and Marshall Jon Fisher, *Tube: The Invention of Television* (Washington, DC: Counterpoint, 1996), Ch. 1.

[25] Paul Ekman, *Emotions Revealed: Recognizing Faces and Feelings to Improve Communication and Emotional Life* (New York: Times Books and Henry Holt and Company, 2003), Ch. 1.

[26] See Noël Carroll, "Film, Attention, and Communication: A Naturalistic Perspective," in *Engaging the Moving Image* (New Haven, CT: Yale University Press, 2003), pp. 10–58; and Carl Plantinga, "The Scene of Empathy and the Human Face on Film," in Carl Plantinga and Gregg M. Smith, eds, *Passionate Views: Film, Cognition, and Emotion* (Baltimore, MD: Johns Hopkins University Press, 1999), pp. 239–55.

over the spoken word when we mobilize our capacities to track the telltale signs of lying as manifested by dissembling conspecifics.

There are, of course, many debates among psychologists about precisely what is involved in our attributions of emotional states on the basis of facial displays.[27] Are such displays best understood as a means of social communication or as eruptile expressions of fundamental emotions?[28] Which emotional facial expressions are recognized nearly universally and which are merely very pervasively identified, and, if so, at what frequency? At this stage, far more research is needed. However, there does seem to be consensus that some facial displays of emotion elicit nearly universal attributions. This, of course, allows that certain emotional displays are culturally idiosyncratic—it is said the Chinese stick their tongues out when surprised—while others are generic: the disgust reaction, for example, would appear rooted in a physiological strategy for rejecting offending smells and tastes. Moreover, it is the emotional displays on the generic side of the ledger that the mass arts gravitate toward—such as fear, elation, sadness, anger, surprise, lust, and so on.[29] This is the stuff upon which mass art thrives, as a quick review of the most popular motion-picture genres attests. Moving-image mass art is able to convey, to a significant degree, this emotional information so effectively to large and diverse audiences of heterogeneous backgrounds because of its reliance on close-ups of faces, something that within a certain range of emotional expressions, ones particularly germane to the territory mass art cultivates, audiences can comprehend in large part by dint of their innate biological equipment.

This is not to say that filmmakers realized the close-up would secure uptake in the way it does because they held a certain theory. They tried it and it worked, and it worked because many of the emotions that mass-art motion pictures represent are identifiable by viewers transculturally, as a consequence of evolutionary processes of natural selection that favored the humans biologically prepared to suss out automatically conspecifics along certain emotional dimensions. In this regard, the people who popularized the close-up of faces for motion pictures were intuitive experimentalists. And their experiment paid off by augmenting the reach of visual mass narration through the way in which it intersected felicitously with our biological make-up. So, once again, we see that, to a perhaps unexpected extent, a rather fundamental level of communication in film and TV transpires by activating elements of our innate cognitive, perceptual, and emotional equipage.

[27] James A. Russell, "Is There Universal Recognition of Emotion from Facial Expression? A Review of the Cross-Cultural Studies," in Alan J. Fridlund, ed., *Human Facial Expression: An Evolutionary View* (San Diego: Academic Press, 1994), Ch. 10.

[28] Alan J. Fridlund, "Epilogue," in *Human Facial Expression*, p. 316. Fridlund, *pace* Ekman, favors the social communication model. But either perspective is compatible with what we wish to say, since we are postulating a hardwired recognitional capacity; whether it is detecting messages or symptoms or a combination of the two is really irrelevant to the point we are trying to make.

[29] Furthermore, the fact that converging, cross-cultural responses to the pertinent emotional displays grows statistically when the photos of the faces in question are posed, strengthens rather than weakens our claim of the relevance of this capacity for mass-market motion pictures, since the close-ups in the vast majority of films and TV programs are posed.

And, furthermore, to a significant degree, it is because these media, in terms of their very structure, engage our shared human nature that they have become the dominant mass artforms of the twentieth century, and now of the twenty-first. They are able to elicit mass uptake, in large measure, just because they trigger evolved capacities.

Of course, what has been said so far is hardly the whole story of what is involved in understanding film and TV. And much of the rest of that story requires close attention to culture and history. But the point that I wish to underline now is that human nature is also part of that story. I have indicated two ways in which it might figure in an account of the rise and dissemination of film and TV; there are others that could be discussed. But, in any event, this much should be clear: though art has a history and though it is probably through studying that history, and the pertinent cultural contexts, that we come to most of our deepest understandings of art, this does not preclude the possibility that, in certain cases, human nature and natural history, as studied by naturalistic disciplines like cognitive science and psychology, may also afford insight into art. The reason for this, as our brief look at some of the fundamental structures of film and TV indicates, is that sometimes historically and culturally specific projects succeed by mobilizing components of our evolved cognitive, perceptual, and emotive architecture.

5. CONCLUSION

Though for over two decades there has been a de facto moratorium in the humanities regarding the relation of art to human nature, it is time to break the silence. Adverting to human nature is not the answer to every question we have about art—maybe it is not the answer to most, or even to most of the important ones. But it is not a resource that should be neglected altogether. It is unlikely that the story of art is art history all the way down. Explanations of the emergence and continued robust existence of art may profit from evolutionary considerations. And, sometimes, the history of art, as the cases of film and TV suggest, could be amplified by noticing the ways in which culturally and historically specific artistic problems may be successfully addressed by activating our nearly universal, evolved, cognitive, perceptual, and emotive capacities. That is, sometimes art history and human psychology may work hand in hand; art history may tell us what to look for, and then psychology may help us find it. It is time for the two cultures—the humanities and the sciences—to come together.[30] And there may be no better meeting place than the topic of art and human nature.

[30] A similar sentiment is shared by Denis Dutton in his "Let's Naturalize Aesthetics," *ASA Newsletter*, 23 (summer, 2003): 1–2.

15

Art and Mood: Preliminary Notes and Conjectures

1. ART AND AFFECT

In recent years, the philosophy of art has profited enormously by applying to the study of art insights derived from the philosophies of mind and language, naturalized epistemology, psychology, evolutionary theory, and cognitive science. A case in point: the discussion of the nature of picturing and pictorial perception has obviously benefited from the influence of perceptual psychology and cognitive studies. Likewise, the theorization of art in relation to the emotions has also exploited contemporary advances in adjacent areas of inquiry.[1]

Of course, that art has something to do with feeling is a commonplace, not only among plain viewers, readers, and listeners, but also among theorists, dating back at least to Plato and Aristotle, iterated maybe most vociferously by proponents of Romanticism, and argued, as well, by Tolstoy, Collingwood, and Langer. Outside the Western tradition, the rasa system of Hindu aesthetics echoes the conviction that art and feeling are intimately joined. Thus, the relation between art and the emotions has been an article of faith for a long time, not merely in the minds of common folk, but, in addition, for theorists.

Yet, although the nexus between art and the emotions has been observed almost perennially, it has not always been well understood. The proposals of previous philosophers, though suggestive, were also often obscure. Collingwood proposes that art clarifies emotions, but precisely what he means by an emotion as well as how he thinks someone would go about clarifying one is unclear. Perhaps a reason for the limitations found in earlier theorists of the connection between art and the emotions is that the concepts of the emotions at their disposal were often not as refined as they might have been. The vagueness in their theories of art, in other words, mirrored the vagueness in their theories of the emotions. But, then, as philosophers of mind over the last three decades have begun to evolve more explicit and precise theories of the emotions, philosophers of art

[1] For example, see the anthology *Emotion and the Arts*, edited by M. Hjort and S. Laver (Oxford: Oxford University Press, 1997).

have followed suit, employing emerging theories of the emotions in order to study art and its emotive address with greater subtlety and detail.

For example, the cognitive theory of the emotions, including both stronger and weaker versions, provided philosophers of art with ways of seeing what is at stake in such longstanding issues as the paradoxes of fiction and tragedy as well as the question of the emotive address, if any, of music. Cognitive theories, and variations thereon, in fact not only afforded philosophers with more fine-grained ways of posing recurring quandaries, but also with suggestions about how to go about resolving them. For instance, if it can be shown that the paradox of fiction arises because of the strong cognitivist commitment to belief as the cognitive component of an emotional state, the weaker cognitive theories of emotion—that maintain that the cognitive component of an emotional state may be less than a belief (a thought imagined rather than asserted, a construal, or a pattern of attention)—suggest ways of dispelling the conundrum. Moreover, by analyzing occurrent emotional states into their components—cognitive, conative, somatic, and behavioral—contemporary research in the emotions has given philosophers of art the wherewithal to isolate the variables artists manipulate in order to elicit emotion and, relatedly, to convey expression. The notion, for example, that the emotional state of comic amusement requires cognizing an object in accordance with at least the criterion of non-threatening incongruity provides the art theorist with a way of beginning to zero in on the functionally significant elements in jokes.

But though cognitive theories of emotion, and variations thereof, have much to offer the philosopher of art, they also come with certain shortcomings. Not surprisingly, these limitations have to do with blindspots in the relevant theories of the emotion.

Cognitive theories of emotion were originally advanced as perfectly general accounts of everything we are wont to call emotions in everyday language. Thus, all emotions were said to possess cognitive states directed at objects subsumable under general criteria (as the object of an occurrent episode of fear meets the necessary condition of harmfulness); which cognitive processing, in turn, ensues in bodily or somatic changes (strictly physiological ones, like accelerated heartbeats and/or more phenomenological ones, such as sensations of chilling).

However, not everything that has a claim to being called an emotional state in ordinary speech meets those requirements. Some of what people count as emotions are affective reflex responses, such as being startled by a loud noise or a fast movement. Yet these appear to proceed without an interlude of cognition. They bypass higher regions of the brain and go straight to the amygdala. On the other hand, some other states, which people also call emotional ones, seem to lack a particular object toward which they are directed. Free-floating anxiety is a frequent counterexample in this regard to cognitive theories of the emotions. It can stand for an entire class of affective mental states, namely, moods, which are arguably beyond the purview of cognitive theories.

Moreover, these gaps in the comprehensiveness of cognitive theories of the emotions have ramifications for the philosophies of art that are modeled upon

them. For there are crucial affective responses to artworks that—inasmuch as they are more akin to affective-reflex responses and moods than they are to the emotions as characterized by even weak cognitive theories—will go theoretically unnoticed, underappreciated, and/or misunderstood by the aesthetician equipped with some or another framework tailored to the sorts of mental episodes that inspired cognitive theories of the emotions. For instance, the arts of spectacle, including theater, film, circus, and fireworks, traffic in startle effects; while there is a great deal of music which may unapologetically be called mood music—music which evokes affective states such as elation, but not elation about anything in particular. So long as the philosopher of art treats the entire gamut of the affective dimension of art in light of a map borrowed from cognitive theorists of the emotions, these regions of the heart will go aesthetically uncharted. Thus, it is time for philosophers of art to look beyond cognitive theories of the emotions in order to broaden their appreciation of the affective life of art. By this juncture, it appears fair to conjecture that the cognitive theory of emotion is not a comprehensive account of all the affects people call emotions. The upshot of this, however, should not be the wholesale abandonment of the cognitive theory of emotion. For there are some affective states it characterizes exceedingly well, both in terms of naturally occurring affective states and those induced by artworks. So perhaps the moral should be: use the cognitive theory of emotions where it well suits the data, whether found in life or art, and develop other models for affective phenomena, such as affective reflexes and moods, as they occur, again, both in life and art. The purpose of this chapter, as a contribution to the aforesaid program, is to initiate an approach to the phenomenon of *mood* as it applies to artworks.

For the purposes of nomenclature, I refer to the entire realm of feeling-charged mental states as the affective domain. This includes at least affective reflexes, phobias, what some call affect programs,[2] moods, *and* that which cognitivists regard as the emotions proper. Different items in this domain call for different accounts. Insofar as some behave in the ways that cognitive theorists indicate, there is no reason to forswear those accounts where they apply just because cognitive theorists, overambitiously, claimed their framework could be extended to everything in the affective domain. By stipulation, I will reserve the label "emotion" for those episodes aptly characterized by cognitive theories of emotion, in part because I suspect that even in ordinary language such episodes, like anger, represent paradigmatic emotional events. Nevertheless, this way of speaking should not be taken as a surreptitious gambit denying or attempting to sweep under the carpet the existence or importance of things like affective reflexes or moods, nor to suggest in any way that these are ersatz or defective emotions. The affective domain is simply broader than what I am calling the emotions proper, and the

[2] See P. Ekman, R. Levenson, and W. R. Friesen, "Automatic Nervous System Activity Distinguishes Among Emotions," *Science*, 221/4616 (September 1983): 1208–10; and P. Griffiths, *What Emotions Really Are* (Chicago, IL: University of Chicago Press, 1997).

affective states that diverge from the pattern of the emotions proper call for different accounts than those typically offered by cognitive theorists of the emotions.

The need for further explanatory frameworks is noticeably evident with respect to art. Theater and perhaps especially film exploit our affective reflexes for artistic effect mercilessly. In staging a theatrical thriller like *The Lady in Black*, a white face pops out of the dark in a way that induces us to jump out of our seats, as do the sudden explosions, fast movements toward the camera, and the offscreen rumblings and screams in so many films, implemented by awesome surround-sound systems of ever increasing magnitude, realism, and complexity. If these effects in cinema sometimes prompt us to start upward, careening cameras encourage us to hold onto our seats for dear life. Manipulating such variables as speed, scale, lighting, and sound, among others, the filmmaker often appears to have direct access to our nervous systems, bypassing the cerebral cortex and triggering automatic affective reflexes. Any account of the affective address of art needs to gauge the measure of the role of affective reflexes, and such accounts cannot rely on cognitivist approaches, since, by definition, such responses do not rely, in the first instance, on cognition. Indeed, they are cognitively impenetrable.

Likewise, understanding moods, as distinct from emotions, is essential to a complete account of the affective dimension of art. Without a doubt, some artworks are noteworthy primarily for their capacity to engender moods. For example, customarily people use artworks in the ordinary course of affairs to change or modulate their moods. Dejected after a hard day at the office, in order to pick up my spirits, I may listen to the Allegro-Andante-Allegro Hornpipe section of Handel's *Water Music* or the mazurka from Delibes's ballet *Coppelia*.[3] Nor do we only listen for moods as a tonic. We may listen to music of a certain pronounced affective quality or contemplate some other type of artwork in order to allow it to guide reflection in such a way that it enables us to recognize and to explore the mood in question. For example, we might try to explore pensively the mood of melancholy by meditating on Caspar David Friedrich's *The Stages of Life*.

Though the role of mood in art is nearly or equally as important as that of emotion, it is often neglected or, worse, mood in art and emotion in art are frequently, carelessly conflated (despite the fact that moods are categorically different mental events than emotions—so different, in fact, that the former cannot be readily accommodated by the types of cognitive approaches to the emotions that have been deployed so effectively in unraveling the connection between art and the emotions). This is not said in order to disparage the contribution of the cognitive theory of emotions to aesthetics, but to motivate

[3] Of course, artworks other than musical ones are also used to alter moods. One might go to a comic film or play to pull oneself out of the doldrums, or read a picaresque novel, or peruse a collection of caricatures.

an attempt to supplement it with a framework for approaching the related, yet different topic of moods in art.[4]

2. MOODS

Before engaging in the topic of mood and art, something should be said about mood as such, or what we might call naturally occurring moods.[5] One way of locating what is distinctive about naturally occurring moods is to contrast them to one of their nearest neighbors in the realm of affective mental states, namely emotions. In fact, these neighbors are so close that, as already mentioned, in ordinary speech and even in technical writing, the boundary between the two is often blurred and sometimes confused. Indeed, frequently the same locution, such as "being depressed," is used to refer both to certain emotional states and to moods. Nevertheless, the phenomenon of mood and that of emotion are discriminable.

One difference that is often remarked upon by ordinary speakers and sometimes by psychologists is duration: occurrent emotional states are said to be short-lived and punctuated, whereas moods persist over longer time intervals. A cutting aside may result in a flash of anger, whereas I may feel up and buoyant for the entire first week of spring. However, though differential duration is often a rough-and-ready guide for distinguishing emotions versus moods, it is not an essential difference between the two. Sometimes one may be angry for weeks on end—think of a nasty divorce—while, on the other hand, blossoming elation can be nipped in the bud by a slew of bad news.

[4] Given what was said above about affective reflexes and art, supplementation of cognitive approaches along those lines is also a worthwhile project of aesthetical research. But that is a topic for some other paper, as are the questions of the relations to art of further affective states, including affect programs, phobias, and other varieties of affect yet to be atomized by cognitive studies.

[5] Works on mood consulted in the preparation of this chapter include: Claire Armon-Jones, *Varieties of Affect* (Toronto: University of Toronto Press, 1991); Richard Davidson, "On Emotion, Mood, and Related Affective Constructs," in P. Ekman and R. Davidson, eds, *The Nature of Emotion* (New York; Oxford University Press, 1994); P. Ekman, "Moods, Emotions and Traits," in *The Nature of Emotion*; Nico Frijda, "Moods, Emotion Episodes, and Emotions," in M. Lewis and J. M. Haviland, eds, *The Handbook of Emotions* (New York; Guilford Press, 1993); N. Frijda, "Varieties of Affect," in *The Nature of Emotion*; Jerome Kagan, "Distinctions Among Emotions, Moods, and Temperamental Qualities," in *The Nature of Emotion*; Eric Lorman, "Toward a Theory of Moods," *Philosophical Studies*, 47 (1985): 385–407; William Morris, *Mood: The Frame of Mind* (New York: Springer-Verlag, 1989); Vincent Nowlis, "The Concept of Mood," in S. M. Farber and R. H. L. Wilson, eds, *Conflict and Creativity* (New York: McGraw Hill, 1963); B. Parkinson, P. Tottendell, R. Briner, and S. Reynolds, *Changing Moods: The Psychology of Mood and Mood Regulation* (New York: Addison, Wesley, Longman, 1996); Robert Thayer, *The Biopsychology of Mood* (Oxford: Oxford University Press, 1989); David Watson and Lee Anna Clark, "Emotion, Moods, Traits and Temperaments: Conceptual Distinctions and Empirical Findings," *The Nature of Emotion*. Throughout, I am especially indebted to Laura Sizer, *A Theory of Moods and Their Place in Our Science of the Mind* (Doctoral Thesis in Philosophy, Madison, WI: University of Wisconsin-Madison, 2000). See also Laura Sizer, "Towards a Computational Theory of Mood," *British Journal of the Philosophy of Science*, 51 (2000): 743–69.

A far more promising demarcation line between mood and emotion may be that whereas emotions are directed toward particular objects or have intentionality, moods do not. That is, when I am angry, I am angry at someone in particular whom I believe has wronged me. But when I am irritable—in an irritable mood—there is no one *in particular* who irritates me. Everyone and everything that falls into my pathway is likely to become the locus of my foul mood. If I think you have insulted me, then the insult is the cause of my anger and you are the particular object of it. But if I am in a cranky mood and I bark at you, nothing you may have done may have elicited the severity of my response, and I may even realize that you are not the object of my ire. I may say to you: "Sorry, it's not you. I'm just in a bad mood."

The difference between moods and emotions often emerges dramatically in the course of criticisms of strong cognitive theories of the emotions.[6] Against the strong cognitivist assertion that all emotions necessarily have objects and intentionality, well-known counterexamples include free-floating depression or sadness (an unfocused sense of loss or of past or present failure) and free-floating anxiety (a pervasive, future-oriented fear or dread). Though some instances of these phenomena may be explained away by cognitivists—invoking subconscious intentional objects, or hypothesizing that the object of such states is just everything—it does not appear credible that every case of putatively objectless depression or anxiety can be dispatched by ad hoc conjectures. I may feel gloomy about everything I survey as it drifts into my purview, but that does not entail that the object of my affective mental state is everything gathered together, so to speak, in a bundle. I may not consciously or subconsciously be thinking of everything as an aggregate—that may be simply too metaphysical a thought to attribute to many depressives. You don't have to view the world as a Schopenhaurian might in order to be depressed. If you ask me when I'm depressed whether everything—the state of the world—is the object of my mental state, I may say that I'm too depressed even to muster the energy to think so big a thought.

Of course, the kinds of counterexamples involving objectless affective mental states that are pertinent to this discussion are not only negative or dark or dysphoric ones like depression or anxiety. Positive states such as elation, euphoria, excitement, cheerfulness, joyousness, and so on can also be objectless. When I am in a good mood, or enthusiastic, or buoyant, I may see the sunny side of everything that comes my way without anything in particular or everything, conceived as an aggregate, being the object of my state. I may know that the condition of the world as a whole leaves much to be desired, but, at the same time, avow that while in my present, ebullient mood, nothing can bring me down. It's not the corn, however high, or even Oklahoma, in the musical of that name, that is the object of the cowboy's affective state. He would be as elated about turnips in New Jersey. His enthusiasm is not directed at a particular

⁶ John Hagueland, "The Nature and Plausibility of Cognitivism," *Behavioral and Brain Sciences*, 2 (1978): 215–60; Roger Lamb, "Objectless Emotions," *Philosophy and Phenomenological Research*, 48/1 (1987): 107–17.

object. Rather, it is free-floating. It is not attached to anything specific. Instead, the mental state engulfs anything in its vicinity, almost come what may. The mean old miser next door, who deprives his family, is not an appropriate object of positive emotions on my part, but, given my present cheerful cast of mind, I construe his penurious habits as harmless, comically amusing foibles. When it is the merry month of May in Camelot, it is not really May that is the particular object of Julie Andrews's mental state. Rather, she battens on May and celebrates it because she is merry. She is not merry for the reason that she believes it is May.

What these positive and negative examples reveal is a region within the domain of mental states where the phenomena are affective—that is, feeling-toned, or tuned or charged—but objectless (that lack intentionality). In this, the states in question diverge sharply from emotions properly so called. Instead they are moods. For moods, as we usually think of them, may be unanchored with regard to particular objects. Related to the objectlessness or lack of the relevant sense of directedness of moods is a second feature of moods, as distinct from emotions. Emotions are selective and exclusive. Moods are incorporative and inclusive. Emotions hone in on those aspects of a situation that are germane to the presiding emotion. When frightened by the charging leopard, one does not attend to its spots; one attends to that which is pertinent to dealing with the danger at hand. Emotions are functionally blinkered. They size up, or gestalt, situations rapidly in accordance with the emotive appraisals that govern the overall state of the subject. Optimally, they draw perception to only the elements in the array that call for action. If flight is called for, we look for exits; if fight, we look for weak spots. Emotions organize our field of apprehension on a need-to-know basis. But moods are different.

Moods are global rather than focal; moods pervade perception, rather than focusing it. In a melancholy mood, whatever one encounters carries a patina of sadness. When feeling high, everything appears bright. A mood pulls ambient details into its orbit, whereas an emotion cuts through the details and edits them in ways appropriate to executive action. Moods incorporate the onrush of phenomena and cast them in the light of the pervasive coloration of the mood. Emotions winnow the onrush of phenomena, putting only some of it in the limelight, while thrusting the rest into darkness. When in the throes of an "Oh-what-a-beautiful-morning" mood or "The-hills-are-alive-with-the-sound-of-music" mood, almost anything can seem radiant and virtually everything one lights upon does.

The globality of moods appears connected to their objectlessness. That a mood has no particular object as its central focus is maximally consilient with its more omnivorous or roving attentiveness. Moods are objectless and global. Moods pervade the area within the perimeter of perception, rather than carving out or shaping its contour, as an emotion does. Though the same word may be used to label an emotion and a mood, it is one thing to be joyful over the marriage of one's child (an emotion with an object) and another thing to be joyous *simpliciter*, ready to greet whomsoever with a hearty hello.

Though emotions differ from moods in the ways cited, they are, in other respects, more like emotions than they are like certain other affective mental states, such as reflex responses, for example, the startle reaction. Whereas reflex responses are thought to bypass cognition altogether, moods, like the emotions, are not disengaged from cognition. Moods predispose the subject in the direction of certain appraisals rather than others of whatever comes their way—in which the work of appraisal, of course, is connected to cognition. In an anxious mood, one is predisposed to see the menacing aspect of things, however innocent. A fine meal looks like an invitation to indigestion, or, at least, unwanted weight gain. Elated, a hovel may be deemed a palace. Moreover, moods can influence cognitive processes such as memory. In a depressed mood, a person is typically slower to recall optimistic words on psychological tests, whereas, contrariwise, a subject in a lighter mood shows a corresponding lag with pessimistic words. So, though moods diverge from emotions in certain regards, they, like emotions, are linked to cognition—to cognitive processes such as appraisal and memory.

But what might that linkage be? Since, unlike emotions, moods are objectless, it cannot be that, like emotions properly so called, they subsume particular objects under generic categories of appropriateness. Indeed, given their globality, moods would not appear to abide by strict canons of appropriateness. Nevertheless, moods are not unrelated to such judgments. They do not amount to such judgments, but rather they bias the subject toward making certain kinds of judgments instead of others. That is, they are conducive to certain mental processes with respect to information management rather than others, including: the accessing of certain memories, the making of certain appraisals, and, in fact, the having of certain emotions (since an essential feature of the emotions involves the making or entertaining of appraisals). When in a joyous mood, all things being equal, one is more apt to feel magnanimous than indignant.

Emotions are optimally responses to states of affairs in the world. In this sense, they can be described as having a world-to-self direction of impact. Moods, as we have seen, are more diffuse. The mood emanates from the self and engulfs everything it touches. Its direction of impact is from the self to the world.[7] In this regard, moods are, in large measure, dependent on the overall state of the organism, its level of energy, the level of resources at its disposal for coping with environmental challenges, and the degree of tension it finds itself in as a result of the ratio of its resources to its challenges.[8] An elated mood brings with it the feeling that one can do anything. A depressed mood: that one can do nothing. Moods may fluctuate with times of day and circadian cycles. As resources flag in the late afternoon, one is more apt to feel down. Moods are also susceptible to changing with the seasons; spring, given the ancestry of our mammalian bodies, signals a time when activity is once again viable as well as bringing a burst of restorative energy.

[7] Sizer, *A Theory of Moods* (cited in n.5, above).
[8] Thayer, *The Biopsychology of Mood* (cited in n.5, above).

Because moods are objectless, they lack representational content of their own, in a manner of speaking. Nevertheless, they guide or influence the mental processes that are engaged in producing and delivering representational content, including information-processing in general, and memory, categorization, appraisal, problem-solving, scanning, sorting, and shifts of attention in particular. Among these processes, of course, are the emotions proper, since, as the cognitive theory of the emotions argues, emotions involve cognitive processes such as appraisal, categorization, and adjustments of attention. Thus, an anxious mood may predispose the subject to episodes of fear, whereas a cheerful or jovial mood may prepare one for outbursts of comic amusement.

Moods, in other words, are linked to cognition (and the cognitive emotions) indirectly rather than directly. Their primary function, as Richard Davidson hypothesizes, "is to modulate or bias cognition. Mood serves as a primary mechanism for shifting modes of information processing. Mood will accentuate the accessibility of some and attenuate the accessibility of other cognitive contents and semantic networks."[9] Mood is, as William Morris puts it, a frame of mind,[10] setting the broad agenda in which a number of other cognitive and emotive processes operate. The melancholy mood invests the subject with the inclination or tendency to call forth sad memories and to ignore happy ones, and to find examples of woe rather than weal in that which it surveys. Thus, even if arguably many moods are not cognitions themselves (where that is thought to require intentional and representational content), their relation to cognition is undeniable: they predispose the subject to certain cognitive and cognitive-emotive states; moods are predilections, bents, proclivities, partialities, or leanings toward certain kinds of recollections, appraisals, categorizations, attentional shifts, and scanning and sorting behaviors rather than others.

Of course, moods are not merely affairs of the intellect. They have a bodily or affective component. They are, after all, *affective* mental states. They have certain feeling tones, like perkiness, as well as sheer physical aspects, such as galvanic skin conduction measurements. Moods probably give the organism information about the subject's levels of energy and tension relative to its preparedness for responding to situations and challenges. In an excited mood, one feels ready for anything, indicating a sense of high capability on the part of the subject. When depressed, one assesses the situation as so dismal that one cannot mobilize any effective action. Undoubtedly, the feelings that attend moods—of energy, lethargy, and tension—contribute to the direction of thought the mood encourages by bringing bodily information about the prospects of the agent's capacity for goal implementation to bear on cognition in general, influencing, from an ultimately pragmatic-adaptive framework, how it categorizes, appraises, scans, sorts, attends to, and reflects upon information, as well as how it responds to it emotionally.

[9] Davidson, "On Emotion, Mood and Related Affective Constructs," p. 52. Laura Sizer develops Davidson's suggestion by arguing that mood is a functional element of our cognitive architecture.
[10] Morris, *Mood: The Frame of Mind* (cited in n.5, above).

Moods are also self-promoting feedback systems. In a gay mood, one has gay thoughts, views things gaily, recollects gay things, and perhaps has emotional episodes of gaiety and fellow feeling, which reinforce and sustain the mood. The feeling tone brings a certain mood—a certain frame of mind—to the fore, which, in turn, influences cognition (especially the scansion and appraisal of the environment relative to the state of one's coping resources), and cognition/emotion in ways that abet the continuance of the feeling tone in question.

Obviously, also, the feeling tones that attach to mood states are usually (but not always) themselves pleasurable or unpleasurable. It feels good to be elated, bad to be depressed. In this, moods provide a phenomenological measure of how prepared the subject feels ready to proceed. In all probability, the feeling itself and our bodily interest in sustaining it (or dispelling it) may supply part of the push that sends our cognitive system in one direction rather than another. And in many cases, our desires notwithstanding, a mood state may be irresistible, directing attention by means of feelings that are connected to broadening or closing down our purview quite literally, to the degree that our body signals that it is prepared to absorb information, and thematizing the content of that to which we attend as pleasurable or displeasurable. That is, when up, attentiveness expands and almost anything gladdens the heart, whereas, when down, the scope of our perspective narrows, and what it finds appears distasteful.

Moods are affective states, feeling states, connected with biasing or modulating cognition in certain directions rather than others. Moods, then, can occur independently from emotional episodes. In the undertow of an anxious mood I may cognitively assess my overall prospects as dreary without any interlude of fear with respect to a particular object. That is, a mood state may involve having a feeling-charged cognitive state sans an outburst of emotion. One is in a mood state only if one is in a feeling state that predisposes information-processing (memory, categorization, scanning, sorting, appraisal, problem-solving, and so on) in certain directions rather than others.[11] Since cognition can be biased globally by feeling without the subject undergoing an emotional episode, one cannot assume, as some theorists have, that the function of moods is to predispose the organism toward certain emotional states rather than others. Instead, moods are affective states, feeling-charged states, whose function is to bias cognitive processes (including, though not exclusively, the cognitive emotions) in ways presumably dependent upon the component feeling tones of the mood, which, in turn, are related to bodily assessments of the preparedness of the subject (its energetic resources and level of tension) to deal with the environment. However, though feelings are essential to counting a state as a mood, they do not afford a perspicuous clue to the identity of the state, since many moods would appear to share converging feeling tones (for example, cheerfulness and joviality may

[11] These are only necessary conditions for being in a mood state. They do not amount to sufficiency conditions, since hunger and thirst may satisfy them. However, for what follows, this partial characterization may prove adequate.

feel the same). Rather, it is the cognitive bias of the state that tells us in what mood we are.

Though moods can be distinguished from emotions, properly so called, they are not unrelated to them. Mood states can give rise to thematically corresponding emotional episodes—for instance, free-floating anxiety can precipitate specific, directed interludes of fear—as one would expect insofar as moods influence information-processing, such as scanning, sorting, and appraisal, which themselves can function as ingredients in emotional responses. Moods do not function *exclusively* to bias emotional reactions; nevertheless, they do so frequently for the reason just given.

Moreover, emotional states can also give rise to mood states. A parade of fearful experiences can engender an anxious mood. That is, the feeling tones associated with episodes of fear can linger and persist as spillover after the relevant dangers have left the field and the residual feelings can then continue to bias cognition globally in the direction of anxiety. Undoubtedly, this spillover effect is in part a consequence of the catenated operation of the hormonal feedback loops in our bodies in the aftermath of an emotional response. And, as we shall see, the capacity of emotional episodes to bring on mood states is an important factor in the capacity of artworks to arouse and elicit moods.

Some adjectival labels describing mood states include: melancholic, ebullient, jovial, angry, arrogant, placid, insecure, serene, cheerful, elated, gloomy, joyful, fearful, anxious, surgent, gay, vibrant, vigorous, zestful, apprehensive, excited, distressed, depressed, nonchalant, active, enthusiastic, morbid, sullen, alert, hostile, nervous, irritable, up, down, blue, indigo, perky, high, low, feisty, dolorous, mellow, ambivalent, obsessive, paranoid, giddy, light-headed, hysterical, schizoid, funny, sanguine, introspective, choleric, phlegmatic, ecstatic, hyper, exacerbated, humorous, and so on. From our perspective, what is interesting is that many of these terms, if not all, can also be applied to artworks and our interactions with them. Of course, many of these words differ widely in the amount of descriptive content they convey. Often, one can only indicate the temper of a mood vaguely in the broadest fashion by saying that it is "negative" ("dysphoric" in technical jargon or "down" in slang) or "positive" ("euphoric" or "up"). This is also true of mood terms in relation to art.

3. MOOD AND ART

That there is a relation between art and mood is indisputable. Mood is the theme of much art, though, of course, not all. Certain artistic genres would appear to specialize in the topic of mood. For instance, a great many lyric poems explore moods, not (or, at least, not simply) by means of naming them, but by showing them forth and exhibiting them—by elaborating concretely the kinds of biases of attention, recollection, evaluation, and outlook characteristic of the relevant moods, along with taking note and vividly recounting (and sometimes

stimulating) the somatic and phenomenological feelings that correlate with them, while at the same time fleshing out pregnant examples of the types of occasions, histories, circumstances, events, scenarios, situations, narratives, and conditions associated with the pertinent moods. Perhaps this sort of detailed examination and manifestation of the various components of mood states is what expression theorists had in mind by the notion of clarification.

The dramatic speaker of the lyric poem, whether the actual author or a persona, rehearses what a specific mood state is like by cataloguing its components, retailing the kinds of thoughts it is apt to bring forward, observing their associated feeling tones, and, maybe, notating, discoursing, or commenting on the states of affairs that occasion or encourage such mental states, or, at least, on how coincident states of affairs appear under the aegis of the pertinent moods. Many lyric poems, in other words, are expressive of moods by way of manifesting or displaying the parts of moods componentially.

Readers of lyric poetry then use the relevant examples to reflect upon moods—to recognize and recall similar experiences of mood of their own, perhaps with greater understanding inasmuch as the reader can use the poem as a model to facilitate her grasp of her own comparable moods. The reader can also use the poem to take notice and comprehend the way in which the components of various mood states go together (either coherently or incoherently),[12] and, in some cases, discover heretofore unencountered moods—their vicissitudes and timbres.

Artforms, like lyric poetry, provide a way of coming to understand moods, of becoming acquainted with them in their specificity and particularity. Because artistic explorations of moods are typically more fine-grained than scientific ones, they afford readers with more readily recognizable and informative access to the varieties and unique profiles of mood states; the poets' exhibitions, dissections, and adumbrations of moods are more diverse than the psychologists'. There are more moods in heaven and earth than can be found in any laboratory list of mood terms (or any dictionary, for that matter), and it is part of the charge of lyric poetry to map that uncharted territory—to make it available for reflection by observing it closely and specifically. Nor is lyric poetry the only artistic forum for exploring moods for the purpose of reflection. Given their close relation to lyric poems, songs can function similarly with the added increment of musical accompaniment, whereby, through melody and rhythm, the tone, tune, or feeling of the mood is captured aurally and then viscerally. Film may also function like lyric poems where shifting subjective points of view, often implemented through editing, exhibit the cognitive biases of moody cinéastes like Stan Brakhage, Jonas Meekas, and Bruce Baillie.

Novels, employing free indirect discourse, enter the minds of characters, portraying moods by showing us or displaying for us what they are predisposed

[12] Jenefer Robinson argues that artworks may clarify the way in which emotions hang together and evolve. I would like to extend her conception to moods. See Jenefer Robinson, "L'Education Sentimentale," *Australasian Journal of Philosophy*, 73/2 (June 1995): 212–26.

to remember and to notice while simultaneously sketching their attendant somatic and phenomenological states, outlining the aspirations toward which their moods incline them, along with the associated mental flexibility or inflexibility that comes with a dominant mood, and, finally, referring to the conditions that contribute to the birth of the relevant mood and/or to the manner in which the mood configures or reconfigures those circumstances. That is, by moving in and out of the mind and bodily feeling states of characters, the novelist can provide a multifaceted portrait of mood upon which audiences are invited to reflect. Similarly, theater affords access to mood not only through action and dialogue, but monologue, whereas painters conjure up moods by means of a single image, cast in the light, the color, the degree of focal sharpness or softness, the distance, and so on, that suits the mood at hand.

Supposing that moods are affective states whose function it is to bias cognitive processes such as remembrance, attention direction, sorting, scanning, and so on, it is plausible to hypothesize that artists can portray moods by imitating and/or evoking or otherwise invoking the relevant sorts of cognitive states, while simultaneously taking notice of the corresponding component feeling tones, by alluding to them or by attempting to induce them, for example, by rhythmic or atmospheric effects.

Rather than telling the reader outright the mood at issue, many authors often show or manifest it by instantiating the kinds of cognitive biases it promotes. In Shakespeare's Sonnet LXXIII ("That time of year thou may'st in me behold"), possibly his most-read poem, the mood is melancholic. The speaker's attention is riveted on images of passing: yellow leaves, barren branches, twilight, sunset, ashes, and so on. Wherever his glance turns, so to say, he finds absence. Each quatrain develops a different image of something waning, something on the brink of extinction. To employ a metaphor that Shakespeare does not, the cognitive processing here reflects a cast or frame of mind that finds every glass already more than half empty. What Shakespeare has done is to provide the reader with the implementation or instantiation of the kind of biasing characteristic of a melancholy mood. At the same time, the meter and rhyme scheme suggest the corresponding flavor of the mood by controlling the cadence that the reader is likely to bring to the sonnet (notably as one reads it expressively to oneself). One would not rush through it like a rap song. As written, it has a slow and deliberate pace; it calls for a muted tone, rather than a declamatory one. And this supplies insight into the feeling component of the mood, its tempo, and its level of energy.

Poetry like this invites the reader to speak it aloud in order to discern its expressive address, or, at least, to sound it to the mind's ear to locate an appropriate cadence.[13] That is, the reader is invited to read it expressively, either audibly or to herself. In this way, Shakespeare encourages the reader to glean a sense of what the feeling component of the mood in question is like by auto-stimulation. At

[13] Peter Kivy, "The Performance of Reading" (unpublished manuscript).

the same time, the procession of images yields access to the putative cognitive states of the speaker, disposing the reader to take them on board imaginatively, and, where that succession is marked by recurring themes, the reader also takes on or possibly impersonates the underlying biases that govern them. This enables the reader to detect the expressive mood qualities of the work and, arguably in some cases, to experience the pertinent mood in full. That is, by performing the cognitive biases of the work and by being drawn into its tempo, one gets access to the mood of the work by being immersed in the central components of the presiding mood state.[14]

In the preceding example, the cognitive biasing is explicitly situated in a speaker who alerts us to his presence by employing second-person address. But, with respect to literature, similar effects of cognitive biasing can also be found in third-person description where no explicit speaker comes to the fore. The survey of Dorothy's home in Kansas in the opening pages of L. Frank Baum's *The Wizard of Oz* finds grayness everywhere. Grayness as a color or as a psychological state is mentioned ten times in six short paragraphs.[15] Additionally, it is overtly contrasted with joy and fun. Other features of the place that are emphasized are its isolation; it is in the middle of vast prairies and the lumber for the house came from far away. It is parched—the grass is burnt-out and the paint blistered. The household itself is claustrophobic and cramped. Dorothy's guardians, Aunt Em and Uncle Henry, are described as austere—both are joyless, or laughless, as gray mentally as the landscape is physically.

The mood that pervades is one of pronounced deprivation, a sense of desiccation that is spiritual as well as environmental. Though this mood has no name that I can readily put to it, it is a downer, perhaps in the neighborhood of depression, since it returns to the idea that something is missing so often that loss seems to be its leitmotif. Following Baum's guidance through the succession of attentional shifts he orchestrates, one traverses imaginatively a series of observations that have been organized around a theme or cognitive bias that calls to mind a discernible mood pattern in such a way that one may dwell upon it reflectively or even dwell in it, sharing something like the dolors suggested by Baum's careful articulation of his fictional Kansas. This is especially likely where one tries to read the passage to oneself expressively.

Needless to say, the ways in which literary descriptions may portray the cognitive biases associated with moods and, in some cases, even contribute toward engendering them can be paralleled by various strategies of selection and emphasis in the depictive arts. Filmmakers may embody cognitive biases by editing together details relevant to specific moods. For example, the foregrounding of rain-soaked streets, seedy, dim locales, cheap bars and offices, hazy from cigarette smoke, manifests a mood we might call *noirish* (after film noir), a sort of cynical, cankered

[14] Admittedly, what such immersion involves is theoretically controversial. Luckily, spelling it out remains a challenge for another day.

[15] Perhaps it was Baum's emphasis on grayness that gave the filmmakers the idea of setting the framing story of the classic movie in black and white.

melancholy. Likewise, theatrical scenographers literally set the stage in an attempt to capture the mood of a play by assuring that what we see as the curtain rises has already been pre-biased in terms of the types of things that would catch the eye of an observer in the desired mental state. And a similar story may be told about the scenography of much representational painting.

In these cases, the world of the work of art has already been pre-structured in terms of the cognitive biases and functionally related mood states that the artist intends the audience to bring to it. The mood state, in highly clarified form, is laid out as an object or itinerary for audience reflection via the ways in which the work structures its world. Following the attentional cues the work provides, the audience tries on the cognitive biases of the relevant moods, in works where moods are advanced, and enters into them in a fashion that not only informs our grasp of the world of the work, but also, upon reflection, informs us about what the pertinent mood is like—ideally, with more perspicuity than we customarily derive from our own naturally occurring moods.

One aim of aesthetic experience is the detection of expressive properties in artworks, including the mood of artworks and/or parts thereof. Artworks that explore moods enable audiences to reflect on the components of moods and the ways they hang together. One motive viewers, listeners, and readers have in contemplating the mood states explored in art is that it affords them insight into the operation of the human heart, if only by placing moods under an artistic microscope.[16] In this way, the artist extends to the audience an opportunity to acquire self-knowledge, knowledge about the kinds of ingredients and cognitive biases that comprise human moods and about how they combine both regularly and specifically. The detection of mood qualities, however, need not be thought of as a dispassionate affair. Often, a glimmering of the mood state projected by the artwork may be felt by the reader, listener, or viewer, supplying further grist for reflection by affording another part of the componential mosaic of the mood for reflection. Of course, these feelings may be more intense and vivid than a mere glimmer, and, in those cases, they make available an immensely clarified grasp of what the mood in question is like.

Clearly, this approach to mood in art is indebted to expression theorists, such as Collingwood. I freely admit that I admire many of their suggestions. Yet it would be a mistake to regard what I have argued as a reversion to the expression theory of art. For there are at least some important differences: (1) where they speak of emotions, we are expanding the canvas to include moods; (2) expression theorists take the clarification of the affective dimension to be the *sine qua non* or defining feature of *all* art; we are only speaking of those artworks that

[16] This is one way in which the exploration of affect in art is educative. Another way may be by cultivating moods; this involves arousing and modulating moods. The latter case might be called educating affect (or emotions, or moods, as the case may be). The former case is a matter of educating people about moods. This can be thought of as an acquisition of self-knowledge, knowledge about the kind of creatures we are and our capacities; in short, knowledge about how we tick (from the inside), especially affectively. Of course, in certain instances, both types of education may be blended.

project moods and we do not presume that all authentic artworks do so or should; (3) expression theorists prize the clarification of highly individualized, virtually unique affective states, ones so elusive that ordinary language barely has words for them, whereas we see no reason to maintain that the clarification of these states is, in principle, superior to the clarification of more generic or common ones; that is, there is no reason to suppose that the clarification of esoteric or rarefied emotions is more legitimate than the clarification of ordinary, garden-variety emotions or moods; (4) expression theorists draw a sharp line between the detection of expressive properties by audiences and the arousal of affective states in audiences, whereas we suspect that the boundary is not so fixed insofar as arousing certain states in audiences may be *a* way of enabling them to detect the expressive properties, in our case, moods that are relevant to the artworks in question. Of course, the very idea that artworks may elicit, induce, or arouse moods in audiences may seem dubious to some. To that issue, we must now turn.

4. A MYSTERY ABOUT MOODS AND ART

In the previous section, it was claimed that artworks can elicit or arouse moods. Initially, this sounds neither strange nor objectionable, since, as mentioned earlier, it is a common practice in our culture to use artworks to change or modify our moods. When we feel down, we may seek out a certain artwork, say, a piece of joyous music, in order to pick ourselves up. We frequently admit that we use artworks to regulate our moods. Indeed, collections of music are marketed with the promise of promoting certain moods, such as relaxation, nostalgia, and romance. And though this use of music strikes some connoisseurs as tacky, it does not appear, in principle, impossible. Even though the expression theorist of art maintains that we should not use artworks in this way—to arouse affective states—the very fact that he rails against it shows that he believes it is possible.

 And yet, if moods are as we have presented them thus far, then it seems that there must be something curious and probably unfathomable about the way in which artworks are said to be able to arouse moods. For, on our account, the cognitive biases that moods enjoin are, in large measure, dependent on certain feelings in the body which are themselves dependent upon the coping resources of the organism, including, importantly, its level of energy relative to environmental challenges. I may be in a depressed mood because I am exhausted and my body's awareness of this biases my appraisal of my prospects. Or perhaps the depression is due to a chemical imbalance in my system that has a comparable effect on my bodily assessment of its coping capabilities. In either case, the overall mood state is intimately connected to factors over which artists have virtually no control. The states are causally linked to internal features of the subject which the artist would appear to have no way of manipulating, save maybe in the extraordinary

case of performance artworks where the audience is fed during the spectacle or administered some other substance. Put baldly, artists seem to have no direct access to the kinds of somatic levers that influence or determine mood states. So how is it possible to maintain that artworks arouse or elicit moods? On the face of it, it is a mystery.

In the next two sections of this chapter, I will try to dissolve this incongruity. My strategy involves acknowledging that artists elicit mood states indirectly rather than directly. They can do this in at least two ways: (1) by arousing emotional states in audiences which then linger on and metamorphose into mood states; and (2) by arousing certain feeling states (somatic, phenomenological ones) in audiences, which feelings are associated with the overall mood states of which they are components or constituents; these feelings, in turn, contribute to the elicitation of the cognitive biases of the mood states in question. Of these two hypotheses, the latter is surely the more speculative. So let me begin by defending the less controversial claim.

5. AROUSING EMOTION

Because moods are objectless and global, it is difficult to understand how an artist would go about eliciting a mood. Simply depicting or describing a lion will not be enough to arouse an anxious mood. That mood, in large measure, depends on the subject's bodily sense of her antecedent coping resources, including her level of available energy and state of overall tension. And that is something that most typically the artist cannot manipulate.

On the other hand, an analogous problem does not arise with the artistic arousal of emotions, since emotions have objects toward which they are directed and which contribute to the explanation of the relevant emotional state. By depicting or describing particular objects of an emotional episode in accordance with the appropriate criteria—for example, by describing or depicting the lion as dangerous—the artist has a portion of the wherewithal to elicit the emotional state in question. Once the lion is appraised in the appropriate way, the feelings that reinforce the presiding emotional state come into play. Thus, there is little dispute that some artworks have the means to arouse emotional states, however much certain expression theorists lament their tendency to do so. But, with moods, it would appear that the pertinent feelings are in motion prior to appraisal (being dependent on prior somatic states); moreover, insofar as moods are objectless, that is, without objects, moods have nothing to appraise, being instead only biases in the direction of, and not the substance of, sequences of information-processing.

But perhaps one way to solve the mystery of moods is to recall that mood states can be engendered by emotional episodes. In the psychological literature, most of the various mood-induction procedures involve precipitating an emotional state in subjects where the spillover or lingering vicissitudes of the emotional response

are used as clues for studying diverse features of mood.[17] Such a strategy seems reasonable in light of everyday experience. After a bout of anger in the morning, we frequently remain in an irritable mood for several hours, if not for the rest of the day. Furthermore, that mood may persist even after whatever motivated the emotional outburst has passed. In all likelihood, the explanation for this is connected to the fact that the self-reinforcing, hormonal-feedback systems thrown into gear by an emotional event continue to operate long past the duration of an angry reaction, thereby prolonging the bias in the subject's cognitive processing in the direction of irritable appraisals, memories, observations, and so on. That is, as pointed out earlier, moods may emerge in the wake of emotions.

Moreover, if moods may be elicited as consequences of emotional episodes, then that suggests one way in which artworks may arouse them, despite the impediments that we have outlined. For, if artists can unproblematically arouse emotions or emotion-like experiences, then they possess the means to elicit certain mood states by arousing emotions whose lingering spillover engenders mood states, that is, affectively charged biases.

What makes the artistic provocation of mood states ostensibly incomprehensible is that critical determinants of mood states lie within the subject's body, beyond the control of the artist. Emotional arousal, however, affords the artist a means of reaching, so to speak, inside the subject's body and manipulating her internal state. So one way in which artists may elicit moods is to arouse emotions whose undertow, figuratively speaking, is a mood, a set of cognitive biases that color subsequent disconnected events in the way that finding a twenty-dollar bill on the sidewalk later predisposes us to remember that even the grumpy postal worker has a mother who loves him, thereby softening our own response to him.

The possibility that artists might elicit moods by arousing emotional responses is not merely an abstract option. It is one deployed by artists with notable frequency. For example, Shakespeare's Sonnet LXXIII, cited previously, concludes with a couplet that fairly explicitly refers to the parting, most likely the death, of a loved one. The effect is a pang of sorrow so that as one re-reads the sonnet, as one typically does with such a poem, the cognitive biases in the preceding lines not only seem natural, but compelling, fostering a preponderant mood of melancholy.

Certain laboratory mood-induction procedures, such as the one named in honor of Emmett Velten, proceed by instructing subjects to read self-referential statements expressing elation or depression.[18] Subjects are also encouraged to imagine or remember events from their own lives that fit such statements as "Every now and then I feel so tired and gloomy that I'd rather just sit than

[17] For a review of such procedures, see Maryanne Martin, "On the Induction of Mood," *Clinical Psychology Review*, 10 (1990): 669–97; see also David M. Clark, "On the Induction of Depressed Mood in the Laboratory," *Advanced Behavioral Research and Therapy*, 5 (1983): 27–49.

[18] Emmett Velten, "A Laboratory Task for Induction of Mood States," *Behavior Research and Therapy*, 6 (1969): 473–82; see also: Pamela Kenealy, "The Velten Induction Procedure: A Methodological Review," *Motivation and Emotion*, 10/4 (1986): 315–35.

do anything," and "I have too many bad things in my life."[19] By concretizing these statements with reference to one's own life, the subject undergoes a mild emotional reaction whose vicissitudes enable psychologists to study features of the persisting mood.

Ex hypothesi, when one reads a lyric poem, performing the text to oneself, one takes on the voice of or impersonates the dramatic speaker. Presumably, this is something very like what one does in the Velten mood-induction procedure, though the relevant imaginings, recollections, observations, categorizations, and so forth need not be one's own, but are supplied by the author. Following the author's guidance, the reader may bring about an emotional state in herself whose lingering effects or spillover can be experienced as a mood. Perhaps this is especially so in cases in which the reader is committed to finding the appropriately expressive reading of the lines—the reading that feels right, the one whose reading promotes a mild but discernible emotional state, one that "clicks" with the text.

Nor would there appear to be any reason in principle why this dynamic would only obtain in cases mediated by the device of a dramatic speaker. The dejected mood of the opening of *The Wizard of Oz* is encouraged to a significant degree by the pity we experience for Dorothy, that contrasting spark of joy amidst all the grayness. Responding to her privation—that she is denied a child's birthright to fun—launches an emotive reaction that retrospectively consolidates and grounds the mood-like biases of the opening passages of the text, if our own attempt at expressively reading those descriptions has not already elicited a quotient of emotional friction in us, that persists as a mood.

The beginnings of temporal artworks, especially narratives, have the important function of establishing the mood for much of what is to come. Thus, they are a particularly useful place to look for the strategies artists use to enlist audiences in mood states, not only in the opening of the work, but throughout. Moreover, even a cursory look at the beginnings of narratives confirms that the provocation of emotions is a frequently recurring technique for instilling or setting the mood pertinent to the work. The novel *Jurassic Park* opens with torrential, unrelenting rain, signaling discomfort and dysphoria; the rain is getting on Dr Roberta Carter's nerves. But her attention is suddenly drawn elsewhere. A helicopter arrives from an island that is 120 miles off the coast. A child has been injured; the helicopter crew says it was an accident involving a backhoe, but the wounds look like the claw marks of a large animal. Anomalies in the case crop up. A palpable emotion of suspicion is elicited that lingers as a wary mood, exactly the sort of mind-set the author, Michael Crichton, wants the reader to have on the ready.

Of course, the film version of *Jurassic Park* begins by putting us at the scene of the mauling that we hear rather than see directly. Here, an initial episode of fear persists as anxiety. Though the moods and emotions in the different versions of

[19] Velten (cited in n.18, above), p. 475.

Jurassic Park vary somewhat, the basic strategy does not. In both instances, the mood is induced by way of arousing an emotional state.[20]

Of course, the use of emotional incidents as a means of setting the mood of a film is hardly original to Spielberg's *Jurassic Park*. During the credit sequence of *Double Indemnity*, the shadowed silhouette of a man on crutches looms ominously larger as it approaches the camera to the sounds of menacing percussion. The mild tremor of fear that attends this image is then ratcheted up in the first scene when a car crash is only narrowly averted as tires screech startlingly.[21] This bombardment of fear-eliciting effects leaves a residual disposition of wariness that is just the mood the director, Billy Wilder, wants the audience to bring to bear in this classic film noir. Toward a different end, the opening sequence of *Monsters, Inc.* engenders an episode of comic amusement in order to invest the audience with a jovial mood in preparation for what is in the offing.

Since the 1950s, popular movies have employed what are called pre-title sequences. Predictably, these are often used to establish the mood in the audience that the filmmaker supposes will best suit the reception of the film. The recent sword-and-sorcery epic, *The Scorpion King*, has such a pre-title introduction. It involves the hero, the Scorpion King (played by The Rock), battling impossible odds in order to save his brother. The Scorpion King prevails, not only due to his immense strength, but also due to his ingenuity; he maneuvers objects in the battlefield as deftly as Buster Keaton and often with analogously humorous effect. The mood of ebullience—of martial elation plus slapstick humor—that ideally the sequence mobilizes in the viewer is anchored in the emotional responses we have toward the Rock's daring deeds as a sort of aftermath.

There is reasonably reliable evidence that certain natural environments have the capacity to arouse emotional responses in us.[22] Due to our evolutionary ancestry, perhaps, open vistas strike us as reassuring inasmuch as they provide us with a clear visual field that enables us to detect the absence or approach of predators. Contrariwise, darkness and atmospheric obscurity provoke trepidation. Given the capacity of environments to engage emotional reactions, it is not surprising that many narrative artworks employ descriptions of habitats in order to promote the moods the author deems suitable.

Again, this occurs with pronounced frequency at the beginnings of works. Horror films often start on dark and rainy nights, introducing us to a viscerally forbidding, or, at least, aversive environment that engenders a low level of fearfulness, often accentuated by startling claps of thunder, in order to foster a mood of anxiety, thus calibrating audience affect for what is in store for them. *The Triumph of the Will* opens with shots of a camera sailing through the clouds. The panorama of vast skyscapes evokes an emotional experience of sublimity,

[20] And, maybe needless to say, the mood then prepares us for having subsequent emotional episodes.

[21] As this example indicates, affective reflex responses can also contribute to or prime the launching of a mood state.

[22] See Noël Carroll, "On Being Moved by Nature," in my *Beyond Aesthetics* (New York; Cambridge University Press, 2001).

putting the audience in the kind of mood the director thinks best readies the audience for the appearance of a "godlike" Hitler. That is, the way in which the landscape is deployed artistically elicits subtle emotional reactions whose spillover establishes the mood the artist intends insofar as the affective tones and biases of those emotive episodes persist. Braiding or embedding descriptions/depictions of emotionally potent landscapes in the text, then, is a significant way of launching a mood state and keeping it aloft.[23]

Dickens initiates *Little Dorrit* with a description of Marseilles that repeatedly emphasizes its scorching, unrelenting heat, its extreme discomfort, its immobilizing glare, and drowsy monotony. It is a place that feels unfriendly to human life and activities. Imagining it, the reader is apt to experience an emotional aversion to it, especially if one is trying to read Dickens's prose expressively. In this way, the text functions analogously to a mood-induction procedure. At one point, Dickens refers to the strong smell of Marseilles, as if to suggest, I think, that it stinks like rotten fish, inviting a shudder of disgust from the reader. The aversive emotions braided through this description, combined with the cognitive biases that consistently notate the paralyzing heat, insinuate a mood of grim lethargy, of externally imposed constraint. Undoubtedly, Dickens finds the induction of this mood to be strategic, for the very next movement in the chapter introduces a prison scene. Indeed, the invocation of mood in the description of Marseilles is so overwhelming that some readers (or, at least, I) initially misread the text as saying that Marseilles itself is a villainous prison, rather than that in Marseilles there was such a prison.

This is not the place to attempt to map exhaustively strategies and examples of the ways in which artists can induce mood states in audiences by exploiting the spillover of emotional episodes. It is hoped that enough has been said to corroborate that this possibility is a live one, thereby going part of the way toward dissolving the mystery of mood in art. By planting emotional interludes amidst descriptions and depictions already biased in the direction of certain moods, the spillover from the emotional event may elicit an overall mood state in audiences. Emotion prompts may be braided through a series of characteristic mood biases—for example, in the form of potent environmental cues—so that the affective tone of the correlative emotion events suffuses the uptake of the depiction or description, resulting in a full-blooded mood state. Or the structure of the text may encourage audiences to read expressively, inducing the pertinent mood states in themselves in the manner an actor might, thereby replicating aesthetically the dynamics of the psychologist's mood-induction procedures. These are some of the means at the artist's disposal for arousing genuine mood states in audiences through emotional arousal. Undoubtedly, there are others.

[23] It may also be the case that certain abstract visual images suggest landscape patterns (horizon lines, depth, atmospheric effects, etc.) in such a way that these arouse deep-seated emotional responses that induce mood states. Also, there are what might be called artificial environments—for example, the play of color, lightness, darkness, and sound in non-pictorial movie title sequences which trigger responses related to landscape perception, and, thereby, set the mood of the ensuing film.

However, even if we have supplied an explanation of how it is possible for mood states to be induced by artworks sometimes or even often, there remains a formidable lacuna in our account. As perhaps is already evident to many readers, all our examples have involved representation. This was probably entailed by our approach to resolving the mystery of moods, since we resorted to the spillover effects of emotions. And emotions take objects and have representational content. Thus, artists have access to audience emotions by means of representing emotionally relevant objects. But some of the most frequently alluded-to mood states with respect to art do not traffic in representation. Pure instrumental music is, in all likelihood, the most notorious case. Much of it seems intimately connected with the arousal of moods. As long as we are committed to emotions as linked fundamentally to representation, nothing we have said so far would appear to render plausible the notion that orchestral music, as well as other forms of non-representational art, can induce mood states. That remains a mystery, indeed a depressingly glaring mystery when one considers how natural it is to suppose that music can influence and modulate mood.

6. AROUSING FEELING

The connection between mood and music is explicit in our culture where beloved tunes bear titles like "In the Mood" and "Mood Indigo." People often say that they select music according to their mood. Where they do so in order to nurture a mood that they are already in, this seems theoretically unproblematic, since the somatic component of the affective state is already in place. The music might be said merely to accentuate or to nurse the biases implicit in the standing mood to elevated potency. So I might listen to Albinoni's "Adagio for Organ and Strings" to enhance my inclination to remember and to reflect on things past or even on the very process of nostalgia.

However, apparently, we also use music to change our moods, not simply to boost those already in place. Feeling low, for example, I may listen to the scherzo from Beethoven's "Ninth Symphony," whereas, feeling wired, I might listen to the adagio from Bach's Violin Concerto in E Major. But this seems curious if the music in question does not address the emotions. For moods are feeling-charged states, states that are somatically rooted in features of the organism beyond the composer's control, save, it would seem, by stimulating the emotions. If music has the capacity to change our moods, it must have the capacity to induce moods. Yet if it cannot engender emotional spillover, how can it induce the bodily constituents of mood states that bias the relevant cognitive processing?

Of course, it is not quite right to say that music cannot arouse emotions. Songs, of course, have representational content and thus can provide listeners with emotionally appropriate objects. Program music, suitably introduced, gives the audience something to imagine, thereby affording the requisite objects. And the music that accompanies theatrical and motion-picture spectacles, and

narrative choreography is attached to those representations in such a way that emotional responses are generally apposite. Opera, inasmuch as it combines songs *and* theater (words *and* enactment), possesses ample representational means to provoke emotions and thence to elicit moods. In these cases, the objectlessness and vague, diffuse or even ambiguous affective profile of instrumental music is supplemented by other representational devices which make definite, focused, contentful emotional responses possible, and, in consequence, emotional spillover as well. So, in these cases, there is no problem in principle with saying that mood music of this sort is feasible in accordance with the account given in the previous section.

Indeed, there may be ways in which even pure instrumental music can sometimes evoke emotional states. Some instrumental music is modeled on the sound of the human voice. Perhaps when a musical interlude sounds like an emotional exchange, maybe one fraught with angry conflict, there is enough information to enlist the listener in an emotional response. And, in virtue of its structural organization, pure instrumental music may surprise and possibly startle us, and, as well, engender certain varieties of suspense and frustration.[24] To the extent that we are willing to call these formally induced states emotions—emotions whose objects are the music—instrumental music can be said to elicit emotional responses and, subsequently, emotional spillover. Nevertheless, despite all these qualifications, quite a lot of important music remains of which it is claimed that it can induce moods, but which does not seem recuperable as emotive in any of the ways so far broached. Thus, if it makes sense to say that this pure instrumental music elicits moods, then an explanation in terms other than emotional spillover is owed.

One hypothesis that may accommodate a large number of these cases is that, while conceding that much of the relevant instrumental music lacks the means to engender emotional states, properly so called, it nevertheless has the capacity to elicit or arouse feelings, that is, affectively charged, phenomenologically sensed states. This much seems uncontroversial. Moreover, feelings are an essential constituent or component of mood states. Presumably, the somatic feelings that are parts of mood states—their affective dimension—contribute to bringing on line the cognitive biases that characterize mood states. These biases, as indicated earlier, are very broad. The feelings at issue merely calibrate the information-processing system in the direction of a wide, but hardly random, range or compass of cognitive operations, such as distinctive vectors of sorting and scanning.

On the present proposal, pure instrumental music has the capacity to induce the kinds of feeling in percipients that are pertinent to biasing the cognitive system in the ways that we identify or associate with certain mood states. That is, by activating the component or constituent feeling elements of moods, music can induce in the audience the cognitive predilections that typify various mood states. The beat of the sprightly jig induces a feeling of lightness in me that

[24] Leonard Meyer, *Emotion and Meaning in Music* (Chicago, IL: University of Chicago Press, 1956).

contributes to the cheerful way I scan and sort my surroundings or bring images to mind, or assess how the world in my ambit strikes me at this moment.

Part of this hypothesis seems unexceptionable, namely that music can stir up feelings. But perhaps some question remains about how those feelings can be connected to cognitive biases. In all likelihood, a major musical lever for the provocation of affectively charged sensations is the impression music gives of movement.[25] Instrumental music possesses tempi and rhythms, and these signal temporal velocities that suggest movement through space. Volume may also play a role. Raising the volume often intimates movement in the direction of the listener; lowering the volume portends receding movement. This is how the music is experienced or felt in the body. Instrumental music, in virtue of changing tempi and volume, can be felt as speeding up and slowing down, rising and falling, pushing, darting, going against the tide, plodding, striding, galloping, pulling, entering, leaving, surging, ebbing, soaring, swooping, gliding, stampeding, dragging, attacking, retreating, stalling, tripping, racing, flowing, resisting, reeling, pausing, resting, and so forth.[26] These terms, and a variety of others, may not only describe the musical text, but also how the music sounds or feels in our bodies.

Grounds for believing this, of course, lie in the common experience that music inspires movement. Some music makes us feel like dancing, and, needless to say, much music was originally composed to accompany dance, especially social dance, and, as well, many traditional musical structures, such as the gigue, the rondo, and waltz are based on dance forms. Likewise, marches and work songs are predicated on inspiring feelings that will dispose listeners to move in a certain way—at such-and-such a pace and level of energy. Moreover, apart from these canonical examples, almost everyone has experienced an inner impulse to move when listening to music, an urge to tap one's toes or sway to the music, to dance, or, at least, to bounce one's leg to the rhythm, or, in our culture, to "conduct" in the air from the couch. With some music, one may feel like raising a clenched fist over one's head, though in public one may refrain from doing so; with other music, a gentle caressing movement seems right. Probably no one feels like leaping to the minuet in Boccherini's String Quintet in E; small, perhaps mincing steps are what come to mind (by way of bodily sensations).

Thus far, the correlations have been primarily between the impression of movement projected by the music and the affectively charged sensations in our bodies that prompt us to move in concert with the music. But where do the relevant cognitive biases come into play? We have advanced the claim that pure instrumental music can induce mood states by triggering certain feelings, namely sensations that make us *feel* like moving certain ways. But how does that get us to the sorts of cognitive biases that crucially comprise mood states?

[25] Anthony Storr, *Music and the Mind* (New York: Free Press, 1992); and James O. Young, *Art and Knowledge* (London: Routledge, 2001).

[26] Young, *Art and Knowledge* (cited in n.25, above), pp. 54–60.

In this way: the same feelings that prompt us to move in response to the music also prompt us to imagine how someone or something would move to the music.[27] Stately music may dispose us to imagine moving in a stately fashion ourselves or to imagine others doing so, or to remember people moving in a regal procession, or to construct mental images of such pomp and ceremony, or simply to imagine a point of view moving through space like a motion-picture dolly shot. Or maybe the stately music will engage our feelings in a way that, when we scan our surroundings, what captures our attention is whatever has a dignified air or ceremonial cadence. Nor are these the only alternatives. They are cited merely to give the reader a concrete sense of the manner in which the bodily feelings, both somatic and phenomenological, generated by the impression of movement in instrumental music, not only inspires certain ranges of overt movement, but also cognitive biases, notably a tendency to *imagine*, imagistically or otherwise, or to recollect, or to attend to the kinds of movement, and perhaps associated activities and habits of mind, suggested viscerally by the movement in the music.

At the minimum, it seems fair to say that the impression of movement in music, with non-random frequency, engenders feelings that in one way or another *bring to mind* certain kinds of movement. And, if this is true, then we have successfully isolated one way in which pure instrumental music can, and often does, elicit mood states in listeners via the arousal of feelings that bias cognitive processing in the relevant ways.

The proposed link between somatic sensations of movement and our cognitive apparatus should not strike us as incredible. Motion detection as well as ascertaining the possible general significance of the movement would have been of the utmost importance to our ancestors, as it is to other animals. Scanning the environment for ambient or encroaching movement and sorting it into various categories (e.g., potentially threatening, largish force, moving rapidly toward me) has survival value both with regard to predators and prey and to our conspecifics. Being able to discern motion in our bodies in such a way that it biases the filtration of incoming information is an asset from the perspective of natural selection. It is such an advantage that we should expect it to be hair-triggered. That is perhaps why we are able to derive the impression of movement in something as "unrealistic" as music in the first place. We come equipped, in a manner of speaking, with innate motion detectors keyed to sound and vibration; it is an alerting system—sometimes an early-warning system, as when a herd of herbivores starts moving at the sound of a distant stampede.

Moreover, it makes sense from the perspective of reverse-engineering for that type of system to be information-sensitive, that it disposes cognition in some directions rather than others, that it draw attention one way instead of another. Furthermore, we are not only aurally/viscerally attuned to the onslaught of disaster, but to subtle nuances in the movement of our conspecifics—including effort and ease—both for the purposes of coordination and interpersonal

[27] This hypothesis was suggested to me by Young (ibid.), p. 57.

interpretation. Movement qualities communicate information about the internal states of others. And these kinds of qualities, too, to a certain extent, can be detected in the movement and rhythm of music as "deciphered" by the sensations that predispose mood states. That is why light and bouncy music predisposes us to both step and think lightly, and why musical tension can tighten our muscles and, at the same time, bring to mind, in whatever fashion, moving against resistance.

By means of features like tempo, volume, and rhythm, pure instrumental music can impart impressions of movement which resonate in bodily sensations that may not only prompt movement in our musculature, but which also engender cognitive biases, including the tendency to imagine certain types of movement—such as an upwardly expanding field of vision coincident with soaring music—or to notice other types of movement such as the solemnity of the funeral procession as it marches to a slow dirge. Musical movement, in other words, can put a lock on the body, infecting us with sensations that predispose our information-gathering processes—*constraining* the movement and related kinds of activities we imagine, remember, or take note of in response to dysphorically moving music, or *opening* our cognitive horizons to the beat of a euphorically moving melody.

Admittedly, the composer does not have access to the energy levels and coping resources that are among the crucial determinants of naturally occurring moods. Instead, the composer in the case of pure instrumental music has a handle on the feelings that ordinarily mediate between those states and the moods they condition. By conveying the impression of movement, in a context in which the organism is standardly, in any case, under no pressure to cope, the feelings are brought into play that already have the tendency to bias cognitive processing, at the very least by bringing certain movements and a sense of their energies to mind. In short, music can arouse somatic feelings (rather than full-scale emotions), which, in turn, can elicit full-blown moods. This is one way that pure instrumental music can be said to induce moods. There may be others. But this at least goes a good part of the way toward rendering less mystifying the common belief that instrumental music can bring on mood states.

A corollary benefit of this approach is that it suggests a way of negotiating a truce in one of the most prominent wars in the philosophy of music. Formalists argue that it is nonsense to maintain that instrumental music arouses emotion. Music lacks the logical machinery to represent the kinds of objects that such emotional states require. At best, the so-called emotions that music conveys are too amorphous, diffuse, global, or ambiguous to count as full-fledged emotions. Yet some nevertheless still claim music can arouse emotions, undoubtedly because it can be so powerful affectively. Maybe the resolution to this dispute is to grant the formalist the concession that music does not arouse emotions properly so called, for the reasons he gives, but add that in many cases what music does arouse are moods—affective states that are objectless, global, diffuse, often ambiguous (does depression possess different discernible qualia from anxiety?) and so on. This proposal gives the formalist his point, while

also acknowledging the opposing faction's estimation of the importance of the affective side of music.

The affective palette of instrumental music is notoriously non-specific; it lacks the specificity associated with particularized emotional states. This is because it trades in moods, which are global directions for thinking rather than specific thoughts. At the same time, instrumental music can become especially powerful emotionally when married to words in song, dramatic enactment in theater and opera, to human expressive movement in dance, to moving pictures in cinema, and to scenarios in programs. Given objects and focus, instrumental music modifies the respective representations affectively in intense ways. This is consistent with the functional capacity of moods to prime emotional episodes.

As well, it is commonly observed that music is eminently flexible in modifying or intensifying a wide variety of different representations. Piano accompanists of silent films replayed the same instrumental repertory for hundreds of diverse films with no loss of affect. The music always seemed to fit. This, too, is consistent with the correlation between such music and mood, inasmuch as moods are merely a matter of extremely broad cognitive biases with no specific content of their own.

Though we have been preoccupied with one way that pure instrumental music might be understood to induce moods without recourse to the notion of emotional spillover, it is hoped that the present conjecture also suggests a strategy for approaching the induction of mood with respect to some other non-representational, artistic means. For there are ways of inducing feelings of movement other than through musical instrumentation: camera movement and editing in film and TV; character movement in theater and dance; maybe certain prosodic devices can trigger the impression of movement. These are obviously subjects for future research.

But, in any event, it is not our intention to say that it is only through the impression of movement, or even only through emotional spillover and/or the impression of movement, that some artworks can, sensibly, be said to induce or arouse moods. Nevertheless, that there appear to be at least these two routes shows that there is nothing philosophically amiss with affirming, along with ordinary viewers, listeners, and readers, that some artworks elicit moods and perhaps are valuable for doing so.

7. SUMMARY REMARKS

The philosophy of art has been the beneficiary of advances in the philosophy of mind and cognitive science. This has been especially true with respect to understanding the relation of art to the emotions. As our grasp of the emotions has become more sophisticated, our comprehension of the emotional address of art has matured apace. However, as research into the emotions has become increasingly refined, it has become evident that the affective domain

is more various than philosophers, emboldened by the cognitive theory of the emotions, imagined. The affective realm is comprised not only of the phenomena characterized so well by the cognitive theory, but it is also populated by affective reflexes, affect programs, phobias, moods, and, most likely, further affective species yet to be isolated theoretically. The relevance of all these diverse affective phenomena to art deserves to be studied in depth. This chapter takes an initial look at the relation of mood to art.

Though much of this chapter concentrates on establishing the possibility that artworks can arouse or induce moods, I do not maintain that this is the only relation that artworks may have to moods. A great deal of attention is lavished on this issue only because the notion that artworks can arouse moods may seem mysterious. I try to relieve that mystery by proposing two ways in which some artworks might induce moods: by generating emotional spillover and/or arousing somatic feeling states. There may be more ways than these two. However, insofar as there are at least these two ways, the arousal of mood by artworks should not be philosophically perplexing.

In addition to inducing mood states, artworks also can express moods, where the expression of a mood state may or may not involve arousing one. On our account, artists express mood states by clarifying them, notably by projecting their constitutive parts, especially their cognitive biases, componentially. This can be done by instantiating or otherwise activating the relevant cognitive biases, and by describing, alluding to, or even stimulating pertinent feeling tones. In this way, the audience may not only savor the mood state in question, but also reflect on it, thereby cultivating deeper insight into the nature of human being.

16

On Some Affective Relations between Audiences and the Characters in Popular Fictions

1. INTRODUCTION

The focus of this chapter concerns aesthetics in the sense that Alexander Baumgarten introduced that concept. It is about sensations, especially about a certain class of feelings in relation to works of art, notably narrative fictions. The feelings in question involve the emotive responses of audiences to fictional characters. Specifically, I will explore a range of cases where, for the most part, the emotive and other affective responses of readers, viewers, and listeners tend to converge, to be congruent, or otherwise to resonate appropriately with what the fiction presents as the emotional states of characters, particularly those characters whom we label the protagonists.

Although I think that my observations are relevant to the understanding of narrative art in general, for methodological reasons I will pay especially close attention to the ways in which the characters in *popular* fictions engage our emotional responses. For, in those cases, typically, the emotions are, by design, extremely pronounced and clearcut. This is due to the fact that standardly it is part of the job description of the popular fictioneer to make his productions immediately accessible. Thus, popular fictions may afford perspicuously insight into the affective structures that also operate in so-called high art, where the emotive address may be more complex, ambiguous, and/or recessive, and, therefore, harder to pith.

As some readers have probably already noticed, rather than labeling my topic with a single term like "empathy," I have chosen instead to describe it—to say

I have profited from comments on the body of this chapter from Amy Coplans, Murray Smith, Jesse Prinz, Peter Goldie, Margaret Moore, Susan Feagin, William Seeley, Stephen Davies, Graham McFee, Martin Hoffman, E. Anne Kaplan, and the other participants in the conference on empathy at California State University, Fullerton, 2006. I have also benefited from a discussion of the main section of this paper at the Myrifield Institute for Cognition and the Arts in July, 2008, where my commentators included David Miall, Keith Oately, Willi van Peer, Margaret Freeman, Donald Freeman, Reuven Tsur, and Ellen Dissanayake. None of these scholars are responsible for the flaws in this chapter. For, despite their sage advice, I did it my way.

that I am interested in cases where the emotional states of audience members converge, are congruent with, or otherwise resonate appropriately with what we are given to imagine are the emotions of fictional characters. I have resorted to these circumlocutions and avoided the word "empathy" because I have been unable to find much consensus in either ordinary language or the relevant technical literatures about how we are to understand *empathy*.[1]

As occurs with people's usage of other emotion-vocabularies, speakers and writers, including experts, employ the relevant terminology in diverse, often conflicting, incommensurate, and/or mutually canceling ways. For example, even what are called emotions can vary appreciably. Some count reflexes and phobias to be emotions, while others categorize moods as emotions—for example, what some psychologists call "mood-induction" procedures might more accurately be called "emotion-induction" procedures, since what they elicit are short-lived, episodic states rather than more enduring ones.

This kind of terminological disagreement is very evident with respect to talk of empathy. Although most of us think of it as taking another person as its object, the term was apparently coined by Titchener who was inspired by the concept of "feeling our way into," as that was used in aesthetics to describe our affective response to objects with pronounced expressive properties, such as the impression of muscularity imparted by bulging architectural columns.[2] As well, some draw a distinction between empathy and sympathy, when they come to define their concepts; yet we find that highly respected researchers may map the terrain in very different ways. Often, in his excellent book, *Empathy and Moral Development*, Martin Hoffman characterizes empathy as others define sympathy, insofar as on his account empathy appears to involve a pro-social disposition of beneficence toward its object.[3] Others restrict empathy to the experience of cognate affective states with no necessary smidgen of concern on the part of the empath. To complicate matters, Lauren Wispé, in contrast, appears to define "sympathy" in the way that the former theorists define "empathy," namely as a condition where the spectator merely undergoes the same emotive state as the victim—which state, for Wispé, must be exclusively some negative experience, such as pain and/or distress; thus, whereas some theorists think that sympathizers can share happiness with others, Wispé thinks that only negative affect can be the medium of sympathy.[4]

For some, the object of empathy is a person; for others, a situation. Sometimes empathy only seems to pertain to simply *understanding* another person's viewpoint which, of course, is possible without feeling anything. According

[1] My suspicions are corroborated in Nancy Eisenberg and Janet Strayer, "Critical Issues in the Study of Empathy," in Nancy Eisenberg and Janet Strayer, eds, *Empathy and its Development* (Cambridge: Cambridge University Press, 1987), pp. 3–13.

[2] See Lauren Wispé, "History of the Concept of Empathy," in *Empathy and its Development*, pp. 20–3. Throughout this chapter, I have benefited from Wispé's useful historical overview.

[3] Martin L. Hoffman, *Empathy and Moral Development: Implications for Caring and Justice* (Cambridge: Cambridge Univesity Press, 2000). See, for example, p. 30.

[4] Lauren Wispé, *The Psychology of Sympathy* (New York: Plenum Books, 1987).

to other authorities, feelings are requisite, although which feelings vary. So some regard empathy as essentially cognitive, some treat it as essentially affective, and, in addition, others think it is a mixture of cognitive and affective elements.[5]

Of those who maintain the relationship involves affect, some require that the empath suffer the identical emotion-types as does the empathee; others slacken the requirement of a perfect match and ask no more than that the emotions or feelings of the emoter be suitable to the emotive state of the object of empathy; for example, Simon Baron-Cohen says empathy involves understanding the situation of another and responding with the appropriate emotion.[6] This may involve no more than feeling some negative affect in response to another's distress, or something positive when the other feels pleasure.[7]

With all this diversity of usage, the temptation to legislate is strong. This is what I think Paul Griffiths does in his book *What Emotions Really Are.*[8] He elects one candidate for the title of "emotion," and tells us little about what we are to make of the rest of the phenomena that have often been slotted under that rubric. Having shown that certain variants of the cognitive theory of the emotions are not comprehensive, Griffiths offers an alternative account of the emotions: that emotions are really affect programs. But this decision unfortunately tells us virtually nothing about how to theorize the kinds of mental states—like academic envy—that the ostracized cognitive theories handled so neatly.

On my view, such terminological vagaries should not serve as invitations to regiment matters à la Griffiths. They are rather signs that it is very likely that there are more kinds of phenomena lurking in this domain than heretofore recognized. Our nomenclature gets confusing, because we don't have enough labels to go around. So different folks keep redeploying the same linguistic repertoire to mark whatever it is that interests them. Successive generations of psychologists, for example, keep employing earlier concepts on behalf of new research programs.

The discourse gets tangled up like a reel of fishing tackle in the hands of an amateur like me because there are so many different things of interest in this sphere of inquiry, and so few markers in ordinary language, or even the available technical languages. Given this, on my view, it may be less profitable to quibble over labels, and more useful at this point to initiate an exploration of the range of the phenomena in this arena—that is, to start, at least, to develop a conceptual cartography of what we might call the realm of affect. With regard to aesthetics, this involves beginning to identify some of the dominant emotive relationships

[5] Hoffman, *Empathy and Moral Development,* p. 29.

[6] Simon Baron-Cohen writes "Empathizing . . . involves recognizing what another person may be feeling or thinking and responding to those feelings with an appropriate emotion of *one's own* [emphasis added]." Baron-Cohen, "The Male Condition," *New York Times* (August 8, 2005), p. A15.

[7] Interestingly, Baron-Cohen's conception of empathy covers the notion of sympathy that will be developed later in this chapter.

[8] Paul E. Griffiths, *What Emotions Really Are* (Chicago, IL: University of Chicago Press, 1997).

between fictional characters and their audiences. Though I make no pretense to exhaustiveness in this matter, that is the purpose of this chapter.

2. IDENTIFICATION

The natural place to start a discussion about the relation between readers, viewers, and listeners and the fictional characters to whom they attend is with the notion of identification. There are several reasons for this. First, when asked for an account of our emotive relation to fictional characters, especially to protagonists, referring to this alleged process is likely to be the answer most people, including a great many professionals, are apt to give. It is probably the oldest account in the Western tradition, where it was first introduced by Plato who feared that citizens would become possessed by the undesirable emotions, such as fear of death, portrayed by characters in the texts of poets like Homer.

Identification is also interesting for our purposes because there is one version of the notion of identification that some might be tempted to appropriate as one possible explication of empathy.

Moreover, we can use the notion of *identification* or, at least, one version of it, in order to probe critically the range of different emotive relations between audiences and fictional characters. That is, by working through various of the inadequacies of the leading notions of identification, we can begin to uncover the rich array of audience/character relationships occluded by the idea of identification.

Of course, identification, like empathy, and almost every other concept in this field of discourse, is fraught with multiple meanings—some more or less misleading, and others completely unobjectionable. In some cases, to identify with a character comes down to wishing one were like that character. It makes no claim to any sort of identity, affective or otherwise, between me and the pertinent fictional being. I wish I felt as fearless as Superman does, but, alas, I have vertigo. And I'd like to have the romantic flair of a James Bond, but I'm too afraid of rejection. But perhaps these cases shouldn't be called identification at all, but rather wishful fantasizing. Furthermore, it is not clear how much of this wishful fantasizing I can indulge while consuming a fiction without losing track of the story. And if the fiction is a movie, how will I keep up with the rapid editing, if I am off dreaming about being invulnerable and/or irresistible?

Frequently, when people say that they identify with a character, they mean no more than that they like the character or, as teenagers say, they think "he's cool." Or maybe it comes down to indicating that they've had a similar experience. The character has been dumped and so have they. These usages come without the Platonic insinuation that the imagined emotional states of the characters have infected the audience. These variants of "identification" really amount to feeling some affinity for the characters in question and might be better called "affiliation" rather than "identification."

Alternatively, sometimes identification is parsed in terms of putting myself in the place of the character. This is not a matter of putting myself in the character's shoes, as they say, but of putting the character in my shoes.[9] But why suppose that this entails that the character and I are in the same emotive states? This might be better labeled "projection" rather than "identification".[10]

What I suspect is the core concept of identification, and, for some, the core of empathy as well, involves the supposition that the audience member is in the same type-identical emotional state in which fictionally the character is.[11] This is certainly what Plato had in mind. The character in the poem fears death and then the reader also fears death. Likewise, this is the view of present-day Platonists: the protagonist evinces aggressiveness, and then the viewers, or, at least, the adolescent male viewers, are contaminated with the self-same species of aggressiveness too.

But identity of emotion-types, even if necessary, is not enough to constitute identification in the variation that I am exploring. The fans of a certain team at a soccer match may be in the same emotive state—they all hate the opposing team. Yet we wouldn't call this identification (let alone empathy). For, with whom are they identifying? Although they may all be inflamed to the same degree with hatred for the rival team, they are not identifying with each other, since they may not even be aware of the presence of the others, so wrapped up are they in the game they are witnessing before them. Or they may be home alone, watching the game on TV, oblivious to the existence of other fans.

[9] This is sometimes called perspective-taking. There are two kinds of perspective-taking, the sort described above and the case where I attempt to embrace the perspective of the other wholesale. However, there is a real question about the extent to which the latter form of perspective-taking (aka empathy and/or identification) is conceptually possible. For we can never be sure that there isn't a mismatch between the kind of person I am and the kind of person whose perspective I intend to take on (where the kind of person I am depends upon many variables of which I am typically unaware). For more sophisticated objections to this sort of perspective-taking, see Peter Goldie's "Against Empathy" in Amy Coplan and Peter Goldie, eds, *Empathy: Philosophical and Psychological Perspectives* (Oxford: Oxford University Press, forthcoming).

[10] Alessandro Giovannelli regards this as one form of empathy. I don't see why, since someone in this state could be totally misunderstanding the empathee as well as experiencing an utterly different emotion. Moreover, contra Giovannelli, experimental data indicate that this projective state cannot be empathy if empathy means having type-identical feelings with the target. For, in magnetic imagining experiments, when one is one's own target, the results differ from cases when another is the target. However, if empathy involves identical feelings, all of the cases should be the same. See Alessandro Giovannelli, "In Sympathy with Narrative Characters," *The Journal of Aesthetics and Art Criticism* (forthcoming). See also: Philip Jackson, Eric Brunet, Andrew N. Meltzoff, and Jean Decety, "Empathy Examined Through Neural Mechanisms Involved in Imagining How I Feel Pain Versus How You Feel Pain," *Neurophysiologia*, 44 (2006): 752–61.

[11] Here I am only requiring that the emotion-types be congruent. I am not stipulating that the audience member and the character must have the emotion in the same degree. I suspect that even those who believe in infectious identification will say that the emotions formed in reaction to the character may differ in intensity from those the character is imagined to suffer. Our emotions, it may be said, can be more or less intense than the characters'. Of course, this may be yet another reason to be suspicious of the notion of infectious identification, but I will not press the issue in this chapter.

Nor is it plausible that they are identifying, in the relevant sense, with any of the soccer players—the players are probably too absorbed in the activity on the field to be emoting anything, and, in any event, it is unlikely that they literally *hate* their opponents. That kind of sports hatred is for the fans, not for the professionals.

But if the sharing of type-identical emotional states is not sufficient for identification, what needs to be added? That the viewers be in the emotional state in question *because* that is the state they think that the characters are in. That is, putatively I identify, in this sense, with Anne Darrow when I am horrified by King Kong *because* she is—or I imagine her to be—horrified by King Kong. In short, the version of identification on the table is: someone x identifies with a fictional character y if and only if (1) x is in the same type-identical emotive state that y is in (2) *because* y is in—or, x imagines y to be in—that state. To speak metaphorically, the audience member has been infected by the ostensible emotive state of the character. Furthermore, this is, I submit, probably the dominant sense of the notion of identification nowadays.

I have no reason to believe that this phenomenon (or something like it) never occurs, especially in *real* life. There is empirical evidence that infants feel distress when they detect distress in their caregivers. I am not sure that this is a full-blown emotive state, rather than merely an affective reflex. But, for now, let that pass; I will talk about affective reflexes like this toward the end of this chapter.

Similarly, recent research shows that women respond in fMRI scans of their significant others being subjected to electrical shocks with the activation—to a certain extent—of the same neural pathways in themselves that are registering pain in their spouses.[12] Again, the question arises about whether these are emotive states (it depends on how you categorize pain),[13] but it doesn't seem altogether improbable to me that some emotional states, like anger, might be transmitted in this way, especially between people involved in intimate personal relationships. Nevertheless, the question remains whether this model of identification has much to offer aestheticians when it comes to our emotive responses to fictional characters. By way of preview, let me say that there is abundant cause for skepticism here.

First, let us consider the preceding characterization of emotive identification—which, for convenience, we might call the *infection model*—as a comprehensive account of our relation to fictional characters. I do not think that I am exaggerating when I say that many subscribe to this view, especially pre-reflectively. That is, they think that this account pretty much covers most,

[12] Tania Singer, Ben Seymour, John O'Doherty, Holger Kaube, Raymond Dolan, and Chris Frith, "Empathy for Pain Involves the Affective but not Sensory Components of Pain," *Science*, 303/5661 (February 20, 2004), pp. 1157–62.

[13] Feeling the pain of the other is often adduced as evidence for identification and empathy-as-identification. But surely we cannot be feeling the *same* pain as the empathee. None save perhaps the most inveterate masochist could stay seated while experiencing the same pain that Jesus experiences as the Roman soldiers flail him in Mel Gibson's *Passion of the Christ*.

if not all, of our emotive relations with fictional characters, or, at least, with the protagonists.

Nevertheless, even a cursory review of the data shows this is false. In the story, the candidate is pumped up by the adulation with which his acceptance speech has been greeted by the crowd; but we know that she is standing in the cross-hairs of a rocket-launcher, manned by an enemy assassin. We do not feel the thrill that the candidate does; we feel suspense, even anxiety. Our emotional states are not type-identical. Nor should they be, since the fiction mandates that we fear for the candidate's life.

This asymmetry of affect is also common throughout comic fictions. Every time the would-be suitor is discovered in a compromising situation, we are amused while he is discomfited. When Bertie Wooster is flustered, we are merry.

Situations in which the emotional states of the characters diverge from those of the audiences abound in fictions of all sorts. One reason for this, obviously, is that generally there is a significant differential between what we know and what the characters know, and this, of course, can have a discernibly different impact on what is felt on both sides of the audience/fiction divide. In some cases, we know more than the characters; we tremble for them as they plunge ahead ignoring clear and present danger. On the other hand, Sherlock Holmes always knows more than we do, so we never share his aplomb in the face of peril.

Circumstances like these are not rare. They may even predominate statistically. But, be that as it may, there are more than enough cases like these to establish that the infection model of identification cannot be comprehensive on readily observed empirical grounds. Furthermore, there are also conceptual considerations that invite us to suspect the infection model. Quite often, both the cause and the object of the audience's emotional state differ from that of the protagonist's affective condition. We are told that the character's son, Moe, died last year. That event was the cause of her grief; the object is her son. But the cause of the audience's emotional state is the character's grieving; and our object is the grieving mother.

Our emotion gestalts a wider situation than the mother's, while also including the object of the mother's state as a constitutory component. Moreover, our emotion is pity for the mother, not grief—who is Moe to us? It is his mother with whom we have become acquainted through the fiction. Indeed, Moe may never even have had his moment on the stage in the fiction under consideration. Since, quite frequently, our emotional states have different causes and take different objects than the putative mental states of the protagonists, the suggestion that our emotions always, or even most often, match each other perfectly is highly unlikely. So, again, the infection model must be abandoned as a comprehensive picture of our emotive relations to fictional characters.

Indeed, there are certain cases, perhaps many, where the audience member's emotional state can only be reasonably thought to be an onlooker's state rather

than one that corresponds to the object's. When we feel nailbiting suspense as the protagonist claws his way to safety, he cannot be feeling that emotion; he is probably not feeling anything. He is so caught up in and focused upon his task that his anxieties are on hold.

Nevertheless, the proponent of infectious identification may point out that, even if there are many cases where the inner states of the audience members and those of the characters diverge, there are also a significant number of cases where the emotive states at issue would appear to be type-identical. In an episode of *Law and Order: Special Victims Unit*, say, the character recoils in contempt at the child molester's ploys; so do we. Emotive symmetry obtains.

Therefore, even if the infection model fails to be applicable across the board, perhaps the argument can be made that it has compelling authority with cases like these. However, in order to test this suggestion, we need to introduce a distinction between emotions that are held in common or co-incidently versus emotions shared due to some intimate causal connection between them.

3. CO-INCIDENT VERSUS CONNECTED EMOTIONAL STATES

Jet bombers have streaked past their fail-safe points and they are winging their way to Beijing. They are freighted with nuclear devices. Atomic warfare looms; millions will die. The protagonist, the president of the United States, is stricken with fear; so are we. Isn't this a case where infectious identification can be said to obtain?

I think that it is not. The infection model of identification requires not only that our emotions match those of the protagonists, but also that our emotions be a causal consequence of the protagonists being in precisely the self-same mental states. Nevertheless, in a great many of the cases in which we find ourselves in the same emotive condition as the protagonist, including the preceding example, it is pretty obvious that we have gotten there by our own route, so to speak. We are not anxious because the president is anxious. We are anxious because we have been encouraged to imagine that a nuclear exchange, threatening a catastrophic number of deaths, is in the offing.

Perhaps some evidence for this is that the fiction could be told without reference to the president's anxiety and we would still feel anxiety. We would feel the same sort of anxiety because the fictional situation has been structured in a way that makes certain features that are appropriate to the state of fear salient—such as assessments of how much explosive power those jet bombers are carrying, their capacity to evade radar detection, their imperviousness to any and all anti-aircraft defenses as well as the putatively uneasy diplomatic relations between the United States and China.

Elsewhere, I have called this sort of structure criterial pre-focusing.[14] By that, I mean that the fiction, by means of either visual depiction, enactment, and/or verbal description, organizes or filters the situations and events it presents in such a way that the features the creators select for emphasis are those that are criterially apposite to the emotional states intended to be excited by the work. In the Odessa Steps sequence of *Potemkin*, Eisenstein foregrounds the callous massacre of old people, a young boy, two mothers, and an infant—in short, those who are culturally figured as defenseless and harmless. His selection of these vignettes, instead of shots of the clouds overhead, is designed to activate the viewer's emotions of moral outrage. For the sequence has been forcefully designed so that these factors, which are criterial to moral indignation, unavoidably command attention in a way that leads the viewer, unless he is a White Russian or a Cossack, to subsume the episode under the category of evil and, in consequence, to feel visceral distress.

Most often, I contend, when the feelings of audiences are congruent with those of the protagonist's, it is a result of criterial pre-focusing, not infectious identification. The difference is that, in the case where criterial pre-focusing leads to emotive uptake on the part of audience members, the correspondence between what the audience feels and what the characters are imagined to feel is co-incident or co-joint rather than causal. That is, the audience has been effectively led to the emotional state it is in by a pathway that can be causally independent of what, if anything, the protagonist feels. Thus, cases of congruent emotions between audience members and protagonists, though quite frequent, are typically not instances of infectious identification, but are better regarded as cases of co-incidentally congruent emotive states engineered by means of criterial pre-focusing.

Indeed, it seems to me that postulating infectious identification in most cases is to take on excess theoretical baggage, since typically congruent emotional states, where they occur, can, *ceteris paribus*, be adequately explained by means of criterial pre-focusing.

Of course, it may be pointed out that, often, the way in which situations are criterially pre-focused in fictions tends to parallel the way the protagonist sees things. Even if the narration is omniscient and not channeled explicitly through the point-of-view of the protagonist, fictional narrators often depict or describe the fictional world from the perspective of leading characters. The gloominess of the portrayal of the environment echoes the apprehensiveness of the hero as he enters the realm of Lord Voldemort.

This is a fair point, but it does not, I think, revive the model of infectious identification, however. For, on the one hand, the audience need not be aware that it is the character's viewpoint that he is being invited to take on; it is the perspective of the narrative. And, furthermore, the criterial pre-focusing will work in the same way whether or not it is crafted in a way that reflects the point-of-view of the protagonist.

[14] Noël Carroll, "Art, Narrative and Emotion," *Beyond Aesthetics* (Cambridge: Cambridge University Press, 2001).

Here, it is interesting to consider the case where the fiction explicitly establishes that the way in which events are criterially pre-focused is congruent with the emotive states of the protagonist. A striking example of this is the use of point-of-view shots in the editing of audio-visual arrays. The character looks off screen, her visage etched with horror; then there is a shot of a slimy creature—part reptile and part arachnid and part lawyer with a maw like a chain saw—and we are horrified too. Isn't that a case of infectious identification? Again, I think not, for the simple reason that we would probably feel the same level of horror if the sequence were shown without the shot of the character looking off screen.[15]

So, once again, hypothesizing infectious identification appears unnecessary. In the largest number of cases, I suspect that its conjecture violates the principle of theoretical parsimony.

Of course, this leaves open the question of why such point-of-view shots—and other perspective-disclosing devices—are used by fictioneers. The short answer, I think, is that they are a means to prime or to prepare the audience by communicating to them in a very broad way the general kind of affect the audience should bring to the objects, persons, situations, and events they are about to encounter. I will have more to say about how this communication works later, in my remarks regarding mirror reflexes.

4. VECTORIALLY CONVERGING EMOTIVE STATES

I have challenged the second condition of the model of infectious identification on the grounds that, even if the audience is in an emotive state congruent with the imagined mental state of the protagonist, that is generally the result of the reader, viewer, or listener having arrived at that state by a process situated in his or her own emotive-appraisal system, independently of any necessary causal input involving the character being in the self-same emotional state. In other words, as those jet bombers race toward Beijing, I fear for humanity because human life is, in the fiction, endangered and not because the protagonist fears for human life. The protagonist's fears need not be a causal ingredient in my fear, even though our fearful states are congruent. My fear is co-incident or conjoint with the protagonist's, while, at the same time, being causally independent from it. Or so I maintain is the standard case.

However, it is important not to misinterpret this example. The claim is not that we are never emotively influenced by the emotional states of characters, especially the protagonists and others to whom we bear a pro-attitude. For example, at the end of *The Gold Rush*, the Tramp accidentally meets up again with Georgia, the woman of his dreams; the two embrace, they kiss and they fade out into the land of happily-ever-after. They are in love, and their successful match gladdens us. Scenes like this happen all of the time in popular fictions.

[15] It might be interesting for psychologists to design an experiment to test this.

However, our previous objections to the infection model of identification should not be taken as an attempt to deny their existence. For cases like these should not be taken as cases of infectious identification.

True, the emotive states of the characters do cause us to be in a euphoric state. But our euphoric state is not precisely the state that the lovers are in. Their emotional state is one of infatuation. That is not our state; we are happy for the couple. I am not in love with Georgia. Were I in love with Georgia, I wouldn't be so happy; I'd be jealous of the Tramp. So I am not in the state of infectious identification. But I am in a state of roughly the same emotive valence. They are, let us say, euphoric and I am euphoric as well. Our emotive states converge vectorially—they both belong on the positively charged side of the scale of the emotions. We are not in the same emotional states, but our states are in broad categorical agreement and we are in that vectorially converging state with the state of the characters, because they are in that condition.

Contrariwise, when the monster in the concluding scenes of *Bride of Franken-stein* is reviled by his reanimated betrothed, we feel sorry for him. Our emotion does not match his. We do not feel the pain of the unrequited lover. Indeed, I doubt that any viewers, no matter how desperate, harbor any desires for the frizzy-haired, electrified corpse, played by Elsa Lanchester. But we do respond to the monster's misery with sorrow. It is in this sense that we share his misery. We are not miserable for being lovelorn but we do pity the monster.

Both misery and pity, of course, are dysphoric or negative emotions. Both sit on the distressful, discomforting, disturbing, or painful pole of emotional states. Again, our emotions are broadly similar in their general valence. They converge vectorially in their negative direction. Our emotions are causally coordinated. But this does not support the notion of infectious identification, unless identification means nothing more than a somewhat similarly charged feeling. But why mobilize the notion of *identity* to describe that?

I suppose that if I were empowered to legislate linguistically in these matters, the category of vectorially converging emotional states would be my preferred candidate for "empathy," since it captures the idea that the audience is resonating emotionally or "communing" with the pertinent characters, while not requiring that the audience and the protagonists be precisely in emotional synch. It is only that our emotional states are "like" each other.

The notion of vectorially converging emotions also seems to mesh with Titchener's early conception of empathy, which maintains that empathy involves feeling our way into the mental state of others. For, with vectorially converging emotions, we grasp the general valence of the internal states of others by means of the directionality of our own inner dispositions. We do not replicate the emotional state of others exactly, but instead approximate its general drift.[16]

[16] Sometimes simulation theorists speak of our *resonating* in feeling with the targets of our attention. "Resonating" seems to me a useful way of describing the relation between our emotions

When we say our feelings are *like* those of the empathee, I suspect we intend this similarity in terms of vectorially converging emotions.

Moreover, since we empathize, in my sense, with the Tramp rather than identifying with him, we are happy for his good fortune and not jealous of him, as we would be if we identified with him emotionally and, like him, loved Georgia possessively. However, I do realize that this suggestion on my part remains stipulative, since many use "empathy" to signal precisely matching feeling states rather than merely vectorially converging ones.[17]

5. SYMPATHY

Mention of empathy invites a discussion of sympathy, insofar as the two states are, though closely related, often differentiated. Sympathy is probably a concept that is used with as many various definitions as is empathy. For present purposes, I will describe sympathy as non-fleeting care, concern, or, more broadly, a non-passing pro-attitude toward another person under which rubric I include fictional characters and anthropomorphized beings of any sort whatsoever (such as Charlotte in her web). Sympathy involves a supportive response to its objects. It provides an impulse toward benevolent action with respect to those to whom it is directed, though, of course, that impulse need not and often is not acted upon, frequently because it conflicts with other interests that we might have. And, needless to say, with fictional characters that impulse cannot be acted upon. Perhaps one reason we are so free with our sympathies toward fictional characters is that, since we need not ever act on their behalf, their needs never threaten to fall afoul of our interests.[18]

Sympathy, construed as an emotional state, involves visceral feelings of distress when the interests of the objects of our pro-attitudes are imperiled, and feelings of elation, closure, or satisfaction when their welfare is secured. The emotion of sympathy under discussion possesses as a component the presiding desire that things work out well for whomever it focuses upon—that their objective interests, goals, and desires be realized. In order to be the object of this pro-attitude, the person in question must be thought to be worthy of our benevolence as a result of our interests, projects, loyalties, allegiances, and/or moral commitments. When someone is appraised to be worthy of our non-passing desire that things go well

and fictional characters in cases of vectorially converging emotions. See: Alvin Goldman, *Simulating Minds: The Philosophy, Psychology and Neuroscience of Mindreading* (Oxford: Oxford University Press, 2006), p. 132.

[17] Perhaps needless to say, I think that many claims made to the effect that our emotions perfectly match those of the characters turn out, upon scrutiny, to be vectorially converging emotions. In fact, my money is behind the claim that this is what is going on in the vast number of cases where we appear to "commune" with protagonists.

[18] Amy Coplan points out that this is a reason why we often sympathesize with fictional characters more readily than with actual people. Rousseau would have concurred, but he would have added that this made theater (the topic of his concern) morally suspect.

with her and this is linked to positive feeling tones when gratified and negative ones when stymied, then that person is the object of the emotional state that I am calling sympathy. Likewise, our response is sympathetic if we hope a character we esteem makes the right choice, as we do when, in reading *Middlemarch,* we wish that Dorothea not give into Casaubon's demands.[19] If you don't like calling this state "sympathy," you can call it feeling benevolently.

Initially, this account may seem indistinguishable from the one I recommended for empathy. The Tramp's fortunes, romantic and otherwise, flourish and we feel happy for him; our emotions converge vectorially. Nevertheless, sympathy does not always track how the protagonist feels. Sympathy concerns what we believe to be the genuine or objective well-being of the character. Should the protagonist go head over heels for the nefarious femme fatale, he may be overjoyed, but we will feel anxiety, because we surmise that his interests are endangered. So although empathy, as I've characterized it—that is, as a vectorially converging emotion—may sometimes be a part of sympathy, it need not be. Though the two states may overlap, they are nevertheless discriminable.

Moreover, I suspect that, at least with regard to the characters in popular fictions, it is probably the case that sympathy generally governs empathy (in my sense). That is, we rejoice when the character rejoices over circumstances we judge to be actually beneficial to him because he is already an object of our benevolence. We do not rejoice when the villain rejoices, because the villain is not an object of our sympathy; his well-being is not something about which we could give a fig. I would not make a similar claim about the relation of sympathy and empathy in everyday life. But, in popular fictions, characters come to us marked as worthy of our concern almost upon arrival.

In life outside of our fictions, our benevolent or altruistic attitudes toward others depend on factors such as kinship, group memberships of all sorts, and group interests. Of course, for both artistic and economic reasons, creators of popular fictions are aiming at larger audiences than a single extended family and often at audiences that exceed regional, ethnic, national, and religious boundaries. And even where their targets are less than global, they must be careful not to trigger the sectarian differences that always exist in virtually every large group. This obviously presents the creator of popular fictions with a problem to be solved, namely, how to enlist the care and concern—the sympathetic feelings—of mass audiences for fictional characters.

In order for us to feel sympathy for a fictional character, we must find the character worthy of our emotions. There must be some reason grounding our wishes that they fare well. But how will the maker of popular fictions motivate diverse audiences with often vastly variegated and sometimes even conflicting real-world interests to get behind the protagonists? As an empirical generalization, my conjecture is that the most frequent solution by far to this design problem is to construct protagonists and the other characters intended to warrant our

[19] The example comes from Susan Feagin's *Reading with Feeling* (Ithaca, NY: Cornell University Press, 1996), pp. 114–15.

concern in such a way that we perceive them to be, broadly speaking, morally good.

Morality, especially of a fairly widely shared and often nearly universal variety, gives the popular fictioneer the interest, or project, or loyalty, or touchstone of allegiance upon which audiences from similar cultures, and even sometimes dissimilar ones, can converge. The protagonists protect the lame and the halt, the helpless and the sick, the young, the old and the defenseless, while simultaneously treating them with dignity and respect. They evince a sense of fairness, justice, loyalty, honor, and are altogether pro-social, and especially pro-family, at least, where the families in question are portrayed as wholesome ones. These characters tell the truth and they keep their promises to good people, because they, themselves, are what we call good people.

By designing protagonists who are morally appealing, the producer of popular fictions purchases the criterial wherewithal necessary to engender the sympathy requisite for keeping audiences emotionally absorbed in the story. The pertinent fictional characters satisfy the criterion of being deserving of our benevolence because, in short, they are fundamentally morally deserving. They exhibit virtue, including Grecian or pagan virtues. Morality, in a very generous sense, is the project that we share with them—usually one wide enough to be recognized by Christian, Jew, Moslem, Hindu, Yankee, Korean, and Chilean alike.

Protagonists are usually good guys, since good guys are exactly what are apt to elicit pro-attitudes from the heterogeneous audiences for popular fictions, whose interests and loyalties are varied and even otherwise at odds. Such characters are attractive, but it is important to emphasize that a significant amount of their attractiveness has to do with their virtue. Morality, of the fairly generic sort found in popular fictions, is something upon which people from different backgrounds are apt to agree. Who would dare to cast the first stone at Cinderella? Even the so-called anti-heroes of popular fictions are seen to be righteous, once you get beyond their gruff exteriors. In the end, for example, Sam Spade turns out to be almost Kantian in his sense of duty.

Sympathy, in my estimation, is the central emotional response that we bestow upon the protagonists in popular fictions.[20] Needless to say, in the course of a popular fiction we may undergo a gamut of emotional reactions to the relevant characters. But it is the sympathy we feel with regard to these characters that generally plays the major structuring role vis-à-vis whatever accompanying feelings may emerge. For we are proud of the hero's success because his well-being is an object of our concern, and we are angry at the heroine for sneaking off with the city slicker because we do not think that is in her best interests. Sympathy is the primary glue that binds us emotively to the protagonists and their fates in popular fictions.

[20] I think that this view would also be shared by Murray Smith in his *Engaging Characters* (Oxford: Clarendon Press, 1995).

6. SOLIDARITY[21]

If sympathy is as central to our emotional response to fictional protagonists as I have maintained, then instances of the strongest version of infectious emotive identification must be uncommon, since sympathetic feelings, construed as emotions, are not ones that we share with their objects. Sympathy, by definition, is directed at others. The protagonist does not feel sympathy for himself; were he to do so—to any extent—that would probably turn the audience off. However, though crucial to our emotional bonding with protagonists, sympathy pure and simple is usually not the whole story of our emotional connections with protagonists. It is usually supplemented by another emotional state—which we may call solidarity.

Some fictions have only protagonists. The film *Just my Luck* is an example. There are two major characters—Ashley Albright and Jake Harden. Their names are clues to their most important attributes. She is always the beneficiary of deliriously good fortune. When she leaves her apartment without an umbrella, it immediately stops raining. And so on. He is just the opposite; if he bends down, his pants will split; if he picks up a five-dollar bill, it will be smeared with canine feces. But their luck changes hands at a masquerade ball when they kiss while dancing. Now everything Ashley attempts leads to disaster, while Jake becomes a very successful record producer. The rest of the story involves Ashley tracking Jake down in order to reclaim her good fortune with another kiss. However, they fall in love and kiss their way to some kind of providential equilibrium; they will live happily and unhappily ever after in the normal proportions.

What is striking about *Just My Luck*—and I think this is true of many romantic comedies—is that there is no real villain. There are some people who present temporary obstacles to the main characters, but they are not full-fledged antagonists. They are not on the scene long enough for our antipathy toward them to take root. We are encouraged to feel care and concern for Ashley and Jake. But there are no real bad guys in the film.

Most popular fictions, however, are not like this. Most popular fictions pit the protagonists and the other nice people against some adversaries. We are not only prompted emotionally to embrace the good people as members of a generic "Us;" their opponents belong to "Them."[22]

If sympathy toward the "Us" is characteristically elicited by portraying the protagonists and the other nice people in the fiction as morally good, then the antipathy generated toward the "Them" is generally provoked by

[21] The notion of solidarity in this chapter is meant to replace the more cumbersome idea of sympathy-cum-antipathy in Noël Carroll, "On the Ties That Bind," in William Irwin and Jorge Gracia, eds, *Philosophy and the Interpretation of Pop Culture* (Lanham, MD: Rowman and Littlefield, 2007), pp. 89–116

[22] See David Berreby, *Us and Them: Understanding Your Tribal Mind* (Boston, MA: Little Brown, 2005), especially Ch. 9.

representing Them as morally blemished. Whereas the protagonist is nice to nice people—treating good people with good manners—the villain is at least rude to inferiors and very often much worse. The antagonists pillage, cheat, rob, kill, lie, and so forth. The hero pets the old dog sleeping on the doorstep; the bad guy kicks it out of his way.

Popular fictions are most frequently *political* in Carl Schmitt's sense.[23] The fictional population is partitioned into friends and enemies—into Us and Them. Sympathy, motivated by morality, disposes us to assimilate the protagonists as belonging to Us. But the bond is usually further strengthened by introducing enemies who, in popular fictions, are customarily marked by being constructed as bad people. As I am using the term, "solidarity" is the name of the complex emotive relation of sympathy-for-the-protagonists plus antipathy-for-the-antagonists which state is typically incited in audiences in response to popular fictions.[24] The reader, listener, and/or viewer feels emotionally allied to the protagonist and against the antagonist. The antagonist instills anger, indignation, hatred, and sometimes even moral disgust in us.

Unlike sympathy in everyday life which we tend, all things being equal, to extend quite readily to most of those around us by default, in fictions our sympathy must be won. In popular fictions, the most efficient way of doing this is to render the relevant characters morally appealing. Our bond with these characters can then be reinforced by setting an array of nemeses against them whom we find repulsive, customarily because their various moral failings—from petty vices to outright viciousness—are emphatically foregrounded by means of criterial pre-focusing.

I suspect that, in most cases, our sympathy for various characters is enlisted by their evident virtues. However, in some instances, characters may obtain our sympathy on the rebound, so to speak. That is, we may be so appalled by the villain that our care and concern goes out to whomever he opposes. In other words, sometimes solidarity in popular fictions may result from the "enemy-of-my-enemy-is-my-friend" phenomenon. This, moreover, explains why it is that we sometimes find ourselves siding with characters whose morals we do not otherwise share, like Hannibal Lecter. It is that we find his enemies, the people who are trying to kill him, so much more depraved than he is, bent, as they are, on feeding him to giant, slavering pigs.[25]

Solidarity involves sympathy and antipathy viscerally felt. Though our sympathetic feelings toward the protagonists are not shared by them, our hatred for the villains often is. But we do not hate the villain simply because the protagonist does. Rather, we have detected co-incidentally on our own many of the same morally noxious characteristics of the antagonists that have impressed

[23] Carl Schmitt, *The Concept of the Political*, transl. George Schwab (Chicago, IL: University of Chicago Press, 1996).

[24] "Solidarity" as a real-world phenomenon, of course, also includes a sense of responsibility to other members of the Us, but, of course, this is not practicable with respect to fictional characters.

[25] For further discussion, see Noël Carroll, "Sympathy for the Devil," in Richard Greene, ed., *The Sopranos and Philosophy* (LaSalle, IL: Open Court, 2004), pp. 121–36.

the protagonists. Thus, when it is congruent with the protagonist's hatred of the bad guy, the antipathy component of our feelings of solidarity with the hero is basically conjoint with his. We may vent our hatred of the bad guy at the same time the hero does, but primarily as a result of our own processes of moral appraisal.

7. MIRROR REFLEXES

So far, I have explored several kinds of emotional relationships between audiences and characters in popular fictions. These have included circumstances: (1) where our emotions may be type-identical with those of the protagonists, but only due to our own independent appraisals of the relevant situations; (2) where our emotions vectorially converge upon the emotional states of the characters; (3) where we sympathize with the character (which, of course, can be an instance of a vectorially converging emotion); and (4) where we emote in solidarity with the protagonist (where the antipathy component may be an instance of a congruent response that we find ourselves in as result of our own appraisal of the situation). None of these cases correspond to the popular model of infectious identification which requires that the audience member be in an emotional state that is type-identical with the protagonist's precisely because the relevant character is in that state. But let me conclude by briefly examining a fifth affective relation—one which comes closer to the notion of infectious identification—and whose very existence probably lends a modicum of credibility to talk about our identification with fictional characters.

What I have in mind can be called "mirror reflexes."[26] This is the sort of motor imitation that Gordon Allport had in mind when he wrote: "the imitative assumption of the postures and facial expressions of other people plays a greater part in ordinary life than is commonly realized."[27] When conversing with another, we often observe ourselves knitting our brows as they knit their brows. They chuckle; we chuckle. They grimace; we grimace.

Moreover, these imitative responses are not confined to facial expressions. They extend to postures as well. We tend to fall into step with our companions; when they're walking tall, so are we. They rub their chin, we do likewise.[28] This mimicry is not restricted to real-life encounters; when Hamlet's muscles bunch up—on either stage or screen—we feel a tug in our own. In short, we have an involuntary tendency to replicate automatically in our own bodies the

[26] See Lauren Wispé, *The Psychology of Sympathy*, especially Chs 7 and 8. See also Elaine Hatfield, John T. Cacioppo, and Richard L. Rapson, *Emotional Contagion* (Cambridge: Cambridge University Press, 1994), especially Ch. 2.

[27] Gordon Allport, *Social Psychology* (Boston, MA: Houghton Mifflin, 1924), p. 530.

[28] Andrew N. Meltzoff and Jean Decety, "What Imitation Tells Us About Social Cognition: A Rapprochement Between Developmental Psychology and Cognitive Neuroscience," *Philosophical Transactions of the Royal Society of London*, 358 (2003): 494.

behavior, particularly the expressive behavior, of our conspecifics. Furthermore, this tendency is inborn and already evident in infancy.[29]

These imitative reflexes grant us some inkling of what others are feeling. When we configure our faces in the shape of another's—frowning when he frowns, for example—the feedback from our facial muscles stimulate our autonomic system in a way that is somewhat similar to his inner feelings, so long as he is sincere. This need not give us full access to his emotional state, but it supplies us with a valuable clue to the nature of that state by providing us with an experiential sense of the bodily component—the feeling state—of the occurrent emotion of the other person.

This feature of the human organism has great adaptive value and is probably bred in the bone.[30] These advantages are especially pertinent for communication. When I "catch" the negative vibes or feelings of distress of another, I immediately survey the environment to locate the source of his discomfort. His negative affect alerts me in my own musculature to the likelihood that I may soon need to mobilize some vectorially converging, negative emotion, such as fear or possibly anger.

Of course, mirror reflexes, which *may* be linked to mirror neurons,[31] are not only relevant for the purposes of gathering information about what surrounds other people.[32] By relaying to us something of what others are feeling, they help us cope with others. Detecting that one's brother is in a bad mood via mirror reflexes is helpful in deciding when to ask him for a loan. And, of course, mirror reflexes are immensely useful for coordinating group activities—for getting the troops revved-up as they march off singing in lock-step comraderie.

The communicative potential of mirror reflexes is widely exploited in audio-visual fictions, especially the theater arts and moving images of all sorts from films to CGI. The Soviet director Sergei Eisenstein, having read Theodor Lipps on the topic, quite consciously attempted to exploit mirror reflexes in his filmmaking.

[29] Andrew N. Meltzoff and M. Keith Moore, "Imitation of Facial and Manual Gestures by Human Neonates," *Science*, 198 (1977): 75–8; and Andrew N. Meltzoff and M. Keith Moore, "Explaining Facial Imitation: A Theoretical Model," *Early Development and Parenting*, 6/3–4 (September–December 1997): 179–92.

[30] Robert Plutchik, "Evolutionary Bases of Empathy," in *Empathy and its Development* pp. 38–46.

[31] On mirror neurons, see G. Rizzolatti, L. Fadiga, M. Matelli, V. Bettinardi, E. Perani, D. Fasio, and S. Fasio, "Localization of Grasp Representations by PET Observation versus Execution," *Experiment Brain Opinion*, 111 (1996): 246–52; T. Jellema, C. I. Baker, M. W. Perrett, and D. I. Perrett, "Cell Populations in the Banks of the Superior Temoral Sulcus of the Macaque, and Imitation," in A. N. Meltzoff and W. Prinz, eds, *The Imitative Mind* (Cambridge: Cambridge University Press, 2002); and L. Fadiga, L. Fogassi, G. Paves, and G. Rizzolatti, "Motor Facilitation during Action Observation: A Magnetic Stimulation Study," *Journal of Neurophysiology*, 73 (1995): 2608–61. Two articles in *Empathy: Philosophical and Psychological Perspectives* that deal with mirror neurons are: Marco Iacoboni, "Within Each Other: Neural Mechanisms for Empathy in the Primate Brain," and Jean Decety and Andrew Meltzoff, "Empathy, Imitation and the Social Brain."

[32] It should be noted that presently the mirror neurons that have been identified by researchers seem primarily dedicated to perceptual, motor, and pain mimicry rather than to emotive mimicry. This is one of the reasons for the caution in the sentence above.

He showed close-ups of clenched fists and horrified faces in the expectation that audiences would mimic these gestures in a way that would jump-start bodily feelings of consternation in them which, given the narrative context, would then segue into the emotional state with which Eisenstein wanted them to respond to the situation. Whether or not they realize their debt to Eisenstein, motion-picture makers ever since have been following his example.

Arguably, mirror reflexes are not fully articulated emotional states, but only not-quite specific, bodily feeling states, such as vague intimations of distress. Since these mirror reflexes are not full scale emotional states, they do not supply evidence for *emotional* identification.[33] But mirror reflexes are undoubtedly affective states and they are contagious.[34] Furthermore, we can use the information that we gather in this way about the putative inner states of fictional characters in the formation of our own integrated, emotional reactions to them. That is, mirror reflexes may function as sub-routines in the activation of our emotional responses to characters by alerting us to the general valence—whether positive or negative—of the characters, enabling us, thereby, to mobilize the appropriate, perhaps vectorially converging, emotional reaction to them: for example, sorrow, if we detect that they are in spiritual pain. Mirror reflexes, in this respect, supply us with clues to the way in which we should size up the situation in which characters find themselves.

Perhaps it is the existence of mirror reflexes that has led people to endorse the notion of the infectious emotional identification. This is understandable, since we do share feelings somewhat similar to those that the characters evince as a result of their ostensible manifestation of the pertinent states. Yet what is shared are not full-blown emotions, but only bodily feelings, and merely roughly similar ones at that. That is, unlike emotions, mirror reflexes do not necessarily involve appraisals, though they may afford data pertinent to forming an appraisal.[35]

Nevertheless, mirror reflexes afford the creators of audio-visual fictions with a powerful repertoire of devices which are unparalleled in literary fiction and

[33] Some, like Iacoboni, and Decety and Meltzoff in *Empathy: Philosophical and Psychological Perpectives*, write as though mirror reflexes and related patterns of mirror neuron firings are tantamount to empathizing. But if empathy is an emotion, then this seems unlikely, since these reflexes don't involve appraisals, whereas emotions do necessarily. Moreover, if empathy involves understanding, then these states can't amount to empathy, since they are pure feeling states. Nevertheless, as I indicate above, these states may contribute to the formation of emotional states. Regarding Iacoboni, and Decety and Meltzoff, see n.31.

[34] I wonder whether Meltzoff and Decety would agree with me about this. In their article, they indicate that behavioral imitation and its neural substrate precede mentalizing. Does that mean that these states in children are not yet emotions, properly so called? On the other hand, the authors speak of "empathy." Nevertheless, it is not clear if, by "empathy," they are speaking of empathy as infectious identification or merely about resonances (which might be only vectorially converging sensations) or simply feeling that we are *like* others. But, if the latter, these would appear to fall far short of the notion of empathy as infectious identification.

[35] I do not think that mirror reflexes involve appraisals, since we may detect distress in a fictional character by means of mirror reflexes, but that may lead to a sympathetic appraisal, if the character is the heroine, or a triumphant appraisal, if she is the villain.

which can be deployed to keep spectators in virtually continuous affective contact with the pertinent characters. By exploiting our biological endowments, mirror reflexes enable us to feel our way into popular visual narratives with an impressive level of ease, accuracy, and assurance which we nevertheless take for granted.

8. SUMMARY

There is no single affective relationship that describes the one and only connection between readers, listeners, and/or viewers, on the one hand, and fictional characters, on the other hand. There are a number of relations; I do not know how many. In this chapter, I have explored several: co-incidentally occurring emotions which may include the antipathy element of solidarity; the condition of vectorially converging emotions, which can encompass certain episodes of sympathetic feeling, and which category is my preferred candidate for the title of empathy (should we wish to retain that label); as well, I have discussed mirror reflexes, affective states that, though not precisely fully articulated emotions, can nevertheless contribute to their formation. In charting these affective states, I have been skeptical about the degree to which infectious identification—and empathy construed as infectious identification—accounts for our emotional bond with fictional characters, especially protagonists. However, I grant that there are more species of affective relationships in this neighborhood of the heart than I have enumerated here, which relations I hope future research will disclose.

APPENDIX: A COMPETING VIEW

Alessandro Giovannelli would undoubtedly agree about the importance that I assign to sympathy in our commerce with fictional characters. However, since his view of sympathy is at odds with mine, his position is a rival one. For Giovannelli, a certain kind of sympathy—which he calls *paradigmatic sympathy*—requires empathy as a component.[36] Empathy, in turn, is thought of by Giovannelli in terms of an empathizer vicariously experiencing the mental states and emotions of another, as if they were her own. Thus, Giovannelli thinks that some sort of identification is a part of sympathy and, therefore, denies my hypothesis that it is sympathy, construed as a state contrasting to identification, that is the primary glue that emotively attaches us to fictional characters.

Giovannelli's reason for this view is that since identification/empathy is a part of sympathy, it makes no sense to say that sympathy is a more comprehensive

[36] See Giovannelli, "In Sympathy with Narrative Characters," and "In and Out: The Dynamics of Imagination in the Engagement with Narratives," *The Journal of Aesthetics and Art Criticism*, 66/1 (winter, 2008): 11–24.

emotive fixative than identification/empathy, because they are, in a significant number of cases, a package deal.

It is not always easy to follow Giovannelli's discussion, since he frequently uses "sympathy" interchangeably with "paradigmatic sympathy"—i.e., sympathy plus identificatory empathy.[37] Thus, he will say that something is a necessary component of sympathy, where counterexamples are easy to come by. But then he will say that he is talking about paradigmatic sympathy, rather than sympathy more generally.

Giovannelli knows that sympathy in general does not require empathy. As he himself notes, a husband may sympathize with his wife who is enduring labor pains, although he lacks the equipment to experience them vicariously. Likewise a male audience member may sympathize with the sentiments expressed by the characters in *The Vagina Monlogues*, but be incapable of representing those experiences to himself. Similarly, we may not be able to imagine the experiences of those stricken by exotic diseases or by unprecedented catastrophes. And, although Giovannelli does not mention this case, we may be sympathetically indignant with respect to the treatment of others—such as the prisoners at Abu Graib—because we feel their suffering to be unjust, even though we do not feel ourselves to be suffering that injustice. I don't have to vicariously experience humiliation in order to mobilize my sympathies for those who are so humiliated.

Giovannelli will concede all this, I think, but go on to say that he is not speaking of sympathy broadly, but only of paradigmatic sympathy. Yet this raises the question of why this kind of sympathy—if there is such a thing—counts as paradigmatic and why Giovannelli thinks it should be accorded theoretical primacy. Giovannelli offers three considerations, none of which I find compelling.

The first consideration might be called "the-best-sort-of-sympathy argument." The idea here seems to be that paradigmatic sympathy is deeper than sympathy sans empathy. It is more sensitive. In everyday life, Giovannelli asserts, we want sympathy that comes garnished with empathy in contrast to sympathy *simpliciter*. With regard to our relation with fictional characters, we value the opportunity for this more sensitive sort of sympathy just because it engages us more deeply to the relevant characters. Moreover, this deeper sort of sympathy may act as a bulwark against the possibility of being manipulated sentimentally.

None of this seems persuasive to me. Paradigmatic sympathy is said to be more *sensitive* than other types of sympathy. But surely there is an equivocation here. It may be more sensitive with respect to the feelings or sensations supposedly experienced vicariously, but that does not mean that it is a more discerning kind of sympathy. I see no reason to doubt that sympathy, without the alleged accompaniment of identificatory empathy, can also be the equal of, and often surpass, what Giovannelli calls paradigmatic sympathy, in discerning the concern

[37] In fairness, it should be acknowledged that he warns us that he will do this, but it is still a little confusing at times.

we ought to bring to others. This will be the case especially where the target of our sympathies is attracted to something not in her best interests. Furthermore, I doubt Giovannelli's assertion that we want those who sympathize with us to vicariously experience what I am feeling. Although I am glad to have their sympathy, I do not want my family or my doctor to feel my pain as I lie in my hospital bed with third-degree burns.

Just because I am unconvinced that so-called paradigmatic sympathy is more sensitive in an artistically pertinent sense than sympathy, as I construe it above, I question whether we value it as the best sort of sympathy to indulge with regard to fictional characters. Nor do I see why Giovannelli thinks that paradigmatic sympathy blocks the threat of sentimentality. Indeed, I think that many, like Plato, who endorse the idea of identification, worry that taking on the experiences of characters will mislead our sympathies, often in an extremely superficial direction.

Giovannelli's next set of reasons for defending his notion of paradigmatic sympathy involve the claim that this idea can handle certain problem cases better than competing theories. These problem cases are labeled respectively as *anticipatory sympathy, conditional sympathy*, and *sympathy by proxy*. Anticipatory sympathy occurs when we muster sympathy for a character before ill fortune befalls her and her lamentations commence; for example, we feel anticipatory sympathy for the character who is about to learn that the rest of her family is dead. Conditional sympathy is extended to characters who will never know about some setback to their interests, such as the dead man who never learns his will has been overturned by his feckless children. And, lastly, there is sympathy by proxy; this involves sympathy for someone who is keenly attracted to some prospect that is not in his best interest, such as the 80-year-old millionaire smitten by the nubile, young gold-digger. Nevertheless, we feel sympathy for him, which, on Giovannelli's account, should imply we are vicariously experiencing what he experiences.

As the last example underscores, these might appear to be cases where empathy is inapposite, since the vicarious feelings of empathizers will be strikingly different from what the targets are experiencing at the moment that our sympathy takes hold.

But not so, claims Giovannelli. He says that with anticipatory sympathy, we empathize with a future or possible state of the character. In the case of conditional sympathy, we empathize counterfactually with what the character *would* feel, were he apprized of the way in which his will has been disrespected. And when it comes to sympathy by proxy, we are said to empathize with what the silly old millionaire *should* be feeling.

I find these suggestions very strange, if we are to conceive empathy as a form of identification, since, following Giovannelli's instructions, it does not appear that I am actually imagining the experiences of these characters as experiences of my own, for the simple reason that the experiences I am entertaining are radically different from the experiences these characters are thought to be having. How can we be said to have the same experiences of the characters when they themselves

are not having said experiences? Perhaps we can send our imaginations in the directions that Giovannelli suggests. But we are not identifying with the characters in question by way of sharing their experiences vicariously.

Giovannelli considers his approach to these three problems in contrast to Susan Feagin's account of audience sympathies as directed toward characters which account, like the view sketched by me above, sees the relevant sort of sympathy as grounded in our endorsement of the interests and desires of the characters, rather than in empathetic identification.[38] According to Giovannelli, his approach can explain the differences in sympathetic reactions to the characters when they are undergoing the emotions we putatively, vicariously emulate, versus when they are not suffering the feelings we emote on their behalf.

But I am not sure that there is always a difference in our experience of sympathy across these cases, and, even if there is, I doubt that it is systematic, and thus, I suspect, the differences would need to be adjudicated on a case-by-case basis, where, in fact, the model that Feagin and I embrace would not appear to be obviously disadvantaged. Moreover, on the basis of what he has said so far, I am not certain what the differences in sympathetic response are that Giovannelli has in mind, nor is it clear to me how exactly his view explains them.

In relation to the preceding point, it also needs to be emphasized that Giovannelli has failed to appreciate the methodological problem the competing theories of sympathy, based on audience alignment with the interests and desires of characters, pose for his empathy/sympathy view. For, since the interest/desire view does a nice job dealing with the cases that Giovannelli introduces, it is incumbent on him to demonstrate what explanatory pressure remains that is being relieved by the postulation of identificatory empathy. Without that, Giovannelli has failed to motivate his conjecture to the effect that empathy is a *necessary* part of (even just some sort of) sympathy. Instead, he's added a wheel to the mechanism that turns nothing, or, to put it less poetically, he's violated the methodological principle of parsimony. Until Giovannelli adduces some compelling explanatory gap in my account of sympathy that can only be closed by introducing the alleged process of identificatory empathy, a theory of sympathy, like the one I proposed earlier, has no reason to take empathy/identification on board. The burden of proof here belongs to Giovannelli.

Finally, Giovannelli believes that an account of sympathy as entailing empathy gains support from the causal connection between empathy and sympathy—namely, that empathy often leads to sympathy. Giovannelli proposes this consideration despite the fact that he realizes the notion of empathy that he presupposes is compatible with the empathizer being hostile or indifferent to the target.

For example, it is often suggested in the literature that the Complete Sadist should be an astute empathizer—all the better to grock what torments his victim. Likewise, suppose I could engender Hitler's feelings toward Jewish people in

[38] Susan Feagin, *Reading with Feeling* (Ithaca, NY: Cornell University Press, 1996).

my own heart; but that could lead me to anathematize him. Nor is there any contradiction involved in suggesting that I might empathize, in Giovannelli's sense, with the rodeo star's experience but remain indifferent to his interests and desires because I'm just not an at-home-on-the-range kind of guy.

Clearly, if there is a causal connection between empathy à la Giovannelli, and sympathy, it is an empirical question, not a conceptual one. But in order to convince us empirically that there is such a connection, Giovannelli will have to show that empathy must be added to the audience member's endorsement of the character's goals, interests, and desires in order to explain our sympathy for the protagonist. Until Giovannelli can adduce some reasons why identificatory empathy has to be added to accounts of sympathy like the one I've sketched, adding empathy/identification to sympathy seems like so much excess theoretical baggage.

PART V

NARRATIVE AND HUMOR

17

Narrative Closure

1. INTRODUCTION

Though philosophical interest in narrative is on the rise, much of it—as in the parallel field of literary study—is focused on things having to do with narrative points of view and fictional narrators, rather than being concerned with elements of plot. In contrast, this chapter will concentrate on a certain recurring, though scarcely invariant, feature of plot structure, namely, closure.[1]

From the outset, let me emphasize that I am interested specifically in *narrative* closure. Closure, of course, can obtain in modes other than narrative. One might achieve closure in a piece of rhetoric by means of a logical argument, or even by means of announcing you have four points to make and then ticking them off. Moreover, artforms other than narrative ones can also educe closure. Most obviously, there is musical closure; for example, the coda of the finale of Beethoven's "Fifth Symphony." Furthermore, there are non-narrative forms of poetic closure, ranging from metrical and rhythmic structures to the use of contrasting moods and themes as a way of rounding off and closing up a sequence of verse.[2] However, my interest here is with narrative closure; I want to isolate the primary means by which narratives secure closure—that is, in those cases where the narratives in question possess closure.

Indeed, as this last remark indicates, not all narratives have closure, or even narrative closure. For, if Aristotle was correct in asserting that tragedies have beginnings, middles, and ends, then it seems equally fair to observe, as many have, that soap operas—an indisputable specimen of narrative—have indefinitely large, expanding, and wide-open middles, with no conclusions in sight. Even if *All My Children* and *The Guiding Light*—which began life on the radio and then sprawled onto television—ever go off the air, they would

I have benefited in the rewriting of this chapter from comments from audiences at Oberlin College and the University of Capetown—and especially from Susan Feagin, Margaret Moore, and Elisa Galgut. Of course, only I am responsible for the mistakes in this chapter.

[1] Moreover, I will be preoccupied with the *structure* of narrative closure as opposed to speculation about its significance for human life, as that topic is examined by Frank Kermode in his *The Sense of an Ending: Studies in the Theory of Fiction* (Oxford: Oxford University Press, 1966).

[2] See Barbara Hernstein-Smith, *Poetic Closure: A Study of How Poems End* (Chicago, IL: University of Chicago Press, 1968).

never be able to tie up into a tidy package all the plot lines they have set in motion.

But soap operas are not the only narrative vehicles that lack closure. Narrative histories of nations—from the founding moment to the present—that is, narratives with titles like *The History of India*, usually defy closure because so many of the chains of events which they are engaged in tracing are still in process by the time the volume is sent off to the printer. It is not the case that all of the pertinent courses of activity that comprise the life of a country converge conveniently on a single terminus in time. And, for that reason, histories of nations generally stop rather than concluding, unless the civilization at hand is one that has disappeared.

Soap operas and national histories, along with many other narrative genres, are still narratives, though they are frequently bereft of closure—not because they intend closure but fail to achieve it, but rather because closure is not always apposite in narratives.[3] Thus, although closure is a recurring feature of some, even a great many, narratives, closure is not a feature of all narratives, let alone, as some have suggested, a distinctive or essential feature of narrative as such.

Therefore, closure is neither unique to narrative nor is it a feature of all narratives. Inasmuch as closure does not represent a sufficient condition for narrative, we will need to speak more precisely of *narrative* closure. But narrative closure is not, as we have seen, a necessary condition of all narratives. Some narratives just stop or come to rest, rather than ending or concluding. Not all narratives have closure. And yet narrative closure recurs so often, is so important to the history and practice of narrative (and narrative theory), and is so vivid in its effect that it nevertheless warrants philosophical discussion.

The notion of closure refers to the sense of finality with which a piece of music, a poem, or a story concludes. It is the impression that exactly the point where the work does end is just the *right* point. To have gone beyond that point would have been an error. It would have been to have gone too far. But to have stopped before that point would also be to have committed a mistake. It would be too abrupt. Closure is a matter of concluding rather than merely stopping or ceasing or coming to a halt or crashing. When an artist effects closure, then we feel that there is nothing remaining for her to do. There is nothing left to be done that hasn't already been discharged. Closure yields a feeling of completeness. When the storyteller closes her book, there is nothing left to say, nor has anything that needed to be said been left unsaid. Or, at least, that is the intuition that takes hold of the reader, viewer, or listener.

But what accounts for narrative closure?

[3] Since closure is not an effect aimed at by all stories or every kind of narrative, it should not be supposed automatically that the lack of closure is a bad thing or that narrative closure is always desirable. Some narratives eschew closure in order to prompt interpretations from audiences. For example, many art films of the sixties withheld closure for the purpose of advancing the theme of the existential meaninglessness of contemporary life.

2. A THEORY OF NARRATIVE CLOSURE

Insofar as closure, including narrative closure, is connected to completeness, it should not be surprising that the first philosopher to be concerned with closure was Aristotle for whom "tragedy is the imitation of a complete, i.e., whole, action . . ."[4] For what Aristotle actually has in mind as the imitation of a complete action is a representation of an action where the representation itself excites the apprehension of closure.

Aristotle says that a complete action has a beginning, a middle, and an end. This sounds very unpromising. Doesn't everything that is measurable—whether a sonata or a sausage—have a point where it begins in time or space, another where it ends, and a midpoint halfway between the two? But Aristotle is not using these words with their usual connotations. These are technical terms for him. They are the names of certain structural components of narratives which have certain functions to acquit. So, when Aristotle says that a tragedy (and related kinds of narrative) has an end, he does not merely mean they have to stop somewhere. He has something very exact in mind.

He says that the "*end* is that which does itself naturally follow from something else, either necessarily or in general, but there is nothing else after it."[5] On the face of it, this, of course, sounds patently absurd. Save utter apocalypse, it is metaphysically inconceivable that there should be an effect after which no further events ensue. But Aristotle's point is literary, not metaphysical. He is using the word "end" here in the way that correlates with the contemporary literary theorist's use of the notion of closure.

Aristotle is saying that the sort of narrative representation he is anatomizing concludes in the precisely appropriate place just as a piece of music with closure finishes on exactly the right note. That is, the kinds of narratives Aristotle has in mind are under no further cognitive burden to tell of subsequent events once they have secured closure. Undoubtedly, it is because tragedies have this property of closure that they evoke an aura of necessity.

We say of a narrative with closure that by the end "everything has been wrapped up." But what is meant by saying that a story "wraps things up?" A very useful suggestion can be found in David Hume's "Of Tragedy," where he observes "Had you any intention to move a person extremely by the narration of any event, the best method of increasing its effect would be artfully to delay informing him of it, and first to excite his curiosity and impatience before you let him into the secret."[6] That is, Hume observes that a very effective technique of narration involves presenting the reader, viewer, or listener with a chain of events

[4] Aristotle, *Poetics*, transl. Malcolm Heath (London: Penguin, 1996), p. 13. [5] Ibid.

[6] David Hume, "Of Tragedy," *Selected Essays*, ed. Stephen Copley and Andrew Edgar (Oxford: Oxford University Press, 1993), p. 130.

about whose outcome she is enticed into becoming curious—about which she wants to know "what happens next"—but then to hold off telling her.[7]

For example, arouse in the audience for a romantic comedy the desire to know whether the young woman will marry the boy next door, or whether she will run off with the city slicker, and then withhold the answer until the last reel. One may confirm the effectiveness of this technique—as well as the hypothesis that the audience is glued to the story by means of its curiosity—by shutting the projector down before that final reel unfolds. The viewers will jump up—as if from a trance—and demand to know who the young woman finally married.[8] For that was the question that had been organizing their viewing.

Hume's suggestion has been seconded by various authors. Eudora Welty, for example, maintains that "Every good story has a mystery—not the puzzle kind, but the mystery of allurement."[9] Edgar Allan Poe says "The thesis of the novel may thus be regarded as based on curiosity. Every point is so arranged to perplex the reader and whet his desire for elucidation."[10] And E. M. Forster notes: "If it is in the plot, we ask 'why?' "[11]

Hume calls what the audience wishes to know "the secret." Even more grandiosely, Roland Barthes labels it an "enigma."[12] But we may describe it in less inflated terminology as a question or a set of questions to which the audience expects answers. The narrator wraps the story up, then, when she has answered all the questions that have stoked the audience's curiosity. Those questions, needless to say, do not come from nowhere. They have been planted by the author in a way that makes them practically unavoidable for the intended audience. These questions hold onto our attention as the story moves forward. Closure then transpires when all of the questions that have been saliently posed by the narrative get answered. It is the point after which the audience may assume, for example, that the couple lived happily ever after and leave it at that.

[7] Sometimes, in discussions of suspense, theorists talk about delaying the occurrence of an event as a way of heightening the audience's emotional state. Sergei Eisenstein, for example, thinks that the scene in *Potemkin* where the battle cruiser meets the Russian fleet is suspenseful due to his temporal distension of the situation. But this doesn't make much sense when we are talking about a 50-minute film, since the event he is alluding to seems to take many hours in the storyworld. But perhaps Eisenstein was getting at what Hume suggests more clearly here: that anticipation can be engendered by delaying *telling* or, in the case of film, *showing* the audience the outcome of the event of which the audience is curious.

[8] On the role of curiosity in following a narrative, see Susan Feagin, *Reading with Feeling: The Aesthetics of Appreciation* (Ithaca, NY: Cornell University Press, 1996), pp. 52–3.

[9] Cited in Susan Lohafer's "A Cognitive Approach to Storyness," in Charles May, ed., *The New Short Story Theories* (Athens, OH: Ohio University Press, 1994), p. 301. The quotation originally appears in Eudora Welty, "The Reading and Writing of Short Stories," *Atlantic Monthly* (February 1949): 54–8.

[10] Edgar Allen Poe, "Mystery," in *New Short Story Theories*, p. 66.

[11] E. M. Forster, *Aspects of the Novel* (New York: Harcourt Brace and Company, 1927), p. 130. As recently as May, 2006, Philip Roth said in an interview with Robert Siegal that "The novel raises certain questions and you know that you're finished when you have answered them." The interview was conducted on *All Things Considered*, a program of National Public Radio, which aired in Philadelphia, PA, on May 2, 2006.

[12] Roland Barthes, *S/Z*, transl. R. Howard, (New York: Hill and Wang, 1974).

For instance, *Oedipus the King* begins with the plague. This naturally raises the question of whether it can be ended. This is partially answered when we learn that it can be, if only the murderer of Laius is identified and punished. Thus, the question "Who killed Laius?" is seamlessly introduced, which, in turn, becomes connected quickly to the question "Who is Oedipus?" As these questions mutate, contract, are partially answered, refined, and then decisively resolved, and we discover that Oedipus killed Laius who was, in fact, his father, and, furthermore, when we come to know that Oedipus punishes himself by gouging out his eyes, the play comes to a close, since the conditions for lifting the plague are then in place, thereby answering the question that initiated the play.

It may seem that this is a rigged example. For *Oedipus the King* is, at one level, a mystery story, and, of course, mysteries, almost by definition, ensnare their audiences with the questions of whodunit and how. Nevertheless, *Antigone*, which is not a mystery, is also driven by questions, such as: will Antigone bury her brother and what, if anything, will Creon do in retaliation? And, once we discover Antigone's fate, we wonder how Haemon will respond, and then how Eurydice will respond to Haemon's suicide.

The completeness of the play, structurally speaking, is a matter of the play answering all the pressing questions it has evoked. This structure, in turn, yields closure—the impression of finality, phenomenologically speaking. Once we discover what happens to Antigone, Haemon, Eurydice, and Creon, the play is over—closured. One doesn't go on to ask whether Tiresias will retire to a house in the country, since that is not a question the play raises in us. Tiresias's character is not such that we wonder about his future doings. Were the play to go past the point where it had answered all its salient questions—were *Antigone* to include a scene in which Ismene ponders her bridal bouquet—the closure of the story would be destabilized.

Likewise, the film *Totosi* revolves, in large part, around the question of whether the infant who has been accidentally kidnapped by Totosi will be returned to his parents. When we learn the answer to that question, the film is over. We do not ask whether the child got into Cambridge, since that is not a question the film has encouraged us to ask. The impression of completeness that makes for closure derives from our estimation, albeit usually tacit, that all our pressing questions regarding the storyworld have been answered.

A narrative of the sort that sustains closure—what we might call an erotetic narrative—is a network of questions and answers. Some scenes or sequences set out the conditions necessary for certain questions to take hold. These scenes themselves, such as the establishing scenes of a movie or the introductory paragraphs in the first chapter of a novel, generally involve answering the standing questions that we have when presented with a description of almost any set of circumstances, namely: where is the action set, when, who are these people and how are they related, what do they want, who are they for and against, why do they behave thus and such, and so on.

Some scenes or sequences evoke questions; others answer said questions directly. Still other scenes or sequences *sustain* earlier questions: the failure to

capture the escaping convict leaves us still asking whether he will be caught in a subsequent interlude. Sometimes our questions are incompletely answered: we learn that the princess will be wed, but we don't learn to whom. One question may be answered in a way that introduces a new question or set of questions, as in the case of *Oedipus the King* where the question of "Who killed Laius?" is transformed into the question of "Who is Oedipus?," or, as in the case of *Antigone*, where answering the question "What will happen to Antigone?" calls forth or (to reintroduce an archaic though immensely useful word) *propones* the question "What will Haemon do about it?"[13]

Not all the questions and answers that belong in the unifying network of the erotetic narrative are of the same order. Some questions orchestrate our attention to the emerging story from one end to the other; others organize large parts of the tale, but not the tale in its entirety, and others are of a still smaller gauge. Questions that structure an entire text or, at least most of it, we can call "*presiding* macro-questions."

Two of the presiding macro-questions of *Moby Dick* are "Will Ahab and his crew ever find the white whale?" and "If they do, will they be able to kill it?" When the *Pequod* encounters other ships that have knowledge of the whereabouts of the whale, those scenes contribute to keeping the reader bound to the story. When we finally learn the outcome of the deadly confrontation and that all of the crew, save one, of the *Pequod* have perished, the novel is over. An added chapter about the grand opening of Ishmael's dry goods store in New London would be inappropriate. For closure correlates with answering all the presiding macro-questions that the story has proposed. And we have not been encouraged to ask anything about Ishmael that is not part of the hunt for the white whale.

Yet narratives are driven from moment to moment by more than presiding macro-questions. In the pursuit of some overarching goal, the protagonist may confront a local obstacle—to save the world from the machinations of Satan, the heroine may have to retrieve a vial of holy water, perched precariously on a ledge in a cavern and protected by carnivorous gargoyles. Will she be able to reach the holy water or not? The solution of this problem is connected to the protagonist's larger project as a means to an end. Thus, this question is a micro-question, a question whose answer will contribute eventually to answering presiding macro-questions but which does not, on its own, answer the relevant presiding question directly and completely.[14]

[13] To see the functions listed in this paragraph and the preceding one enumerated, consult my "Toward a Theory of Film Suspense," in my *Theorizing the Moving Image* (New York: Cambridge University Press, 1996), p. 98.

[14] Where the answer to such a question extends over a large part of the story, comprising many scenes, I am inclined to call it a macro-question, but not a *presiding* macro-question. This vocabulary is admittedly imprecise, and I can imagine disagreement about whether something is a presiding macro-question or merely a macro-question. However, I don't think anything interesting hangs on the imprecision here, since for closure to obtain all the presiding macro-questions and all the connected, even if not presiding, macro-questions will have to be answered.

Clearly, there is a hierarchical relationship between the questions posed by an ongoing narrative. Micro-questions are *generally* subordinate to the presiding macro-questions. Closure obtains when all of the presiding macro-questions and all the micro-questions that are relevant to settling the macro-questions have been answered.

I think that partial confirmation for this hypothesis can be found in our ordinary critical responses to certain narratives. One sort of customary complaint about a story—whether on stage, screen, or page—is that something has been left out. A character is introduced in a way that grabs our attention, but then disappears. We want to know what happened to that character. Indeed, quite literally we give voice to this kind of criticism by saying "What happened to so-and-so?" For example, in *Squid and Whale,* after being alerted more than once to the fact that the prepubescent Frankie has a serious drinking problem, this character gets dropped in favor of his older brother, his problems, and his coming to face the reality of his circumstances.

In certain cases like these, not knowing may be disturbing enough to even feel irritating. What is irritating is that closure has not obtained. Why? Because certain bits of information—namely, answers to certain questions, like "What about Frankie?"—which were implicitly promised were not delivered.

Or a subplot is set in motion, but then dropped. Perhaps half of the survivors of a desert plane crash head North and the other half head South. We learn what happens to the latter group but not the former. We feel a kind of intellectual discomfort in cases such as this. We feel the story has not been finished; it remains incomplete. Why do we feel it is incomplete? Because the story engendered in us questions that it then failed to answer.[15]

Stories of the sort we are discussing—erotetic narratives—come with the promise of outcomes to the courses of events that comprise them. Though the outcomes are generally unpredictable, strictly speaking, nevertheless we expect to be able to say what happened next with respect to every significant line of action in such stories.[16] Where we cannot answer that question, or provide some interpretation of the point served in the narrative by refraining from answering said question, we feel a species of dissatisfaction that is the antithesis of the

[15] Of course, sometimes a narrative may intentionally skirt closure in order to make a point. Perhaps *Last Year at Marienbad* refuses closure in order to reveal to us a modernist lesson about the degree to which our customary practice of processing stories is driven by questions. Thus, the absence of closure is not always a bad-making feature. *Last Year at Marienbad* is not less for lacking closure. However, the carelessness regarding the plight of Frankie in *Squid and Whale* is a blemish in that particular movie.

[16] Louis Mink, discussing W. B. Gallie, says that a story gives the sense of a "promised although unpredictable outcome." I think it is more accurate to say a "promised although *generally* unpredictable outcome," since sometimes the outcome may be a foregone conclusion. Earlier scenes in a story may fully determine their consequences. However, this, I conjecture, is fairly rare. Moreover, it is because the outcomes are generally unpredictable that we have eager questions about what will happen. See Louis Mink, "History and Fiction as Modes of Comprehension," in Brian Fay, Eugene Golob, and Richard Vann, eds, *Historical Understanding* (Ithaca, NY: Cornell University Press, 1987), p. 46.

impression of closure. Thus, since it is the lack of the pertinent sorts of answers that provokes a state contrary to that of closure, it seems reasonable to hypothesize that closure is a state that is brought about when the answers are not withheld but communicated.

An alternative framework for describing the aforesaid closure-effect invokes the vocabulary of *problems* and *solutions*. Closure, in this way of speaking, occurs when the protagonists have solved all the problems with which the narrative has saddled them. The problem/solution idiom certainly applies to a very large number of cases. However, I think that the question/answer model is superior for several reasons.

Clearly, the question/answer framework will apply to every case where the problem/solution model works, since we can always ask: will the protagonist solve her problems or not? But there are also cases where the question/answer model fits, but the problem/solution model appears strained. Does it really make sense to regard the question of whether two people will fall in love as a problem? Certainly, their falling in love could involve problems—obstacles, like parents and rivals, to be overcome and so on. But it need not. Though all problems may be translated into questions, it is not evident that all questions can be translated into problems.

Moreover, is the problem/solution model suited to deal with cases where the problem goes unsolved—where the alien invaders really do inherit the Earth? Consequently, since the question/answer model for characterizing closure is more comprehensive than the problem/solution model, the former framework is to be preferred to the latter framework.

Nevertheless, even if I have motivated the notion that narrative closure is a matter of finally answering without remainder all of the presiding questions the story has raised, two further issues remain to be addressed. First, since the narratives under examination rarely contain these so-called questions literally and overtly, is this characterization of narrative closure anything more than a heuristic metaphor? Most of the representations of events that we are talking about are indicative representations—for example, literary works comprised, for the most part, of declarative sentences. So in what sense can they be construed as interrogative? Are narratives that do not ask audiences the putative questions outright really describable as posing questions? Or is this merely a *façon de parler*?

And, second: even if there is this mode of closure, why call it *narrative* closure? What connection, if any, does it have to fundamental features of narrative? And how is this supposedly fundamental feature of narrative such that it is capable of raising the kinds of questions that narrative closure succeeds in answering?

Let me attempt to answer these questions in the order I have posed them.

3. INDICATIVES AND INTERROGATIVES

Narratives are representations of series of events. Written and spoken narratives are generally made up of declarative sentences. Pictorial narratives, like motion

pictures, contain sentences, but they also represent the events they depict iconically. Nevertheless, the largest number of these iconic representations are, very roughly speaking, in the indicative mood—they propose that it is the case that x or that it is fictionally the case that x. Without the addition of further conventions, these pictorial representations do not express commands or ask questions. For the most part, they are, along with declarative sentences, what we may call indicative representations. But if narratives are mostly made up of so-called indicative representations, how can it be said that they raise questions?

Though I claim no originality in this matter, I maintain that questions can and quite frequently do arise from indicative representations.[17] When we learn that the doctor married one of the nurses, we automatically ask which one. Likewise, if told that an assassination attempt on the prime minister has just been thwarted, it is normal to ask who launched the attack and why. We ask these questions in virtue of certain background beliefs and presuppositions we already hold about the nature of assassinations—that they involve agents; and about agents—that they have motives.

Question formation on the basis of received information is a *natural thought process*. Such question formation plays a role in every kind of inquiry. With respect to erotetic narratives, we use the questions evoked by the narrative to organize and to keep track of the representations of the events and states of affairs that the story presents to us. A young man's father is ambushed by the local militia. This raises the question of what the boy will do. Next he purchases a gun. We process this in light of our previous question by surmising that he is contemplating revenge.

A question, narrative or otherwise, indicates a range of admissible answers.[18] The questions a narrative elicits from us provide a coherent framework of possible outcomes which we use to follow the incoming events in the story and to determine their significance. The questions map a circumscribed space of possibilities; the answers plot, so to speak, a line through that space which connects the specific options that obtain.

Collingwood claimed that we don't understand what a proposition means, unless we know the question to which it is an answer; indeed, he was so convinced of this that he suggested that we replace the notion of a proposition with that of a "proponible."[19] As a generalization, Collingwood's view strikes me as hyperbolic. However, with respect to erotetic narratives, it may be the case that we do not understand the significance of an event for the story, unless

[17] Throughout this section, I have been deeply influenced by Andrzej Wiśniewski, *The Posing of Questions: Logical Foundations of Erotetic Inferences* (Dordecht, Holland: Kluwer Academic Publishers, 1995).

[18] Henry Hiz, "Questions and Answers," *Journal of Philosophy*, 59/10 (May 10, 1962): 253–65.

[19] R. G. Collingwood, *An Essay in Metaphysics* (Oxford: Clarendon Press, 1940), p. 52. See also James Somerville, *The Epistemological Significance of the Interrogative* (Aldershot: Ashgate, 2002), p. 100.

we know the questions it is either answering or raising. We don't understand the import of the secret agent's hijacking the speed boat, unless we recognize it as the answer to the question of how she will gain access to the enemy's island fortress, a question subordinate to the superordinate question of how she will prevent their march to world domination. Moreover, the impression of narrative closure occurs not simply when all the presiding macro-questions and auxiliary micro-questions have been answered, but only when the informed audience member *realizes* they have been answered.

An indicative representation, such as the declarative sentence "George fell out of the moving roller coaster," *naturally* generates questions, such as "Did he die?" Answers to such questions, in turn, may generate further questions. Learning that George did not die inclines us to ask "Why not?" Each direct answer to our question modifies the range of possible, subsequent questions and answers. Being told that George did not die because the paramedics arrived in time, prompts us to ask what they did, where the answer to that is restricted to a range of medical procedures. Being told that, as George plummeted to earth, a man in blue tights and a red cape—who just happened to be flying by—caught him, opens up an entirely different range of questions. With regard to narrative closure, the successive partial and direct answers to the presiding macro-questions and their connected micro-questions progressively narrow down the field of possibilities until the occurrence of one set of events sates our animating curiosity.

In terms of erotetic narration, an indicative representation, or a set of them, or a combination of antecedent questions plus a set of indicative representations can be said to evoke a question just in case they imply that the question has an answer, but they do not entail the answer, and, furthermore, that cognizance of that question, if only tacitly, is material to understanding story.[20] The description of the murdered victim in the locked room implies there is an answer to the question of "whodunit?" without entailing the identity of the culprit and, at the same time, awareness of that question is what makes sense to the audience of the behavior of the characters.

Though it may not seem strange to think that once a story gets rolling we are lured into it by questions, one might hesitate to think that narrative questions play a role in the opening of most narratives, save for those cases where we are plunged *in medias res* into a mystery. Suppose we are introduced to a happy couple in their beautiful house. Isn't it reasonable to think that we don't have any questions until the harlot down the street appears and sets her sights on the husband. Then the plot thickens and we want to know whether the wife will meet this challenge successfully, and how, as well as whether the family will survive. But before the onset of the harlot—a complication, if you will—there do not seem to be any questions abroad.

And yet such scenes, sometimes called establishing scenes, are underwritten by the pressure to answer certain standing questions that we have in response to being introduced to any situation. If the first shot of a movie shows us a street,

[20] Adapted, with modification, from Wiśniewski.

we expect to learn where it is. And is the scene set in the past, the present, or the future? That is: "When is it?' If we are shown people, we want to know who they are, what they are doing, how they are related to one another, and so forth. If, as in the beginning of Stephen King's recent novel *Cell*, we are introduced to a series of acts of senseless violence, we desire to know what is happening here and why.

Aristotle says that a "beginning is that which itself does not follow necessarily from anything else, but some second thing naturally exists or occurs after it."[21] As with his notion of *the end*, understood metaphysically, this definition is, *prima facie*, imponderable. But Aristotle is not thinking of the beginning as an event in nature, but as a narrational unit. Every event in nature occurs as the consequence of some earlier events. However, the beginning of the sort of narrative that we are discussing need not elucidate all of the causal antecedents of the event being depicted in order to proceed intelligibly for the audience.

Stories begin on a need-to-know basis—specifically, they supply us with the information that we need to know in order to follow the action as it starts to evolve. When Aristotle says the beginning does not follow from anything else, I interpret him to mean that we do not need to know anything other than what we are told at the outset in order to understand the events that are to follow immediately. What is prior to the action but unsaid is not necessary, as the story begins from the point of view of narrative comprehension. Down the line, we may need more information as the plot adds more details, relations, and becomes more complex. And, in narratives with closure, we will get it. Nevertheless, at the beginning, we generally need to know nothing other than what we have been told in order to fathom the presentation of events as the beginning starts to evolve into the middle. The beginning is a tidy packet of information, providing us with what we need to track what happens next.[22]

But this does not mean that we have no questions at the beginning of the story. Rather, the beginning is supplying us, usually unobtrusively, with the answers we expect to the standing questions that we bring to a description of any situation. Where is it situated and when? Who is involved? Who are they? What are they doing? Why? And so on. Establishing the action, in other words, is a matter of answering the kind of questions we automatically use to structure the states of affairs we encounter. Indeed, this function of the beginning—to answer standing, though generally, implicit w-questions—is archly disclosed and exploited when, at the opening of Spike Lee's *Inside Man*, the criminal genius poses these questions explicitly and then answers them (though not quite forthrightly).

Furthermore, the erotetic structure of a narrative need not correspond in a linear way with the temporal order, in the storyworld, of the event-series being

[21] *Poetics*, p. 13.

[22] At least one qualification is required here. In addition to the establishing information, some narratives also lead off with a question. For example, the opening of *Citizen Kane* prompts us to ask for the meaning of "Rosebud," while the beginning of *Mildred Pierce* leads us to question "who killed the Zachary Scott character?"

described. That is, an answer to a question that the narrative poses may require that the story move back in time into the past of the storyworld, rather than ahead, thereby moving in the opposite temporal direction of the telling of the tale which telling, of course, goes inexorably forward in real time. Certain events in the narrative may raise questions that call for a flashback, for example. In the recent thriller *Nightlife* by the novelist Thomas Perry, certain questions about why the character we first encounter as Tanya behaves as she does are gradually illuminated by giving us her backstory in flashbacks. Even more radically, the recent films *Memento* and *Irreversible*, as well as Martin Amis's novel *Time's Arrow*, tell their stories backwards, thoroughly reversing the temporal order of the storyworld in order to answer the questions the narrative raises in us.

Furthermore, answers to our questions about events in a narrative may also be provided by flashforwards, as those might be employed by a historian who jumps ahead in time to tell us the reason why a certain White House reception was significant is that one of the young men shaking the hand of JFK in the accompanying photograph will himself be the future president: William Jefferson Clinton, who was inspired to emulate Kennedy on that very day. In the movie *Don't Look Now*, the flashforward to the funeral launch prompts us to ask "Who has died?"

Indicative representations, such as declarative sentences, can evoke questions. This includes narrative representations of sequences of events. The answers to the questions proponed by the story can follow the temporal arrow of the storyworld or they can depart from it. In any event, closure will obtain when all of the presiding macro-questions and the micro-questions whose answers are required cognitively to render the answers to the macro-questions intelligible are resolved.

4. ON THE NATURE OF NARRATIVE AND ITS RELATION TO NARRATIVE CLOSURE

Even if providing answers to self-posed questions is the way in which narratives achieve closure, it remains to be explained why this should count as *narrative* closure. After all, one could organize a philosophy essay like this one by promising to answer a certain brace of questions and then proceed to do so. Well done, such an essay might instill a pleasing sense of closure as it concludes, but presumably it will not be narrative closure. So what is it that makes for narrative closure in a narrative? A narrative, of course, may have more strategies for securing closure than plot structures. If it is an epic poem it may also have metrical devices at its disposal. But what is it about narratives and the kinds of questions that drive them that make for narrative closure?

In order to say how the species of closure discussed in the preceding section might count as *narrative* closure and in order to explain how certain fundamental features of narrative have the capacity to engender questions, I need

to say something about the nature of narrative. Building upon work published elsewhere,[23] I contend that narratives are characterizations of sequences of events which are comprised of what I call "narrative connections." Different kinds of narratives—novels, character studies, short stories, memoirs, national histories, the recountings of battles, and so forth—are proper members of the pertinent *narrative* genres only if they contain a certain proportion of narrative connections which connections are presented with sufficient salience or emphasis. I have not worked out the application of this hypothesis for any particular narrative genre. Nevertheless, I think that one consequence of this view—one to which I am happily committed—is that the possession of *some* narrative connections is a necessary condition of anything we are prepared to call a narrative.

Obviously, my account of the concept of narrative depends upon my conception of the narrative connection. So let me say, without further adieu, that, by my lights, a narrative connection obtains when: (1) the discourse represents at least two events and/or states of affairs; (2) in a globally forward-looking manner; (3) concerning the career of at least one unified subject; (4) where the temporal relations between the events and states of affairs are perspicuously ordered; and (5) where the earlier events in the sequence are at least causally necessary conditions for the subsequent occurrence of the events and/or states of affairs in the chain of events being described, or are a contribution thereto.[24] This last condition, of course, allows that the relation of the earlier events cited in the discourse may be so strong as to be fully sufficient causally to account for the subsequent events in the description. However, the relation can be, and, I believe, most often is, weaker than this. The earlier event cited in the description of the sequence may be no more than an insufficient but necessary part of an unnecessary but sufficient condition for the subsequent, correlative event, or perhaps it need be no more than merely informative about the event's causal history.[25]

My emphasis on the role of causation in the approach to narrative is scarcely novel. One might even call it the common view. What may have some claim to originality in my version of this approach is the way in which I have tried to tame the relevant causal requirement. For a frequent objection to theories of narrative that advert to causality is that they make the causal condition too stringent, often by inadvertently suggesting, through omitting any pertinent qualifications, that all the relationships between the earlier and subsequent events cited in a narrative are causal and/or that the causal relationships in question are of the strongest sort, namely, that the antecedent events cited fully determine the occurrence of subsequent events. I have tried to correct these excessively powerful claims by (a) claiming that only some of the events at issue need be causally connected and (b) by noting that the causal relationships in question can be very weak indeed.

[23] See my "On the Narrative Connection," in my *Beyond Aesthetics* (New York: Cambridge University Press, 2001), pp. 118–33.

[24] "On the Narrative Connection," pp. 119–28.

[25] That is, it may only merely be some kind of contribution to the elucidation of the causal history of the later event. This notion comes from David Lewis, "Causal Explanation," in his *Philosophical Papers*, vol. II (Oxford: Oxford University Press, 1986), pp. 214–40.

The earlier events need be no more than INUS conditions for the citation of the later events[26] or merely otherwise informative about the causal history of the event.

Nevertheless, though I have weakened the role that causation plays in narrative, it is still the case that causation, very broadly construed, figures in my account importantly as an essential, identifying feature of narrative. Moreover, I conjecture that it is primarily the causal inputs in erotetic narratives that raise the presiding macro-questions and the pressing micro-questions whose answers secure closure with respect to such stories and histories. A character forms an intention, has a desire, a need, a purpose, a goal, or a plan; or she has a commitment, an ideal, or makes a promise. These motivational states comprise part of the causal conditions of her action. They also generate questions about whether her intentions, desires, purposes, goals and/or plans will be realized. Can she live up to her commitments, ideals, and promises? Certain obstacles, challenges, or problems erupt. These too structure the causal context of her action. Can she meet them or will they defeat her?

An abduction motivates a rescue attempt. This generates a question: will it succeed? A murder causes the desire for revenge: will it be realized and how? Someone finds himself in a crushing financial predicament—his bicycle has been stolen and he cannot afford a new one. But he needs a new one in order to find work to support his family. What will he do? Can this crisis be resolved?

Characters form beliefs about the situations in which they find themselves. They interpret their circumstances. Othello, led on by Iago, comes to believe Desdemona has been unfaithful. Recognizing Othello's belief, we ask: "What will he do?" "Will he kill his wife?"

So far, these examples have exploited the mental states of fictional characters (and, implicitly, the intentional states of actual people in non-fictions) as the causal inputs that frequently generate the kinds of questions whose answers eventually bring on closure. However, there is no reason to restrict the causal inputs to subjective states. Objective causal conditions can also raise narrative questions. In the film *March of the Penguins*, the rapidly falling temperature abets the presiding macro-question of whether the eponymous penguins and their progeny will survive.

Of course, not only causal inputs but effects may raise presiding macro-questions. Presented forcefully with certain effects, like the crop circles in the movie *Signs*, we will expect answers about their origins. Thus, in addition to causal inputs, presiding or large-scale macro-questions can be introduced by puzzling events. This, of course, is the way of classical detective stories. Consequently, any question that arises from the causal nexus of the story will count as a narrative question proper whose answer may then be an ingredient in narrative closure.

[26] On INUS conditions, see J. L. Mackie, "Causes and Conditions," in Myles Brand, ed., *The Nature of Causation* (Urbana, IL: University of Illinois Press, 1976), and J. L. Mackie, *The Cement of the Universe* (Oxford: Oxford University Press, 1980).

In one of the most famous episodes in *Dallas*, after almost every character who has made an appearance in that installment is supplied with a motive, J. R. Ewing is gunned down outside his office. Which one of them did it? Throughout the summer months, an anxious nation asked "Who shot J.R.?" What was the cause of that fateful effect?

As argued earlier, the evocation of such questions is the result of a natural thought process. Moreover, the very insufficiency of the stated causal connections in most narratives—as noted above—incites our curiosity.[27] For, though typically unpredictable, strictly speaking, an outcome will be presumed to be in the offing. Thus, it is natural to ask, if only tacitly, what it shall be. Such questions are *narrative* questions because they arise from an internal feature of narratives. And that is why the closure that correlates with these questions warrants being designated narrative closure.

That is, in order to qualify as a narrative, stories require the citation of causal linkages that connect earlier episodes to later ones. The citation of these causal linkages, in turn, has the capacity to raise the kinds of questions with respect to the narrative that prepare the way for closure. The sorts of questions that are generated by the causal networks that contribute to connecting the past, present, and future in stories warrant being called narrative questions because of their intimate relation to an essential feature of narrative, and, furthermore, answering said questions provokes the phenomenological condition that deserves to be called *narrative* closure because the questions at issue have been generated narratively.

In contrast, the use of a series of questions to organize a philosophical essay and to imbue it with closure would not be narrative closure, since, in the usual case, the questions are not being generated by the citation of causal networks that connect the earlier and later events described in the discourse. Instead, the questions are presumably being introduced rhetorically, perhaps enumerated or listed, and then answered argumentatively. They are neither evoked nor resolved by an ongoing story. Since they are neither raised narratively nor answered narratively, they are not narrative questions nor do they portend narrative closure. *Narrative* closure obtains when it is the description of the causal nexus or parts thereof which generates the presiding macro-questions and the subordinate micro-questions which rivet our attention and which finally answers them, thereby eliciting a sense of completeness in us.

5. RECENT OBJECTIONS

The preceding account of narrative closure depends on my conception of narrative. My view of narrative is a fairly unexceptionable one. It relies heavily on the notion of causation, though I have tried to temper my deployment of this concept by explicitly acknowledging that not all the relations between earlier and

[27] I owe this point to Susan Feagin.

later events in narrative are causal and that the relation of those earlier events to later ones that are causal need not be fully deterministic; the earlier events and states of affairs may only be causally necessary conditions for the events or contributions of information about the event's causal history.

Nevertheless, even my watered-down version of the causal approach has come in for criticism. Specifically, critics have denied that causation is a necessary ingredient in narratives. These criticisms, moreover, are multiply threatening to my project, since, if successful, they would not only undermine my theory of narrative but also my account of the way in which narratives raise questions, since my account is fundamentally dependent upon the causal component of the narrative connection. In short, if it is denied that causation plays a necessary role in narrative, then it looks as if my analyses of erotetic narration and narrative closure must be abandoned.

Various criticisms of my view of narrative, however, miss their mark because they are aiming at the wrong target. I have hypothesized that we classify discourses as this or that kind of narrative on the basis of their possession, to a salient degree, of a certain proportion of narrative connections. I then go on to propose an analysis of the narrative connection. Notice: I am defining the narrative connection, not narrative. But some of my critics proceed as though I were defining narrative.

They challenge some of the conditions I advance—such as the causality condition or the temporal perspicuity condition—on the grounds that not all the successive events and states of affairs in a narrative need be connected causally nor need the temporal relations be unambiguous throughout.

I, of course, concede both of these points with respect to an entire work of narrative, such as a novel. But I am not analyzing a narrative as a whole, but only one of its crucial ingredients—namely, the narrative connection. To argue that a given type of narrative must possess, with a certain salience, a certain proportion of narrative connections admits there can be relations between some of the events in the narrative that do not meet my criteria. In order to defeat my conjecture, the critic would have to maintain that you could have a narrative where there were no temporally perspicuous and/or causal relations between the events in the alleged story. But I don't think any of my critics have gone as far as that.

J. David Velleman agrees that narratives are full of causal relations, but he disagrees that therein dwells the crux of narrative. As I understand him, he thinks that a narrative is a description of a sequence of events that completes what he calls an emotional cadence—where an emotional cadence would be something like the catharsis of pity and fear that Aristotle predicts tops off a genuine tragedy.[28]

But I do not find Velleman's counter-proposal very compelling. Surely, one may tell an affectless narrative—perhaps one about the collision of a comet with an asteroid in a galaxy far, far away. I see no reason to deny that such a story

[28] See J. David Velleman, "Narrative Explanation," *Philosophical Review*, 112/1 (January, 2003): 1–25.

could be a narrative, even though it arouses no emotion. Many scientific and historical narratives are dispassionate, but they are still narratives. Perhaps most aesthetic narratives engage the emotions. But there are also literary experiments that strive for a clinical, affectless presentation of events.

Maybe the emotional completion that Velleman has in mind is the impression of closure; perhaps he suspects that all narratives have closure. But, as was emphasized in the opening portions of this chapter, not all narratives, properly so called, possess closure. Suppose a man keeps a diary, recording his affairs day by day. One morning he is run over by a truck and he dies immediately. He is important enough that his diary is published. Just beneath his last entry, his editor appends the following notice: "XY died on September 15, 2005; he was run over by a truck."

Since this diary will be full of narrative connections, it will be classified as a narrative according to my approach. And I suspect that most people will agree that it is a narrative. But it will not have closure. Like poor XY's life, the diary ends abruptly. Perhaps some will argue that this is not really a narrative, but only an incomplete narrative, since XY did not get to finish it. But if that is your worry, then imagine a novel just like XY's published diary, where the author has scribbled "The End" on the last page.

So, since not every narrative provokes affect (not even the feeling of closure), the completion of an emotional cadence is not a necessary condition for narrative. Nor is it a sufficient condition. For a xenophobic rant such as the following is not a narrative:

> These foreigners have come to our country illegally. They have flooded our schools and hospitals. They have exploited our public services. They have taken our women. We must deport them!

This speech, though describing a series of events, is an argument, albeit one of questionable merit. Nevertheless, the last step in this harangue will probably arouse a cumulative emotional state in intended audiences. Yet, clearly it is not a narrative, although it is difficult to see how this conclusion can be blocked on Velleman's view.

On the other hand, my account can explain why the rant is not a narrative. The reason is that the event-descriptions that comprise the speech are related primarily as premises in an enthymematic argument rather than in terms of what I call narrative connections.

6. SUMMARY

In this chapter I have attempted to develop an account of narrative closure. On my view, narrative closure is the result of a narrative structure's answering of all the pressing questions it has stirred in the audience. The work of provoking these questions (and then answering them) is accomplished predominantly through the causal networks in the story. Since said causal networks, properly construed,

are essential features of narrative, the closure secured through the relevant causal networks is appropriately called *narrative* closure. Though narrative closure is not a feature of all narratives—it rarely figures in the stories folks tell their mates about their day at work—it recurs with great frequency in narratives created for aesthetic consumption. Indeed, it is often a key element in what makes such stories exciting.

18

Narrative and the Ethical Life

In recent years, the conjunction of "narrative" and "ethics" has become increasingly frequent. There are even books with titles like *Narrative Ethics*.[1] In this chapter, I will not attempt anything as ambitious as the construction of a narrative ethics. Rather, I will explore certain relations between these two practices, focusing especially on the ways in which various recurring structures of typical narratives can abet some of the purposes of our ethical lives.

For more than a decade, some philosophers, perhaps most notably Martha Nussbaum, have drawn a contrast between the quality of moral insight to be had from ethical theory (and the reasoning it enjoins) versus that available from narrative. In this comparison, narrative is often said to win. Without trying to establish that one of these modes is superior, across the board, to the other, in this chapter I will examine several of the kinds of contributions that (some) typical narratives—in virtue of specific structural features—can make to ethical understanding and deliberation.

I will begin by sketching the advantages certain typical narratives have over ethical theorizing when it comes to promoting clear and often convergent moral understanding; this advantage has to do primarily, I maintain, with the emotive resources at the disposal of typical narratives. Next, I will investigate what it is structurally about some typical narratives that make them particularly suitable for educating readers, listeners, and viewers about virtue (and vice)—that is, for improving our understanding of the virtues (and the vices) and our ability to recognize them when we encounter them face to face. Lastly, I will consider how narrative plays a role in moral deliberation both at the local level of how to act and also in the more comprehensive sense of designing a meaningful life.

1. THE NARRATIVE ADVANTAGE

In *Tales of Good and Evil, Help and Harm*, the late Philip Hallie writes:

General principles, like John Stuart Mill's greatest happiness (which makes an action good insofar as it tends to create more pleasure than pain) or Immanuel Kant's categorical

[1] For example, Adam Zachary Newton, *Narrative Ethics* (Cambridge, MA: Harvard University Press, 1995).

imperative (which makes an action good if the idea behind it can be made into a universal law without conflicting with itself), do not make the goodness in helping as clear to me as do the stories of The Good Samaritan or Father Damien. At their best Kant's and Mill's philosophies are ingenious generalizations about particular people and doing particular things. I can understand their principles only insofar as I can understand a story that embodies them. If there were no stories to illuminate their principles, I would not understand the principles at all. They would be words about words.[2]

In this quotation, Hallie is drawing a contrast between moral theories, which he refers to in terms of general principles, and narratives; and he is claiming that narratives have certain advantages that moral theories do not. Specifically, they have a greater power to clarify moral issues than do narratives. In conversation, Hallie also often said to me that it was his experience that when teaching ethics, he found that students were more likely to converge in their moral judgments when exposed to a typical narrative—a narrative composed of developed characters and particularized situations—than they would if left to negotiate an issue equipped with moral theories and the deductive type of reasoning they recommend.[3] In fact, disagreement, he claimed, was more likely to eventuate where only the latter were deployed. Hallie's sentiments in this matter are not uncommon. In this section, I would like to explore the question of whether there is anything about typical narratives—about their structure—that would lend credence to such a view.

Hallie, himself, suggested one reason why typical narratives might have the power that he attributes to them. He writes: "It has been said that God dwells in detail; be that as it may, it is plain that good and evil and help and harm dwell in detail, or they dwell nowhere else."[4] Poetically put, this observation suggests that what typical narratives possess and which general moral theories lack is detail, particularity, and concreteness. Moreover, this is a frequently repeated conjecture. Whether fictional (such as *Great Expectations*) or non-fictional (such as Plutarch's *Lives*), typical narratives are more fleshed out than the steps in a deductive argument that employs abstract moral principles (for example, citing general rules, duties, and obligations) and thin descriptions of particular situations.

Among other things, the concreteness ascribed to typical narratives involves the fact that typical narratives are, comparatively speaking, richer in terms of their contextualization. We have a better idea of who the characters are (of their motivations, commitments, thoughts, reasons, desires, and feelings), of what (often moral) problems they confront, and of what options are practically available to them. We are problem-solving animals and, in this regard, typical narratives get our pragmatic juices flowing. Because typical narratives are concrete, they function to engage us in grappling with the situated problems they show

[2] Philip Hallie, *Tales of Good and Evil, Help and Harm* (New York: HarperCollins, 1997), p. 6.
[3] Hallie and I were colleagues at Wesleyan University in the 1980s.
[4] Hallie, *Tales of Good and Evil, Help and Harm*, p. 7.

forth in a way that enables us to find moral clarity. That is, the greater detail found in a typical narrative gives the mind more to work with and elicits greater understanding because it encourages a quotient of active problem-solving on one's own part for the reader, viewer, or listener as she contemplates the predicaments of the agents in the story.

It seems reasonable to believe that this might be part of the story. It is certainly said often enough to count as a truism. But it cannot be the whole story for two reasons. First, ordinary experience is detailed, particular, and concrete, but no one would allege that it is a source of moral clarity. Indeed, quite the opposite seems to be the case. And, second, there is nothing in the concreteness hypothesis that satisfactorily explains why many typical narratives are very frequently able to elicit convergent moral judgments—for example, that Claggart is evil.

In order to deal with observations like these, it is necessary to supplement the concreteness hypothesis by noting that, in addition to being concrete, typical narratives are also abstract. They are patently more abstract than ordinary events, since the detail they afford has always been selected from an indefinitely larger array of further potential details. Moreover, it is probable that whatever advantages typical narratives possess for enlisting roughly convergent responses is highly dependent on the principles of selectivity or abstraction (abstraction as extraction or distillation) that operate as a necessary condition of narrativity.[5]

So the advantage that typical narratives possess relative to general moral principles is that they are both complex *and* simplified, rich *and* compact, concrete *and* abstract. However, this sounds less like an explanation and more like an invitation to inconsistency. Perhaps it only appears to be an explanation because everything follows from a contradiction.

The philosopher of history Peter Munz thinks of narratives as concrete universals, echoing Hegel's characterization of artworks in general.[6] Maybe because the phrase "concrete universal" has a distinguished lineage and has been repeated sufficiently often, it strikes us as less offensive logically than alternatives such as "concrete abstraction." But it is still paradoxical. Nevertheless, rather than discarding it peremptorily, I would like to probe the possibility that it can be interpreted, at least with respect to typical narratives, in a way that may elucidate what it is about such narratives that make them more useful for certain moral purposes than other modes of presentation.[7]

[5] That is, selectivity is a necessary condition of narrative. No narrative can tell the "whole story" (if it even makes sense to speak of such a thing).

[6] Peter Munz, "Introduction," *The Shapes of Time* (Middletown, CT: Wesleyan University Press, 1977); Nina Rosenstand, *The Moral of the Story* (Mountain View, CA: Mayfield Publishing Co., 1994), p. 28; and G. W. F. Hegel, *Introductory Lectures on Aesthetics* (London: Penguin, 1993).

[7] In order to avoid cumbersome verbiage, throughout I speak of typical narratives and their potential contributions to ethics. But obviously I am not speaking of *every* typical narrative, since some may have little or nothing to do with ethical matters and others that intend to contribute to ethics may fail to do so. So the reader should understand that in this chapter I am only talking about *some* typical narratives, namely, those which are concerned with ethical issues and which deliver on

Both Munz and Hegel connect their concrete universals to purposes that they take to be connected to universal historical processes. The images and stories that concern them are parts of larger stories, ultimately of the story of History writ large. This is not a way that we can understand the phrase, however, since we are both skeptical of the notion that there is a story of History writ large and because it is improbable to suppose that every typical narrative can be nested neatly inside such an overarching tale anyway. And yet it does seem plausible to construe narratives as having a dimension of particularity or concreteness along with a dimension, if not of universality, then at least of generality. The real problem here is showing how these dimensions fit together in a straightforward and non-paradoxical fashion, and then going on to show how this specific constellation of features has something to do with the power of typical narratives to clarify moral understanding and even to encourage converging moral judgments.

Undoubtedly, it is easiest to start with the particularity side of this relationship. Typical narratives—narratives with moderately worked-out characters, circumstances, problems, options, and so forth—are concrete insofar as they recount singular events by means of detailed descriptions and/or depictions. Whether alluding to fictional worlds, or to the actual world, they are usually primarily concerned with individuals. This seems uncontroversial. But where does generality enter the picture?

At least one avenue—and one of especial interest to us—is the way in which those particular persons, places, things, states of affairs, actions, and events are framed emotively. The inhabitants of narratives are not only described and/or depicted in terms of their physical and psychological characteristics. Most frequently, particularly when we are speaking of the major players in our narratives, an emotional stance—whether explicitly or more often implicitly—toward the character is also part of the description. The stature, fortitude, and strength of the hero are not merely described; the hero is described admiringly in a manner that is intended to elicit admiration from us. Events and actions in narratives are also standardly described/or depicted through an emotive perspective that the reader, listener, or viewer is invited to share; and even places and objects are frequently subjected to what we might call affective coloration. This is true of typical narratives, both fictions and non-fictions alike.

But what does this undeniable feature of affective coloration have to do with the generality component of typical narratives? Let us pause to recall the nature of what are called cognitive or garden-variety emotions, the sort of emotions most comprehensively pertinent to typical narratives, especially written ones.

Certain emotions—such as pity, fear, anger, horror, admiration, awe, indignation, outrage, sorrow, joy, and so on (emotions often at the very heart of typical narratives)—have a cognitive component. This involves the subsumption, often

that interest successfully. This chapter is an attempt to say something about the structures of such narratives which make their success possible. I do not mean to be claiming that all typical narratives are successful in these matters or that all concern ethical issues, but only that some are and that part of their success—in ways spelt out above—is due to the structures discussed herein.

automatic, of the particulars toward which the emotions in question are directed under the pertinent emotion-category in virtue of specific, necessary criteria of application. To be angry, for example, I must regard the object of my mental state to be someone or something that has wronged me or mine. To be angry, in other words, is to be in a cognitive state—to believe, or to construe, or to entertain the thought that, or to somehow otherwise cognize the object of my anger under the category of perceived injury (or affront) to either myself or to some person, affiliation, cause, or even thing to which I am allied. Thus, the "universal" figures in an emotional state inasmuch as that state is governed by certain *necessary* criteria of application.

Emotions, that is, are comprised of, among other things, a generality component—garden-variety emotions or cognitive emotions involve concepts, concepts whose general criteria of application must be perceived or cognized to obtain with respect to the particular object of the emotion before the emotion, if we are not malfunctioning, can take off. Or, more simply, in order to be enraged at the particular pickpocket who filched my wallet, I must categorize his action under the concept of a wrongness done to me; if I conceptualized it as a favor, I would not be angry.

But what does this have to do with typical narratives? Typical narratives elicit or are intended to elicit emotional responses from audiences. This may be achieved by blatantly stating the intended emotional stance outright. But more often than not the relevant emotion is called forth or *proposed* by the way in which the persons, places, things, events, and actions are portrayed. Specifically: they are portrayed in such a way that certain features of the situation are foregrounded or made salient. The monster in the horror novel is arrestingly described in terms of those features that emphasize what is slimy and noxious about it, on the one hand, and what is life-threatening, on the other hand.

These descriptions may be routed through the mind of a character via what literary theorists call focalization.[8] Or these properties of the monster may be called to mind by an omniscient narrator. Either way, they focus attention on the monster in virtue of certain attributes rather than others. Which attributes? Those that satisfy the categories of the impure and the harmful, the disgusting and the fearsome. Why? Because those are the categories that are constitutive of horror, the emotional state the author hopes to engender in readers. By describing the monster saliently in light of those general properties that satisfy the criteria of the mental state of horror, the author disposes the reader to subsume, usually automatically, the particular monster in the text under the concept of the horrific and, thereby, the author hopes to jump-start the appropriate response in the reader. And, once in such a state, the reader will search out, albeit with the help of the author, further details in the descriptions and ongoing story that will reinforce the prevailing state of horror.

[8] Gerald Prince, "A Point of View on Point of View or Refocusing Focalization," in Willie Van Peer and Seymour Chatman, eds, *New Perspectives on Narrative Perspective* (Albany, NY: SUNY Press, 2001), pp. 43–50.

That is, once the emotional state is aloft, it will guide the subject cognitively, inclining her to track further details in the narrative that are relevant to the presiding emotional condition. The reader, with the author's assistance, will gestalt or configure the fictional state of affairs under the rubric of horror, or, less prosaically, will be horrified. This state, moreover, is not a punctal eruption. Once alerted by its outburst to the horrific variables in the description, the reader's horizons of expectation continue to be shaped by the forward-looking emotion, disposing her to attend to incoming variables that can be assimilated into her emotive gestalt while overlooking others.

A similar account can be developed for visual narratives. In that case, the director will depict the array in such a fashion that details relevant to the intended emotion are selected for emphasis and given visual prominence in the scenography. Through images rather than words, ideally, the details criterially pertinent to horror will come to dominate what we see and what fills our minds, triggering the subsumption of the spectacle under the desired categories, thereby engendering the anticipated emotional state which, in turn, once engaged, will continue to influence the audience's continued scansion and organization of her perceptual field.

I call this structural feature of typical narratives *criterial pre-focusing*.[9] The author or director describes or depicts narrative events in a way that is pre-filtered or emotively pre-digested in its details so as to promote and then sustain certain emotional responses rather than others. The way in which the relevant details are pre-filtered or pre-focused—that is, selected in the first instance and then made to stand out distinctively—is in accordance with the criteria that govern the activation of the desired emotional state. By addressing the affective system in this manner, ideally, the system is primed and then thrown into gear, inducing how the audience reacts initially and then how it follows, processes, and configures subsequent descriptions and depictions.

The objects of the emotions described and depicted in detail in the typical narrative are concrete particulars, but the principles of selection and salience that preside over their representation by the text are generic or general, namely, they are the necessary conditions for the emotions in question which serve to criterially pre-focus the text. Thus, typical narratives are concrete universals in at least this sense: their emotional address involves a concrete individual as the particular object of the wonted state *and*, as well, the operation of universal or necessary conditions—what were once called the formal objects of the emotion—as those play a role in the way the narrative has been pre-focused criterially. The concrete components of the narrative are the particular objects it describes, depicts, and/or displays, while the general component enters in the manner in which the particular object is presented in consilience with the criteria essential to the pertinent emotional state. Or, in other words: the particular is what the typical narrative is about, but its emotive address requires a level of

[9] See Noël Carroll, "Art, Narrative, and Emotion," in *Beyond Aesthetics* (Cambridge: Cambridge University Press, 2001).

generality—criterial pre-focusing—which pre-focusing belongs to its mode of presentation of whatever it is about. This is one important sense in which a typical narrative possesses both concrete and general dimensions.

Whereas Aristotle drew the contrast between history, poetry, and philosophy in terms of distinctions between what is, what is probable, and what is necessary, I am proposing distinctions between what might be thought of as an unadorned chronicle of a series of events, a typical narrative, and moral theory: where moral theory is concerned with abstraction, unadorned chronicles are concerned with particulars, and typical narratives occupy a middle ground, concerned with abstract particularity or concrete universality—at least in terms of the emotive address characteristic of them due to their criterially pre-focused, particular details.

If we have made some sense of the notion that typical narratives can be called concrete universals, it still remains to be shown what relevance this putative finding might have for moral understanding. *Ex hypothesi*, this admixture of particularity and abstraction provides some advantages, at least for some purposes, for typical narratives vis-à-vis moral theory. But what are the nature of these advantages?

Concreteness and abstraction interact in the typical narrative at the level of emotive address.[10] The play between these factors puts the audience in an emotional state. But emotional states are not merely a matter of bodily feeling states. They are also mechanisms for judging situations and sizing them up, usually automatically. Emotions sift through stimuli, weigh or assign different strengths to pertinent variables, and organize said details quickly and clearly, blinkering some and highlighting others. Moreover, emotions not only structure incoming information, they assess it. Perhaps it might even be said they organize the relevant details by assessing them.

Emotions are fast mechanisms for evaluating things. The emotions are marvels of computing that single out, sort, and weigh a large number of variables in a manner that makes situations pellucid to us. Our emotions "look out" for our concerns and, thereby, embody our values. Emotions put us in touch with our values. They enable us to size up a situation in terms of value. By portraying a situation in terms of an emotive optic, then, an author or director can mobilize

[10] Some readers may feel that what I am referring to as the "emotive" address of the typical narrative would be better labeled the "aesthetic" address. I have no objection, so long as the aesthetic address is understood as including the emotive address. Baumgarten introduced the concept of the aesthetic as his name for sensitive knowledge—knowledge acquired through feeling. If this is what is meant by "the aesthetic," and if the emotions are counted as feelings in the broad non-technical sense, then I see no problem in saying that typical narratives succeed where moral principles may falter because of their aesthetic address. If aesthetics refer to the mode of presentation of whatever a representation is about—its mode of sensuous embodiment as Hegelians might say—then criterial pre-focusing is an aesthetical strategy that yields a feeling response. My point is only that this can be even further specified as, more precisely, an emotional response. Furthermore, if Hegelians want to refer to narrative artworks as sensuous universals, I am happy to accommodate their lingo by means of the demythologizing notion that the works in question are representations of (sensuous) particulars presented under general emotion concepts.

some of our most important automatic mechanisms for detecting value and then comprehending the situations in question under its aegis.

Many of the values embodied in emotions are moral values. As noted already, wrongness is a criterion of anger. Engaging the emotions thus can be morally clarifying; an emotional response to a situation can draw our attention quickly and sharply to the pertinent moral variables involved, weighing them differentially and subtly, thereby enabling us to assess and to understand the situation rapidly and clearly. I suspect that this accounts for Hallie's belief that a typical narrative has the power to make him apprehend goodness more effectively than moral principles.

The application through deliberation of moral principles to situations is often indeterminate. Judgment is needed to supplement the principles in question. Emotions are a tool for making judgments which do not require reflection on abstract principles, but which size up circumstances automatically. By employing abstraction and concreteness in the ways outlined above, the typical narrative can enlist the emotions in the service of ethical understanding, shaping the situation in a way that makes it morally intelligible, that shows us what is at stake, and how to evaluate it.

In their capacities to detect ethically relevant variables, to weigh them, and to illuminate moral situations, emotions are sensitive and effective mechanisms. How precisely they manage to do all this is, of course, in large part still mysterious. For all intents and purposes, emotions remain in a black box. But their function as devices that, among other things, scope out moral situations and render them intelligible seems undeniable. Typical narratives, in virtue of criterial pre-focusing, are capable of clarifying situations and issues morally due to the ways in which they engage the emotive resources of readers, listeners, and viewers; audiences fill in the story with their own emotive responses as those are encouraged by the text. Once activated, our own moral-emotive powers bestow intelligibility on the narrative virtually automatically.

The operation of the emotions is itself clarificatory. It is the function of the emotions to clarify situations for us quickly and in a context-sensitive way where proliferating details might otherwise overwhelm, confuse, or distract. By employing criterial pre-focusing, narrators start the emotional ball moving and, as it gains momentum, our own emotions—our own devices for making sense of situations, especially morally charged ones—swing into action. Thus, by sparking the reader's, listener's, or viewer's natural powers of making sense, the narrator elicits moral understanding.

If typical narratives are concrete universals, then the emotions supply the middle term between the concrete and the abstract. The black box of the emotions sizes up and configures narrative situations with a clarity more legible and comprehensible for most than dispassionately contemplating whether the premises about complex particular situations correspond to abstract moral principles in a deductive argument. This is why, I submit, it is so frequently claimed that typical narratives afford a more dependable source of moral clarity than do moral principles. Moreover, insofar as members of a moral community

are, by dint of both nature and nurture, apt to share emotive repertoires, such narratives have the power to provoke convergent moral assessments with regularity, though, of course, not with universality.

One response to the claim that typical narratives possess these advantages in virtue of their emotional address is that, if this is the basis for the claim, then it is groundless. For the emotions themselves are suspect as sources of moral understanding. The clarity they may appear to engender is really an illusion. Furthermore, if that supposed clarity is a result of the textual structures I've limned, then so much the worse, since everyone knows that the emotions can be manipulated, and what has been called criterial pre-focusing is just the name of the rhetorical lever that does the manipulating. There is no genuine clarity to be had from typical narratives. At best, their distortions are mistaken for clarity as the result of the emotional manipulation of readers, listeners, and viewers.

Two things, however, need to be said here. First, though typical narratives can distort and though the emotions can be manipulated, both can also be reliable. Some typical narratives can mislead, but others can illuminate. Likewise many emotional episodes *are* morally clarifying. Simply because typical narratives avail themselves of an appeal to the emotions does not show that they are never or even only rarely truth-tracking. Furthermore, it should be added that moral theorizing and its application to particular cases can also be defective; there is casuistry (in the bad sense of the word). Neither a typical narrative with respect to moral issues nor a comparable moral argument is self-certifying. We need to evaluate both in terms of broader experience.

In virtue of their fusion of concreteness and abstraction *and* the way in which this involves the emotions, some typical narratives would appear to have differential advantages over moral theory for some purposes. They may be more effective instruments for instilling moral clarity and they may be more likely to promote convergent responses among members of the same moral community. This, of course, is not said in order to advocate the wholesale replacement of moral theory by narrative ethics; it is far more plausible to regard these endeavors as supplemental.

Moreover, the capacity of the relevant sorts of typical narratives to endow situations with moral clarity suggests that they have an important role in moral education—both in the inculcation of moral understanding and in its subsequent refinement and cultivation. Not only do such narratives induct us into a moral culture, awakening and calibrating inborn emotions and harnessing them to the pertinent considerations, but, as we continue to mature, stories are a continued source for exercising our emotions, for keeping them in tune, so to speak, and refining them by presenting us with varied situations in the way that a martial arts devotee practices parrying every sort of different imaginable thrust. That is, we cultivate our moral-emotional responses through exposure to typical narratives which keep us alive to far more diverse problems than most of us are likely to encounter in our routine lives. Furthermore, because the moral sensitivity developed in this manner engages the emotions, its lessons may

go more deeply than those tutored simply in terms of moral principles, since experiences enlivened by emotional arousal are more memorable.[11]

2. RECOGNIZING VIRTUE

Because typical narratives marshal the emotions in their presentations of particulars, it has been claimed that they can invest what they represent with enhanced moral clarity. Perhaps because this speculation is itself an attempt at moral theory, it remains a bit abstract itself. But maybe some of that abstractness can be relieved by reviewing in a bit more detail a species of moral data that is brought to particular clarity by the typical narratives. Virtue and vice are data I have in mind. What I would like to explore now are the structural features of typical narratives that are especially advantageous for instructing our moral understanding about virtue and vice. This, of course, involves criterial pre-focusing in ways to be discussed. However, it also involves structural potentials of typical narratives that have so far gone unmentioned.[12]

Virtues and vices, of course, are traits, dispositions to act in certain ways in different situations. In this regard, they are temporally extended properties of persons. They have an outside—the bodily actions, behaviors, and speech acts that issue from them; and, as Collingwood would say, they have an inside—the thoughts, desires, emotions, attitudes, intentions, beliefs, and so on which give rise to further mental events, like plans and assessments, which issue in actions and behaviors.

Also, the behaviors that result from virtuous and vicious dispositions are not robotic. They can vary immensely from one occurrent episode to the next because the particular situations that summon them into action can diverge wildly. Consequently, in one set of circumstances generosity may require giving, while in another situation it may recommend that we refrain from intervening in any way whatsoever. Sometimes courage mandates speaking out; sometimes it advocates silence. Virtues (and vices) may manifest themselves differently because, given the "inside" of the virtue (or vice) in question, the purposes that underwrite that virtue can only be secured by different means as dictated by the exigencies of novel concrete circumstances.

So virtues (and vices) have at least these three properties: they are (1) temporally extended qualities which (2) have insides as well as outsides, and which

[11] James L. McGaugh, *Memory and Emotion: The Making of Lasting Memories* (New York: Columbia University Press, 2003).

[12] Throughout this section I have been influenced by the writing of Robert C. Roberts, including his "Virtues and Rules," *Philosophy and Phenomenological Research*, 51 (1991): 325–43; "The Philosopher as Sage," *Journal of Religious Ethics*, 22 (1994): 409–31; "Kierkegaard, Wittgenstein, and a Method of 'Virtue Ethics,'" in M. Matustic and M. Westphal, eds, *Kierkegaard in Post/Modernity* (Bloomington, IN: Indiana University Press, 1995), pp. 142–66; "Narrative Ethics," in Philip Quinn and Charles Taliaferro, eds, *A Companion to Philosophy of Religion* (Oxford: Blackwell, 1999), pp. 473–80; and *Emotions* (New York: Cambridge University Press, 2003).

(3) manifest themselves differentially in different concrete situations. Undoubtedly, the property of differential manifestation is an aspect of the temporally extended dimension of virtue, since differential manifestations need time over which to occur, just as the notion of a disposition or a trait assumes temporal extension in order to accommodate the possibility of recurrence.

This, of course, is hardly a full account of virtue. Nevertheless, it is useful to remind ourselves of these three features of virtue, if we wish to understand why typical narratives are so effective at representing virtue. Obviously, typical narratives are temporal representations. They present sequences of states of affairs and events. Thus, they are perfectly suited vehicles for displaying virtues (and vices); they can show traits manifesting themselves in successive circumstances and they can also show those dispositions expressing themselves differentially as conditions vary.

Likewise, typical narratives possess conventions that allow us to enter the mind of agents—whether fictional characters or real historical actors. These conventions involve penetrating the minds of agents, quoting their thoughts directly or displaying their perceptions (point-of-view shots), or telling us what they are thinking through what is called free indirect discourse—that is, the omniscient narrator tells us what characters are thinking, feeling, seeing, hearing, planning, intending, and so on. Thus, narrative possesses the means to exhibit both the inside and the outside of virtues and vices.

Furthermore, access to the inside of the character or historical agent permits a narrator to connect the character's temporally extended overt behavior—her repeated, though differential, manifestations of the trait in question—by relating her actions to the underlying patterns of thought, belief, feeling, intention, desire, and so on that give rise to it. That is, the aforesaid features of the typical narrative provide a natural resource for capturing and portraying virtues and vices as the coherent or connected manifestation or expression of underlying character traits or dispositions over time.

I call this a natural resource, since the use of stories in this way appears to be nearly universal; every culture I know of tells stories about exemplary figures as a way of articulating an understanding of the virtues it holds dear. Christianity tutors believers in mercy by portraying repeated episodes in which Jesus exhibits it. Moreover, this way of educating people about applying concepts of virtue and vice appears superior to handing them definitions of the traits in question. Definitions are too thin to have traction when it comes to particular circumstances. "Showing" a virtue by means of a narrative that displays its dynamics by charting the interplay of the inside and the outside of the virtue over time gives most a better sense of what the virtue is and a surer means for recognizing it than "telling" them a definition. This, of course, has to do with the ways in which the represented behavior in question is criterially pre-focused in terms of positive or negative emotions. But it also has to do with the potential of narratives to disclose the disposition over time from both the inside and the outside and to underscore the connection between them.

Narratives can provide exemplars of virtue and vice that assist in recognizing the congruent traits in people we encounter in everyday ethical life.[13] This is why we often use the names of fictional characters and famous (and infamous) historical personages to tag our contemporaries. However, narratives are not only an aid to the recognition or perception of virtue (and vice). They also increase our understanding of these phenomena. And they are able to do so because of the way in which they unfold the coherence of the traits by connecting its inside and the outside over time. They reveal the virtues as dynamic and unified; they show how a series of disparate actions arise from a consistent set of purposes, thoughts, desires, emotions, values, and so forth. Through a narrative, a virtue or a vice is articulated as an intelligible pattern of activities regulated purposively by governing habits of mind (and, in some cases, of body). Think, for instance, of Kierkegaard's portrait of Don Juan in *Either/Or*.

Narratives, then, can improve our command of virtue concepts. Insofar as at least some concepts have theoretical or explanatory elements, narratives can illuminate virtue concepts by displaying the causal relations between the inside and the outside of the virtue as the overt behaviors that belong to the virtue are shown to permutate intelligibly in varying concrete situations. Narratives can illustrate the otherwise hidden connections that obtain between the inside of the virtue and its outward expression. In this way, narratives can alert us to variables we should be on the lookout for when we attribute virtues to people in our own experience.

Narratives can sharpen our capacities for detecting virtues and vices not only by providing exemplars to match with people we meet, but also by giving us an operational sense of how various virtues hang together. Narratives can provide the "sense" of the virtue and not only its "reference." Thus, tutored by informative narratives, we can begin to scope out virtues and vices in cases that do not look patently like ones we have seen before. In this, narratives have an important advantage over summary definitions of virtue—such as "justice involves giving everyone her due"—which leave one stymied about how to apply such threadbare formulas to concrete cases.

Virtue and vice concepts have what Wittgensteinians call grammars (*"Essence* is expressed by grammar,"[14] to quote the master). A grammar tells one what kind of thing something is; it gives us desiderata pertinent to the application of the concept. In order to employ our concepts successfully we rely on a more or less vague grasp of this grammar. Narratives have the capacity to bring our incipient intuitions about the grammar of virtue and vice concepts into greater articulateness by elucidating through exemplification the network of thoughts, feelings, actions, and their interplay that identify the virtues and vices in question.

[13] Here exemplars function as a subclass of what psychologists call "personae." See Robert Nisbett and Lee Ross, *Human Inference: Strategies and Shortcomings of Social Judgment* (Englewood Cliffs, NJ: Prentice-Hall, 1980), p. 35.

[14] Ludwig Wittgenstein, *Philosophical Investigations*, transl. G. E. M. Anscombe (New York: Macmillan, 1953), p. 116.

That is, narratives may function to mark the critical variables that govern the application of the concept. Moreover, again in concert with Wittgenstein, one way in which to mark these grammatical conditions of application is to show them in operation.[15] And this, of course, is what narratives can do, given the structural resources we have been discussing.

Sometimes we may gain a grasp of certain virtue and vice concepts along with a character in a fiction. We refine our concept of pride along with Darcy in Austen's novel as he comes to see that accurate judgment untempered by humility is a form of arrogance; adjusting our interpretation of a character, like Darcy in relation to pride or Elizabeth Bennet in respect of prejudice, that is, can be a way of coming to grasp the grammar of the relevant concepts.[16] Of course, we need not conduct our grammatical investigations in parallel development with characters; they may exhibit the virtue or vice without evolving in their understanding of it—as does Achilles or Captain Jack Aubrey in *Master and Commander*. Nor need the emotional engagement with the characters, discussed in the previous section, be irrelevant to these grammatical explorations, since the emotions themselves can function as searchlights alerting us to and then leading our attention toward pertinent grammatical variables, especially the ones that are themselves value charged.

Narratives exercise our talents for detecting virtue and vice and applying the concepts thereof. In this, they sophisticate our operational skills in navigating our moral universe. But, in addition, the grammatical skills that narrative-marking augments can also be brought to reflective consciousness, and, indeed, certain narratives seem predicated on doing just this. That is, some narratives, such as Yasmina Reza's play *Art*, appear self-consciously to invite and then to guide an examination of the virtue of friendship.[17] In this way, once again, one can think of narrative as a supplement to moral theory.

Robert C. Roberts has astutely observed that talk of narrative ethics has arisen alongside renewed interest in virtue ethics.[18] This is no accident, since, as we have suggested, narrative is an ideal medium for characterizing virtues and vices inasmuch as narrative possesses the structural wherewithal to exhibit perspicuously the structures of the virtues and vices. In this regard, narrative is an ally rather than the rival of a certain approach to moral theory, namely, virtue ethics.

One objection to according narrative a place of honor in ethics, however, might be the allegation that the virtues displayed in narratives are too contrived,

[15] Philip Hallie, "Scepticism, Narrative, and Holocaust Ethics," *Philosophical Forum*, XVI/1–2 (fall–winter, 1984–5): 46.

[16] Richard Smith, "Teaching Literature," in Randall Curren, ed., *A Companion to the Philosophy of Education* (Oxford: Blackwell, 2003), p. 387; Duke Maskell, "Education, Education, Education: or What Has Jane Austen to Teach David Blunkett?," *Journal of the Philosophy of Education*, 33/2 (1999): 157–74.

[17] See Noël Carroll, "Art and Friendship," *Philosophy and Literature*, 26/1 (April, 2002): 199–206.

[18] Robert C. Roberts, "Narrative Ethics," p. 473.

and, in the case of fictional narratives, they are invented; they do not correspond to reality, so they can be of little educative value. Of course, this generalization is too broad. As an initial response it needs to be pointed out that there is no reason to presume that all the virtues represented in typical narratives are contrived.

But it must also be added that whether the represented virtues are contrived or invented is really of no moment, if what narrative offers is the opportunity to exercise the operational or practical skill of applying the virtue concepts. Flesh-and-blood cases are not requisite here; soldiers practice target-shooting by aiming at cut-outs of hostiles rather than real people, but their accuracy improves nonetheless.

Moreover, if the objection is that because real-life instances of virtue and vice are likely to diverge so far from the exemplars found in narratives that the latter are useless, then the argument appears to presuppose illicitly that the narrative exemplars are meant to function as rigid templates applied by rote to actual cases which, the critic adds, they will inevitably fail to fit. But this is not the way in which the narrative exhibition of virtue operates. Rather, by clarifying the grammar of the relevant concepts through practice, the narrative prepares or sensitizes readers, viewers, or listeners to discriminate novel expressions of virtue and vice. The narrative is not simply a mold into which actual cases must be slotted or forced. Narrative instead sharpens and refines our powers of observation and inference relative to discerning virtues and vices in their varied manifestations.

The divergence-from-reality objection would only seem to pertain were we thinking that the virtue shown forth by a narrative were something like an exact model of what we could expect to find in life outside of the story. But instead the skill to be derived from narratives is more a matter of cultivating finesse in being able to suss out variations of virtue manifestations due to our command of the grammar of the virtue in question.[19]

Likewise, the objection that the virtues and vices exhibited in narratives are invented has no sting if it is intended to disqualify the use of these examples in reflection upon the concept of virtue, since there is no reason to imagine that such reflection or analysis (conceptual, grammatical, or philosophical) requires actual cases. In fact, there is every indication that made-up examples are often more efficacious in the probing and elucidation of concepts than actual cases.[20]

Insofar as narratives are devices for representing changes in state over time—which devices have conventions for portraying the insides and the outsides of actions and the relations thereof—narratives are particularly well adapted to displaying virtues and vices clearly. Commerce with successful narratives of this

[19] This theme is also explored in Noël Carroll, "Art, Narrative, and Moral Understanding," *Beyond Aesthetics*, pp. 270–92.
[20] Noël Carroll, "The Wheel of Virtue: Art, Literature, and Moral Knowledge," *The Journal of Aesthetics and Art Criticism*, 60/1 (winter, 2002): 2–26.

sort exercises skills in detecting manifestations or expressions of virtue and vice, refines and sharpens sensitivity to often non-obvious variables, can enhance our understanding of virtue and vice by illustrating how the inside and outside of these phenomena hang together, and can even facilitate and guide the reflection upon or analysis of the grammar of the virtues and vices in question. If the definitions of moral theories are like engine diagrams that illustrate the parts of the virtues, then narratives are like motion pictures that show how those parts move and work together. Perhaps needless to say, *pace* enthusiasts for narrative ethics, there is no reason to opt for one of these mediums of moral understanding over the other if we can have both.

3. DELIBERATING ACTIONS, CONSTRUCTING LIVES

So far we have been concentrating our attention narrowly on the ways in which narrative may provide a service to ethical life in terms of exercising and refining our powers of evaluating situations morally, and of judging instances of virtue and vice, rather than considering its relation to the deliberation of action, though, perhaps needless to say, the kinds of narratives of virtue, especially of exemplars, discussed in the previous section can provide one with clues, in the form of scenarios, to contemplate how to go about acting in such a way as to cultivate the virtue in question. Nevertheless, in this section, I intend to explore more explicitly some of the ways in which narrative, because of its structures, can contribute to moral deliberation, both at the level of local decisions about how to act and at the more comprehensive level of how to construct a meaningful life.

Narrative, of course, is not only integral to moral deliberation. It is central to deliberation of all sorts. Consequently, before zeroing in on its frequent contribution to moral deliberation, something needs to be said about its role in deliberation *tout court*. Narrative is a cognitive instrument. It is probably the most pervasive tool that humans have for relating the past to the present and to the future. And it is because narrative functions to relate the past and the present, on the one hand, to the future, on the other hand, that it comes to play a role in deliberating about what we will do and in planning for what is ahead.

Narrative is an awesomely adaptive asset from an evolutionary perspective. It enables humans to think about and communicate information about absent situations. One can imagine—by telling oneself a story—what would happen if one stumbled into the lair of a predator, and then proceed to adjust one's behavior accordingly. Or you might tell a story to the tribe about the land of milk and honey on the other side of the hill as a way of preparing them for the journey. That is, narratives can be informative about situations not being experienced in the here and now and, thus, narratives are expeditious ways of envisioning how things might be counterfactually. The elders can warn children about what

might befall them in the swamp by recounting either past disasters or imagined
ones. In effect, narratives are a means for running cost-free trial runs in thought
of possible courses of action. The trial runs are cost-free, since no real alligators
pose a clear and present danger to the children. The elders are able to influence
their thinking about where they will play by telling the children stories about
where dangers lurk.

Narratives not only connect the past, present, and future; they connect them
by showing how the future emerges from the past and the present as a realization
of a possibility that belongs to a range of alternative possibilities opened up by
earlier events and states of affairs in the narrative. If the narrative concerns a
battle, the earlier stages of the story call forth a certain package of possibilities:
that one side will win and the other lose, or each side will annihilate the other, or
both sides will throw in the towel. As the narrative unfolds, ideally, one of these
alternatives will be realized and our expectations of this structure will be the way
in which we track the narrative.

Following a narrative with understanding involves being able to assimilate
the incoming information from the story in terms of the range of possibil-
ities that preceding portions of the narrative make available. That is, following
a narrative with understanding hinges upon mobilizing a horizon of expect-
ations in the audience member who then renders subsequent events in the
story intelligible to herself, given her sense of what is possible on the basis
of the antecedent narrative. When the story eventuates in one of those possi-
bilities it is assimilated intelligibly, due to the audience's antecedent horizon
of expectations. Where the putative story fails to realize any instance of
the range of possibilities it propones, or where the details in the story are
so amorphous that they leave the audience floundering with no horizon of
expectations, the example at issue defies being followed and is unintelligible.
The successful story, in other words, must structurally engage the audience's
capacities to project future possibilities as a condition for finding a story fol-
lowable and intelligible. Thus, functioning narratives by dint of their structure
of address exercise and sharpen the talent for projecting future possibilities
and this, of course, is a *sine qua non* of deliberation in general. Thus, it
comes as no surprise that traffic with narratives may have consequences for
deliberation.

Narratives often structure the audience's horizon of expectations because the
events they recount raise inevitable questions in the audience's mind. If we are
introduced to two attractive young people, we wonder whether or not they
will become lovers, and, if they become lovers, will they be married, and, if
parted, will they get back together, and so on. So many of the situations in
narratives call forth a matrix of future possibilities that we use to organize the
incoming story stream. As well, the essential link between incidents in stories,
the narrative connection, is causation—whether the earlier events in a story fully
determine subsequent events as sufficient conditions or whether they are only,
as is more frequently the case, causally necessary conditions (in the sense of
INUS conditions) for subsequent events, a degree of causation is necessary before

something will count as a narrative.[21] But, of course, providing readers, listeners, and viewers with causes unavoidably invites them to ponder possible effects, just as questions point the mind in the direction of possible answers. Thus, once again, we see that narratives, due to their structure, enlist audiences into thinking about future possibilities. And, in this light, it seems fair to propose that exposure to narratives hones a talent necessary for deliberation of any sort.

Steven Pinker regards exposure to narratives, especially fictions, as a form of training whereby we familiarize ourselves about what to do and what not to do in a variety of situations that we have not yet encountered; like the chess player who pores over the scenarios of a great many games in order to amass knowledge about what works and doesn't work in a wealth of situations that have not confronted her in her own experience, so we consume narratives, fictional and otherwise, in order to store up a repertoire of possible moves and countermoves in the game of life.[22] Moreover, many psychologists argue that we negotiate much of everyday life by means of mental representations called scripts—essentially narrative flow-charts of how to do things like getting a meal in a restaurant.[23] In both these ways, narrative plays an important role in deciding how to act. But, in addition, there is an even deeper way in which narrative contributes to decision-making, since exposure to narration is a primary site for training people to think about future possibilities, facilitating this skill by putting it to work in the process of following stories.[24]

Of course, we are not merely audiences to the narratives of others. We also construct narratives, both for ourselves and others. The transit from being told narratives to telling them appears to arrive with the maturation of linguistic mastery. To become sensitive storytellers, we have to become facile at connecting the past and present elements in the story with the possibilities that lie in the future of the earlier segments. Narrative competence requires that we neither forget to actualize at least one of the possibilities convoked by earlier developments, lest we leave our audience bewildered by what is effectively a narrative non sequitur, nor that we allow the story to wander to the point that the reader, with no notion of where it could be possibly headed, finds it unintelligible. Narrative competence, in other words, requires that we evolve the

[21] Noël Carroll, "On the Narrative Connection," in *Beyond Aesthetics* (Cambridge: Cambridge University Press, 2001).

[22] Steven Pinker, *How the Mind Works* (New York: Norton, 1997), pp. 538–43.

[23] R. C. Shank and R. Abelson, *Scripts, Plans, Goals, and Understanding* (Hillsdale, NJ: Lawrence Erlbaum and Associates, 1977).

[24] It is sometimes argued that exposure to narratives can be of little use for actual deliberation, since the stories agents have at their disposal are unlikely to match the situations in which they find themselves. However, if it is the case that what is practiced and expanded by exposure to narratives is a skill for projecting future possibilities, then the problem of mismatches falls by the wayside. At the deepest level, the importance of exposure to narratives is that they increase one's facility for projecting future possibilities, not that the stories we hear can be mapped onto the circumstances and predicaments in which we are engulfed on a one-to-one basis. Instead, the value of exposure to narratives is that it can extend our ability to process new situations because we have already become adept at following all different kinds of stories.

knack for projecting future possibilities—for tying them to the past and for keeping track of them—and, in fact, producing narratives ourselves, rather than merely consuming the narratives of others, is for most people the primary way of developing that knack.[25]

This latter point is important to underline, moreover, for once we note the intimate relation of narrative competence to projecting future possibilities, it becomes evident that narratives are not only a means for strengthening that ability; they are also a means of expressing it. That is, narration—whether to ourselves or others—is itself a way of projecting future possibilities. Thus, narrative does not merely exercise capacities essential to deliberating about future action. It is itself a way of carrying that deliberation forward.

In part, one frequently deliberates about how to act by telling oneself a story. I think about moving from one city to another by thinking about what possibilities the move will open up for me versus those it will close down; I may imagine two scenarios and then compare them. Or my friends may tell me alternative scenarios, perhaps in the hope of persuading me one way or another, or maybe only in order to help me clarify my decision.

This should not appear as an unfamiliar picture of deliberation. Often we are asked to deliberate politically by being offered different scenarios by opposing factions about what will happen consequent to the adoption of the policies of their side and of the other side. But what happens in political deliberation is merely an echo of deliberation in general which comprises, to a large degree, projecting future possibilities narratively and then thinking about whether and/or which story suits one.

If narrative can play a role in all kinds of deliberation, it obviously has a role to play in moral deliberation. But can anything more be said about the role of narrative in moral deliberation? The kinds of narratives that we tell ourselves in the process of moral deliberation are not merely exercises in projecting future possibilities; they belong to a subclass of narratives that we might call *orientational*. That is, they are undertaken in order to find our bearings in relation to future possibilities, where finding our bearings is a matter of determining which future possibilities cohere best with whom one already is.

Narratives connect past events to future outcomes. The earlier parts of the narrative constrain the pertinent future possibilities available to the storyteller. Moral deliberation involves asking whether some action is a future possibility for me. In order to do that, one needs to construct a narrative of who one is relevant to the decision at hand in order to assess whether some contemplated action is a genuine possibility. An orientational narrative involves a retrospective moment in which one examines one's commitments as they emerge from the narrative pattern or patterns in one's life thus far. This then creates a *backstory* which, in

[25] Though undoubtedly reading narratives and watching narrative motion pictures also helps people develop their narrating skills. Part of this has to do with appreciating professional narrators and modeling our own attempts on them. But these products also shape our own narrating practices when, as is so often the case, we retell the plots of such fictions to friends and family.

addition to the particulars of the present situation, generates a forward-looking field of possible actions and responses that I might take in the situation at hand. The question before me then is whether I can prospectively construct a *continuing story* on the basis of the contemplated action that coheres with the retrospective story that I believe best captures who I am. My retrospective story orients my choice of present behavior in the here and now by testing possible actions in terms of whether or not they can be incorporated in a continuation of the story that, so to speak, I've already begun or in which I find myself *in medias res*.

Suppose I know an obscure language that no one else in my field knows and I read an article in that language in a defunct, small-circulation journal by an author who is dead; suppose as well that due to a series of bloody purges there are no scholars left in that far-off country—no one who was familiar with the original article is alive; so if I were to plagiarize that article, the likelihood of my being unmasked is infinitesimal. Now, since the idea has crossed my mind, the moral issue is whether or not I should plagiarize the article. I can easily deduce that it is wrong; it would not be a moral question for me if I couldn't. In order to answer this question, I think one of the most natural ways to proceed is to ask whether plagiarizing this article is a continuation of the story I want to tell about myself as a forthright and productive scholar; does this way of carrying my story forward realize the possibilities that the rest of my story indicates to me I value? Or is the ensuing story one of which I say "It's not me; that is not my story, or, at least, the story that I want." My deliberation over whether or not to plagiarize can be readily staged through the question of how I wish to continue my story, or of which continuing story I am willing to endorse, given my own retrospective story. Clearly, if the story I want to tell is one in which I am an honest, creative, and resourceful researcher, I would choke on the story where the plagiarism were an episode. The narrative in which the plagiarism plays a role, perhaps because it addresses me emotionally, makes a dramatic contribution to the deliberative process. Nor do I think this example is exceptional. Most cases where we are really pressed to deliberate morally—as opposed to the many moral actions, like not running over pedestrians with our car, that we perform automatically—will elicit orientational narration from us or from our moral advisers. That is, we will use our pre-existing backstories to probe which possible courses of action are most suited to telling the next episode of the story we wish to continue.[26]

In the coordination of our retrospective story with future possibilities, a premium is typically placed on conserving as much of the past and the values it evinces as possible, but in telling the backstory sometimes the agent may find contradictions (in the Marxist sense) in it that suggest the need to opt for future possibilities that jettison problematic parts of the retrospective story for a better continuing story. One searches for the best continuing story. Usually, this will be the story that coheres best with our retrospective story; where the

[26] For parallel observations, see Hilde Lindeman Nelson, *Damaged Identities, Narrative Repair* (Ithaca, NY: Cornell University Press, 2001), especially Ch. 3.

retrospective story is one we find satisfying, the tendency will be to consider the possibilities that maximize the commitments of the retrospective story as the way of moving the story forward. Since the retrospective story will reflect our moral commitments, if we are moral and take that to be part of who we are, continuing the story by opting for an immoral possibility, like plagiarism, will strike us as cognitively and emotively incoherent and will turn our deliberations against it. At the same time, it may happen that in constructing my backstory I find disturbing anomalies in it which lead me to elect a possibility that cancels offending parts of the retrospective story and uses the remaining fragments to start a new story. Undoubtedly, the latter course is less frequent, but not so rare that we could argue that, in deliberating trying to tell our story coherently, we always only favor stories that conserve most fully the bulk of the story we have already told.

Orientational narratives serve the purposes of deliberation by reflecting upon the past as a way of continuing the story into the future. They answer the question "What is to be done?" They orient us to that question by telling us a retrospective story, which tells us where we are, as a way of helping us to decide where to go next. These narratives may be called into play not only when what to do next is a question of which action is next, but also when we ask what project is next. The college graduate is not just deliberating about whether to mail the application off to law school. She is deliberating about her next project. Often when one makes such decisions, one attempts to maximize the coherence between one's story so far and the next chapter. Perhaps our college student has a talent and a relish for argumentation and that inclines her toward starting a career in law. Law to her feels like a good way of continuing the story coherently.

However, it may also be the case that when one takes the measure of one's past projects, one discovers that they have been pursued as far as possible and that it is time to look for a new beginning. Thus, an ageing athlete tells the story of his days of glory and, realizing that that story is ending, becomes convinced that he needs to search for a new story. Should he put his well-earned reputation, his backstory, in the service of a company that advertises alcoholic beverages, in a way that is seductive to minors, by becoming its spokesperson? Is that how he wants the narrative to continue? In this way, narrative reflection is not only useful for moral deliberation; it is a natural and effective way of conducting it.

The gauge, so to speak, of the stories told to oneself for the purposes of deliberation come in different scales. As we have seen, they can be told in relation to actions or to projects. But they can also take as their unit of interrogation an entire life. In this way, narrative can contribute to the question that most interested ancient ethicists, namely, what makes a life worthy or excellent or good, or, as the question is often posed today, what makes a life meaningful?[27]

[27] That is, whereas the primary focus of contemporary ethics is said to be "what makes an action good?," it is often observed that the ancients, including Aristotle and the Stoics, were concerned with the question of what makes a human life worthwhile.

Though the question of the meaning of life is often neglected in contemporary moral theory, it is traditionally an ethical question of the highest order and one that almost inevitably perplexes every thoughtful person. But it is also fraught with at least two daunting challenges. Though the question seems unavoidable, there is the problem of whether it makes sense: are lives, in contrast to linguistic utterances, the sorts of things that can have meaning? And, even if they can, how is one to go about organizing the messy, transitory details of a life in a way that would render them cognitively accessible—that is, legible enough for scrutiny? Narrative, I contend, answers both of these questions.[28]

Though linguistic utterances are paradigmatic examples of what has meaning, narratives also can be said to be meaningful or not. A meaningful narrative, as we have seen, is one in which later stages in the story are intelligible as realizations of possibilities called forth by earlier stages. In a perfectly ordinary sense of the phrase, a meaningful story is a story that can be followed—a story that is not so cluttered that it is impossible to determine what possibilities are at stake and that does not end without realizing some of the possibilities that it has put in motion. Whether the narrative of a life is meaningful depends on whether it can be followed intelligibly.

In order to be in a position to tell whether a life is worthwhile, first we need to be in a position to produce a meaningful narrative of that life. Have the questions posed by that life narrative been answered? Have the possibilities (or, at least, some of them) that were opened been realized? Is the story coherent in its continuation of its past into its future, and, if not, were there good reasons for changing the story? Does the story make sense? Presuming that the life narrative is an honest one, if it makes sense, then it indicates that the life in question has a degree of unity—as much unity as can be captured by a sincere and intelligible life narrative. Thus, the narrative, if meaningful and sincere, gives us a holistic, though selective, configuration that is open to scrutiny. That configuration, in turn, is something that can be evaluated in terms of whether or not it is worthwhile—in terms of whether the possibilities elected, given where one finds oneself, as Heidegger says, "thrown into the world," were worthy ones pursued well and whether those possibilities figure in a coherent evolution of past concerns and actions into the projects and activities of the later stages of life.

The notion of a meaningful life, then, is parasitic on the notion of a meaningful narrative, a narrative that coherently connects past segments of the story to their

[28] The connection of narrative to the meaning of life is a theme of continental philosophers such as Paul Ricoeur and Hannah Arendt, and of analytic philosophers who have studied that tradition deeply, including Alasdair MacIntyre, Charles Taylor, and Richard Rorty. Perhaps the idea originates in Nietzsche's notion that meaningful lives are works of art—a view also endorsed by Michel Foucault late in life. Sartre then in *Nausea* specifies the kind of artwork in question as a narrative. And, of course, the hero of that novel goes on to discover the meaning of his life by writing a book, presumably the book we are reading, which is a fictional narrative. Though some of these philosophers appear to claim that meaningful lives *are* narratives, one need not enter that ontological quagmire in order to benefit from their speculation. One need only maintain that the construction of a meaningful narrative is the best means at our disposal for approaching the question of whether our lives, as unified wholes, are worthwhile.

future as projected possibilities realized. This is not to say that lives are stories, but that the ability to produce a meaningful narrative is a test for the coherence of a life. Moreover, structurally speaking, narratives, as we noted earlier, are necessarily selective. A life narrative is one that is told retrospectively, using later stages of a life story to focus narrowly on the earlier events and recurring themes that have brought the agent to the relevant juncture in her life. By retelling one's life in this way, one begins to organize it, filtering out a mass of ephemeral details and hierarchically ordering those that remain. In this way, narratives prepare the apparently inchoate confusion of a life for close examination and then evaluation.

Once one has configured her life narratively into a manageable unity, one is in a position to ask whether the story told represents something worthwhile. In this way, narrative is probably the only tool at the disposal of most for organizing the data pertinent to assaying whether a life as a whole is worthwhile.[29] Of course, finding that a life can be configured as a meaningful narrative does not entail that it is a worthwhile life; coherence is not enough. Whoever is telling the story, whether the agent herself or some outside party, must also weigh the worthiness of the coherent themes isolated by and exhibited in the life narrative. However, constructing that coherence, finding that life story, is a necessary condition for this next stage of deliberation.

And, of course, one reflective test that the agent of the life story has at her disposal to estimate the worthiness it implies is whether or not it is a story that she finds satisfying to tell and then to tell again. Perhaps that is what Nietzsche had in mind with his notion of the Eternal Return.

Life stories are indispensable to deciding about the worthiness of one's life when one is entering the home stretch. But they also have a purpose to serve at earlier stages. One can construct retrospective life stories long before the end is in view as an orientational narrative designed to plot where one has been, in order to find a way forward.[30] A life story assembled before most of one's life is over can function as an opportunity to locate the best possibilities to pursue in the near and/or distant future and as an instrument to reflect on what sorts of activities and commitments need to be either abandoned or emphasized for the story to continue in accordance with one's deepest themes. And life stories may also serve deliberation as thought experiments about how one might change one's life by imagining setting off on a different branch of possibilities other than the ones you have been pursuing thus far. Imagining alternative life stories, in short, is also a means of conducting in the mind what Mill called life experiments. The narrative of such an experiment, in turn, then can serve as a map for planning and plotting the rest of one's life.

[29] One might argue that there is no need to speak of narratives here; one can determine the worth of a life in terms of the roles lived. However, roles themselves come with subtending narratives, so the appearance of a zero-sum rivalry here is misleading. And, in any event, one will have to consider how well the agent played her roles and this, of course, will send us in the direction of narrative.

[30] One important source for learning to tell life stories is literature, especially certain genres, like *Bildungsromans*.

4. CONCLUSION

In this chapter, I have explored the ways in which narrative can be related to ethical life. As we have seen, there is no single way, but several, and, in addition, I do not claim that I have exhausted the connections in this cursory tour of the landscape. To sum up, I hope to have shown that, due to their structural features, typical narratives can clarify our understanding of situations that call for moral judgments, especially in cases that involve the recognizing and comprehension of virtue. But narratives do not only play a role in evaluating and morally understanding actions and events that we observe from the outside. Narrative also contributes to the kinds of facility with projecting possibilities that we need to deliberate on how we shall act and, in fact, telling ourselves narratives that link our past, present, and future together coherently provides an important instrument for reaching the pertinent decisions. Philosophers like to reduce the relation of practices such as narrative and ethics to a single dimension; they prefer economy and elegance. That the relation between narrative and ethical life is so multifarious may be one of the reasons it has eluded philosophical attention for so long. But, insofar as a *prima facie* case for the relevance of narrative can be made, as I have attempted to do in this chapter, then the time is ripe to begin to articulate, in greater depth than achieved here, the many and diverse ways that narrative plays an intimate role in moral understanding and deliberation.

19

Humor

1. THEORIES OF HUMOR

Humor is a pervasive feature of human life. We find it everywhere—at work and at play, in private and public affairs. Sometimes we make it ourselves; often we pay others to create it for us, including playwrights, novelists, filmmakers, stand-up comics, clowns, and so on. According to some, such as Rabelais, humor is alleged to be distinctively human, a property of our species and no other. But, even if that is not the case, humor seems to be a nearly universal component of human societies. Thus, it should come as no surprise that it has been a perennial topic for philosophy—especially for philosophers ambitious enough to attempt to comment on every facet of human life.

Plato believed that the laughter that attends humor is directed at vice, particularly at the vice of self-unawareness (Plato 1961). That is, we laugh at people who fail to realize the Socratic adage—"Know thyself"—and who instead deceive themselves, imagining that they are wiser than they are, or stronger, or taller, and so on. Thus, amusement contains an element of malice. Plato also distrusted humor, because he feared that it could lead to bouts of uncontrolled laughter and, of course, Plato was suspicious of anything that contributed to a lack of rational self-control. For this reason, he discouraged the cultivation of laughter in the guardian class of his Republic and urged that they not be exposed to representations of gods and heroes laughing (Plato 1993).

A similar distrust of humor can be found in Epictetus and the Stoics, who, like Plato, placed a premium on emotional self-control. Church Fathers, such as Ambrose and Jerome, assimilated the Stoic suspicion of humor, despite the fact that Jesus himself valued laughter (Phipps 1979).

Like his mentor Plato, Aristotle defines the joke as a form of abuse (Aristotle 1941) and thinks that comedy involves the portrayal of people as worse than average (Aristotle 1993). Unlike Plato, however, Aristotle allows a role for humor in the virtuous life. But the laughter of the virtuous person must be tactful and moderate. Aristotle agrees with Plato that laughter can get out of hand. Thus, he warns the virtuous against the danger of buffoonery—an inability to resist the temptation to provoke laughter, no matter what the occasion, and whatever the means required. Such a person could hardly be regarded as a reliable citizen.

The association—found in Plato and Aristotle—of humor with malice and abuse toward people marked as deficient suggests what has been called the *Superiority Theory of Humor*, which was articulated in its most compact form by Thomas Hobbes. Hobbes wrote: "I may therefore conclude that the passion of laughter is nothing else but sudden glory arising from some eminency in ourselves, by comparison with the infirmity of others, or with our own formerly" (Morreall 1987).

That is, according to Hobbes, laughter results from perceiving infirmities in others that reinforce our own sense of superiority. Hobbes adds that the object of humor may also be our former selves, in order to accommodate the fact that we sometimes laugh at ourselves. But when we laugh at ourselves for some stupid behavior—say, putting shaving cream on our toothbrush—we do so putatively from a present perspective of superior insight that sees and savors the ridiculous absentmindedness exhibited by the person we were.

There is a lot to be said for the Superiority Theory of Humor. Much humor is undeniably at the expense of characters who are particularly stupid, vain, greedy, cruel, ruthless, dirty, lubricious, and deficient in other respects. Consider, for example: Polish jokes as told by Americans, Irish jokes as told by Englishmen, Belgian jokes by the French, Chelm jokes by Jews, Russian jokes by Poles, Ukrainian jokes by Russians, Newfie jokes by Canadians, and Sikh jokes by Indians—not to mention blonde jokes, told by anyone. These are all essentially moron jokes; they can all be retold by asking "why did the moron do X?" or "how does the moron do X?" But moron jokes are obviously aimed at monumental lapses in intelligence to which virtually anyone can feel superior.

Similarly, many jokes are told at the expense of people with physical disabilities (e.g., stuttering) or cultural disadvantages (e.g., illiteracy) and from an implicit position of superiority. What the Superiority Theory asserts is that we find the comic butts in such humor not merely different from us, but inferior to us. The Superiority Theory has the virtue of handling a great deal of data, from laughter at moron jokes to laughter at people slipping on the ice (i.e., people clumsier than we are). Much laughter is nasty, directed at foolishness, and the Superiority Theory ostensibly explains why this is so. Laughter is a sign of pleasure, and the pleasure we take in the foolishness of others is the recognition that we are better than they are.

However, despite the explanatory reach of the Superiority Theory, it suffers notable limitations. Feelings of superiority cannot be a necessary condition for laughter, since there are many cases of laughter that do not involve them. We laugh at word wit such as puns with no tendentious edge. But when we laugh in these cases, it is far from clear to whom one feels superior, or in what way the utterer of such word wit is inferior to us. Indeed, they may strike us as being cleverer than we are.

As well, we may laugh when we are amiably teased, but this is hard to explain in terms of feelings of superiority we supposedly have, since it is not some former self whose shortcomings are being tweaked, but ourselves in the present moment. Moreover, children laugh at an extremely early age at things like "funny faces"

and "fort/da" games, but it is difficult to presume that they have yet evolved anything worth calling a concept of superiority. And, in any case, how would superiority figure in an account of laughter in response to a "fort/da" game?

Furthermore, we sometimes laugh at comic characters whose behavior is decidedly superior to anything we could imagine achieving ourselves. For example, in the film *The General* (1926), when Buster Keaton uses the railroad tie on his chest to catapult another one off the track in front of him, this magnificent insight into how to avoid derailment prompts our laughter, though few of us could have solved this predicament so elegantly (Carroll 1996). In such a case, it makes no sense to say that our laughter flows from our feeling of superiority to Keaton. If anything along this line of thought occurs to us, it is more likely that we realize that we are inferior to Keaton in respect of lightning ingenuity.

Nor is the recognition of our superiority to others a sufficient condition for laughter. As Francis Hutcheson pointed out, we realize that we are superior to oysters, but we don't laugh at them (Hutcheson 1973). Nor, he said, do we laugh at heretics, though presumably the true believer will feel quite superior to them. Consequently, though the Superiority Theory appears to work well with many examples, at the same time, it ill suits too much of the rest of the data.

Furthermore, the Hobbesian version of the Superiority Theory is framed in terms of laughter, and is putatively an account of the springs thereof. Undoubtedly, this enhances the intuitive plausibility of the theory, since, as is readily observed, laughter often accompanies triumph. However, there remains the real question of whether laughter is, in fact, the proper object of analysis for a theory of humor. For, on the one hand, laughter is a response not only to humor, but also to tickling, nitrous oxide, belladonna, atropine, amphetamine, cannabis, alchohol, the gelastic seizures that accompany certain epileptic fits, nervousness, hebephrenia, and, of course, victory; while, on the other hand, some humor does not elicit laughter, but only a mild sensation of joy or lightness, i.e., levity. Thus, in focusing on laughter, it is not clear that Hobbes's theory is really a theory of humor at all.

A theory of humor need be concerned only with amused laughter—the laughter that issues from comic amusement—and there is no reason to suppose that triumphant laughter, say, is amused laughter. To determine that would require an analysis of amusement. But it is doubtful that the Superiority Theory can provide an analysis of amusement, since the object of the passion that concerns Hobbes is the self triumphant, which does not seem to be the object of comic amusement, even if a sense of superiority can cause a certain type of laughter.

Many of the limitations of Hobbes's Superiority Theory were noted in the eighteenth century by Francis Hutcheson, who endeavored to replace it with what has come to be known as the *Incongruity Theory of Humor*. This theory was perhaps already suggested by Aristotle, who proposed that the proper objects of comedy were people who are worse than average. Here we find the germ of the idea that comic amusement is rooted in deviations from some

norm. However, Hutcheson's theory is generally recognized as the best-known early, explicitly worked out, version of the Incongruity Theory. To date, the Incongruity Theory of Humor has attracted the largest number of philosophers, including Schopenhauer (1966), Kierkegaard (1941), Koestler (1964), Morreall (1983), Clark (1970), and, arguably, Kant (1951), and Bergson (1965).

The leading idea of the Incongruity Theory is that comic amusement comes with the apprehension of incongruity. We are amused by the animated fowl in the film *Chicken Run* (2000) because their movements, their behavior, and their very look call to mind human beings. However, this is incongruous or absurd. It would be a category error to subsume chickens under the concept of human being: it would violate a standing category; it would be an incongruous instantiation of that concept. The makers of *Chicken Run*, nevertheless, invite us to contemplate just such a prospect, and in doing so they elicit comic amusement.

Similarly, puns generally involve violations of conversational rules, shifting the likely meaning of a word or phrase in a specific context to a secondary or metaphorical meaning, or exchanging the predictable usage of a word for that of one of its homonyms. In other words, a pun is incongruous because it involves activating word meanings that are out of place, given the direction of the surrounding discourse. Moreover, the wacky logical inferences so frequently indulged by the denizens of jokes, satires, and burlesques count as incongruities; they are absurdities, given the laws of logic, both deductive and inductive, formal and informal.

Speaking drily, the notion of incongruity presupposed by the Incongruity Theory can initially be very roughly described as a problematization of sense. This can occur when concepts or rules are violated or transgressed. But the scope of these transgressions need not be limited to conceptual mistakes, linguistic improprieties, or logical errors. Sense can also be problematized by being stretched to the breaking point. Thus, it is very common to field comic teams composed of a very thin man and a very fat man (e.g., Don Quixote and Sancho Panza, Abbott and Costello). In this case, there is no category error. However, we are presented with instantiations of the concept of the human being that lie at the extreme ends of the relevant category: the characters are so dissimilar that one is, oddly enough, struck by the heterogeneity of the category, rather than by its homogeneity. Similarly, incongruity accrues when a concept is instantiated in an unlikely way, rather than in an erroneous way. Shown a 90-pound weakling outfitted in the gear of a sumo wrestler, we are struck by the incongruity, since the character is such an unrepresentative example of our stereotype for athletes of this sort.

As the preceding example indicates, not only can concepts be problematized for the purpose of incongruity, but so can stereotypes. Our stereotypes can be distorted either through the exaggeration of stereotypical features or through their diminution. Caricature often exaggerates—as in cartoons of Richard Nixon that turn his five o'clock shadow into a beard. Indeed, exaggeration is a standard strategy throughout burlesque, parody, and satire. The previous example of the

90-pound sumo wrestler, on the other hand, is an example of incongruous diminution.

As all of our examples so far suggest, incongruity involves deviations from a background of norms—conceptual, logical, linguistic, stereotypical, and so forth. These can also include moral and prudential norms, as well as those of etiquette. Using a person as an armrest, as Charlie Chaplin sometimes does, or a tablecloth as a handkerchief, are both incongruous, since they represent deviations from normatively governed behavior. Thus, the incongruous can also comprise the morally or prudentially inappropriate, as well as the just plain gauche.

Conflicting viewpoints supply another source of incongruity. In comic narratives—including novels, plays, and films—it frequently occurs that certain characters misperceive their circumstances; they may think they are speaking to a gardener, when in fact they are speaking to the master of the house. The audience is aware of this and tracks the spectacle under two alternative, but nevertheless conflicting, interpretations: the limited perspective of the mistaken character, and the omniscient perspective of the narrator. Inasmuch as these viewpoints effectively contradict each other, the comic theorist counts them as further instances of incongruous juxtaposition.

Some jokes are called meta-jokes because they call attention to the conventions of joke-telling by deviating from them. The joke "Why did the chicken cross the road?/To get to the other side" is a meta-joke, because it violates while also revealing our conventional expectations about jokes, namely, that they possess surprising and informative punchlines (Giora 1991). That chickens cross roads to get to the other side is hardly informative; being told that they do so is surprising only as the conclusion of a joke. Likewise, non sequiturs are incongruous, because they subvert our expectations that conversations and stories will be comprised of parts that are coherently linked. Moreover, emotional incoherence can also figure as incongruity, as when a character matches the wrong feeling or attitude with a situation, or simply vastly exaggerates an apposite one. Comic amusement, on the Incongruity Theory, presupposes that the audience has access to all the congruities—concepts, rules, expectations, and so on—that the humor in question disturbs or violates, and perhaps part of the pleasure of humor involves exercising our abilities to access this background information, generally very rapidly.

Prototypical incongruities, then, include deviations, disturbances, or problematizations of our concepts, rules, laws of logic and reasoning, stereotypes, norms of morality, of prudence, and of etiquette, contradictory points of view presented in tandem, and, in general, subversions of our commonplace expectations, including our expectations concerning standard emotional scenarios and schemas, and comic forms. Given this list of prototypical incongruities, the theorist can begin to chart a theory of humor.

Humor, for the Incongruity Theory, is a response-dependent property of a certain type of stimulus, namely, stimuli that support amusement in response to their display of incongruities. That is, perceived incongruity is the object of the

mental state of comic amusement; one is in a state of comic amusement only if the object of that state is a perceived incongruity. This state may be in response to found humor—we may suddenly notice that people in everyday life are in some way funny (incongruous)—or in response to invented humor such as jokes, which are intended to bring incongruities to our attention, usually forcefully.

This suggestion is an advance on the Superiority Theory, since perceived incongruity, or absurdity, would appear to be a more likely object of comic amusement than pride of self. After all, feelings of superiority and accompanying squeals of cruel laughter can attend something that has nothing funny about it, like the bloody slaying of a sworn enemy; whereas a derailment of sense, if encountered in the right context, is a natural candidate for comic laughter, whether at our own expense, at the expense of others, or at no one's expense; for example, we may be comically amused when we find running shoes in the freezer, since that is an absurd place for them to be, even if we are not laughing at someone else, real or imagined.

However, incongruity is at best a necessary condition for comic amusement. As Alexander Bain pointed out, there are many instances when we encounter incongruities that are hardly amusing (Bain 1975). So, even if incongruity is part of the story of comic amusement, it cannot be the whole story: incongruity simply does not correlate perfectly with comic amusement. Often confrontations with incongruity and deviations from expectations are threatening occasions, fraught with anxieties. If a total stranger makes "funny faces" at a child, the child is apt to be frightened; but, equally, if a familiar caregiver assumes the same "funny" (incongruous) face, the child is likely to giggle. What this indicates is that, for comic amusement to obtain, the percipient must feel unthreatened by it, must regard the incongruity not as a source of anxiety, but rather as an opportunity to relish its absurdity (Hartz and Hunt 1991).

Cases of found humor, then, require that the situations that comically amuse us not be ones in which we feel personal threat; we will not be amused if the gallumphing 300-pound man is headed on a lethal collision course toward us; nor will we be comically amused if we perceive the situation as in some other way dangerous, for example, as threatening harm to others (Carroll 1999), for that will produce anxiety.

Invented humor deploys various external and internal conventions in order to assure that its incongruities will not be anxiety-producing. The incongruity is generally introduced as non-threatening by conventional signals—such as the locution "Did you hear the one about such and such?" and/or by changes in intonation—that herald a joking situation, which type of situation, in turn, is marked by custom as an arena for playfulness. Indeed, these conventional markers not only announce that the participants should not feel threatened themselves, but also call for a kind of comic distance—an absence of empathy and moral concern for the characters in jokes and satires—that relieves us of worries and anxieties about what is happening to the beings that inhabit the joke worlds and other fictional environments of invented humor. They can be burning in hell or being eaten by sharks or falling from tall buildings. Yet the convention of comic

distance tells us to bracket any anxieties on their account. As Bergson observed, humor demands a momentary anaesthesis of the heart.

And, of course, this comic distance or comic anaesthesis is not merely a function of conventions external to the humor in question. Jokes, slapstick, and the like are also internally structured in a way that supports bracketing anxiety by refraining from dwelling upon or calling attention to the consequences—physical, moral, or psychological—of the harms that befall comic characters. That is, after we are told in a joke that some character has been blown apart, we are not reminded that he would be bleeding profusely, for that might elicit empathy. In fact, invented humor generally traffics in fictional worlds that are bereft of sustained acknowledgments of pain in such a way that our normal empathetic and moral responses remain in abeyance, thereby divesting the situation of the potential to provoke anxiety.

Comic amusement for the Incongruity Theory, then, requires as its object a perceived incongruity, of the sort inventoried above, which is neither threatening nor anxiety-producing but which can, on the contrary, be enjoyed. Invented humor is that which is intended to afford such a state. Of course, this is not yet an adequate definition, since the definition so far could be satisfied by mathematical puzzles, whose solutions, though sometimes occasioned by laughter, are not *prima facie* either humorous or objects of comic amusement.

The problem here is that our responses to incongruities are not partitioned just into being threatened as opposed to being comically amused. Often, incongruities simply puzzle us and motivate us to solve the problem in question. But, in contrast to humor and comic amusement, puzzles, puzzle-solving, and whatever pleasures they afford are committed to really resolving incongruities, to making genuine sense, and to dispelling apparent nonsense. In the state of comic amusement, on the other hand, we are not concerned to discover legitimate resolutions to incongruities, but, at best, as in the case of jokes, to marvel at the appearance of sense, or the appearance of congruity, in what is otherwise recognized as palpable nonsense (Carroll 1991).

Moreover, that we are to suspend our inclinations to puzzle-solving is signaled by the external conventions and internal structures of invented humor. That is, the conventions that indicate the presence of invented humor announce that real resolutions of incongruity are not in the offing, while, at the same time, the content of the humor defies veridical resolution. Whereas, in problem-solving, enjoyment with respect to the puzzle attaches primarily to finding the solution, with comic amusement the enjoyment focuses on the incongruity itself.

Summarizing one version of the Incongruity Theory, then, someone is comically amused if and only if (i) the object of her mental state is a perceived incongruity, (ii) which she regards as neither threatening or anxiety producing, and (iii) which she does not approach with a genuine, puzzle-solving attitude, but (iv) which, rather, she enjoys. Humor is the response-dependent property that affords comic amusement. Found humor differs from invented humor in that the latter is proffered with the intention, supported by external and internal features of the presentation, to afford comic amusement, whereas in the case

of found humor the percipient herself not only discovers the incongruities, but brackets wariness and the disposition toward puzzle-solving on her own, thereby opening herself to the possibility of enjoying the stimulus.

However appealing the Incongruity Theory of Humor may appear, it does have at least one problem that cannot be overlooked: it is the very notion of incongruity. For we do not have a clear definition of it. In the past, when philosophers like Schopenhauer attempted to define humor rigorously—he thought it was essentially a category mistake—the definition has appeared to be too narrow to accommodate everything we would typically count as humorous. This then tempts one to try to elucidate incongruity, as above, by enumerating prototypical examples. But these examples run a very broad gamut of cases, ranging from conceptual and logical errors to inappropriate table manners, to subverted expectations in general. Thus, one fears that the notion of incongruity may not be exclusive enough, especially if it unqualifiedly countenances something as pervasive as the subversion of expectations as an incongruity. And, furthermore, the definition as developed so far may also be too exclusive, since many Surrealist artworks that we would not regard as comically amusing would appear to satisfy it (see Martin 1983). Though promising, the Incongruity Theory of Humor remains a project in need of further research.

The third traditional theory of humor is called the *Release Theory*. Some have speculated that Aristotle may have propounded such a theory in the lost second book of his *Poetics*, which we are told analyzed comedy. Since the first book explicated tragedy in terms of the notion of catharsis, it has been hypothesized that it is probable Aristotle would have similarly regarded comedy as a way of dissipating built-up feelings.

The Earl of Shaftesbury suggested that comedy released our otherwise con-strained, natural free spirits (Morreall 1998), a view shared by Freud, who argued that jokes liberate the energy expended by rationality to repress both infantile non-sense and tendentious feelings (Freud 1976). Similarly, Herbert Spencer regarded laughter as a discharge of nervous energy that occurs when the mind, taken unawares, is led from the consciousness of something large (grave, or at least serious) to something small (silly or trivial) (Spencer 1911). Presumably, when this happens, the nervous energy accumulated to grapple with serious matters is displaced or vented into laughter, and thereby flushed out of the system.

The theories of Spencer and Freud have the liability of presupposing hydraulic views of the mind that are highly dubious. They postulate the existence of mental energy that behaves like water—flowing in certain channels, circumventing blockages, and seeking outlets as the pressure builds. Their language, though couched in the scientific jargon of their day, seems at best metaphorical from the viewpoint of the present. Or, to put the objection in a less *ad hominem* form, their theories assume that there is something to be released, something that has built up or been repressed, some quantity of energy. But there seem to be scant scientific grounds for such assumptions.

It might seem that the Release Theory could be rephrased in less contentious language, perhaps using the notion of expectations. When asked a riddle or told

a joke, it might be said, naturally enough, that expectation builds as we await the punchline. When it arrives, the pressure of those expectations is released or relieved, and laughter ensues. But it does not seem that the notions of release or relief provide a necessary, accurate, or desirable way of describing how expectations are engaged by jokes.

Jokes and riddles ideally inspire a desire for closure in listeners—a desire, for example, to hear the answer to the riddle or the punchline of the joke. When the answer or punchline arrives, that desire is satisfied, and such satisfaction contributes to the enjoyment that ensues, enjoyment that is often marked by laughter. But there is no cause to speak of release here; talk of expectations or desires and their fulfillment suffices.

Perhaps it will be proposed that, once our desires are fulfilled, we are in effect released from them. But, since they are our desires, this seems a misleadingly metaphorical way of speaking. It says no more than that we no longer have the desire in question. After all, we possess the desire; the desire does not possess us. Just as it makes more sense to say—from a non-theological point of view—that when we die we are no longer alive, rather than that we have been released from life, so it is better to say we no longer have the expectations, rather than that we have been released from them, when those expectations have been satisfied.

Jokes belong to the category of what might be called temporal humor; they promise closure. But not all humor is like this. Some humor involves no build-up of expectations. So, even if we accepted the Release Theory as an account of the play of expectation in temporal forms of humor, like jokes, it could not be extended to forms of humor that do not build up expectations over time. When the 90-pound sumo wrestler appears on stage, or when we find the running shoes in the freezer, we are comically amused. But it is wrong to say that our expectations have had anything done to them, since in these cases we had no antecedent expectations. Here, of course, it is open to the proponent of the Release Theory to attempt to postulate that there is always some subconscious processing, however brief, going on, and that this involves expectations. But until one is told more about the way in which these alleged processes work, this gambit sounds exceedingly ad hoc.

Alternatively, it may be said that we do have the requisite expectations without hypothesizing subconscious processing; that is, we have standing expectations about what is normal, and it is these expectations that have been subverted. Thus, we are released from our standing or normal expectations. And, it might be added, this is also what happens when we are confronted with the nonsensical endings of jokes, as well as with confrontations with 90-pound sumo wrestlers. But, again, the idea that we are possessed by and then released from our normal conceptual schemes seems strained here, unless we suppose that those expectations are invested with powers to constrain or to repress, or that they require some supplemental quotient of mental pressure in order to continue functioning. However, that then sends us back to an earlier problem—the tendency of Release Theories to proliferate unwarranted mental processes. Nor

does it seem plausible to imagine that having our normal expectations about the world is like being shackled, since the "shackles" are us.

Many contemporary theories of humor are variations on the Superiority Theory, the Release Theory, and, more frequently, the Incongruity Theory. One interesting contemporary theory of humor that breaks with precedent has been offered by Jerrold Levinson (1998). According to Levinson, something is humorous just in case it has the disposition to elicit, through the mere cognition of it, and not for ulterior reasons, a certain kind of pleasurable reaction in appropriate subjects (that is, informationally, attitudinally, and emotionally prepared subjects), where this pleasurable reaction (amusement, mirth) is identified by its own disposition to induce, at moderate or higher degrees, a further phenomenon, namely, laughter. Thus, for Levinson, humor cannot be detached from all felt inclination, however faint, toward the convulsive bodily expression of laughter.

This theory can be called the Dispositional Theory of Humor. Like the Incongruity Theory, it acknowledges the importance for humor of a cognitive-response element. But Levinson does not define that response as narrowly as the perception of incongruity. Rather, he leaves uncharacterized the nature of the relevant cognitions and their intentional objects, requiring only that said cognitions have some intentional object at which they are directed and that they elicit pleasure for its own sake from suitable percipients.

Of course, this much of Levinson's analysis could be satisfied by mathematical theorems of sufficient cleverness. In order to forestall counterexamples like this, Levinson's final requirement is that the pleasure elicited by the cognition of the humorous be identified by its own disposition to induce laughter; for, though mathematical ingenuity may provoke laughter for some, it has no reliable disposition to do so, even among mathematicians who take pleasure in it.

Though Levinson's theory locates humor in a certain kind of pleasure, he does not give us much by way of a characterization of the nature of that pleasure. By suggesting that it is mirth or amusement, the definition appears to flirt with the kind of circularity one finds in definitions of the "dormative power" variety. In order for the theory to be of any use in identifying humor, Levinson needs to link the unspecified feelings of pleasure that he has in mind to their disposition to elicit laughter. Thus, given Levinson's account, it is the disposition to elicit laughter, laughter grounded in pleasurable cognitions, upon which we must rely in order to hive off humor from puzzle-solving.

This disposition toward laughter, moreover, need not be intense. It may be only a faint inclination, and, of course, it need not actually find expression in overt laughter. This is dispositional theory, since it does not, like the Incongruity Theory, specify anything about the structure of the intentional object of comic amusement, but only demands that whatever pleasures the cognitions give rise to have the further disposition, however slight, to elicit laughter.

It is not evident how strictly Levinson intends us to understand the notion of a disposition toward laughter. Some invented humor is very low key. It invites an extremely mild, but nonetheless real, sense of pleasure that, at best, manifests

itself in a brief, almost undetectable, smile or maybe nothing more than a
twinkle of the eye. Are we to regard this as a felt, albeit faint, inclination toward
laughter? Ordinarily, I think we would not, though perhaps Levinson should be
allowed either to stipulate that any slight feelings of levity that can be physically
manifested count as inclining us toward laughter, or else to re-write his theory in
terms of any slight inclinations to laughter or smiles of any sort, including very
discreet and very transitory ones.

Nevertheless, there is a problem with both of these alternatives. Both, like
Levinson's original proposal, connect humor necessarily to certain kinds of
bodies—paradigmatically human bodies. Thus, communities of telepathetically
communicating brains in vats, disembodied gods, and aliens without the bio-
logical accoutrements to support laughter or even smiling could not be said by
us to have humor as a feature of their societies. But I am not convinced that our
ordinary concept of humor is so restrictive. We would not charge a science-fiction
writer with conceptual incoherency if she imagined an alien society of the sort
just mentioned and also described it as possessing humor.

Standardly, we grant that there are pleasures, such as certain aesthetic and/or
intellectual pleasures, that do not require any distinctive bodily sensations.
Suppose a community of disembodied gods enjoyed incongruities but neither
laughed nor felt sensations of levity, because they lacked the physical equipment.
Would we say there was no humor there, even though they create, exchange,
and enjoy things that look like jokes, even if we don't get them? Remember that
these jokes give them pleasure—pleasure akin to certain aesthetic or intellectual
pleasure—though sans laughter or the inclination thereto.

Or imagine a community of humans who, as a result of grave cervical cord
injuries, lack the ability to move air owing to the inhibition of the muscles in
their diaphragm, thorax, chest, and belly. These people cannot laugh, since they
do not possess the necessary motor control to respirate, or even to feel any of
the pressures that dispose "normals" toward laughter. They lack even residual
feelings of levity. But surely they, like the gods, could create, exchange, and enjoy
in-jokes that we outsiders might not get, but that we can still recognize as jokes,
either on formal grounds or because the injured jokesters tell us. Would we say
that this society lacked humor?

My intuition is to answer "no" in the cases of such disembodied gods,
biologically alien aliens, and injured humans, because I do not think that our
concept of humor necessarily requires an inclination toward laughter, though
admittedly laughter is a regularly recurring concomitant of humor among
standard-issue human beings. Yet, if the laughter stipulation is dropped from
Levinson's definition, he will, unlike certain versions of the Incongruity Theory,
have no way to exclude puzzle solutions from the ambit of humor, since he has
left the structure of the intentional object of humor wide open. Nor can he say
that the type of pleasure afforded by puzzles is necessarily not humorous without
appearing to beg the question.

Levinson does not specify the nature of the cognitions requisite for humor
because he feels that specification—of the sort one finds in the Incongruity

Theory—may be too exclusive. He does not, though, offer any compelling counterexamples to the Incongruity Theory. The one brief case that he alludes to is that of someone slipping on a banana peel; but, in acknowledging that it may be humorous in that it involves a deflation of expectations, or strangeness or surprise, Levinson makes the case sound more like an exemplification of a generous notion of incongruity rather than a counter-instance. Bergson, of course, would analyze such an example as a matter of mechanical absentmindedness—a deviation from the norm of properly functioning sentience—and, therefore, as an incongruity. Consequently, it is not clear that Levinson has a persuasive reason to avoid specification of the relevant cognitions in terms of perceived incongruity, or else something like it—perhaps some refined successor notion.

One reason to suspect Levinson's liberalism about the scope of the cognitions he allows with respect to humor is the following counterexample. Certain avant-garde films, such as those of Godard, contain allusions to other works of art—not only other films, but paintings, and so on. When suitably prepared viewers—the cognoscenti, if you will—detect those allusions, they laugh in order to mark their pleasure in recognizing the reference. This is quite customary, as can be confirmed by frequenting any avant-garde film venue. But the allusions need not be funny or humorous. They obviously engage cognition, directed at the allusion, which gives rise to pleasure, which in turn disposes cinéphiles toward laughter—a disposition that is often manifested. Admittedly, some of these allusions may be humorous in the ordinary sense, but they need not be. And, where the allusion is not itself funny in context, it seems wrong to call it humorous, though Levinson will have to.

Moreover, the problem here is not restricted to just this single counterexample; recent research on laughter maintains that most laughing does not occur after jokes or funny remarks, but as a kind of conversational lubricant in everyday discourse (see Provine 2000). This constitutes a formidable problem for Levinson's theory, since as a matter of fact laughter often follows pleasures engendered by cognitions that are not comic in nature (e.g., cognitions about a couple's plans to become engaged). But surely not every sort of phatic laughter issuing from ordinary cognitions signals humor.

Traditional theories of humor and the more recent Dispositional Theory all have their share of difficulties. However, the Incongruity Theory still seems the most promising, because it offers the most informative approach to locating the structure of the intentional object of comic amusement. This allows us to employ it productively in comic analysis—enabling us to pinpoint and to dissect the designs that give rise to amusement in jokes, plays, satires, sitcoms, and so on. Of course, current versions of the Incongruity Theory are unsatisfactory, because the notion of incongruity is simply too elastic. Nevertheless, perhaps the way to proceed, at this point in the debate, is to embrace the notion of incongruity as a heuristic which, though vague, is not vacuous, and apply it to a wide number of cases and counterexamples in the hope of isolating, as precisely as possible, the pertinent recurring structures of humor. With that in hand, maybe the

concept of incongruity can be more rigorously refined or a successor concept identified.

2. HUMOR, COMEDY, ART

The term "comedy" covers a multitude of forms—burlesques, farces, satires, sitcoms, parodies, caricatures, travesties, stand-up monologues, cartoons, slapstick, screwball comedies, downing, sight gags, jokes, and much more. In ordinary language, it would appear that "comedy" is the usual label for invented (rather than found) humor that is expressly designed to be presented formally in some institutional setting (such as a theatre, a club, a circus, a motion picture, a television or radio program, a music hall). Thus, we call a monologue an instance of comedy when it is presented as an act at a comedy club, but we are less disposed to categorize the same monologue as comedy when it is retold by a coworker on a coffee break. Broadly speaking, in everyday usage, the concept of comedy seems to apply most naturally to the inventions of professionals who intend to elicit comic amusement as the predominant response—or, at least, as a significant part of the response—of spectators playing the relevant institutional role of audience members. It is on such grounds that sitcoms, caricatures, slapstick comedies, and even certain game shows are generally catalogued under the rubric of comedy, and that the agents who create them are called "comics" or "comedians."

However, there is also a narrower, quasi-technical, notion of comedy. In this usage, "comedy" is the name of a genre of dramatic narration, one that stands in contrast with tragedy. Whereas tragedies typically end badly for their leading characters, comedies end well. *Hamlet* concludes with bodies everywhere; *A Midsummer Night's Dream* with marriages all around. On this view, then, the difference between comedy and tragedy is a matter of plot structure.

Of course, many of the recurring plot structures of what are called comedies can be analyzed in terms of humor. A frequent plotting device of comedy involves conflicting points of view in which the way the character understands the situation parts company incongruously (but in a way that does not provoke anxiety) with the way in which the audience perceives the situation; for example, the town officials think that Khlestakov is the government inspector, but we know better, while Titania thinks Bottom an exemplar, but we see him for the ass he is.

Similarly, frequently comic plots incongruously pair the efforts of characters with their outcomes: a fool, if morally upright, is apt to succeed—for example, to win his beloved—in a comedy, whereas his smarter, stronger, "more normal" adversary is almost always thwarted, despite the extreme improbability of such events in real life.

Nevertheless, though comedies often have plot devices that are reducible to structures of comic amusement, not all of the narrative features that are associated with comedy are reducible to humor. For instance, a happy ending

is often advanced as the hallmark of comedy, but a happy ending need not be either humorous or incongruous, given the rest of the pertinent plot. For example, the comic protagonist need not be a fool and his success need not be wildly improbable. Thus, with respect to plot structure, a comedy, in the narrow sense, does not, in itself, have to be humorous. Moreover, certain narratives, like Westerns, may have happy endings, but have virtually no humor in them, while Chaplin's *The Circus*, a comedy in the broad sense, ends sadly.

Consequently, the narrower conception of comedy may produce results quite at odds with contemporary usage. This is understandable, since the narrower concept was designed to sort narratives into only two kinds—comedies and tragedies. However, given the proliferation of narrative genres since the time of the Greeks, perhaps the kindest thing that can be said about the narrower concept of comedy is that it is obsolete; it is no longer fine-grained enough to accommodate the data, if it ever was.

As some of the preceding examples indicate, some comedies are art. Certainly, if anything is art, *A Midsummer Night's Dream* is. But it is not obvious that everything that falls into the category of humor has the status of art. For example, are all jokes art?

Ted Cohen (1999) has suggested important analogies between jokes and artworks. Like artworks, jokes mandate audiences to complete them—to fill in the presuppositions, emotions, and attitude the joke requires for uptake. Moreover, in mobilizing this material, and by celebrating with laughter their mutual understanding of a joke, listeners and joke tellers come to form an intimate community of appreciation like the communities of taste that arise in response to artworks. These common features, then, suggest that jokes are artworks, albeit miniature ones.

However, there are also noteworthy disanalogies between artworks and jokes. Typically, artworks are designed in such a way that they are supposed to invite sustained contemplation. In the ideal case, one returns to the artworks again and again, each time taking away a new or enriched insight. Jokes, on the other hand, are not usually like this. They are generally one-shot affairs. One listens to jokes, gets them, and that's that. One may store them in memory in order to repeat them on another occasion. But one does not normally contemplate them, seized by their structural complexity and ingenuity, or intrigued by their perspective on the human condition. Some jokes may be capable of affording such responses, but the vast majority are not. Therefore, it appears reasonable to suppose that not all comedy or invented humor falls into the category of art; it would seem that jokes do not.

3. HUMOR AND MORALITY

The earlier review of theories of humor reveals that humor comes in contact with ethics in many ways, a number of which are apt to trouble the moralist.

Humor often involves ridicule and malice, feelings of superiority, scorn toward infirmity, the transgression of ethical norms, and intentional offensiveness; it may even presuppose the anaesthesia of the heart—the bracketing of empathy and moral concern—at least for the creatures of comic fictional worlds. It presents for delight spectacles of greed, venality, promiscuity, cruelty, gluttony, sloth—in short, every manner of vice. All this makes the moralist nervous.

The ethics of humor has, as a result, been a recurring theme in the philosophy of comedy. In recent years, this discussion has become increasingly prominent, perhaps as an academic reflection of the tides of political correctness in the larger culture. Philosophers have been especially concerned to locate exactly what is ethically wrong about humor—that is, at least when it is morally remiss. Two sophisticated attempts in this direction have commanded particular attention: Ronald de Sousa's hypothesis that our laughter at an evil joke reveals in us an evil character, and Berys Gaut's ethicism.

Many jokes are sexist, racist, classist, homophobic, anti-Semitic, and the like. Such jokes contain an element of malice, directed at women, African Americans, workers, gays, Jews, and so on. Ronald de Sousa (1987) calls this element phthonic, and distinguishes it from wit, presumably the simple cognitive play of things like incongruities. All jokes are conditional; they require listeners to fill in their background assumptions, to recognize the norms that are under fire, and to access the emotions and attitudes the joke requires in order to be intelligible (Cohen 1999). When a joke pressupposes malicious and immoral attitudes in order to succeed and we laugh, de Sousa contends that this shows that we are morally flawed, insofar as we share the phthonic attitude showcased in the joke.

For example, de Sousa invites us to contemplate this joke: "M (a well-known celebrity, widely rumored to be sexually hyperactive) visits a hockey team. When she emerges, she complains she has been gang-raped. Wishful thinking." Putatively, this joke relies on a series of sexist presuppositions, including: (a) that rape is merely a variant form of allowable sexual intercourse; (b) that many women's sexual desires are indiscriminate; (c) that there is something objectionable about a woman who has a lot of sex. De Sousa maintains that in order to get this joke one must access these sexist attitudes toward women, and that, if one laughs, this shows that one literally shares these attitudes—that one is a sexist.

Clearly, sexists can use jokes like this in order to cement their fellowship with other sexists. But the question is whether *anyone* who laughs at this joke is a sexist, a member of the sexist fellowship. De Sousa says "yes," because he alleges that the attitudes required for uptake of this joke cannot be assumed hypothetically: they must be attitudes that compliant listeners actually share with the joke.

One problem with de Sousa's argument is that he supposes that there is only one interpretation of this joke, that is, the sexist one that presupposes that rape is merely a variant form of sexual intercourse, with no moral stigma attached. When I first heard this joke, however, I did not interpret it that way. I thought that it was about hypocrisy. M was a supposedly well-known Donna Juanita. Thus, I thought that the joke was suggesting that she *had* had sex with the hockey

team, but then tried to cover it up by saying she had been gang-raped—to which the skeptical narrator of the joke replies, effectively, "dream on if you think we'll buy that one." The humor, I supposed, was akin to that of unmasking a Tartuffe. That explained to me why the central character is marked as someone noteworthy for her sexual appetite. Moreover, de Sousa's interpretation does not seem completely coherent. If M had been raped and the joke assumes that rape is just a variant of sexual intercourse, what is it that she still wishes for? What is the significance of the punchline "Wishful thinking"?

It does not make much sense to quibble over the correct interpretation of this joke. But there is a theoretical point here. Many jokes support a variety of interpretations, several of which may promote laughter. This is not to say that jokes are completely open texts. The interpretations generally fall within a circumscribed range. However, a joke may possess more than one reasonable interpretation, each of which may lead to laughter. In de Sousa's example, the target of ridicule may be female sexuality, as he says, or it may be hypocrisy, as I thought. But if a non-sexist interpretation of the joke promotes comic laughter, then de Sousa cannot infer, as he does, that anyone who laughs at the joke reveals a morally flawed, sexist character. De Sousa neglects the possibility that some jokes that appear on his interpretation to be sexist may be risible to others under non-sexist interpretations. Consequently, the inference pattern he proposes is inadequate.

But let us look at an unequivocally sexist joke of the sort de Sousa wants—an old *Playboy* definition: rape is an assault with a friendly weapon. Does laughter at this reveal a sexist character? Many would deny it, arguing that what they laugh at is the incongruous word wit, the oxymoronic juxtaposition of opposites (assault and deadly weaponery yoked together with friendship). True, they must in some sense recognize the sexist attitude that underwrites this nonsense. But the question is whether they have to affirm it. They might be laughing at the implied speaker of this joke—after all, they regard it as silly and nonsensical, a faux definition.

But even if this is too baroque an interpretation of what is going on here, still it seems plausible for the amused listener to say: I was only laughing at the word "wit" and I was entertaining the notion that rape is not really grievous bodily assault simply for the sake of accessing the wit. My laughter no more signals my endorsement of the fallacious view in question than my laughter at a crazy definition of death would show that I really feel that death is not a morally serious event.

De Sousa denies this possibility, maintaining that the attitudes revealed in phthonic humor cannot be assumed merely hypothetically. De Sousa does not really offer an argument to this conclusion. And, on the face of it, it appears counterintuitive. In jokes, we entertain or imagine all sorts of possibilities that we do not believe: that there are genies who grant wishes, that there is an afterlife, that peanuts can talk, that death can be outsmarted. Why then is it not possible for us provisionally to imagine, incongruously, that rape is just sexual intercourse? Indeed, it may be the very incongruity of this thought that provokes

amusement, though to be amused in this way presupposes that we disbelieve it (i.e., find it incongruous) rather than affirm it. Such amusement may involve the anaesthesia of the heart so common in humor, but, by the same token, it need not belie one's true attitudes any more than entertaining a disparaging view of alleged Irish drinking habits shows a malicious attitude to real Irishmen.

De Sousa's answer, I conjecture, is that the requisite attitudes with respect to phthonic humor are not merely of the order of beliefs, but are emotionally charged, and for that reason cannot be merely entertained, but must be deeply sedimented in our being. However, this seems unsubstantiated. Blonde jokes appear to presuppose certain negative attitudes toward blonde women and their intelligence. Yet I can laugh at them while being happily married to a blonde whose intelligence I admire. My wife laughs at them too; often she tells them to me. De Sousa seems insensitive to the fact that we are dealing with a fictional genre here, in which the Blonde is an imaginary being and a fictional convention. Certainly, it is possible for us to entertain emotions toward fictional beings that we would not mobilize for their comparable real-world counterparts. Given the fictional context, I cheer on the imaginary ageing gunslinger; but if I met up with him on the street, I would probably slink away and notify the police. The emotions I entertain in response to fictions need not be taken as an index of my authentic attitudes. I take the blondes in Blonde jokes to be fictional conventions, and I take pleasure in the clever manipulation of the convention.

That de Sousa neglects the role that imagination and fiction play in jokes compromises his hypothesis about phthonic humor. Though such humor may serve as a vehicle for malicious attitudes—and be morally contemptible for that reason—such cases do not support the generalization that laughter in response to predominantly phthonic humor always reveals an evil attitude, since the laughter may be at whatever wit resides in the joke, and the presuppositions and emotions required to access that wit may merely be imaginatively entertained and directed at fictional beings.

Jokes, even ostensibly phthonic jokes, are often far more complicated than de Sousa acknowledges. There is the story about a genie who comes upon an African American, a Jew, and a redneck. He grants each a wish. The African American wishes that his people be returned to Africa; the Jew that his people be returned to Israel. Once the redneck realizes that the blacks and the Jews have all left America, all he wishes for is a martini.

Told by a racist to racists, the joke may celebrate communal hatred; told by a liberal to another liberal, there is still a laugh, though this time at the expense of the redneck and his very limited, monomaniacal, and warped economy of desires. The context of a joke utterance and the interpretations and purposes that listeners bring to it are crucial to assessing the ethical status of a joke transaction. De Sousa is too quick to assume that apparently phthonic jokes always have an invariant meaning and invariably elicit authentically malicious responses. But this need not be so.

Surely de Sousa is correct in claiming that, when a joke serves to convoke a community of genuine malice against the innocent, it is evil. But he is simply

wrong in hypothesizing that every joke transaction with strong phthonic elements serves that purpose. Moron jokes are not usually told to commemorate or reinforce hatred for the retarded; in fact, I have never heard one told for this purpose. Rather, their conventions and stereotypes, including their stereotypical attitudes, are entertained, rather than embraced, in order to motivate incongruities.

Much humor is transgressive. But the transgressiveness of *The Simpsons*, *South Park*, *The Man Show*, and Bernie Mac's aggressive rant against children in *The Original Kings of Comedy* (2000) has a double edge. Not only are "forbidden" ideas and emotions aired, thereby engendering amusement through the exhibition of incongruous improprieties, but, at the same time, the attitudes underlying those transgressions may be, ironically enough, satirized. Al Bundy's misogynistic badinage in *Married With Children* provokes laughter by flouting moral rules, but also pokes fun at the character himself whose attitudes, like Homer Simpson's, are revealed to be nearly Neanderthal. Responding to such phthonic humor, then, need not signal endorsement of the attitudes displayed in the humor, but may indicate our feelings of superiority to them. And, even if in some cases we are laughing because we recognize something of Homer Simpson or Al Bundy in ourselves, our laughter may not be affirmative, since we are, in effect, knowingly laughing reflexively at ourselves as well, and in that sense hardly endorsing the attitudes in question. Similarly, the outrageous views of Canadians voiced by the citizens of *South Park* are really satiric reflections on the chauvinism of US citizens. Because phthonic humor can come replete with so many complex layers of meaning (including ironic meanings), de Sousa's confident conclusions about implications of responses to phthonic humor appear too facile.

Ethicism, a position developed by Berys Gaut, is another attempt to explore the relevance of immorality to humor, specifically jokes (Gaut 1998). Most would concur that there are immoral jokes—jokes that should not be told and should not be encouraged. However, there is an extreme form of moralism that goes so far as to claim that such jokes are not even humorous—that they are not funny at all. That is, such jokes are not only evil: they are not even amusing. Gaut's ethicism is best understood in contrast to this sort of extreme moralism.

For Gaut, immorality does not preclude the humorousness of a joke utterance. Nevertheless, immorality does always count against its humorousness. A joke utterance that contains immoral elements may also contain elements of formal wit and cleverness, and the latter may outweigh the immoral elements in an all-things-considered assessment of its humor. But, even if they are outweighed, the immoral elements are always bad-making features of a joke utterance *qua* joke (or *qua* humor), and not merely in terms of its moral status. If a joke utterance with immoral elements is humorous overall, according to Gaut, that is only because it contains other relevant features that counterbalance its moral blemishes. And, of course, in some situations the immoral elements may overwhelm whatever traces of cleverness obtain; in such circumstances the joke utterance is not, all things considered, funny.

Gaut defends ethicism by means of what can be called the *Merited Response Argument*. When we judge a joke utterance to be humorous, we do not do so

on the grounds that it in fact causes laughter in a certain number of people. That is, humorousness is not merely a statistical concept. Everyone else in the room might laugh at it, but we may still judge the joke utterance unfunny. Our judgment here is a normative one. Does the joke utterance merit a positive response? Is our laughter appropriate? Does the joke utterance deserve laughter?

Comic amusement is a complex response to many aspects of the joke utterance, not simply to its cleverness, but also to the affect the joke summons up. And these elements can come apart. The joke utterance may merit a positive response because of its word play, but the affect it calls forth may be inappropriate—for instance, because it is repulsively immoral. If the negative aspects of the affective dimension are more commanding than the cleverness, then, all things considered, our positive response to the joke is unmerited (the joke utterance is not, overall, funny). If on the other hand, the cleverness is more compelling, the joke merits being called humorous, all things considered—i.e., funny—though nevertheless still flawed or blemished *qua* joke.

Ethicism, unlike extreme moralism, can grant that some joke utterances with immoral elements can be funny, thereby appealing to our ordinary intuitions about the matter. But, in regarding said elements as inappropriate features, ethicism can also accommodate the possibility that there are jokes so thoroughly and repellingly evil that they are no longer truly funny.

The persuasiveness of ethicism depends on the Merited Response Argument. Opponents of it claim that the argument begs the question (Jacobson 1997). For moral appropriateness seems built into the criteria of appropriateness of Gaut's concept of the humorous. But this is what Gaut should be demonstrating as his conclusion: he cannot just presume it from the outset. Whether a joke candidate merits being called humorous, it can be argued, depends upon whether, with reference to the prototypical case, it engenders enjoyment through its manifestation of incongruities, which, of course, can include moral incongruities. To show that moral transgressions count against classifying a joke utterance as humorous requires an argument to that result. Gaut has not supplied such an argument; he has merely assumed the conclusion as a premise—conflating the *prima facie* criteria for appropriateness in humor with those of appropriateness *tout court*, which, of course, include moral rectitude.

If Gaut wants to convince those who are skeptical that, in order to be humorous, a joke utterance cannot be saliently immoral, he needs to share common premises with the skeptic. The skeptic will deny that to be a merited response *qua* humor to a joke utterance requires that the joke itself be morally meritorious (or, at least, not morally reprehensible). Humor is amoral, the skeptic will say. Thus, the skeptic will reject that a merited response to humor must take into account the moral merit or demerit of the work. To confuse the meritedness of the humorous response with moral merit is, according to the skeptic, an equivocation.

Ethicism has yet to respond to the skeptic. Consequently, the jury is still out on the question of whether immorality is *always* a bad-making feature with respect to humor. However, ethicism has perhaps suggested enough to make it plausible

to suppose that sometimes immorality can compromise the humorousness of a joke. For a joke-utterance may be so blatantly and appallingly immoral that virtually no audience will be prepared attitudinally to fill it in or to engage with it in the way required to enjoy its incongruities.

This will not always be the case with every joke utterance that contains immoral elements, since typically those elements may not be flagrantly posed and/or obviously evil to a degree that would deter uptake on the part of the standard listener. But in those cases where the immorality of the joke utterance is so disturbing to the relevant listeners that access to the enjoyment of incongruity is altogether blocked—where the joke utterance itself is, for example, a predictable source of anxiety—it seems reasonable to say that immorality can contribute to alienation of humor. Sometimes, owing to excessive moral outrageousness, the anaesthesia of the heart will be too difficult for intended listeners to sustain. And they will not be amused.

REFERENCES AND FURTHER READING

Aristotle. 1941. *Nicomachean Ethics*, in *The Basic Works of Aristotle*, ed. R. McKeon. New York: Random House.

—— 1993. *Poetics*, transl. Malcolm Heath. Harmondsworth: Penguin.

Bain, A. 1975. *The Emotions and the Will*, 3rd edn. London: Longmans & Green.

Bergson, H. 1965. *Laughter*, ed. W. Sypher. Garden City, NJ: Doubleday.

Carroll, N. 1991. "On Jokes." *Midwest Studies in Philosophy*, 16: 250–301.

—— 1996. "Notes on the Sight Gag," in N. Carroll, *Theorizing the Moving Image*. New York: Cambridge University Press, pp. 146–57.

—— 1997. "Words, Images, and Laughter." *Persistence of Vision*, 14: 42–52.

—— 1999. "Horror and Humor." *Journal of Aesthetics and Art Criticism*, 57: 145–60.

Clark, M. 1970. "Humour and Incongruity." *Philosophy*, 45: 20–32.

—— 1987. "Humour, Laughter and the Structure of Thought." *British Journal of Aesthetics*, 77: 238–46.

Cohen, T. 1999. *Jokes*. Chicago, IL: University of Chicago Press.

Freud, S. 1963. "Humor," in *Character and Culture*, ed. P. Rieff. New York: Collier Books, pp. 263–9.

—— 1976. *Jokes and their Relation to the Unconscious*, transl. and ed. J. Strachey. Harmondsworth: Penguin.

Gaut, B. 1998. "Just Joking: The Ethics and Aesthetics of Humor." *Philosophy and Literature*, 22: 51–68.

Giora, R. 1991. "On Cognitive Aspects of the Joke." *Journal of Pragmatics*, 16: 465–85.

Hartz, G., and Hunt, R. 1991. "Humor: The Beauty and the Beast." *American Philosophical Quarterly*, 25: 299–309.

Hutcheson, F. 1973. "Reflections on Laughter," in P. Kivy, ed., *An Inquiry Concerning Beauty, Order, Harmony, Design*. The Hague: Martinus Nijhoff, pp. 102–19.

Jacobson, D. 1997. "In Praise of Immoral Art." *Philosophical Topics*, 25: 155–99.

Kant, I. 1951. *Critique of Judgment*, transl. J. H. Bernard. New York: Hafner.

Kierkegaard, S. 1941. *Concluding Unscientific Postscript*, transl. D. F. Senson. Princeton, NJ: Princeton University Press.

Koestler, A. 1964. *The Act of Creation*. New York: Macmillan.

LaFollete, H., and Sharks, N. 1993. "Belief and the Basis of Humour." *American Philosophical Quarterly*, 30: 329–39.

Levinson, J. 1998. "Humour," in E. Craig, ed., *Routledge Encyclopedia of Philosophy*. London: Routledge, pp. 562–7.

Martin, M. W. 1983. "Humour and the Aesthetic Enjoyment of Incongruity." *British Journal of Aesthetics*, 23: 74–84.

Monro, D. H. 1951. *The Argument of Laughter*. Melbourne: Melbourne University Press.

Morreall, J. 1983. *Taking Laughter Seriously*. Albany, NY: State University of New York Press.

—— ed. 1987. *The Philosophy of Laughter and Humor*. Albany, NY: State University of New York Press.

—— 1989. "Enjoying Incongruity." *Humor*, 2: 1–18.

—— 1998. "Comedy," in M. Kelly, ed., *Encyclopedia of Aesthetics*. Oxford: Oxford University Press, pp. 401–5.

Oring, E. 1992. *Jokes and their Relations*. Lexington, KY: University Press of Kentucky.

Palmer, J. 1994. *Taking Humour Seriously*. London: Routledge.

Pfeiffer, K. 1994. "Laughter and Pleasure." *Humor*, 7: 157–72.

Phipps, W. 1979. "Ancient Attitudes toward Laughter." *Journal of the West Virginia Philosophical Society*, 16: 15–16.

Plato. 1961. "Philebus," in E. Hamilton and H. Cairns, eds, *The Collected Dialogues of Plato*. Princeton, NJ: Princeton University Press, pp. 1086–150.

—— 1993. *Republic*, transl. R. Waterfield. New York: Oxford University Press.

Provine, R. 2000. *Laughter: A Scientific Investigation*. New York: Viking.

Roberts, R. 1988. "Is Amusement an Emotion?" *American Philosophical Quarterly*, 25: 269–73.

Schopenhauer, A. 1966. *The World as Will and Representation*, vol. I, transl. E. F. J. Payne. New York: Dover.

Scruton, R. 1982. "Laughter." *Proceedings of the Aristotelian Society*, suppl. vol., 56: 197–212.

Sousa, R. de. 1987. *The Rationality of Emotion*. Cambridge, MA: MIT Press.

Spencer, H. 1911. "The Physiology of Laughter," in *Essays on Education and Kindred Subjects*. London: Dent, pp. 375–88.

20

Two Comic Plots

A great deal of the humor that we encounter is narrative in form. This is obviously the case with many, if not most, jokes. But humor also occurs in more expanded narrative frameworks, including plays, novels, films, short stories, TV programs, comic books, and so forth. The purpose of this paper is to explore the question of whether there are any plot structures—of magnitudes greater than that of the joke—that might be thought of as comic in virtue of their narrative form.

That is, clearly we will call a novel, a play, or a film comic, if it is full of comic incidents. Yet a novel or play or film may be replete with comic incident, while, at the same time, it possesses a plot structure not discernibly different from a story that we would not be disposed to call comic—for example, a serious romance ending in marriage although sans any amusing mishaps along the way. Consequently, our question is: are there, in addition to the humorous content of narratives (the funny incidents), anything worthy of being considered to be comic forms—that is, narrative structures that have some special claim on being regarded as characteristically comic in their own right. In this chapter, I will attempt to identify two such plots, though I suspect that there are more.

Traditionally, comic narratives are said to be those with happy endings. As recently as 2003, Albert Bermal asserts that comedy is "a genre in which the ending of a play or film script proclaims happiness through a love match, a wedding, a triumph over adversity, or a reconciliation."[1] But a happy ending cannot be the identifying mark of that which we are wont to call a comic narrative. At the very least, it is not sufficient for comedy. The film *Seabiscuit* has a happy ending, but it is not apt to be called a comedy. Moreover, a happy ending is not a necessary condition for comedy. *The Circus* concludes badly for the Tramp; and inasmuch as we are intended to sympathize with him, it is an unhappy ending.

Admittedly, a great many comedies—probably even most—have happy endings. But so do a lot of other genres. Horror fictions, statistically speaking, usually end well insofar as the monster is dispatched, though few horror fictions count as comedies. And though, as Bermal notes, many comedies end with love requited, weddings, and reconciliation, a comedy can end in apocalypse, as does

[1] Albert Bermal, "Comedy," *The Oxford Encyclopedia of Theatre and Performance*, ed. Dennis Kennedy (Oxford: Oxford University Press, 2003), p. 293.

Dr Strangelove or: How I Learned to Stop Worrying and Love the Bomb. If there are comic narrative structures, they are not such simply in virtue of their possession of happy endings.

Ex hypothesi, if there are narrative structures worth calling comic, they should have some special connection with humor or amusement. That is, they should either be funny themselves or be naturally conducive to eliciting comic amusement. They should bear some internal relation or otherwise intimate connection to provoking mirth. The happy-ending structure does not, as we have just seen, meet this desideratum, since the successful defeat of the monster in a horror story rarely elicits a chuckle nor even an inclination to be comically amused. Even if happy endings predispose audiences toward generically positive or euphoric emotional states, happy endings of themselves are not fine-grained enough to arouse precisely comic merriment. Our question is whether any plot structures are.

In order to answer that query affirmatively, we would have to show that the plot structures we have in mind have some intimate connection with the springs of comic amusement—that funniness is a property of the plot structures at issue or that there is a way in which the plot structures contribute naturally to comic elation. In other words, a significant relationship between the pertinent plot structures and the essence of comic amusement must be discovered in order to establish that these plots are *comic* in the strong sense. Needless to say, we are not arguing that people should refrain from calling fictions comedies if they are packed with amusing incidents but lacking these plot structures. Rather our claim is only that some comedies may be classified as such due to both their content *and* their narrative form.

Since, in order to show this, we must connect the relevant plot structures to humor as such, our first order of business is to say something about the nature of comic amusement. To this end, we will sketch a version of the incongruity approach. Once we have done that, we will then attempt to apply our findings concerning comic incongruity to two recurring plot structures in the hope of elucidating the ways in which they activate necessary conditions of humor.

1. ON THE NATURE OF COMIC AMUSEMENT

Before we are in a position to identify certain narrative structures as comic, we need some conception of the nature of comic amusement. We will call a narrative structure comic, if it is comically amusing in itself or naturally conducive to comic amusement. But, in order to determine whether a narrative structure possesses such properties, we first require a characterization of comic amusement.

At present, the most popular approach to comic amusement, among philosophers and psychologists alike, it seems fair to say, is the incongruity theory of humor. This theory began to take its current shape and gain momentum in the eighteenth century. To a certain extent, it can be seen as a response to

many of the theoretical inadequacies of the sort of superiority theories of humor suggested by Plato and Aristotle, and propounded most succinctly by Hobbes. For Hobbes, "the passion of laughter is nothing else but sudden glory arising from some eminency in ourselves, by comparison with the infirmity of others, or with our own formerly."[2] That is, laughter expresses our feeling of superiority over others whose stupidity, ugliness, unmannerliness, or other deficiencies show them to be less than we are, or it expresses our superiority over our former selves—as when we laugh at ourselves on remembering the dinner party at which we absentmindedly sprinkled the sugar, rather than the romano cheese, over the pasta. All laughter, according to the superiority theory, is of this sort. It is at the expense of comic butts, including our past selves, and it celebrates the superiority of those who laugh last.

Undoubtedly, the superiority theory appears to suit a large number of cases. It is not hard to see that much humor is tendentious and malicious, predicated on denigrating the intelligence, probity, cleanliness, virtue, diligence, and so forth of others, often transparently for the sake of exalting oneself and one's kind. However, though the superiority theorist can point to many cases that appear to support his conjecture, there would also seem to be a wealth of examples that defy his generalization. Much humor involves word wit, such as puns. In many instances, when a pun is voiced, it is difficult to identify to whom he who laughs believes himself to be superior. Is it he who has perpetrated the pun? But don't we often regard the punster as wittier than ourselves? And, in any case, is it creditable to suppose that when puns abound in a conversation, it must always be a matter of someone being unmasked as inferior? Perhaps all share in the delight to the discredit of no one. But if humor can take this form, then the superiority theory of laughter, if it is a theory of comic amusement, is not fully comprehensive.

Similarly, when mildly joshed or kidded or ribbed by friends, we often laugh at ourselves—not our past selves, but ourselves in the here and now. But this would appear to reduce the superiority theory to incoherence—positing that we simultaneously find ourselves to be superior and inferior to ourselves. Clearly, superiority is not a sufficient condition for laughter; humans are superior to snails, but we don't laugh at them. Nor is superiority a necessary condition for laughter; nitrous oxide will turn the trick quite effectively.

As this last example perhaps suggests, one problem with the superiority theory is that it is posed in terms of laughter and it pretends to isolate the triggering mechanisms thereof. But this may render it irrelevant as a contribution to the theory of comic amusement or humor. For, as we have just seen, laughter can be induced chemically. Though laughter generally accompanies humor, not all laughter is connected to humor. Some results from the administration of "laughing gas." For this reason, a theory of laughter would not automatically be a theory of humor. Some laughter has nothing to do with humor. The only

[2] Noël Carroll, "Humour," *The Oxford Handbook of Aesthetics*, ed. Jerrold Levinson (Oxford: Oxford University Press, 2003), pp. 344–65.

laughter that is pertinent to the theory of humor is comically amused laughter. But is that the sort of laughter picked out by the superiority theory?

The superiority theory invokes an undeniable species of laughter—the laughter of victory. But is that amused laughter? One reason to think that it is not is that the object of the passion that preoccupies the superiority theorist is the self-triumphant, but that does not seem to be the object of comic amusement. I do not appear to be the object of my mental state when I am comically amused by the riddle "What is the definition of a hangover? The wrath of grapes." Rather, the word wit is the object of my amusement. If my laughter is amused here—if I am not laughing, as I presume I am not, at any suspected mental defectiveness on the part of the punster—then the superiority theory has no way of explaining it, since it lacks an analysis of the objects of comic amusement. Though the superiority theory refers to a variety of laughter whose existence cannot be doubted, it is not evident that it provides us with any insight into the relevant kind of laughter—namely, amused laughter—since the superiority theory presupposes a different object from that of comic amusement and, therefore, the theory is mute about the nature of the object of the mental state germane to humor (comic amusement).

It is at this dialectical juncture that the incongruity theory of comic amusement enters the picture. For what the superiority theory lacks, the incongruity theory has—an account of the object of the mental state of comic amusement. Comic amusement, on this view, is emotion-like; it is directed at an object. The object in question must meet certain criteria before the mental state takes hold. Specifically, the objects of comic amusement must be perceived to be incongruous. Lecherous priests have been staples of comedy at least since the Renaissance because their sexuality is so at odds with our concept of a Reverend Father; likewise, the Abbess in *The Decameron* who mistakenly doffs an undergarment instead of a wimple is doubly incongruous both in terms of her anomalous headgear and what it implies about her relation to her vow of chastity. Similarly, when Gussie Fink-Nottle delivers a drunken oration at the awards ceremony featured in P. G. Wodehouse's *Right-Ho Jeeves!*, the episode is uproarious exactly because his impolite ramblings so ill befit the decorum expected of speakers on such occasions.

According to the incongruity theory, a necessary condition for comic amusement is my perception of something that clashes with my standing mental patterns and expectations.[3] Here it is important to underscore that the object of comic amusement must *appear* incongruous to the subject; comic amusement will not ensue even if the stimulus is incongruous unless it is also viewed as such—that is, as conflicting with standing mental patterns and expectations. In most cases, the expectations that are subverted are not ones that have been formulated consciously, but are rather the default assumptions we always carry with us. With respect to the joke "What do you get when you cross fish with

[3] John Morreall, "Enjoying Incongruity," *Humor*, 1/2 (1980): 1–18. See also John Morreall, "Funny Ha-Ha, Funny Strange, and Other Reactions to Incongruity" in J. Morreall, ed., *The Philosophy of Laughter and Humor* (Albany, NY: State University Press of New York, 1987), pp. 188–207.

elephants? Swimming trunks," it is not as though we had expressly formulated an answer to the riddle that was then ousted from our minds by the punchline. Instead, the punchline itself lies outside any standing pattern of thought that we would typically mobilize for forming a hypothesis. That is, the answer, and indeed the question itself here, are unexpected not because we have other thoughts about the issue of the putative mating in mind, but because both the prospect and the supposed outcome of the wedding being contemplated are off our mental map entirely, presumed by default to belong in terra incognita.

That which the incongruity theory counts as incongruous can be quite various. As indicated, the unexpected, as observed early on by Quintilian, can count as an incongruity either because it thwarts what we expected to unfold or because it realizes something that, given our standing cognitive stock and its default assumptions, we would never imagine happening. On the one hand, if we believe that the weight in front of us is no more than an ounce, but, when we attempt to lift it, it seems to be 300 pounds, then we are likely to be amused—at least if there is no reason why we must pick it up immediately. On the other hand, we also find funny things that deviate radically from our default assumptions about the world—like Sponge Bob Squarepants, the talking soap-pad.

The incongruous encompasses the unexpected, including both the absurd or illogical (e.g., category errors), and the improbable. That is, category errors such as the cowardly lion in the *Oz* stories are funny because he contradicts our standing idea of lions which, however biologically ungrounded, counts lions as the epitome of bravery. Logic may also be flouted in the syllogisms of the Marx Brothers. Yet not only deduction can be prey to humor. In the joke "Did you hear that a taxi was overturned in Edinburgh? Twenty people were injured," the humor rides on the improbability of packing 20 people—even 20, penny-pinching Scots stereotypes—into a normal-size cab.

Humor accrues not only to the violation of the laws of logic but to violations of the laws of language as well. Conversational maxims, for example, may be ignored for incongruous effect—for example, the practical joke secured by answering "yes" to the question "Do you know what time it is?" violates the Gricean maxim of quantity.[4] Puns also count as incongruities, of course, since typically they unexpectedly exchange an anticipated meaning of a word for a secondary or, at least, unforeseen one. Puns do not reduce ambiguity, they accentuate it. Moreover, puns not only incongruously preserve in context two or more senses of the relevant linguistic units; these alternative senses are also irreconcilable.

Linguistic humor can also arise when changes are rung on clichés—for example, when in *The Importance of Being Earnest* Jack says, "it is a terrible thing for a man to find out suddenly that all his life he has been speaking the truth," rather than mouthing the more customary sentiment that it is a terrible thing to find out that one's been living a lie. And, of course, comic irony depends

[4] Umberto Eco, "The Comic and the Rule," in U. Eco, *Travels in Hyperreality* (New York: Harcourt, 1983); see also Salvatore Attardo, *Linguistic Theories of Humor* (Berlin: Mouton de Gruyter, 1994), pp. 272–92.

on asserting one thing by uttering its contradictory, thereby returning us to the theme of flouting logic.

As should already be evident, humorous incongruities involve undermining norms, including logical and linguistic ones. But these are not the only norms breached by comedy. Moral and prudential norms and those of politeness may also serve as its targets. Thus, many jokes celebrate adultery and larceny, among other things, in their subversion of moral norms, while slapstick comedy brutalizes the human body mercilessly. Bathroom humor, on the other hand, affords incongruities by violating the taboos of polite society, as in Rabelais's *Pantagruel* when all the dogs in the vicinity drench the Parisian lady, as if, to speak anachronistically, she were a fire hydrant.

Scrambling dress codes can also provoke amusement—for example, wearing flippers with a tuxedo or a coonskin cap with hospital scrubs. Burlesques of etiquette invite comic amusement, which is why for years the spectacle of lowbrows eating peas with their knives was thought to be a laugh riot.

Historically, ugliness is also a ready provocation to amusement, since it involves deviations from the culturally affirmed norms of human appearance. Clowns and comics, as well as caricaturists, travesty human features for comic effect, while certain unfortunate disabilities or deformities, such as dwarfism or obesity, are often regarded as laughable; in these cases, the pretext for amusement is the apprehension of some arresting divergence from some notion of the standard-issue human body—either a nose too large or a head too small. Humor finds its natural home in the abnormal. This, moreover, applies not only to looks, but to behavior. The clown not only looks absurd, but he also acts absurdly, pressing his romantic suit for the hand of the beautiful tightrope walker who is obviously in love with the lion tamer.

Clown figures often traffic in physical absurdities or impossibilities, such as Homer Simpson's adversarial relationship to his own brain—a self-contradictory proposition if there ever was one. And, though much humor relies on stereotypes, it can also flourish by undermining or contradicting them—as, for instance, when the fascistic bully Roderick Spode in the Wodehouse comedies is revealed to be a designer of ladies' lingerie, an unlikely sideline for an aspiring dictator with imperial ambitions. Much humor involves juxtaposing opposites: placing a tall thin clown next to a short fat one in a way that rattles the norms we usually associate with our concept of the human by stretching them to the breaking point, where its polarities of difference rather than sameness glaringly stand out. And puns, of course, also hold clashing or irreconcilable alternatives in tandem, though, in this case, the opposites in question are alternative meanings.

The incongruities that are relevant to comic amusement include the unexpected, the illogical, the improbable, the absurd, the ambiguous, the abnormal, the immoral, the improper, the ugly, the inappropriate, the impolite, the inapposite, and, in short, that which deviates from virtually any pre-existing standard imaginable. Jokes, one of the primary vehicles of humor, deploy incongruity by initiating stories that appear to abide by the canons of everyday realism only to end with punchlines that veer off into the unreal, the abnormal, and/or the

impossible.[5] For example: "A priest, a doctor, and a lawyer find themselves on an island surrounded by sharks; only the lawyer is able to swim to safety. Why? Professional courtesy." A premise that describes a vaguely possible state of affairs, that is, suddenly yields way to an impossible denouement. Here, of course, the opposition of the possible with the impossible occurs sequentially. But the confrontation of opposites can also be staged continuously as when Homer Simpson is *shown* debating (!) with his own brain.

Nevertheless, even if perceived incongruity is a necessary condition for comic amusement, it cannot be a sufficient condition. The reason for this is simple. In order for comic amusement to obtain, the percipient must enjoy the incongruity she encounters. But enjoyment is not the automatic response that people have to incongruities. In many cases, incongruities may signal danger; thus, the incongruous may be threatening or otherwise anxiety-producing. It can engender fear, or anger, or some other negative emotion. Consequently, if a perceived incongruity is to support comic amusement, it must not provoke fear or anxiety or concern for ourselves or others (including the fictional inhabitants of a joke[6]).

Invented humor employs many conventions to guarantee that audiences will not take what they see or hear as serious in any way and, therefore, as not potentially threatening to anyone. For example, jokes are introduced by disarming locutions such as "did you hear the one about?" that alert listeners to the fact that no one is really about to die, be cuckolded, robbed, cheated, and so forth, thereby permitting us to appreciate the incongruity worry-free. Similarly, the characters in jokes and comic fictions are either more physically resilient than normal humans—capable of drubbings that would kill mere mortals—or their suffering is kept out of sight so that we do not become concerned about the evils that befall them. Whatever the sharks did to the priest and the doctor in the "professional courtesy" joke is not mentioned and, consequently, does not engage our anxiety.

Of course, anxiety and enjoyment are not the only possible responses to incongruity. Curiosity may be another reaction, one that is likely to take the incongruity in question as a puzzle to be solved or explained. Confronted by the fact that Americans today are, on average, materially better off than their parents, but nevertheless feel worse off, the social scientist neither laughs nor flies into some negative emotion, such as indignation, but rather attempts to craft an account of the phenomenon. The social scientist does not sit back and delight in this paradox or inconsistency. Rather, her reaction to incongruity is to regard it as a problem to be resolved or a conundrum to be dispelled.

This is distinct from the response to incongruity pertinent to comic amusement. For when a humorist tenders an explanation—such as "professional courtesy"—the explanation is a faux explanation, often an absurdity that is as

[5] Victor Raskin, *Semantic Mechanism of Humor* (Dordrecht: Reidel, 1985); and Salvatore Attardo, *Linguistic Theories of Humor* (cited in n.4, above).

[6] As noted by Aristotle in his *Poetics* where he observes that the comic should involve error and/or disgrace (that is, incongruities), but not pain and destruction.

incongruous as the incongruity it is supposed to dissolve. With comic amusement, incongruities are not proffered in order to stir the sort of curiosity that encourages genuine problem-solving and authentic attempts at explanation, but rather to titillate. The comic incongruity is neither cause for alarm nor for a solution, but is nonsense to be savored for its deviation from the expected—for its absurdity, ambiguity, or paradoxicality.

Gathering together these observations into a formula, then, we may hypothesize that someone is comically amused if and only if: (1) the object of her mental state is a perceived incongruity; (2) which she regards as not threatening or anxiety-producing, or as the source of any other negative emotion; (3) which does not motivate her to engage in genuine problem-solving or serious explanation; but (4) which she enjoys. Humor is the response-dependent property that affords comic amusement. Humor can be divided into two broad classes: invented humor, the humor contrived by comics in the form of jokes and the like which are intended to stimulate comic amusement; and found humor, the humor that we observe occurring naturally in everyday life, as when we mistake a plate-glass wall for an open doorway but then stop before it just in the nick of time.

One objection that has been raised against this sort of incongruity theory is that perceived incongruity is not a necessary condition for comic amusement. For example, it has been argued that the humor in a caricature depends on congruity rather than incongruity—the idea being that we will not be amused by a caricature unless it strikes us as disclosing something that rings true (and that is, therefore, congruous) about the character of its victim.[7] Similarly, it has been pointed out that the incongruous punchline of a joke is intended to provoke an experience in the minds of listeners of "things falling into place." Hearing "Why can you always depend on fat men? Because they'll never stoop to anything low," the apparently irrelevant answer to the riddle comes to make sense—to be congruous—once it dawns, as it quickly does, on the listener that this is a pun. Recognized as such, the nonsensical exchange appears reconfigured as a (somewhat) meaningful whole. Here, allegedly, it is the transit from the puzzlement of the response to its solution—from incongruity to congruity—that is the locus of pleasure. Consequently, it is held that what is necessary for comic amusement can be congruity rather than incongruity.

These reservations, however, appear to derive from the ambiguity in the ways in which the notions of *congruity* and *incongruity* are being employed here. It is maintained that a caricature needs to hit its mark, to be true to its subject, in order to amuse—that exaggerating Richard Nixon's five o'clock shadow, for example, revealed his inner brutishness. I do not know whether this is so, inasmuch as I seem to be able to be amused by caricatures of historical personages (for instance, from vintage copies of *Punch*) about whom I know nothing, but still find funny simply due to the exaggerations the caricatures perpetrate on the human form. But suppose that it were true that, in order to amuse, a caricature

[7] Roger Scruton, "Laughter," *Proceedings of the Aristotelian Society*, suppl. vol., 56: 197–212.

must strike viewers as true to the character of its subject. Does that establish that comic amusement is a matter of congruity rather than incongruity?

Not really, because the relevant dimension of congruity—truth to the character of the subject—does not preclude the incongruity the theory appeals to—namely, an incongruity in the subject's appearance, usually in terms of an exaggeration. It is a necessary condition of a caricature that it be incongruous in this sense, even if it goes on to reveal some deeper truth or "congruity" about its subject's character. Surely, a perceptually accurate photograph of someone that is revelatory of her character, in and of itself, is otherwise unlikely to elicit comic amusement.

Similar ambiguities beset the idea that jokes are matters of congruity rather than incongruity. Granted: the punchline of a joke elicits an initial state of puzzlement—that is, it does not make sense—until the listener interprets it in a way that relieves the perplexity. However, it does not pay to think of this resolution of the perplexity as a "congruity," because it generally has lodged in it some further incongruity or perplexity—that sharks can extend professional courtesies, that the inability of overweight men to bend over makes them more reliable morally, and so on. The ostensible resolution of a joke only gives the appearance of providing an adequate explanation; at a deeper level, it remains absurd and, in that sense, incongruous. Though some may refer to the listener's resolution of the puzzle posed by the punchline of a joke as a transition from incongruity to congruity, this is misleading, since typically the so-called resolution gives birth to further incongruity.

Moreover, even if it were apposite to describe the resolution of the joke-puzzle as a transition from incongruity to congruity, that would not show that the perception of incongruity is not a necessary condition for comic amusement, since incongruity would still be required for the putative transition to kick in. But an even more serious objection to this line of argument, as already shown, is that the second stage in this process—our interpretation of the incongruous punchline—involves an even deeper incongruity, albeit one that forces itself upon us irresistibly as an explanation of an earlier puzzle.

Undoubtedly, the pleasure found in a joke comes from at least three sources. There is the pleasure to be had in arriving at the interpretation of the anomalous punchline—figuring out that there were 20 people in that cab in Edinburgh because they are the proverbially cheap Scots. This involves a pleasurable quickening of thought akin to puzzle-solving. But there is also the pleasure in contemplating the practical absurdity of packing 20 full-grown people in a cab. And, finally, there is the additional pleasure that this absurdity has something compelling about it—it is an interpretation that fits the facts in a way that unavoidably importunes our assent at the same time that we recognize that it is palpably ridiculous. We are caught, so to speak, coming and going—in an intellectual position where our minds have succumbed to the temptation to latch onto an interpretation that they realize is nonsensical—and this leaves us giddy. We find ourselves ensnared by an interpretation that is as irresistible as it is ridiculous. It feels as though we must accept it while, at the same time,

we cannot accept it; and, since there is no cause for anxiety at hand, we laugh at our predicament. Moreover, in defense of the theory of amusement we are considering, it is noteworthy that incongruity is *essential* to all these pleasures.

Though the perception and enjoyment of incongruity appear to be necessary for comic amusement, it may be argued that they do not amount to sufficient conditions. One problem here is that artworks may compound incongruities intended to be enjoyed aesthetically, but not comically. Max Ernst's composite figures are certainly incongruous—and they are meant to be seen as such—but they are not comical. Likewise, a film such as *Citizen Kane* appears to advance a paradox—explaining a man's life with a clue like "Rosebud" at the same time that it claims it cannot be done—but with neither comic intent nor effect. How can one differentiate between aesthetically interesting incongruities and comically amusing ones without rendering the incongruity theory of humor circular? After all, it will not do to stipulate that the objects of comic amusement must be enjoyed in a comic spirit, since it is *comic* enjoyment that we are attempting to define.

Undoubtedly, the problem here is complicated by the fact that the comic overlaps with the aesthetic. The funniness of *The Taming of the Shrew* is certainly one of its central aesthetic properties *qua* work of art. But not all aesthetic incongruities are comic. The aesthetic incongruities of Surrealist works, such as those of Max Ernst, are not, like comic incongruities, presented under the pretense that they make sense in the way that a joke feigns an intelligible explanation for its incongruous punchline. Surrealist incongruities are presented as unfathomable mysteries and, to that degree, are meant to be unsettling. Thus, aesthetic incongruities of the Surrealist variety will not count as instances of comic incongruity because there is something worrisome about them.

On the other hand, not all aesthetic incongruities, such as the example of *Citizen Kane*, are unsettling. But neither are they comic. Rather, they are puzzling and are designed to engage the audience's attention in order to spur us into contemplating the role of this incongruity in the meaning and/or structure of the work. That is, some aesthetic incongruities invite genuine puzzle-solving (including artistic puzzles) and are enjoyed for that reason. Others—what we might think of as the Surrealist ones—are meant to engender at least a modicum of ill-ease, which negative emotion is uncharacteristically fascinating or intriguing for the way in which the artwork permits us to experience a mildly disturbing feeling state and to examine it introspectively, without having to be concerned that it signals literal peril. But, in contrast, in the case of comic amusement proper, where the incongruity is also aesthetic, the enjoyment involves a positive relish in the incongruity itself.

However, even if the incongruity theory can deflect the preceding objections, it is liable to the charge that it is perhaps overly elastic. The things that count as potential incongruities by its lights comprise quite a laundry list: the unexpected, the absurd, the illogical, the improbable, the inappropriate, the ambiguous, and so on. This seems extremely wide-open and very imprecise. One would wish that

the notion of the relevant sort of incongruity were less vague. To that extent, the incongruity theory of humor appears to be still an unfinished project.

Perhaps, at this point in the discussion, the best way to proceed in order to achieve greater precision is to embrace the incongruity theory heuristically as a way of isolating and dissecting the recurring comic designs that give rise to comic amusement in jokes, plays, sitcoms, cartoons, and so on. Though the incongruity theory may be vague, it is not altogether vacuous. It offers us in broad outline a sketch of the intentional object of the state of comic amusement. We can use the notion of incongruity and its paradigmatic examples to clarify further the structures that give rise to humor, in the hope that this will eventually make our understanding of comic amusement more exact.

That is, due to the incongruity theory, we are not completely ignorant about the nature of comedy. We know that it involves incongruity and we also know something about the recurring forms of incongruity—which include the unexpected, the absurd, the illogical, the improbable, the inappropriate, the linguistically nonsensical, the immoral, the impolite, and so forth. Consequently, it seems most advisable that we should use what we do understand about humor to try to assemble more insight into its structures in the expectation that by attaining more precision about these cases we may some day put ourselves in a position to refine the relevant concept of incongruity more rigorously or to identify a successor concept.[8]

That is, I propose that we adopt the incongruity theory of comic amusement as a heuristic probe and employ it to analyze recurring comic figures—figures we already know to be comic—in order to locate definitely the comic variables (the incongruities) that make them work. As we accumulate greater insight into these variables, our understanding of comic amusement will become more and more detailed and, to that extent, more precise. To this end, we will now turn to the analysis of two plot structures whose essential deployment of incongruity give them a natural affinity to comedy. This will not, of course, in itself render the pertinent notion of incongruity immediately pellucid. But, by explaining why certain plot structures naturally contribute to levity, it will assist in making the application of the concept of incongruity more fine-grained.

2. THE EQUIVOCAL PLOT

The object of comic amusement is perceived incongruity. Broadly speaking, one perceives an incongruity when there is a clash between some stimulus and one's standard mental patterns and expectations. As we have seen, these clashes can take various forms from the absurd to the inappropriate. In some cases, the

[8] This represents a departure from the position I staked out in my "On Jokes," where I was more dismissive of the incongruity theory of humor. At present, I see the incongruity theory as our only way forward with respect to the analysis of humor. See Noël Carroll, "On Jokes," in N. Carroll, *Beyond Aesthetics* (New York: Cambridge University Press, 2001).

mental pattern under attack is a default assumption; in other cases, an expressly formulated expectation is undercut.

For an example of the latter, consider this joke:

A Scandinavian woman, Lena, calls a newspaper inquiring about the cost of an obituary for her husband, Olé. When she learns that it is five dollars a word, she sighs and asks that the paper print only "Olé died." The newspaper agent feels sorry for her and claims he has just remembered that there is a sale today; for every two words paid for an obituary, the buyer gets three words for free. After contemplating this opportunity, Lena revises the obituary to read "Olé died; boat for sale."

This joke subverts our expectation that the next three words will be sentimental, delivering instead the opposite—hard-headed, cash-conscious, no-nonsense practicality, with perhaps a dash of well-deserved vengeance to boot.

Humor thrives on opposition—on the sequential reversal or derailment of expectations, as in the preceding joke; or on the simultaneous juxtaposition of opposing or, at least, irreconcilably alternative meanings in puns like "Some members of Congress should have their mouths taped instead of their speeches." Incongruity presupposes as a condition of possibility the perception of such conflicts—between sense and nonsense, possibility and impossibility, sentimentality and economic calculation, appropriateness and inappropriateness, probability and improbability, primary and secondary meanings, and so on. Thus, if there are to be such things as comic narrative plot structures, then they must have the formal capacity to set forth the relevant clash of incongruities. In this regard, there seem to be at least two recurring plot structures that warrant our attention: the equivocal plot and the improbable plot (or, perhaps more accurately, the wildly improbable plot). In this section, I will discuss the equivocal plot; in the next, the improbable plot.

Comic amusement requires exhibiting incongruities or oppositions. This can be done in two ways: *sequentially*, as in the preceding Lena-and-Olé joke where the sentimental framework is suddenly subverted by a callously realistic and practical framework; or *simultaneously*, as in the case of puns that invite us to entertain two or more alternative (and often opposed) meanings at the same time. (That is, with puns, instead of settling on one stable pattern of meaning, the mind is forced to vacillate between two or more often conflicting or irreconcilable alternatives.)

Likewise, a division can be drawn between two kinds of comic plots—those that propose the relevant oppositions simultaneously and continuously, and those that unfold the pertinent subversions of expectations sequentially. The former possibility is represented by the equivocal plot; the latter by the improbable plot.

An equivocal plot is made up of equivocal situations, situations open to one or more alternative and frequently conflicting interpretations. For example, there is a noteworthy scene in Alfred Hitchcock's film *The 39 Steps*, in which the character played by Robert Donat has been handcuffed to the woman played by Madeleine Carroll. She is effectively his prisoner and she absolutely detests him. They are constantly bickering. They arrive at an inn where the landlady takes

them to be a pair of newlyweds who can barely keep their hands off each other. In fact, their closeness is a result of the handcuffs; they can't help appearing inseparable. When Donat pulls his prisoner closer to him, this is an effort to gain more control over her. However, the landlady mistakenly reads these gestures as further signs of the supposed "lovers'" infatuation, although we hear them exchanging hostilities all the while.

The scene is shot and blocked in such a way that we not only see how things truly stand between these "lovers," but we also simultaneously grasp how someone situated in the landlady's position could systematically misinterpret the event. Our amusement here is rooted in the fact that the scene is staged to show not only what is actually the case, but also how that series of actions could equally be misapprehended so as to support an alternative, and, in this instance, contradictory interpretation. Here the same situation, the same stimulus, gives rise to two opposing versions—the actual situation in which the man and the woman are adversaries, and the contrary situation as misperceived, albeit not unreasonably, by the landlady, in which they are lovers. Though here the ambiguity is visual and dramatic, the structure is not unlike that of a pun; it invites the audience to entertain two incompatible interpretations of the situation at once and to delight in the incongruity that both interpretations fit the facts nicely, relative to one's point of view; but nevertheless the interpretations are inconsistent. Similarly, in the film *Back to the Future*, given the time-travel conceit, the audience follows the scene in which the teenager who is, in effect, Marty's mother, flirts with him from two perspectives—Marty's, in which the "nasty" prospect of incest looms comically, and his mother's, in which she is "innocently" attracted to the new kid in town.

Equivocal situations could also be called double-interpretation or multiple-interpretation situations. They are susceptible to more than one interpretation. In most cases, one of these interpretations captures what is actual in the world of the fiction, while the other(s) is (are) merely notational or imaginary, often keyed to one or more characters' skewed conception of things. At the limit, it could perhaps be the case that there are only multiple interpretations from the viewpoints of different characters to be had, with no interpretation fixed as actual in the world of the fiction. But, in any event, what is important about this structure is that these conflicting interpretations are set out simultaneously and continuously. That is, the ambiguity in the "dramatic meaning" of the scene obtains on the moment-to-moment basis throughout its duration.

Equivocal plots, then, are built up from equivocal situations. They are plots whose scenes and sequences sustain alternative, generally conflicting, or otherwise irreconcilable interpretations from the beginning to almost the end—to the penultimate scene in which the misunderstandings about what is going on that plague the characters and that account for their misadventures are explained and put to rest.

These misunderstandings can be the result of chicanery on the part of one or more of the characters. In *The Importance of Being Earnest*, Algernon Moncrieff, for example, sets in motion a slew of multiple-interpretation situations when

he shows up at Jack Worthing's manor house, pretending to be Ernest, Jack's non-existent brother; while in *Twelfth Night*, by disguising herself as a boy, Viola precipitates a series of scenes that equivocate delightfully between homosexual and heterosexual passion. By administering love potions to various characters, Puck multiplies equivocal situations in *A Midsummer Night's Dream*, including, most memorably, Titania's wooing the donkey-headed Bottom.

In many cases, the conditions that generate the equivocal plot have been intentionally engineered by one or more of the characters—as when a man deceives two women each into believing that he is her own true husband, but then the two wives meet to comic effect. However, the emergence of the equivocal situation can also be a result of a fact about the fictional world, which is unbeknownst to any of the characters. For example, many of the equivocal situations that occur in the film *Bringing Up Baby* are the result of the extravagant lying of the character Susan, played by Katharine Hepburn. But the ultimate case of mistaken identity, regarding the leopard called "Baby," is not a consequence of her doing nor of anyone else's intentions. A dangerous leopard has escaped and Susan erroneously takes him for the more docile Baby. She drags the snarling cat at the end of the rope, acting as if it were a pouty child, while we realize, at the same time, that at any moment the leopard could attack. Perhaps part of the humor in this scene is that the ferocious leopard seems so taken aback by her high-handed behavior that he puts up with Susan's shenanigans.

Equivocal situations can arise from facts about the fictional world of which characters are unaware. For example, twins—or even two sets of twins—separated at an early age may once again find themselves, though they do not know this, in the same city, as in Shakespeare's *Comedy of Errors*, which itself was based on Plautus's *Menaechmi*. In such circumstances, the unmarried twin may find himself in the boudoir of his brother's wife—he supposing it to be his good fortune to have encountered such an eager lady, while she believes herself to be discharging her wifely contract (and all of this while her real husband is kept locked out of his house, since the servants believe he is inside with his wife). This sort of farce of mistaken identity was quite popular in the French and Italian theatrical traditions and is said to have made its first appearance in English in the play *Jack Juggler* in 1563. Moreover, the plot *donnée* of the unsuspected existence of twins provoking comic chaos continues in contemporary films like *Big Business*.

However, twins are not the only device that can generate equivocal situations. Sometimes they are the result of what might be thought of as the intervention of magic or the fantastic. In *All of Me*, the soul of an ill-tempered millionairess, played by Lily Tomlin, gets relocated in the body of an idealistic lawyer, played by Steve Martin. As the two of them vie for control of the body, other characters in the fiction are confounded by comically anomalous behaviors that are nevertheless transparent to viewers because we know how things stand, so to say, metaphysically. Likewise, the repeated scenes in *Groundhog Day* carry a double significance for us because we, like Phil (Bill Murray), know that he is reliving the same day again and again, and, therefore, we follow his behavior

as often playful comic variations on a theme, whereas from the perspective of the other characters each morning is simply the first day of the rest of their one and only life. In the movie *Freaky Friday*, a Chinese incantation results in a middle-aged mother trading bodies with her teenage daughter; this generates a string of multiple-interpretation situations in which, for example, the daughter's handsome young schoolmate appears to be falling for her mother—a patently incongruous matching—though, of course, we see the budding romance as a case of ontologically mistaken identity.

Gogol's *Inspector General* is a case of an equivocal plot that comes about through circumstances, rather than being intentionally contrived by any character in particular. But as time goes on, the primary beneficiary of the misunderstanding, Ivan Aleksandrovich Khlestakov, the ne'er-do-well who has been mistaken for a government inspector general, gradually figures out what is going on and starts to exploit the situation to his advantage.

The play opens in the home of the mayor of a rural town in nineteenth-century Russia. The mayor has just learnt that an inspector general from Petersburg will be examining his village and that the inspector may be traveling incognito. The mayor barks out a series of instructions designed to cover up the flagrantly pervasive corruption of his administration. However, the mayor realizes that this may not be adequate, since the inspector general may already be in their midst, carrying out his investigation in disguise. Alert to this possibility, the mayor and his cronies put themselves on the lookout for any indication that the inspector is already afoot.

Thus, it comes to their attention that there is a man at a local inn who has the bearing of a gentleman. This is Khlestakov. His bills are in arrears and the landlord seems ready to have him arrested. But when the mayor and his entourage arrive at the inn, Khlestakov, supposing that he is about to be clapped into irons, issues a series of empty, blustering threats—like "I'll go straight to the minister"—that the townsfolk misinterpret as evidence that Khlestakov is a government official. As a result, the mayor opens his house to Khlestakov, fetes him exorbitantly, and, along with other town officials, showers him with bribes. Khlestakov is vain enough to imagine that this is his due and to explain away the excessive generosity as the customary hospitality of the region. Meanwhile, as Khlestakov brags inventively about his standing in the capital, the villagers become more and more convinced of his official status, even though he never says that he is the inspector general (indeed, he knows nothing about the rumor that one is on his way).

These early scenes are doubly comic since neither Khlestakov nor the townspeople understand what is actually going on. Thus, when Khlestakov boasts fancifully that, though he always attempts to go around unnoticed, he is too well-known not to be recognized, the mayor and his gang take this as confirmation that Khlestakov must be the inspector in mufti, though Khlestakov has not got a clue that he is actually intimidating everyone. Townspeople, such as the judge Ammos Fyodorovich Lyapkin-Tryapkin, arrive in his apartment with money literally in their fists. And whenever Khlestakov sees cash,

he asks for a loan. At least at first, he really seems to believe that people are lending him this money, though we see clearly that the village officials intend it as subornation. Eventually, however, Khlestakov does begin to catch on to what is really happening and he starts to bilk the town in a major way before he takes his leave. Yet the situation remains equivocal, since the townspeople continue to believe that Khlestakov is the inspector general, an illusion that is not dispelled until halfway through the fifth and final act of the play.

One way in which to understand the humor of the equivocal-situation plot is to note its structural relationships with better understood forms of comic amusement. In one respect, the equivocal-situation plot resembles the joke—at least in the sense that it offers more than one interpretation of the situation. However, the joke typically poses these interpretations sequentially. That is, we begin processing the joke narrative with our normal default assumptions intact, only to have that mode of interpretation disrupted and then overthrown by the punchline that calls forth a more compelling, though fantastical, improbable, scandalous, or otherwise outlandish interpretation/explanation. In the joke, in other words, the irreconcilable interpretations are advanced sequentially, whereas in the equivocal narrative, the multiple interpretations of the situation are sustained simultaneously; both interpretations are held before the mind at the same time. In this regard, the equivocal plot is more like the simple pun than it is like the joke.[9]

Puns incongruously preserve two or more rival senses of a word or phrase in context. In the "Fat-men-don't-stoop-low" pun, the meanings of "stoop" as (literally) "to bend over" and as (metaphorically) "to engage in immoral activities" are both activated at the same time and remain stubbornly and irrepressibly co-present as we rehearse the word wit in our minds. Whereas, in normal conversation, context tends to disambiguate words and phrases in a way that renders their meaning univocal, in the case of the pun the different, irreconcilable meanings of the linguistic unit both clamor for attention. In the preceding case, metaphorical meaning vies inexpungibly with literal meaning, but neither trumps the other. Moreover, these are not merely alternative meanings; they are opposed meanings, since one is literal and the other figurative. And yet, in some sense we accept this conflict inasmuch as we do not dismiss one of these alternatives in order to understand the saying; rather, we hold onto both.

The pun clashes incongruously with our expectation that language will be univocal in context and, as well, it rivets our attention to the often irreconcilable ambiguities that incongruously infect our words and phrases. Indeed, often these ambiguities are incongruous in the strong sense that they contradict each other, as in the previous example of "Some members of Congress should have their mouths taped instead of their speeches"—that is, their speaking should be *silenced* rather than preserved to be *heard* in the future.

[9] By a "simple pun," I mean a pun that is not functioning as the punchline of a joke. Simple puns are the sort of "free-standing" puns that figure in conversation all the time.

Likewise, the equivocal situation supports two or more conflicting interpretations at the same time. Generally, there is the defective interpretation (or interpretations) believed by some of the characters, which is usually based on an incomplete understanding of the facts of the case; and there is the interpretation that matches the way in which things actually are in the fiction. The equivocal plot proceeds by suppressing the emergence in the fictional world of the information that would resolve this conflict. As a result, the erroneous conception of affairs held by the benighted characters nevertheless strikes us as intelligible, relative to what they think they know about matters. Though wrong, their viewpoint is reasonable, giving rise to the incongruity that a viewpoint so mistaken can also be so compelling.

Moreover, in the normal course of events, the kinds of confusions that beset equivocal situations would be cleared up in context very quickly. But it is the genius of the equivocal plot to sustain misunderstandings over appreciable periods of time by keeping pertinent information away from the relevant characters (by, for instance, assuring that the twins are never on stage together until the time has come to wrap up the story).

The equivocal plot is not exactly analogous to the pun, since in general one interpretation of affairs is privileged—namely, the one that belongs to the omniscient narrator. However, like the pun, the equivocal plot mandates that the audience track the action under two irreconcilable interpretations in order to grasp what is going on. That is, in the equivocal plot, two or more clashing interpretations are co-present indispensably. As well, the audience is maneuvered into appreciating the force and fitness of the mistaken interpretation relative to what the characters believe they know. They can see that the misinterpretation is intelligible, perhaps even unavoidable in the narrative context. But, at the same time, they see that it is incorrect. As with a joke, then, part of the laughter in the equivocal plot appears to derive from the spectacle of characters caught in the grip of a compelling interpretation that is also dead wrong. Whereas, in jokes, listeners are usually in this predicament, with equivocal plots, the characters are the prey. And we laugh at them as we laugh at ourselves when we find that we are ensnared in a compelling interpretation that also is wildly mistaken.

Of course, an equivocal plot in and of itself will not guarantee comic amusement. The central characters in the play *Oedipus Rex* and the film *Mystic River* are trapped in compelling misinterpretations of their situations, but they are not objects of comic amusement. The reason for this, of course, is that the incongruities in these cases are sources of negative emotion; the stories are not marked and/or articulated in such a way that their incongruously ambiguous situations can be enjoyed. The equivocal plot, in order to support comic amusement, must present its incongruities as opportunities for pleasure, not anxiety. But if anxiety is bracketed—by the types of devices discussed earlier—the equivocal plot can deliver pleasure in virtue of its incongruities. This pleasure includes the quickening of thought involved in keeping track of the interplay of various interpretations—figuring out and often anticipating the next mistake the characters are bound to commit given their misguided beliefs. And

there is also the pleasure derived from the frequent contradiction between the avowed intentions of characters and the actual consequences of their deeds—for example, angering rather than pleasing a husband by mistakenly romancing his twin instead of him. Hegel spoke of the "cunning of reason" to describe the unintended consequences of action; with respect to the equivocal plot, we may speak of the "comedy of reason" where characters contradict their intentions because things are other than the way they suppose them to be. And, so long as potential sources of negative emotion are neutralized, this incongruity, moreover, is all the more delightful for being as compelling as it is ungrounded.

The equivocal plot may lay title to being a comic narrative form in virtue of its structure. Because of its participation in the essence of comic amusement—because of the ways in which it foregrounds incongruity—the plot structure is a vehicle for displaying the kinds of incongruity that are essential to humor. The equivocal plot, though of greater magnitude, is closely related to the pun in that it incongruously sustains the coexistence of opposing "dramatic meanings" through its elaboration. Like the pun, the equivocal plot unfolds its irreconcilable interpretations simultaneously. However, there are also comic plot structures where incongruities erupt sequentially.

3. THE IMPROBABLE PLOT

Narratives, of course, represent sequences of events and actions. Moreover, narration typically is intimately involved with expectation. Therefore, narrative is optimally suited to subverting expectations sequentially.

That is, narration is a means for charting causal relations; it is a way of representing the connection between causal conditions and their consequences. As a narrative unfolds in time—establishing intentions to be realized, goals to be pursued, obstacles to be overcome, constraints to be negotiated, and so forth—the audience assimilates incoming information about the evolving situations and their causal potentials *and* it anticipates the effects of the actions and events already set in motion. To follow a narrative intelligibly is to have some sense of where it is headed, some idea of the range of possibilities that might ensue given the story so far.[10]

If we are introduced to two eligible, worthy, and attractive young characters, for example, we will ask ourselves whether or not they will become romantically involved. This range of possibilities, then, will be further complicated when we learn each has other suitors and/or parents with agendas different from the lovers', and so on. The range of possibilities which we use to track a story and to render it intelligible can be called a horizon of expectations. A narrative structure can be comic, then, when it egregiously disrupts our horizon of expectations in a way that neither raises negative emotions nor motivates us to explain—in

[10] Noël Carroll, "On the Narrative Connection," *Beyond Aesthetics* (cited in n.8, above).

accordance with factors deeper than those available in the story—why our expectations were unrealized by the conclusion of the plot.

Consequently, insofar as raising expectations is a typical function of narrative sequencing and upsetting expectations is the business of humor, it should come as no surprise that the two are naturally suited for each other. Of course, this point hardly needs much demonstration. It is probably already all but self-evident, since a major form of humor is the narrative joke. In certain respects, that which we call an improbable plot resembles the narrative joke. But it also differs from it in important respects. In order to clarify both the differences and similarities, let us begin with another example of a narrative joke.

A truck driver amuses himself on long trips by running over lawyers who are walking alongside the road. He sees a lawyer, swerves to the side, and snickers when he hears a loud "thump" as the lawyer bounces off the truck. But, one day, the driver sees a pious, elderly priest hitchhiking; the driver picks the priest up and agrees to drive the priest to his rectory in the next town, three miles away. The priest climbs into the cab of the truck and settles into the passenger seat. Suddenly, the truck driver sees a lawyer jogging on the side of the road and instinctively the trucker barrels towards him. However, recalling that the priest is next to him, at the last second, he swerves away. Nevertheless, he still hears a loud "thump," though he is certain he avoided the lawyer. Confused, the driver turns to the priest and says "Sorry padre, I almost hit that lawyer." "That is all right, my son," whispers the priest. "I got him with the door."

Though we might not have had anything in mind when the preceding punch-line arrived, surely, for most listeners, the priest's conspiratorial "confession" is among the most unexpected explanations of that unaccounted-for "thump" imaginable. For as improbable as the situation is to begin with—killing roadside lawyers for sport—the prospect of a "pious," "elderly" priest joining in the fun is even more incongruous—radically at odds with our stereotypes of clerical behavior. Like jokes such as this one, the improbable plot also trades in incongruities that wildly violate our sense of probability, but it does so without the device of a punchline.

For example, in the film *Legally Blonde 2: Red, White, and Blonde*, the leading character, Elle Wood, a Harvard Law School graduate who bizarrely enough simultaneously has a world-view made up of equal parts of sorority lore, fashion magazine advice, and beauty parlor gossip, heads to Washington, DC, to pass an animal-rights bill. Given her awesome naivety and her lack of insider knowledge about the ways of the capital, along with her penchant to reduce every challenge to the kinds of solutions afforded by her "Blonde" (aka Dumb Blonde) world-view, the likelihood of her succeeding is frankly infinitesimal. Of course, that she might succeed is a possibility that we entertain, once she initiates her project. It has a niche on our horizon of expectations, but only barely so. For the likelihood that she has any realistic hope of actualizing her intentions is about as low as one can go without dissolving into zero. And yet, in improbable scene after improbable scene, she advances until she finally achieves everything to which she aspires.

In such plots, the relevant incongruity is the improbability of the consequences, given the causal conditions that give rise to them—for example, that someone like Elle Wood could pass a bill in Congress, especially employing the strategies she adopts, which include passing out cupcakes and deploying rumbustious cheerleaders. Unlike the preceding narrative joke, which enlists an improbable explanation as a response to its incongruous punchline, the improbable narrative is itself an explanation of a wildly unlikely chain of events. The finale of the improbable narrative, unlike the punchline of a joke, is not a puzzle that can only be managed cognitively by resorting to an equally anomalous hypothesis or worse. We understand how the conclusion of the improbable plot came about. Nevertheless, it still produces mirth because it is so unlikely, even given the world of the fiction, that it could have happened.

A narrative invites the audience to fill it in with their operating assumptions about how the world works. *Legally Blonde 2* encourages the audience to mobilize what it knows about Washington politics, power, and prestige to process the story, but then it sends up the expectations we would form on that basis by straining the bounds of common sense to the laughing point.

Like jokes, the improbable plot rests on an opposition between what is plausible versus what is vastly implausible, with the latter taking the prize. But, unlike the joke, this resolution of affairs does not call for a further explanation. The triumph of the deliriously improbable is simply given by the narrative, which presents improbabilities as true in the fiction that are so extreme that in ordinary language we would be disposed to call them impossibilities. The object of comic amusement with regard to the improbable plot is the incongruous (i.e., wildly unlikely) outcome of a chain of events—as when the vastly sweeter, weaker, dumber, more cowardly, and in every way outclassed son of Satan defeats his vicious brothers in the film *Little Nicky*.

Standardly, the improbable plot has a happy ending. However, it is important to stress that it is not the happy ending that leads me to count such plots as comic. Rather, it is the fact that the outcome of the story, given what is true in the fiction, is so absurdly unlikely. We are presented with a chain of causes and effects that establish that the wildly improbable—the extremely outside possibility—has eventuated, but it is so at variance with our assumptions about how the world works that we find it astonishing. But we are not astonished in a way that annoys us, or motivates us to explain this incongruity away. Rather, we enjoy it.

This characterization of the improbable plot as comic, however, requires additional comment. For, quite clearly, there are a great many narratives in which improbable outcomes obtain. Tales of suspense would appear to require that the heroic rescues and the execution of all those other sorts of daring deeds that throw audiences into apoplexies of anticipation be unlikely.[11] It is their

[11] Noël Carroll, "My Paradox of Suspense," *Beyond Aesthetics* (cited in n.8, above).

improbability of success that has us biting our fingernails and clenching our muscles. And yet, though comedies can be suspenseful, it is not the case that all suspense is comic.

Perhaps the reason for this is that, though the triumphant outcome of a suspense fiction is improbable (or, at least, no more probable than the untoward outcome), its unlikelihood is not so pronounced as to appear to be effectively impossible. If it is, of course, the suspense fiction is apt to engender laughter rather than consternation. And this, needless to say, will be a defect in a suspense story. But it is the desired effect in comedy.

Pitting an ageing, overweight hero against a young buff adversary may elicit an inadvertent and unwanted guffaw at the expense of a suspense film. On the other hand, it may be the recipe for a satiric comic skit on *Saturday Night Live*. Though suspense must entertain some degree of improbability about its outcome, it cannot be so great that it strikes us as utterly outside the realm of plausibility, unless, of course, it is an example of suspenseful comedy. Thus, a pure suspense fiction will attempt to hide its more excessive improbabilities and try to draw attention away from them. The master of suspense will do everything possible to avoid reminding the audience of the most outrageous improbabilities presupposed by the plot. The master of comedy (of the wildly improbable plot variety) will foreground them aggressively.

Consider, for example, Buster Keaton's film *College*. It begins during a torrential rainstorm as the citizens of a small California town gather for a high school graduation. Ronald, played by Buster Keaton, is the class valedictorian. Though he impresses the faculty with his speech, "The Curse of Athletics," the student body, including Mary Haines, the girl he loves, is appalled by it. Mary scolds Ronald, saying "When you change your mind about athletics, then I'll change my mind about you," and stalks off with Jeff Brown, a jock who also has an eye for Mary. Mary is headed for Clayton College and Ronald follows her there, enrolling in the hope that he can win Mary's heart, despite the fact that the stronger, taller, more athletic Jeff is her constant companion.

As Ronald unpacks in his dormitory room, we realize that he is determined to become as accomplished a sportsman as he is a scholar in order to make Mary change her mind and fall in love with him. His trunk is filled with sporting gear of all sorts, along with books about how to play baseball, football, and so on. The only problem with this is that Ronald is thoroughly inept physically. He takes a job as a soda jerk, but fumbles scoops of ice cream and splashes customers, thereby establishing his utter lack of dexterity. Next, Ronald shows up for the baseball practice. Not only does he not understand the game, but he cannot catch or bat. Upon forcing two other men out, he is shouted off the diamond.

After several more misadventures, Ronald then tries out for the track team. Again, he shows himself to be astoundingly incompetent physically. He attempts the high jump and the broad jump; he throws the discus, the javelin, the shot-put, and the hammer; he sprints, and pole vaults. Each activity results in a new disaster, as when he topples every hurdle in an obstacle course. These mishaps give Keaton the performer the opportunity to stage a series of marvelous gags,

and, with respect to the story, they establish that Ronald is one of the weakest and least coordinated humans on the planet. This is important, moreover, because at the end of the film, Ronald is called upon to save Mary from the clutches of a larger, stronger, all-around-athlete, Jeff.

Given what we see of Ronald's various performances on the playing fields and at work, the viewer has little reason to believe that he will be able to impress Mary athletically. Thus, when it falls to him to rescue Mary from the bully Jeff, everything we have seen so far indicates that this will be impossible. The narration has repeatedly made it a point to underline that Ronald is a hopeless specimen, physically. It is true that Ronald has led the rowing crew to a victory; but that was more a matter of quick thinking than brawn. If he is to wrest Mary from Jeff, it will have to involve a hand-to-hand, man-to-man battle in which, considering everything we know, Ronald's chances are nearly zero.

But, of course, he emerges victorious. Inexplicably, he has become incredibly agile and adroit. Running to the rescue, he cuts his way through crowds with the skillfulness of a star quarterback. He runs so fast that the background begins to blur. He jumps over bushes and ponds as if they were a steeplechase. As he approaches the window of Mary's apartment, he grabs a stick that is holding up her clothesline and pole vaults into her window. Once inside, he throws objects at Jeff with the speed and accuracy of a pitcher. When Jeff returns fire, Ronald bats the objects back at Jeff like so many line drives. Finally, when Jeff jumps out of Mary's window and attempts to run away, Ronald picks up a lamp as if it were a javelin and hurls it at Jeff with deadly precision.

Clearly, this comic rescue is organized around the kinds of sporting activities that defeated Ronald earlier in the film. It seems as though Keaton, the director, was at pains to set those earlier frustrations out in such detail in order to reverse them in the final moments of the story. Moreover, the audience is encouraged to notice that these feats on Ronald's part are successful variations on the tasks that earlier bedeviled him. When Ronald pole vaults through Mary's window, it is all the funnier for recalling his three previous ill-fated attempts at the sport, in which he barely left the ground.

But not only is this mirror structure with variations humorous in its own right; the earlier scenes of Ronald's complete physical ineptitude also establish the virtual impossibility that Ronald can meet the demands of the situation that face him at the end of the film. Keaton, the director, saliently reminds us of this by confronting Ronald with precisely the tasks that overcame him in the first half of the film. When Ronald rises to the occasion, it is humorous not only because of its incongruous improbability, but, even more importantly, because the effective absurdity of that prospect has been so forcefully established by the earlier narrative.

Unlike a film such as *The Karate Kid*, in *College* there is no gesture toward rendering Ronald's transformation credible. It is not as though some master has taken him in hand and cultivated his latent talents. It is simply that suddenly Ronald goes from being barely capable of running to being a decathlon champion. It is unexplained and ridiculous, albeit joyously so. Though it is shown to happen

in the world of the fiction, this scarcely possible event is incongruous, thus subverting our expectations about the way the world operates.

Some commentators, upon encountering plots like this, are tempted to interpret them thematically—Ronald's metamorphosis might be said to imply Keaton's commitment to a belief that the power of love transcends all obstacles. Or others might attack it as an adolescent wish-fulfillment fantasy.[12] Both views, however, misunderstand what is at issue. This plot, with its strident emphasis on the improbability of the outcome of the story, is itself a comic device, a way of compounding incongruity sequentially. It has neither thematic nor moral significance. It is simply, blatantly comic.

Like the joke narrative, the improbable plot enlists our standing assumptions about things only to depart from our expectations radically. However, the improbable narrative does not have a punchline that elicits an absurdist interpretation from us. It is the scarcely possible outcome that is the target of our amusement. In this regard, the improbable plot does not evoke the kind of pleasurable quickening of thought that attends the successful joke narrative. Rather, the pleasure is rooted in the recognition of the incongruity of the outcome of the story, whose staggering improbability has been foregrounded arrestingly throughout.[13]

4. CONCLUSION

In this chapter, I have identified two narrative structures that can be called comic in the sense that they possess the resources to spark amusement. Moreover, they are able to do so because of the way in which they tap into the wellspring of humor, namely, incongruity. The equivocal plot poses its incongruities simultaneously and continuously; the improbable plot develops its incongruities sequentially. Though these plot structures can exist in isolation from each other, they can also be combined. Moreover, it is not my contention that these are the only comic plot structures; there may be others, such as auto-destructive narration of the sort one finds in *Don Quixote*, where the more the narrator seeks to confirm the historical authenticity of his text, the more he undermines his case. Nevertheless, the discovery of further comic narrative structures is a project for future research. It is to be hoped that, by analyzing at least two structures, we have advanced comic theory beyond the old saw that comic narratives are essentially a matter of happy endings.

[12] David Moews, *Keaton: The Silent Features Close-Up* (Berkeley, CA: University of California Press, 1977).

[13] The picaresque is a narrative form that is often associated with comedy. Perhaps we are now in a position to explain this—specifically, it is the improbability of the linkages from scene to scene that engenders humor through narrative structure in the picaresque. That is, it is so wildly unlikely that the diverse concatenation of misadventures that evolve sequentially in a picaresque, such as Terry Gilliam's *The Adventures of Baron Munchausen*, should ever follow upon each other.

PART VI

THE ARTS

21

Philosophy and Drama: Performance, Interpretation, and Intentionality

1. THE PHILOSOPHY OF THEATER

The purpose of this chapter is to probe one of the central questions of the philosophy of theater, namely, "What is drama?" However, before broaching the issue of the nature of drama, there is a more basic question: how are we to understand the very notion of a philosophy of theater? For surely one's conception of the philosophy of theater will influence one's approach to answering the query, "What is drama?" So let me begin by saying briefly where I am coming from philosophically before we plunge into the more substantive topic of the nature of drama.

The brand of philosophy to be mobilized in this chapter is often referred to as analytic philosophy. So a first step in clarifying what is involved in this sort of philosophy is to say what it is that analytic philosophers analyze. If one is a philosopher of theater, upon what aspects of theater does one focus?

Notice that the label—the philosophy of theater—is reminiscent structurally of the philosophies of so much else. It is the philosophy of something. What fills in the blank in the "philosophy of?" Usually the name of some practice—such as the philosophy of law. Often these are practices of inquiry—for example, the philosophy of science or of mathematics or of history. But there may also be a philosophy of some practical activity or set of activities—such as the philosophy of sport. The philosophy of theater is this sort of activity or practice—primarily a matter of making and doing, rather than one of pure inquiry.

Practices, moreover, have a conceptual dimension. That is, practices are organized by certain deep concepts that make the practice possible or, to put it differently, that constitute the practice as the practice it is. For instance, law is a practice. In order to conduct legal activities a whole set of often interrelated concepts are presupposed, including guilt, personhood, intentionality, and, of course, the very idea of law itself. The analytic philosophy of law takes as its fundamental task the analysis of the concepts that make a practice like the law

I would like to express my gratitude to Sally Banes for her help in the preparation of this chapter, though she is not responsible for any of the errors or infelicities herein.

possible.[1] A philosopher of law asks what constitutes legal personhood, guilt, *mens rea*, and, most importantly, what makes something a law. Is something a law in virtue of its relation to some transcendent morality, sometimes called natural law, or is it merely that which has been promulgated by a duly appointed body of legislators applying recognized procedures in the right way?

Just as the philosophy of law attempts to clarify the nature of the concepts that make the practice of law possible, similarly the philosophy of theater interrogates or analyzes the founding concepts of the art of theater. One such concept is that of drama. In this chapter, I attempt to elucidate the notion of drama. One discovery about the concept of drama that I will attempt to defend is that it involves not one concept, but at least two. That is, the concept *drama* can apply to either a play text or play plan, on the one hand, or to a play performance, on the other hand. I will then go on to try to illuminate the distinction between these two applications of *drama*. One conclusion that I will draw is that drama-as-performance differs in profound ontological respects from mass mediatized performances. This finding is at odds with the position recently and ably defended by Philip Auslander.[2] So the final section of this chapter will address the kinds of objections Auslander raises to the type of analysis advanced of drama-as-performance.

2. WHAT IS DRAMA?

One of the fundamental concepts that organizes the practice of theater is *drama*. According to Aristotle, the concept of drama was derived from a Greek word for "doing" or "acting."[3] Aristotle used this word to refer to the representation of action. But, of course, the action that concerned Aristotle could be represented in two ways: by means of the play text, as composed by a Sophocles, or by means of a performance of the play text by some ancient Athenian troupe or a contemporary one. This duality in the notion of drama is mirrored in our own usage. For example, if we want to find the play scripts in the bookstore, we will have to go to the drama section. On the other hand, if we want to take courses in acting, directing, stage designing, or lighting for the theater, we will enroll in what is often called the Drama Department or the Department of Dramatic Arts. Moreover, such departments may or may not have courses in playwriting, though they will always have courses in acting, reflecting the fact that their emphasis is on the performance of plays, rather than their composition.[4]

[1] This characterization of philosophy is developed in Noël Carroll and Sally Banes, "Theatre: Philosophy, Theory, and Criticism," *Journal of Dramatic Theory and Criticism,* 16/1 (2001): 155–63; and Noël Carroll, *Philosophy of Art: A Contemporary Introduction* (London: Routledge, 2000), introduction.

[2] Philip Auslander, "Against Ontology: Making Distinctions between the Live and the Mediatized," *Performance Research,* 2/3 (1997): 50–5.

[3] Aristotle, *Poetics,* transl. Malcolm Heath (London: Penguin, 1996), 5–6.

[4] Parts of what follows have been adapted from my article "Text" in *The Oxford Encyclopedia of Theatre and Performance,* ed. Dennis Kennedy (Oxford: Oxford University Press, 2003), pp. 1343–5.

Though *drama* is one word, for the purposes of the philosophy of the art of theater, that one word applies to two distinguishable artforms: the art of composing play texts (or, more broadly, performance plans) and the art of performing them. Drama, in this respect, is a dual-tracked or two-tiered artform.[5] This duality, of course, is openly acknowledged by theater academics, who sort themselves under the headings of "stage" and "page." On the one hand, as typically practiced in contemporary Western theater, drama is a literary art; a drama is a verbal construction that can be appreciated and evaluated by being read, just as one might read a novel. On the other hand, drama is also a performing art; it belongs to the same family as music and dance, and, *qua* performing art, it can only be appreciated and evaluated through enactment.

Of course, the preceding distinction needs to be immediately amended and qualified somewhat. The way in which it has been stated is too parochial, tied, as it is, to contemporary Western practice. Not everything we may be disposed to call drama in the first sense need be associated with a literary or written text, even if that has become the standard case nowadays. The script, so to speak, of a performance may live in the memory of the performers—who may be a troupe of actors or the members of some subculture enacting a ritual whose instructions have been passed down orally through the ages. Though we think first of a written text in this context, it may be more fruitful to think of this dimension of drama as a play plan or performance plan. The play or performance plan can be discussed and evaluated in its own right, that is, apart from its performance. This is perhaps most obvious in the case of the text of the well-made play. But an untranscribed harvest ceremony also has a performance plan, albeit unwritten, that can be analyzed and appreciated independently of its performance, just as a traditional folk dance has a design that can be scrutinized in isolation from any particular performance of it. Improvised theater, as well, also usually has a performance plan broadly construed as a set of scenarios, strategies, gambits, or riffs that the performers call upon and then elaborate on the spot.

The first step in developing a philosophical analysis of the notion of the art of drama, then, is to note that there are two concepts here. We might call them drama as composition and drama as performance. In order to elucidate the concept of drama as composition, let us use the example of the well-made play, and then go on to add the necessary qualifications for dramas that do not possess written texts.

The play as a literary work—our leading example of drama as composition—is created by a playwright (or playwrights) who is (are) the author(s). This artist or collaborative group of artists is a *creator;* the creator brings the play text or performance plan into existence, though in some cases we may not know the name or names of these creators. In contrast, there is another group of artistic

[5] J. O. Urmson treats literature as this sort of artform. I disagree with his contention that literature is two-tiered; nevertheless, I think the idea of two-tiered artforms is a useful one. See J. O. Urmson, "Literature," in George Dickie and Richard Scalafani, eds, *Aesthetics: A Critical Anthology* (New York: St Martin's Press, 1977), pp. 334–40.

functions involved in making the performance plan manifest. In contemporary theater, these roles include the actors, directors, designers, music directors, and so on, who literally embody the performance plan. Whereas the artist with respect to drama as composition is a creator, the artists with respect to drama as performance are *executors*. *To* simplify matters drastically: Edward Albee created *Who's Afraid of Virginia Woolf?*; Uta Hagen, among others, *executed* it. The different kinds of artists here signal different arts of drama: the art of composition or creation, and the art of performance or execution.

Needless to say, the same person could be both the creator of a play, its author, and one of its executors—its director or a player, for instance. Shakespeare, in point of fact, was both an author-creator and a player-executor with respect to his artworks. However, the roles of creator and executor are nevertheless categorically distinguishable. As the choreographer is to the dancer troupe, and the composer is to the conductor-cum-orchestra, so normally the author of the play text is to the director, actors, designers, and so forth. In these cases there are two discriminable arts: the art of composition and the art of performance. The creation of the author—the play text—is fixed by her intentions. The art of the performance is variable. Just as we expect different violinists to bring out different qualities in a musical score, so we expect actors and directors to disclose different aspects of the relevant composition, at least in contemporary Western theater. We prize texts for the singularity of their design, but performances are valued for their variability and diversity.[6]

In this regard, we are really making a virtue out of necessity. No text, no performance plan, no matter how elaborate, is determinate with respect to every feature relevant to its manifestation or implementation in performance. There are always some questions unanswered by the text or performance plan about matters like how a character looks, how she speaks, how the performance space is shaped, what motivates a line reading, what gesture goes with it, and on and on. Different performances make different choices concerning these questions. In order to produce a performance, the executors must go beyond what is given in the play text or performance plan.

We evaluate performances in contemporary theater in virtue of the choices they make in this respect, noting their insight, profundity, and inventiveness—often comparing and contrasting the performance at hand with other variations on the same play text or performance plan. Though there are significant debates about the latitude or degree of compliance performers should respect in filling in the unavoidable indeterminacies of the text, no one can deny that all performances involve interpretations of play texts or play plans in the sense that dramatic performances must go beyond what is given in the text or play plan.[7] That is,

[6] These remarks pertain to contemporary drama. Ritual dramatic enactments may be evaluated primarily for their realization of some norm. I will attempt to take account of this in my analysis of the concept of drama as performance a bit further down the line in this chapter.

[7] An exception here might be improvisation, though I suspect that most improvisation involves a performance plan, albeit sketchy, that the performer has ruminated over, at least mentally.

there is always a latitude of play—some scope for invention in putting flesh on a performance plan. A performance plan needs to be filled out by performances; that is why performances are often called interpretations: they are interpretations of performance plans, or, in the typical case nowadays, they are interpretations of play texts.

As literary art, play texts (dramas-as-compositions) are types from which copies are derived. Moreover, your copy of *Middlemarch* and my copy are both tokens of the type created by George Eliot. These tokens are material objects that grant us access to the abstract type, the artwork *Middlemarch*. If my copy of *Middlemarch* is destroyed by fire, the novel by George Eliot nevertheless continues to exist. For it is an abstract object, a type, and it cannot be burned. Moreover, this type is complete. Save the discovery of a hidden manuscript by George Eliot that reveals her intentions on the matter, there are no new words to be added to *Middlemarch*.

It is true that the reader will have to presuppose certain mandated details that are not stated on the page—such as that Casaubon has a four-chambered heart. But otherwise the book is closed; the artwork is fixed. Likewise, a drama as a literary *work*—*The Master Builder*, for example—is fixed as the art type it is for all time in terms of the relevant aesthetic elements that constitute it as determined by the intentions of its author, Ibsen.

However, dramatic performances are variable. This is because when viewed from the perspective of drama as a performing art, play texts are regarded simply as recipes—semi-porous formulas to be filled in by executors in the process of producing performance artworks—rather than as fixed artworks in their own right. They are blueprints rather than finished buildings, figuratively speaking. That is, they are sets of instructions to be elaborated upon—embroidered even—and executed by actors, directors, and so on. Play texts specify the ingredients of the performance—such as lines of dialogue, characters, and perhaps some props—as well as the range of global emotional tones or flavors appropriate to the work. But just as a culinary recipe calls for the cook to interpret how much vinegar a "dash" is, so the executors of the play text must exercise judgment in arriving at, for example, the precise tempo of a performance. However, this does not allow the executors of the play text to do anything they wish with the text, just as the cook cannot legitimately "interpret" a "dash" of vinegar as an instruction to add a pint of cream.

Nevertheless, the play text as recipe permits a robust space for variations and inventions—for play—as do recipes in the culinary arts and scores in music, though, of course, within the bounds of a set of indeterminate instructions. (Where those boundaries lie, needless to say, is subject to much dispute; for example, should performances be constrained by an author's, such as Chekhov's, original intentions, or by the hypothetical intentions that we infer someone like

Of course, if there is pure improvisation, that would not show that there are not two artforms denominated by the notion of drama, but only that, in some cases, some dramatic works only exist as pure performances.

Chekhov would have had were he alive today, or are the constraints proffered by the text even looser still?) In order to be incarnated as a performance, every play text requires interpretive activity on the parts of the executors who must extrapolate beyond what has been written or otherwise previously stipulated (as in the case of orally transmitted performance plans).

Some play texts—such as Megan Terry's script for *Comings and Goings*—permit a generous scope for improvisation, while others may attempt to exercise more authorial control. But inasmuch as any performance plan will be, necessarily, riven with indeterminacies to be filled in by executors, every dramatic artwork *qua* performance will be an interpretation. Moreover, it is because the play text is always inevitably somewhat indeterminate, in the way of a culinary recipe, that it makes sense that we savor different performances in the way that we do different preparations by different chefs of the same sauce. Each variation brings out different aspects of the recipe type.

Both the dramatic artwork as composition and the dramatic artwork as performance are types. However, the manner in which tokens of these two types are brought into existence is notably different. Where the dramatic artwork is a literary work, nowadays tokens of it typically come to us in the form of printed matter. Generally, these tokens are mass produced by some mechanical or electronic system of replication. Moreover, if they are handmade—done by quill as one supposes Shakespeare's folios were composed—I suggest that the manuscripts were still mechanically produced in the sense that ideally they were rote transcriptions where the scribe's penmanship was artistically indifferent (if a scribe refigures such a play type imaginatively, perhaps by adding illustrations or illuminations, then the writing becomes a singular artwork in its own right and is not merely a token of the pertinent type).

Tokens of Shakespearean dramatic compositions are generated mechanically—either by anonymous scriveners striving to achieve the status of carbon paper or, nowadays, by machine processes; once the type is set, token copies of it are stamped out mechanically (or electronically). At this point, the tokens are generated by a series of sheer physical processes. A token of a particular play by Shakespeare—my copy of it—is an object, brought into the world by a sequence of brute causal events.

However, a token of a play by Shakespeare from the perspective of drama as performance is a very different affair. Because of the duality of drama, plays have as tokens both objects and performances. Considered as a literary work, a token of *The Libation Bearers* is a graphic text of the same ontological order as my copy of *Middlemarch*. But considered from the perspective of drama as performance, a token of *Libation Bearers* is something else again. It is an event, rather than an object. Indeed, it is a specific kind of an event; it is a human action. The production of a token instance of *Libation Bearers* by way of performance requires intentionality. It is not a consequence of a process of physical causation. It involves mentation (where the mark of the mental, as Franz Brentano proposed, is intentionality).

The production of my copy of *Libation Bearers*—which grants me access to the dramatic artwork as composition that Aeschylus created—required a template (either hot type or an electronic file); this template itself is a mere physical entity or process that unlike the type, *Libation Bearers*, is spatially situated and can be destroyed physically. The production of a performance token of *Libation Bearers*, on the other hand, requires something above and beyond mere bodies in motion, causally interacting. As we have seen, it requires an interpretation given the indeterminacies of the play text. For, as we have already argued, the play type by Aeschylus—when viewed from the perspective of performance—is akin to a recipe that must be filled out by executors, including actors, directors, and the rest.

This interpretation, moreover, is a conception of the play type, and it is this conception of the production that governs the performances from night to night. These interpretations, furthermore, may be performed in different theaters, and by touring companies; and they may even be revived after a hiatus. Thus, these interpretations of the recipe are themselves types that then generate performance tokens. The relation of the play type to its performances is mediated by an interpretation, suggesting, then, that an interpretation is a type within a type. What gets us from the play type *qua* recipe to the token performance of it is an interpretation that is itself a type. On the other hand, what gets us from the dramatic artwork *qua* composition to a token instance (my copy of *Libation Bearers*) is a template that is a token.

The action of the template token in the production of the token instance of the literary art type *Libation Bearers* is starkly a matter of physical causation. The action of the interpretation type in the production of the token performance of *Libation Bearers* is quite different. Not only is it the case of a type rather than a token in action, but the type in question involves, ineliminably, mental or intentional components. Indeed, not only is the interpretation that governs the performance itself intentional; to enact that interpretation, to instantiate it tonight on stage requires thought—requires an interpretation of the interpretation relevant to the immediate circumstances of the live performance.

So far, then, we have argued that drama is a two-tiered or double-decker artform. There is drama as composition and drama as performance. Drama as composition involves an author who creates an artwork—a play text or performance plan. Drama as performance involves executors—performers who make the performance plan *qua* recipe manifest by way of an interpretation (or an iterated series of interpretations). Token instances of dramatic artworks as compositions are material objects generated mechanically by templates; token instances of dramatic artworks as performances are events generated intentionally by interpretive acts. Moreover, we call an art a performing art just in case it exhibits this duality.

Two possible counterexamples to our claim about the duality of drama are plays created with no intention that they be performed (Seneca's tragedies, for example); and works of pure improvisation, that is, improvisations with no previous production plan. For my own part, I am very suspicious of the

notion of utterly pure improvisations—ones engaged without any previous planning or entered into with altogether no background repertory of strategies or tested response patterns to certain types of situations or challenges. Even the improvising comic, asked to enact a scene on the spot, pauses for a moment to think out a plan (and, I suspect, to rummage through past skits for pieces for the new one). Furthermore, though some plays may be written with no thought of performance, that does not entail that they literally cannot be performed. And, finally, if my rejoinders to these counterexamples strike you as too ad hoc, it might also be noted in favor of the duality thesis that the concept as such of drama may still be dual even if there are some dramas that are only dramatic compositions and others that are only dramatic performances.

What is drama? Drama is a two-tiered artform, an artform comprised of two kinds of artworks: creations, on the one hand, and performances, on the other hand. Drama, moreover, is a paradigmatic performing art, where a performing art is one marked by precisely this sort of duality.[8]

3. CAN DRAMATIC PERFORMANCES BE MEDIATIZED?

If the preceding discussion of drama as performance is correct, then it follows that there is a categorical distinction between dramatic performance and what may be called the mass-mediatized arts of film, television, and computer-generated imaging. In order to see why this is so, let us quickly review again the way in which a performance of a token of a mass-mediatized artwork, such as a film, reaches its audience versus the way in which a performance token, such as the enactment of a well-made play, reaches spectators.

In many important respects, the story about how the token instance of the mass-mediatized artwork reaches its audience repeats what we have already said about the way in which the token instance of the drama type as composition is transmitted to its readers. Just as my copy of *Baal* gives me access to the type created by Bertolt Brecht, so the token performance of *Finding Neverland* (its screening), in my neighborhood cineplex, gives me access to the film type *Finding Neverland*. If my copy of *Baal* were torn apart or if the showing of *Finding Neverland* was canceled midway due to a bomb threat, neither event would imperil the existence of the relevant art types. These mishaps would be a matter of the destruction of token instances of the artworks in question; the pertinent artworks, as types, would continue to exist.

Mass-mediatized artworks of the sort that immediately concern us—fictional narratives—are types in the sense that they can be incarnated by an inde-terminately large number of tokens. Unlike paintings and sculptures, they

[8] This analysis follows the one offered in my "Defining the Moving Image," in my *Theorizing the Moving Image* (New York: Cambridge University Press, 1996), pp. 49–74. See also my *Philosophy of Mass Art* (Oxford: Clarendon Press, 1998), esp. Ch. 3, pp. 172–244.

support multiple instantiations of the same artwork. Identical tokens of the same mass-mediatized artwork can be consumed simultaneously by people in different locales. Among other things, this is what makes a mass-mediatized artwork so potentially lucrative. You can show it—like a soap opera—all over the world at the same time, thereby commanding immense audiences.

But drama is also a multiple instance artform. There can be many token performances of *Cats*—indeed of the same production of *Cats*—in different places and yet at the same time. There may, for example, be touring companies. And perhaps, with enough touring companies, *Cats* could reach comparably sized audiences across as many different locales as *Finding Neverland* does. This would be extremely expensive, but not literally impossible.

So it looks as if mass-mediatized artworks and some theater performances might be on a par: both examples are type artworks and, in some cases, the type in question can be exhibited simultaneously at different reception sites. This is what the WPA Federal Theater project attempted with its production in 1936 of *It Can't Happen Here*, which, after a movie company dropped out, opened in 18 cities at once. Does this suggest that mass-mediatized art and drama as performance are in the same boat ontologically? I contend that they are not, because there are subtle, but important, differences between the delivery of mass-mediatized artworks to their audiences versus the way in which a token of a work of dramatic art as performance makes its way from the type to the stage.

Contrast how you get from the type *Finding Neverland* to its token performance (the screening) in my multiplex tonight with a token performance of *Baal* at the university theater down the road in the same neighborhood at the same time. To produce a token instance—a performance/showing—of *Finding Neverland*, you need a template, for example, a film print, which itself is a token of the type *Finding Neverland*. Once the film projector is adjusted properly, you run the template, the print, on the mechanism. You flip on the switch and certain mechanical and electronic processes take over automatically, generating a token performance of *Finding Neverland*.

But this is not how you generate a token performance of *Baal* nor, for that matter, even a token performance by one of the touring companies of *Cats*. These live performances are not generated automatically from a template. Rather, the performers have access to a script and perhaps to a set of directorial instructions that, in turn, constitute a recipe or blueprint—rather than a template—which the executors go on to interpret in order to bring a token instance of the play to life.

The live performance—whether of *Baal* or *Cats*—is the result of the executors's intentions, beliefs, and desires, and not the mere consequence of fully automatic mechanical, chemical, and/or electronic processes. Live performance tokens of plays such as *Baal* and *Cats* (and of all those other recipes here unsung) are the result, first and foremost, of *mental* processes—interpretive acts; whereas token performances of *Finding Neverland* are not—once the projector starts humming—immediately a matter of a series of mental acts, but

a matter of brute, scientifically law-governed, physical processes. What the projector operator believes about the fiction has no impact on the unfolding of the celluloid storyworld frame by frame.

What gives rise to tonight's 7:30 p.m. performance of *Finding Neverland* is a mechanical-electronic apparatus engaging a chemically fixed, predetermined template in accordance with certain technical procedures and natural laws. The process can be completely automated; it's mostly pure physics. But the factors giving rise to tonight's token performance of *Cats* are continuous processes of judgment about how to interpret the production recipe on the part of the actors, dancers, singers, lighting crews, and the like.

If you ask yourself why you are seeing three characters screen left in tonight's showing of *Finding Neverland*, the answer has to do with the physical structure of the template; the images and the positions of the three characters are chemically fixed in the template. What you see in *Finding Neverland* is counterfactually dependent upon the physical structure of the template. Had the physical structure of the template been different, that is, the image would have been different. If there had not been three characters imprinted on the template, you would not be seeing their image. Had the three characters—contrary to fact (or counterfactually)—been on the right side of the image instead of the left, you would be seeing them screen right.

On the other hand, when you see three characters on stage left in *Cats*, that is because the actors in question have interpreted the production recipe in such a way that they *believe* that they should be on stage left at that moment. What you see on stage, in other words, is counterfactually dependent upon the beliefs of the performers. Quite simply, if they did not believe that they should be on stage left, they wouldn't be there, and, for that very reason, you wouldn't see them there.

What you see on screen, then, is counterfactually dependent upon the structure of the template as it is processed primarily through a series of sheer physico-causal processes. What you see in a live performance of a play, however, is generated by the interpretative acts and beliefs of the performers. The token performance of *Finding Neverland is* generated through mindless physical procedures, whereas the live token of *Cats*, as a dramatic performance, is generated intentionally—it is proximately mediated, moment by moment, by the beliefs and judgments of performers striving to interpret the production recipe. Call this the difference between generation by intentional systems (systems of mediation operating through intentional or mental states) versus generation by physical systems (systems of mediation operating through exclusively physical states).

This is an important ontological distinction. Put into a crude slogan—one that admittedly requires further refinement—it is the difference between mental properties and physical properties. Since mass-mediatized artworks are type artworks that rely upon templates to produce token performances, mass-mediatized artworks differ categorically from dramatic performances that rely on intentional states—interpretative acts—in order to be made manifest. It is the role of intentional states in the generation of token dramatic performances that I believe

disposes us to call these events live. For, were *Cats* performed by zombies, I do not think we would be comfortable with calling the performance live or the troupe a living theater. For, though zombies are supposedly animate, they have no intentions of their own.

But, in any event, the performance of the mass-mediatized token is almost exclusively an affair of matter in motion, whereas the token dramatic performance is ineliminably an artifact of mind. Or, mediatized-mass art tokens are to tokens of dramatic performance as matter is to mind. Thus, a token dramatic performance as a work of art in its own right cannot be a mass-media artwork.

One reason for this is that the token performance of a mass-mediatized artwork is not itself an artwork. Recall: a token performance of *Finding Neverland* is brought about by putting the template—a reel of film—on the projection mechanism and operating the machine strictly according to established routines. On the other hand, a token performance of a dramatic performance is an artwork in its own right, just because it depends on the mindfulness of the performers.

A successful token performance of *Finding Neverland*—the projection of the film or the running of a videocassette or DVD—does not command aesthetic appreciation, since it is not an artwork. We do not applaud the projectionist as we do a pianist at the end of a successful performance. We may complain when the film burns up in the middle of the screening and may even demand our money back. But we regard this as a technical failure, not an artistic failure. If we regarded this as a matter of artistry, then we would expect people to cheer when the film does not burn, but they don't. For the happy film performance only depends on operating the apparatus as it was designed to be operated, and, since that involves no more than often quite minimal mechanical savvy, running the template through the machine is not held to be an aesthetic accomplishment. The projectionist is, in other words, not an artist of any sort, let alone a performing (or interpreting) artist.

On the other hand, the successful delivery of a token dramatic performance involves a token interpretation of an interpretation type, and, inasmuch as that depends on artistic understanding and judgment, it is a suitable object of aesthetic appreciation. This is why the token *performance* of a mass-mediatized artwork is not an appropriate object of artistic evaluation, whereas the token dramatic performance is. For it is the mentation of the executors that merits praise or blame, not merely matter in motion.

Perhaps another, more scandalous way of putting this point is to say that the pertinent mass-mediatized artforms—notably film and television—are not performing arts in terms of the framework developed in this chapter. This may sound incredibly bizarre, since many of the people who contribute to the making of a motion picture are what we usually think of as performing artists—actors, directors, lighting and sound engineers, set designers, costumers, choreographers, fight coaches, and so on. However, it is essential to note that whatever the interpretive activities and performances that these artists contribute to artwork are indissolubly integrated into the motion picture type as constituent parts in a way that is determinately fixed forever at the inception of the final version

The Arts

of the type. The acting is not adjusted or reinterpreted given the exigencies of different theaters or audiences. Once the motion picture has been edited and put in the can for good, there is no opportunity left for intentionality; token performances of the type will be as alike as two quarters, though token performances of the dramatic type *Baal* can be very different, because they are different interpretations.

With respect to mass-mediatized artforms, a fixed interpretation of the script comes to be built into the very token template. The template is then run mechanically. There is no further interpretation of the script involved. In this respect, the mass-mediatized artwork is not a two-tiered artform, but single-tiered, more like a novel than a performance. Consequently, since they lack the required duality, movies—whether film, broadcast TV, video, or CGI—are not works of performing art, though some of their contributors may have been trained as performing artists. Moreover, the person who is responsible for the performance of a movie—the projectionist—is not an artist, performing or otherwise. He or she is just a technician.

Undoubtedly, the hypothesis that movies are not a performing art will please neither the drama department nor the cinema department. The drama folks will rue the loss of all those students who want to study acting in order to become movie stars; while the cinephiles will resent the loss of prestige they fear they will suffer, if they no longer sit at the same table with music, drama, and dance. However, neither money nor fame counts for much when it comes to ontology. And, ontologically, the mass-mediatized arts of narrative fiction are profoundly distinct categorically from drama *qua* performing art.

One theorist who has advocated the destabilization—even the deconstruction—of the distinction between mass-mediatized artworks and dramatic performances is Philip Auslander.[9] One reason why Auslander objects to the distinction is that he thinks it is motivated in contemporary circles by spurious political motivations.[10] He contends, for instance, that Peggy Phelan's characterization of live performance as a mode of disappearance—whose transience enables it to be politically resistant[11]—is false; Phelan's conception of live performance would not have the political ramifications she assigns to live performance even if her characterization of the difference between live performance and mass-mediatized art were compelling (which, of course, Auslander thinks it isn't).[12] However, even though I think that Auslander's objections to Phelan and to similarly disposed theater theorists are spot-on, I do not think that Auslander is correct in alleging that there are no significant ontological differences between mass-mediatized artworks and live dramatic performances.

9 Philip Auslander, *Liveness: Performance in a Mediatized Culture* (London: Routledge, 1999).
10 Auslander, "Against Ontology," 50–2.
11 Peggy Phelan, *Unmarked: The Politics of Performance* (London: Routledge, 1993).
12 Auslander, "Against Ontology," 50–3.

For Auslander, there can be live, token dramatic performances that are functionally equivalent. That is, the token performance of the Disney staging of *Beauty and the Beast* in one city could be functionally equivalent to a counterpart token performance, enacted in another city, at precisely the same time of day. The actors playing the flatware, for example, would be made up in the same way, deliver the same lines, dance the same steps, and so on. From the orchestra pit, one might imagine, the performances will be pretty much perceptually indiscernible—presumably as indiscernible as the projection of two different prints of the same film template.[13] Auslander, in fact, suggests that the California producer Barrie Wexler's *Tamara* "franchise" is another such example.[14]

But I am skeptical. Mass-mediatized artworks, such as movies, are types that require templates that generate token performances through automatic processes of sheer physical causation. They are solely the result of the movement of matter in accordance with scientific laws. Once the lens is focused and the machine is activated, the rest is pretty much blind nature grinding through its paces. But no live performance, not even one of the *Tamara* franchises, is like that. Token dramatic performances require actors, lighting crews, and so on, who generate the relevant performance tokens through processes of ongoing decisions—mental acts comprised of beliefs, judgments, and interpretations. Token performances of *Tamara* are not automated physical processes; they are mind-mediated through and through.

Even if, *per impossibile*, a movie of *Tamara* and its token performances looked indiscernible and were functionally equivalent in every way, that would not entail that there are no ontological differences between them. For these perceptual and functional congruencies are not ontologically bedrock. They are only superficial or surface similarities insofar as these phenomena have radically different, metaphysically significant provenances. These similarities, in other words, are only skin-deep. But there are deeper distinctions here. One token performance reaches us by way of mind and the other by way of matter.

Auslander attempts to elude this conclusion by maintaining that the distinction that I draw between generation-by-template and generation-by-interpretation is not as sharp as I suppose.[15] Actors' interpretations, Auslander argues, can be as mechanical as a physical template, such as a film print or a DVD disk. I see no compelling reason, even if one is a materialist about what exists, to believe that mental properties are fully reducible to physical properties. Mental causation is ontologically different from sheer physical causation in pertinent respects (while, also, obviously being related to physical processes). And, given these distinctions,

[13] Philip Auslander raised these sorts of considerations in an untitled essay that was supposed to be published, along with a comment by me, in an issue of *Performance Research*. Unfortunately, the exchange was never printed.

[14] Auslander, "Against Ontology," 50–3.

[15] Auslander in the unpublished essay cited in n. 13.

the differentiation between mass-mediatized artworks and live performance falls out naturally.

Auslander may think that many of the actors' interpretations in the *Tamara* franchise are *mechanical*, but surely "mechanical" in such a context would probably mean something like "uninspired" or "unimaginative." It cannot literally pertain to the decision-making and judgments of the performers in question, for they are not machine-tables churning out mindless sequences of behavior.

As is well known, actors adjust their performances to live audiences; they assay the temper of the crowd, and reinterpret their lines appropriately. Tonight add a dash of irony; tomorrow, be a pound more serious. This is an important distinction between movies and live theatrical performances, one noted by Walter Benjamin in his discussions of mechanical reproduction.[16]

The Purple Rose of Cairo notwithstanding, the actor in a token performance of a motion picture cannot modify his approach to suit the sentiments of the spectators in the house. But this is commonplace in token dramatic performances. Even where the actor relies on so-called technique, rather than inspiration, to get through the evening, there are always subtle reinterpretations of the recipe to fit the occasion. This is why it makes sense to say that the actor's performance, no matter how reliant upon technique, was better yesterday than it was today. But it would be absurd to say that Johnny Depp's acting in a token performance of *Finding Neverland* was better yesterday than it was today. And this very absurdity marks the difference between a token performance of a mass-mediatized movie versus a token enactment of a specimen of drama-as-performance.[17]

4. CONCLUSIONS

Drama is not one artform, but two: the art of dramatic composition and the art of dramatic performance. Moreover, the art of drama as performance, though perceptually very much akin, in many respects, to the mass fictions projected by movies, is nevertheless radically, categorically different. Indeed, even if there were a point-perfect motion picture replica of a token instance of a dramatic artwork as performance, that was, in certain circumstances, effectively indiscernible from

[16] Walter Benjamin, "The Work of Art in the Age of Mechanical Reproduction," in *Illuminations*, ed. Hannah Arendt, transl. Harry Zorn (New York: Schocken, 1955), 217–51.

[17] Unlike Auslander, I maintain that there are ontological differences between dramatic performances and mass-mediatized performances. However, I do not think that this disagreement ultimately compromises Auslander's work. For he has shown us many arresting ways in which recent live art has been influenced stylistically and structurally by the mass media. His insightful observations do not seem to me to be undercut by the fact that there is an ontological distinction between mass art and dramatic performances. Borrowings can occur between ontologically discrete categories. Fashion designers can imitate foliage. Auslander's compelling comparisons between live performances and mass media do not require him to deconstruct or to abjure ontology. He can have everything he wants and some metaphysics too.

the original, that would be only at best a *recording* of the dramatic performance token. Moreover, a performance of that document—a screening—would not be an artwork in its own right.

Why?

Because it would be mindless.

22

Literary Realism, Recognition, and the Communication of Knowledge

My topic is the significance of realist art for the philosophy of art, particularly for the anglophone philosophy of art as practiced in the twentieth century. I am addressing the problem in terms of anglophone aesthetics, since that is the tradition I know best; nevertheless, I think that the type of issues realist art raises touches upon the ingrained habits of other philosophical approaches as well. In this chapter, I will be construing realist art rather broadly. For my purposes, realist artworks are artworks that represent the social and psychological dimensions of human affairs in such a way that the works are intended to impart knowledge or understanding, among other things, to viewers and readers. Thus, I am not restricting realism to naturalism or even to visual artworks that strive for optical verisimilitude. So the caricaturist George Grosz counts as a realist, on my view.

By characterizing realism as art intended to deliver social knowledge and understanding, its significance for the philosophy of art becomes immediately apparent. It is a challenge or, at least, a problem for the philosophy of art because, throughout the twentieth century, and earlier, many philosophers have attempted to defend the idea that art, properly so called, is not, cannot, or, at least, should not be in the business of knowledge production, social or otherwise. Consequently, realism is at theoretical loggerheads with an influential tradition in philosophy, a tradition, moreover, which claims, perhaps illicitly, its authority from Immanuel Kant.

In order to trace the origins of this conflict, we need to turn back to the eighteenth century. Before the eighteenth century, the association of art with knowledge was commonplace. Though it annoyed Plato, Homer was called the educator of the Greeks. Greek art was mimetic, and Aristotle maintained that the primary pleasure to be derived from mimetic representation is that of learning—that is, the pleasure of acquiring knowledge. Such a view was also borne out in the practices of successive cultures that employed art as a way to communicate its ethos to its people. Stained-glass windows, for example, addressed the eyes and minds of the parishioners, tutoring them in Christian precepts. But certain things occurred in and around the eighteenth century that led to an enormous sea-change in thinking about the arts.

The first change was the formation of what has been called the Modern System of the Arts. Painting, poetry, sculpture, dance, drama, and music began to be thought of as a unit—the Fine Arts or the Beaux Arts or, perhaps more simply, just Art with a capital "A." In the classical period, the arts were any practice involving skill. Medicine was an art, as was archery, and so forth. Some of our present-day Fine Arts, such as music, were sometimes associated with mathematics, rather than with poetry. Aristotle was not a philosopher of art; he was the philosopher of a particular art, poetry. There were no philosophers of Art with a capital "A," because we did not yet self-consciously have that category in play. That category appears to have taken hold dramatically around the eighteenth century or thereabouts. Though the collection of practices in our art schools today strikes us as natural, it is the result of a historical conjunction.

Of course, once we had the concept of Art, or, of Fine Art, the philosophical question arose about what criteria qualified an object or performance for membership in this category. An initial suggestion, undoubtedly following in the footsteps of Aristotle, was that representation, particularly the representation of the beautiful in nature, was that which qualified a candidate as a work of fine art. However, this proposal did not withstand an important development in the history of music: the ascendancy of absolute or pure orchestral music. It was hard to construe most absolute music as the representation of anything. Philosophically, the need for a new paradigm became pressing.

Several, of course, offered themselves. One of the most enduring and, for us, the most interesting is that artworks, properly so called, are objects and performances designed to afford a certain kind of pleasure, called disinterested pleasure, which pleasure, furthermore, is derived from attention to the form of the work. Since this experience of pleasure is generally referred to as aesthetic experience, this philosophy of art can be called aesthetic formalism—the theory that an artwork is something intended to support, by means of its form, an appreciable degree of aesthetic experience.

Note here that the object of pleasure that defines the purpose of art is the form of the work. Not the content. In other words, it is not that which the artwork represents that is constitutive of its art status, but the way in which it represents it. This view of art does not preclude representational artworks, but it does imply that their representational content is fundamentally irrelevant to their artistic function and to our appreciation of the work. What counts is the form in which whatever the work is about is presented, in terms of whether it delights us by absorbing us in disinterested contemplation. As you may anticipate, this way of thinking possesses an inherent bias against realist art, insofar as an extremely important part of the achievement of realist art is its representational content.

The aesthetic theory of art did not arise in a social vacuum. It emerged in a period where patronage of the arts was evolving in noteworthy ways. In earlier times, the primary patrons of the arts were political or religious. Generally, art was commissioned to serve the functions of the Church and the state. But, as

the bourgeoisie appeared, a new market for art dawned as well. The bourgeoisie used art as a way of enlivening the leisure time that was increasingly at their disposal. Whereas previously art was frequently encountered incorporated into the portentous affairs of culture—for example, in the form of civic or religious statues of moral exemplars at the appropriate institutional sites, or in the form of music, song, and pageants as parts of political or religious rituals—the arts were re-conceived as a kind of play, a contemplative play in response to the form of the work, irrespective of the cognitive, political, social, spiritual, and/or moral content of the work.

The bourgeoisie sought beautiful things to brighten their lives, including not only furniture, tableware, and carriages, but pictures, exquisite writing, and the like. Taste became a marker of social capital for the rising middle class. Art became more and more an object of bourgeois consumption. Though the participants in this practice would probably not have described it this way, the artwork became a commodity whose purpose was precisely—by means of its form—to engender disinterested pleasure, also known more obscurely as aesthetic experience, or, even more obscurely, as the purposeless play of one's contemplative powers. That is, the theory of aesthetic formalism neatly fit the bourgeois practices of connoisseurship and consumption—quite probably because, in this case, theory and practice were mutually informative.

In order to have a proper aesthetic experience, on this view, the percipient had to attend to the artwork in the right way. This involved bracketing every putative distraction—that is, everything allegedly extraneous to deriving pleasure from the form of the work. These exclusions included its representational content—whether cognitive or moral, social, political, economic, or religious. Whereas previously art, in virtue of its representational content, was thought to be a vehicle for communicating knowledge, the aesthetic formalist disenfranchised art as a source of belief and understanding, social or otherwise.

Of course, the philosophers who reached this conclusion did not do so simply by reflecting on the emerging transformation of the practice of art into a market ever more catering to the taste of the bourgeoisie. There were also reasons internal to the project of philosophy that predisposed theorists toward the conception of the artwork *qua* artwork as a formal design meant to afford disinterested pleasure. Foremost among those reasons is the recurring commitment of philosophy, since the time of Plato, to attempt to ascertain the *essence* of things—to get at what makes something what it is and not something else.

With respect to the arrival of the Modern System of the Arts, the philosopher had to ask what warrants counting something as belonging in this system, or, more colloquially, "What is art?" That is, what, in other words, defines the domain of Art with a capital "A"? What licenses entry into the republic of art rather than inclusion under some other category?

Given the essentialist tendency of philosophy, the answer that art is a matter of form intended to deliver an aesthetic experience is virtually irresistible. For,

aesthetic experience itself is defined as a disinterested experience, that is, as an experience divorced from every other kind of interest—cognitive, moral, religious, financial, social, and so forth. Thus, since the end of art is a state that is separate from every other practice, it would appear to follow almost immediately that the means *qua* art to attaining that state must be equally distinct from every other category of activity. That is, if the end state is to be untainted by interest, it stands to reason that the means to that mental state must be undiluted as well, lest interest seep into the pertinent mental state. The conception of art as the promotion of *sui generic* value, therefore, neatly hives art off from every other human enterprise at a stroke and by definition, since something that is aimed at producing an experience that is categorically disparate from the interests attached to other human practices must be, it seems fair to infer, a thing apart.

That the aesthetic-formalist definition of art fits the essentialist program of philosophy so well is undeniably one factor that makes it so attractive. Indeed, I speculate that this very special sort of theoretical seductiveness explains why this conception of art never seems to go away for long, but always returns. By this, I mean not only that periodically defenders of the aesthetic formalism arise even after it appears to have been soundly defeated; I also have in mind that some of the implications of the theory—such as the view that communicating social understanding is aesthetically irrelevant—are so deeply embedded in philosophical thought, that they are voiced by philosophers who would not explicitly identify themselves as aesthetic formalists. The reason for this, on my view, is that the results of aesthetic formalism fit the essentialist aims of philosophy so well that philosophers take it on board almost subconsciously.

But, in any event, the fact that a theory suits one's meta-philosophical program is not enough to endorse a theory of art. Arguments are required as well. And the aesthetic formalists have some very formidable considerations in their arsenal. Let me discuss three of them.

However, before sketching these arguments, let me also allay the worry that some of you may have that we are drifting far away from the topic of the chapter, namely, realism. My point in raising these arguments is precisely because I believe that realism, in every instance, reveals what is wrong with these arguments and with aesthetic formalism. That is, the most powerful desiderata in favor of the kind of aestheticism that has exerted such a powerful grip on the philosophy of art in the twentieth century and that continues to do so are decisively challenged by realism. Or, in other words, the theoretical significance of realism is that it is an antidote to aesthetic formalism.

The first argument for aesthetic formalism can be called the common-denominator-argument. As its name suggests, it asks: "What is the common feature between all the things we are willing to call artworks?" Many artworks are representational, such as Bernini's *David*, but many are not. String quartets are not representational. Many artworks are expressive of human emotions; but,

again, there are exceptions. A readymade comb by Duchamp, for example, is arguably affectless. Some artworks aspire to cognitive value, but probably not Fabergé eggs. Is there any property that every artwork possesses, or, at least, is intended to possess? Form seems to be the best candidate. Every artwork is designed, or, at least, intended to be designed one way or another and, presumably, invites audiences, perhaps among other things, to contemplate that form as part of what it is to experience the work fully and appropriately.

The form of an artwork is the ensemble of choices the artist makes to realize the point or purpose of the work. The large scale of Courbet's painting *The Burial at Ornans* is part of the formal structure of the work. One aspect of the point of the work is to acknowledge the existence and frankly to enhance the esteem of everyday life. Courbet achieves this, to an important degree, by portraying an ordinary village funeral on a canvas of the dimensions of that grandest of artistic genres, the history painting. According to the aesthetic formalist, the aesthetic satisfaction we derive from a painting like this has to do with noticing the appositeness of such choices relative to their purposes. Putatively, it is not the purpose of the painting that we value—the valorization of the quotidian—but rather the artfulness with which it is articulated.

Furthermore, the aesthetic formalist maintains that all artists are in the business of finding forms that suit the purposes or that embody appropriately the meaning of their projects and that, when we appreciate their endeavors *qua* art, it is their formal invention—their artfulness—that commands our attention.

Though there may appear to be exceptions to this generalization, the aesthetic formalist argues that they are merely deceptive. Consider John Cage's *4′33″*. A man sits at a piano, opens a score for four minutes and thirty-three seconds, and does nothing. Ambient noises invade the room. A woman coughs, a chair scrapes along the floor, a dog barks, a cellophane wrapper crackles, then there is a sneeze, a cellphone rings, and so on. Surely, this is a formless flow of noise. But *4′33″* is widely considered to be an artwork. Isn't it a formless one?

Not really, the aesthetic formalist replies. It has a purpose—to draw one's attention to the sounds of the world, to make us hear what we usually ignore, perhaps to appreciate its richness. As such, it deploys its resources ingeniously. The concert hall context alerts us to perk up our ears. The silence of the pianist coerces us to listen to what comes naturally, gently prodding us to realize that the silence is anything but quiet and may contain noise that is as worth listening to as music. At the very least, it is an economical device to redirect our attention to ordinary sounds which, of course, is Cage's polemical purpose. Similarly, it may be suggested, the various antics of Dada that seem to be merely random have a formal dimension, once one identifies them as strategies intended to implement certain points or purposes.

On this view of art, it is not the apparent purpose of the work that constitutes its status as art. Some art inspires the worship of Christ, other art the recognition of the plight of the working class. It is not the subject matter that makes it art, but how it is rendered in terms of the discovery of forms suitable to that about which the work is committed. Realism is not artistic in virtue of its

aspiration to communicate social understanding. If a realist work, such as *The Burial at Ornans*, is art, then that is due to its articulation of that program in a formally artful way. The essence of art is form for the sake of disinterested contemplation. What motivates formal invention—whether it be romanticism, realism, expressionism, or whatever—is adventitious.

From the point of view of art *qua* art, what the work is about is irrelevant, and praising a work of art for its content is an aesthetic category error. That is, the representational accuracy of a realist work of art is not an aesthetic virtue. Perhaps it is a journalistic virtue, if it is a virtue at all. But, in any event, it is not an *artistic* property of the work, properly so called, and it should not be recommended as such.

A second argument in support of aesthetic formalism is the no-expertise argument. This argument is explicitly directed against the notion that art has anything essentially to do with the production or communication of knowledge. As noted earlier, according to Aristotle, the value of mimesis is supposedly connected to learning. On this view, representation is putatively related to the acquisition of objective knowledge, knowledge about the world, typically general knowledge about human affairs. In order to advance the cause of form—over that of representation—as the quiddity of art, the aesthetic formalist contends, skeptically, that artists *qua* artists are not qualified to broker knowledge of the relevant sort.

Consider the way in which someone becomes an artist. They study their craft and the materials of their medium. Painters learn perspective and color theory; poets, prosody; musicians, scales; photographers, lens; filmmakers, editing; and so forth. Their expertise involves mastering the tools of their trade and discovering the formal opportunities they afford. Artists as such have no special expertise in any branch of knowledge other than that pertaining to their artform and medium. Considering contemporary political art, how does going to art school give one insight into globalization? In what way does a course in studio arts prepare one to make original contributions to debates about bio-technology? It seems highly unlikely that taking voice lessons puts one in the position to say anything genuinely knowledgeable about international law.

This, of course, is the argument that Plato made against the rhapsode Ion over two millennia ago. In the hands of the aesthetic formalist, it reinforces the conviction that the business of the artist is the creation of forms—that is, after all, what she has been trained to do—rather than the production of knowledge, something which is sometimes claimed as belonging to the province of art, but which is really outside the expertise of the artist *qua* artist.

The last argument in favor of aesthetic formalism is also a skeptical sally against the notion that art might have some essential connection with knowledge, as representational theorists of art and other friends of art are wont to maintain. It is the no-evidence argument. It begins by observing that much of the knowledge and understanding that art is lauded for dispensing is general in nature. Recall that Aristotle praised poetry for being closer to philosophy precisely because its crystallizations of the ways in which people act are supposedly more general than

those of history. Art, that is, allegedly conveys general knowledge about human affairs. But the aesthetic formalist wants to know: how is this possible?

If we are talking about literature, most literary fictions present us with no more than one or two cases of whatever human tendency they are concerned to depict. How could one case evidentially support a claim about any human tendency of substantial regularity? How could Courbet's *Stonebreakers* illustrate anything beyond the particular activity of the two workers it pictures?

Moreover, recall that much art is fictional in nature. Where the situation in question is fictional, the problem is not only that the evidence being offered for the thesis at hand is too scant because it is particular. The problem is also that the ostensible evidence is apt to be distorted. The artist has made up the story to support the theme in question. Or, in the case of visual art, if the artist has drawn the working-class figures in a way that emphasizes their unjustifiable immiseration, then it is always an open question whether or not that is merely a reflection of his ideology.

So art is not a convincing vehicle for the production or communication of knowledge. Art may communicate beliefs. But knowledge requires justification along with belief. Justification of general claims about human life, in turn, requires evidence. Yet art is not well suited for providing the sort of evidence demanded by the knowledge claims for which art is often applauded. For art typically trades in particulars, indeed imagined or invented ones (or, less sympathetically, contrived ones)—hardly the stuff of evidence for generic propositions about human affairs.

Therefore, on the basis of the no-evidence argument, the aesthetic formalist, once again, denies that art has any epistemic reach. Its talents reside elsewhere—specifically, they lie in the creation of forms that entice our contemplative powers and yield satisfying aesthetic experiences.

The aesthetic formalist's arguments are not negligible. That is undoubtedly why they keep returning again and again. However, neither are they insurmountable. Moreover, I think that a consideration of realism can show how they can be defeated, while also suggesting new openings in the philosophy of art. Let us begin this by revisiting the common-denominator argument.

The common-denominator argument proceeds by attempting to isolate a property that putatively obtains in everything we are willing to call art. The candidate that it arrives at is form—or, more specifically, form-intended-to-afford-aesthetic-experience. It is not obvious that every artwork—even every artwork that possesses form—is intended to promote aesthetic experience. Some may be meant to instill a reverence so absorbing that attention to the form of the work would be an unwanted, maybe even idolatrous, response. But let that pass. Let us assume, for the sake of the debate, that the common-denominator argument succeeds in isolating a thread that runs through every artwork. Even if this were the case, this will not grant the aesthetic formalist his most ambitious conclusions concerning the irrelevance of content to the appreciation and evaluation of art *qua* art. That is, even granting the supposition that form is a feature of every artwork, it would not follow that the

pursuit of knowledge should never be endorsed as the end of any artwork *qua* art.

For, consider this analogy to the common-denominator argument, as developed by the aesthetic formalist. What do all motor vehicles have in common? Let us suppose that it is the intended capacity of locomotion under their own power. This is what tractors, trucks, family cars, sports cars, SUVs, RVs, armored cars, and the Batmobile all have in common. Does this entail that the only way in which to assess any motor vehicle is in terms of its capacity to locomote? Clearly not. Sports cars should be appreciated in terms of their capacity to remain stable while taking tight corners at high speeds, whereas this will be irrelevant when thinking about tractors. The capacity to sustain mortar fire is pertinent when it comes to armored cars, but not family cars.

The reason for this is obvious. Though all these vehicles are motor vehicles, not all motor vehicles are designed with the same purposes in mind. Yes, they all ideally should be able to move under their own power, but different types of motor vehicles have other functions as well—functions that are essential to the category of motor vehicle to which they belong. That is, there are different kinds of motor vehicles and, in order to appreciate a given motor vehicle in the right way, one must take into account its category and the subtending functions of that category. Moreover, it would be absurd to suggest that sports cars should not be capable of accelerating rapidly just because that is a feature that is irrelevant to tractors.

Or to put the matter more technically: at best, the preceding common-denominator argument has identified a necessary condition of motor vehicles; *qua* motor vehicles, they are all intended to move on their own power. But there are not motor vehicles as such. There are different sorts of motor vehicles in terms of what they are supposed to move, how they are supposed to move, where, how fast, and so forth. The essence of each of these different kinds of motor vehicle involves more than simply the intended, albeit required, power to locomote. Moreover, this is related to how we go about understanding and assessing specific kinds of motor vehicles. We do not commend a certain model of dump truck because it can move, but because it can move heavy loads.

The relevance of these observations for the common-denominator argument advanced by the aesthetic formalist should be transparent. Supposing that there is such an abstract category as Art with a capital "A" and, furthermore, that form is the ingredient that marks every one of its members; it does not follow that form is the only pertinent object of appreciation for every instance of art. For there are different kinds of art—different artforms, genres, styles, and movements—that, in virtue of their particular essences, demand to be appreciated in terms that are specific to the category to which they belong. Even if it were the case that certain abstract paintings can only be appreciated formally, it would not follow that one should refrain from appreciating the canvases of Max Beckman for their expressive content. Nor should the affectlessness of readymades preclude

the possibility that some art, given its nature, can legitimately—*qua* art—strive to be expressive.

The aesthetic formalist asserts that one must appreciate an artwork on its own terms. But, even allowing that there is this abstract category of Art and that the discovery of appropriate form is a concern of every practitioner who belongs to this enterprise, it should be painfully evident that practitioners of the various artforms, genres, styles, and movements that comprise the artworld may have further commitments, given the kinds of artists they are—commitments, that is, in addition to the creation of form.

Let us grant that the aesthetic formalist is correct in maintaining that an artwork must be approached with due respect to its nature *qua* artwork. Nevertheless, the aesthetic formalist wrongly assumes that the nature of given artworks must be located exclusively in what is common to every artwork—allegedly, its form. For artworks belong to specific kinds which possess their own terms of engagement, which terms may be far more relevant to the appreciation of the specific artwork *qua* artwork—that is, *qua* the kind of artwork it essentially is—than generic considerations of form. To be truly beholden to the artwork on its own terms, then, requires acknowledging the kind of work it is. And the kind of artwork it is may mandate that one attend to it as something other than a *sui generic* formal design. That is, the essentialism of the aesthetic formalist ironically may actually stand in the way of respecting the essential nature of a given artwork.

Consider, for example, the realist novel. Given the nature of the realist novel, we do not expect of it that it simply create a coherent novelistic form, as we might of an installment of the *Star Trek* novelization series. The realist novelist is also expected, as part of his essential job description, to be an accurate and penetrating observer of society, or, at least, of the social milieu that he describes. This is central to his charge as a realist novelist.

It is not an accidental feature of Balzac's *Comédie humaine* that he charted recent transformations in French society, including the erosion of the landed gentry, the emigration, especially of ambitious young men, from provincial France to Paris, the reduction of all value to cash value, and the corresponding explosion of unbridled individualism and egotism. The point of Balzac's vast, interconnected series of novels was to hold a mirror to recent social mutations in order to enable readers to recognize themselves and their circumstances in its reflections.

Balzac did not, as some erstwhile formalist might have it, choose the social world of the Bourbon Restoration for the purpose of motivating his formal virtuosity—his dazzling control of a giant cast of characters in a veritable Gordian knot of stories. His point was to measure the temper of the times in order to shed the light of understanding on developing social tendencies. Balzac aspired to give a shape to recent history. *Lost Illusions*, for example, is designed to chart the commodification of literature along with the relevant technological developments in printing.

Moreover, this is the sort of thing that readers found in Balzac's work and then came to expect from it. It constitutes the core understanding of the literary

contract between the realist author and his public. The very concept of the realist novel, as presupposed by all parties to this form of literary exchange, involves a commitment to the observation and clarification of social reality.

One major way in which realist novelists achieve this goal is through the creation of characters that embody emerging constellations of personality traits. As society ebbs and flows, new social types appear. The realist novelist tries to pith the brave new fauna in the exfoliating social jungle. Balzac sketched Eugène de Rastignac and Lucien de Rubempré; Turgenev, the radical young empiricist, Bazarov, in *Fathers and Sons*; Dostoyevsky, the deracinated Ivan Karamazov; Gissing, the "flexible" journalist without much of a conscience; Musil, the man without qualities; Budd Schulberg, the eponymous Sammy in *What Makes Sammy Run?*; and in *Bonfire of the Vanities*, Tom Wolfe dissected a specimen of that eighties figure of New York greed that he labeled with the satiric epithet "Master of the Universe."

Characters like these are designed to clarify the direction of the social world they inhabit. They function rather like concepts in orienting readers to the lay of the behavioral landscape. They are a distillation from the cultural atmosphere of prevailing attitudes, behaviors, postures, styles, motives, dreams, anxieties, scenarios, reflexes, ambitions, morals, and the like, which are then recombined by the alchemy of fiction into representative figures that we can use to map the pertinent lifeworld.

A character such as "Willy Loman," from Arthur Miller's *Death of a Salesman*, at the very least is a label that enables us to see more clearly a certain social type by giving us a symbol that helps us pick it out and hold onto it. But "Willy Loman" is not just a name. It is also a coherent bundle of traits—of recurring and related aspirations, convictions, stratagems, fantasies, limitations, resources, emotions, prejudices—and circumstances whose assimilation in one figure enables us to comprehend what makes such an agent function, or, in this case, malfunction.

Understanding how the pieces of a character such as Willy Loman fit together may help one to recognize and grasp an otherwise easily overlooked regularity in one's social world and even aid in the understanding of the conditions that give rise to this syndrome. Though a character, "Loman" can operate like a concept to provide us with a symbol that fits the world in a way that throws it into intelligible relief.

Although the examples so far have come from the genre of literary realism, a similar kind of acuity with respect to the social world is expected categorically of the serious caricaturist. Though employing figural distortion, and, therefore, not a realist in the sense of perceptual verisimilitude, a draughtsman such as George Grosz was a social realist, a fellow traveler in the movement called *Neue Sachlichkeit*, or the New Objectivity, a movement devoted to analyzing visually the social convulsions of Weimar society.

Grosz offers viewers a conception of a moment in German history. He pictures a world of insatiable appetite and intoxication, world devouring and besotting itself. If a man is well dressed, he is likely to be bloated. Consumption,

signaled by excessive portliness and exaggerated orality, is the order of the day. Mouths are everywhere emphasized—food, drink, cigars—twisted mouths on fat chops. Typically, women are naked. Prostitution appears to be about the only relationship between the sexes. Grosz's portrait is of a society run on money and consumption, desire and predation. Grosz offers a reductive picture of Weimar culture that nevertheless organizes it, enabling the viewer to get a fix on what is new and disturbing in post-World-War-I German society.

That is, Grosz helped viewers to clarify the sense of malaise of which they were perhaps already dimly aware, but which they could better recognize by being given a graphic symbol of it, one selectively shaped, simplified, and inflected so pointedly. A picture, such as a fictional character, can function like a concept to batten upon and fix in the mind certain social phenomena at the same time that it helps orient viewers to its pertinent features.

As the case of realism illustrates, the essentialism of the aesthetic formalist is inherently unstable. For, a commitment to essentialism at the level of Art with a capital "A" may be incompatible with being an essentialist with respect to a specific kind of art. It cannot be the case that the representation of society is always irrelevant to the appreciation of art *qua* art, since it is of the nature of realist art, given the kind of art it is, that representing insight into the social world is precisely the sort of achievement that we expect from a realist artwork and that we reward with our attention to it. It is just a non sequitur to argue that the realist artist should not aspire to producing or communicating knowledge about society because that is not a concern of the composer of string quartets. The common-denominator argument can no more show that social representation is irrelevant when it comes to realist art, than a comparable argument could show that sharpness is not pertinent with respect to steak knives, just because butter knives are blunt.

Realism also shows that the no-expertise argument fails as a generalization about all art. For some artists—such as realist novelists—are expected to develop their powers of social observation. Though it is true that music theory does not give a composer any special understanding of human rights, not all artists master their craft in the same way, since not every artform is the same. And the realist novelist is expected—given the nature of his art—to become an astute scrutinizer of social mores.

Aspiring realists are advised to hone their skill—their art—of observation. The talent for comprehending social conditions is not a dispensable responsibility for the realist novelist. It is not an add-on. It is a constitutory element of what it is to be a realist novelist. Observation is part and parcel of realism. The realist novelist, as the kind of artist he is, not only creates a consistent, probable narrative-dramatic structure, but also strives to provide penetrating commentary about the society he depicts. And, to this end, he studies society. Learning to write for the realist is not just learning composition; it is a matter of nurturing a knack for finding what is really going on in a given social milieu. This is something that the realist must train himself to do, in order to succeed at his trade.

It would be simply ad hoc for the formalist to argue that the aspect of realism concerned with revealing social facts is merely journalism or reportage, while the genuinely artistic part of realism is the way in which the novelist formally unifies a variety of characters and events under an overarching theme. For, to split in half in this manner the role of the realist *qua* the kind of artist he is, falsifies the way in which this form of art is understood and conceptualized both by those who write in this genre and those who read their novels. Neither side of this literary relationship regards the social commentary of the realist as nothing but a pretext for formal invention.

That is why aspiring novelists of this sort are told to fortify their powers of observation. Thus, the realist novelist as a young artist makes the ability to dissect society part of his curriculum. By the time he is mature, if everything has worked out well, he *is* an expert in social affairs. Moreover, it needs to be added that with many of the things for which realist authors possess an expert eye—such as the emerging signs of status, the daily intrigues of micro-power, the ways of the heart, everyday anxiety, or the emerging claims of social justice—it is scarcely clear exactly whom the better experts would be. That is, *pace* the no-expertise argument, sometimes artists are experts, or, at least, expert enough to be in a position to impart knowledge, including social knowledge.

According to the no-evidence argument, artworks cannot deliver knowledge because they are rooted in particulars and are fictional. Of course, some artworks may be about communicating knowledge about particulars and, as well, may have the capacity to put us in contact with sufficient, substantiating evidence. Isn't this true of straight photography? Also, even apart from photography, there is *non*-fiction art that can meet reasonable standards of evidence. The text of James Agee's *Now Let Us Praise Famous Men* is unquestionably literature, literature that meets journalistic standards of evidence not only for its particular claims, but for certain generalizations, as grounded by a series of case studies (not to mention by the portfolio of supporting, realistic, non-fictional photos by Walker Evans in the same volume).

But even when it comes to artworks which are fictional, and which appear to advance generalized assertions, the no-argument argument is not the last word. For the no-evidence argument sets the bar for communicating knowledge too high. No one denies that the journalism on the op-ed pages of newspapers can convey knowledge. But the beliefs advanced there typically come to us without the kind of evidence it would take to vindicate such claims in the highest courts of reason. Rather, the author typically leaves it up to the reader to reflect upon her assertions, encouraging us to weigh them against our own experience and to search out further proof of their accuracy on our own.

Similarly, a realistic novel like *Bonfire of the Vanities* provides a sketch of the 1980s that we are invited to substantiate on our own. Insofar as we allow the aforesaid journalists into the knowledge game, so should a certain kind of realist be accorded admission.

Indeed, if we look at the matter squarely, I think we see that the communication of knowledge, including social knowledge, usually leaves some, if not

most, of the work of corroboration up to the audience. That includes philosophy books like this one, as well as most of the articles that we read on current affairs. Consequently, artworks that encourage audiences to test the hypotheses—perhaps about emerging character types—in what might be called the laboratories of their minds incur no epistemic deficit, since that is how it goes with most cognitive communication.

Shortly after the death of the American playwright Arthur Miller, the playwright David Mamet wrote in the *New York Times*:

I met Arthur backstage after a performance [of *Death of a Salesman*].

"Arthur," I said, "it's the oddest thing, but in the scene between Biff and Willy, it was as if I was listening to a play about my relationship with my father . . ."[1]

Here we see the manner in which a realist artwork typically functions, when it is functioning well. The artist depicts with clarity a situation, often one newly emerged from shifting social pressures, which, though perhaps obscurely sensed by many, has not yet been articulated. The realist puts us in a position to *recognize* something of our environment of which heretofore we were at best only vaguely aware, if aware of it at all. But, under the realist's spotlight, we suddenly see it clearly. We are able to inspect the phenomena on the basis of our own experience. Men of a certain age can refer to their own relationships with their fathers, as well as noting the relation of their peers to theirs.

A realist play like *Death of a Salesman* gives us an insight, which it beckons us to corroborate in our own experience. It puts us in a position to recognize a feature of the social world that previously was not perspicuously on our radar screen, and it invites us to enrich our understanding of our social surround by using it as an optic. That we assess the power of the hypothesis on our own should not count against our conviction that the play has taught us something.

Just as Zola's *The Ladies' Paradise* provided readers with the opportunity to examine the newly emerging institution of the department store, Manet's *The Plum* calls attention to a new facet of its social world. It shows viewers a young woman, sitting alone, enjoying her cigarette and a candied liquor in a public place. By doing so, Manet called his contemporaries' attention to a phenomenon of modern urban life of which they were only recently becoming aware—young working women, unaccompanied, in public savoring the possibilities of a new social environment. Manet did not offer any statistics about how many young working girls were frequenting Parisian cafés. He exhibited one, and left it to viewers to confirm the trend. But who can deny that he made possible for many an observation that they might not have made themselves about their milieu?

[1] David Mamet, "Attention Must be Paid," *New York Times*, Section 4 (February 13, 2005), p. 15.

Likewise, a photomontage by a social realist such as John Heartfield may have supplied his contemporaries with a clarifying figure that they could then go on to apply to the surrounding world. In one image, he pictures a hyena in a top hat scavenging dead bodies on a battlefield (*Krieg und Leichen—Die Letze Hoffnung Der Reichen*). The metaphor—the plutocrats are jackals—gives one a powerful framework for re-conceptualizing social relations. Viewers may have to find the corroborating evidence for themselves. But outside the protocols of academia, and often not even there, that is generally the case.

If the no-evidence argument were strictly applied, it would be a rare occasion when we could say that knowledge had been conveyed. In this regard, artworks, as in the case, most notably, of realist artworks, seem no worse off than most other information networks. Certainly, realist artworks are not worse off than most journalistic commentary inasmuch as both leave the task of substantiation primarily in the hands of the audience. Indeed, even philosophers often conduct themselves in this manner, as I am doing right now, insofar as I am leaving it up to you to find the evidence in your own experience for my hypothesis that most of the time we leave the corroboration of knowledge claims—that is, legitimate knowledge claims—up to the audience. Why, *pace* the no-argument argument, should things stand differently with artworks, or, at least, with those artworks that aspire to imparting knowledge?

Realism shows what is wrong with the aesthetic formalist's proposal that the communication of knowledge, social or otherwise, is not, cannot, or should not be part of the vocation of art, properly so called. The practice of realism refutes the common-denominator argument, the no-expertise argument, and the no-evidence argument. But realism not only challenges the letter of aesthetic formalism; it challenges the spirit as well. For, across the board, aesthetic formalism—both as an explicit doctrine and as a subconscious prejudice that governs the thinking of many philosophers (and, dare I say it, art critics)—is fundamentally an exclusionary proposition. It seeks philosophically to detach art from a whole welter of things—not only knowledge, but morals, politics, history, and so on. In doing so, philosophy makes art virtually irrelevant to the life of the culture. In this respect, realism calls the philosophy of art back to life and beckons it to concentrate on all those aspects of art it has neglected under the spell of aestheticism.

Furthermore, it may be the case that realism has something to teach the artworld as well. Aesthetic formalism, of course, is, among other things, a reflection of the purist strand of modernism that dominated the artworld for much of the twentieth century. But as modernism retreated to the galleries and the museums, realism thrived unabashedly in such popular formats as the novel and movies. While the artworld languishes hermetically, it might do well to heed the lesson of realism. People have a genuine need to get their bearings in

ever-changing times. They have a need for symbols to map their experience. Realist art, as I have argued, is one of the most effective means for doing so. Thus, to exile realism from the kingdom of art—as both modernism and its philosophical doppelgänger, aesthetic formalism, attempt to do—is virtually willful inattention.

23

Dance, Imitation, and Representation

Cowritten with Sally Banes

1. INTRODUCTION

The relation of dance—theatrical dance—to representation has undergone a seismic shift in the course of the modern period. In the eighteenth century, in the founding texts of the modern philosophy of dance in the West, notably those of John Weaver and Jean-Georges Noverre, dance, properly so-called, was identified with representation, narrowly construed as the imitation of action. By the twentieth century, however, this theoretical assumption came under attack, perhaps nowhere more fiercely than in the writings of André Levinson. Indeed, by the late twentieth century, the notion that there is any deep ontological affinity between dance and representation of any sort appears obviously outmoded. And yet representation, and even imitation, is still a feature of *some* dances, even if it is not regarded as a necessary condition of *all* dances. Thus, dance theory must still take account of the relation of dance to representation, even though it is no longer possible to suppose that representation is the essence of dance.

In this chapter, we want to take a look at the relation of dance to representation. The first part is diagnostic. In it, we will try to explain why early dance theorists attempted to identify the essence of dance with representation. In this respect, they were mistaken, but their mistakes were influential, so influential that much—perhaps most—of the dance canon traffics in representation. Even if most of the ambitious dance produced today is not primarily representational, much—perhaps most—theatrical dance, historically speaking, is. Consequently, it is still incumbent on dance theorists to provide a framework for discussing dance in relation to representation. Thus, in the second part of this chapter, we will develop a way of talking about dance and representation which, among other things, suggests a clue for contrasting representation in dance with representation in other artforms.

2. DANCE AS IMITATION

Western dance in the modern period is linked explicitly with representation in the early theoretical writings of both John Weaver and Jean-Georges Noverre.

According to both writer-choreographers, dance is essentially a representational art, where "representation" is primarily understood as imitation—the endeavor to refer to actions, events, and people by simulating their appearances. Both Weaver and Noverre attempt to annex the Aristotelian theory of mimesis as a theory of dance.

In this, Weaver and Noverre stand in contrast to Adam Smith, for whom anything is dance so long as it involves movement structurally composed of cadenced steps functionally aimed at displaying grace and agility. For Smith, dance, whether of the eighteenth century or not, could either be imitative or not imitative. Smith notes that dance is not necessarily or essentially mimetic, citing what he calls "common dances" (social dances) as exceptions to any presumption that dance is by its very nature imitative. Smith, of course, realizes that some dance is mimetic but, because he regards this as an optional feature of dance and not its quiddity, imitation does not appear in his philosophical description of dance, in which he claims that:

a certain measured, cadenced step, commonly called a dancing step, which keeps time with, and as it were beats the measure of, the Music which accompanies and directs it, is the essential characteristic which distinguishes a dance from every other sort of motion.

(Smith 1980: 207)

Given the sort of dancing available to eighteenth-century observers, Smith's characterization of dance seems eminently commonsensical. As a comprehensive, descriptive account of dance, it seems more accurate than theories of dance that aspire to assimilate dance solely to imitation.

Yet Weaver writes, "I shall endeavour to shew in what the Excellency of this *Art* [dance] does or ought to consist; the Beauty of *Imitation*," and "the chief Business then, and aim of these *Pantomimes*, was, (as I have said) the *Imitation* of Persons, or Manners and Passions" (Weaver 1712: 159, 140); while Noverre adds:

A well-composed ballet is a living picture of the passions, manners, ceremonies and customs of all nations of the globe . . . ; like the art of painting, it exacts a perfection the more difficult to acquire in that it is dependent on the faithful imitation of nature.

(Noverre 1966: 16)

Thus, unlike Smith, Weaver and Noverre appear to regard imitation as an integral, if not essential, feature of dance.

But surely, like Smith, they knew that a great deal of dancing was not concerned with imitation. So what could dispose them to place such great emphasis on imitation? Of course, the first difference between them and Smith seems to be that their domains of discourse are not the same. Presumably, Smith intends to be talking about all dance, including folk jigs and elite social dancing, whereas Weaver and Noverre are talking only about theatrical dancing and of what it "does or ought to consist." That is, Weaver and Noverre are dealing with dance for the stage, specifically autonomous dance compositions (rather than dance as part of drama or opera), and their theories pertain to what that kind of dancing is or should be.

Moreover, it is instructive that Weaver waffles between speaking of what such dance "does or ought to consist." Both Weaver and Noverre slip between advancing descriptive accounts of dance and normative accounts (accounts of what theatrical dancing should be). Clearly, both know that not all theatrical dancing is—speaking pre-theoretically—imitative. It is fair to say this, because both rail against the non-imitative tendencies of theatrical dancing of their own day, decrying what they see as an excessive emphasis on divertissements. Thus, from what we might call the statistical-descriptive, ordinary-language point of view of their own day, both Weaver and Noverre can agree that what is called dance—even with reference to the stage—is not definable in terms of imitation.

But both also regard such divergences from imitation as a failure to realize the *true* nature of dance (or theatrical dancing), since, by their lights, dance essentially *is* imitative. The non-imitative jumping and scampering that people call (theatrical) dancing is not accurately categorized, according to these theorists. Thus, Noverre asserts:

I am of the opinion, then, that the name of ballet has been wrongly applied to such sumptuous entertainments, such splendid festivals which combine magnificent scenery, wonderful machinery, rich and pompous costumes, charming poetry, music and declamation, seductive voices, brilliant artificial illumination, pleasing dances and *divertissements*, thrilling and perilous jumps, and feats of strength.

(Noverre 1966: 52)

Weaver and Noverre bolster their conviction that theatrical dancing is essentially imitative in a number of ways. Weaver, especially, talks at great length about ancient Roman pantomime, assuming that this is the genuine template from which dance has subsequently deviated. In this, he invokes the authority of past practice to identify the essence of dance and is perhaps convinced of its efficacy because of the great power to move audiences that classical authors attribute to it. Both Weaver and Noverre speak of *restoring* dance to its proper state, which essentially involves the imitation of action. Both have a sense of the correct nature of dance that prompts them to regard mere divertissements and graceful airs as categorically defective or not proper instances of the species, even if a simple statistical-descriptive use of language might count them as such.

A second reason why both Weaver and Noverre connect dance to imitation essentially is their reliance on Aristotle. Both cite Aristotle explicitly. Aristotle, of course, linked drama with the imitation of action ("drama" is intimately related to the Greek word for "doing"), and, inasmuch as theater is drama, one supposes that Weaver and Noverre thought it natural to infer that theatrical dancing is a subspecies of the imitation of action—since the representation of action is, according to Aristotle, the essence of drama (theater). And, as well, classical authors such as Plato and Aristotle counted dance as a part of theater. Moreover, since, on Aristotle's view, all the parts of theater are supposed to be subservient to the plot—to the representation of action—in an Aristotelian theory of the dance, such as Weaver and Noverre were advancing, it seemed evident that

dance, if it was to realize the *telos* of theater, would contribute to the imitation of action.

It is undoubtedly the authority of Aristotle that inclines Weaver and Noverre toward the conception of dance as imitation, a conception of dance that continues to dominate nineteenth-century ballet. But the question unavoidably arises as to why theorists like Weaver and Noverre would have invested Aristotle's theory of mimesis with so much credibility, especially in the face of so much counter-evidence—that is, so many divertissements of the sort that exercised their disapproval.

Here it is important to recall that, as eighteenth-century theorists, Weaver and Noverre were writing at a time when our Modern System of the Arts was only just being consolidated (see Kristeller 1980). That is, it is only in the eighteenth century that consensus on exactly what counts as the Fine Arts begins to emerge decisively.

Nowadays, this system is generally taken to comprise at least painting, sculpture, music, and poetry, with drama and film often added. That these practices go together seems natural to us. Together, they are what we mean by the "Fine Arts"; these are the *Arts* with a capital "A." For us, this group seems composed of practices sharing deep affinities. We may even think that there is no other way of grouping these practices. But, until the eighteenth century, there were different ways of sorting these practices. The Greeks, for example, sometimes grouped music with mathematics.

However, in the eighteenth century, the Fine Arts enlisted its core membership. According to Paul Oskar Kristeller, Abbé Charles Batteux wrote the first well-defined, systematic treatment of the Fine Arts. The title of Batteux's 1747 treatise was *Les Beaux-Arts réduits à un même principe* (*The Fine Arts Reduced to a Single Principle*). And that principle was none other than the Platonic-Aristotelian principle of mimesis. Batteux wrote:

We will define painting, sculpture, and dance as the imitation of beautiful nature conveyed through colors, through relief, and through attitudes. And music and poetry are the imitation of beautiful nature conveyed through sounds, or through measured discourse.

(Batteux 1989: 101)

For Batteux, membership in the system of the Fine Arts required that a practice meet certain necessary conditions; namely, that it be an imitative, or, more broadly, a representational practice. In this, Batteux articulated a presupposition widely upheld in the eighteenth century—that art is to be defined in terms of the Aristotelian notion of mimesis.

Weaver and Noverre obviously share in this emerging consensus about the Fine Arts. One way of reading their commitment to Aristotle is to reason that, insofar as they believed that dance is a fine art, then dance as art must meet the conditions necessary for anything to count as a fine art. On this view, mere virtuoso divertissements were not dance—dance art—properly so called, despite how people might talk pre-theoretically.

Another way of interpreting the polemics of Weaver and Noverre is to remember that they were reformers. Part of their self-appointed mission was to get dance taken seriously. In the context of the eighteenth century, an obvious way in which to get dance taken seriously was to promote its recognition as a fine art, which, in turn, required the assertion that its identity was essentially a matter of imitation. Poetry and painting were accepted as legitimate instances of fine art in virtue of their imitative powers. Drama was accorded the status of fine art, again because of its capacity to imitate action. Similarly, Noverre agitated for the *ballet d'action*, we hypothesize, because this was conceptually the most clearcut way for theatrical dance to acquire the coveted cultural status of art.

This is not to suggest that Weaver and Noverre endorsed the position that dance is imitation simply for opportunistic reasons—that, for example, they would have been equally hospitable to any other slogan that might have lent theater dance cultural prestige. They believed that dance is a matter of imitation in their hearts as well as their minds. But their minds were deeply shaped by eighteenth-century presumptions about the relation of art and imitation.

Weaver and especially Noverre are interested in analogies between poetry and painting—the arts of imitation discussed at greatest length by Plato and Aristotle. Moreover, since poetry for Plato and Aristotle is primarily dramatic poetry, Weaver and Noverre often draw analogies with drama. Noverre calls for dance to look to the work of dramatists such as Racine, Corneille, Voltaire, and Crébillon for inspiration. In this, we conjecture, Noverre is asserting not only that theater dance resembles drama in its essential nature, but that drama provides a model for dance—a direction that dance can follow in order to recover its genuine nature, too long forgotten in the flurry of "meaningless" divertissements and graceful airs. The point of emphasizing the relation of dance to drama was, in other words, not only as a way of enfranchising dance as art, but also as a way of implementing a dynamic new style in dance, a style that for being more like drama would return dance to its original essence and power.

Drama is especially important for Noverre as a model because of its emphasis on plot, which, of course, for Aristotle was the representational core of theater. Through plot, Noverre saw a way to unify dance spectacles. But, at the same time, Noverre did not wish to blur the distinction between dance and drama altogether. He criticizes the intrusion of words in dance, regarding wordlessness as the quintessence of dance. He complains about dances that use long recitatives and banners with words on them as antithetical to the dance. Though dance shares certain features with drama, according to Noverre, words are not something dance should take from drama.

What dance shares with drama—the common resource that it should exploit—is plot or story. Words should be avoided. But how can words be avoided, if dances are to tell stories, to represent actions? Here, Noverre recommends that choreographers tell well-known stories, with plots familiar enough to spectators that they can recognize and follow their enactments without the accompaniment of speech. In this way, Noverre was convinced that ballets imitating unified actions could have the power and impact of tragedy (though

to what extent this is likely is an issue to which we will return at the end of this chapter).

The writings of Weaver and Noverre in their theoretical assertion of the view of dance-as-representation (imitation) sounds ambiguous to us. We wonder, even if we restrict our attention to theater dance, whether they mean that dance is representational or whether they mean it should be. Given the data available to them, it seems hard for us to see how they could have thought that, just speaking statistically, dance is essentially representational. So they must have meant that dance *should* be representational.

However, granting them the Aristotelian framework in which they were operating, it is likely that they probably did not draw the distinction between whether dance is or should be representational in the same way that we draw it. For them, the *telos* of dance is imitation, and this sort of essence is normative. Apparent counterexamples to the theory, no matter how numerous statistically, are not genuine instances of dance, no matter how people talk, since the nature of dance is imitation. And this conception of dance, partially as a result of the reforms and influence of people like Noverre and Weaver, could have even mustered impressive empirical support in the nineteenth century. For, after all, the typical Romantic Ballet was primarily a *ballet d'action*.[1]

But, by the end of the twentieth century, the suggestion that dance is a representational art clearly commands no support. The reason for this is not simply that by now the number of counterexamples is overwhelming, but also because the underlying representational theory of art, derived from Aristotle and assumed by Batteux, Weaver, and Noverre, has been shown false for art in general and for every artform, including dance, in particular. Counterexamples cannot be waved aside by appealing to some representational essence. Dances like Merce Cunningham's *Events* can be enfranchised by theories of art demonstrably more powerful than the view that art is essentially representational.

For us, the suggestion that dance *is* representational can only be regarded as a covert way of saying that dance *should* or *ought* to be representational, where *should* and *ought* here cannot be glossed in the Aristotelian idiom of essential norms, but must be understood as expressing an evaluative preference. When Weaver and Noverre maintained that dance should be representational, we may now reinterpret them as saying that they wanted, perhaps for good reason, dance to become representational. They wanted it to become representational because they wanted it to be art. But since we now realize that representation is not a necessary condition for art, their theory of dance is no longer compelling to us.

However, this does not mean that the relation of dance and representation is no longer of interest for dance theory. For, even though the theory that *all* dance is representational needs to be discarded, much dance has been representational and some even continues to be. Thus, dance representation is a topic that still requires philosophical attention. And it is to this issue that we now turn.

[1] For a broader overview of the relation of dance and imitation, see Cohen (1983).

3. DANCE AND REPRESENTATION

Though the contemporary dance theorist readily concedes that the identification of dance with representation is inadequate, that theorist must nevertheless say something about how representation operates in dance and, if possible, what is characteristic of it, at least in dance as we know it. For, as already noted, much modern theater dance is representational. Before the twentieth century, there are no ballets without stories (and, therefore, representation), while throughout the twentieth century not only does much ballet continue to tell stories, but so does a great deal of modern dance and even some postmodern dance. How dance represents is therefore a nagging theoretical question, as is the question of whether there is something characteristic of dance representation in contrast to representation in the other arts.

In order to facilitate a discussion of dance and its representational powers, it is useful to begin by looking at a continuum of different ways in which artforms represent. By "represent" here we mean that x represents y (where y ranges over a domain comprised of objects, persons, events, and actions) if and only if:

1. A sender intends x (for instance, a picture) to stand for y (for example, a person); and
2. An audience recognizes that x is intended to stand for y.

This definition is broader than the standard notion of imitation, for reasons that will become evident as we proceed, though imitation, as that notion standardly figures in discussions of art, clearly falls under this concept of representation. Moreover, as the admission that imitation is but one subcategory of representation entails, there are more kinds of representation than one.

Four types of representation are especially useful for our purposes.[2] They sit as on a continuum of representational practices in terms of the different, though sometimes overlapping ways that audiences can come to comprehend or recognize that x stands for y. These four points on the continuum include:

3.1. Unconditional Representation

This is the sort of representation that obtains by triggering the audience's innate recognitional capacities—the capacities that enable viewers to recognize that the referent of the *Mona Lisa* is a woman simply by looking at the picture. In cases of unconditional representation, we can recognize that x stands for y on the basis of the same recognitional powers that enable us to recognize ys in, so to speak,

[2] This taxonomy has been drawn in terms of different ways that viewers come to realize what x represents. We do not deny that different taxonomies could be constructed. Nor do we deny that more distinctions could be made with respect to the viewer's comprehension of representations than the ones we emphasize. We merely maintain that the distinctions we mark are useful and based in the facts. We also understand that some of our categories tend to blend into others. That is why we speak above of a continuum of categories.

nature. If we can recognize women in the real world simply by looking, then we can recognize that the *Mona Lisa* pictures a woman by means of the same perceptual processes we use to recognize women.

This dimension of representation is closely associated with the notion of imitation—understood as the simulation of appearances. When an actor on stage or screen represents eating by imitating eating—by lifting a fork to her mouth and simulating chewing—the audience recognizes her actions as a portrayal of eating without recourse to any specialized codes. Often, the mechanism subtending such examples of direct recognition has been discussed in terms of similarity, though, more recently, the idea of natural generativity has gained popularity (see Schier 1986). Whether similarity or natural generativity affords the superior explanation of the phenomenon is a question we may leave to psychologists to resolve. Our only point is that much representation—for example, in mass-market movies and TV—proceeds by triggering innate recognitional capacities and, in that sense, is immediate (that is, not mediated by the manipulation of an arbitrary or conventional code).

3.2. Lexical Representation

If some representation is unmediated by arbitrarily established codes, other forms of representation are coded or lexicographic. In these cases, in order to realize that x stands for y, a spectator must know the relevant code. In dance, certain gestures and movements are correlated to certain meanings in a dictionary-like fashion. An averted glance and a forfending backhand raised to the face stands for contempt in certain balletic practices. One cannot realize this by looking; one must also know the relevant lexicon. Of course, the boundary between unconditional representation and lexical representation often yields mixed cases, since what we sometimes recognize in an unmediated way is a socially (rather than an artistically) coded signal (for example, we unconditionally recognize the fire truck in part because it is red, but its being red is the result of an antecedent social code).

3.3. Conditional Specific Representation

Sometimes we recognize what is being represented only on condition that we already know what is being represented. One is unlikely to realize that poison is being put in the king's ear in the play within the play in *Hamlet*, unless one already knows that this is what the play within the play is supposed to represent. Once we know that this is what is intended to be represented by the playlet, we easily pick up what the otherwise obscure gestures stand for. But most of us, in all probability, would be at sea without such antecedent knowledge.

This is not a case of unconditional representation, since we wouldn't have a clue as to what is going on without being told. Being told, here, is, in other words, a condition for understanding the representation. However, once told (that is, once the condition is met), we can use our native recognitional powers to decipher the otherwise elusive gestures.

Nor is this a case of lexical representation, since there is no pre-established code for ear poisonings in drama. The actor proceeds by imitation, not by strictly coded signaling. Lexicographical or semiotic representation is, of course, conditional, insofar as it depends upon the existence of a code, but not all conditional specific representation need be lexical, since in many cases it can operate by engaging natural recognitional capacities once those have been cued in terms of what to expect. Deciphering a case of conditional specific representation can involve a complex interplay of cognitive abilities, requiring natural recognitional capacities working in concert with fragments of lexicographical knowledge (along with homologies and linguistic associations, including our sensitivity to synesthetic or cross-modal effects). However, this category still marks an important difference, since, in order to mobilize these capacities and structures, we need the clue that something is being represented. Indeed, these category (3) representations require that we know that something specific—for example, an ear poisoning—is being represented. In that, it contrasts with our next category.

3.4. Conditional Generic Representation

Here, the spectator is able to detect or to recognize that x stands for y on condition that she knows that something is being represented. For example, unless you know that I am trying to represent something, you might not take my rolling arm movements to stand for waves. But if you know that I intend to represent something, even if you do not know antecedently what I want to represent, you would be likely to see my arm movements as waves right off the bat. It would be one of your first hypotheses. Likewise, if we know that a piece of music is a tone poem, then we are likely to interpret certain "rushing" or "flowing" phrases as water. Simply knowing that an artistic signal is meant to be representational, even if we are not told exactly what it represents, leads us to mobilize our natural recognitional capacities, our linguistic associations, our capacities for following homologies, our sensitivity to synesthetic effects, and our knowledge of strict semiotic codes to determine appropriately what the representation is a representation of, without being told its specific, intended meaning.

The contrast between conditional specific representation and conditional generic representation can be illuminated instructively by contemplating the game of charades. Imagine two teams—A and B. Team A gives a player on Team B a saying which she must elicit from the other members of her team by means of gestural prompting. Suppose, as well, that she tries to do this by acting out the whole saying. Since the members of Team A know the saying—since they know what her gestures are intended to represent—they relate to her performance as an instance of conditional specific representation. They are able to follow and to appreciate her gesticulations, because they know exactly what she is trying to signal. Her fellow team members, however, know only that she intends to signal something. They do not know exactly what it is. They try to infer what it is, using a variety of cognitive skills that they put into gear simply because they

know that she is playing charades. If they were not playing charades, they might not think that she was trying to signal anything at all. But knowing that she is playing charades, knowing that she intends to represent something, they try to determine what. And they are quite often successful at this.

For Team B, their teammate's gestures are regarded as conditional generic representations at the same time that for observers from Team A, they are conditional specific representations. That is, members of Team B disambiguate her gesturing on condition that it presumes that something is represented, though they know not what beforehand. For members of Team B, the charade is a matter of conditional generic representation and, alerted to this, they use this understanding as a framework for disambiguating the array, exploiting all kinds of clues to infer what is being represented. Team A, on the other hand, knows what is being represented ahead of time. For them, following the charade is a matter of matching gestures with the saying they are designed to recall. They know the solution to the problem that the player from Team B is trying to crack, and they use that knowledge to appreciate player B's ingenuity.

Clearly, the players on Team A and the players on Team B are engaged in different cognitive tasks, which we can characterize as responding to conditional specific representations, on the one hand, and responding to conditional generic representations, on the other hand. Moreover, this is not simply a matter of charades, since artworks can employ either sort of representation as well—*Pacific 231* and *Symphonie Fantastique* are examples of conditional specific representation, while the thunder in Beethoven's *Pastoral* is more of the nature of conditional generic representation (one wouldn't hear it as thunder unless one knew the piece was illustrative).

The resources available to us for identifying such representations in the case of conditional generic representation, like those of conditional specific representation, are varied. They may involve recognitional analogies, fragments of lexical knowledge, synesthetic effects, homologies and the existence of certain common descriptions for musical or movement motifs and certain objects (for instance, "flowing music," "flowing movements," and "flowing water"). However, there is still a difference between these forms of representation since, with conditional specific representation, you know antecedently exactly what is being represented whereas, with conditional generic representation, you only know antecedently that something is being represented. Both forms of representation may involve the deployment of natural recognitional capacities as well as fragments of lexicographic knowledge. But, in order to access such information, you need to be alerted to the fact that either something or something specific is being represented.[3]

Clearly, each of these types of representation is found in dance. Examples of unconditional representation would include: fighting scenes in Beijing Opera where the simulation of fighting stands for fighting, or peasant dances in *Giselle*

[3] For similar ways of drawing these and related distinctions, see Sparshott (1995), p. 71, and Kivy (1984), pp. 28–60.

that stand for harvest celebrations, or regal entrances in *Raymonda* that stand for royal promenades, or the enactment of children's play in Donald McKayle's *Games*. We see an example of this type of representation in *Coppélia* when Swanilda impersonates the automaton by moving in a jerky, abrupt, mechanical way. She is imitating a puppet, and we can recognize this by looking, just as we recognize that she is running away from Coppélius without referring to a code. This most elementary and direct form of representation can range from reproducing the simple act of ordinary walking in order to depict walking, to creating a stylized, rhythmic, but nevertheless still recognizable rendition of an action.

For instance, in "Taxi," the final number of the musical *Bring in 'da Noise, Bring in 'da Funk*, a number of African-American men from different class backgrounds and walks of life try unsuccessfully to hail a taxi. The dancers enact first a street kid, then a college student, then a well-dressed professional man, and, finally, Colin Powell making the familiar pointing gesture with an outstretched arm, and, in frustration mounting to anger, watching the cab drive by. They do this rhythmically, to music, gradually adding in more and more tap footwork. We understand instantly what this narrative means. We see four men in a row fail to get a taxi to stop. This is the literal content of the representation, although thematically we also understand the political implication that no matter how famous or successful a black man becomes, he is still invisible and considered dangerous in American culture. Nevertheless, at the literal level, this is an example of unconditional representation inasmuch as we recognize the relevant simulated activity by looking, although it is not altogether an unmixed case, since the simulated activity involves imitating a social (rather than a dance) gestural code for hailing a cab.

In terms of our second category, there are many different gestural codes in dance—from the mudras of Indian dance to the Delsarte system of bodily movements popularized by Ted Shawn and others. And, in the 1980s, a number of postmodern choreographers began using American Sign Language as a gestural code in their dances, often speaking and signing simultaneously. Such systems exemplify the use of lexical representation in dance, as does the circular hand movement around the face that symbolizes "beautiful woman" in nineteenth-century ballet.

By the late nineteenth century, European ballet choreographers had elaborated a conventional code of pantomime gesture, which educated audience members learned to decode. Derived from the traditions of the Italian *commedia dell'arte*, ballet pantomime emerged as early as the beginning of the eighteenth century, when ballet separated from opera and thus newly required non-verbal means to advance the dramatic narrative. John Weaver, for instance, describes his innovative experiments with restoring ancient pantomime gesture to convey specific emotions in *The Loves of Mars and Venus* (1717):

Admiration is discover'd by the raising up of the right Hand, the Palm tuned upwards, the Fingers clos'd; and in one Motion the Wrist turn'd round and Fingers spread; the

Body reclining, and Eyes fix'd on the Object . . . The left Hand struck suddenly with the right; and sometimes against the Breast; denotes *Anger*.

<div align="right">(quoted in Winter 1974: 58–9)</div>

Cyril Beaumont explains the use of ballet pantomime, as it had crystallized in the late nineteenth-century Russian Imperial ballet, in several passages in the Petipa-Ivanov ballet *Swan Lake*, for instance:

The Princess-Mother shows her disapproval of Siegfried's boon companions. To convey this, she mimes: I pray you—these companions—have not. That is, she places both finger-tips to her breast, clasps her hands in entreaty, points to Siegfried, extends her arms towards his companions, then, turning her hands palms downwards, crosses and uncrosses them in a horizontal plane. All negative actions are achieved by first presenting the required phrase of mime in positive form, then negativing it by the crossing and uncrossing of the extended hands.

<div align="right">(Beaumont 1982: 78–9)</div>

In another passage, Beaumont explains:

Odette declares that she is doomed to die. To convey this, she mimes: I—here—must die. That is, she places both finger-tips to her breast, points to the ground, then raises her arms above her head, clenching the fists, crosses her wrists, lowers her arms straight in front of her, then, just as the arms fall vertically downwards, she unclenches her hands and sharply separates them. Death is conveyed by a gesture of strength which is suddenly snapped in two.

<div align="right">(Ibid.)</div>

Conditional specific representation is indispensable to much dance, for without titles, program notes, and other descriptive texts a great deal of dance movement would be utterly indecipherable. Indeed, this is the most important category of dance representation. To know which fairy gifts the dancing represents in the Prologue of Petipa's *Sleeping Beauty*, one must know the specific details of the ballet's libretto, while in order to realize that the eponymous Radha turns back into a stone statue rather than simply entering a state of repose at the end of her dance of delirium requires an acquaintance with Ruth St Denis's program notes. Likewise, in Graham's *Night Journey*, one must know that the dance retells the story of Oedipus (as well as knowing that myth) in order to grasp that the man on the "pogo stick" is Tiresias.

In Noverre's *Orphée et Euridice*, and equally in George Balanchine's *Orpheus*, background knowledge of the Greek hero's tragic adventure in the underworld is essential, just as in Balanchine's *Apollo* we need to know that he is the god of the arts, that the women he dances with are the Muses, and, indeed, which of the Muses they are. When a Yoruba dancer in Nigeria or Dahomey dances the image of the spirit Egungun with swirling red cloths that appear to carry humans away like a whirlwind, the dance will be meaningless to spectators who are unfamiliar with Yoruba cosmology (see Thompson 1974). In fact, whenever one encounters mythological or historical backstories in dance, whether in the

Western ballet tradition, the many dance dramas in both East and West based on the Hindu epics *The Mahabharata* and *The Rantayana*, African ritual dances, or other dance cultures, one is likely to find conditional specific representation.

This is equally the case for the many dances, in various cultures, based on plays, poems, and other works of literature. For instance, José Limón's *Moor's Pavane* is a distillation of Shakespeare's *Othello*. Using the choreographic form of a Renaissance court dance for two couples—the key characters Othello, Desdemona, Iago, and Emilia—the dance itself almost seems to create with its intricate floor patterns a tangled web of psychological conflict. That the dance represents the fanning of Othello's murderous jealousy and its vicissitudes is a meaning irretrievable for the uninformed spectator. To anyone unfamiliar with Shakespeare's play, the meaning of the choreography along with the significance of the lace handkerchief the dancers drop or pass from one to another (as well as the sequence of its passing), of one male dancer's whispering constantly into another's ear, or of the angry or anguished glances the dancers cast, will be lost.

An example of conditional generic representation may be found in Kei Takei's *Light*. Realizing the overall representational intentions of the piece warrants our interpretation of much of the imagery as cosmic. In Part 10, "The Stone Field," Takei holds the center of the stage, jumping and turning as rocks are flung at her feet in a way that prompts us to regard her as a goddess amidst a meteor shower. In Simone Forti's *Planet*, the title alerts us that representation is afoot. Thus, we are predisposed to see the dancers moving from crawling on all fours to walking to running as a representation of the process of evolution. But whereas, in the example of the Egungun dancer, one has to know the specific attributes of the spirit to recognize the object of the representation, in *Planet* the title suffices to signal representational intent, without telling us what specific attribute of our planet is being represented. That remains for the spectator to conjecture.

Admittedly, the boundary between conditional specific representation and conditional generic representation can become quite slim. Near the border sits, for instance, Balanchine's *Jewels*, where without the titles we might not see the choreography in terms of the representation of gemlike features.

If, as this brief inventory indicates, dance representation can fall into any of these categories, one may wonder whether the taxonomy can tell us anything particularly informative about dance representation. The taxonomy, it might be said, would be informative, if it turned out that dance representation fell into only one of these categories. But how informative is it if dance can exemplify all of the categories? Indeed, the problem may seem even worse, since it is not only the case that dance can exemplify all of these categories, but so can all the other arts, including theater, film, video, sculpture, painting, photography, literature, and even music. So can we learn anything distinctive about choreographic representation by being shown that dance can fall into all the same categories that all the other arts do?

We think that there is a way to use the taxonomy informatively. It is true that dance representation can fall into all of our four categories and it is also true

that representation in other artforms can instantiate each of these categories as well. And yet it does seem that dance does rely on some of these categories more than the other arts do—or at least more than the neighboring arts of dramatic enactment (such as realist theater, movies, and TV).

What we have in mind is this. Contrasting dance with theater, film, and TV, dance seems to rely more on categories (3) and (4), above, than do theater, film, and TV. This is not to say that dance does not employ categories (1) and (2); perhaps dance even employs these categories as much as or more than it does categories (3) and (4). Nevertheless, theatrical dance as we know it does employ forms of conditional representation more than the dominant forms of theater, film, and TV do in Western culture. Indeed, these artforms rely more exclusively on category (1) than on the other categories of representation on our list. Call this difference in choice of representational strategies a *proportionate difference* in representational means between dance and its dramatic neighbors.

This is not to deny that theater, film, and TV as typically practiced may use category (2). And in certain avant-garde instantiations—like Brakhage's *Antici-pation of the Night*—they may even deploy forms of conditional representation. Nevertheless, in the main (the mainstream), theater, film, and TV use categories (3) and (4) to a lesser extent than they use category (1); whereas, while dance uses category (1), it also relies very heavily on using category (2) and, especially, categories (3) and (4) for purposes of representation. This should be clear from the degree to which even mainstream dance representations depend on accompanying descriptive texts—such as program notes and titles—for intelligibility, whereas mainstream theater, film, and TV are generally accessible without such enabling texts.

Thus, there is a proportionate difference in the choice of representational means between dance, on the one hand, and theater, film, and TV, on the other. Dance relies more on conditional representation than they do. But what of music? Doesn't it also rely heavily on conditional representation? Is there no difference between music and dance with respect to representational means? Certainly, there is: dance uses unconditional representation more than music does. So where dance differs from theater, film, and TV by its emphasis on forms of conditional representation, it differs from music in its far more frequent use of unconditional representation. Moreover, it differs from the remaining temporal art—literature—insofar as literature operates primarily via lexicographic representation, relying on that category of representation far more than dance does; or, for that matter, than theater, film, TV, and music do.[4]

By marking off four types of representation in terms of the way in which viewers come to comprehend them, then, we can say something about the characteristic, though not the unique, use of representation in dance. We are not speaking about what is unique about dance representation because, as we've

[4] We are uncertain about the gross proportionate differentials between dance and the non-temporal arts of painting and sculpture, though of course the representations in the latter arts differ from those in dance in that they are static.

seen, dance employs the same types of representation that other artforms do. However, dance characteristically relies on these different types of representation with different emphases from those of the other arts. It mobilizes unconditional representation more than music does, lexicographic representation less than literature, and it depends more on both types of conditional representation far more than theater, film, and TV do.

Our taxonomy of types of representation can say something informative about dance representation, especially in relation to its neighboring dramatic arts: dance representation is far more frequently a matter of conditional representation—especially conditional specific representation—than are typical theatrical, film, and TV presentations. That is, there is a proportionate difference in representational means between dance and its near neighbors—the other temporal arts and the other theatrical arts.

The differences between dance and the other theater arts is particularly telling because it may help explain why dance often requires the acquisition and application of background knowledge in order to be comprehended, whereas the other forms of contemporary dramatic enactment ride more exclusively on the audience's natural recognitional powers. Theater, film, and TV are more accessible than dance to the degree that they rely more exclusively on unconditional representation.

Moreover, if the preceding analysis is correct, it may have some interesting ontological implications concerning dance representation: namely, that insofar as certain descriptive texts (such as program notes)—or, at least, their propositional contents—are indispensable for parsing certain dance representations, such descriptive texts should be regarded as part of the dancework proper, and not merely as accompanying paraphernalia. That is, in the relevant cases, not only the choreography but the underlying story, no matter how generic, is an ineliminable part of the dance representation.

Earlier, we noted that it was Noverre's ambition to get the words out of dance. He aspired to make ballets with the power of Racinean tragedies, but through movement. Yet it has never been clear that movement alone can secure such sustained effects. The movement needs to be contextualized; it needs a backstory.[5]

In this section, we have examined four categories of representation in terms of how viewers comprehend instances of them. These categories can be implemented

[5] In his 1803 preface to *Letters on Dancing and Ballets* (first written in 1760), Noverre writes, "There are, undoubtedly, a great many things which pantomime[-ballet] can only indicate, but in regard to the passions there is a degree of expression to which words cannot attain or rather there are passions for which no words exist. Then dancing allied with action triumphs" (Noverre 1966), p. 5. Despite his belief in the emotive power of wordless dancing and his railing in *Letters* against any "complicated and long-drawn-out ballet . . . the plot of which I cannot follow without constant reference to the programme" (Noverre 1966), p. 19, in the preface to his ballet *Euthyme et Eucharis* (1775), he nevertheless acknowledges the need for program notes as well as a backstory: "I shall admit that the Programme tells the historical or mythological story and states clearly what the Dance can only vaguely hint, because our Dancers are not Greeks and Romans" (quoted in Winter (1974), p. 121).

by all the arts, including dance. But different artforms rely differently on alternative representational categories. Dance places greater emphasis on forms of conditional representation than arts like theater, film, and TV, which, in turn, rely more heavily on unconditional representation. This suggests not only a contrast between dance representation and representation in the other arts, but also explains why, in general, theater, film, and TV often appear more conducive for popular consumption than dance. In addition, we have argued that the backstory and other referents in dances employing conditional specific representation are proper parts of the dance ontologically, and that the heavy use of conditionally specific representation in dance is connected to the challenge of trying to make dance dramatically powerful at the same time it is wordless.

REFERENCES AND FURTHER READING

Batteux, C. 1989. *Les Beaux-Arts reduits à un même principe*. Ed. Jean-Remy Mantion. Paris: Aux Amateurs de Livres.

Beaumont, C. W. 1982. *The Ballet Called Swan Lake*. New York: Dance Horizons; reprint of 1952 edition.

Cohen, S. J. 1983. "Dance as an Art of Imitation," in R. Copeland and M. Cohen, eds, *What is Dance?* Oxford: Oxford University Press, pp. 15–22.

Kivy, P. 1984. *Sound and Semblance*. Princeton, NJ: Princeton University Press.

Kristeller, P. O. 1980. *Renaissance Thought and the Arts*. Princeton, NJ: Princeton University Press.

Levinson, A. 1925. "The Spirit of the Classic Dance." *Theatre Arts Monthly* 9 (March): 165–77.

Noverre, J.-G. 1966. *Letters on Dancing and Ballets*, transl. C. W. Beaumont. New York: Dance Horizons; reprint of 1930 edition.

Schier, F. 1986. *Deeper into Pictures: An Essay on Pictorial Representation*. Cambridge: Cambridge University Press.

Smith, A. 1980. *Essays on Philosophical Subjects*. Oxford: Oxford University Press.

Sparshott, F. 1995. *A Measured Pace*. Toronto: University of Toronto Press.

Thompson, R. 1974. *African Art in Motion: Icon and Act*. Berkeley, CA: University of California Press.

Weaver, J. 1712. *An Essay towards an History of Dancing*. London: J. Tonson; reprinted in facsimile, in Richard Ralph, *The Life and Works of John Weaver*. London: Dance Books (1985).

Winter, M. H. (1974) *The Pre-Romantic Ballet*. London: Pitman.

24

Feeling Movement: Music and Dance

Cowritten with Margaret Moore

1. INTRODUCTION

The actual and possible relationships between music and dance are multifarious. It is not the purpose of this chapter to attempt to chart their various permutations, nor to offer a general theory of them. Our aim is more modest. We shall try to provide a philosophical framework, amplified by speculation grounded on recent work in cognitive psychology, for characterizing the relation of one kind of dance to one kind of music.

The kind of music that we have in mind is the sort that inspires feelings of movement in listeners, as is the case with the music that propels most social dancing, such as the jitterbug. It is the kind of music of which Victor Zuckerkandl observes: "Hearing tones, I move with them; I experience their motion as my motion."[1] It is not our contention that all music is like this, but only that some is. Though we will have more to say on this matter, we trust that our hypothesis has some *prima facie* plausibility. Perhaps those of you who have ever felt the urge to air-conduct or have found yourselves tapping your toe to a snappy tune can provisionally confirm our claim on the basis of your own experience. Of course, we do not pretend to have discovered this phenomenon. Rather, it is only our intention to place it within a useful philosophical framework in terms of its relationship to one sort of dance (though a sort with many different stylistic variations).

The question of what is meant by saying music itself moves is vexed. We grant that this usage may be metaphorical, and wish instead only to call attention to the various ways in which music is said to move, and to show how the motions in dance can relate to these.[2] Moreover, music does not simply "move" as a result of its having a pulse that we can recreate for ourselves physically, but it also moves through configuring patterns of tension and relaxation, impressions of rushing

[1] Quoted in Francis Sparshott, *A Measured Pace: Toward a Philosophical Understanding of the Arts of Dance* (Toronto: University of Toronto Press, 1995), p. 497.

[2] The question of whether the notion that music moves is metaphorical is beside the point for our purposes, however, for we are ultimately concerned with how people feel, and a metaphor may characterize that aptly.

forwards and pulling back, of advancing inch by inch or vaulting great distances, of expanding outwards and contracting, as well as many other larger-scale patterns that are not merely a succession of pulses. Thus, an explanation of movement prompted by music requires more than the mere acknowledgment that we can keep time with the beat.

The kind of dance we have in mind is the sort that essentially involves a performative interpretation of, and/or expansion upon, the music that accompanies it, such as the music visualizations of Denishawn and the more complex endeavors of George Balanchine. We do not claim that all dance aspires to this end. Some dance, such as some postmodern dance, eschews music altogether, while the generally aleatoric relationship of Merce Cunningham's choreography to the music is one of indifference. It is perhaps more apt to say that, with respect to Cunningham's work, the dance co-occurs or is merely simultaneous with the music, rather than that the music accompanies the dance.

Nevertheless, much dance has an intimate relationship with the music, as one might expect, since, in all likelihood, dance and music emerged in human history in tandem and, to a great extent, have remained that way since the beginning. In the twentieth century, from Isadora Duncan to Mark Morris, a great deal of dancing—indeed, probably most of it—has been coordinated with the music, rather than being detached from it. Furthermore, much of this dance has been dedicated to either performatively interpreting that music—that is, calling attention to aspects of its qualities and structures—or expanding upon it, by either reinforcing or completing structural or qualitative, including emotively qualitative, tendencies in the music, or by creating an altogether new accent by means of counterpoint and contrast.

The philosophical framework that we would like to mobilize to characterize the relationship between this sort of dance and this sort of music is, roughly speaking, a modification of the expression theory of art, especially as that view was propounded by R. G. Collingwood.[3] That theory identifies the defining function of art to be the clarification of emotion. However, we believe that specifying the role of art in terms of *emotion* is too narrow. We wish to broaden the approach to encompass the clarification of affect in general—including affects that are not emotions properly so called, such as moods, reflexes, and somatic feelings. That is, whereas emotions are often construed to involve essentially a cognitive component, there are realms of affect—feeling states—that are not mediated by thoughts. Bodily or kinesthetic sensations—such as movement impulses—are like this.

We have already asserted that some music inspires feelings of movement in audiences. In addition, we hope to establish that some dance does so as well, often by activating certain mirror reflexes in viewers—that is to say, certain muscular,

[3] R. G. Collingwood, *Principles of Art* (Oxford: Clarendon Press, 1938). For a thorough overview of the relation of art and expression, see Francis Sparshott, *The Theory of the Arts* (Princeton, NJ: Princeton University Press, 1982), pp. 303–70. Throughout, we have benefited from and adapted Sparshott's language in setting forth various aspects of central ideas of the expression approach.

motor impulses that correlate to the movements observed in the relevant dance.[4] In this way, the movement in the dance clarifies, enlarges, or expands upon the feelings of movement already available in the pertinent sort of music. That is, the aforesaid process of clarification is abetted in part by the mobilization of proprioceptive feedback in the bodies of spectators, due to our tendency to respond to the movements of others with mirror reflexes, thereby priming feelings in our own motor system. In this way, the dance enables the spectator to sharpen, deepen, or otherwise develop the intimation of movement she intuits in the accompanying music. This is fundamental to the aesthetic experience of this sort of choreography, which involves attentiveness to the movement-impulse

[4] In order to advance this case, we shall advert to certain recent findings in psychology. However, as aestheticians who rely on psychology in this way, we need to defend our methodology against some well-known objections of George Dickie's.

In 1962, in *The Philosophical Review*, George Dickie published an article entitled "Is Psychology Relevant to Aesthetics?" His answer was "no." His argument was based on examining three types of psychological research that some might claim were pertinent to aesthetics and then showing that none of them are. The three types of research were: (1) experiments designed to show convergence among subjects in their attribution of meaning—that is, of expressive properties; (2) experiments designed to establish preferences orders among objects of aesthetic interest; and (3) psychological characterizations of aesthetic experience. Dickie concluded that none of this research could contribute to the solution of any of the problems of philosophical aesthetics.

According to Dickie, polling people about expressive properties they attribute to a piece of music does not address the philosophical problem of whether it is possible for music to possess expressive properties. Likewise, people's preferences are irrelevant to establishing normative standards. And, finally, psychology has little to offer by way of an account of aesthetic experiences, because that is not a scientific question, but a matter of conceptual analysis.

Obviously, a lot has changed in both psychology and philosophy since Dickie wrote that article, and some of it would seem to render Dickie's dismissal of the relevance of psychology obsolete. Much of the psychology that aestheticians rely upon today does not involve introspection and self-reports, but fMRIs. Similarly, views of the nature of philosophy have also expanded, especially in the area of the philosophy of mind. Post-Quine, the boundary between the conceptual and the empirical is more porous as philosophers avail themselves of the findings of, for example, evolutionary psychology.

However, we wonder whether Dickie was even justified in his rejection of psychology when he wrote the article, especially with reference to the description of aesthetic experience. For, even in 1962, any theory of aesthetic experience would have had to be constrained by what is psychologically possible (not to mention *actual*).

Of course, the kind of account of aesthetic experience Dickie is after may also be a creature of the past. Dickie appears to think that a theory of aesthetic experience will be uniform across the arts—an account that covers literature as well as architecture and music, that is, both concrete artifacts and abstract artifacts in very different media, addressing often very different sense modalities and cognitive faculties. But can such a characterization be anything but insufferably vague and threadbare?

Instead, a more informative approach might be to consider the ingredients that go into the experience of understanding specific artforms. And this is what we intend to attempt in this chapter. We will examine one kind of music—music that engenders the impulse to move in listeners—in relation to one kind of dance, which we regard as a performative interpretation of the music, for illuminating how this kind of artistic symbiosis can affect the audience's experience of it. To that end, contra Dickie, we will exploit the resources of recent psychological research in order to substantiate our claim that the experience, which we suggests results from the combination of the relevant sort of music with the relevant sort of dance, is possible. Of course, Dickie may charge us with aesthetic revisionism here. Yet we believe that our approach is in keeping with Baumgarten's original definition of aesthetics as "the science of how things come to be cognized by means of the senses."

qualities in the dance-cum-music,[5] and it is the truth behind the notion of kinesthetic communication, an idea often dismissed as hopelessly confused and "mystical."

In advancing this hypothesis, we are not endorsing the expression theory of art as a general theory of art.[6] Rather, we are simply adapting parts of it to construct a model of the aesthetic experience of certain kinds of concert dance. This is a model that isolates and accounts for one of the ways in which spectators relate to dance—they use dance, in many cases, as an entrée into the music, notably as a means of clarifying the feelings the music imparts, particularly the feelings of movement. Obviously, dance is naturally suited to this function, since dance is primarily a matter of movement—a practice whose basic elements are *steps*.

Our modest claim, then, is that some dance is best understood as the clarification or deepening of the feelings of movement inspired by the music, and that this clarification or deepening is secured, in part, by the activation of the motor reflexes in the body of the spectator; the body of the spectator, in a manner of speaking, is the vehicle through which the clarification or deepening of the pertinent feelings of movement is consummated. This process of clarification—about which we will have more to say later—is, in the first instance, a matter of making the feelings of movement suggested by the music more articulate. This transpires through the addition of a layer of affective stimulation—emanating from the bodies of the dancers—which either reinforces or foregrounds by counterpoint the movement impulses available in the music. The ensuing symbiosis of dance and music may result in the dance making the music more legible, the music making the dance more legible, or both, or in evolving a new feeling not available independently or antecedently in either the music or the dance, but one that issues as their combined product.

Again, this is a claim about *some* dance in relation to *some* music. Other dance may be concerned to emphasize other aspects of the music, such as its emotive content, rather than its intimations of movement. And some dance, as already noted, abjures any relationship to the music. But, at the same time, much dance works with the music for the purpose of clarifying the feelings of movement to be found in either channel of expression and/or in both in concert.

The philosophical import of this process will be adumbrated in the concluding section of this chapter. But, before reaching any conclusions, we must first make the case for a correlation between music and the impression of movement, and we will then go on to establish that dance not only has the resources to hone this impression of movement, but that it often does so, by recruiting our innate tendency to process the movement of others by means of mirror reflexes, which process we will argue supplies some grounds for rehabilitating the often disparaged notion of kinesthetic communication.

[5] These impulse qualities are aesthetic properties in virtue of their heightened coherence and structure.

[6] For we do not maintain that art necessarily expresses anything affective at all. There is art that is purely a cognitive affair, though we would concede that a large amount of art has some affective, even emotive address.

2. MOVEMENT IN MUSIC

It is a commonplace that music moves. However, there is little consensus about how music moves, or what precisely is meant by "movement" with respect to music. Part of the problem lies in trying to reconcile what we know about sound waves and the way they move, with our subjective experience of music as moving. Many philosophers and music theorists would argue that these two things simply cannot match up. We know that sounds are created by vibrations that travel through the air as waves, and so clearly all music requires that there be something moving, but it is not the motion of these waves that we have in mind when we say that music moves. Instead, we talk of scales that ascend and descend, of rhythms that march along, and of music's pulse—something that we don't just move *to*, but *with*. It is hard to deny the conviction that there is a way that music moves that we can imitate with the movement of our bodies, though it may be the case that, in describing the movement of music, we are merely using a recalcitrant metaphor.

While the metaphysical niceties of movement in music are both interesting and important, for our purposes we need not claim that every case in which we can coherently talk of motion in music is a case in which something literally moves. All that we require is that the motion perceived in the music is often central to our experience of the music. For example, we often describe the musical structures we hear as expressive of feelings of movement, as if we detect those movements in the music the same way we detect the movements of the tide in the ocean. These feelings can systematically be traced to central features of the music itself. Music may not move spatially in any literal sense, but it does have sonic contours that are easily understood through spatial analogues, be they rising and falling melodic lines or jagged and smooth rhythmic motives.

There is overwhelming anecdotal evidence that people do in fact perceive music as moving. That is how people frequently describe music. Indeed, research projects in the psychology of music take this as a basic presupposition.[7] Furthermore, even music theorists who have a specialized vocabulary with which to describe music use phrases like "oscillating triplets" and other movement terms to refer to musical events. Methodologically, we begin by presupposing that how people talk and think about a practice should have some initial authority for philosophers. So, rather than proceeding by advancing a priori arguments against the possibility of hearing movement in the music, let us begin by trying to discover reasons in favor of the common view.

[7] Many articles that make this presupposition can be found in *Music Perception*. Examples include R. W. Mitchell and M. C. Gallaher, "Embodying Music: Matching Music and Dance in Memory," *Music Perception*, 19 (1991): 65–85; G. Schellenberg, A. Krysciak, and J. Campbell 2000, "Perceiving Emotion in Melody: Interactive Effects of Pitch and Rhythm," *Music Perception*, 18 (2000): 155–71.

Some highly suggestive evidence comes from neuroscience; fMRI studies have shown that music is processed in the same parts of the brain that are responsible for the processing of movement, and that listening to or imagining music results in activation of the pre-motor cortex.[8]

The vocabulary used to describe the activity of music is perhaps even more closely linked to the vocabulary of temporal movement than to that of spatial movement. Music is said to "unfold" or "progress," capturing the idea that part of the essence of music is that it travels through time. We talk of time flying, dragging, and marching, just as we talk of musical notes doing these same things through time. In fact, given the close relationship between music and time, it is quite possible that the reason we perceive music as moving is because it progresses through time, and we perceive time as moving. The similarity is not just a matter of movement *simpliciter*, but of *directed* movement. For one thing that separates music from mere sound is that music is heard as moving toward its destination; it is directed. We experience time in the same way; it is always moving inexorably forward.[9]

This fundamental difference between music and mere sound is not a new discovery. In discussing what is required to hear something as a unified piece of music rather than as a mere succession of sounds, Roger Scruton proposes that we must hear "the experience of a musical unity across time, in which something begins, and then moves on through changes in pitch—perhaps to an audible conclusion. A melody has temporal boundaries, and a musical movement between them."[10] Edward T. Cone makes the same point about musical phrases, pointing out that "the typical musical phrase consists of an initial downbeat, a period of motion, and a point of arrival marked by a cadential downbeat."[11] The point is not only that we happen to hear a great deal of music as moving through time, but also that in order to hear sounds as music at all, we must in general hear these sounds as relating to each other in a temporal succession that is *directed*—which is to say: to hear music is to hear musical movement.[12] That is, insofar as time, or at least the experience of time, is unidirectional, we will unavoidably experience a succession of musical notes as going somewhere. Music is closely tied to time, which it structures, and since time is experienced as moving, so is music.

[8] See references in Noël Carroll and Margaret Moore, "Not Reconciled: Comments for Kivy," and Laura Sizer, "Moods in Music and the Man: A response to Kivy and Carroll," *Journal of Aesthetics and Art Criticism*, 65/3 (summer, 2007): 318, 307–11 respectively.

[9] There are still debates in physics about whether or not time, apart from our experience of it, must be unidirectional. A resolution to this question is irrelevant to our claim. The similarity we point out is between the way music is experienced and the way time is subjectively experienced. It is the congruity of these two phenomena that allows us to experience music as occurring in, and thus shaping, time.

[10] Roger Scruton, *The Aesthetics of Music* (Oxford: Clarendon Press, 1997), p. 40.

[11] Edward T. Cone, *Musical Form and Musical Performance* (New York: W.W. Norton, 1968), p. 27.

[12] Some aleatoric music may be an exception to this claim. Yet it is the exception that proves the rule, for the point of aleatoric music is to have sounds that appear to occur randomly. The expectation that we have for organized, directed sound is thwarted.

It seems, then, that the most natural way to describe what music does is to say that it moves. We describe the ways in which it moves in the same terms we would use to describe physical movement. For example, a piece might be marked *andante grazioso*, indicating that the tempo should be a walking tempo, and that the style of walking should be gracious. Or the marking could be *sehr rasch*, meaning very hurried. These directions for performance are able to indicate both the tempo and the characteristic of the music at once, precisely because it is so easy for the musician to understand how to play music in a way that is hurried, or is gracefully walking. If the performer heeds these markings, the listener will hear the music as hurried or as graceful.[13]

Since it has been established that we do in fact mean something by saying music moves, it is important to distinguish all the different ways in which music can move, linking these to the various technical devices or features that can contribute to this movement. These devices include pulse, meter, phrase structure, changes in dynamics and instrumentation, patterns of accents and articulation, harmonic motion, and others. Pulse is perhaps the most fundamental element that contributes to musical movement, since it is the pulse that creates temporal order in music by establishing a pattern of beats which becomes a background against which melody and harmony play out. Pulse also contributes to the impression of musical movement, since it is generally the pulse we are enticed to move to.[14] And the aforementioned neuroscientific studies support the hypothesis that we process the music we hear in part by activating the portions of the brain that would be involved in producing those movements; thus, it is no wonder that we want to move to the music, since hearing the music primes us to move in time.[15]

But there are other elements of music less tied to pulse and time that nevertheless contribute to the experience of music as moving. In almost every culture, music consists of rhythms and melodies, and these melodies are constructed out of scales. As the pitches get higher, one talks of ascending the scale, and of descending into the lower-pitched notes.[16] But it is not enough to combine a

[13] There need not be a precise correspondence between the marking in the score and the words a listener might use. The point is merely that it is movement terms that are used, and there is general agreement about whether the marking is being followed or not.

[14] One feature of pulse that makes it of cardinal importance is that to interrupt the pulse is to interrupt the music itself. Composers often exploit this feature for dramatic effect, as is the case with the first movement of Beethoven's *Fifth Symphony*.

[15] B. Calvo-Merino, D. E. Glasser, J. Grezes, R. E. Passingham, and P. Haggard, "Action Observation and Acquired Motor Skills: An FMRI Study with Expert Dancers," *Cerebral Cortex*, 15 (2005): 1243–9; Ricarda J. Schubotz and D. Yves von Cramon, "Functional-Anatomical Concepts Human Premotor Cortex," *Neurobiology*, 20 (2003): 1120–31; R. I. Schubotz, D. Y. von Cramon, and G. Lohmann, "Auditory What, Where and When: A Sensory Somatotopy in Lateral Premotor Cortex," *NeuroImage*, 20 (2003): 173–85.

[16] The exception is in ancient Greek music, which is exactly backwards. But this is because "up" and "down" the scale were thought of in terms of up and down the neck of a stringed instrument. It is easiest to explain this to modern readers in terms of the bass or the cello. As the cellist moves his finger *down* the string or fingerboard toward the bridge, the pitches get higher, not lower. The Greek scales were described in terms of the motion of the musician's hand, which results in a system that is backwards with respect to ours.



lower note and a higher note to produce upwards motion; we have to hear these notes in a temporal sequence. Once this is done, we hear the music as moving toward the higher note, and thus hear the melody or phrase as rising.[17]

Most classical pieces exploit a combination of elements in order to create highly sophisticated musical structures. For example, the graceful, swaying waltzing character of the third movement of Tchaikovsky's "Sixth Symphony" is created by the juxtaposition of melody and rhythm. The melody ascends through one bar, and then turns back in the next, and this sequence continues in the next two bars, adding to the feeling that the waltz moves as a dancer would across the floor. The unusual feature of the Tchaikovsky waltz is that it is in five rather than the typical triple meter. We feel the first and third beats as emphasized, and so this rhythmic background confers a lilting feeling onto the melody. Of course, not every person who listens to this piece would be able to explain why the waltz moves in the way it does, in part because some structural elements adding to the motion of music are more readily identifiable upon hearing than others. Also, which patterns are felt will depend upon the attention and experience of the listener, and the particular interpretation put forth in performance.

Needless to say, as the preceding example illustrates, another reason it is natural to describe music in terms we use for bodily movement is that many musical forms were created for dancing. While it might be difficult to dance a minuet of a Beethoven string quartet, his minuets retain many of the characteristics of the Baroque musical form that developed along with the dance of the same name. Despite the fact that minuets by Beethoven were not written to be danced, it still makes sense to think of the music as "mincing," a term that might better describe the steps of the original Baroque dance. The parallel developments of the music and dance make it impossible to tell whether it is the dance that lends the music its characteristic grace, or whether the gestures of the dance developed in response to the graceful character already perceived in the music. While the minuet is perhaps the most familiar example of a musical form developed from a dance, there are many other forms that have characteristic musical gestures that match their dance counterparts, including the Baroque Sarabande, Gavotte, Bourrée, and Gigue, the Polish Mazurka, the gypsy Czardas, and so forth.

So far, we have shown a way in which we can legitimately describe music as moving. At the same time, it is widely reported that certain music makes people feel like moving. This is obvious with dance music designed to encourage, regulate, and even propel the prospective dances. Here, one supposes that there is some relation between the movement patterns in the music and the feelings of movement it inspires in the dancer. To a certain extent, the dancer tries to mimic the musical movement impulses where the imitation is guided by musical

[17] For an additional discussion of movement in music, largely in agreement with ours, see Stephen Davies, *Musical Meaning and Expression* (Ithaca, NY: Cornell University Press, 1994), pp. 229–39.

patterns. For example, her foot automatically taps to the beat, or her arms reach upwards with the rising melodic line.[18] Of course, not all music is made for dancing. Some is made for listening. But where the stationary listeners detect the impulse to move to music, it is likely that the same structures are in operation. They feel prompted in their musculature to mimic aspects of the perceived musical movement.[19] It is this feeling of being prompted that we have in mind by referring to "movement impulses" inherent in the music.[20] The relevant musical structures, that is, operate as sonic cues.

Despite what might by now be the obviousness of the claim that music does *have* these movement impulses and that in virtue of these we either imagine bodily movement or actually move in consort with the music, some philosophers balk at the idea of linking the motion of music with any other sort of motion. This stems from the belief that music is *sui generis*, and as a result those who think that what they hear in music has any link to the extra-musical world are merely confused. So, when we imagine movement as we listen to music, we are allegedly just letting our minds wander, as if we were using the music as an excuse for indulging in an idiosyncratic fantasy.

But while it is true that some people may use music as an excuse to escape into their imaginations, and are, in effect, flagrantly oblivious to the structural features of the music, it would be ill advised to deny the link between music and imagined movement altogether. For, as we have tried to show, there are features of the music itself that are heard as moving, and these features actually cue movements in both our imaginations and in our motor systems. The response is in a way automatic, and is simply a feature of how we perceive music.

It is perhaps for this very reason that not just any movement will go with any music. In a recent psychological study, subjects were able to match a choreographed dance to its accompanying music at a far greater than random frequency.[21] If the dancer's movements were not somehow prompted by the motions we hear in the music, this would not be the case. Though we have no reason to claim that one piece of choreography is necessarily more suited to the music than another alternative, this experiment indicates that the movement we imagine with respect to the music is not a function of arbitrary wool-gathering but is intersubjective and thus converging.

In meeting the wool-gathering objection, we do not go so far as to claim that specific musical gestures can be matched to bodily movements in something like a one-to-one correspondence. The relation between musical movement and dance

[18] This phenomenon is not unique to dance, as anyone who has found herself walking or jogging in time to music will recognize.

[19] Mitchell and Gallaher, "Embodying Music."

[20] This phenomenon is frequent enough that, in an op-ed piece, Daniel Levitin has ironically suggested that Lincoln Center rip out the seats in its concert halls in order to give the audience the opportunity and the space to air the movement impulses they feel in response to the music. See: Daniel Levitin, "Dancing in the Seats," *New York Times*, October 26, 2007 (<http://www.nytimes.com>).

[21] Mitchell and Gallaher, "Embodying Music."

movement is much looser. But, despite the fact that no musical movement could entail a particular bodily movement, we can easily tell the difference between congruent and incongruent movements. Sharp, jabbing arm motions do not seem to make sense as an interpretation of soft, graceful music. In the case where a dancer chooses to lift where the music falls, the combination of music and dance creates a kind of counterpoint of rising and sinking lines. This is only possible because we really do perceive musical movement and bodily movement as subspecies of a wider class.

3. DANCE, MUSIC, AND MOVEMENT

With respect to certain types of music, listeners report that they are able to discern movement in the sonic array—that is, listeners maintain they can detect the feeling of movement of which the musical contour is expressive.[22] This may prompt a listener to imagine movement consonant with the music—to imagine either that one is moving, or to imagine others moving, or, more abstractly, to imagine simply that *something* is moving. As well, such music can often inspire or encourage movement in the listener. The movement impulse expressed in the music may be felt literally in the percipient's body. One may sway, clap one's hands, or stamp one's feet to the rhythm or, in the privacy of one's living room, one might indulge in broad sweeping gestures as the music on the radio appears to soar.

That music has the power to infect our muscles in this way, of course, explains why music and dance appear together worldwide in rituals of all sorts and in social dancing. Though the specific dances differ from tribe to tribe and from nation to nation, the phenomenon of dancing to music that incites the associated movement is as nearly universal as language is. From premodern rain dances through modern waltzes and onto contemporary breakdancing, dancing to or with or for the music is ubiquitous.

Professional choreographers and dancers often reaffirm their conviction that the dance they practice is inspired by the music. Moira Shearer argues "It is the music that has caused the choreographer . . . to want to compose movements and dances."[23] Alexandre Benois, summing up the project of the early Ballets Russes, asserted, "For us it was the music which provided ballet with its centre of gravity. The moment had arrived when one listened to the music, and, in listening, derived an additional pleasure from seeing it. I think this is the mission of ballet."[24] And George Balanchine appears to agree: "I cannot move,

[22] Perhaps these movement impulses are part of what Stephanie Jordan has in mind by her wonderful idea of physicality embodied in music. See Stephanie Jordan, *Stravinsky Dances: Re-Visions across a Century* (Alton, Hampshire: Dance Books, 2007), p. 16.

[23] Quoted in Barbara Newman, *Striking a Balance: Dancers Talk about Dancing* (Boston, MA: Houghton Mifflin, 1982), p. 105.

[24] Quoted in Stephanie Jorden, *Moving Music: Dialogues with Music in Twentieth-Century Ballet* (London: Dance Books, 2000), p. 1.

I don't even want to move, unless I hear the music first. I couldn't move without a reason, and the reason is the music."[25] Hegel, for once, put it succinctly—the music "gets into our feet," making, as the ancients believed, feelings visible.[26]

With these artists, it seems fair to hypothesize that the movement of the dancers enables the participants to clarify the feelings of movement that they detect in the music by acting out those impulses. Susanne Langer called dance "the gestural rendering of musical forms." This may not be true of all dancing, especially not all theater dance. But it surely pertains to a great deal of social dance, as most of us can affirm on the basis of our own experiences. Indeed, sixties post-Twist, freestyle dancing was explicitly predicated upon incarnating the movement one heard beckoning from the music.

In cases like these, it should be unproblematic to say that the dancer expresses the feeling of movement that she derives from the musical contour. She brings outside, in a manner of speaking, the inner feeling of movement that the music excites inside her. She embodies the feeling, thereby clarifying it in the process of making it manifest. But what is the effect of this performance on spectators?

It is our conjecture that the dancer's activity can also serve to clarify the audience member's intimation of the movement that he intuits in the music. For, in addition to the movement stimulation that the spectator receives from the music, there is also further stimulation streaming from the dancers' bodies, which can affect the receptive viewer kinesthetically.

How is this possible? Here, it is instructive to recall a readily observable, everyday fact of life. Who has not noticed that often when we are speaking to other people, we take on their behaviors? They clench their face in a mask of high seriousness, and we do likewise. They look off to the doorway; so do we. They punctuate their sentence with a laugh; we chuckle in concert. If you have never noted this in your own behavior, just look at the people locked in conversation as you pass down the hallway. Quite often, they will appear as mirror images of each other.

Moreover, that which obtains with respect to facial expressions and behaviors also occurs with regard to posture. When one's interlocutor bends forward to confide in us, we automatically follow suit and lean inward. When we watch a football player stretching forward in order to catch a pass that is just barely within his reach, we sense our muscles tugging slightly, but insistently, in the same direction.

During a boxing event or a television broadcast of one, scan the audience. Notice how many of them are gesturing in ways that suggest they are blocking punches or preparing to deliver one. They are, of course, not fully imitating the movements of the fighters. Their gestures are obviously truncated versions of

[25] Ibid.
[26] G. W. F. Hegel, *Aesthetics*, transl. T. M. Knox (Oxford: Clarendon Press, 1975), vol. II, p. 906; and Francis Sparshott, *A Measured Pace*, p. 216.

what they are seeing. Nevertheless, it is clear that they are gleaning some measure of understanding of that which they are watching by mirroring it partially in their own bodies. Needless to say, they are not doing this as a matter of reflection or deliberation. It is a reflex, as were our previous, mundane examples, all of which were meant to substantiate the pedestrian observation that we humans have an involuntary tendency to mirror automatically the behavior of our conspecifics. Call this phenomenon the "mirror reflex."[27]

One function of the mirror reflex is to gather information about the inner states of others. By involuntarily mimicking the facial disposition of our inter-locutor—by furrowing our eyebrows ever so gravely when he does—we gain an inkling of what is going on inside of him. The feedback from our own muscles stirs our own autonomic nervous system in a way that is roughly parallel to what is happening in him (that is, as long as he is not dissembling). We get an inward taste, so to speak, of some of what he is feeling by feeling something very like it in our own bodies.

Mirror reflexes are an indispensable feature of human life. Children on their care-giver's lap learn automatically what feelings go with this or that stimulus by "playing" mother's grimaces and giggles on their own bodies.[28] Moreover, the mirror reflexes that manifest themselves in outward behavior possibly have a physiological substrate in what cognitive scientists have labeled mirror neurons.[29] Indeed, the activation of the mirror neurons suggests a physical basis for the claims, often dismissed as "mystical," by dancers that choreography involves a dimension of kinesthetic communication.[30]

Mirror reflexes, it seems safe to postulate, afford a crucial channel of com-munication that is undoubtedly adaptive for social animals like us. In virtue of mirror reflexes, we are not only able to perceive the outer behavior of others, but we are also enabled to gain a glimpse of what they are feeling. Barbara Montero has introduced the verb "proprioceive" to label this phenomenon.[31] Through mirror reflexes, and their putatively subtending system of mirror neurons, we are able to proprioceive some aspects of what our conspecifics are feeling. They slouch and we slouch. The feeling relayed through our posture and ignited in

[27] Sometimes this is also called emotional contagion. See Elaine Hatfield, John T. Cacioppo, and Richard L. Rapson, *Emotional Contagion* (Cambridge: Cambridge University Press, 1994), Ch. 2.

[28] A. N. Meltzoff and A. K. Moor, "Imitation of Facial and Manual Gestures by Human Neonates," *Science*, 198 (October 1977): 75–8.

[29] The conjecture concerning mirror neurons is based on research with macaque monkeys. M. A. Umilta, E. Kohler, V. Gallese, L. Fogassi, L. Fadiga, C. Keysers, and G. Rizzolatti, "I Know What You Are Doing: A Neurophysiological Study," *Neuron*, 31: 155–65; V. Gallese, L. Fadig, L. Fogassi, and G. Rizzolati, "Action Recognition in the Premotor Cortex," *Brain*, 119: 593–609; G. Rizzolatti, L. Fadiga, V. Gallese, and L. Rogassi, "Premotor Cortex and the Recognition of Motor Actions," *Cognitive Brain Research*, 3: 131–41.

[30] Not only would this claim demystify the phenomenon of kinesthetic communication, but it would also account for the similarity of responses by providing material grounds for claims of intersubjectivity.

[31] Barbara Montero, "Proprioception as an Aesthetic Sense," *Journal of Aesthetics and Art Criticism*, 64/2 (spring, 2006): 231–42.

our bodies alerts us, if only subliminally, to what is going on in them—that they are not, for example, in a state of ebullience, but are feeling something heavy weighing upon them inwardly.

Mirror reflexes are often activated in our responses to strenuous physical activity—not only to sporting events, but action movies. As the hero struggles to pull himself up over the edge of the cliff, we feel the muscles in our hands and forearms tightening. Likewise, dance movements of all sorts have the capacity to enlist motoric mirror reflexes from onlookers. Standing by, watching a lively group doing the Hora, one feels oneself leaning in the direction of the centripetal pull of the revelers, and even into their animated, circular pathway. Indeed, we learn social dances by mirroring the movement of our mentors until the feelings radiating from the motions of our limbs converge on the feelings of movement we feel to be excited by the accompanying music.[32]

Though this is an example of social dancing, it should be evident that mirror reflexes also have an important role to play in our reception of theater dance. Think of the way in which the rhythm of *Lord of the Dance* is contagious. Indeed, there is a recent (September 2005) ad for Verizon Wireless that comically acknowledges this phenomenon. People walking down the street suddenly launch themselves into a dance pose. Then we are shown the cause. They are watching music videos on their cellphones, and that inspires them to match the movement. Their mirror reflexes here are exaggerated for humorous effect, of course. But the laugh is predicated upon the expectation that everyone in the viewing audience will recognize the behavior, perhaps even to the point of recalling that one has done it oneself.

Much theater dance since the early twentieth century—undoubtedly, in part, in an effort to liberate itself from the demands of narrative—has been, in one way or another, about the feelings engendered by the music that accompanies it, either by way of drawing attention to or expanding otherwise upon these experienced aspects in the music.[33] This is true not only in the modern dance movement—including figures such as Isadora Duncan, Denishawn, Doris Humphrey, and, at present, choreographers like Paul Taylor and Mark Morris—but also in the balletic tradition, ranging from Michel Fokine's *Chopiniana* through Leonid Massine's *Symphonic Ballet* to George Balanchine's abstract ballets, and those of his progeny (to cite only a few of the people interested in making dances that are intimately connected to the music).[34]

Historically, when choreographers began to avail themselves of pieces of the symphonic repertoire, which had not been originally created for the dance, they supplied themselves with a basis for sustaining evening-long performances without a whiff of narrative.[35] Instead, their dances could be about the music

[32] Those mentors need not be "live." Consider the case of teenagers in the 1950s who learnt the newest dance moves by aping the dancers they watched on *American Bandstand*.

[33] See Jordan, *Moving Music*, Ch. 1. [34] Ibid. [35] Ibid.

or aspects thereof. And perhaps for fairly obvious reasons, one of the foremost aspects of the music to which choreographers mean to direct our attention involves the feelings of movement that the music engenders, in virtue of the kinds of sonic elements discussed in the last section.

In the pertinent examples, the music in question awakens a feeling of movement in the listener, who also sees the dancer literally moving to or with the music, thereby enabling the receptive listener to refine or enlarge upon that feeling through the addition of the somatic input derived from her mirror reflexes. Whereas in listening to the music apart from the dance, one relies solely upon one's own imaginative resources. Music-cum-dance ideally provides the audience with an image of appropriate movement which, by enlisting our mirror reflexes, heightens or extends our apprehension of the evolving feeling of movement. Abetted by our mirror responses to the image of movement created by the dancers' bodies, the feeling of movement initiated in the music can be apperceived ever more precisely and richly due to the conjunction of a kinesthetic dimension in addition to the aural one.

To mention just a few of the ways in which choreographic movement qualities can further articulate—either by illustrating or by expanding upon—the feelings of movement of which the sonic profiles of music are expressive, recall that the dancer can move slowly, lightly, hurriedly, carefully, smoothly, softly, weakly, forcefully, flowingly, hesitantly, firmly, tensely, quickly, abruptly, gradually, tightly, jerkily, nervously, urgently, and evenly, where all of these movement qualities, and more, can echo, underscore, enhance, or contrastively modify the movement impulses manifest in the music.

The dancer can rise and sink, grow and shrink, circle and dissipate in response to the call of the score. Dance gestures may describe or depict comparable musical gestures: the dancer may turn abruptly, push, pull, sweep ahead, freeze, swell, oscillate, subside, flutter, swing, undulate, jerk, tap, jab, punch, confront, fight, prolong the moment or hasten it, float, spread, fluctuate, change cadence, retreat, speed up, reverse direction, slow down, recede, advance, crawl, fall, or suspend movement altogether. Moreover, the choreography can introduce these gestures in anticipation of the music, along with the music, or as a retrospective reflection upon it, or even as a counterpoint to the music. The dance movement can be heavy or light, ponderous or airy, staccato, syncopated, conflicted, tense, or equilibrated, either in synch with musical movement impulses or in contrast to the feelings of motion issuing from the orchestra. But, in any event, the dance activity may serve as a provocation for a succession of mirror responses, which, in turn, can palpably refine or accent our grasp of the evolving sense of movement as it emerges in concert with the suggestions of motion intimated in the musical score.

It is our suspicion that this phenomenon is primarily what many dancers and choreographers have in mind when they speak of "kinesthetic communication," the experience of converging feelings of bodily motion engendered especially by music-cum-dance. With respect to observed movement, the idea is that through gesture or dance a person can either convey a sense of movement,

or can signify something through this movement. While the term "kinesthetic communication" has been admittedly vague enough to include everything from sign language and non-verbal signals such as winks and nods, it is the idea of a dancer communicating a movement-feeling to another dancer or to a spectator with which we are concerned. And, in this regard, there seems to be a strong affinity between this sort of communication and what the mirror reflex response makes possible.

In the simplest cases, the dance movement functions as a translation from one medium to another—from the musical movement impulse into flesh-and-blood movement. For example, the slow, restrained, processional music of "Air on the G String" is realized by the stately, regal movement of Humphrey's dancers in her choreography of the same name to this piece by Bach. As the intuited musical lines of movement blend into each other cyclically, the accompanying dance phrases seamlessly interlace—the continuous feeling of the movement in the music captured in evenly flowing gestures whose energy vibrates quietly and softly inside the receptive viewer.

The dance, in examples like this, is, in effect, a performative interpretation of the movement impulses expressed by the music.[36] Just as a dramatic performance of a play is an interpretation of the text—one which draws out and makes evident some of its various qualities—so the performance of a piece of choreography can function as a further articulation and amplification of certain qualities that are inherent in or that supervene upon the music.

As we have seen, dance and music can be correlated across a number of dimensions. Thus, a choreo-performative interpretation of music can elect to make visible many different features of the music from the association of the sounds of various instruments with certain shapes, or even body types, to the imitation of musical movement (however that is explained). Of these dimensions of correspondence, of course, the ones that interest us most are those that involve the embodied translation of the musical motion impulses into moving choreographic forms and figures (for example, *climbing* toward a climax matched by a *grand jetée* which is then caught and frozen mid-air with dramatic finality). Or, as a musical phrase is passed sequentially from one group of instruments to another, a corresponding dance phrase moves from one group of dancers to the next.

A great deal of choreography is best thought of as a performative interpretation of the music that accompanies it. It is a *performative* interpretation, rather than a *critical* one, since it is a sensuous realization of the features of the music, rather than a propositional elucidation. It is an *interpretation*, at the very least, in that it only selects some of the features in the music for bodily emphasis instead of all of the features it could embroider through overt action. That is, as a matter of fact, no choreo-performative interpretation of music has, to our knowledge,

[36] On the notion of performative interpretation, see Jerrold Levinson, "Performative vs. Critical Interpretation in Music," in Michael Krausz, ed., *The Interpretation of Music: Philosophical Essays* (Oxford: Clarendon Press, 1993), pp. 33–60.

ever attempted to visualize every element of its corresponding piece of music that could be illustrated, and, furthermore, perhaps no piece of choreography could. Choreo-performative interpretations are perforce selective practically and maybe even theoretically.

Moreover, the dances or parts of dances we have in mind are choreo-performative interpretations of *the music*, since they are about the musical experience (even if they are also involved in simultaneously advancing some story line, character trait, atmospheric mood, or theme). And, lastly, undoubtedly related to their selectivity, a very large number of choreo-performative interpretations of the same piece of music are equally tolerable, since different interpretations of this sort may highlight different features of the music.

The choreo-performative interpretations we care about are those that cast into bold relief—those that literally give added dimensions to—the intimation of movement available in the music. Such choreo-performative interpretations realize the movement impulses of the music by finding bodily gestures and behaviors that correspond to or augment them. In this way, the dances make the impressions of movement proponed by the music more accessible and more perspicuous to audiences by providing the opportunity to us to fill them out or to color them further with the activity of our own mirror reflexes, as those are thrown in gear by the dance.

Of course, a dance may not just interpret the movement impulses expressed by the music by way of selectively imitating or echoing them. The dance may go beyond merely translating the intuited musical motions. The dance may expand upon the feelings of movement suggested in the music by either completing some sonic movement tendency in the music or by counter-pointing, complementing, supplementing, or evolving a contrast to it (as Balanchine does in *Agon* where the regular dance beat is posed against Stravinsky's jerky rhythms).[37] In any dance, the music may stop, and, in the silent interval, the dancers may stamp out a brace of steps that either resolves, subdivides, or colors what we have just heard. This too counts as a choreo-performative *interpretation*, inasmuch it goes beyond the musically given.

Mark Morris's *L'Allegro, il Penseroso ed il Moderato* is, first and foremost, a performative interpretation of the oratorio of the same name by Handel. Notice how in the second movement, initiated by the introduction of the male voice, the choral *entrances* are marked by the entrances of dancers; as more voices enter, more dancers enter. The leg movements imitate the orchestral ornaments. As the music delivers the impression of speeding up, the dancers appear to be running in place exaggeratedly. Throughout the section, the music has a lively, highly animate character, ingeniously implemented by the dancers in a way that can touch viewers kinesthetically. When a *skipping* laugh rhythm punctuates the singing, two dancers bounce up and down like pogo sticks. Obviously, the audience does not follow suit precisely; we stay seated. But the receptive spectator

[37] Marcia B. Siegel, *The Shapes of Change: Images of American Dance* (New York: Avon Books, 1979), p. 228.

also feels a ripple of that enthusiasm swell in her legs, thereby integrating what she sees and hears in her own body, undoubtedly as a result of the synthesizing powers of the central nervous system. Of the piece in general, Joan Acocella observes "When the music, runs, plods, skips, sweeps, glides, meanders, so do the dancers,"[38] whose gamboling we track as our own mirror reflexes are awakened.

Of course, Mark Morris is a genius when it comes to clarifying music choreographically. In his piece "Double" from his *Mozart Dances*, which was choreographed to Mozart's Sonata in D Major for two pianos K448, Morris gives us a lovely example of a performative interpretation of musical motion. The first movement *Allegro con spirito* is a 4/4 sonata allegro form, and we find the choreography highlighting both the treble melody and the bass accompaniment. The solo dancer's feet walk in tempo to the bass motion in the pianists' left hands, while his arms mimic the right-hand scalar flourishes. There are gestures that highlight the small ornamental features in the music such as grace notes and trills with hand positions taken from eighteenth-century court gestures. These elements propose a fairly typical, literal interpretation of the surface features of the music, but what is especially interesting about this choreography is that Morris also brings out the harmonic and formal motion of the sonata form. In a section full of activity in the pianos, the dancer, his arms held like two curved windmill blades, moves them approximately one time per second, emphasizing only one of the eight notes occurring in that time span. What this does is to underscore the harmonic sequence in the second section of the exposition so that the viewer is able to feel the prolonged cadential motion as it drives toward the new tonic key.

As is typical of sonata allegro form, the exposition is given a literal repetition, and it is here that the resources of dance can provide the viewer with a deeper understanding of the music. Morris repeats his choreographed gestures, but this time with additional dancers. It is possible for the dance to supply a slightly different interpretation (and experience) of the same musical material in a way that is quite obvious to the audience, whereas the musicians make only subtle changes in emphasis in the repeated section. In the repeat section just discussed, while the solo dancer performs his gestures emphasizing the progression of half-note chords, the chorus of male dancers now swirls around him to highlight the sixteen notes running underneath. Morris has given us a sophisticated reading of Mozart, making both melodic and harmonic motion corporeally intelligible, in large measure through kinesthetic communication.[39]

[38] Joan Acocella, *Mark Morris* (New York: Farrar, Straus, Giroux, 1993), p. 241.
[39] Of course, the idea of kinesthetic communication is a controversial one and the arguments leveled at it need to be addressed. The notion of kinesthetic communication that we have been defending has been disparaged as the sort of fanciful nonsense that dancers and choreographers spout when pressed to wax profound. Objections to kinesthetic communication come from two major directions—from those who distrust the underlying idea of *kinesthesis* and from those who distrust the use of the concept of *communication* that the notion appears to presuppose.

An example of a critic of the first sort is Mary M. Smyth. She emphasizes that kinesthesis is a matter of detecting movement in one's own body. Thus, it would seem that kinesthesis in relation to

Perhaps needless to say, the idea—that choreographers may dragoon the mirror reflexes of receptive spectators for the purpose of honing our sense of the movement impulses available from the music—is compatible with the fact that the feeling emerging from the integration of the dance and the music may also have additional purposes to perform. For example, during the first appearance of Death in Kurt Jooss' *The Green Table*, the forceful, percussive piano music, pounded out in a minor key, is articulately embodied by consistently powerful gestures—jabbing arm movements, and legs arrested in air so that bulging muscles pop forth as the foot is about to hit the floor with great weight. The mechanical repetitions of the music are matched by stylized, somewhat rigid, and

dance would only come into play when we are ourselves dancing. However, the notion of kinesthetic communication is more often applied to the spectator's reception of a dance. But it appears unlikely that this could proceed *solely* by kinesthesis. How would external movement be tracked by internal movement detectors? Telepathy? Clearly, the external movement will have to be perceived by our system. So kinesthesis cannot be the whole story about the reception of dance. To suppose it to be is tantamount to a category error.

This is true but not particularly compelling, since we feel no temptation to claim that kinesthetic communication involves only kinesthesis and no other sensory system. Smyth begins by quoting Jack Anderson who said "Dance is not simply a visual art; it is kinesthetic as well; it appeals to our inherent sense of motion." But note that Anderson is not claiming that we respond to dance exclusively by kinesthesis. He concedes that dance is also a visual art. So we are not sure who has perpetrated the category error that vexes Smyth.

At any rate, the category-error charge is easily dismissed by considering the following case. The objection is that kinesthetic communication is suspect because it cannot operate without the aid of vision. Analogously, one might insist that poetry conveys no aural elements when presented as a text to be read silently. But surely this is is not the case. We can apprehend the musical elements of poetry such as assonance or ontomatopoeia by reading as well as by listening. Vision serves as an intermediary here, just as it does in the the case of the dancer's communication of bodily feelings.

Smyth does consider the possibility that kinesthetic communication might involve visual perception *and* kinesthesis, but she wants to know how visual perception and kinesthesis are related. That is a fair question. We have attempted to answer that in part. The perception of movement in the dances activates mirror responses in the motor system which *may* be related to mirror neurons which we experience as motion impulses that tend to clarify or deepen the motion impulses suggested in the accompanying music. Smyth wants to know how audiences get from the perception of external movement to the feelings of movement in our bodies. We hypothesize that the relay in part involves the mirror reflexes discussed above.

An alternative line of attack—offered to us by Grahman McPhee in a private communication—takes issue with the second half of the locution "kinesthetic communication." Although McPhee concedes that there can be communication that is not intentional—it can be what he, following David Best, calls a percomm—and though McPhee allows that the activation of motor reflexes is of this category of communication, he questions what reference to such processes can contribute to the understanding of *artistic* communication, because artistic communication is intentional. However, it strikes us as perfectly consistent to maintain that dancers and choreographers intend to communicate feelings to spectators by means of their movement while at the same time they do not understand transparently all of the mechanisms that make that transmission possible. Dancers and choreographers voluntarily elect to communicate feelings through movement even if not all of the processes that come into play are under anyone's voluntary control. The choreographer does exhibit intelligence in choosing the movements that have the desired effects without her possessing psychological knowledge of why those effects obtain. But that lack of knowledge does not compromise her action of communicating artistically.

See Mary M. Smyth, "Kinesthetic Communication in Dance," *Dance Research Journal*, 16/2 (fall, 1984): 19–22.

automaton-like marching which engenders a feeling of gathering momentum in our bodies. However, here, of course, the point of the choreography is not just to illustrate the movement impulses in the music, but also to use those musical impulses in conjunction with the kinesthetic feelings erupting from our mirror reflex responses to the dancer in order to characterize Death as unstoppable. The sense of implacable propulsion we feel in our bodies, that is, is not just a reflection upon the musical experience, but is intended to serve a dramatic function as well. Choreographers may recruit mirror reflexes in order to articulate the movement impulses in the music at the same time the feelings engendered are woven into broader artistic tapestries.

On our view, one way of understanding the relation of dance to the music is to regard the choreography as a performative interpretation of certain aspects of the music, namely, its movement impulses, which then activates the mirror reflexes of the receptive spectator in such a way that we are able to clarify the feeling of movement that we intuit in the music. In this way, we come to have a better sense of certain aspects of the music.

In response, an objection might be raised of the following sort. For those who understand the music already, what need have they for this kind of choreography? On our construal, dance seems to be nothing more than a crutch for the musically illiterate. What value can the antecedently musically informed audience member derive from dance of this sort?

But surely everyone agrees that musically literate audiences value the performative interpretations by musicians and orchestras of the musical works they already understand. This is because it is widely acknowledged that musical works have indefinitely large numbers of alternative ways in which they can be performed legitimately—alternative interpretations that emphasize different aspects of the work, bring out different qualities, and so forth. Musical connoisseurs are interested in the exploration of the range of ways in which a musical work can be inflected. A new performance can always disclose a hitherto neglected feature of the work.

Yet why should it be any different when it comes to choreography? Different choreographers draw attention to different facets of the experience of the musical work. Each choreographer of this sort assembles a different package of possibilities regarding how the music can be framed. Like the conductor and his orchestra, the choreographer and his dancers are exploring the different accents that the work can speak. Music lovers are interested, at the limit, in learning all the things a piece can say in all the ways that it can say it. In this regard, choreographers are performative translators of the relevant aspects of the music on a par with conductors and musicians. If the musically informed devotee does not regard the musical performance of a work to be a crutch, then he need not suspect a comparable choreo-performative interpretation to be such. For the two kinds of interpretations perform roughly the same service.[40]

[40] Another more technical objection to our view, posed by Barbara Montero in conversation, is that so far the activation of motor neurons has only been observed in response to single agents, not

4. CONCLUDING REMARKS

The purpose of this chapter has been to place the aesthetic experience of one very prominent type of combination between dance and music in a philosophical framework ramified by speculations suggested by research in cognitive science. The framework we propose is a customized version of the expression theory. Needless to say, we are not endorsing the expression theory wholesale, but only helping ourselves to parts of it—and even those parts are being modified to suit our purposes.

Let us be clear: we do not believe that the expression theory succeeds as a theory of art, nor of any particular artform, neither music nor dance. Furthermore, whereas the expression theory concerns the clarification of feeling on the part of the artist, we are primarily concerned with the aesthetic experience of the spectator. Moreover, where the classic expression theory sees the work of art as a mere vehicle for the expression of the artist's feelings, we make no claim about the nature of the musical artwork. We have no commitment one way or the other about whether the composer or the performers are expressing their feelings in the music.

One concept of the expression theory that we are exploiting is the notion of clarification. However, we are extending the application of that concept beyond the domain of the emotions to the realm of feelings, specifically somatic impulses toward movement. It is our contention that receptive spectators automatically use the movements of dancers in the pertinent works to clarify or otherwise deepen and enrich the feelings of movement available in the music. Undoubtedly, the music and the choreography co-determine the feelings of movement the receptive spectator comes to intuit. But, since the topic of our paper is dance, we have opted to concentrate on the contribution that the choreography makes to the spectator's aesthetic experience of the response-dependent movement qualities she detects in the music.

Another chapter could be written elucidating the ways in which the impressions of movement emanating from the music modify or mutually determine the feelings of movement the receptive spectator proprioceives in the choreography. However, we suspect that that will be a somewhat different story than the present one, since, on our view, a key to proprioceiving the movement impulse of the dancers in our body is the activation of the felt impulse to move as the dancers do. That is, the dancer's movement triggers our mirror reflexes in such a way

groups. But we have spoken of mirror reactions to both individuals *and* groups. Here, two points are worth noting. First, our emphasis is primarily on mirror reflexes, not mirror neurons. And, second, it is evident that we often mirror the movement of ensembles. Watching a parade, I may feel its pulse not by focusing on one of the marchers, but in response to the group movement. Similarly, I may sway to the rhythm of an undulating chorus line without picking out any of the chorines. That is, when it comes to mirror reflexes, we appear sensitive to both individual movement and to coordinated group or "gestalt" movement. This is especially the case where the same movement is being performed by the ensemble focused upon.

that we derive a kinesthetic sense of what the dancer feels as she moves in a manner that is appropriate to the music. And this, in turn, provides the viewer with the opportunity to experience a more articulate and defined feeling for the movement impulse she detects in the music.

In short, the dancer nurtures the movement impulse she finds in the music — she visualizes, articulates, expands upon, completes or otherwise develops it. The receptive viewer, moreover, is likewise involved in clarifying the feeling of movement she intuits in the music, but also takes advantage of the matching choreographic movement, which further parses the musical movement impulses by energizing our mirror reflexes. The choreography functions to focus and define the feeling of movement which fixes the feeling in the receptive spectator and assists her in clarifying both it and the musical structures that prompt it.

Here, the concept of clarification, inspired by the expression theory, is crucial. So let us try to suggest some of the components involved in the receptive viewer's experience. First of all, it is a participatory experience: the viewer makes an active response to the dance-cum-music, though part of that activity is automatic. In the process of response, the spectator's experience of the movement qualities becomes more articulate — the selectivity and emphasis of the choreo-performative interpretation afford a more simplified, inflected, oriented, and, therefore, more graspable characterization of the movement qualities than that which is available solely through the music. This abets the clarity of the experience by rendering it more coherent in outline.

But the dance not only makes the feeling of movement clearer. It also makes it more distinct, because it connects the aural impression of movement with a visual and kinesthetic image or interpretation of it. Thus, the dance quite literally makes the movement quality more concrete by embodying it externally. In this way, the impression of movement we imagine we hear in the music is integrated with our visual system, yielding a more embedded and unified experience than what may be procured from the music alone. And in virtue of this unity — this integration of sight and sound — the receptive viewer develops a firmer hold on the relevant feeling of movement. Through reflecting upon these perceived motion impulses, the viewer may discover just which structural elements in the music are responsible for them, thereby deepening his grasp of the music itself.

Undoubtedly, to a significant degree, this experience is part of the legacy of our biological inheritance. Our tendency to detect movement in the music is at least in some way connected — in a manner yet to be explained — to our sonic motion detectors. These detectors were indispensable to our evolution. In order to be alert to predators and prey, these detectors evolved with hair-triggers, since that would be the optimal insurance policy in the context of the prehistoric savanna for sussing out predators and prey. But music works a strange magic on those detectors when it stimulates them with inputs they were never adapted to evaluate. The question of how the movement qualities, grounded in the temporal structures of the music, act as sonic cues or prompts for our motion detectors,

needless to say, is one for another day and, most probably, for a discipline other than philosophy.

On the other hand, though still speculative, we can say a bit more about the mechanisms that enable us to proprioceive the feeling of movement in the dance. These are mirror reflexes that are likely to be connected to a system of mirror neurons—what dancers have alluded to for decades in terms of the kinethestic medium of choreographic address. These reflexes prompt cognate movement impulses upon exposure to the actions of conspecifics. These mirror reflexes are means by which we glean a sense of what others are feeling and, for that reason, a vehicle for communicating feeling.

They are also a way of coordinating group activity. Since way back when, group cohesion has been secured by ritual, dance, and drill where mirror reflexes have not only—most often in concert with music—kept the community in step, but also suffused the group with a glow of fellow feeling. Through mirror reflexes, orchestrated in the context of ritual, dance, and drill, human societies grew in scale in ways that were decidedly advantageous in the competition with other species. For the type of organization mirror reflexes fosters imparts feelings of solidarity as well coordination in space and time.

Unlike the religious, ritual, courtly, and otherwise communal dance from which theater dance evolves, when choreography reaches the stage, professionals take over, and the rest of us are not invited to the dance. We sit and watch. Nevertheless, it seems plausible to suppose that those mirror reflexes that are so deeply ingrained in our being are still at work communicating the kinesthetic feeling of the dancers to us and perhaps even instilling a momentary impression of solidarity among the audience or, at least, an intuition of fellow feeling for the nonce. In this way, an important aspect of the aesthetic experience of dance-cum-music is a cultural enlargement upon our naturally evolved (and perhaps still evolving) endowment.

Though, with our emphasis on the spectator and our speculative invocation of cognitive science, it may seem that we have drifted far afield from any recognizable version of the expression theory, it should be noted that we have remained committed to one of the traditional aims of expression theories of various stripes. Such theories typically presume, as we do, that there are strata of human feeling for which we lack linguistic symbols and which we find virtually impossible to describe with adequately satisfying specificity. According to many expression theorists, the role of art is to find ways of grasping those feelings by other means—ways of marking them or showcasing them for reflection. On our view, that is one function that dance in consort with music discharges. It is a way of making the ineffable, if not effable, then, at least, a little more perspicuous.

25

Music, Mind, and Morality: Arousing the Body Politic

Cowritten with Philip Alperson

1. INTRODUCTION

If, like Aristotle, one agrees that the responsibility of philosophy is to offer as comprehensive a picture of phenomena as possible, then one must admit that sometimes the methods and goals of analytic philosophy stand in the way of getting the job done properly and they may even distort one's findings. This is not said in order to eschew analytic philosophy. It is simply a reminder that sometimes we need to stand back and check to reassure ourselves that the tail is not wagging the dog.

One example of where this danger looms is in the philosophy of art. In the eighteenth century, the Modern System of the Arts was born.[1] It included the practices that we think nowadays are the appropriate inhabitants of art schools and art centers, and the legitimate beneficiaries of programs like the National Endowment for the Arts in the United States. These arts included poetry, painting, sculpture, music, dance, and sometimes gardening. These are what we might call the arts with a capital "A."

This is a different way of understanding the notion of the arts and the nomenclature from which they derive in Latin and Greek. For Socrates, Aristotle, and Plato, arts were simply any skilled practice. Poetry, for Aristotle at least, was an art, but so were navigation, medicine, and statecraft. And there were, of course, the martial arts. What happens with the emergence of the Modern System of the Arts—aka the Fine Arts, or the Beaux Arts, or, for us, the Arts with a capital "A"—is that a subset of the arts in the Greco-Roman sense was selected out and christened as a class unto itself, different from the other small "a" arts. Whereas, once upon a time, chemists and painters might have been grouped together in the same guild in virtue of the fact that both types of workers ground substances, such as pigment, with the advent of the Modern System of the Arts, chemists and painters became first and foremost categorically different.

[1] Paul Oskar Kristeller, "The Modern System of the Arts," in Peter Kivy, ed., *Essays on the History of Aesthetics* (Rochester, NY: University of Rochester Press, 1992), pp. 3–64.

However, the consolidation of the class of Art with a capital "A" demanded a theoretical answer to the question of what criterion an artform had to meet in order to gain membership in the Modern System of the Arts. The first suggestion was that a candidate practice had to possess the capacity to imitate the beautiful in nature. This was not a definition that had legs. For, when absolute or pure instrumental music—or, as Professsor Kivy calls it, music alone[2]—took center-stage as the most important form of music as well as the Art with a capital "A" to which all the other arts putatively aspired, the criteria for entry into the Modern System of the Arts had to be re-conceived. Since music alone could not creditably be described as the imitation of the beautiful in nature (or, for that matter, the imitation of anything else), a new license for practicing Art with a capital "A" had to be found. And this has become one of the animating tasks of the analytic philosophy of art.

But the analytic philosophy of art comes with a certain bias toward discharging this task. It is committed to finding an essentialist answer to resolving the question of what warrants citizenship in the republic of Art (with a capital "A"). That is, what makes something an Artistic practice or, for that matter, a work of Art such that it is different from other things? What separates the Arts and the artworks from everything else?

Perhaps, not surprisingly, one of the most popular and recurring proposals here is that the Arts are what are *primarily* intended to promote aesthetic experience where that has formerly been characterized as disinterested pleasure but, more recently, as experience valued for its own sake. Experience valued for its own sake, of course, is virtually by definition conceptually independent from any other end, whereas the practices that do not belong to the Modern System of the Arts are primarily devoted to securing other ends—useful or utilitarian ends, knowledge, social order, and so forth. By identifying Artistic practices and works of Art in terms of the affordance of aesthetic experience (which experience is divorced from any other than *sui generic* value), the analytic philosopher of art almost automatically severs Art from everything else with their primarily interested values, and thereby achieves his essentialist aim at a stroke. Since experience valued for its own sake is disconnected from every other sort of value—which values are connected to the aims of other practices—the Arts are effectively defined as a realm unto themselves, divorced from the rest. And this is the sort of definition about which analytic philosophers dream of having inscribed on their tombstones.

If artists and lovers of art have espoused a comparable view, sometimes called "aestheticism" or, more awkwardly, the "autonomy of art thesis," in order to bolster their status, the analytic philosophers of art are attracted to a converging viewpoint for intellectual reasons. The aesthetic definition of art—the definition of art in terms of aesthetic experience—satisfies their essentialist yearnings by providing them with a conceptual instrument for cleaving Art from every other social endeavor.

[2] Peter Kivy, *Music Alone* (Ithaca, NY: Cornell University Press, 1991).

However, the problem with this is that the Arts are not divorced from the rest of our cultural practices. They are intimately bound up with moral education, political programs of every persuasion, spiritual matters, the articulation of ideals and purposes, the modeling of manners and sentiments, the exemplification of styles of gesture, carriage, fashion, and speech, the dissemination of general cultural *savoir faire*, and so forth. Investigating all of these relations should be on the agenda of a comprehensive theoretical approach to the Arts—a philosophy of Art with Aristotelian ambitions. Yet it is foreclosed conceptually by the tendency of analytic philosophy to detach Art categorically and in principle from every other form of cultural practice. And, in this regard, there is a danger that if analytic philosophers of art proceed unaware of the bias in our method, our philosophy of Art will be distorted by being overly narrow.

Moreover, it is our worry that a parallel, though not unrelated, problem threatens the analytic philosophy of music. In its analytic urge to differentiate its object from everything else, the philosophy of music tends to privilege absolute music or music alone. Admittedly, musical purism also arises from within the ranks of music lovers who wish to defend the right for music to develop autonomously. Yet, even if this is part of the attraction of some philosophers of music to lavishing their almost exclusive attention on absolute music, they are also drawn to focusing upon music alone because they are committed to saying analytically of each practice what makes it different from the rest.

Questions about the relation of music to the arousal of the emotions, to knowledge or morality, tend to be framed in terms of whether *music alone* can arouse emotions, discover or impart knowledge, guide behavior, and so forth.[3] And these queries then tend to be answered negatively. For the skeptic argues that, insofar as absolute music lacks propositional content, it can do none of these things. For example, there is no point in calling music profound, if it has no cognitive—aka propositional—content. Others then respond by arguing that absolute music may have the requisite resources. There is nothing wrong in our view with having this debate. Nevertheless, it is deaf to the kinds of music that most people have listened to throughout history and to the kinds of concerns and purposes music has served.

For most music has not been absolute music. Historically (and cross-culturally), music evolved in tandem with song, epic poetry, dance, ritual, and drama (including, in our own day, televisual dramas). Whether or not absolute music has the kind of semantic machinery it takes to transmit religious, moral, political, spiritual, and otherwise cultural messages and sentiments, song, epic poetry, ritual, dance, and drama have those capabilities. Music, accompanied collectively or distributively with the aforesaid referential practices, does have the power to do the things that the skeptic denies that music alone can achieve. Most music—worldwide and historically—is not music alone. And it is for this reason

[3] For example, see Peter Kivy, "Musical Morality," *Revue Internationale de Philosophie*, forthcoming.

that much music, as it enters the lives of peoples, is an integrated and functional part of culture and that it can take its place in the moral life of the culture.

Marches, hymns, dirges, love songs, work songs, union songs, social dances, liturgies, anthems, movie music, program music, and advertisements are all aligned with cognitive content whose social and psychological effectiveness they modify and lubricate. It is our view that the philosophy of music needs to address these phenomena in order to be anywhere near complete. Moreover, given the recent developments in the philosophy of mind, especially in terms of its cognitive turn, one task for philosophers of music might be to begin to speculate about the properties of music and organized sound that enable them to perform their various moral and cultural roles.

It is that conversation we would like to advance in this chapter.[4]

2. MUSIC IN THE MORAL LIFE

Let us start by canvassing transhistorically and cross-culturally a range of examples where music does participate in or contribute to the moral life of the culture. First, some descriptive, prescriptive, evaluative caveats. In this chapter we do not claim to be providing an exhaustive account of the ways that music can figure in the moral life. Still less do we wish to argue that music must serve any or all of the purposes we mention. And we do not wish to argue that when music does contribute to the moral life of the culture it must be judged on that basis. What follows is instead simply a catalogue of some of the ways in which music does in fact function in the moral world. We separate these various functions out for the purposes of analysis and identification. In the complexity of real life, we can expect that they will overlap, reinforce one another, or sometimes be mutually antagonistic.

Music is used, for example, to regulate behavior, enforcing compliance with social norms and mores. Chants and bells call the faithful to mosques, temples, and churches around the world. In Pyongyang, the government wakes its citizens up with music broadcast on loudspeakers. The reveille bugle call is a wake-up call in the military. The purveyors of canned-music programs such as Muzak claim that their product affects the psychological states of people, encouraging them to purchase items in shopping malls or to temper their frustration while on hold in phone queues. (The music also has the unintended effect of infuriating people who detest Muzak.) Music also directs the behavior of young children. *The*

[4] There have been some exceptions to some of the general patterns we describe here. Among the exceptions are Kathleen Marie Higgins, *The Music of Our Lives* (Philadelphia, PA: Temple University Press, 1991); Lydia Goehr, *The Imaginary Museum of Musical Works: An Essay in the Philosophy of Music* (Oxford: Oxford University Press, 1992); Aaron Ridley, *The Philosophy of Music: Theme and Variations* (Edinburgh: Edinburgh University Press, 2004); Jenefer Robinson, *Deeper Than Reason: Emotion and Its Role in Literature, Music, and Art* (Oxford University Press, 2005); and Constantijn Koopman and Stephen Davies, "Musical Meaning in a Broader Perspective," *The Journal of Aesthetics and Art Criticism*, 59/3 (summer, 2001): 261–73.

Itsy Bitsy Spider teaches children basic skills of interaction, for example. Music has long been used as a means to help foster certain states of consciousness in religious contexts. Perhaps this occurs because of a presumed similarity between aesthetic experience and religious experience. The long melodic elaborations of Gregorian chant, for example, are conducive to solemnity and a contemplative, peaceful frame of mind appropriate to religious devotion. The range of moving, triumphal affective feelings evoked in the "Hallelujah" chorus of Handel's *Messiah* is appropriate to the affirmation of the kingdom of the Lord.

Music can serve to integrate society by marking or celebrating significant events in the life of a community. Carnival signifies the last day for eating meat before Lent, while at the same time providing an opportunity for members of a community to come together under the light of a shared project for entertainment and merriment. In Philadelphia, upwards of 10,000 musicians and dancers celebrate New Year's Day with the Mummer's Parade, a day-long pageant of elaborate costumes and bands with the unlikely orchestration of saxophones, banjos, accordions, violins, upright basses, glockenspiels, and drums, bringing the city together in a display of civic, neighborhood, and ethnic pride. Funerals and weddings have their characteristic songs, dances, and pieces of music. Indeed, we know some of these tunes by their functional names as much as by their provenance. The third movement of Chopin's Piano Sonata No. 2 is "the funeral march;" the bridal chorus from Wagner's *Lohengrin* is "Here Comes the Bride." Elgar's "Pomp and Circumstance" has become the iconic processional music at graduation ceremonies to mark the value accorded to education and the pride one is entitled to take in finishing a course of study. The use of music to consecrate, celebrate, and glorify significant rituals and events seems near universal. In the ethnic minority cultures of the Tây Nguyen central highlands of Vietnam, gong music has for centuries betokened the animistic, agrarian, and ancestral aspects of traditional ethnic life, marking important points in the cycle of life such as birth, marriage, pregnancy, and death, as well as the planting and harvesting seasons and rituals in honor of ancestors. In all these ways music contributes to the stability of society.

Music may also induce behavior that can be construed as detrimental to society. Or it can serve integrative and disintegrative functions simultaneously. Some forms of acid rock of the 1960s encouraged detachment from society ("Turn on, tune in, and drop out," in Timothy Leary's formula), while simultaneously providing a cultural touchstone and a common music for members of the counterculture. This double function was accomplished in part by references to LSD and other drugs, and by the use of drones and long-form musical pieces (by the Beatles and other groups) that were especially congenial to the mental states of listeners under the influence. In both its integrative and disintegrative functions, music has affinities with sets of behaviors that Ellen Dissanayake calls "making special."[5]

[5] See Ellen Dissanayake, *What is Art For?* (Seattle: University of Washington Press, 1988).

Music can enhance personal relationships. Music has had a long history of playing a role in courtship and love. Orpheus charmed nymphs and retrieved Eurydice from the Underworld with his music; nowadays, youth trade iPod tunes. The songs learned at one's mother's knee may serve as a remembrance of maternal love. The "our song" effect may remind us of a past love relationship or even a current one.

Music may also have a healing or restorative function. Since ancient Greek speculations about the connection between musical modes and certain states of the soul, there have been many claims about the therapeutic effects of music. To be sure, many of these claims have been bogus, prompting Eduard Hanslick's sarcastic remark that "up to now no doctor has ever been known to send his typhus patients to Meyerbeer's *The Prophet* or to reach for a horn instead of the lancet."[6] As a matter of fact, however, practitioners in music therapy have used musical performance and improvisation, song writing, and listening as effective therapeutic interventions to deal with a variety of medical afflictions such as autism, Alzheimer's disease, brain injuries, and acute and chronic pain.

The restorative function of music also plays out in the public sphere. Elegies, dirges, and requiems for the dead have been staples of musical composition for centuries. In some instances, the music is expressly composed to memorialize individuals, as in the case of Purcell's *Music for the Funeral of Queen Mary*. Or the music may be part of a liturgical service as, for example, in the case of requiems. At a military funeral "Taps" signals the death of a soldier. A frequent feature of these compositions is slow, deliberate, and solemn music appropriate to a mournful, melancholic, or nostalgic frame of mind. But not all funereal music has a mournful cast. The traditional New Orleans funeral uses a slow, mournful dirge on the way to the cemetery, but breaks into lively tunes such as "Feel So Good" and "When the Saints Go Marching In" on the return trip, as an affirmation of a life lived. Nor need music in honor of the dead be expressly composed for the purpose. Samuel Barber's serene and heartbreaking "Adagio for Strings" helped millions of people cope with the deaths of Princess Grace of Monaco and US Presidents Franklin Delano Roosevelt and John F. Kennedy. The piece has become a virtual anthem of grief in America. The "Adagio" familiar to so many is in fact an orchestration of the *molto adagio* portion that begins the second movement of Barber's Op. 11, entitled simply, String Quartet in B minor. In all these cases, music serves both memorial and cathartic purposes, helping people to come to terms with the meaning of the ends of lives.

Music can also play an explicit role in the promotion of social and political action and this can occur in several guises. Music may discharge a cognitive function by marking or bringing to attention conditions that call for political action. For over 30 years, the African-American female a cappella

[6] Eduard Hanslick, *On the Musically Beautiful*, transl. Geoffrey Payzant (Indianapolis, IN: Hackett Publishing Company, 1986), p. 53.

group, Sweet Honey in the Rock, has been singing songs testifying to the history and traditions of African Americans and to the ideals of freedom and social justice. They are part of a vocal tradition in the African-American community dating back to the latter part of the nineteenth century. As Dr Bernice Johnson Reagon, founder and 30-year member of the group said:

It would just be very strange for Black people in the fifties and sixties to challenge racism within the communities of the South in which we lived and not be singing as we came together walking and talking about freedom. When you take a stand that puts your life at risk, you bring everything to it and singing, of course, is a cultural practice that is inseparable from the fact that you're involved in a fight for your life.[7]

In his 2002 State of the Union Address, President George W. Bush declared that North Korea, Iran, and Iraq "and their allies" constituted an "axis of evil," a group of states seeking weapons of mass destruction, sponsoring terror, and threatening the peace of the world. In 2004, Erik Hillestad produced a CD entitled, *Lullabies from the Axis of Evil*, containing lullabies sung by women from North Korea, Iran, Iraq, Afghanistan, Palestine, Syria, and Cuba.[8] These examples are part of a well-established tradition of promoting reflection on social and political states of affairs by means of the representational potential of music.

In some cases, the political significance may come by way of associated or acquired meaning, as in the case of Chopin's Piano Étude in C Minor, No. 12, Op. 10, now known by its nickname the "Revolutionary Étude" and which, legend has it, was written by Chopin in reaction to the failed Polish rebellion against Russian rule in 1831. It turns out, however, that the piece was probably composed a year before the rebellion. The name and the significance endure nonetheless.

In other cases, music is explicitly composed or performed to raise awareness of oppressive conditions. The blues have traditionally expressed not only feelings associated with loss, anomie, and alienation, but also the root causes of the conditions that land people in a world of trouble. The meanings may be subtly encoded as in the case of slave songs of the American South. Or the messages can be overt, as in the case of protest songs that highlight conditions of oppression and injustice. This use of protest songs is also well established. The fourteenth-century song "The Cutty Wren" expresses the sentiments of peasants in medieval England. Closer to our own time, we might think of Woody Guthrie's songs such as "So Long, It's Been Good to Know Ya" and "This Train is Bound for Glory," that have become rallying cries for advocates for oppressed people. Economic conditions, racial, ethnic, and gender discrimination, and militarism are frequent targets of such songs. "Ol' Man River," written by Jerome Kern and Oscar Hammerstein, ostensibly a song about the mighty Mississippi, is also a song about the hardships of the life of black people in the Mississippi delta.

[7] "Sweet Honey in the Rock," PBS national broadcast, June 29, 2005.
[8] *Lullabies from the Axis of Evil*, Valley Entertainment, VLT-15187.

Ah gits weary,
An' sick o' tryin',
Ah'm tired o' livin',
And skeered o' dyin',
But Ol' Man River,
He jes' keeps rollin' along.

The song became especially well known in the hands of African-American bass-baritone and civil rights activist Paul Robeson. The song "Strange Fruit" is the story of a lynching in the American South that has received haunting renditions by the singers Billie Holiday and Nina Simone. Another castigation of American racism can be heard in Neil Young's, "Southern Man." Jamaican Bob Marley's 1973 reggae song, "Get Up, Stand Up," is a message of social protest, pride, and Rastafarian faith in the face of oppressive social, economic, and political conditions. Music played an important role in the anti-Vietnam War protests of the late 1960s and 1970s, with such world-wide hits as Yusuf Islam's (aka Cat Stevens's) "Peace Train," John Lennon's "Give Peace a Chance," Joni Mitchell's "One Tin Soldier," and Edwin Starr's "War—What is it Good For?," which became veritable anthems of a generation. Hip hop and rap music express some of the concerns of urban blacks, especially concerning matters of urban crime and racism, as do many of the songs of Stevie Wonder such as "Living for the City" and "You Haven't Done Nothing," and the song cowritten with Paul McCartney, "Ebony and Ivory."

Music that confronts social issues by arousing awareness may itself also be regarded as morally or politically symbolic action. There are general examples of this, as in the case of music that serves to affirm national, geographical, and institutional identities and the narratives that are thought to express the ethos of the collective. We see this in national anthems such as "Marseillaise," "God Save the Queen," "The Star Spangled Banner," or the ANC national anthem "Nkosi Sikelel' iAfrika," as well as in official state songs such as "My Old Kentucky Home." It is no coincidence that people stand as a gesture of public display when these pieces of music are performed. In some cases, traditions of ethnic or national musics are preserved explicitly as a bulwark against the encroachment of invasive cultures. This is true of the music of many Native American cultures. The Flathead and Blackfoot, for example, steadfastly maintain certain aspects of their vocal styles even though so many other aspects of their life have become Westernized. Some musical pieces such as "God Bless America," Aaron Copland's "Fanfare for the Common Man," and "Deep in the Heart of Texas," do not have official sanction but drift into iconic status. They are no less powerful in the effects that they have. And, in some cases, the political action of music is quite direct and straightforward, as in the case of war songs and dances.

Sometimes the moral force of music is directed at particular events or situations. On August 15–17, 1969, over 400,000 music fans camped out at Max Yasgur's farm in Bethel, New York, to attend the Woodstock Festival, billed as "Three

Days of Peace and Music." Woodstock, which was the largest rock concert the world had seen, was a celebration of youth counterculture and a protest against the Vietnam War. On July 13, 1985, Live Aid, the largest multi-site rock music concert in the world occurred on stages in London and Philadelphia, attended by 72,000 and 90,000 people respectively, with other, smaller, concerts held in Sydney, Moscow, and elsewhere. The event, conceived by Bob Geldof, was simulcast to an estimated 1.5 billion viewers in over 100 countries and raised nearly $250 million for famine relief in Ethiopia. Twenty years later, on July 6–8, 2005, Geldof staged another multi-site concert, Live 8, timed to coincide with the meeting of the G8 nations in Scotland and to urge the leaders of the G8 countries to increase aid to the world's poorest nations. In 1939, the Daughters of the American Revolution refused permission for the distinguished African-American contralto Marian Anderson to sing at the whites-only DAR Constitution Hall in Washington, DC. Anderson's performance later that year on the steps of the Lincoln Memorial at the invitation of First Lady Eleanor Roosevelt, to an audience of 75,000 and millions of radio listeners, was a repudiation of the segregationist and racist policies of the DAR and the United States. Anderson recalled in an interview years later, "I was naturally concerned about how the voice might sound and how the whole performance would come off. But that seemed to be secondary as far as many of the people who were there were concerned. They were there because a principle was involved and they wanted to show on what side of the fence they stood."[9] The performances of folk singer Pete Seeger were politically charged enough that in 1955 Seeger was subpoenaed to appear before the United States House of Representatives Un-American Activities Committee, where he was repeatedly questioned about whether he had sung the songs "Wasn't That a Time" and "If I Had a Hammer."

There is, finally, also the view that the political threat of music comes, not from its potential to goad political action, but, to the contrary, from its soporific effects that can lead to political apathy. This view, too, was voiced in both ancient Greece and in more recent times. Vladimir Lenin, on listening to a Beethoven sonata, is reported by Maxim Gorky to have said, "I can't listen to music very often, it affects my nerves. I want to say sweet, silly things and pat the heads of people who, living in a filthy hell, can create such beauty."

If we pause to take stock of what has been said so far, we can see that music, as a matter of fact, does often participate functionally in a wide variety of contexts in the moral domain. We see that music is frequently regarded as reflecting and affecting moral conditions, as regulating behavior in the service of supporting social norms, and of integrating the social fabric by reinforcing the sense of community and identifying key cultural values and activities of a culture, by enhancing interpersonal relations, by providing a healing or restorative function in times of sorrow or anxiety, by identifying social problems, and by encouraging action to address those problems.

[9] See <http://www.metoperafamily.org/_post/education/marian-anderson/html/early_career.htm>.

3. FEATURES OF MUSIC THAT CAN CONTRIBUTE TO THE MORAL LIFE OF CULTURES

As has been shown, music very frequently—perhaps most frequently—is not alone. Rather, it is married to activities—such as rituals, processions, marches, and work—and events—like coronations, weddings, funerals, and other rites of passage—as well as frequently being supplemented by programs, song, recitals, and dance—reverential, lyrical, epic, or otherwise narrative—and drama, theatrical, cinematic, and televisual. Even the austere musical formalist will concede that when music is accompanied by fellow travelers of this sort, it possesses the referential apparatus required to enter the conversation of morality and to contribute to the ethical life of cultures. Helping ourselves to elements from the philosophy of mind and recent cognitive science, let us now examine—albeit non-exhaustively—some of the ways in which music is able to do this.

As may be readily observed, most music has a pulse that induces feelings of movement in listeners. This may even manifest itself in tapping, or clapping, or snapping our fingers in concert with the beat. In the field of popular music, James Brown (the Godfather of Soul) was a master of creating music of this sort by accentuating the first and third beats of the measure and insuring that all the supporting horn parts were crisply rhythmical. But nearly all music exhibits features of arsis (lifting) and thesis (lowering). Think, for example, of the cumulative effect of Ravel's *Boléro*. This commonplace observation would appear to have a biological basis. Scientists using neural scans have noted that when people listen to classical music, the cerebellum, a region of the brain connected to movement, reacts.[10] Most probably, this is related to the movement impulses we feel in our muscles in response to the pulse of the music.

If we are walking, we may tend to walk in time to the music. (One musical term that stipulates that a passage be played at moderately slow tempo—*andante*—is actually derived from the Italian *andare*, to walk.) Furthermore, our responses to the pulse of the music quite often converges with the responses of others and can easily be coordinated with theirs. William H. McNeill calls this "muscular bonding."[11] This, of course, is the basis for processions (ritual, political, and otherwise), social dancing, marching, and much else. That is, by organizing and moving through time in the way that it does, music can be dragooned into the service of morally significant cultural projects where it functions to coordinate the concerted activities of the participants. For example, the music at weddings, such as the wedding march, reaffirms the marital bonds of the couple as they march in time to it.

[10] See "Music of the Hemisphere" by Cove Thompson in the *New York Times*, The Arts and Leisure Section (Sunday, December 31, 2006), p. 26. See also Daniel J. Levitin, *This is Your Brain on Music: The Science of a Human Obsession* (New York: Dutton, 2006).

[11] William H. McNeill, *Keeping Together in Time* (Cambridge, MA: Harvard University Press, 1995).

But music does not only activate convergent movement impulses. It also stimulates sectors of the brain connected with affect.[12] Music can incite a common mood among listeners, thereby promoting shared fellow feeling amongst the group.[13] This again contributes to the cohesion and solidarity of the listeners who, sharing mood-like feelings, are to a certain extent thereby being prepared emotionally to act in concert to achieve certain aims. In a manner of speaking, the music may not simply abet the coordination of group activities, but lubricate them affectively. A bugle charge not only unleashes feelings of rapid, forward propulsion, but ideally infects the cavalry squadron or the football team with a sense of ebullience. That is, the music can evoke a level of charged emotive bonding.

Moreover, the music can encourage converging moods not only in virtue of its rhythm. The melodic profile may play a role as well. Even before they are able to understand their caregiver's language, infants are able to detect the caregiver's mood in large measure through the sonic properties of his or her voice. Whether she is up or down can be gleaned from the sound. Thus, when the mother is anxious, the child is as well. In addition, it seems probable that the caregiver's voice is serving to cue some sort of automatic process of inner mimesis in the infant, since so much else of the communication between the infant and the caregiver is based on mirror reflexes.

And, perhaps needless to say, music can tap into this reflex capacity and build upon it as well, as in the case where the group is drawn together in common sorrow and gloom by the sound of a dirge such as the *Dies Irae*. An ethical community is a community of feeling, and music can function as an important ingredient to confect shared sentiment.[14]

But not only does certain music trigger the affective regions of the brain; it can also awaken neural sites linked to reward in terms of pleasure and displeasure.[15] So the socially enabling fellow feeling spread across the group by means of music can be further experienced as pleasurable, thereby reinforcing the cohesiveness of the group even more intensively in ways that enhance the prospects of the purposes of group undertakings of morally significant projects.

Among tribal peoples, this might have taken the form of hunting dances and war dances. In modern times, this phenomenon of "muscular bonding" (as

[12] See Levitin, *This is Your Brain on Music*.

[13] Noël Carroll, "Art and Mood," *The Monist*, 86/4 (October, 2003): 521–55.

[14] In some cases, the relation of the music, even music with song, to affect may not be a matter of arousal. Rather, the music may simply exhibit or manifest or embody a certain emotive profile—such as sadness—without provoking it in listeners. In such cases, some philosophers of music prefer to say that the music in question is *expressive of* sadness (where the concept of expression is narrowly construed and stands in contrast to the notion of *arousing* sadness). When music is expressive in this sense, it may nevertheless still perform important functions in the ethical life of a culture in a number of ways, by providing a common symbol for socially significant, including moral, emotions (as, for example, in "Auld Lang Syne") and/or by affording more information about or annotating culturally significant ideas by supplementing or matching the lyrics with the appropriate affective profiles (as occurs in cases of what is called text-setting).

[15] See Levitin, *This is Your Brain on Music*, and Robinson, *Deeper Than Reason*.

facilitated by music) is readily observable in military marches and close order drill. But we need not restrict our examples to warlike endeavors. The bonding magic of music is widely evident with respect to communal dancing during festivals and public celebrations, as we have seen in the cases of musical parades and pageants.[16]

So far, we have been talking about the service music plays in regard to one of the most fundamental ethical functions of culture—fostering the feelings of cohesion among a people. This is an ethical function because, without this, there is no ethos, no ethical life.

Moreover, as we have already noted, once we add words to the account, the roles music performs in the creation of the ethical life of peoples becomes unmistakable. For many people, the very word "music" first brings to mind *song*. What song adds to absolute music is not only voice, with its affective contours, but also propositional content. Thus, song can invest the sonic array with precise emotional direction and shading. For song can supply the affective states, vaguely suggested by the music alone, with appropriate objects of moral significance.

In hymns, the object may be God and His grandeur ("Holy God We Praise Thy Name") or the Blessed Virgin Mary ("Ave Maria") and the singing may inspire exaltation. Or the object can be the nation and what it stands for ("This Land is Your Land"). Songs can endorse commitments—for example, "The Battle Hymn of the Republic" or "Over There"—and then the words and the music can conspire to articulate the evaluative attitude that the songwriters intend to be brought to said endeavors. In such cases, the lyrics refer to the objects of the affects at issue and also help set forth the emotion the authors of the song mean to be directed toward the relevant objects, while music and voice further color and inflect that emotion ever more finely.

Through songs, the makers of music can endorse and underwrite mores. Songs can glorify certain moral aims, as in "Soldier Boy" which calls for overthrowing "the despot and the knave." Or they may recommend certain morally significant ethical stances, as do many African-American spirituals and gospel songs—such as "Amazing Grace" and "We Shall Overcome"—which counsel the persistence of hope for a better future.

Because songs have propositional content, they can pick out a state of affairs and comment upon it. As is often remarked, language alone does not have enough words for all the subtle, imaginable variations in emotional states. Nevertheless, in song, music can make the pertinent emotions more concrete, specific, and definite by arousing feelings in the movement and affective centers of the brain, which then transmit vibrations with distinctively associated moods (such as euphoria and dysphoria) into our musculature. In this way, songs can infect listeners with very powerful and vivid emotions that can have ethical significance. For example, song can communicate an accusatory sense of moral indignation that grabs the

[16] Barbara Ehrenreich, *Dancing in the Streets* (New York: Metropolitan Books, 2006).

body as well as the mind, as in the case of "Brother Can You Spare a Dime?," which expresses a poignant recollection of better times and a plea for help in a languid, chromatic melody in a minor key.

Songs, including perhaps especially popular ones, also help educate our emotions regarding many of the recurring events and passages in life: they express for us the experiences of loss, betrayal, ageing, love, anger, resolution, and so forth. They enable us to organize and cultivate our life of feeling, for we not only listen to them, but sometimes sing along aloud, or by ourselves, or replay them in our head imaginatively for our mind's ear. In this way, songs may give us a handle on our emotions. Moreover, this is ethics in the broad sense of the term that Aristotle had in mind—that is, *ethics* as it encompasses the whole of life. For it is the emotions that imbue our lives with meaning or significance, and songs are a major cultural vehicle for giving our feelings shape and definition.

When music is added to words, it helps to clarify their meaning or, perhaps more accurately, their *significance*, by giving the message a certain emotional heft or weight—by annotating it, so to speak. The music modifies what is exclaimed with certain feeling tones (or tunes), while, at the same time and reciprocally, the words help make the attitude more pointed, directing it, as they do, toward a specific object. Thus, the importance of the moral claims, articulated in Copland's *Lincoln Portrait*, are revealed to be monumentally earnest by the music that echoes their pronouncement.

As we have seen, songs can be joined with movement, including processions, marches, rituals, and social dances of indefinitely large numbers of kinds and variations. When bodily movement, word, and music are mobilized together for a concerted effect in this way, so many dimensions of the person are engaged that the resulting states of bonding and affective affiliation can be nearly irresistible. That is why song, together with dance and other sorts of movement, may be regarded as a kind of a primal social cement.

Song not only functions to coordinate people in body and spirit; it is also an effective lever for educating people in the ethos of their culture.[17] Song imprints—sometimes indelibly—the tenets of a group on the memories of its members.[18] When a song lodges itself in our head, it is hard to shake. That is why song is such an efficacious teaching tool. How many of us still use the song

[17] The combination of music with words also, among other things, may imbue the ideas being transmitted with an additional layer of information. For, where the music projects or expresses an affective or emotive contour that reinforces or is appropriate to the message in the verbal text, the ideas at issue are more specific, precise, and, for that reason, comprehensible. This too is a reason why music is scarcely dispensable as an educational means toward broadcasting the ethos of cultures.

On the relation of expression and text-setting, see Peter Kivy, *The Corded Shell: Reflections on Musical Expression* (Philadelphia, PA: Temple University Press, 1980).

[18] This may include the encoding of mystical tenets, as in the case of some Javanese gamelan music. See, for example, Susan Pratt Walton, "Aesthetic and Spiritual Correlations in Javanese Gamelan Music," *The Journal of Aesthetics and Art Criticism*, 65/1 (winter, 2007): 38.

we learned in our earliest school days in order to recall the alphabet? Songs are mnemonic devices.

This has been known since the ancients. The epics of the Greek and Indian civilizations, for example, were sung. The musical patterns, amplified by sonic devices like meter and rhyme, made the stories of the founding fathers memorable.[19] Moreover, these songs themselves propounded the values of the relevant cultures in arresting, gripping images. Virtues were not catechized abstractly but dramatized, exemplified in the epic songs about heroes, such as Rama. This, as in the case of narrative songs across the board, makes the moral of the message more generally accessible and unambiguous, since vivid imagery—in the form of concrete examples—is usually better at rendering converging moral responses and understanding than the enunciation of abstract principles.[20] Thus, the moral education disseminated by song—which can be found worldwide and transhistorically—serves the moral life of peoples by deeply ingraining the ethos of their culture in their very being where it is readily available for retrieval, guidance, and application.

Whereas the aesthetical purist prefers to compartmentalize different channels of communication—such as word, image, music, sound, and sense—culture opts to integrate its address simultaneously to the body, mind, perception, imagination, and memory of its members by means of frequently overlapping, redundant, and mutually reinforcing lines of attack. Redundancy is favored in the dissemination of cultural information, including moral messages, for several reasons, including: (first) should one approach fail to hit its target, it is a good insurance policy to have backup; (second) reinforcement across several reinforcing dimensions makes retrieval more likely as, for example, when the tune calls up the associated idea; and (third) repetition, despite its bad reputation, works when it comes to getting a message to stick in the mind.

Cultures, including their moral and ethical dimensions, are in the business of reproducing themselves—of surviving from generation to generation. This requires the constant re-circulation of its animating ideas, mores, and feelings. We hypothesize that, if the arts were not initially evolved to acquit this function, they certainly in the course of history came to have the dissemination of the ethos of peoples as a central purpose. As well, this function is very often most effectively pursued by integrating several artistic channels toward the same end. That is perhaps why cinematic and televisual *gesamkunstwerkes* are a leading source of moral influence in the contemporary world, and why song, dance, and music are so often found together in earlier cultures—and, we wish to emphasize, in our own.

Culture does not characteristically fetishize the arts as valuable for their own sake, but uses them to achieve its ends, of which moral ones are

[19] See David C. Rubin, *Memory in Oral Traditions* (Oxford: Oxford University Press, 1995), especially Ch. 4.
[20] Chip Heath and Dan Heath, *Made to Stick* (New York: Random House, 2007).

among the most pressing. A central question for the philosopher of music then becomes: how can music do this? In this chapter, we have catalogued some of the more obvious ways in which music can implement these functions. But, admittedly, we have only begun to scratch the surface of this topic.

Index

Index